REMBRANDT AND THE FACE OF JESUS

Rembrandt

and the Face of Jesus

EDITED BY

LLOYD DEWITT

WITH A PREFACE BY

SEYMOUR SLIVE

AND CONTRIBUTIONS BY

LLOYD DEWITT, BLAISE DUCOS, FRANZISKA GOTTWALD,
GEORGE S. KEYES, SHELLEY PERLOVE, LARRY SILVER,
KEN SUTHERLAND, AND MARK TUCKER

PHILADELPHIA MUSEUM OF ART
MUSÉE DU LOUVRE, PARIS
DETROIT INSTITUTE OF ARTS

IN ASSOCIATION WITH

YALE UNIVERSITY PRESS

NEW HAVEN AND LONDON

Published on the occasion of the exhibition *Rembrandt and the Face of Jesus*

Organized by the Philadelphia Museum of Art, the Musée du Louvre, Paris, and the Detroit Institute of Arts

Organizing curators: Lloyd DeWitt, Blaise Ducos, and George S. Keyes

Musée du Louvre, Paris, April 21 to July 18, 2011

Philadelphia Museum of Art, August 3 to October 30, 2011

Detroit Institute of Arts, November 20, 2011, to February 12, 2012

In Philadelphia, the exhibition was supported in part by The Pew Charitable Trusts and The Robert Montgomery Scott Fund for Exhibitions. Additional support was provided by Lois G. and Julian A. Brodsky and other generous individuals, and by a grant for conservation from the Samuel H. Kress Foundation.

In Detroit, the exhibition was supported in part by the Michigan Council for Arts and Cultural Affairs, National Endowment for the Arts, and the City of Detroit.

This catalogue was made possible by The Andrew W. Mellon Fund for Scholarly Publications at the Philadelphia Museum of Art and by Furthermore: a program of the J. M. Kaplan Fund.

Front cover: Detail of *Head of Christ*, c. 1648–56, Philadelphia Museum of Art, John G. Johnson Collection (see plate 2.2)
Back cover: *Head of Christ*, c. 1655, Netherlands Institute for Cultural Heritage, on loan to Bijbels Museum, Amsterdam (top left; see plate 2.3); *Head of Christ*, c. 1648–56, private collection (top center; see plate 2.4); *Head of Christ*, c. 1648–56, Harvard Art Museum/Fogg Museum, Cambridge, Massachusetts (top right; see plate 2.5); *Head of Christ*, c. 1648–50, Gemäldegalerie, Berlin (bottom left; see plate 2.6); *Head of Christ*, c. 1648–54, Detroit Institute of Arts (bottom center; see plate 2.7); *Head of Christ*, c. 1648, Museum Bredius, The Hague (bottom right; see plate 2.8)
Pages ii–iii: Detail of *The Hundred Guilder Print*, c. 1649, The Metropolitan Museum of Art, New York (see plate 1.2)

Produced by the Publishing Department
Philadelphia Museum of Art
Sherry Babbitt, The William T. Ranney Director of Publishing
2525 Pennsylvania Avenue, Philadelphia, PA 19130 USA
www.philamuseum.org

Published by the Philadelphia Museum of Art
in association with Yale University Press
P.O. Box 209040
302 Temple Street
New Haven, CT 06520-9040
www.yalebooks.com/art

Edited by David Updike
Production by Richard Bonk
Designed by Katy Homans
Index by Mary Gladue

Color separations, printing, and binding by Conti Tipocolor S.p.A., Florence, Italy

English-language text and compilation © 2011 Philadelphia Museum of Art

French-language text and compilation © 2011 Musée du Louvre

The book was published in French as *Rembrandt et la figure du Christ* by Musée du Louvre éditions, Paris, and Officina Libraria, Milan.

LIBRARY OF CONGRESS CATALOGING-IN-PUBLICATION DATA

Rembrandt Harmenszoon van Rijn, 1606–1669.
Rembrandt and the face of Jesus / edited by Lloyd DeWitt ; with contributions by Lloyd DeWitt ... [et al.].
p. cm.
Published on the occasion of the exhibition held Apr. 21–July 18, 2011, Musée du Louvre, Paris, Aug.–Oct., 2011, Philadelphia Museum of Art, Philadelphia, and Nov. 2011–Feb. 2012, Detroit Institute of Arts, Detroit.
Includes bibliographical references and index.
ISBN 978-0-87633-227-6 (PMA : cloth) — ISBN 978-0-87633-228-3 (PMA : pbk.) — ISBN 978-0-300-16957-7 (Yale)
1. Rembrandt Harmenszoon van Rijn, 1606–1669—Exhibitions. 2. Rembrandt Harmenszoon van Rijn, 1606–1669—Criticism and interpretation. 3. Jesus Christ—Art—Exhibitions. 4. Jesus Christ—Face—Exhibitions. I. DeWitt, Lloyd. II. Musée du Louvre. III. Philadelphia Museum of Art. IV. Detroit Institute of Arts. V. Title.
ND653.R4A4 2011
759.9492—dc22
2010039892

CONTENTS

TO THE MEMORY OF WILLEM K. DIKLAND (1943–2008),

WHOSE EARLY SUPPORT AND VISION HELPED MAKE THE RESEARCH

FOR THIS PROJECT POSSIBLE

Foreword

Rembrandt van Rijn's religious scenes are striking for their originality, dramatic power, and range of emotional intensity. In representing Jesus, the subject of so many of these works, the artist at first faithfully followed the precedents found in Netherlandish and Italian art. In mid-career, however, Rembrandt took a radical turn away from tradition by using a living model—remarkably, probably a young Jewish man from the artist's neighborhood—to generate the series of small, sketch-like oil studies of the face of Jesus that form the core of this exhibition. For the first time in more than 350 years, the surviving panels, traditionally ascribed to the artist, have been reunited in this international exhibition that explores Rembrandt's revolutionary accomplishment.

Our own project began to crystallize in 2006 with Peter Klein's dendrochronological analysis of the painting now in the collection of the Philadelphia Museum of Art. His examination of the tree rings in the Philadelphia *Head of Christ* panel demonstrated that it had likely been expanded into a larger, more finished work of art during the seventeenth century, much earlier than was previously thought. As a consequence, a discussion that had begun a decade earlier between curators in Philadelphia and Detroit about reuniting the surviving sketches was renewed. Joseph J. Rishel, The Gisela and Dennis Alter Senior Curator of European Painting before 1900 at the Philadelphia Museum of Art, encouraged a critical collaboration with the Musée du Louvre, home of Rembrandt's great *Supper at Emmaus* of 1648. The artist is thought to have used the same Jewish model as the source of inspiration for the central figure of Christ in this deeply meditative image as well as in his *Hundred Guilder Print* of the following year. The surviving panels depicting the face of Jesus form a "penumbra" around these two important works, and we are exceptionally fortunate to be able to include both of them in the exhibition and catalogue, where their relationship with the panels can be fully explored.

One major goal of this exhibition, so ably guided by the co-organizing curators from our three institutions—in Philadelphia, Lloyd DeWitt, Associate Curator of European Painting before 1900; in Paris, Blaise Ducos, Curator in the Département des Peintures; and in Detroit, George S. Keyes, Curator Emeritus of European Paintings—joined in their explorations by Mark Tucker, the Philadelphia Museum of Art's Aronson Senior Conservator of Paintings, has been to compile and share new technical information about the small panels of the head of Christ to foster a better understanding of this pivotal moment in Rembrandt's career and to clarify its significance. This goal has been augmented by the analysis and conservation of the Louvre's *Supper at Emmaus*, directed at the Centre de Recherche et de Restauration des Musées de France (C2RMF) in Paris by Bruno Mottin and Pierre Curie, and the restoration work carried out by Isabelle Leegenhoek. Thanks to their efforts, the experience of this masterpiece itself promises to be a revelation for the visitor.

We are especially grateful to the international team of scholars who contributed to the catalogue. Seymour Slive's groundbreaking 1965 article on the heads of Christ marked the Fogg Art Museum's acquisition, under his direction, of their example from this series. His article forms the point of departure for the present project, and we are deeply thankful to Professor Slive for providing a preface to our catalogue. In the essays, Keyes places the works in the context of Rembrandt's long career as a painter of religious subjects; Tucker, DeWitt, and Philadelphia Conservation Scientist Ken Sutherland present their technical investigation of the series; Larry Silver and Shelley Perlove explore the role of faith in Rembrandt's art; Franziska Gottwald discusses where the panels of Christ fit within Rembrandt's novel use of models and sketches; and Ducos examines the role of the Orient in Rembrandt's redefinition of the figure of Christ. We join them in hoping that this volume will provide a touchstone for further scholarship on these provocative paintings.

The generosity of our lenders has provided for rare and revealing comparisons around major themes in Rembrandt's religious art, such as the *Supper at Emmaus* from the Louvre and fascinating workshop versions from the Statens Museum for Kunst and the Louvre, as well as many drawings of the same subject, all showing Rembrandt refining his conception of the subject and encouraging his students to experiment further with it. We are enormously indebted to the many institutions and private individuals who have so generously agreed to part with their precious works of art to make this international touring exhibition a reality.

The portrait of Rembrandt that emerges from this exhibition is one of an artist deeply engaged with past and present, enmeshed both in the long history of Christian art and in the extraordinary dialogue between Christians and Jews taking place in Amsterdam at the very time he conceived of his radical new image of Jesus. It is our hope that the exhibition and catalogue will open new avenues along which to explore these and other relationships surrounding this pivotal moment in Rembrandt's career, when his artistic inventiveness, his searching spirituality, his role as a teacher, and his place in cultural history all intersected.

Most of all, we hope that viewers will be drawn to contemplate Rembrandt's intensely personal artistic engagement with the image of Christ as reflected in this remarkable group of works, brought together again after three and a half centuries.

Henri Loyrette
Président-directeur
Musée du Louvre, Paris

Timothy Rub
The George D. Widener Director and Chief Executive Officer
Philadelphia Museum of Art

Graham W. J. Beal
Director, President, and Chief Executive Officer
Detroit Institute of Arts

Preface

Seymour Slive

In July 1656 it was clear to Rembrandt that he was on the verge of bankruptcy. This sad fact made him apply on July 14 to the Supreme Court in The Hague for a *cessio bonorum*, a writ that would enable him to sell voluntarily his property and movables, with the proceeds to be distributed among his creditors. The arrangement, in turn, would give him the court's protection against all further claims and harassment by his creditors. The court approved his petition. Its positive response enabled him to avoid outright bankruptcy.

Subsequently the court moved swiftly. On July 24–25 an inventory was made, under its supervision, of the contents of his great Amsterdam house on St. Antoniesbreestraat (now the home of the Museum het Rembrandthuis, Jodenbreestraat 4–6). Almost everything he owned is listed in the inventory—even his pots and pans and handkerchiefs at the laundry—but not the equipment he used for his paintings and etchings. Dutch quasi-bankrupts, like outright ones, were allowed to keep tools of their trade.

Additionally, the inventory offers a precious glimpse of Rembrandt's huge, encyclopedic collection, which included sculpture, a number of paintings and works on paper by Italian Renaissance and Baroque masters, and even more by early and later Netherlandish artists. Both the size and variety of his collection suggest that a passion to possess what he found of special interest on Amsterdam's lively art market helps account for his disastrous financial situation.

Of course the inventory also includes the vast number of the artist's own paintings, drawings, and etchings that were in studios and other rooms of his large house. Among the paintings in the room identified as "behind the parlor," which was his bedroom, were two by our artist of heads of Christ (no. 115, *Een Cristi tronie van Rembrant*; no. 118, *Cristus tronie van Rembrant*). Included in the list of works in his small studio is an unattributed "Head of Christ, done from life" (no. 326, *Een Cristus tronie nae 't leven*).

When the well-informed London dealer C. J. Nieuwenhuys first published the 1656 inventory from the original manuscript in 1834 he was baffled by the reference to *Een Cristus tronie nae 't leven*. Nieuwenhuys placed an interrogation mark after his translation of it. We can almost hear him ask incredulously: "How is it possible to paint a portrait of Christ from life?" In 1836, in his pioneering catalogue raisonné of Rembrandt's paintings, John Smith included a translation of the inventory and likewise had difficulty with the item. Smith incorrectly rendered it as "A Head of Christ, of the size of life." Three years later the Dutch art historian J. Immerzeel published the original Dutch text of the entire inventory. He did not know what to make of the description either. Immerzeel resolved the problem by ignoring it: He shamelessly deleted *nae 't leven* from his transcription.

We are no longer vexed by the entry. It is common knowledge among the Dutch and people who work with seventeenth-century texts that *nae 't leven* (*naar het leven*) means "after life" or "from

nature." Today there is universal agreement that the item that troubled early nineteenth-century specialists refers to a painting for which a live model was used for the head of Christ.

A major component of the present exhibition is the group of unsigned studies of the head of Christ (see pages 30–68). All are virtually the same size and are painted on oak panels. They appear to be inspired by the same model, the one who sat for the artist as he worked from life. Each study concentrates upon the model's head seen against a neutral background. Attitudes and expressions vary to show aspects of Christ's character: his humility, his mildness, his vulnerability, and his inner preoccupations.

Most probably we will never know if any of the existing studies are identical with those cited in the inventory, but the hypothesis that some are is not improbable. This is the very first time the existing heads of Christ have been mounted in an exhibition as a group (the inclusion of the panel now in the Museum Bredius, The Hague [cat. 30], was uncertain when the catalogue went to press). The wider public will recognize immediately that they are closely related to Rembrandt's mature Christ-type. As their earlier attributions have not been uniformly compelling, hopefully their juxtaposition in this show will stimulate interested visitors to consider which were painted by the master and which, if any, are by an exceptionally gifted member of his workshop.

The organizers of the exhibition must be credited with establishing another precedent: Never before have so many of Rembrandt's finest paintings, etchings, and drawings that depict Jesus Christ and events of his life been assembled for an exhibition. Masterwork after masterwork in every medium he employed is included. They represent every phase of his activity, from his juvenilia to his full maturity, and range from lightning-quick sketches that are first thoughts or aide-mémoires for future pictures to works he considered finished (Rembrandt is reputed to have declared: "A piece is finished when the master has achieved his intention").

It is hard to suppress the feeling that the laudable effort of the organizers of Rembrandt and the Face of Jesus would have pleased the master himself. Judging from his existing oeuvre, religious pictures were closest to his heart, and as authors of the catalogue's essays demonstrate, Jesus was his favorite protagonist. Thanks to Rembrandt's predilections, visitors to the exhibition and readers of the catalogue will be treated to inordinate pleasure and find very much to contemplate.

Acknowledgments

The organizers of the exhibition would like to thank the many individuals and institutions whose help and support made *Rembrandt and the Face of Jesus* a reality. We are especially indebted to the late Willem K. Dikland, who lent his support to the research at an early stage, shortly before his untimely passing in November 2008.

In Philadelphia, the unwavering faith shown by the Museum's late director, Anne d'Harnoncourt, and her successor, Timothy Rub, has sustained this project since its inception. In the Department of European Painting at the Philadelphia Museum of Art, we thank Joseph J. Rishel for his advice, tireless support, and encouragement. Carl Strehlke and Jennifer Thompson have been constant sources of guidance and support. Our special thanks go to Mark Castro, who assisted with many aspects of the exhibition, provided the thoughtful and comprehensive Chronology, and devoted his care to the exhibition checklist. Mark gathered photographs, as did Jennifer Vanim, who also attended to travel and research needs. Cathy Herbert has been very helpful on provenance issues. Director of Special Exhibitions Suzanne F. Wells and her assistant Zoë Kahr (and her successor Eliza Johnson) have turned the project from idea to reality. In the Museum's Publishing Department, a great salute is owed to Sherry Babbitt, who steered this publication project with enthusiasm and grace, and especially David Updike, our editor, for his boundless patience and uncommon ability. We thank Richard Bonk for accommodating our photographic ambitions for this catalogue and Katy Homans for creating the elegant design. In the Conservation Department, we are very grateful to Mark Tucker and Ken Sutherland, whose intensive research on the core group of panels forms the nucleus of the exhibition and catalogue. We are also grateful to Beth Price and Jo-Fan Huang for their contributions to the technical research. The production and calibration of images of the panels occurred under the purview of the Conservation Department's photographer Joe Mikuliak and photography technician Steven Crossot. In the Museum Library, Mary Wassermann and others indulged us in our constant need for obscure publications. In the Education Department, we thank Marla Shoemaker, Mary Teeling, and Victoria Conte for their work in bringing the exhibition to the public.

In Paris, numerous colleagues at the Musée du Louvre have been instrumental in this project. Président-directeur Henri Loyrette has been an enthusiastic proponent of the exhibition. Vincent Pomarède, head of the Département des Peintures, has been steadfast in his support, as has Juliette Armand, head of the Direction de la Production Culturelle. Soraya Karkache and Pascal Perinel guided the exhibition in Paris, and Violaine Bouvet-Lanselle and Camille Sourisse worked tirelessly to coordinate the French edition of this book, in collaboration with Marco Jellinek and Paola Gallerani of Officina Libraria in Milan. Carel van Tuyll van Serooskerken has been exceptionally helpful with the drawings, and a number of loan problems as well. At the Centre de Recherche et de Restauration des Musées de France (C2RMF) in Paris, Bruno Mottin and Pierre Curie were especially generous with advice and access to works of art and results of new research.

At the Detroit Institute of Arts, enthusiastic support was provided at the earliest stages

by director Graham W. J. Beal. We are indebted for our technical analysis to Cathy Selvius DeRoo and Alfred Ackerman of the Conservation Department for providing materials and advice. Salvador Salort-Pons, Associate Curator of European Paintings, and Amy Hamilton Foley, Exhibitions Manager, offered additional exhibition assistance.

Many colleagues on both sides of the Atlantic were extremely generous with their time and expertise. We are deeply grateful to Ernst van de Wetering of the Rembrandt Research Project for consulting with us at key moments and for sharing unpublished material. We were very fortunate to have the ear and research assistance of Michiel Francken, Rudi Ekkart, Charles Dumas, and others at the Rijksbureau voor Kunsthistorische Documentatie in The Hague. We wish to thank also Volker Manuth of Radboud University in Nijmegen, who lent his thoughts. Peter Schatborn is to be singled out for his frank advice and very sensitive and thorough appraisal of our materials. We are especially grateful for the involvement of Peter Klein, whose dendrochronological analysis of the Philadelphia panel was a starting point of our project, and who generously traveled to other museums to broaden what we know about the supports and creation of the works.

In North America, we are especially grateful to Alfred Bader of Milwaukee for his continued interest, input, and help with loans, as well as his sponsorship of the international conference at Herstmonceux in England in 2009, which enabled us to present the project and consult with so many colleagues at a crucial moment. David DeWitt of the Agnes Etherington Art Centre in Kingston, Ontario, has been a continual source of advice and translation help. We thank Martha Peacock of the Museum of Art at Brigham Young University in Provo, Utah, who along with Larry Silver of the University of Pennsylvania in Philadelphia helped shape our conception of the exhibition; both have played a continuing role in its realization. At the Museum of Art at Brigham Young University we also thank Emily Poulsen and Campbell Gray, who were exceptionally generous with their time and resources. Gajus Scheltema and Ferdinand Dorsman of the New York Consulate of the Kingdom of the Netherlands have lent their aid at crucial points. At the Hyde Collection in Glens Falls, New York, we are indebted to David Setford and Erin Coe, who shared their expertise and gave us access to valuable records from an exhibition celebrating their Rembrandt *Christ with Arms Folded* many years ago. At the Bob Jones University Museum and Gallery in Greenville, South Carolina, we thank Erin Jones and John Nolan and their staff for their continued support, and for facilitating our examination of their *Head of Christ* painting. We thank Eric Lee, Nancy Edwards, and Bart Devolder at the Kimbell Art Museum in Fort Worth, Texas. At the National Gallery of Art in Washington, DC, we would like to thank Peter Parshall for his help and advice, Greg Jecmen for his assistance in the Print Room, and especially Arthur K. Wheelock, Jr., for his input and encouragement. Walter Liedtke and Dorothy Mahon at The Metropolitan Museum of Art in New York were very generous with their time, advice, and resources, as were Dita Amory of the Lehman Collection and Nadine Orenstein in the Print Room. At the Harvard Art Museum/Fogg Museum in Cambridge, Massachusetts, Ivan Gaskell, Teri Hensick, and William Robinson aided us in our research. Dr. and Mrs. Sheldon Peck were most generous in sharing their time and access to their collection. We thank Natan Saban and Karin Groen for their help with *Head of a Pilgrim*. Dominique Surh of the Leiden Gallery in New York gave assistance with a number of issues as well. We also thank Anne Haas at the Bowdoin College Library in Brunswick, Maine, and Karen Buckey at the Sterling and Francine Clark Art Institute Library in Williamstown, Massachusetts.

At The National Gallery in London we thank Marjorie Wieseman for her gracious help and support, and also Ashok Roy and Marika Spring in the Scientific Department for their advice and consultations. Our gratitude is also extended to Markus Dekiert of the Alte Pinakothek in Munich; Nicolas Sainte Fare Garnot of the Musée Jacquemart-André in Paris; and Irina Antonova, Vadim Sadkov, and Inna Orn of the Pushkin State Museum of Fine Arts in Moscow. For their assistance with loans and research, we thank Achim Riether at the Staatliche Graphische Sammlung in Munich; Michiel Plomp of the Teylers Museum in Haarlem; Kasper Monrad of the Statens Museum for Kunst in Copenhagen; David Scrase at The Fitzwilliam Museum in Cambridge; Jolanta Talbierska at the University of Warsaw Library Print Room; Antony Griffiths and Martin Royalton-Kisch at the British Museum in London; and Desmond Shawe-Taylor and Jennifer Scott of the Royal Collection, London. A special debt of gratitude is owed John Hoogsteder and the staff of the Museum Bredius in The Hague. At the Mauritshuis in The Hague we thank conservator Petria Noble, scientist Annelies van Loon, director Emilie Gordenker, and curator Edwin Buijsen, who provided valuable technical insights and generously lent facilities and aid with the analysis of the Museum Bredius painting. The analysis of the Bijbels Museum painting involved the help of many people, including Eric Domela Nieuwenhuis of the Netherlands Institute for Cultural Heritage and the Bijbels Museum's director, Janrense Boonstra, as well as Hermine Pool and especially Taco Dibbits, Arie Wallert, and Gwen Tauber of the Rijksmuseum in Amsterdam. At the Rijksprentenkabinett in Amsterdam, Huigen Leeflang also lent help and advice. Our thanks go to Niels de Boer of the Kunsthandel P. de Boer in Amsterdam for his assistance. At the Gemäldegalerie in Berlin, we are indebted to Stephan Kemperdick, to Berndt Lindemann, and especially to Claudia Laurenze-Landsberg and Babette Hartwieg of the Conservation Department, who provided research assistance and materials. Holm Bevers of the Kupferstichkabinett in Berlin also lent his assistance. We are grateful for the help and advice of Silke Gatenbröcker at the Herzog Anton Ulrich-Museum in Braunschweig and Albert Elen and Jeroen Giltaij at the Museum Boijmans Van Beuningen in Rotterdam. Our special thanks go to Ger Luijten, director of the Fondation Custodia, Paris, from whose support and advice we know we can always benefit. Without the generosity of these people this project could not have happened.

Lloyd DeWitt
Associate Curator of European Painting before 1900
Philadelphia Museum of Art

Blaise Ducos
Curator, Département des Peintures
Musée du Louvre, Paris

George S. Keyes
Curator Emeritus of European Paintings
Detroit Institute of Arts

Lenders to the Exhibition

Bayerische Staatsgemäldesammlungen, Alte Pinakothek, Munich

Bibliothèque Nationale de France, Paris

Bijbels Museum, Amsterdam

Bob Jones University Museum and Gallery, Greenville, South Carolina

British Museum, London

Collegiate Church of St. Vincent, Le Mas d'Agenais, France

Detroit Institute of Arts

E. W. K., Bern, Switzerland

The Fitzwilliam Museum, Cambridge

Bob P. Haboldt, Paris

Harvard Art Museum/Fogg Museum, Cambridge, Massachusetts

Her Majesty Queen Elizabeth II

Herzog Anton Ulrich-Museum, Braunschweig

The Hyde Collection, Glens Falls, New York

Institut de France, Musée Jacquemart-André, Paris

Kimbell Art Museum, Fort Worth, Texas

Kunsthalle, Hamburg

The Metropolitan Museum of Art, New York

Musée des Beaux-Arts, Nancy

Musée du Louvre, Paris

Museum Bojmans Van Beuningen, Rotterdam

Museum of Art at Brigham Young University, Provo, Utah

Museum of Fine Arts, Boston

The National Gallery, London

National Gallery of Art, Washington, DC

National Gallery of Scotland, Edinburgh

Nationalmuseum, Stockholm

Netherlands Institute for Cultural Heritage

Pavlovsk Palace Museum, Russia

Peck Collection, Boston

Petit Palais, Musée des Beaux-Arts de la Ville de Paris

Philadelphia Museum of Art

The Print Room, University of Warsaw Library

Pushkin State Museum of Fine Arts, Moscow

Rijksmuseum, Amsterdam

Mr. and Mrs. Avram Saban, Miami Beach, Florida

Staatliche Graphische Sammlung, Munich

Staatliche Museen Preussischer Kulturbesitz, Gemäldegalerie, Berlin

Staatliche Museen zu Berlin, Kupferstichkabinett

Statens Museum for Kunst, Copenhagen

Teylers Museum, Haarlem

And private individuals

As of January 31, 2011

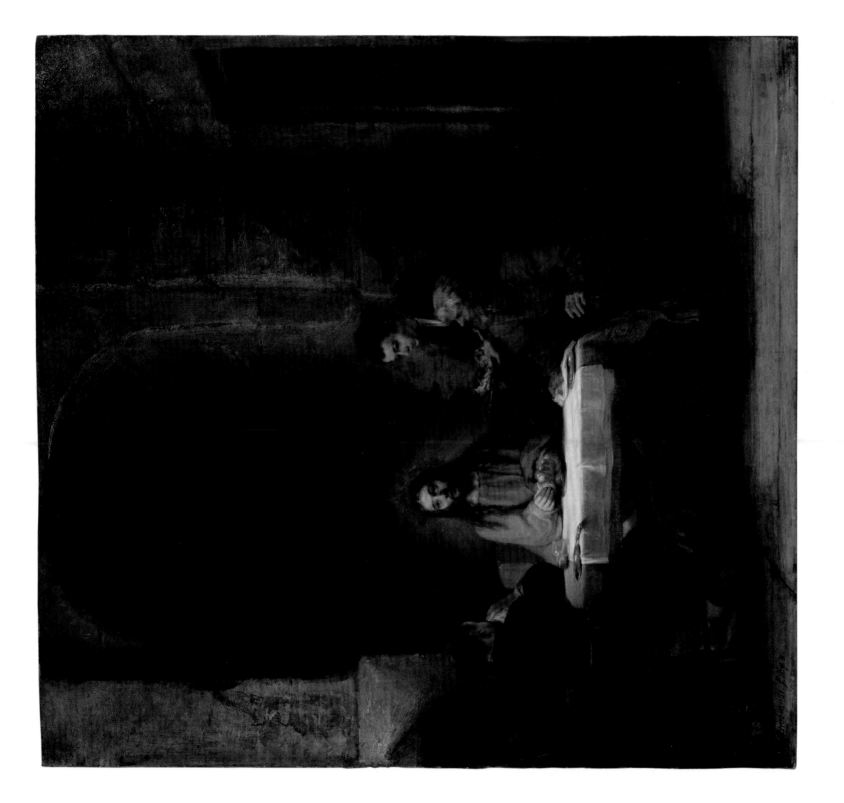

PLATE 1.1

Rembrandt Harmensz. van Rijn

The Supper at Emmaus, 1648

Oil on mahogany panel, 26¾ × 25⁹⁄₁₆ inches (68 × 65 cm)
Musée du Louvre, Paris, inv. 1739
Photograph © 2010 Musée du Louvre / Philippe Fuzeau

CAT. 27

Perception and Belief

THE IMAGE OF CHRIST AND THE MEDITATIVE TURN IN REMBRANDT'S RELIGIOUS ART

George S. Keyes

In 1929 the Soviet government sold a *Head of Christ* at auction in Berlin (see plate 2.7). The following year Dr. Wilhelm Valentiner purchased this picture from the Goudstikker Gallery in Amsterdam for the Detroit Institute of Arts.[1] Soon after its acquisition Valentiner published the painting,[2] positing that it was a study by Rembrandt van Rijn (1606–1669) for the head of Christ in his celebrated painting *The Supper at Emmaus*, signed and dated 1648 and now in the Musée du Louvre in Paris (plate 1.1).

The Detroit picture and a group of similar painted heads of Christ found general acceptance as autograph works by Rembrandt (see Tucker, DeWitt, and Sutherland, this volume);[3] They were duly included as such by Abraham Bredius in his catalogue raisonné of Rembrandt's paintings in 1935.[4] In fact, Bredius himself owned one such painting (see plate 2.8), which he acquired in Kassel in or shortly before 1912.[5] This picture, now in the Museum Bredius in The Hague, soon attracted a number of serious admirers, thereby catapulting it into the mainstream of Rembrandt literature. Publishing this panel in 1912, Kurt Freise categorized it as an *Andachtsbild*, a private and intimate devotional object intended for religious meditation.[6]

When the Bredius picture was exhibited in The Hague in 1915, F. Schmidt-Degener, in his introduction to the accompanying catalogue,[7] waxed eloquently on the distinctive character of this *Head of Christ*. He stressed the degree to which Rembrandt rejected the traditional, more Apollonian image of Christ found in Italian art, and replaced it with an image of the Nazarene so believable that, in Schmidt-Degener's estimation, it was one of the most treasured monuments of Christian art.[8] Other scholars, including H. P. Bremmer, H. E. van Gelder, and H.-M. Rotermund, responded to this picture with equal emotional fervor.[9]

What this group of early-twentieth-century admirers found so compelling in these painted images of Christ was Rembrandt's bold redefinition of Jesus not as a heroic figure embodying suffering but as an inward, undemonstrative being who compels reverence by his very existence in the mind and imagination of the beholder. Christ becomes an object of meditation not because of his suffering but through his very presence as an affirmation of goodness and a source of deep spiritual inspiration. This bold departure is predicated on the viewer's personal identification with divine inspiration and spiritual nourishment.

It is no coincidence that these depictions of Christ have been linked to two great religious images by Rembrandt, both of which date from the late 1640s. The first is the Louvre *Supper at*

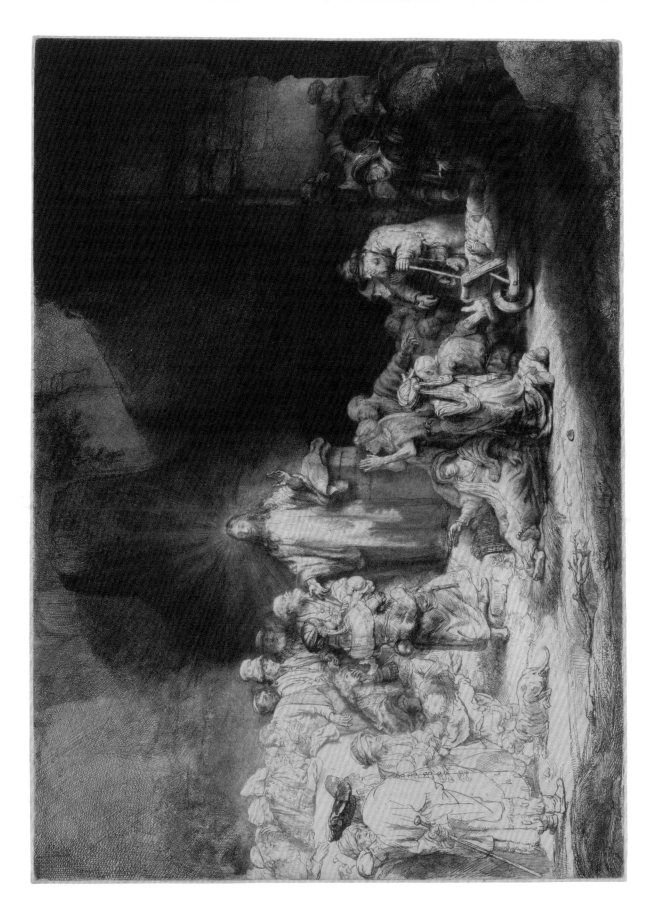

PLATE 1.2

Rembrandt Harmensz. van Rijn

The Hundred Guilder Print (*Christ Preaching; Bring Thy Little Children unto Me*), c. 1649

Etching, engraving, and drypoint on paper; plate 11 × 15½ inches (28 × 39.3 cm)
The Metropolitan Museum of Art, New York, H.O. Havemeyer Collection, Bequest of Mrs. H.O. Havemeyer, 1929 (29.107.35)
Photograph © The Metropolitan Museum of Art / Art Resource, NY

CAT. 44A

Emmaus (see plate 1.1); the second is one of Rembrandt's most celebrated works on paper, *The Hundred Guilder Print* (*Christ Preaching; Bring Thy Little Children unto Me*) of about 1649 (plate 1.2).[10] These seminal works represent a significant shift in Rembrandt's approach to religious subject matter toward a quieter, more meditative frame of mind—a shift that spawned the artist's exploration of a number of related subjects (see Silver and Perlove, this volume). His interest, in turn, inspired his pupils and former associates, who found stimulus in these subjects as well. Along with the heads of Christ, these works by Rembrandt and others in his orbit constitute the focus of this exhibition.

The painted heads of Christ remained unchallenged as autograph works by Rembrandt for more than three decades following Bredius's 1935 publication. The group was even expanded by Seymour Slive, who published a hitherto unknown *Head of Christ* (see plate 2.5) acquired by the Fogg Art Museum of Harvard University in 1964.[11] In more recent years, however, the attribution of these heads of Christ has been questioned. Because these pictures have not yet been analyzed and published by the Rembrandt Research Project, they have entered a limbo governed largely by verbal opinions and published asides.[12] These have carried sufficient weight to cause certain museums to query the attribution of the heads of Christ in their possession.[13]

Albert Blankert, on more than one occasion, has defended the traditional attribution of the Museum Bredius *Head of Christ*,[14] positing, as have others, that three such heads of Christ were cited in the inventory of the contents of Rembrandt's house on the Jodenbreestraat in 1656. This inventory, drawn up as a consequence of Rembrandt's insolvency, describes in the artist's "back parlor" (*de agtercaemer*) "#115 a head of Christ by Rembrandt" (*Cristus tronie van Rembrandt*); "#118 Christ's head by Rembrandt" (*Een Cristi tronie van Rembrandt*); and, "in the small studio" (*Op de cleyne schildercaemer*), "#326 A head of Christ from life" (*Een Cristus tronie nae 't leven*).[15] That these three pictures were in Rembrandt's possession at the time of his bankruptcy provides compelling evidence that he painted such likenesses and retained at least some of them as part of his encyclopedic collection.

Throughout his career Rembrandt explored the essential nature of self—what it means to exist and the degree to which outward appearance can be perceived as a tangible measure of inner being. If inner being can be equated with the spiritual, then it comes as no surprise that sustained representations of biblical subjects would play such a central role in what has recently and very aptly been characterized as "Rembrandt's journey."[16] At the heart of this journey is the figure of Christ. Rembrandt's concept of Christ changed significantly as his art evolved from one decade to the next, as is especially evident when contrasting works of the 1630s with those of the 1640s. As one traces this evolution, the two aforementioned works—*The Supper at Emmaus* and *The Hundred Guilder Print*—mark a watershed. In both, the figure of Christ projects a sublime stillness and serenity in the midst of wide-ranging human drama. In contrast to Rembrandt's earlier representations of Jesus in dramatically charged events, Christ here becomes an object of profound meditation.[17]

Considerably earlier in his career Rembrandt represented Christ as a powerful and active presence. For example, in his etching *The Raising of Lazarus* of about 1632 (see plate 3.12),[18] Christ, seen from behind, his face in lost profile, directs the action. His emphatic gesture and dominant silhouette shape the drama in a manner analogous to that of a conductor leading an orchestra. Rembrandt reinforces Christ's pivotal role by employing a low vantage point and a mysterious setting flooded by an intense burst of light. Other early works, such as his 1634 painting *The Incredulity*

of *Thomas* (see plate 4.5) and the etchings *Christ at Emmaus* of 1634 (plate 1.3) and *Christ Driving the Money Changers from the Temple* of 1635 (see fig. 3.7),[19] portray a Christ whose actions are emphatic and decisive. In Rembrandt's earliest version of the Supper at Emmaus, a novel and precocious interpretation of this subject from about 1629 (see plate 4.1), the artist boldly silhouettes Christ's profile before intense light. This light and Christ become synonymous[20] as the two disciples, one kneeling and one seated, recognize the risen Messiah. The drama unfolds forcefully, as demonstrated by the overturned chair and the gestures of the disciples, who are overcome by the miracle that they behold. Rembrandt segregates their world of wonderment and mystery from that of the maidservant dimly perceived in the distance on the left.

A drawing now in the Harvard Art Museum/Fogg Museum (plate 1.4), most likely an old copy after a now-lost original pen sketch by Rembrandt, represents the same subject as the 1629 painting now in the Musée Jacquemart-André (see plate 4.1) and must date from about the same time. Its composition differs from that of the painting in several notable ways. First, the supernatural light is represented by bold zigzag penwork defining the aura of light emanating directly from Christ's head. One disciple, seen seated from the back, raises both hands in wonderment. The other witness, seen *en face*, has risen from his chair. The subject is more concentrated in its presentation, with no reference to an extended space—nor does the artist add dramatic visual props such as the overturned chair in the painting. Nonetheless, Rembrandt still exploits chiaroscuro by casting much of the figure of Christ in deep shadow even though his face is fully illuminated. As Rembrandt's art continued to evolve during the 1630s, his indication of the supernatural radiance emanating from Christ's face became more subtly integrated into the surrounding space, blending his presence within the narrative in a seemingly more normative manner.

During the 1640s Rembrandt's religious subjects displayed an increasing sense of quietude that culminated in *The Supper at Emmaus* of 1648. The hushed atmosphere of this work underscores a palpable sense of tranquillity. As Christ reveals himself while breaking the bread, his disciples express their dawning wonderment with great restraint. The setting, reminiscent of the Romanesque phase of medieval architecture, reinforces this mood of stillness. By placing the seated Christ before a hemicycle Rembrandt evokes the austere simplicity of the early Christian church. This unembellished yet monumental setting, with its roughly hewn stone and nearly bilateral symmetry,[21] becomes a visual metaphor for the enduring structure of the Christian church even at its inception. By placing Christ in alignment with the niche and hemicycle, Rembrandt has set him, by inference, before the most sacred space—at the eastern end of a traditional Christian basilica.[22]

Throughout the decade, Rembrandt also evinced great interest in the architectural backdrops of his religious subjects.[23] *The Visitation*, signed and dated 1640 (fig. 1.1), now in the Detroit Institute of Arts,[24] displays the artist's keen awareness of architecture and its implied significance. Zacharias emerges from a partially ruined, barrel-vaulted structure that, as it progresses in three bays into the left distance, is reminiscent of Roman imperial architecture as exemplified by the Basilica of Maxentius and Constantine in Rome. Beyond, emerging from the pervading darkness, is a view of the ancient city of Jerusalem dominated by its temple. The theme of the Visitation refers to the first public acknowledgment of the incarnation of the Messiah. In Rembrandt's painting, Christ appears in a setting that references both Jerusalem, as the embodiment of the old dispensation, and the grandeur of ancient pagan Rome, as indicated by the barrel-vaulted structure at the

left. The arched shape of the panel itself, which calls to mind a triumphal arch,[25] could possibly denote the triumph of the new dispensation as it frames the world that Christ is about to enter.

In his presentation of *The Hundred Guilder Print*, Rembrandt was no less attentive to the setting—which is mysterious, evocative, and, to a certain degree, architectural. Christ stands before what appears to be a sheer rock face modulated by pockets of deep shadow. At the right, a multitude of people emerges from a monumental arched opening as if through the ramparts of an ancient city. Christ performs his healing miracle on the outskirts of a metropolis, in an open space large enough to accommodate the crowd. Rembrandt devoted particular attention to defining Christ's halo, the rays of which glow before the space in deep shadow behind him, leading one commentator to describe the halo as melting away into the deep blacks.[26] Likewise, on Jesus's white robe the artist has projected the shadow of Christ's raised left hand, as well as that of the pair of hands held up in prayer and supplication by the old woman kneeling before the plinth to the right of him. Strong, natural light entering the scene from the foreground picks out highlights and casts deep shadows. Thus Christ as "the light of the world" exists in the wider natural

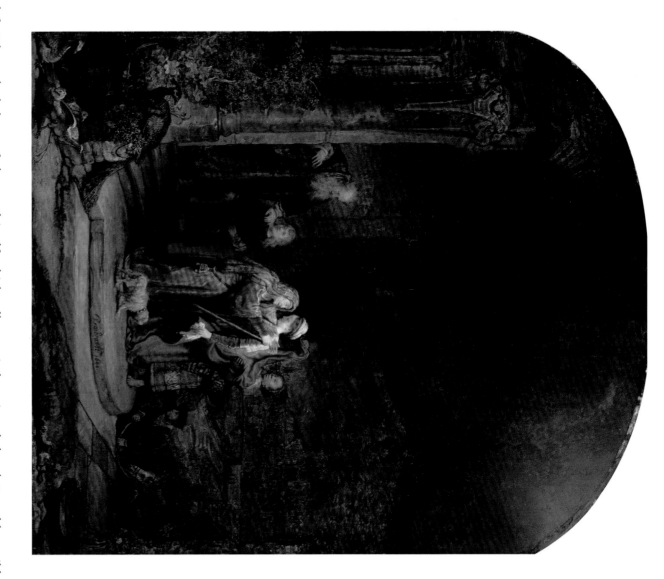

Fig. 1.1. Rembrandt Harmensz. van Rijn, *The Visitation*, 1640. Oil on cedar panel, 22¼ × 18⅞ inches (56.5 × 47.9 cm). Detroit Institute of Arts, City of Detroit Purchase (27.200)

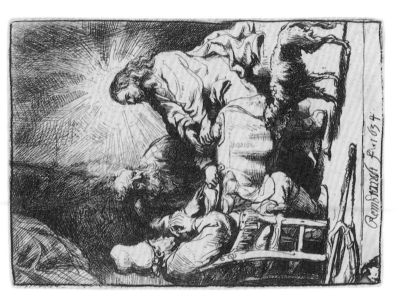

PLATE 1.3

Rembrandt Harmensz. van Rijn

Christ at Emmaus, 1634

CAT. 13A

Etching on paper; plate 4 × 2⅞⁄₁₆ inches (10.2 × 7.4 cm); sheet 5⅞ × 4⅙⁄₁₆ inches (14.9 × 11.6 cm)
Museum of Fine Arts, Boston, Katherine E. Bullard Fund in memory of Francis Bullard, 2000.649

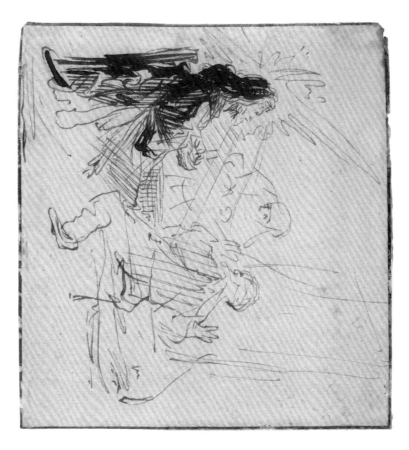

PLATE 1.4

School of Rembrandt Harmensz. van Rijn

Supper at Emmaus, C. 1630–33

Pen and brown ink with touches of black chalk on paper, 3¹⁵⁄₁₆ × 4⁵⁄₁₆ inches (10 × 11 cm)
Harvard Art Museum/Fogg Museum, Cambridge, Massachusetts, Friends of the Fogg Art Museum Fund, 1968.18
Photograph by Allan Macintyre © President and Fellows of Harvard College

CAT. 7

7

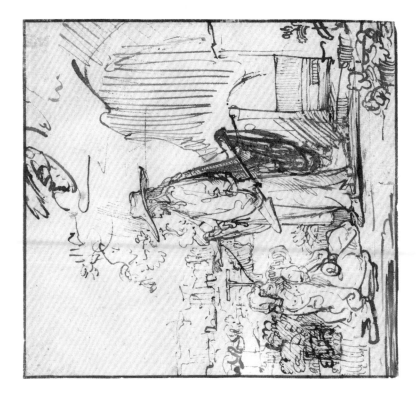

Fig. 1.2. Rembrandt Harmensz. van Rijn, *Christ as Gardener Appearing to the Magdalene*, c. 1640. Pen and brown ink, corrected with body color, on paper; 6�116 × 5¾ inches (15.4 × 14.6 cm). Rijksmuseum, Amsterdam, RP-T-1961-80

world.[27] Light becomes the perfect metaphor for the universality of Christ's anointed role as the redeemer.

In a sense, Rembrandt's interest in architecture culminates in his monumental drypoint *Christ Presented to the People* (*Ecce Homo*), signed and dated 1655 in the seventh state (see plate 4.17). Here Christ, the criminal Barabbas, and Pontius Pilate appear on a tribune of a structure that symbolizes the rule of law and the dispensing of justice.[28]

During the 1640s, as Rembrandt shaped his religious imagery to be progressively more meditative, he came to address subjects in which the beholder's perception of Christ and reaction to his presence were paramount concerns. Several of these subjects involved Christ's appearance following his crucifixion, death, and resurrection, including Christ as Gardener Appearing to the Magdalene, the Noli Me Tangere, the Pilgrims Journeying to Emmaus, the Supper at Emmaus, Christ Appearing to His Apostles, and the Incredulity of Thomas. Rembrandt often explored these subjects in depth[29] in works that date from the time of *The Supper at Emmaus* of 1648 well into the 1650s. Moreover, pupils and former associates also represented these subjects—mostly in the form of drawings, many of which until recently were classified as works by Rembrandt himself. These works demonstrate that Rembrandt's engagement with and unique way of interpreting these subjects greatly interested those artists working under his influence and attracted to the power of his genius.[30]

An early harbinger of this meditative turn in Rembrandt's religious imagery is his *Christ as Gardener Appearing to the Magdalene* of 1638 (see plate 3.16). In this painting, Christ appears behind the startled Magdalene, who kneels in wonderment before his empty tomb. Her companions have already departed, leaving the Magdalene alone to witness the miraculous appearance of Christ. In the biblical account (John 20:11–18), she initially sees two angels seated by the tomb. Upon turning she sees Jesus standing yet does not recognize him, supposing him to be the gardener. Only

when he addresses her by name does Mary Magdalene recognize him as Christ.³¹ Rembrandt explores this theme further in a drawing now in Amsterdam (fig. 1.2) and one in the Peck Collection (plate 1.5),³² in which he stresses the part of the Gospel account where the Magdalene attempts to touch Christ as further confirmation of her belief in his resurrection (John 20:17). Two other well-known drawings of this subject, now attributed to associates of Rembrandt, are in Amsterdam (fig. 1.3) and Dresden.³³ *Noli me tangere* (Latin for "Touch me not"), the renunciation of physical confirmation through touch, places sole emphasis on the Magdalene's perception of Christ by sight, but ultimately as registered in her mind. Sight becomes the access route to belief. In other words, her perception of the risen Christ becomes the reality governing her unshakable belief in his resurrection.

This audacious notion of perception as the conduit of faith is also evident in several of Rembrandt's depictions of Christ at Emmaus. In this biblical tale (Luke 24:13–32), two pilgrims, both disciples of Christ, encounter the risen Jesus on the road to Emmaus. Impressed by this mysterious traveler, but failing to recognize him as their savior, they invite him to dine with them. When Jesus breaks the bread, the two disciples suddenly recognize him as the risen Christ, at which point he disappears. Rembrandt's celebrated drawing of their meeting on the road to Emmaus, now in the Louvre in Paris (plate 1.6), is especially moving in capturing the dawning realization on the part of the two pilgrims that their new companion is a remarkable presence whom they do not yet fully fathom. Rembrandt concentrates on the drama of the incipient interaction of these three figures as they progress on their journey.³⁴ A number of drawings attributed to Rembrandt's school, including one at the Courtauld Gallery in London (fig. 1.4), ultimately fail to capture the wonderfully suspended concentration that emanates from the Paris sheet. Instead, the anonymous artist of the Courtauld drawing dilutes the central narrative by the inclusion of a plethora of details within the landscape that detract from its psychological focus. Another drawing

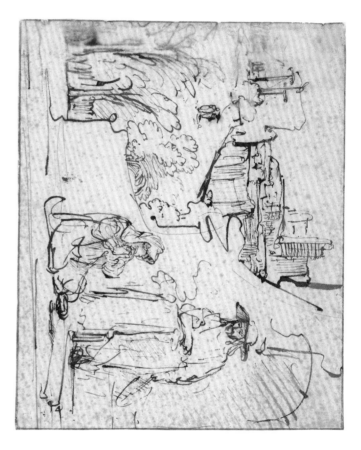

Fig. 1.3. Attributed to Ferdinand Bol (Dutch, 1616–1680), *Christ as Gardener Appearing to the Magdalene*, c. 1640. Pen and brown ink, corrected with body color, on paper; 6⅛ × 7½ inches (15.4 × 19.1 cm). Rijksmuseum, Amsterdam, RP-T-1930-29

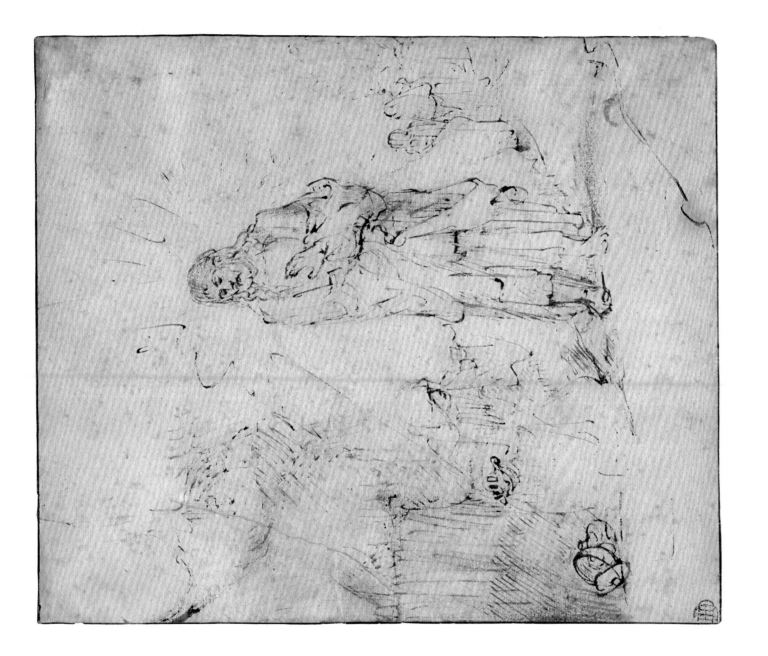

PLATE 1.5

Rembrandt Harmensz. van Rijn

Noli Me Tangere, c. 1655–56

Quill and reed pens in brown ink with touches of brown wash on paper, corrections in white; 8⅝ × 7¼ inches (21.8 × 18.5 cm)

Peck Collection, Boston

CAT. 64

now in Warsaw (plate 1.7) seems more effective in capturing the intensity with which Rembrandt imbues the Paris drawing. This may be explained partly by what appears to be Rembrandt's bold corrections to this pupil's study.

Rembrandt returned to the theme of the encounter at Emmaus, most notably in his *Christ at Emmaus: The Larger Plate* of 1654 (see plate 3.3).[35] Here Christ seems older than his counterpart in the Paris painting of 1648, exuding a benevolence that somehow captures a sense of wisdom borne of all the ages since time began. As has been pointed out by various scholars,[36] the setting with its suggestion of a canopy is reminiscent of Rembrandt's sanguine chalk drawing *The Last Supper* of 1634–35 (see plate 3.4), now in the Metropolitan Museum of Art in New York. Although Rembrandt's drawing was inspired by the reproductive engraving by Giovanni Pietro Birago (fl. c. 1471/4–1513) after Leonardo's celebrated fresco in Milan, he rigorously rethought the engraved prototype throughout, not only eliminating the deep architectural space but also completely rejecting the characterizations of all of the figures. In this he chose to emulate Peter Paul Rubens (1577–1640), as evidenced by the drawing by Pieter Soutman (1580–1667) after Rubens now preserved at Chatsworth House in England.[37] Interestingly, Rembrandt made a further modification to the head of Christ, whom he represents with a thick, almost wig-like mop of hair parted down the middle.

In the *Christ at Emmaus* print of 1654, the canopy behind Christ imposes a bilateral symmetry echoed by the monumental presence of Christ, here seen *en face* and flanked by his two disciples, who appear in profile.[38] The canopy projects forward, with a fringe caught in light that finds an echo in the tablecloth below. To the right, the wall gives way to an opening in which a vine appears before the open sky. This inclusion of the larger world of nature within an otherwise enclosed interior space may imply that Christ's reincarnation does not occur in isolation but projects itself

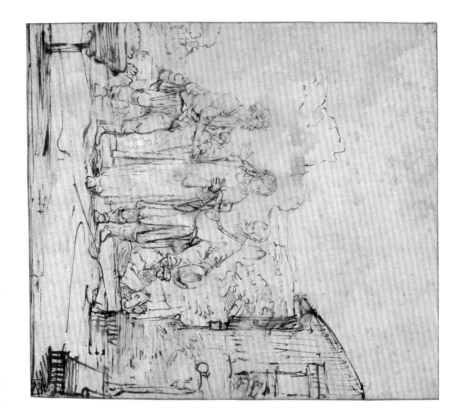

Fig. 1.4. School of Rembrandt Harmensz. van Rijn, *Christ and the Two Disciples Arriving at Emmaus*, c. 1647. Pen and brown ink on paper, 9¼ × 8⅜ inches (23.5 × 21.2 cm). The Samuel Courtauld Trust, The Courtauld Gallery, London, D.1978.PG.194

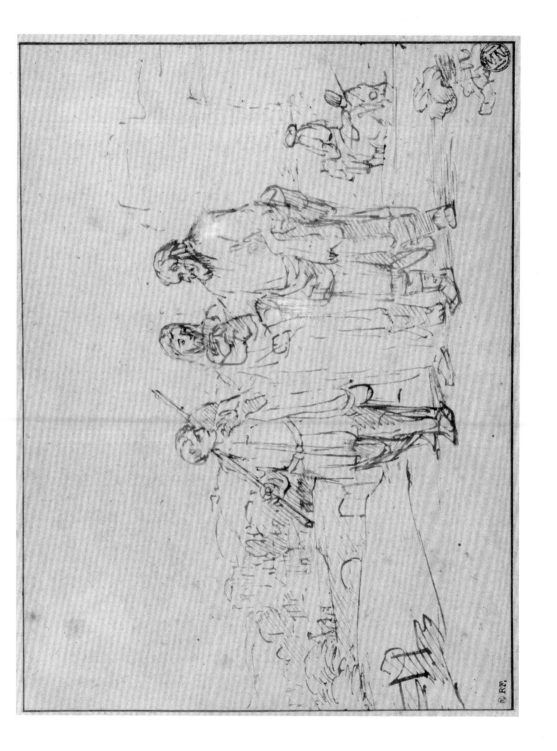

PLATE 1.6

Rembrandt Harmensz. van Rijn

Christ and Two Disciples on Their Way to Emmaus, 1655–56

Pen and brown ink with traces of white body color on paper, 6½ × 8⁹⁄₁₆ inches (16.5 × 22.4 cm)
Musée du Louvre, Paris, inv. 22886
Photograph © Réunion des Musées Nationaux / Art Resource, NY

CAT. 63

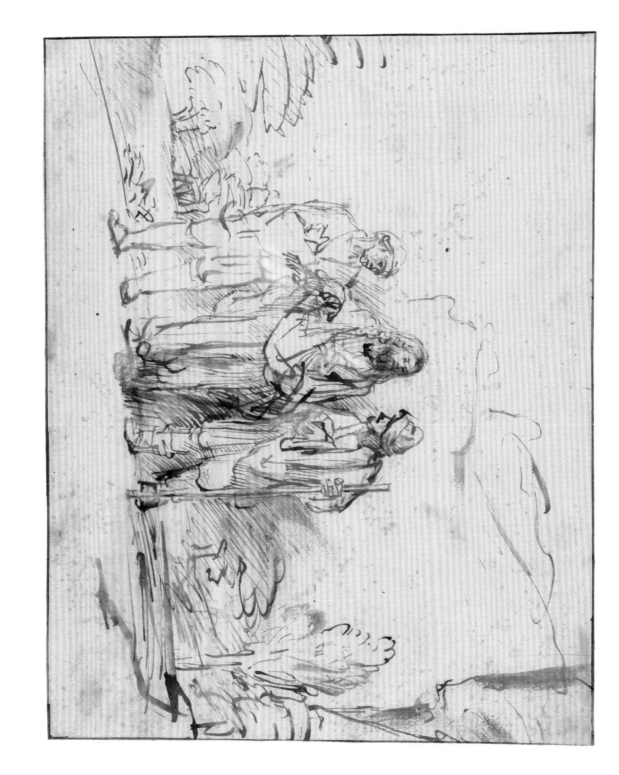

PLATE 1.7

Pupil of Rembrandt Harmensz. van Rijn, corrected by Rembrandt

Christ with Two Disciples on the Road to Emmaus, c. 1655

Pen and brush in brown ink and wash with white highlights on paper, 7⁹⁄₁₆ × 9¾ inches (19.2 × 24.8 cm)

The Print Room, University of Warsaw Library, zb.d.480

Photograph © University of Warsaw Library

CAT. 62

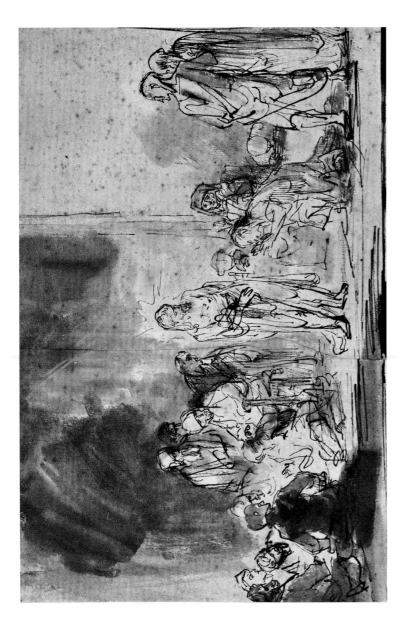

throughout the wider world. An analogous use of this motif can be found in the sliver of vegetation included at the edges of some Venetian representations of the Madonna and Child produced during the Renaissance. Giovanni Bellini (c. 1431–1516) includes such vignettes on either side of a gold cloth in his *Madonna and Child* (*Madonna degli Alberetti*), signed and dated 1487, now in the Accademia in Venice,[39] and in his *Sacra Conversazione* of 1505, still in situ in the Church of San Zaccaria in Venice.[40] Likewise, the baldachin in Rembrandt's print recalls innumerable early Netherlandish paintings, including several characteristic examples by Hans Memling (c. 1430–1494), in which the Virgin and Child appear enthroned before a suspended cloth of gold flanked by landscape vistas.[41] If Rembrandt was inspired by such venerable prototypes, he interpolated this architectural backdrop into a substantially different configuration that is far more enveloping and intimate. Rembrandt's etching *Christ Appearing to the Apostles* (see plate 3.15),[42] signed and dated 1656, is very different in tenor from *Christ at Emmaus* of 1654. This print exhibits a mysteriousness that is enhanced by the delicacy of its etched lines. Christ here seems to be more of a dematerialized apparition—a quality reinforced in certain notable impressions printed with transparent surface tone on warm Japanese paper.

Thomas, the only apostle not present in the scene depicted in the 1656 print, becomes a focal point in Christ's later appearance to his disciples. Here, the risen Messiah encourages Thomas to touch his chest wound to assure the skeptical apostle that he has indeed risen from the dead (John 20:26–29). Rembrandt captured Thomas's incredulity forcefully in his early painting of 1634, now in the Pushkin Museum in Moscow (see plate 4.5), in which Thomas recoils from Christ even as their eyes are locked onto each other's. Many of the other figures gathered around Christ and Thomas express a wonderment that reinforces the heightened drama of the scene. Their perception of Christ encapsulates a full range of responses from devout prayer to powerful gesticulations.

Rembrandt continued to represent this subject during the 1640s and early 1650s. In a pen and wash study from the early 1640s (fig. 1.5), formerly in the collection of Georges Renand in

Paris, the artist has placed the standing figure of Christ in an ample interior space, with his followers gathered in four groups of seated and standing figures. Thomas kneels in left profile to the right of Christ, expressing his piety, humility, and wonderment. Light forms an irregular halo around the head of Christ. In subsequent drawings Rembrandt and certain of his pupils or associates retain this narrative formula in which Thomas kneels before Christ at the center of a frieze of bystanders, all of whom, whether seated or standing, witness the event.[43] One of the most interesting of these, now in the Rijksmuseum in Amsterdam (plate 1.8), contains a number of adaptations from the Renand drawing; Christ is now fully framed in a mandorla-like burst of light at the center of a scene mostly containing standing figures, all of whom concentrate their attention on the central pair of Christ and Thomas. In his thorough analysis of this drawing, Peter Schatborn considers it to be a copy after a now lost drawing by a student of Rembrandt who incorporated features from various sources, including works by Rembrandt and others stemming from him.[44]

Rembrandt's return to this subject in the mid-1650s, in a drawing now in Paris (plate 1.9), is even more reductive in its conception. The figures are more boldly outlined, with less interior modeling of their garments. Moreover, spatial elements such as the platform on which Christ stands are set parallel to the picture plane to create a clear yet elemental sense of shallow space. Christ here wears a cape but is otherwise largely nude. This display of his body is further emphasized in a drawing now in Munich (plate 1.10),[45] considered to be a copy after a lost original by Rembrandt.[46] Here Christ displays his chest wound before the kneeling Thomas. Christ's radiance illuminates a monumental vaulted interior. The bilateral symmetry of this space, with its subtle variations at left and right of center, is remarkably reminiscent of *The Supper at Emmaus* of 1648 (see plate 1.1). The monumentality of the setting and the particularly rhetorical gestures of Christ possibly lend credence to the notion that the original from which this drawing derives might have been conceived as a preliminary idea for an unrealized painting. Had Rembrandt produced such a picture, it would have offered a compelling visual and thematic parallel to *The Supper at Emmaus* painting. The Munich drawing also makes an interesting comparison to Rembrandt's print *Christ Preaching* ("*La Petite Tombe*") (see plate 3.9), in which Jesus, who stands on an elevated platform surrounded by many figures, gestures with both hands raised. The monumental architectural setting of the print—in this case, a courtyard—is analogous to the barrel-vaulted interior of the drawing. The greatest difference between the two is the nature of the audience and its response to Christ. Whereas in the Munich drawing Christ's followers respond in wonderment at the miracle they behold, in *Christ Preaching* an audience representing the larger public responds in various ways to Christ's exhortations.

In his depictions of several intimate subjects drawn from Jesus's ministry, Rembrandt focused on the response of others to Christ's presence in their midst. Most notable is the theme of Christ in the House of Mary and Martha in Bethany (Luke 10:38–42), which Rembrandt and his students treated in several known drawings, and which Rembrandt tackled in at least one now lost painting.[47] Rembrandt sketched the subject in a drawing from the early 1630s now in the Teylers Museum in Haarlem (see plate 3.1).[48] In its vigorous penwork, compact space, and tightly knit grouping of figures, this drawing is analogous in dramatic force to Rembrandt's etched *Christ at Emmaus* of 1634 (see plate 1.3). Martha, standing in profile at the left, gestures forcefully to Christ, who gently deflects her exhortations by indicating with his open left hand the seated figure of

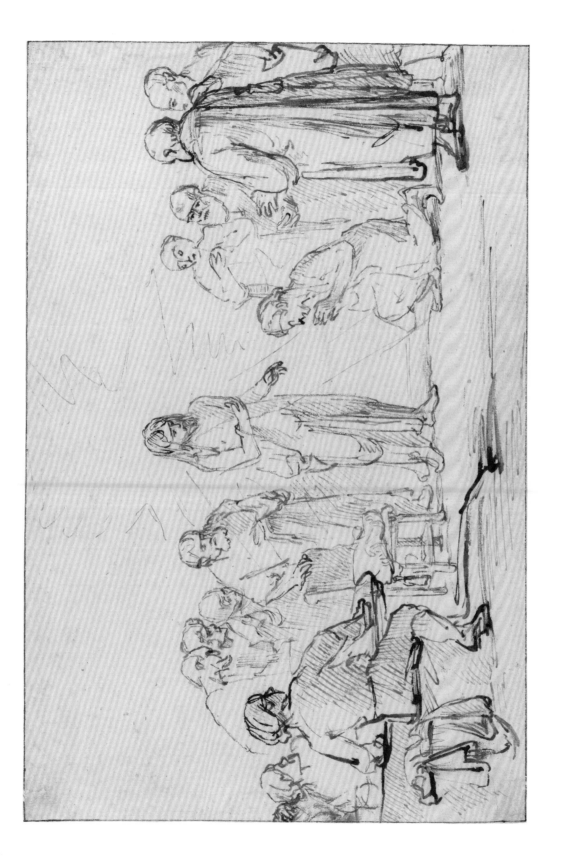

PLATE 1.8

Copy after Rembrandt Harmensz. van Rijn

The Incredulity of Saint Thomas, c. 1651

Reed pen and brown and gray-brown ink on paper, 6⅞⁄₁₆ × 10¹⁵⁄₁₆ inches (17.6 × 27.1 cm)
Rijksmuseum, Amsterdam. Purchased with support of the Vereniging Rembrandt
with additional funding from Prins Bernhard Cultuurfonds

CAT. 52

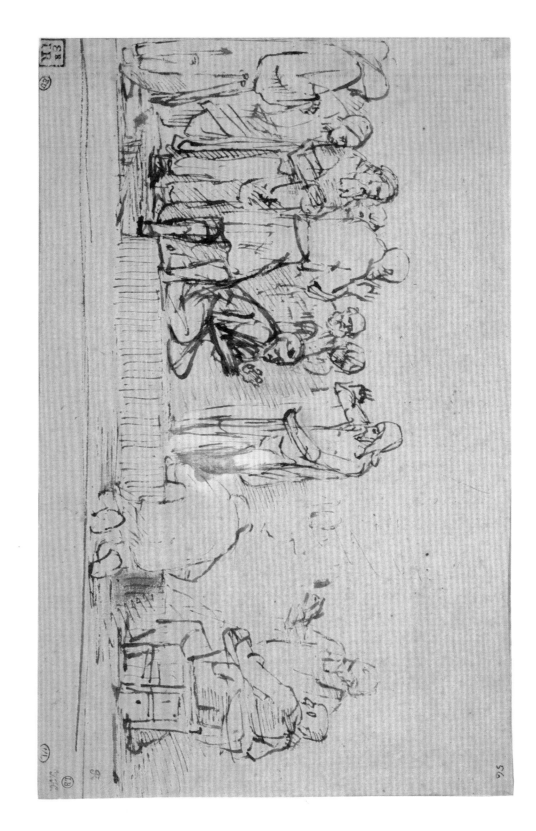

PLATE 1.9

Rembrandt Harmensz. van Rijn

The Incredulity of Saint Thomas, c. 1654

Pen and brown ink on paper, 5⅞ × 9⁷⁄₁₆ inches (15 × 23.9 cm)

Musée du Louvre, Paris, L. Bonnat Bequest 1919, RF 4726 recto

Photograph © Réunion des Musées Nationaux / Art Resource, NY

CAT. 56

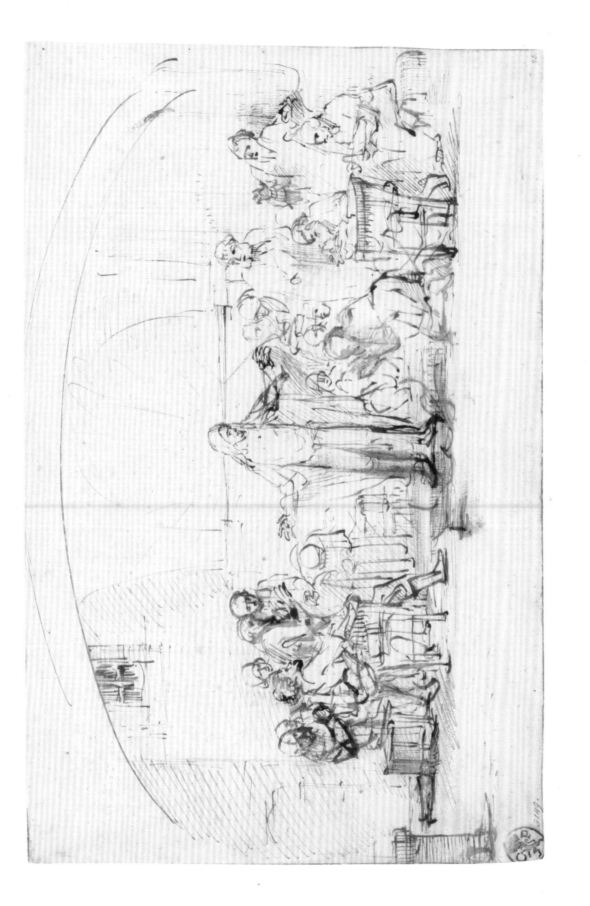

PLATE 1.10

Studio of Rembrandt Harmensz. van Rijn

The Incredulity of Saint Thomas, c. 1650–55

Pen and brown ink on paper, 7 13/16 × 12 1/16 inches (19.8 × 30.7 cm)
Staatliche Graphische Sammlung, Munich, 1417 z

CAT. 50

Mary. Seated at the center with his right arm resting on the table, Christ is the perfect fulcrum, gazing at Martha while simultaneously gesturing to Mary to his other side.

Rembrandt returned to this theme in a drawing from the late 1640s now in the Musée du Petit Palais in Paris (see plate 4.18). Here he devotes his attention to Martha, who tends to the fire-place at the left. She is in deep shadow, whereas Christ is framed in radiant light. Mary, the object of his consideration, is seated at the right perusing a large tome. Rembrandt elaborated on this mise-en-scène in a drawing from the same period now in Munich (see plate 4.19).[49] The setting has become more elaborate, with the inclusion of curtains at the right and a large bed before the wall behind Christ. Martha, now seen from the back, attends to her cooking at a large, open fireplace, the vent of which projects into the room. A third drawing, now in London (plate 1.11) and most recently published by Martin Royalton-Kisch as a copy,[50] again places Martha at the hearth as Christ expostulates with her while gesturing with great delicacy to Mary who, seated at the right, diligently reads a large book.

Several other drawings representing this subject, although not by Rembrandt, were pro-duced in his studio and clearly date from about the same time. The most remarkable of these is a highly worked-up sheet in the British Museum (plate 1.12)[51] that is unusual in placing Christ seated *en face* with his head *contre jour* before a window. That this drawing is a visual tour de force is indicated, among other things, by the remarkable trees seen shimmering in strong sunlight through the windowpanes. Likewise, the interior space is complex and evocative.[52] The placement of Christ before the intensely illuminated window causes the viewer to experience him as a somewhat ghostly silhouette—a novel and effective means of creating an aura of mystery and spirituality.[53]

This arresting means of defining the perception of Christ finds one of its most remarkable and original conceptions in a drawing from the mid-1650s, *Christ Finding the Apostles Asleep on the Mount of Olives*, now in Berlin (plate 1.13).[54] Although this work is no longer considered to be by Rembrandt, in its audacity and originality it almost assuredly reflects his invention and is likely a copy after a lost original. Strong rays of light pierce the sky behind Christ, so that Peter, who reclines in Christ's shadow and gazes up at him, would only have been able to fathom his silhouette. The shaded sky was added later but may reflect Rembrandt's original intention to evoke the enveloping darkness of night, a feature so poignantly captured in his print *The Agony in the Garden* of about 1657.[55] The extraordinary gulf that exists between Peter and Christ in the drawing, mediated by light piercing through the encompassing darkness, creates an emotive synapse that underscores the mysterious process of perception. This dramatic moment, just prior to Christ's acceptance of his impending sacrifice, is no less astonishing in its intensity than the equally audacious drawing of the *Supper at Emmaus* from the early 1640s (plate 1.14),[56] now in the Fitzwilliam Museum in Cambridge, in which Christ, having broken the bread, vanishes in a burst of light. This is the moment in which, quoting from the Gospel of Luke, "their eyes were opened and they recognized him; and he vanished out of their sight" (24:31).

A drawing now in Bern, *Christ Awakening the Apostles on the Mount of Olives* (plate 1.15), makes an interesting comparison to the *Christ Finding the Apostles Asleep on the Mount of Olives* now in Berlin (see plate 1.13) in that all the figures are cast in light but set before the inky gloom of deep night. The foreboding mood cast by the sky is underscored by the arrival of the distant company of sol-diers bent on taking Christ prisoner. Only Peter shows signs of awakening, barely raising himself

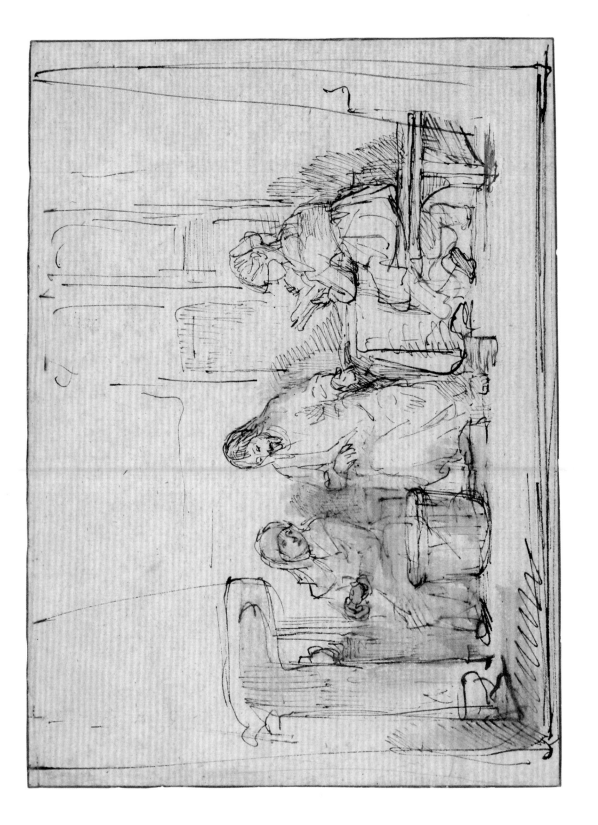

PLATE I.II

Pupil of Rembrandt Harmensz. van Rijn

Christ Conversing with Martha and Mary, c. 1650

Pen, brown ink in two tones, and brown wash, touched with white gouache, on paper; 6⅝ × 9⁹⁄₁₆ inches (16.8 × 23.4 cm)

British Museum, London, PD 1895,0915.1254

Photograph © The Trustees of the British Museum

CAT. 47

20

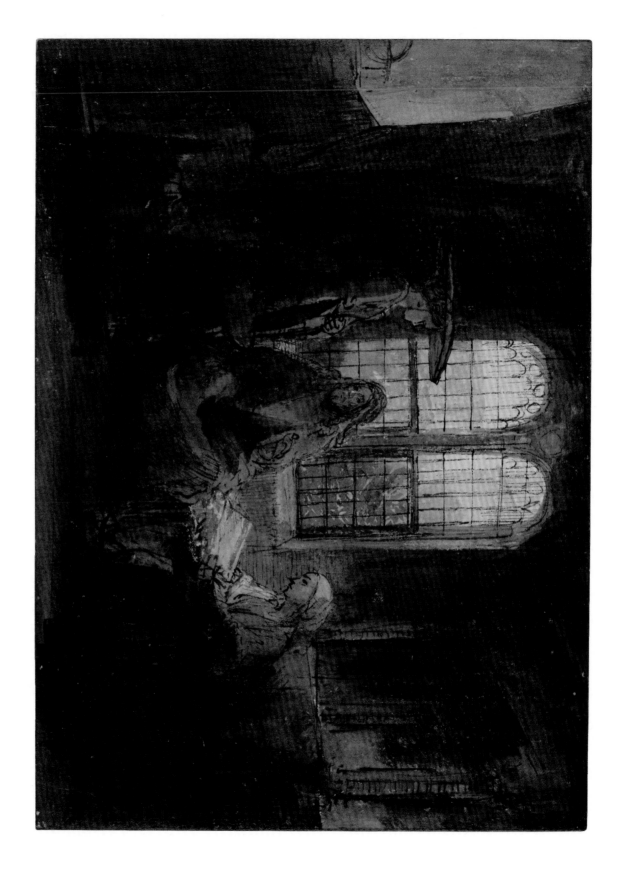

PLATE 1.12

Circle of Rembrandt Harmensz. van Rijn

Christ Conversing with Martha and Mary, c. 1652

Pen and brush in brown ink with gray and gray-brown wash and white gouache on paper, 7¼ × 10¼ inches (18.4 × 26.1 cm)

British Museum, London, PD Oo.10.123

CAT. 54

21

as he gazes upward at the standing figure of Christ. Christ's commanding presence in this interpretation of the subject contrasts markedly with the almost imploring figure of Christ in the Berlin drawing. These divergent representations of the subject indicate the potential range of emotions that can come into play as an artistic genius such as Rembrandt plumbs the dramatic scope of these wrenching moments as narrated in the Gospels recounting the Passion of Christ.

This group of meditative images, focused largely on the believers' perceptions of Christ and the meaning associated with his presence in their midst, forms a current in Rembrandt's art during the 1640s and 1650s that parallels his more overtly emotionally charged images of Christ's Passion, which found their ultimate expression in two drypoints, *The Three Crosses*[57] of 1653 and *Christ Presented to the People* (*Ecce Homo*) of 1655 (see plate 4.17). This strong emotional tenor also found expression in his "series" of four prints from about 1654—*The Presentation in the Temple* (*in the Dark Manner*), *The Descent from the Cross by Torchlight*, *The Entombment*, and *The Supper at Emmaus*.[58] This last print differs from the other three in its quietude, as the pervading light imbues the subject with a calmness and serenity following the two wrenching events that precede it.

In all of these works Rembrandt directs the narrative to focus on the beholder's response to the presence of Christ. What does his presence and what it signifies trigger in the mind of the beholder? The beholder's self-identification with the suffering and sacrifice of Christ in the Passion attains a level of almost unbearable emotional intensity, edifying and yet charged with a sense of human guilt at the injustice and brutality of Christ's crucifixion and death. By identifying empathetically with the suffering of Christ, the devout continuously reinforce their Christian faith in highly emotive terms. In the biblical account, Christ's resurrection and appearances in Gethsemane and Emmaus and among his disciples reinforce their faith in his eternal presence in the world of human affairs. Their perception of his presence serves as a guiding light as they set about constructing their church on earth as an enduring monument to the new dispensation. In the images of Christ's appearance to his believers following his death and resurrection, Rembrandt shapes the narrative to stress a sense of quiet wonderment mediated by meditation and acceptance of the miraculous. Furthermore, by inference the artist intends that the beholders of such images experience their own sense of wonderment.

In Rembrandt's haunting images of these subjects, the primary focus is on what the human mind and soul behold.[59] What the artist articulated so indelibly in *The Supper at Emmaus* of 1648 (see plate 1.1), *The Hundred Guilder Print* (see plate 1.2), and other related works from the late 1640s was a radical reorientation of the function of a meditative religious image. The more traditional *Andachtsbild*, such as the many versions of *Christ Crowned with Thorns* associated with Dieric Bouts (c. 1415–1475) and his son Albrecht (c. 1452–1549), for instance, echoed Thomas à Kempis's self-identification with the suffering of Christ.[60] Instead, Rembrandt focuses on Christ's universal goodness and unalloyed presence in the ongoing realm of human affairs, which, once embedded in the human mind and soul, remain a continuous beacon of hope and redemption.

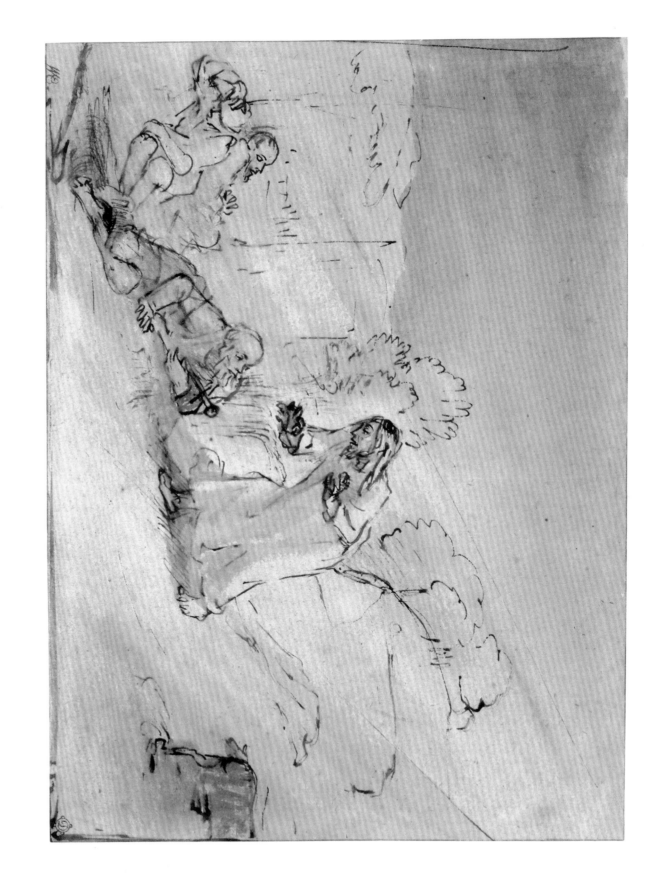

PLATE 1.13

Follower of Rembrandt Harmensz. van Rijn

Christ Finding the Apostles Asleep on the Mount of Olives, 1654–55

Pen, brown ink, and washes on paper; 7 × 9 9/16 inches (17.8 × 24.3 cm)
Staatliche Museen zu Berlin, Kupferstichkabinett, kdz 2700
Photograph © Bildarchiv Preussischer Kulturbesitz / Art Resource, NY

CAT. 57

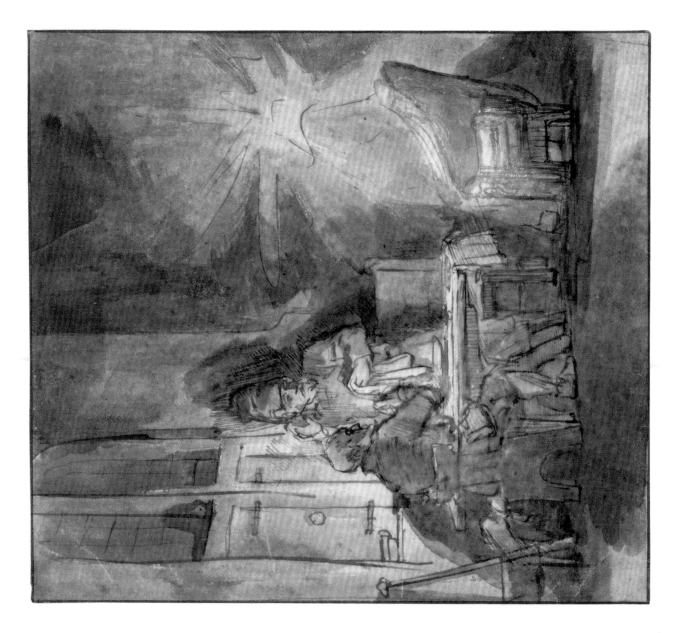

PLATE 1.14

Attributed to Rembrandt Harmensz. van Rijn

Supper at Emmaus, c. 1640–41

Pen, East India ink, brown ink, and wash on paper, heightened with chalk; 7¹³⁄₁₆ × 7⁷⁄₁₆ inches (19.8 × 18.3 cm)

The Fitzwilliam Museum, Cambridge, R.A. 1937, no. 2139

Photograph © The Bridgeman Art Library International

CAT. 20

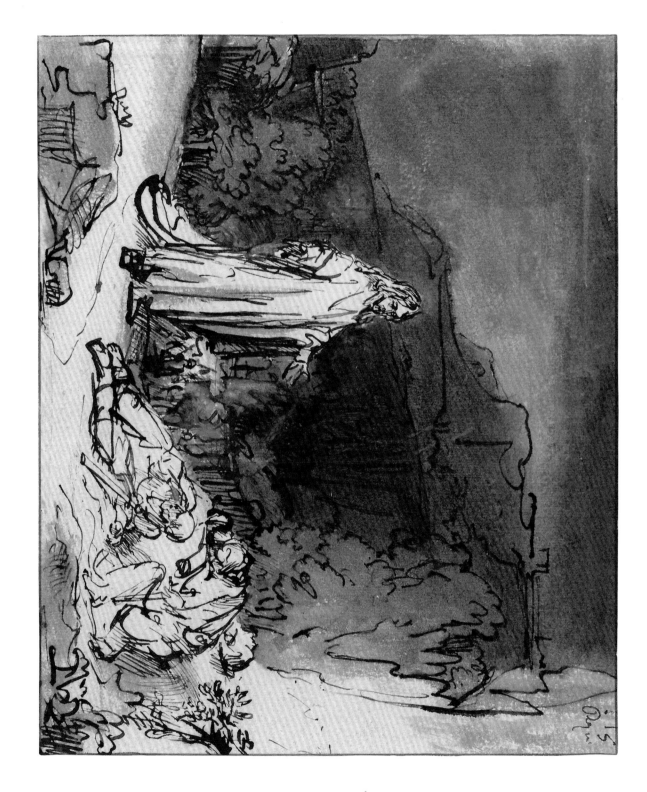

PLATE 1.15

Rembrandt Harmensz. van Rijn

Christ Awakening the Apostles on the Mount of Olives, c. 1641–42

Pen, brown ink, and wash on paper; 6⅝ × 8³⁄₁₆ inches (16.8 × 20.8 cm)

Collection E.W.K., Bern, Switzerland

CAT · 21

1. George S. Keyes et al., *Masters of Dutch Painting: The Detroit Institute of Arts* (Detroit: Detroit Institute of Arts; London: D. Giles Ltd., 2004), pp. 176–79.

2. W. R. Valentiner, "Bust of Christ by Rembrandt," *Bulletin of the Detroit Institute of Arts*, vol. 12, no. 1 (October 1930), pp. 2–3.

3. Other heads of Christ also entered the public domain in the early twentieth century. Martin Bromberg gave his *Head of Christ* (from the collection of his brother-in-law, Rodolphe Kann) to the Prussian State Picture Gallery in Berlin in 1907. John G. Johnson acquired the *Head of Christ* now in the Philadelphia Museum of Art from the Sedelmeyer Gallery in Paris, probably in 1901. Johnson's collection entered the public domain following his death in 1917 and was first on view at his house from 1923 until 1933, when it was transferred to the Philadelphia Museum of Art.

4. Abraham Bredius, *Rembrandt Gemälde* (Vienna: Phaidon, 1935), published in English as *The Paintings of Rembrandt* (London: Allen and Unwin, 1937); hereafter abbreviated as Bredius followed by the catalogue number.

5. Albert Blankert, *Museum Bredius: catalogus van de schilderijen en tekeningen* (The Hague: Dienst voor Schone Kunsten der Gemeente 's-Gravenhage, 1978), pp. 105–6, cat. 135.

6. Kurt Freise, "Neue Bilder in holländischen Sammlungen," *Der Cicerone*, vol. 4 (1912), pp. 653–63, esp. pp. 653, 655, pl. 1.

7. F. Schmidt-Degener, *Oude schilderyen bijeengebracht uit de verzamelingen van Dr. A. Bredius en J. O. Kronig*, exh. cat. (The Hague: Kunstzaal Kleykamp, 1915), cat. 14.

8. Cited in Blankert, *Museum Bredius*, p. 105.

9. Cited in ibid.

10. Although *Christ Preaching* is neither signed nor dated, it is now generally considered to be from the late 1640s, the same period during which Rembrandt produced the Louvre *Supper at Emmaus*, as well as the painted heads of Christ. Gary Schwartz, *Rembrandt: His Life, His Paintings* (Harmondsworth, UK: Viking, 1985), pp. 284–85, dates most of the heads 1645–55. Shelley Perlove and Larry Silver, *Rembrandt's Faith: Church and Temple in the Dutch Golden Age* (University Park: Pennsylvania State University Press, 2009), p. 314, also accept the idea that these heads were produced by Rembrandt and members of his studio in the late 1640s and 1650s. Others have dated them later, partly on the questionable assumption that the examples cited in Rembrandt's bankruptcy inventory of 1656 pinpoint their genesis to that date or only slightly earlier; see, for example, Laurence Sigal-Klagsbald and Alexis Merle du Bourg, eds., *Rembrandt et la nouvelle Jérusalem: Juifs et Chrétiens à Amsterdam au siècle d'or*, exh. cat. (Paris: Panama musées; Musée d'art et d'histoire du judaïsme, 2007), cat. 107, who date the Berlin *Head of Christ* as 1655–56.

11. Seymour Slive, "An Unpublished *Head of Christ* by Rembrandt," *Art Bulletin*, vol. 47, no. 4 (December 1965), pp. 407–17.

12. For example, Blankert, *Museum Bredius*, p. 106, cites the existing correspondence regarding the Rembrandt Research Project's rejection of the *Head of Christ* in the Museum Bredius. Set up in 1968, the Rembrandt Research Project (RRP) was initially comprised of a committee of specialized Dutch art

historians who sought to establish a set of rigorously defined criteria to determine the authenticity of the paintings included in Abraham Bredius's catalogue raisonné, subjecting each to a thorough scientific analysis in conservation laboratories wherever possible. The RRP developed a cataloguing system with the letters A–C as a means of locating each category of painting within the orbit of Rembrandt and his studio. To date the RRP has produced four volumes. The committee has changed radically from the time of its conception and is now led by Ernst van de Wetering.

13. See, for example, Edgar Peters Bowron, *European Paintings before 1900 in the Fogg Art Museum* (Cambridge, MA: Harvard University Art Museums, 1990), p. 126 (as follower of Rembrandt).

14. See Blankert, *Museum Bredius*, pp. 105–6, cat. 135; and, more recently, Blankert, *Jezus in de Gouden Eeuw* (Zwolle: Waanders; Rotterdam: Kunsthal, 2000), pp. 20–25.

15. J. van der Veen, in Bob van den Boogert et al., *Rembrandt's Treasures*, exh. cat. (Zwolle: Waanders; Amsterdam: Museum het Rembrandthuis, 1999). Appendix 2, pp. 148, 151.

16. See Clifford S. Ackley et al., *Rembrandt's Journey: Painter, Draftsman, Etcher*, exh. cat. (Boston: MFA Publications, 2003).

17. Christian Tümpel and Astrid Tümpel, *Rembrandt: Images and Metaphors* (London: Haus, 2006), p. 212, point out that Rembrandt's aim was to capture the scope of the special nature of Christ's activities—as a miracle worker, as a teacher, and as a magnet of inspiration-seeking followers. As noted repeatedly, Rembrandt here incorporates several episodes from Matthew 19. Because of its wide-ranging narrative this print has received various titles. Two recent exhibition catalogues refer to it, respectively, as *Christ Healing the Sick: The Hundred Guilder Print* (Erik Hinterding et al., *Rembrandt the Printmaker*, exh. cat. [London: British Museum Press; Amsterdam: Rijksmuseum, 2000], pp. 253–58, cat. 61 [entry by M. Royalton-Kisch]) and *Christ Preaching (The Hundred Guilder Print)* (Ackley et al., *Rembrandt's Journey*, pp. 204–8, cat. 135).

18. See Hinterding et al., *Rembrandt the Printmaker*, pp. 118–22, cat. 17 (entry by Hinterding in which he reduces and renumbers the existing states).

19. Adam Bartsch, *Catalogue raisonné de toutes les estampes qui forment l'oeuvre de Rembrandt et ceux de ses principaux imitateurs*, 2 vols. (Vienna, 1797), cats. 88 and 69, respectively (hereafter abbreviated as Bartsch followed by the catalogue number); Christopher White and Karel G. Boon, *Rembrandt's Etchings: An Illustrated Critical Catalogue*, 2 vols. (Amsterdam: Van Gendt; New York: Abner Schram, 1969), cats. 88 and 69, respectively (hereafter abbreviated as White and Boon followed by the catalogue number).

20. Wolfgang Stechow stresses this visual connection in "Rembrandts Darstellungen des Emmausmahles," *Zeitschrift für Kunstgeschichte*, vol. 3, no. 6 (1934). p. 333.

21. Although, as Stechow points out, Christ and the two disciples have been shifted to the left of center; ibid., p. 338. Nonetheless, this effect is counterbalanced by placing Christ before the niche and hemicycle.

22. Tümpel and Tümpel, *Rembrandt: Images and Metaphors*, p. 204, stress how this interior is very reminiscent of a church,

with the niche functioning like a chancel. Perlove and Silver, *Rembrandt's Faith*, pp. 311–15, discuss in detail this painting and its theological significance as a metaphor for the early apostolic church.

23. Most recently, Perlove and Silver, in *Rembrandt's Faith*, have stressed the importance of Rembrandt's interest in the reconstruction of the temple of Herod as he depicts the architectural spaces in many of his religious images.

24. Bredius 562. See also Keyes et al., *Masters of Dutch Painting*, pp. 172–75, cat. 71 (entry by Susan Donahue Kuretsky).

25. Rembrandt's print *The Triumph of Mordecai* depicts the narrative taking place before a monumental arch—a fitting metaphor for the triumph of justice over deceit. Bartsch 40; White and Boon 40. See also Ackley et al., *Rembrandt's Journey*, pp. 177–79, cat. 108. Shelley Perlove discusses the temple and the arch framing it in great detail in "An Ironic Vision of Utopia: Rembrandt's *Triumph of Mordecai* and the New Jerusalem," *Zeitschrift für Kunstgeschichte*, vol. 56 (1993), pp. 38–60, esp. pp. 41–45. Although secular in subject, *The Nightwatch* of 1642 (Rijksmuseum, Amsterdam) represents the militia company of Captain Frans Banning Cock emerging through a massive, arched city gate reminiscent of the grandeur of ancient Rome—a highly appropriate measure of Amsterdam's rise to greatness as the international hub of a far-flung mercantile empire and the financial center of north-western Europe. E. Haverkamp-Begemann discusses the formal and thematic parallels between this print and *The Nightwatch* in "Rembrandt's *Night Watch* and the *Triumph of Mordecai*," in *Album amicorum J. G. van Gelder*, ed. J. Bruyn et al. (The Hague: M. Nijhoff, 1973), pp. 5–8. In his monograph on *The Nightwatch*, Haverkamp-Begemann discusses the arch in the painting and considers it an embodiment of a triumphal arch; E. Haverkamp-Begemann, *Rembrandt: The Nightwatch* (Princeton: Princeton University Press, 1982), pp. 103–5.

26. M. Royalton-Kisch, in Hinterding et al., *Rembrandt the Printmaker*, p. 253.

27. Ackley, *Rembrandt's Journey*, pp. 205–6, discusses and characterizes many of these distinctive features of this celebrated print with great sensitivity. See also Perlove and Silver, *Rembrandt's Faith*, pp. 270–74.

28. For a close reading of this print as it evolved from state to state, see M. Carroll, "Rembrandt as a Meditative Printmaker," *Art Bulletin*, vol. 63 (1981), pp. 585–610. See also Perlove and Silver, *Rembrandt's Faith*, pp. 283–89.

29. Focusing on Rembrandt's depictions of the Supper at Emmaus, Arnold Houbraken noted how the artist often explored an individual subject, producing variations on a theme and adjusting the expression and poses of the figures from one study to the next. See Houbraken, *De groote schouburgh der nederlantsche konstschilders en schilderessen*, 3 vols. (Amsterdam, 1718–21; reprint, Amsterdam: B. M. Israël, 1976), vol. 1, pp. 257–58. His observations on the Supper at Emmaus could apply equally to Rembrandt's many representations of related themes, such as the Incredulity of Thomas, the Pilgrims Journeying to Emmaus, the Noli Me Tangere, and Christ in the House of Mary and Martha in Bethany.

30. William Robinson posits that it would appear that Rembrandt would make a drawing of a specific subject as a demonstration of how to represent it and then encourage his students to produce variants of it as a rigorous studio exercise. See W. R. Robinson, "Rembrandt's Sketches of Historical Subjects," in *Drawings Defined*, ed. Walter L. Strauss and Tracie Felker (New York: Abaris Books, 1987), pp. 241–57, esp. p. 249. In a more general way, Franz Landsberger envisaged that Rembrandt employed his drawings as a didactic stimulus for his students. Franz Landsberger, *Rembrandt, the Jews, and the Bible*, trans. Felix N. Gerson (Philadelphia: Jewish Publication Society of America, 1946), p. 140.

31. Perlove and Silver, *Rembrandt's Faith*, pp. 308–11, stress the primacy of hearing over sight and touch.

32. See Sheldon Peck, *Rembrandt Drawings: Twenty-five Years in the Peck Collection* (Boston: Peribo Documenta, 2003), pp. 42–45, cat. 10. I am much obliged to Dr. Peck and his wife for their hospitality and for kindly sharing their collection with me. This drawing was recently reattributed to Willem Drost, in my opinion incorrectly, by Jonathan Bikker, *Willem Drost (1633–1659): A Rembrandt Pupil in Amsterdam and Venice* (New Haven: Yale University Press, 2005), pp. 64–65, fig. 5D, cited under cat. 5.

33. For the drawing in Amsterdam, see Otto Benesch and Eva Benesch, *The Drawings of Rembrandt: A Critical and Chronological Catalogue*, 6 vols. (London: Phaidon, 1973), no. 537 (hereafter abbreviated as Benesch followed by the catalogue number); and M. D. Henkel, *Catalogus van de Nederlandsche tekeningen in het Rijksmuseum te Amsterdam*, vol. 1, *Teekeningen van Rembrandt en zijn school* (The Hague: Algemeene Landsdrukkerij, 1943), p. 20, cat. 45 (as Rembrandt); Peter Schatborn, *Tekeningen van Rembrandt in het Rijksmuseum* (The Hague: Staatsuitgeverij, 1985), p. 51, fig. 22b (as Ferdinand Bol), cited under cat. 22. The drawing in Dresden (Benesch 929) has recently been reattributed to Willem Drost—see Christian Dittrich and Thomas Ketelsen, with K. Bielmeier and C. Melzer, *Rembrandt: die Dresdener Zeichnungen* (Cologne: W. König, 2004), cat. 79; and Christian Dittrich and Thomas Ketelsen, *Rembrandt: les dessins de Dresde* (Paris: Fondation Custodia, 2006), pp. 102–3, cat. 45. To my mind, the flaccid draftsmanship and lack of spatial differentiation between the foreground figures, the two women beyond, and the distant buildings lead one to query whether this drawing is not merely an old copy after Drost. Another example of this subject is in the Musée du Louvre, Paris, inv. 22.974 (Benesch 869a)—see Frits Lugt, *Inventaire général des dessins des Écoles du Nord: École hollandaise*, vol. 3, *Rembrandt, ses élèves, ses imitateurs, ses copistes* (Paris: Éditions des musées nationaux, 1933), p. 15, cat. 1139, pl. 26.

34. In a drawing now in the National Gallery of Scotland in Edinburgh (Benesch 68a; see plate 4.13), a different moment in the story is recounted in which the two disciples appear to be persuading Christ to accompany them into the inn at Emmaus. This drawing relates to a considerably earlier moment in Rembrandt's studio than the drawing in Paris. The rather frenzied pen work recalls examples by Ferdinand Bol. The name Govaert Flinck has also been associated with this drawing. I am much obliged to William Robinson for discussing this drawing with me. See Keith Andrews, *Catalogue of Netherlandish Drawings in the National Gallery of Scotland*, 2 vols. (Edinburgh: Trustees of the National Galleries of Scotland, 1985), vol. 1, p. 122, inv. D5131; vol. 2, fig. 879.

35. See Perlove and Silver, *Rembrandt's Faith*, pp. 318–21, as well as their essay in this volume, for a detailed discussion of the theological significance of this image as it relates to the Last Supper and the covenant of the New Testament.

36. Egbert Haverkamp-Begemann et al., *Fifteenth- to Eighteenth-Century European Drawings in the Robert Lehman Collection: Central Europe, the Netherlands, France, England* (New York: Metropolitan Museum of Art, 1999), p. 209; Ackley et al., *Rembrandt's Journey*, p. 67.

37. Reproduced in Haverkamp-Begemann, *European Drawings in the Robert Lehman Collection*, p. 209, fig. 66.3.

38. Stechow, "Rembrandts Darstellungen des Emmausmahles," pp. 329–41, esp. p. 339, stresses the centrality of the composition and Rembrandt's inspiration drawn from Leonardo da Vinci.

39. Philip Hendy and Ludwig Goldscheider, *Giovanni Bellini* (Oxford: Phaidon, 1945), pl. 56; Giles Robertson, *Giovanni Bellini* (New York: Hacker Art Books, 1981), pl. 73.

40. Hendy and Goldscheider, *Giovanni Bellini*, pl. 100; Robertson, *Giovanni Bellini*, pl. 98.

41. Max J. Friedländer, *Early Netherlandish Painting*, vol. 6, part 1 (Leiden: A. W. Sijthoff; Brussels: Éditions de la Connaissance, 1971), pp. 46–47, 53, nos. 9, 10, 55, 56, 60, 61.

42. Recently discussed and reproduced in Ackley et al., *Rembrandt's Journey*, pp. 230–31, cat. 152 (entry by Ackley). See also Perlove and Silver, *Rembrandt's Faith*, pp. 321–22.

43. In several drawings representing Christ and the Woman Taken in Adultery, Rembrandt uses this narrative formula in an analogous way. This is most evident in his drawing now in Stockholm (Benesch 1038; see plate 3.8) and a school drawing now in the Museum Boijmans Van Beuningen, Rotterdam, inv. R37 (Benesch 964; see plate 3.7). For the latter, see Jeroen Giltaij, *The Drawings by Rembrandt and His School in the Museum Boymans–van Beuningen* (Rotterdam: Museum Boijmans Van Beuningen, 1988), pp. 28–86, cat. 154 (as pupil of Rembrandt). L. Hendricks, in Holm Bevers et al., *Drawings by Rembrandt and His Pupils: Telling the Difference*, exh. cat. (Los Angeles: J. Paul Getty Museum, 2010), p. 215 n. 5, queries the attribution of the Stockholm drawing to Rembrandt.

44. Schatborn, *Tekeningen van Rembrandt*, pp. 182–84, cat. 86 (with a tentative attribution to Samuel van Hoogstraten). As Schatborn further points out, Van Hoogstraten continued to display interest in this subject. His signed drawing in the Rijksmuseum depicts Christ forcefully seizing the right hand of Thomas. Christ's head is set off by a halo and his entire body seems to glow within the darkly shaded interior. This drawing was earlier attributed to Nicolaes Maes (1634–1693) by Henkel, *Catalogus van de Nederlandsche tekeningen*, vol. 1, pp. 97–98, pl. 171.

45. Wolfgang Wegner, *Die niederländischen Handzeichnungen des 15.–18. Jahrhunderts*, 2 vols. (Berlin: Mann, 1973), vol. 1, p. 174, no. 1195, and vol. 2, pl. 331 (as school of Rembrandt); Thea Vignau-Wilberg and Peter Schatborn, *Rembrandt auf Papier: Werk und Wirkung* (Munich: Hirmer, 2001), pp. 309–11, cat. 86 (as school of Rembrandt).

46. This drawing contains corrections, especially on the figures of Christ and Thomas. A flaccid copy now in the Herzog Anton Ulrich-Museum in Braunschweig has incorporated these corrections, suggesting that the composition was highly regarded. Thomas Döring et al., *Aus Rembrandts Kreis: die Zeichnungen des Braunschweiger Kupferstichkabinetts*, exh. cat. (Petersberg: Imhof, 2006), p. 157, cat. A40. See also Vignau-Wilberg and Schatborn, *Rembrandt auf Papier*, p. 310, fig. 1. Interestingly, in another drawing in Munich (inv. 1906.279), attributed to Constantijn van Renesse (1626–1680), the artist has altered the space by framing the scene with a low, massive archway and by lowering the vaulted space beyond. Moreover, not only does Renesse reduce the number of witnesses, but he also places several of them beyond a table-like structure behind Christ, who stands in right profile facing the kneeling figure of Thomas. These changes to the composition dilute the powerful interrelationship between the architecture and the figures it contains. For this drawing, see Wegner, *Die niederländischen Handzeichnungen*, vol. 1, p. 120, no. 852, and vol. 2, pl. 403 (as Constantijn de Renesse); Vignau-Wilberg and Schatborn, *Rembrandt auf Papier*, pp. 306–8, cat. 85 (as Constantijn van Renesse with corrections by Rembrandt).

47. Houbraken, *De groote schouburgh*, vol. 2, pp. 246–47, describes Martha in this composition as cooking and baking food at the fireplace.

48. Michiel C. Plomp, *The Dutch Drawings in the Teyler Museum*, vol. 2, *Artists Born between 1575 and 1630* (Haarlem: Teylers Museum, 1997), pp. 292–93, cat. 322. Peter Schatborn recently attributed this drawing to Govaert Flinck; see Bevers et al., *Drawings by Rembrandt and His Pupils*, p. 67, cats. 4.1 and 4.2. See also Peter Schatborn, "The Early, Rembrandtesque Drawings of Govert Flinck," *Master Drawings*, vol. 48, no. 2 (Spring 2010), pp. 4–38, esp. pp. 14–16, fig. 14.

49. Wegner, *Die niederländischen Handzeichnungen*, vol. 1, pp. 153–54, no. 1094, and vol. 2, pl. 309 (as Rembrandt); Vignau-Wilberg and Schatborn, *Rembrandt auf Papier*, pp. 216–18, cat. 56 (as possibly Rembrandt).

50. M. Royalton-Kisch, *Drawings by Rembrandt and His Circle in the British Museum* (London: British Museum Press, 1992), pp. 192–93, cat. 93 (as school of Rembrandt).

51. Blaise Ducos and I are much obliged to Martin Royalton-Kisch for discussing this drawing with us and sharing his enthusiasm for its great qualities.

52. In certain respects this configuration recalls that in Rembrandt's *Holy Family with a Curtain* painting of 1646 now in Kassel (see fig. 3.2) to such a degree that it seems almost inconceivable that the draftsman of this sheet did not know the painting first-hand. Unfortunately, this intriguing drawing has been compromised by the addition of substantial prosaic washes; enough telltale signs remain, however, to indicate that the artist followed Rembrandt's narrative device of placing Martha largely in shadow while illuminating the figure of Mary.

53. Curiously, this same subject is cast from a different angle, roughly 90 degrees to the left, in an anonymous Rembrandt school drawing in the Staatliche Graphische Sammlung, Munich (inv. 5147). See Wegner, *Die niederländischen Handzeichnungen*, vol. 1, p. 185, no. 1267, and vol. 2, pl. 346 (as circle of Rembrandt); Vignau-Wilberg and Schatborn, *Rembrandt auf

Papier, pp. 219–20, cat. 57 (as school of Rembrandt—possibly Ferdinand Bol). Christ is seen in right profile with the window at his back. The existence of this drawing and its relationship to that in London may suggest that the setting was a commonly shared space, possibly within Rembrandt's house on the Jodenbreestraat.

54. In his discussion of this drawing, H.-M. Rotermund focuses on Christ's distress and agitation as he seeks help and support from the sleeping disciples. The light appearing behind Christ indicates that he is not forsaken by God. H.-M. Rotermund, "The Motif of Radiance in Rembrandt's Biblical Drawings," *Journal of the Warburg and Courtauld Institutes*, vol. 15, nos. 3 and 4 (1952), pp. 101–21, esp. p. 107.

55. Bartsch 75; White and Boon 75.

56. See Benesch C47. Despite Benesch's doubts, many scholars have defended the traditional attribution to Rembrandt; see, for example, J. R. Judson and E. Haverkamp-Begemann, *Rembrandt after Three Hundred Years*, exh. cat. (Chicago: The Art Institute of Chicago, 1969), pp. 169–70, cat. 122 (entry by E. Haverkamp-Begemann and A.-M. Logan). Houbraken recognized the unique power of this invention and reproduced at least a variant of it in *De groote schouburgh*, vol. 1, following p. 258.

57. Bartsch 78; White and Boon 78.

58. Respectively, Bartsch 50 and White and Boon 50; Bartsch 83 and White and Boon 83; Bartsch 86 and White and Boon 86; Bartsch 87 and White and Boon 87. The serial character of this quartet of upright compositions has been noted for some time. Recently, Ernst van de Wetering has argued that Rembrandt conceived of such groupings of prints with a degree of deliberation hitherto unseen; see Van de Wetering in Hinterding et al., *Rembrandt the Printmaker*, pp. 44, 46–47. In his more nuanced reading of this issue, Ackley posits that Rembrandt, although he may have thought serially, never put this into formal practice, as had printmakers such as Albrecht Dürer, Lucas van Leyden, and Hendrick Goltzius, three artists Rembrandt admired enormously. See Ackley et al., *Rembrandt's Journey*, p. 232.

59. In consideration of Rembrandt's later works, Jan Bialostocki posits that the artist concerned himself far less with the narrative than with the intense, intrinsically human experience, thereby transforming his subjects into psychological dramas of individuals. J. Bialostocki, "A New Look at Rembrandt's Iconography," *Artibus et Historiae*, vol. 5, no. 1 (1984), pp. 9–19, esp. p. 15.

60. Max J. Friedländer, *Early Netherlandish Painting*, vol. 3 (Leiden: A. W. Sijthoff, 1968), plates 75–78, 92; cats. 62, 63, 83, including variants and copies.

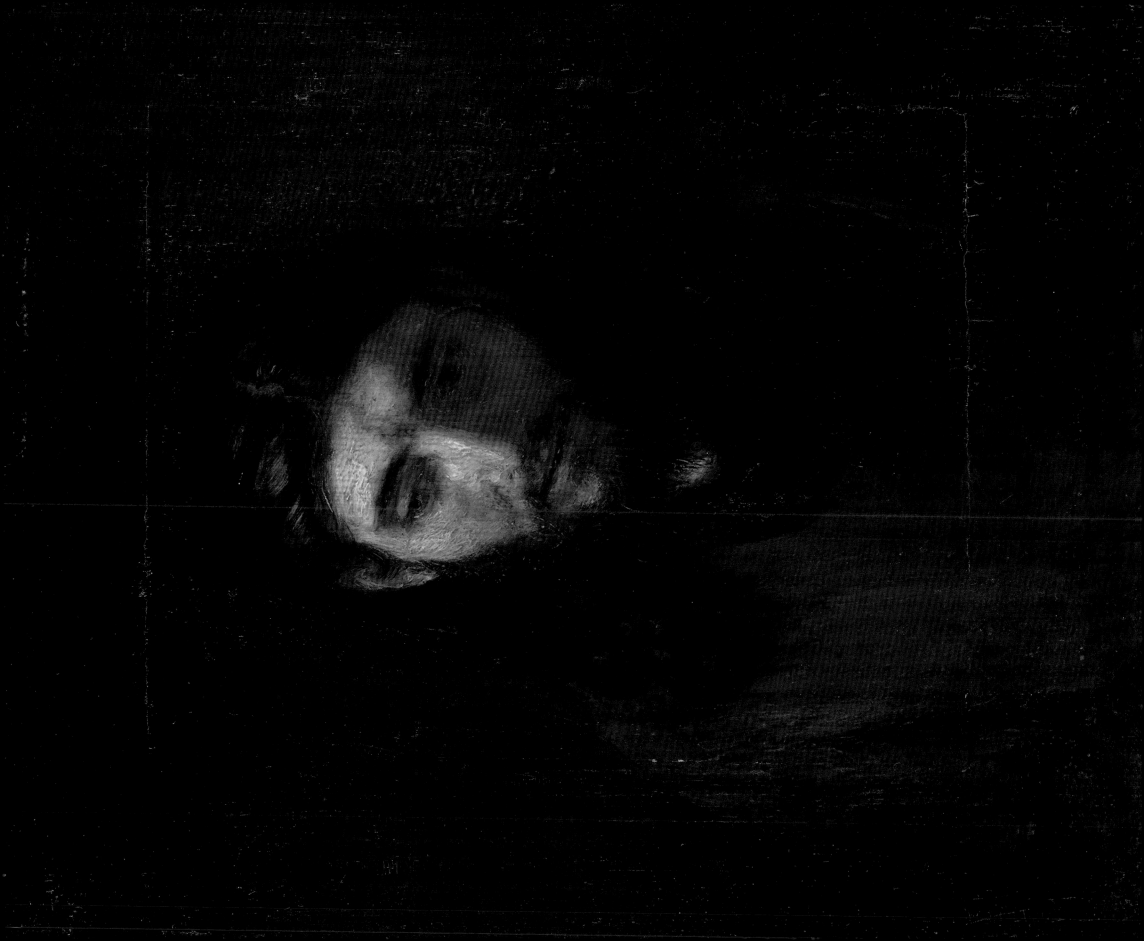

The Heads of Christ
A TECHNICAL SURVEY

Mark Tucker, Lloyd DeWitt, and Ken Sutherland

In 1965, on the occasion of the Fogg Art Museum's acquisition of a newly discovered small panel painting of the head of Jesus, Seymour Slive published an article discussing that work in the context of a group of six other similar paintings of Jesus attributed to Rembrandt van Rijn.[1] In the oeuvre of Rembrandt and his circle, this enigmatic group of tightly conceived meditative figure studies, very closely related in format, technique, conception, and style, stands out as a singular phenomenon. Of the seven, one remains in private hands (plate 2.4); the other six are held by museums in Philadelphia (plate 2.2; fig. 2.1), Amsterdam (plate 2.3), Cambridge, Massachusetts (plate 2.5), Berlin (plate 2.6), Detroit (plate 2.7), and The Hague (plate 2.8). The present exhibition and catalogue, which bring together the panels along with related works by Rembrandt and his circle, provided a unique opportunity for a focused study of the group, including close visual and technical comparisons of the examples in museums and a detailed scientific study of the materials of the Philadelphia painting. The findings of this comparative study, as well as the current state of scholarship surrounding the heads of Christ, are the focus of the present essay.

We recognized from the outset that any attempt at definitive attribution, chronology, or ranking of "quality" within this core group of panels depicting the head of Jesus would remain largely conjectural. Such efforts are challenged not only by the lack of anything other than circumstantial documentary evidence on this group, but also by the altered and compromised condition of a number of the panels. Instead, it was our hope that a close, objective examination of the technical features of the panels and similarities and differences within the group would shed light on their relationship to each other and to such mature Rembrandt masterpieces as *The Supper at Emmaus* of 1648, now in the Musée du Louvre, Paris (fig. 2.2; see plate 1.1), and *The Hundred Guilder Print* of about 1649 (see plate 1.2). The distilled emotional tenor and direct realism of the latter works would appear to be the result of experimentation through a number of sketches, perhaps similar to the panels considered here. By examining the head of Christ panels closely, and by analyzing the materials to investigate how their appearance may have changed over time, we hoped to revisit with more information existing hypotheses about the creation of the group.

RECENT SCHOLARSHIP ON THE HEADS OF CHRIST

The heads of Christ series has posed a number of challenges for scholars. No consensus exists, for instance, on the circumstances under which the paintings were created. What were the dates and sequence of their execution? What was the motivation for creating many versions? Were they made with a view toward any specific painting or graphic project? How many artists' hands are represented,

Fig. 2.1. Rembrandt Harmensz. van Rijn and Studio, *Head of Christ* (entire panel; see plate 2.2 for inset portion), c. 1648–56. Oil on panel, 14⅛ × 12⅜ inches (35.8 × 31.2 cm). Philadelphia Museum of Art, John G. Johnson Collection, cat. 480

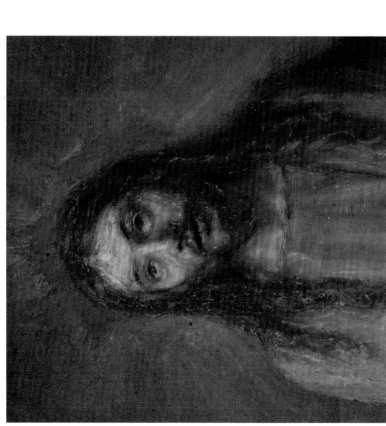

Fig. 2.2. Detail of the face of Christ in Rembrandt's *Supper at Emmaus* of 1648, Musée du Louvre, Paris, before cleaning. © C2RMF / photograph A. Thomasset

Fig. 2.3. Follower of Rembrandt Harmensz. van Rijn, *Head of Christ or an Apostle*, mid to late seventeenth century. Oil on panel, 7⁷⁄₁₆ × 8⁹⁄₁₆ inches (18 × 22 cm). Location unknown (formerly in the collection of A. H. Kleiweg de Zwaan, Neerlangbroek, the Netherlands). Photograph courtesy Rijksbureau voor Kunsthistorische Documentatie

and is Rembrandt's own? What implications does the organization of Rembrandt's studio—conceived either as a standing workshop of several assistants or a studio in which the artist brought in one or more assistants only as needed—have for the authorship of this group? Is only one model represented? Indeed, are any or all of the paintings clearly based on a live model, or are they studies of general types from the imagination?

Works in Rembrandt's orbit in the same format as the heads of Christ—that is, oil sketches on oak panels measuring around 10 by 8 inches (25.4 × 20.3 cm)—often also depict heads of bearded men, such as the 1647 example in the Galerie Willem V in The Hague.[3] One such painting, formerly in the collection of the Dutch art dealer Jacques Goudstikker (fig. 2.3), even resembles the Christ panels but uses an older man as a model. There are, in addition, whole families of similar-looking character heads in this format painted in Rembrandt's style by followers. The Christ group stands out among such works as a more intense, concentrated project depicting a figure turned various ways to exploit the expressive potential of different angles of illumination. The panels are not repetitions of each other or figures precisely excerpted from existing works of art.[4] Rather, they represent refinements of expressions, likely driven by a practical concern to obtain realistic models that could be used for a range of narratives.

In 1965 Slive still held that the seven panels of Christ were attributable to Rembrandt; by 1997, however, Albert Blankert would note that "since the Rembrandt Research Project team made its first conclusions known in the early 1970s, the authenticity of a growing number of heads of Christ has been called into question. At present none of them are believed to be autograph. The painting in Berlin is considered the best, but even so is thought to be a studio piece."[5] The Rembrandt Research Project, a group of scholars formed in 1968 to study and determine the authenticity of paintings attributed to Rembrandt, clarified this view in the latest volume of its *Corpus of Rembrandt Paintings*, published in 2006: "While the complex problems of authenticity surround the series of

extant Rembrandtesque heads of Christ (Bredius 620–627), it is fair to say the Berlin example is the most likely to be an autograph work by Rembrandt."[6]

Condition and later alterations may, in the end, thwart any consensus about which if any of the panels are fully and unquestionably autograph. However, our findings challenge the commonly accepted view that the group is stylistically heterogeneous.[7] Our conclusion that some of the works postdate the masterpieces for which they were once taken to be studies is also by no means inconsistent with how Rembrandt's studio functioned, as discussed below. We hope that the results presented here will stimulate further debate about the status of this group. For the purpose of identifying the works in this exhibition and catalogue, however, the dates and attributions of the panels follow those accepted by the lenders.

Based on the Rembrandt Research Project's assessment, one interpretation might be that these panels represented a studio exercise, with Rembrandt creating one of the panels while others worked from various positions seated around the model. A studio drawing now in Darmstadt even seems to depict such a group exercise in Rembrandt's studio (fig. 2.4). The drawing broadly exposes the various kinds of relationships within the studio, as Peter Schatborn has explained.[8] Rembrandt is seated in the middle as he and his pupils sketch a nude woman posed on a bench. The youngest pupil watches the master drawing, and a well-dressed amateur observes the exercise, while the three others, dressed in work attire, are busy sketching the figure from different angles.

The variety of poses and angles of lighting in the Jesus sketches, however, make it seem unlikely that they represent a simultaneous studio exercise. Furthermore, Schatborn has pointed to the dearth of oil sketches of models, as well as evidence from studio drawings themselves, to show that such lessons did not mainly involve sketching in oil; rather, the students drew on paper while Rembrandt drew the same model on an etching plate with a stylus. Many surviving student drawings of models (likely other pupils) appear to document such lessons, but the only images securely

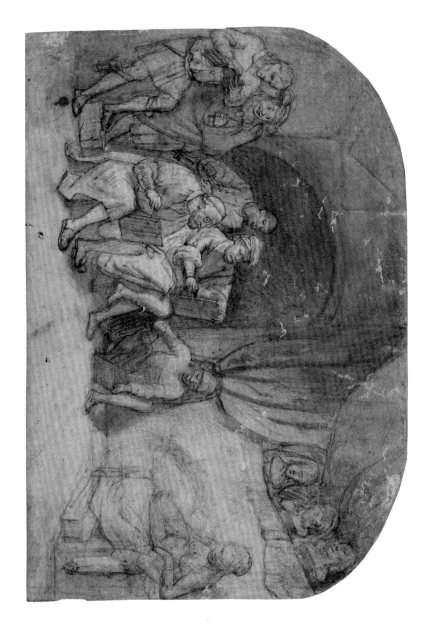

Fig. 2.4. Attributed to Constantijn van Renesse (Dutch, 1626–1680), *Rembrandt and His Pupils Drawing from a Nude Model*, c. 1650. Black chalk, brush, and brown wash with gouache; 7⁄₁₆ × 10⁷⁄₁₆ inches (18 × 26.6 cm). Hessisches Landesmuseum Darmstadt

attributable to Rembrandt are two etchings of the same session from about 1646, *The Walking Lesson* and *Seated Male Nude*.[9] Michiel Francken has convincingly argued that oil sketches were instead favored for exercises in which students made partial copies, excerpting figures or other portions from Rembrandt's own paintings.[10] The Rembrandt Research Project will consider this type of sketch under the rubric of "satellite" painting in the forthcoming fifth volume of the *Corpus*.[11] The heads of Christ could be such "satellites" derived from existing paintings. None of these panels, however, exactly duplicates a figure from Rembrandt's known paintings in the direct manner of the partial copies. Head of Christ panels may have been kept in the studio for students to copy, explaining the existence of the painting now at the Bob Jones University Museum and Gallery in Greenville, South Carolina (plate 2.9), which duplicates the panel in the Museum Bredius, The Hague (plate 2.8). Other scholars have dismissed any connection to living models, asserting that all of the panels are based on an ancient description of Christ (see DeWitt, this volume).[12]

The range of poses in the group is consistent with Rembrandt's drawing practice and calls to mind the biographer Arnold Houbraken's description in his 1718 *Groote schouburgh der nederlantsche konstschilders en schilderessen* (Great Theater of Netherlandish Painters and Paintresses): "One frequently sees so many different sketches of the same subject by his hand, which are also full of alterations as regards characterization, posture and details of costume. In this he deserves to be praised above others—especially those who combine in their works identical characterizations and draperies, as if the figures were all twins. I know of no one else who has made so many alterations in the sketches for one and the same composition."[13] The focus on emotional expression in the Christ sketches is also consistent with Rembrandt's artistic concerns. Decades earlier, Constantijn Huygens, secretary to the stadtholder of the Dutch Republic, had noted the young Rembrandt's expertise in this aspect of history painting, describing the protagonist in his 1629 *Judas Returning the Thirty Pieces of Silver* (see fig. 5.5) as "that one maddened Judas, screaming, begging for forgiveness . . . all traces of hope erased from his face; his gaze wild."[14] It is noteworthy that three heads of Christ—two of them specifically attributed to Rembrandt—were documented as being in the artist's house in 1656.[15] Nevertheless, when our investigation began, the prevailing hypothesis was that none of the Christ panels was autograph, suggesting that they were produced by pupils or assistants, perhaps as part of an exercise or event in the studio, either a session with a live model or as interpretations of an ancient description of Christ.

FINDINGS FROM OUR SURVEY

To investigate the various theories about the origin of the panels, we set out to examine how the paintings were made. In contrast to the Rembrandt Research Project's specific aim to determine Rembrandt's authentic oeuvre, we hoped our distinct focus on observable technical and stylistic relationships within this group, without concern for establishing relative "authenticity" in any larger sense, could lead us in a different and perhaps complementary direction. We undertook to visit the collections where the panels were accessible and to examine them closely under similar conditions, using low-power stereomicroscopes whenever possible. With the help and accommodation of our colleagues, this was accomplished for the six panels now in museums (plates 2.2, 2.3, 2.5–2.8); the related panels in Greenville, South Carolina (plate 2.9), and Provo, Utah (plate 2.10); and the *Portrait of a Young Jew*, now in the Gemäldegalerie, Berlin (see plate 4.6), which shares some technical features

with the Christ sketches. Very importantly, we also had close access to a touchstone in Rembrandt's oeuvre, the 1648 *Supper at Emmaus* (see plate 1.1, fig. 2.2).[16] We became aware of the location of the seventh panel in the core group too late to examine it for our technical study; its owner has graciously assisted us in obtaining information that promises to enhance what we know about the group.

A complement of examination methods was used in our study to provide insights into the painting technique and condition of the panels. In addition to close visual examinations using stereomicroscopy and observation of the paintings' visible fluorescence under ultraviolet (UV) illumination, we compared reflected infrared images of the paintings and X-radiographs of all except the Provo panel. Dendrochronological analysis to characterize and date the wood panels has been carried out on the seven paintings in the core group.[17] Microscopic and instrumental analysis was undertaken to characterize the pigments and media of the Philadelphia panel using visible and fluorescence light microscopy (VLM, FLM), polarized light microscopy (PLM), scanning electron microscopy with energy dispersive spectroscopy (SEM-EDS), Fourier transform infrared microspectroscopy (MFTIR), and pyrolysis gas chromatography mass spectrometry (Py-GCMS). Pigment analysis was carried out on the Detroit and Amsterdam panels using X-ray fluorescence (XRF).

GENERAL OBSERVATIONS ON MATERIALS AND TECHNIQUE

Our observations concerning technical features of the seven core-group panels are presented in this section, with general discussions of the painting materials and technique and the influence of physical condition on their appearance. More specific descriptions of the individual panels, including salient stylistic and art-historical comparisons and examples of their more unusual or anomalous technical features, are given in the separate entries at the end of the essay.

THE PANEL SUPPORT

The paintings are all on oak panels similar in size, with current dimensions (not including later additions) ranging from 10⅛16 to 9⅜ inches (25.5 to 23.8 cm) high and from 8⁷⁄₁₆ to 7⁹⁄₁₆ inches (21.5 to 19 cm) wide.[18] The few other works attributed to Rembrandt and his studio on similarly sized and dated supports are also rapidly executed oil sketches, such as the Berlin *Portrait of a Young Jew* (see plate 4.6). The grain runs vertically on all panels except that of the Berlin *Head of Christ*, which runs horizontally. The panels have all been altered (variously thinned, cradled, or enlarged); the more significant changes are detailed in the individual entries below. Dendrochronological analysis by Peter Klein determined that five of the panels are Baltic/Polish oak, while the oak of the Detroit and private collection panels originated in the Netherlands or western Germany.[19] The earliest possible felling dates for the group fall between the years 1626 (private collection) and 1650 (Cambridge). Under standard dating assumptions for the two timber sources, the earliest possible creation dates for all except the Philadelphia and private collection panels are in the period 1641 to 1653, with plausible creation dates based on median numbers of sapwood rings ranging from 1645 to 1661.[20] The dendrochronology of the private collection and Philadelphia panels yielded earliest plausible creation dates of 1638 and 1640, respectively.[21] Significantly, the data indicate that the Cambridge panel comes from the same tree as the Berlin *Portrait of a Young Jew* panel, and that the Berlin *Head of Christ* panel comes from the same tree as a *Self-Portrait* panel in Leipzig (Bredius 40).

Fig. 2.5. (a) Cross-section sample from a thinly painted area of the hair in the Philadelphia panel (plate 2.2) and (b) back-scattered electron (SEM) image of the same sample, showing the wood cells of the panel support (1), chalk ground (2), imprimitura (3), and translucent brown paint layer (4). Photographs by Ken Sutherland

THE PREPARATION LAYERS

Wood panels were traditionally prepared by the application of pigmented layers known as grounds to provide a smooth, even surface for painting. The preparation of the six core-group panels we examined is consistent in appearance, observable in thinly painted areas as a translucent, yellowish-to off-white layer through which the grain of the oak panel is visible. Examination of a cross-section sample from the Philadelphia panel revealed ground layers typical for Rembrandt's panels (fig. 2.5).[22] A very fine lower ground made with natural chalk (calcium carbonate) was first applied to the panel, visible particularly in the SEM (backscatter) image as an irregular, discontinuous layer embedded in the grain of the wood. This ground layer was covered with a tinted *primuersel*, or imprimitura, containing calcium carbonate, lead white, and scattered particles of bone black (a carbon-based pigment produced by charring animal bones) and umber (an earth pigment colored with iron and manganese oxides). This pigment mixture provided a medium-value, buff-toned surface for painting. In the X-radiographs of all panels in the group, the chalk ground and imprimitura exhibit low density, with the exception of bright lines and tiny spots occurring along the grain of the wood, likely corresponding to the accumulation of pigmented material from the preparation layers in the grain texture and wood pores. In reflected infrared photographs, the high reflectance of the ground is striking; as discussed below, this layer performs an important visual function in the painting technique and flesh modeling in the Christ panels and comparable works by Rembrandt. The X-radiographs and reflected infrared photographs of the panels in the core group are reproduced in the Appendix to this volume.

PAINT

On the panels we examined, the figure's head is consistently worked up to a more advanced level of finish than the garment and, where present, the hands. In some cases it is difficult to judge whether paintings originally appeared sketchy and unfinished or if this appearance is the result of some better-resolved and more finely worked passages having been partially dismantled through injudicious cleanings. The hair, for example, looks flat and clumsily schematic in several paintings.

Previous studies have established that Rembrandt's standard panel-painting technique included working up the painting from an initial brown monochrome lay-in of modeling, a so-called dead coloring.[23] Although the predominance of brown tones in the palette of these works complicates the identification of this distinct foundational stage, evidence for the brown dead coloring can be seen on close examination in areas of illuminated flesh where the built-up opaque tones were applied over already-established shadow tones, and not blended wet-into-wet with them, as would be the case were they being worked simultaneously. Especially in the case of paintings created as studies, which often show markedly varying levels of finish, no discrete division necessarily existed between phases of execution throughout all parts of the painting; however, in the more finished faces on the panels examined here, at least two stages of execution—the sketch and the subsequent working up of full modeling—are visible.[24] It is clear that the paintings progressed steadily and directly through the working up of full local coloring toward the application of finishing strokes of deepest shade and touches of purer, higher-chroma color and impasto highlights in flesh. The boldness and character of these passages range from the slab-like highlights on Christ's brow in the Berlin panel (fig. 2.6) to the built-up paint teased into interwoven ridges and furrows on the cheek and nose in the Philadelphia panel (fig. 2.7).

A key technical and optical aspect of the painting of flesh in the panels is the interplay of opaque and translucent paint. This exploitation of variations in opacity is evident in the luminosity of transition zones between opaquely painted areas of fully illuminated flesh and those of deepest shadow. A luminous glow is created by gaps in the paint layers, through which the ground layers are either fully exposed as a buff tone or covered only by a thin application of translucent brown paint. Reflected infrared images reveal these zones particularly effectively, due to the high reflectance of the ground compared with the paint layers. Our interest in the infrared images of the paintings arose from the initial observation that the infrared photograph of the Philadelphia panel strikingly revealed the relationship between passages of opaque paint and exposed or thinly veiled ground throughout the flesh.[25] The effect was found to be characteristic of the painting materials and technique of the core group, as well as the Berlin *Portrait of a Young Jew* (see plate 4.6), the Greenville and Provo panels of the head of Christ (plates 2.9, 2.10), and the Louvre *Supper at Emmaus* (see plate 1.1; fig. 2.2).

Fig. 2.6. Detail of the forehead in the Berlin panel (plate 2.6) showing handling of thick impasto.

Fig. 2.7. Detail of Christ's cheek in highlight in the Philadelphia panel (plate 2.2), showing delicately manipulated impasto. Photograph by J. Mikullak.

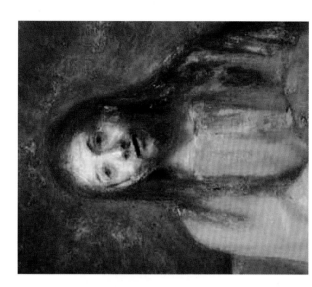

38

In gaps in paint of a closely related color, as on the lit side of a face, the contrast of the exposed preparation layers with adjacent paint, where apparent, is moderate in the infrared images; however, in areas that were deliberately left exposed or only thinly painted over to serve as a component of shaded flesh or a transition zone between lit and shaded flesh, the contrast of boundaries between exposed ground and opaque paint is surprisingly distinct. Especially where opaque paint representing illuminated flesh is blended with darker, infrared-absorbing pigments to model a surface turning away from the light, the boundary is abrupt—perhaps hardened by the abrasion of an originally more delicately feathered transition—giving the shaded edge of the opaque paint a somewhat "charred-edge" effect in reflectographic images (figs. 2.8, 2.9). The reflected infrared photograph of the Louvre *Supper at Emmaus* (fig. 2.10) prominently exhibits this appearance along the left side of Christ's face. Originally, the exposed ground in the paintings was incorporated virtually seamlessly within the scheme of tonal ordering and modeling gradations. In some cases it continues to function this way; in others its role as an effectively integrated element of modeling transitions has been disrupted by the effects of abrasion sustained in cleanings.

The manipulation of paint texture in the six examined panels of the core group shows a concern throughout for producing variety within each painting, demonstrated by a range of paint consistencies and handling, from smooth, exposed ground to low, soft texture where paint leveled after application; from areas worked with more viscous dragged paint, to areas of paste-like stiff paint that retains the marks of the brush, to those showing emphatic, decisively placed impasto. Most of the panels include lines drawn into the wet paint with a hard tool of some kind to suggest texture and highlights. In two of the panels (Philadelphia and Cambridge), closely spaced parallel lines made with a single stroke may indicate the use of the splayed nib of a reed pen (figs. 2.11, 2.12). Melanie Gifford first observed the apparent use of this tool to scratch into the wet paint of the dark painted sketch in Rembrandt's landscapes, and into the final paint of other works such as the *Self-Portrait at the Age of 63* of 1669 (National Gallery, London).[26]

Analysis of microscopic paint samples from the Philadelphia panel showed that the artist achieved his range of effects using a limited palette and a drying oil medium,[27] a finding consistent with previous research on paintings by Rembrandt.[28] Brown and yellow earth pigments, including

Figs. 2.8–2.10. Infrared reflectographic details of the Philadelphia (fig. 2.8) and Hague (fig. 2.9) heads of Christ and the Louvre *Supper at Emmaus* (fig. 2.10) showing the "charred edge" appearance of transition zones of opaque flesh paint blended with an increasing proportion of dark pigment toward the boundary where it meets translucently painted shadow tone, which itself appears unnaturally light due to strong IR reflectance of the ground layer. Photographs by J. Mikuliak (fig. 2.8), Mark Tucker (fig. 2.9), and C2RMF/A. Thomasset (fig. 2.10)

the organic brown Cassel earth, were used in variable quantities to many of the paint mixtures. Lead white was used for opaque highlights in the flesh and hair, whereas chalk was incorporated into paint mixtures—sometimes as the major component—to achieve more translucent effects. Vermilion (mercuric sulfide) was used in pink flesh tones and, in smaller quantities, to add warmth to dark paint mixtures, and it was applied sparingly in a few fine, finishing strokes of bright red. The same pigment was observed on the surfaces of the Philadelphia and Detroit paintings in tiny, isolated pockets or clumps, sometimes in lower paint layers visible through cracks in the overlying paint (fig. 2.13). A similar phenomenon has been described recently in a painting by Rembrandt's pupil Carel Fabritius (1622–1654);[29] in that case, the microscopic aggregates of vermilion were explained in terms of the poor grinding properties for this pigment in oil.[30]

Pigment analysis carried out on the Detroit panel by Cathy Selvius DeRoo, and on the Amsterdam panel by Arie Wallert, suggested a similar palette to that of the Philadelphia Christ.[31] Although instrumental analyses of the other paintings in the group were not possible, based on the close similarities in their technique and tonality it appears that a similar range of pigments was used. The materials analysis of the Philadelphia panel is summarized in table 1; some more unusual aspects of the pigments identified are discussed, in the context of the painting's condition, in the following section.[32]

X-radiographs provided useful indications of compositional changes made during the painting process, as well as an understanding of the buildup of paint layers as reflected in the correspondence between the modeling visible in the surface image and densities visible in the radiographic images. In most cases the correspondence was close, demonstrating foresight and resolve in the modeling of the heads. Only the Detroit painting's X-radiograph showed clear pentimenti in the composition of the figure and some paint densities in the face that did not correspond closely to modeling visible on the surface. X-radiographs had to be interpreted with caution, however, since the images were created with different equipment and exposure parameters; consequently, the images' overall lightness or darkness and contrast did not provide directly comparable information about the paintings' materials.

Fig. 2.11. Detail in the hairline of the Philadelphia figure showing marks scratched in wet paint, suggesting the use of a reed pen. Photograph by J. Mikuliak

Fig. 2.12. Detail in the hairline of the Cambridge figure (plate 2.5) showing marks scratched in wet paint, suggesting the use of a reed pen. Photograph courtesy Harvard Art Museum/Fogg Museum, Cambridge, Massachusetts

Fig. 2.13. Photomicrograph detail of the forehead in the Philadelphia panel showing aggregates of vermilion pigment (image width approximately 3 mm). Photograph by Ken Sutherland

GENERAL OBSERVATIONS ON CONDITION

The considerable differences in surface condition among the paintings posed challenges for their comparison and interpretation. None of the paintings studied could be examined with their actual present condition fully visible; at the time of our examinations, the surfaces of all the paintings were partly obscured by restorations and, in most cases, by moderately to very dark varnish. Only the Provo panel had been cleaned and restored recently. The visible light fluorescence of the paintings under UV illumination indicated the extent of some of the restorations present, but the strong fluorescence of thick varnishes frequently made detection of restorations inconclusive or impossible. Where restorations and thick varnishes were present, they interfered with assessment of the condition of the painting, including the precise degree of wear due to insensitive cleaning. Looking at the paint surfaces through the varnish under a low-power stereomicroscope, it was often possible to see a variety of closely related paint tones invisible to the unaided eye under gallery light. It immediately became clear that the range of hues and small finishing touches of color, particularly in flesh paint, is masked by even moderately yellowed varnish, and distinctions between closely related colors are virtually eliminated by very discolored varnish. Such varnish, when accumulated in the recesses of impasto, imposes an exaggerated awareness of texture that interferes with the reading of the paint's actual color range and modeling gradations. At the same time, the thickness of the accumulated varnish fills the recesses of the built-up surface, subduing the physical relief and light-catching effect of surface texture. The Louvre 1648 *Supper at Emmaus*, which has since been cleaned (compare figs. 2.2 and 6.1), stood out as a particularly powerful example of the effects of discolored varnishes in confusing forms and neutralizing color and texture.

As discussed, under close visual inspection the paint colors, consistencies, layering, and handling in the panels we studied appear very similar. As might be expected from such apparently uniform materials and technique, the vulnerability of certain modeling elements—namely, thinly painted darks and delicate touches of surface color and highlight—to aggressive cleanings shows in recurring patterns of disruption to the tonal continuity and subtlety of modeling. More general loss of paint surface (as appears to afflict the Cambridge painting) was also a factor, making comparison among the paintings even more tenuous. Notable instances of the results of insensitive cleaning are discussed below in the entries on individual paintings.

When considering condition, changes in the original paint materials must also be taken into account. The restorer Johannes Hell remarked that "paintings age, and we don't know how a painting by Rembrandt really looked."[33] Some years ago Ernst van de Wetering made an effort to gauge the magnitude of changes brought on by the aging of Rembrandt's paintings, based on observations about the quality and permanence of his materials and comparisons with contemporary visual documentation such as prints and copies. Noting that the artist "appears to have used very few pigments with a tendency to change," he concluded that "a painting by Rembrandt, as long as it has not been impaired by heavy overcleaning or overpainting—or by severely yellowed layers of varnish—can safely be enjoyed as mirroring Rembrandt's original artistic imagination."[34] More recently, however, there has been an increasing general awareness of the complicating factor of alterations occurring within the paint.

Recent studies have highlighted the complex changes that have occurred over time in the paint materials used by Rembrandt and his contemporaries, notably the blanching (lightening) of

Color	Pigment	Occurrence
Red	Vermilion (mercuric sulfide) [2, 3]	Flesh tones; fine red paint strokes in hair and flesh; minor component in most paint mixtures
	Organic red lake (colorant not determined) on alum-derived substrate [1, 3]	Scattered particles in smalt paint in collar of undergarment (possibly overpaint)
Yellow/ brown	Earth pigments (iron oxide-based) [3, 4]	Used to various extents in most paint mixtures and for fine yellow paint strokes in hair and flesh
	Umber (manganese and iron oxide-based) [3, 4]	Scattered particles in upper ground layer (*primuersel*)
	Cassel earth (organic earth pigment) [2, 3, 4]	Hair and flesh tones
Blue	Azurite (basic copper carbonate) [3, 4]	Lower layer in collar of undergarment; minor component in most paint mixtures
	Smalt (cobalt potassium glass) [1, 3, 4]	Thick paint layer in collar of undergarment (possibly overpaint)
Black	Bone black (carbon-based) [3, 4]	Used to various extents in collar of undergarment (possibly overpaint)
White	Lead white (basic and neutral lead carbonates) [3, 4]	Flesh tones; highlights in hair; light areas of background (covered by overpaint); upper ground layer (*primuersel*)
	Chalk (calcium carbonate) [3, 4]	Used to various extents in most paint mixtures and ground layers

Methods of identification:
[1] Visible/fluorescence light microscopy
[2] Polarized light microscopy
[3] Scanning electron microscopy with energy dispersive spectroscopy
[4] Fourier transform infrared microspectroscopy

paint associated with certain pigments or mixtures.[35] In detailed studies of several of Rembrandt's paintings at the Mauritshuis in The Hague, blanching has been associated with the use of pigments such as lead white, bone black, smalt, and organic red and yellow lakes, or combinations of these.[36] In the Philadelphia panel, blanching was observed as lines and spots of whitened paint occurring primarily in raised strokes of impasto in the darks and mid-tones, whereas in other cases, such as the Detroit painting, a more general blanching was evident in some dark painted areas. Alterations such as these impede a clear reading of the painting—by reducing contrasts and flattening the image in the case of broad areas of lightened paint, or by introducing false and distracting highlights in the case of fine lines of blanching.

Close examination of the affected paint areas in the Philadelphia panel revealed that the lightening results from degradation in the paint layer, and not simply from surface abrasion of varnish or paint on raised parts of the impasto (fig. 2.14). To investigate the possible causes of degradation, microscopic samples from a blanched paint stroke in the hair and from an adjacent area of paint unaffected by blanching were compared. A cross-section of the blanched paint is shown in figure 2.15. Analysis of the composition of the brown paint layer showed that the artist used a mixture rich in chalk,[37] in combination with bone black, vermilion, iron oxide earth, and Cassel earth pigments. No obvious differences were seen in the pigment composition or layer structure of the

Fig. 2.14. Photomicrograph detail of the proper left eye in the Philadelphia panel showing blanching of the flesh paint (image width approximately 15 mm). Photograph by Ken Sutherland

Fig. 2.15. Cross-section sample from an area of blanched paint of the hair in the Philadelphia panel, showing the imprimitura (1) and translucent paint layer rich in chalk with particles of vermilion, bone black, iron oxide earth, and Cassel earth (2). Photograph by Ken Sutherland

blanched and unblanched paint samples. This suggests that external factors such as exposure to light or humidity—which would be more pronounced in the raised areas of paint where the overlying varnish is thin or absent due to wear or uneven cleaning—may play a part in promoting blanching.[38] The predominance in the paint mixture of chalk, a hygroscopic (moisture-absorbing) pigment, would support this interpretation.[39]

The use of chalk-rich paints by Rembrandt and his circle was not unusual: as discussed, Rembrandt is known to have experimented with properties of paint such as transparency and texture. The painter of the Philadelphia panel was likely exploiting contrasts between the translucent, glaze-like paints produced by mixing chalk with oil, and the more opaque mixtures based on pigments such as lead white. The presence of chalk in paintings from this period is sometimes associated with the use of organic yellow lake pigments, which typically were made by casting a yellow dye on a chalk substrate, but the presence of the organic colorants is often difficult to confirm since they are fugitive and prone to degradation.[40] Although the use of yellow lakes in the Philadelphia painting cannot be ruled out, the widespread use of chalk in different color areas—including the hair, flesh tones, and light-colored paint from the background—makes it seem more likely that it was employed as a colorless extender.

Another type of paint degradation observed in the Philadelphia panel—and now recognized in many paintings by Rembrandt and other artists—is the occurrence of aggregates of translucent white material formed from the reaction of lead white pigment with fatty acids from the oil medium to form lead carboxylates (soaps).[41] This phenomenon often manifests itself as tiny white spots, caused by the lead soap aggregates pushing through the surface paint layers. The speckled appearance of thinly painted areas in the Philadelphia panel (fig. 2.16) might at first seem attributable to this type of alteration, though it could also simply be a consequence of aggregates of poorly ground lead white pigment in the imprimitura, made more apparent by the abrasion of the overlying paint.[42] On closer examination, lead paint alteration is more readily observable as fine white lines composed of translucent lead soaps, with some unaltered particles of lead white pigment, protruding through cracks in the dark upper paint layers (fig. 2.17).[43] In some cases these lines are visually misleading, being easily confused with the fine strokes of paint applied by the

artist as finishing touches. An ambiguous feature of the Philadelphia painting is the fine white highlight in the mouth of Christ, which superficially suggests a deliberate depiction of teeth by the artist, but on close inspection appears more likely to have been caused—or at least exaggerated—by degradation in the paint layers. This effect could relate to alteration of lead white pigment, or perhaps to local blanching of the dark upper paint.

In the Philadelphia panel, a third paint-alteration phenomenon is evident in the dark undergarment painted around Christ's neck. A cross-section from this garment reveals a thick layer of coarse, angular particles of the pigment smalt—a blue cobalt potassium glass—in mixture with bone black and organic red pigment (fig. 2.18).[44] Popular as a blue pigment in Rembrandt's time, smalt is notoriously unstable in an oil medium, often losing its color and causing darkening of the oil.[45] This is apparent in the Philadelphia panel, in which the undergarment now appears almost black, with a grayish blanching in some areas. The appearance and composition of the smalt layer are typical for Rembrandt's painting technique.[46] However, because of the enlargement and restoration that occurred to this panel, including extensive repainting of the background and clothing (see the entry on this painting below), the possibility that the smalt was used to repaint the collar during an early restoration cannot be ruled out. This idea might be supported by the appearance of the cross-section in figure 2.18, in which an underlying layer containing bright blue particles of the pigment azurite (basic copper carbonate) can be seen, followed by a gray layer containing lead white and bone black pigments, as well as remnants of a thin varnish separating these layers from the upper smalt paint, suggesting several campaigns of painting.[47] Because of these complexities, the intended appearance of this area of the painting remains ambiguous.

CONNOISSEURSHIP AND CONDITION

As is so often the case in research that must address questions about closely related works of art by studying them individually over an extended period of time and across great distances, this essay would surely have benefited from being written after the works had been brought together for direct comparison in the exhibition. The chance to judge whether such side-by-side comparison of the panels settles any questions or merely multiplies them will be one of the most engaging offerings

Fig. 2.16. Photomicrograph detail of a thinly painted area of the beard in the Philadelphia panel showing a speckled appearance, likely resulting from exposed aggregates of lead white pigment in the imprimitura (image width approximately 6 mm). Photograph by Ken Sutherland

Fig. 2.17. Photomicrograph detail of the dark paint of the beard in the Philadelphia panel showing an inclusion of translucent lead soaps, with some particles of unaltered lead white pigment (image width approximately 2 mm). Photograph by Ken Sutherland

Fig. 2.18. Cross-section sample from the collar of the undergarment in the Philadelphia panel in visible (a) and ultraviolet illumination (b), showing a lower layer of azurite paint pigment (1); a gray paint containing lead white and bone black pigment (2); a thin varnish (3); and a thick paint layer with coarse, angular particles of smalt (4). Photographs by Ken Sutherland

50 µm

of the exhibition. As of this writing, one conclusion that can be put forward is that appraisals of the paintings' quality and relationship to one another will likely remain conjectural, due in part to their varied states of preservation.

Even if condition were not at issue, any effort based primarily on visual comparisons to determine how many artists the group represents, or to establish convincingly whether any of the paintings is more likely than others to be by Rembrandt himself, would face difficulties. If it were somehow possible to view the paintings side-by-side, all in pristine original state, with every detail and nuance of handling intact and unclouded by discolored varnishes and restorers' retouching, attempts to draw strict distinctions between them would still be vexed by their deliberate similarity of technique and style. If not identical, the paintings are similar enough in paint colors, texture and buildup, level of finish, and reliance on a specific repertoire of techniques to appear as the products of a uniform process and aesthetic. All were produced by capable hands working with a will to conform to a technical and stylistic paradigm observable in Rembrandt's own work—produced, in short, to look convincingly consistent. If the paintings did look very similar initially, as the appearance and handling of their materials suggest they must have, their varying states of preservation impose spurious differences among them while obscuring subtler variations that would have been visible in their original state.

Subtleties such as eloquent details of color, modeling, and handling can be the first casualties of repeated and poor cleanings, of obscuring varnishes and restorations, and of optical alterations in the aging paint itself. Alterations brought about by previous restoration or by the presence of discolored varnishes, even if recognized as complicating factors in the study of paintings, are not always fully taken into account in discussions of quality and authorship. Changes in the original paint materials such as blanching have only more recently been studied in detail in Rembrandt's paintings. Such study contributes to a growing awareness of the degree to which inherent alterations may further compromise fundamental pictorial qualities, such as tonal relationships and spatial effects, on which connoisseurship depends. Thus, in questions of relative artistic quality or the presence of separate artists' hands, our estimations of a painting and its relationship to others are skewed by the factor of condition toward comparisons of broader qualities, both positive and negative.

Absent clear-cut, decisive technical factors, many questions about authorship and comparative quality will, as they historically have, find what answers may be had in connoisseurship. Our study of this group of paintings reinforced the understanding that connoisseurship, the necessary foundation of so much in the world of Rembrandt studies, is very much at the mercy of the clouding influence of the picture's condition. Though specialists exercising their most informed and discriminating judgment may well understand the pitfalls of condition, they nonetheless work at a severe disadvantage when faced, for example, with alterations that may be minor in one painting but profound in another with which it is to be compared. Our hope is that the images and observations provided here will be of interest to scholars and visitors to the exhibition, and will aid them in reaching their own understanding of this remarkable group of paintings.

CONCLUSIONS

These panel paintings of the head of Jesus emerge from close examination as works of greater expressive character than their often compromised condition first indicates. The youthfulness and gentleness of Christ are reinforced through the brushwork, which is smoother and less dramatic than in other similarly sketched heads from this period, such as the Berlin *Portrait of a Young Jew* (see plate 4.6). By using soft, fine strokes in the cheeks, the artist (or artists) did not seek to conceal his hand but rather aimed toward a unity between the character of his paint handling and that of the youthful, gentle, empathetic figure he was creating through facial expression and pose. This specific handling and the resulting character are shared by the face of Jesus in the Louvre *Supper at Emmaus* (see plate 1.1; fig. 6.1). The sketches show a concern for the refinement of a figure, presumably connected to finished works of art, within a narrow range of poses, expressions, and angles of the fall of light. This exercise may have been repeated for the figure of the pilgrim to the right of Christ in the *Supper at Emmaus* painting, for whom three small studies in the same format were made (plate 2.1).

Dendrochronological analysis of the panel supports of the core-group paintings suggests that most of the panels in this group were executed later than the 1648 *Supper at Emmaus*, but could have been executed before 1656; thus, it remains possible that three of the sketches correspond to the heads of Christ mentioned in Rembrandt's 1656 inventory (see DeWitt, this volume). The panels may represent the kind of open-ended series in Rembrandt's work that Julius Held called "themes," initially in reference to prints of beggars. Arthur Wheelock has posited that the heads of Christ series formed the basis of one or two paintings in the later group of religious portraits that includes *The Risen Christ*, now in the Alte Pinakothek, Munich (see plate 4.2), and possibly *Christ with a Staff*, now in the Metropolitan Museum of Art, New York (see plate 4.8).[48] The consistency of appearance, materials, repertoire of techniques, handling, and expressive character furthermore allow for the possibility that they are the work of a single artist—a hypothesis that will likely never be proven.

These sketches are evidence of an extraordinary and sustained engagement with the figure of Christ, but their function remains obscure due to meager documentation, vagaries of past treatments, and other factors of condition. By gathering them together, we hope to better understand their logic as a group and their place in Rembrandt's work. The entries that follow provide additional information about each panel in the core group, along with several related paintings, including any features or qualities that distinguish a particular work as exceptional. The panels in the core group have been reproduced at full scale.

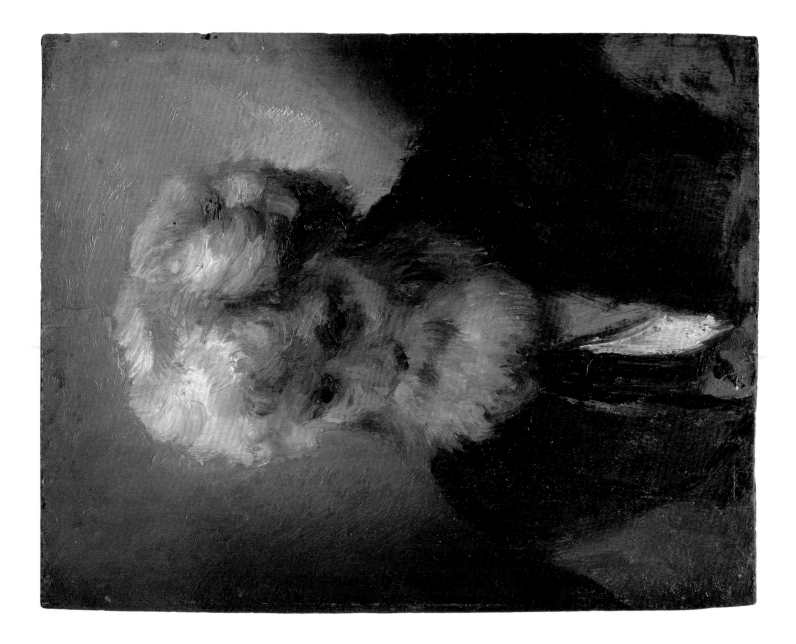

PLATE 2.1

Studio of Rembrandt Harmensz. van Rijn

Head of a Pilgrim, c. 1648

Oil on panel, 10⅛ × 8⅛ inches (25.7 × 20.6 cm)
Mr. and Mrs. Avram Saban, Miami Beach, Florida

CAT. 34

1. Seymour Slive, "An Unpublished *Head of Christ* by Rembrandt," *Art Bulletin*, vol. 47, no. 4 (December 1965), pp. 407–17.

2. Walter Liedtke, in Roland E. Fleischer and Susan C. Scott, eds., *Rembrandt, Rubens, and the Art of Their Time: Recent Perspectives*, Papers in Art History, vol. 11 (University Park: Pennsylvania State University, 1997), pp. 37–48. Liedtke proposes that Rembrandt engaged assistants on an ad-hoc basis rather than maintaining a workshop of steady employees.

3. Abraham Bredius, *Rembrandt Gemälde* (Vienna: Phaidon, 1935), published in English as *The Paintings of Rembrandt* (London: Allen and Unwin, 1937), cat. 247; hereafter abbreviated as Bredius followed by the catalogue number. Among the examples of Rembrandtesque sketches of bearded men in the Johnson Collection are *Head of a Man* (cat. 477)—another version of which was catalogued by Hofstede de Groot (no. 444) and is now in the collection of Alfred Bader in Milwaukee—and *Head of an Old Man* (cat. 476), after Bredius 241. See *Paintings from Europe and the Americas in the Philadelphia Museum of Art: A Concise Catalogue* (Philadelphia: Philadelphia Museum of Art, 1994), p. 90.

4. For the practice of excerpting figures from existing works of art, see Michiel Francken, "Copying Paintings in Rembrandt's Workshop," in Ernst van de Wetering et al., *Rembrandt: Quest of a Genius*, exh. cat. (Amsterdam: Museum het Rembrandthuis, 2006), pp. 169–70.

5. Albert Blankert et al., *Rembrandt: A Genius and His Impact*, exh. cat. (Melbourne: National Gallery of Victoria; Sydney: Art Exhibitions Australia; Zwolle, Netherlands: Waanders, 1997), pp. 171–72. Blankert is referring to the verbal opinions given to him by Ernst van de Wetering and J. Bruyn. See also J. Bruyn et al., *A Corpus of Rembrandt Paintings*, 4 vols. (The Hague: M. Nijhoff, 1982–2006), vol. 4, p. 381.

6. Bruyn et al., *A Corpus of Rembrandt Paintings*, vol. 4, p. 381.

7. Gary Schwartz, *Rembrandt: His Life, His Paintings* (New York: Viking, 1985), p. 284.

8. Peter Schatborn, in Eva Ornstein-van Slooten and Peter Schatborn, *Rembrandt as Teacher*, exh. cat. (Amsterdam: Museum het Rembrandthuis, 1984), p. 11.

9. Adam Bartsch, *Catalogue raisonné de toutes les estampes qui forment l'oeuvre de Rembrandt, et ceux de ses principaux imitateurs*, 2 vols. (Vienna, 1797), cats. 193, 194. See also Schatborn in *Rembrandt as Teacher*, pp. 11–12.

10. Francken, "Copying Paintings in Rembrandt's Workshop," pp. 169–70.

11. Bruyn et al., *A Corpus of Rembrandt Paintings*, vol. 4, pp. 381–82.

12. Mirjam Alexander-Knotter, Jasper Hillegers, and Edward van Voolen, *De 'joodse' Rembrandt: de mythe ontrafeld* (Amsterdam: Joods Historisch Museum, 2006), pp. 52–53. Alejandro Vergara, *Rembrandt, pintor de historia* (Madrid: Museo del Prado, 2008), p. 182.

13. Arnold Houbraken, *De groote schouburgh der nederlantsche konstschilders en schilderessen* (Amsterdam, 1718–21), vol. 3, pp. 57–58, translated by Charles Ford in *Lives of Rembrandt* (London: Pallas Athene, 2007), pp. 59–60.

14. Huygens, in *Mystery of the Young Rembrandt*, ed. Ernst van de Wetering and Bernard Schnackenburg, exh. cat. (Wolfratshausen, Germany: Edition Minerva, 2001), p. 396.

15. Walter L. Strauss and Marijon van der Meulen, *The Rembrandt Documents* (New York: Abaris, 1980), pp. 361, 383.

16. Bruno Mottin and Pierre Curie are investigating this painting and will publish their findings in the *Revue du Louvre*.

17. The results of dendrochronological analysis by Dr. Peter Klein of the University of Hamburg on four of the panels (The Hague, Detroit, Berlin, Cambridge) were published in Bruyn et al., *Corpus of Rembrandt Paintings*, vol. 4, p. 658. He subsequently analyzed the Philadelphia, Amsterdam, and private collection paintings; see his reports of September 14, 2004, September 9, 2008, and January 4, 2011, respectively, in the curatorial files of the Department of European Painting before 1900, Philadelphia Museum of Art. Dendrochronology is a technique used to estimate the earliest possible creation date of wooden artifacts such as panel paintings, and to determine the geographical source of the wood. Results are derived from comparison of measured intervals between annual growth rings in the wood of the study object with those in wood of known age and place of origin. Dendrochronological dating is possible for many European paintings on oak because European panel makers usually prepared the panels from planks cut from the log in an orientation that allows the growth rings to be measured as a continuous sequence across the panel's end grain. The presence in a panel of light-colored sapwood, a layer of wood that forms just beneath the bark and contains a number of the youngest growth rings, indicates proximity of the year those rings were formed to the tree's felling date. However, sapwood was considered undesirable and was often removed during panel fabrication; if none remains, dating is far less certain. If sapwood is present, or there is evidence that care was taken not to remove more than just sapwood, dating can be carried out on the assumption of the probable number of missing sapwood rings, based on the statistical range of sapwood rings for trees growing in a specific region. A second variable requiring estimation is the time that elapsed between the felling of the tree and the creation of the work of art, including a period of seasoning to make the panel dimensionally stable for use. For oak panels of the sixteenth and seventeenth centuries, in most cases the interval between the felling of the tree and the creation of the painting was approximately two to eight years. These two factors—the assumed number of missing growth rings and the estimated number of years' seasoning—must be added to the year determined for the youngest measured ring to arrive at a most probable period of creation for the work of art.

18. Ernst van de Wetering, *Rembrandt: The Painter at Work* (Amsterdam: Amsterdam University Press, 1997; reprint, Berkeley: University of California Press, 2000, 2009), p. 19. Van de Wetering has analyzed the panels used by Rembrandt during his Leiden period to point out the standardization in panel sizes in the Netherlands.

19. Bruyn et al., *A Corpus of Rembrandt Paintings*, vol. 4, p. 658; and Klein's reports of September 14, 2004, September 9, 2008, and January 4, 2011 (see note 17 above).

20. According to Klein's reports on the analyses, the dendrochronological dating assumes a minimum of two years' seasoning in all cases plus, for Baltic oak, a minimum of nine sapwood rings (for earliest creation date) or a median of fifteen sapwood rings; for oak from the Netherlands and western Germany, a minimum of nine sapwood rings (for earliest creation date) and a median of seventeen sapwood rings is assumed.

21. Note that the dates represent *termini ante quem*: the painting could have been created at any subsequent point.

22. Van de Wetering, *Rembrandt: The Painter at Work*, pp. 17–23; Ashok Roy, "The Ground Layer: Function and Type," in David Bomford et al., *Art in the Making: Rembrandt* (London: National Gallery, 2006), pp. 27–28.

23. Van de Wetering, *Rembrandt: The Painter at Work*, p. 24.

24. Ibid., p. 27. Van de Wetering's observation that "the deadcoloring stage evidently was in Rembrandt's case not a mere transitional stage, but a provisionally completed whole" appears particularly apt to the paintings in question.

25. Infrared reflectography is most frequently used for the study of underdrawings, though none were detected in this study. Infrared reflectographic images were either captured by us or made available for our study. All digital infrared photographs taken by us were captured using a Nikon D100 camera fitted with a No. 87 gelatin filter.

26. Melanie Gifford, "Material as Metaphor: Non-Conscious Thinking in Seventeenth-Century Painting Practice," in *Studying Old Master Paintings—Technology and Practice, The National Gallery Technical Bulletin 30th Anniversary Conference, September 16–18, 2009* (London: Archetype Publications, forthcoming).

27. Analysis of the paint binder was carried out by Py-GCMS, which revealed a fatty acid composition characteristic for linseed oil, including a high level of azelaic acid and a ratio of palmitic to stearic acid (P:S) in the range of 1.4 to 1.9 for four paint samples from different color areas. Diagnostic values for these ratios are drawn from the analysis of reference materials and from published studies; see John S. Mills and Raymond White, *The Organic Chemistry of Museum Objects* (London: Butterworths, 1987), pp. 141–43. The relative proportions of dicarboxylic acids did not indicate the use of a heat-pretreated oil. Traces of oxidized diterpene compounds (dehydroabietic acid and 7-oxo-dehydroabietic acid) were detected in all samples, indicating a Pinaceae resin, and one sample contained paraffin wax; since the painting was not sampled in a cleaned state, these components most likely derive from residual varnish or other conservation treatments. However, the possibility that the resin is a minor component of the binding medium cannot be ruled out. Py-GCMS analysis was carried out as follows: paint samples (c. 10–20 μg) were placed in Frontier Lab stainless steel sample cups, and 2 μL of a 25-percent solution of tetramethylammonium hydroxide (TMAH) in methanol added prior to insertion into a Frontier PY-2020iD vertical microfurnace pyrolyzer, attached to an Agilent 6890N GC equipped with J&W DB5MS column (30 m, 0.25 mm i.d., 0.25 μm film) interfaced to a 5973N MS. The pyrolyzer furnace temperature was 550°C. The GC oven was programmed from 40°C, with a 2-minute hold, then increased at 20°C per minute to 140°C, at 15°C per minute to 320°C, and held isothermally for 11 minutes; total run time 30 minutes. The inlet was operated with a split ratio of 1:10. Helium was the carrier gas, with a flow of 1 milliliter per minute. The MS interface temperature was 320°C; the MS was run in scan mode (m/z 35–600) with the source at 230°C and quad at 150°C. Data were collected and processed using Agilent Chemstation software.

28. Ashok Roy and Jo Kirby, "Rembrandt's Palette," in Bomford et al., *Art in the Making*, pp. 35–48.

29. Gwen Tauber, "A Note on Technical Peculiarities in a Portrait by Carel Fabritius," *Art Matters: Netherlands Technical Studies in Art*, vol. 2 (2005), p. 106.

30. Arie Wallert et al., "A Note on the Imaging of Lead White and Vermilion Paint Layers by Synchrotron Radiation-Based, Simultaneous Dual Energy K-Edge Absorption Radiography," *Journal of the American Institute for Conservation*, vol. 48 (2009), p. 165.

31. XRF analyses of the Detroit panel were carried out in the analytical laboratory of the Detroit Institute of Arts by Research Scientist Cathy Selvius DeRoo using a Bruker ARTAX micro-XRF spectrometer equipped with a molybdenum tube. Analysis conditions were 50 kV and 700 μA, helium purge, no filter, 3-minute acquisition time. XRF analyses of the Amsterdam panel were carried out in the Ateliergebouw of the Rijksmuseum by Curator of Technical Painting Research Arie Wallert; the same instrument type and configuration were used as for the Detroit panel but with settings of 45 kV, 400 μA, and 1-minute acquisition time. XRF provided information on the combined elemental composition of the paint and ground layers; although this technique does not allow for specific identification of pigments, or for information on their distribution in the different layers, the range of elements detected was consistent with the pigments identified in the Philadelphia panel.

32. Paint samples for VLM/FLM were embedded in Bio-Plastic polyester/styrene resin (Ward's Natural Science). Once cured, the resin cubes were cut and polished to reveal the paint stratigraphy. The cross-section samples were examined in both visible and ultraviolet (UV) light using a Leitz Laborlux S microscope equipped for epi-illumination in UV light. A Leitz D filter cube was used (355–425 nm excitation, 460 nm suppression filter), and a 100 W mercury lamp. Fiber optic lights were used for visible light. Samples were photographed using a Nikon Digital Sight DS-5M camera with Nikon Eclipse Net image capture software. PLM was carried out by Jo-Fan Huang, Mellon Fellow in Paper Conservation at the Philadelphia Museum of Art, using a Nikon Eclipse E600POL microscope. Paint samples were dispersed and mounted on a glass microscope slide using Cargille Meltmount medium (refractive index 1.662); pigments were characterized by comparison with reference samples and visual pigment/particle atlases. For SEM-EDS, paint scrapings and samples prepared as cross-sections were mounted on carbon tape on an aluminum stub and carbon-coated using a Denton Desk II cold sputter coater with carbon rod evaporation accessory. Backscattered electron imaging and EDS analyses were performed using a JEOL 6460LV SEM with an Oxford INCA X-sight EDS detector and INCA Energy 200 software. An

accelerating voltage of 20 kV was used. For MFTIR, representative portions of samples were flattened on a Spectra-Tech diamond window for analysis by MFTIR. The FTIR data were collected in transmission mode between 4000 and 600 cm⁻¹ at 4 cm⁻¹ resolution and 200 scans per spectrum using a Thermo Nicolet Continuum microscope with an MCT-A detector, interfaced to a Nexus 670 spectrometer. Omnic software was used; spectra were processed using Happ-Genzel apodization.

33. Johannes Hell, "Beobachtungen über Rembrandts Malweise und Probleme der Konservierung," *Kunstchronik*, vol. 10, no. 5 (May 1957), p. 138, excerpted in *Issues in the Conservation of Paintings*, ed. David Bomford and Mark Leonard (Los Angeles: Getty Conservation Institute, 2004), p. 32.

34. Van de Wetering, *Rembrandt: The Painter at Work*, pp. 257, 263 (wording from 1997 edition). The author discusses alterations in pigments such as smalt and organic red and yellow lakes, but suggests that Rembrandt used these pigments infrequently or applied them in such a way that they are not a significant cause of change in the appearance of his paintings.

35. Annelies van Loon, "Color Changes and Chemical Reactivity in Seventeenth-Century Oil Paintings" (Ph.D. diss., University of Amsterdam, 2008); Annelies van Loon and Jaap Boon, "The Whitening of Oil Paint Films Containing Bone Black," in *ICOM Committee for Conservation 14th Triennial Meeting, The Hague: Preprints*, ed. Isabelle Sourbès-Verger (London: James and James: Earthscan, 2005), pp. 511–18; Marika Spring and Larry Keith, "Aelbert Cuyp's *Large Dort*: Color Change and Conservation," *National Gallery Technical Bulletin, 30th Anniversary Volume* (2009), pp. 71–85.

36. Petria Noble and Annelies van Loon, "New Insights into Rembrandt's *Susanna*," *ArtMatters: Netherlands Technical Studies in Art*, vol. 2 (2005), pp. 76–96; Petria Noble and Annelies van Loon, "Rembrandt's *Simeon's Song of Praise*, 1631," *ArtMatters: Netherlands Technical Studies in Art*, vol. 4 (2007), pp. 19–36; Van Loon, "Color Changes and Chemical Reactivity," pp. 150–67.

37. The identity of natural chalk was confirmed by the presence of microfossil coccoliths, visible in SEM images of paint cross-sections.

38. The possible role of environmental factors in the promotion of blanching has been noted for a painting by Philips Wouwerman (1619–1668); see Van Loon, "Color Changes and Chemical Reactivity," p. 169. A similar suggestion has been made for paintings by Aelbert Cuyp (1620–1691) in which blanching was less pronounced in areas covered by the frame rebate; see Marika Spring, "Pigments and Color Change in the Paintings of Aelbert Cuyp," in *Aelbert Cuyp*, ed. Arthur K. Wheelock, Jr., exh. cat. (Washington, DC: National Gallery of Art, 2002), p. 68.

39. The degradation of chalk-containing paints exposed to moisture has been noted in outdoor applications; see Manfred Hess, *Paint Film Defects: Their Causes and Care*, 2d ed. (New York: Reinhold, 1965), p. 272. For other occurrences of blanching in paintings associated with the use of chalk, see

Karin Groen, "Scanning Electron Microscopy as an Aid in the Study of Blanching," *Hamilton Kerr Institute Bulletin*, no. 1 (1988), p. 49; Noble and Van Loon, "New Insights into Rembrandt's *Susanna*," p. 87; Bradford Epley, "Jan Both's *Italian Landscape*," *Hamilton Kerr Institute Bulletin*, no. 3 (2000), pp. 127–34.

40. Spring and Keith, "Aelbert Cuyp's *Large Dort*," p. 80; Van Loon, "Color Changes and Chemical Reactivity," pp. 181–83; Jo Kirby and David Saunders, "Sixteenth- to Eighteenth-Century Green Colours in Landscape and Flower Paintings: Composition and Deterioration," in *Painting Techniques: History, Materials and Studio Practice*, ed. Ashok Roy and Perry Smith (London: International Institute for Conservation of Historic and Artistic Works, 1998), pp. 155–59.

41. Jaap Boon et al., "Mechanical and Chemical Changes in Old Master Paintings: Dissolution, Metal Soap Formation and Remineralization Processes in Lead Pigmented Ground/Intermediate Paint Layers of 17th Century Paintings," in *ICOM Committee for Conservation 13th Triennial Meeting, Rio de Janeiro, 22–27 September 2002: Preprints*, ed. Roy Vontobel (London: James and James, 2002), pp. 401–6.

42. Petria Noble, personal communication to Ken Sutherland, April 5, 2010.

43. The presence of lead fatty acid soaps in these locations was confirmed by MFTIR, SEM-EDS, and Py-GCMS analysis.

44. The detection of aluminum, sulfur, and potassium in the red lake particles by EDS suggests the presence of alum (potassium aluminum sulfate, $AlK(SO_4)_2 \cdot 12H_2O$), possibly as a consequence of incomplete reaction of this common ingredient used to produce hydrated alumina in the manufacture of the pigment. See Jo Kirby, Marika Spring, and Catherine Higgitt, "The Technology of Red Lake Pigment Manufacture: Study of the Dyestuff Substrate," *National Gallery Technical Bulletin*, vol. 26 (2005), pp. 71–87.

45. Marika Spring, Catherine Higgitt, and David Saunders, "Investigation of Pigment-Medium Interaction Processes in Oil Paint Containing Degraded Smalt," *National Gallery Technical Bulletin*, vol. 26 (2005), pp. 56–69. For a discussion of smalt degradation in relation to Rembrandt's paintings, see Noble and Van Loon, "New Insights into Rembrandt's *Susanna*," pp. 82–86.

46. For smalt-based paint layers similar in appearance and composition, see, e.g., discussions of Rembrandt's *Portrait of Margaretha de Geer* and *Portrait of Frederik Rihel on Horseback* in Bomford et al., *Art in the Making*, pp. 176–77, 188–89 (respectively).

47. The presence of intermediate varnishes has been noted in paintings by Rembrandt and his contemporaries and does not necessarily imply that the subsequent layers were applied later by a different artist. See Van de Wetering, *Rembrandt: The Painter at Work*, p. 247; Van Loon, "Color Changes and Chemical Reactivity," p. 152; Spring and Keith, "Aelbert Cuyp's *Large Dort*," p. 76 and n. 35.

48. Arthur K. Wheelock, Jr., et al., *Rembrandt's Late Religious Portraits* (Washington, DC: National Gallery of Art; Chicago: University of Chicago Press, 2005), p. 30.

PLATE 2.2

Rembrandt Harmensz. van Rijn and Studio

Head of Christ (detail showing inset portion), c. 1648–56

Oil on oak panel, laid into larger oak panel; 14¹¹⁄₁₆ × 12⁵⁄₁₆ inches (35.8 × 31.2 cm)

Signed lower right: *Rembran. / f. 1656*

Philadelphia Museum of Art, John G. Johnson Collection, cat. 480

CAT. 40

The support of the Philadelphia painting presently comprises an oak panel measuring 9⁹⁄₁₆ × 7⅞ inches (25 × 20 cm) set into a recess in a larger oak panel (figs. 2.1, 2.19) measuring 14¹¹⁄₁₆ × 12⁵⁄₁₆ inches (35.8 × 31.2 cm). The presence of the inset panel is not noticeable from the verso. The size of the inset panel, which contains the entire head of Jesus, is in the range of the other sketches. The painting was illustrated in Wilhelm Valentiner's Rembrandt catalogue raisonné of 1909 with an arched top and larger composition (fig. 2.20), but curiously Valentiner listed it as 33.5 × 29 cm, smaller than its current size. In the 1901 catalogue of masterpieces sold by his firm, Charles Sedelmeyer illustrated the painting in its current format but gave much larger dimensions—15¼ × 13 inches (38.7 × 33 cm)—that correspond roughly to the painting as illustrated by Valentiner. There was clearly some confusion about the size and format of the work, but by 1914, when Valentiner wrote his catalogue for the collection of the Philadelphia lawyer John G. Johnson, the recorded dimensions reflected its current size. Wood had been removed from the top and left, leaving only a vestige of the arch at the upper right corner.[1] Dendrochronological analysis in 2004 established the Baltic/Polish region as the source of the oak for both the original panel and the larger one into which it is set. The youngest heartwood ring of the inset original panel could be dated to 1622.[2] This yields an earliest possible creation date of 1632, and a more statistically plausible creation date from 1640 on. The youngest heartwood ring of the larger panel was dated to 1611, corresponding to an earliest possible creation date of 1622, or a more statistically plausible creation date from 1628 on.

The preparation layers appear as a warm buff color where visible in locations throughout the figure's head; in the reflected infrared photograph (see Appendix), these areas are evident as the lightest zones, which also show the wood grain. The materials of the preparation layers are typical for the panel paintings of Rembrandt and his circle, comprising a thin chalk ground and a tinted *primuersel* composed of chalk, lead white, and small amounts of bone black and umber pigments.

Where the ground is visible in thin passages of the shaded areas of the face, it is veiled with a fine application of brown paint. These areas may be the only visible portions of the monochrome lay-in stage, in which the placement, contours, and modeling of the head would first have been established.

The use of a hard tool to draw lines in the paint—a technique observed in all the panels we examined in this group except those in Berlin and Detroit (plates 2.6, 2.7)—is visible in this painting only at the hairline to the left of the part in the hair (see fig. 2.11). Two closely spaced parallel lines are visible in the paint, very similar in appearance to a mark found in the same location

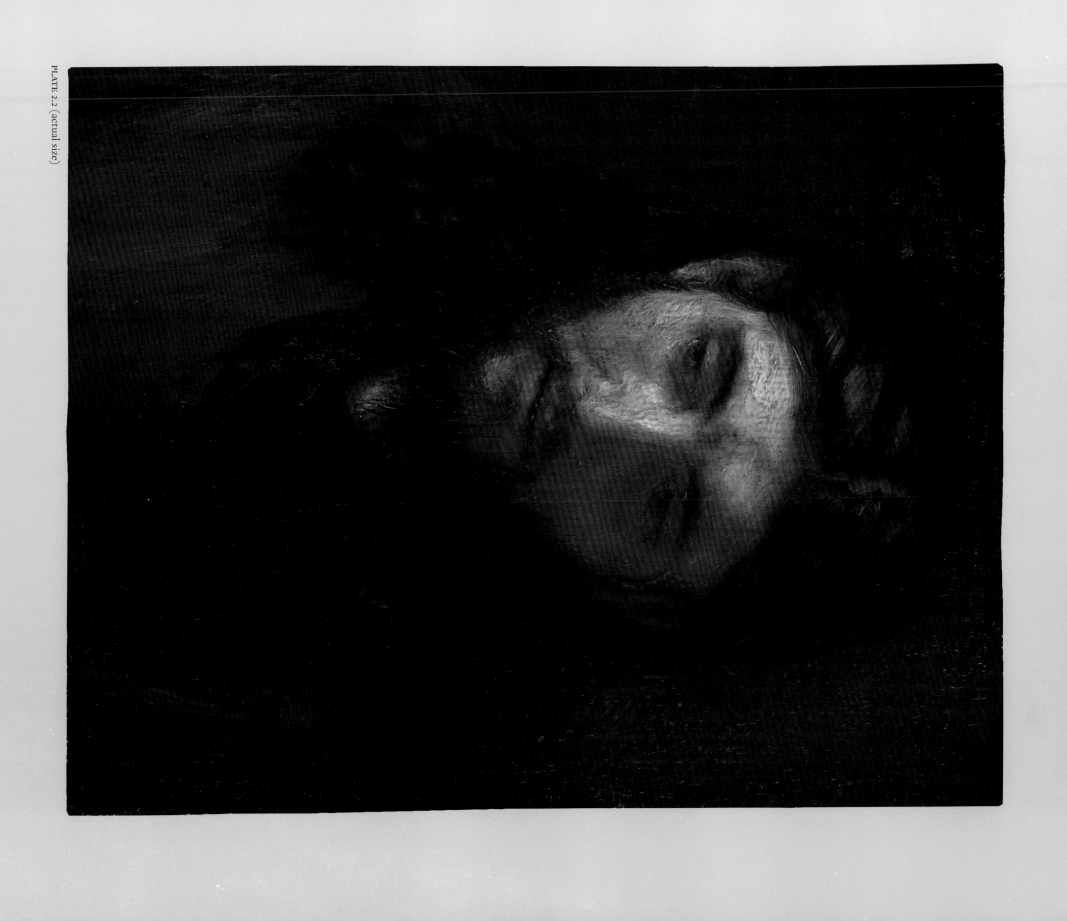

PLATE 2.2 (actual size)

on the Cambridge painting (plate 2.5). Melanie Gifford has described this type of mark in paintings by Rembrandt, and has proposed that the parallel strokes were created by the nib of a reed pen.[3]

As with all of the panels in the core group, the hair is modeled by the addition of strokes of opaque black and brown over the translucently painted darks of the sketch stage and finished with lights blended wet-into-wet with the opaque tones, as well as highlights in the form of individual fine strokes. The modeling of illuminated areas of flesh was worked up largely by blending paint of a viscosity and stiffness that allowed its manipulation with a fine brush into teased and interwoven ridges and troughs, evoking an evanescent, flickering play of light over the features. Fine strokes of purer reds in the face, and lines depicting strands and highlights in the hair and beard, are well preserved, though translucently painted areas of the hair and flesh show light abrasion. The lighter areas of flesh were probably subtly blended into shadow by smoothly feathering the opaque paint onto areas of translucent darks of the lay-in sketch that were to remain exposed. Some of these zones of modeling transition now have an abruptness—visible clearly, for example, in the right side of the forehead in the reflected infrared image—that suggests abrasion to the thin feathered edge of the upper paint layer and/or loss of dark tone from the surface of the lower layer. One or both of these changes hardened some of the modeling transitions—an effect also visible in the shaded half of the face in the panel from The Hague (plate 2.8) and in its reflected infrared photograph (see Appendix), and perhaps most strikingly in the Provo painting (plate 2.10). As with the panels in Berlin and The Hague, as well as the 1648 *Supper at Emmaus* now in the Musée du Louvre, Paris (see plate 1.1; fig. 2.2), accumulations of darkened varnish in the recesses of the paint surface give a mottled appearance that produces a false emphasis on textural relief. Changes to the original paint materials also impede a clear visual interpretation of the picture. Blanching of the paint is

Fig. 2.19. X-radiograph showing the smaller panel on which the Philadelphia painting was originally executed inset into a recess in the larger panel. Photograph by J. Mikuliak

Fig. 2.20. The Philadelphia panel as illustrated in Wilhelm Valentiner's *Rembrandt: Des Meisters Gemälde in 643 Abbildungen*, Klassiker der Kunst (Stuttgart: Deutsche Verlags-Anstalt, 1909), p. 390.

visible as fine lines occurring primarily in raised strokes of impasto in the darks and mid-tones of the face and hair (see fig. 2.14), a phenomenon also observed in the Hague and Louvre paintings. Other fine white lines or spots in dark-painted areas, which superficially resemble finishing touches of paint, may result from the transformation of lead white pigment in underlying paint or preparation layers into translucent lead soaps that have protruded through cracks in the dark upper paint. A thick, bulky paint rich in the pigment smalt, used for the collar of Christ's undergarment, has darkened and discolored; it is not clear if this was part of the original composition or was added during an early restoration.

The close correspondence between the built-up light tones of the head and areas of higher density in the X-radiograph suggests a direct and confident arrangement of light and shade that is both expressive and descriptive of form and surfaces (see fig. 2.19 and Appendix). The X-radiograph also shows changes associated with the repainting of the background during the enlargement of the panel and in subsequent restorations. The head and possibly the small, dark section of costume at the base of the throat are the only areas little affected by the overpainting. The X-radiograph shows that the head originally had a more dynamic, undulating silhouette, most similar to that of the Berlin panel in its suggestion of a mass of hair tucked over the ears. The shape of this original silhouette is made strongly apparent by another feature visible in the radiographic image but obscured by background repaint: the indication of a background surface that catches the light illuminating the figure and shows his cast shadow. This device, also used to a greater or lesser degree in the other panels, is more texturally emphatic in the Philadelphia painting, as indicated by the loosely brushed application of a dense paint material that appears light in the X-radiograph. A paint cross-section from an area of the background that includes this dense paint layer indicated a complex buildup of layers, with multiple applications of restoration paint separated by thin layers of varnish (fig. 2.21). The complete layer structure is not represented in the cross-section, and it is difficult to determine the boundary of the original paint surface with confidence. However, the earliest (lowest) paint layers visible in figure 2.21—a light paint mixture rich in lead white with particles of yellow-brown earth pigment, vermilion, and bone black, with a very fine layer (a few micrometers thick) composed of chalk, lead white, earth pigments, and bone black applied directly on top—would explain the high density observed in the X-radiograph and suggest that this part of the composition may

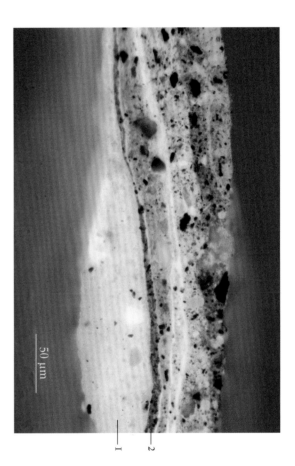

Fig. 2.21. Cross-section sample from the over-painted background of the Philadelphia panel, in ultraviolet illumination, showing multiple superimposed layers of paint and varnish. The lead white-based paint layer (1) with a thin layer of gray-brown paint directly on top (2) may represent the original surface of the background. Photograph by Ken Sutherland

originally have consisted of an opaque, off-white paint with a warm, translucent toning layer. An X-radiograph of the Berlin *Portrait of a Young Jew* (see plate 4.6) shows a similar though less-pronounced buildup of textured paint that produces the illuminated background to the right of that figure. At the far right edge of the inset panel of the Philadelphia painting, just above the figure's shoulder, the heavy buildup of paint trails off, leaving a thinner area that coincides with the location of the figure's cast shadow in the paintings from Berlin, The Hague, and Cambridge, suggesting that a similar effect, placing the figure in space, was originally achieved in the Philadelphia image. The X-radiograph of the Philadelphia panel also shows that some original background paint along the inset panel's upper edge and upper left corner was scraped away, and an X-ray-absorbing fill material was used to correct imperfections in fit and level between the panel and the addition (see fig. 2.19).

The dendrochronological dating of the panel into which the smaller study was inset does not rule out the possibility that the enlargement was done in the seventeenth century. The comparatively inert uniformity of paint opacity and color throughout the reworked background and costume and the simplification of line and form in the repainted areas show little sensitivity, however, to the original artist's command of telling, expressive contour, of variety in paint translucency and handling, or of the use of light to underscore a subject's convincing presence within pictorial space. Nevertheless, the addition of an arched top and the transformation of the head of Christ into an asymmetrical composition are both consistent with distinct features of some of Rembrandt's key paintings of the 1640s and 1650s and suggest that the addition may have had some connection to his studio or practice.[4]

The Philadelphia panel's composite support and associated modifications were the subject of much discussion and comment by experts who visited the Johnson Collection during the 1950s and left their comments with the curatorial staff. The consulted experts' general unease about the perceived inauthenticity of the enlargement, which they unanimously considered to be a nineteenth-century modification, and their suspicions about the signature and date of 1656 painted on the addition led them to advise the museum either to remove the addition or to install the painting in a frame that covered all but the smaller, inset panel; the painting was so framed in 1958.[5]

The date derived from the 2004 dendrochronology established, however, that the enlargement of the painting could have taken place any time after the third decade of the seventeenth century. This corroborated what a number of authors had concluded, namely, that the painting was the same one auctioned in 1772 at the sale of Louis-Michel van Loo (1707–1771) in Paris and illustrated by the indefatigable French draftsman Gabriel de Saint-Aubin (1724–1780) in one of the sale catalogues (figs. 2.22, 2.23).[6] Saint-Aubin's drawing indicates the pose in the Johnson painting, but also an arched top to the panel similar to that depicted in Valentiner's 1909 catalogue. The dimensions given in the 1772 sale catalogue (1 pied 2 pouces × 1 pied = 14¹⁵⁄₁₆ × 12¾ inches [37.9 × 32.5 cm]) are virtually the same as those given in Sedelmeyer's 1901 catalogue (15¼ × 13 inches [38.7 × 33 cm]).[7]

As R. Langton Douglas discussed in 1942, the provenance that extends to Michel van Loo is significant, since he was a descendant of Magdalena van Loo (1641–1669), the wife of Rembrandt's son Titus van Rijn (1641–1668).[8] The couple died leaving no children, meaning that their possessions reverted to the family of Magdalena as heir to Titus, who predeceased her. However intriguing the possibility is that the painting may have passed from Rembrandt through Magdalena's family to Louis-Michel van Loo, the trail goes cold prior to that point.

No comparable examples exist in Rembrandt's oeuvre of the type of inlay construction used for the enlargement of the Philadelphia panel, but seventeenth-century parallels can be found in works by Rembrandt's pupil Gerrit Dou (1613–1675; Staatliche Kunstsammlungen, Dresden) and Dou's pupil Frans van Mieris (1635–1681; The National Gallery, London).[9] The best-known example of an autograph work by Rembrandt being overpainted in the studio is the 1634 *Self-Portrait* (private collection), which was turned into a *tronie* of a Russian aristocrat.[10]

1. Wilhelm von Bode and C. Hofstede de Groot, *The Complete Work of Rembrandt*, vol. 6, trans. Florence Simmonds (Paris: C. Sedelmeyer, 1901), p. 8. Between 1901 and 1914, the same period during which the overall height and width of the painting were reduced, the proper left forearm and hand of the figure, added after the panel was enlarged and visible at the bottom edge in Sedelmeyer's illustration, were painted out (see fig. 2.20). The hand had the same cursory execution and resulting blocky shape found in the hands of several of the Jesus sketches. Its pose curiously resembles that of the hand of the young man holding his hat in the black chalk drawing of about 1648 now in a private collection in New York (see plate 4.9).

2. Although no end grain of the inset panel was accessible, the measurement could be taken from the X-radiograph. The end grain of the larger panel could be measured conventionally.

3. Melanie Gifford, "Material as Metaphor: Non-Conscious Thinking in Seventeenth-Century Painting Practice," in *Studying Old Master Paintings—Technology and Practice, the National Gallery Technical Bulletin 30th Anniversary Conference, September 16–18, 2009* (London: Archetype Publications, forthcoming); and personal communication with Mark Tucker, April 1, 2010.

4. Bruyn et al., *Corpus of Rembrandt Paintings*, vol. 4, pp. 615–26.

5. More recently the painting has been exhibited in a frame that shows both the inset panel and the addition.

6. R. Langton Douglas, "Three Pictures by Rembrandt from the van Loo Collection," *Art in America* 36 (April 1948), pp. 69–74. Slive, "An Unpublished *Head of Christ*," p. 414.

7. Sales catalogue, Louis-Michel van Loo collection, Paris, F. Basan, November 1772, p. 21. Charles Sedelmeyer, *Illustrated Catalogue of the Seventh Series of 100 Paintings by Old Masters* (Paris: Sedelmeyer Gallery, 1901), p. 6, no. 33.

8. Douglas, "Three Pictures by Rembrandt," pp. 69–74.

9. We thank Ronnie Baer for pointing out examples of expanded and inset panels by Dou, including *Still Life* from about 1660 in the Staatliche Kunstsammlungen, Dresden (acq. no. 1708), and two paintings titled *The Hermit* (private collection, Germany; Christie's New York, June 9, 2010, lot 32). Q. Buvelot and O. Naumann, "Format Changes in the Paintings by Frans van Mieris the Elder," *Burlington Magazine* 150 (February 2008), pp. 102–4.

10. Bruyn et al., *Corpus of Rembrandt Paintings*, vol. 4, Nr. Addendum 2, pp. 615–26.

Fig. 2.22a, b. Pages from sale catalogue, Louis-Michel van Loo Collection, at Le Bas, France, November 1772. Photograph courtesy Bibliothèque Nationale de France, Paris

Fig. 2.23. Detail of fig. 2.22 showing illustration of the Philadelphia panel by Gabriel de Saint-Aubin (French, 1724–1780)

PLATE 2.3

Attributed to Rembrandt Harmensz. van Rijn and Studio

Head of Christ, c. 1655

Oil on oak panel, 9⅜ × 7⁷⁄₁₆ inches (23.8 × 19 cm)

Netherlands Institute for Cultural Heritage, NK 2774, on loan to Bijbels Museum, Amsterdam

CAT. 60

The youngest heartwood ring of the Baltic oak panel of the Amsterdam painting was dated by dendrochronology to 1642, corresponding to an earliest possible creation date of 1653, or a more statistically plausible creation date from 1659 on. The panel has undergone two changes in the shape of its top edge. Pieces of wood were added to the reverse of the original rectangular panel along the top and bottom. The remnant of a curving chamfer cut into the addition across the top shows that the top was given an arched shape. The painting was later converted back to a rectangular format by the addition of triangles of wood to restore the squared-off upper corners, and the additions were painted to match the rest of the background.

The correspondence of built-up areas of lighter paint to areas of density in the X-radiograph is very direct, suggesting clear foresight by the artist in constructing the composition (see Appendix). The only observed uses of a tool to draw lines into the wet paint are a single broad mark at the bottom of the hair at left and several long, sweeping strokes at the back of the head that are most visible in the reflected infrared photograph (see Appendix). The infrared photograph also shows the extent to which the ground and the translucent browns of the monochrome sketch serve as mid-tones throughout the face—for example, in the secondary reflected light on the underside of the tip of the nose, extending back over the nostril. The costume is notable for its clear indication of buttons and, especially apparent in the infrared photograph, for the bold strokes that define the front opening and particularly the shoulder.

This painting is unusual in presenting the figure with eyes closed and turned in profile—even more so than in the other two paintings that do not show the figure frontally or nearly so, those in a private collection (plate 2.4) and in Berlin (plate 2.6). Although the Amsterdam panel seems to serve as model for a scene such as Christ on the Mount of Olives (see plate 4.12), like the others in the group it has no clear connection to a finished painting by Rembrandt or anyone in his orbit. This painting was copied in the late seventeenth century by the French engraver Bernard Picart (1673–1733) in a mezzotint (fig. 2.24) that identifies the subject as the philosopher Zeno (Zenon); the lack of attributes or canonical pose for the figure in the Amsterdam panel led Picart to employ it as a *tronie*.

Fig. 2.24. Bernard Picart (French, 1673–1733), after Rembrandt Harmensz. van Rijn, *Zenon*, 1699. Mezzotint, 6⅞ × 4¹¹⁄₁₆ inches (17.5 × 12 cm). Rijksmuseum, Amsterdam, RP-P-OB-17.263

PLATE 2·3 (actual size)

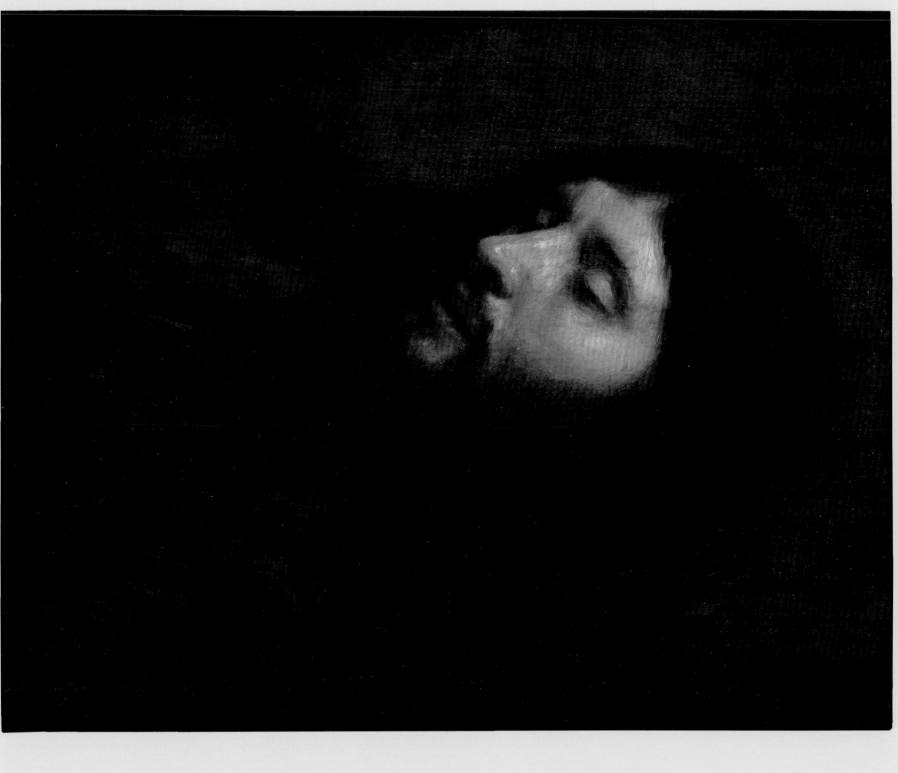

PLATE 2.4

Rembrandt Harmensz. van Rijn

Head of Christ, c. 1648–56

Oil on oak panel, 10⅟₁₆ × 7⅞ inches (25.5 × 20.1 cm)
Private collection

CAT. 41

The oak panel of this painting from a private collection was determined to be of Netherlandish or western German origin, with a youngest heartwood ring dated by dendrochronology to 1619, corresponding to an earliest possible creation date of 1628, or a more statistically plausible creation date of 1638 on. This compelling member of the core group of paintings was not accessible at the time of our study, but we are fortunate to be able to reproduce it here for the first time in color. The composition shares with the other panels the cast shadow and area of illuminated background to the right, here worked with a pronounced texture reminiscent of that feature (now overpainted) on the inset portion of the Philadelphia panel (plate 2.2).

The modeling of the face appears to incorporate fewer areas of the translucent shadow tone and associated striations of the wood grain, though some such areas are visible between the proper left eyelid and brow and along the line where the forehead and hair meet at the left. The pulled texture of the viscous paint recalls similar handling in the Philadelphia panel, though the effect is more uniformly distributed here, consistent with the more frontal lighting and consequent buildup of paint associated with fully illuminated flesh. The paint handling shows less variety and textural relief and appears to relate most closely to the Amsterdam and Detroit panels (plates 2.3, 2.7). Like the Detroit painting, it exhibits a change in the outline of the figure against the background, clearly visible in the infrared photograph (see Appendix); a larger reserve for the figure's arm at left was cursorily filled in with background color at a later stage of painting.

While the face of Jesus in this panel shares the larger scale of the Berlin, Philadelphia, Cambridge (plate 2.5), and Amsterdam paintings, the figure's raised, clasped hands are also included, indicated in only the most cursory fashion by rapid brushstrokes that suggest the interlocking fingers with efficiency and facility.

Like the Amsterdam panel, this one was perhaps conceived as a model for Christ on the Mount of Olives, the biblical episode in which Jesus confronts his imminent crucifixion. Rembrandt's sustained interest in that episode is demonstrated by his many drawings of the scene (see plate 4.12); however, as with his drawings of the disciples' encounter with Jesus on the road to Emmaus (see plates 1.6, 1.7), they did not result in any known painting.

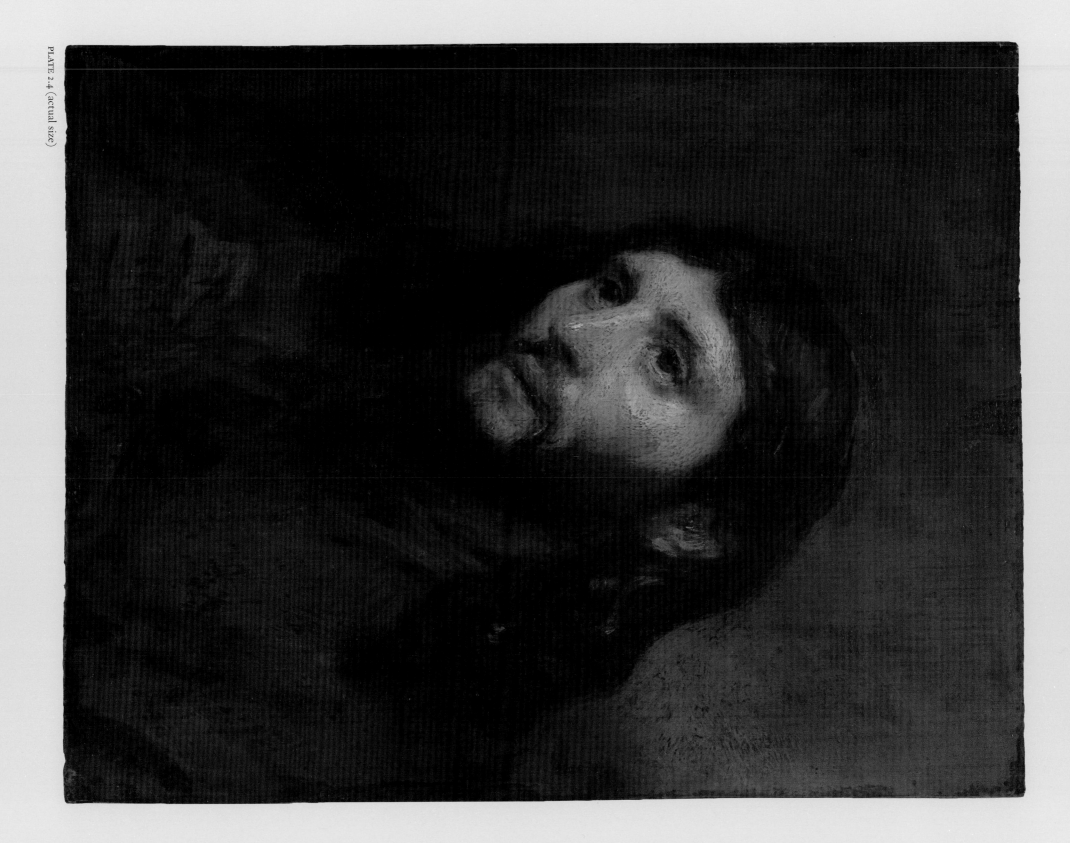

PLATE 2.4 (actual size)

PLATE 2.5

Rembrandt Harmensz. van Rijn

Head of Christ, c. 1648–56

Oil on oak panel, 10⅜ × 8⅟₁₆ inches (25.5 × 20.4 cm)

Harvard Art Museum/Fogg Museum, Cambridge, Massachusetts, Gift of William A. Coolidge, 1964.172

CAT. 39

Dendrochronological analysis of the Cambridge painting established that the Baltic/Polish oak panel is from the same tree as the Berlin *Portrait of a Young Jew* (see plate 4.6) and indicated an earliest possible creation date of 1652, or a more statistically plausible creation date from 1658 on. Slive argued that the Cambridge panel, and not the Bredius painting (plate 2.8), served as a model for *The Hundred Guilder Print* of about 1649 (see plate 1.2). However, not only does the dendrochronological analysis rule this out, the tilt of the head and the intimate gaze in the Cambridge panel also place it farther from the print than the Bredius example.[1]

The Cambridge painting gives the odd impression of a dead-colored sketch punctuated by isolated patches of opaque flesh tone. On no other panel are passages of fully illuminated flesh dominated, as they are here, by the tone of the translucent ground, through which the wood grain can be seen. The modeling consequently has a flatter quality, as well as a more sallow cast. Also present, however, are strokes of highlight and brighter color of the sort worked into built-up and textured flesh tone toward the end of the painting process in the other panels examined. The stark highlights on the forehead, nose, and cheek, as well as the occasional touches of purer reds and yellows, are similarly bold in this painting, but they do not appear convincingly merged with the surface, nor are they integrated into a logically unified system of modeling based in tonal continuity.[2] It is difficult to conceive how this face could have existed in a state of fully developed modeling, with a level of finish observable in all the other faces, and ended up looking as it now does, with some details intact, if clearly abraded, but with the usual continuity of paint and modeling curiously absent. The blocky modeling, with its hard boundaries, and the discontinuity of the paint are accentuated in the X-radiograph (see Appendix).

The use of a tool to incise lines into the paint far exceeds that seen in any other panel in the group. Rather than merely suggesting occasional highlights or linear detail, the beard was here created largely by drawing lines into a dark mass of paint. The result is at odds with the restrained and merely suggestive nature of this graphic effect in the other panels. Given the apparent loss of surface throughout large areas of the face, it is possible that this anomalous handling was not the final intended effect but was later exposed by abrasion, though more visible damage to the beard might be expected if that were the case. Of particular note is the pair of parallel incised marks on the forehead just to the left of the part, which are strikingly similar to those in the same location on the Philadelphia painting, both apparently made with a reed pen (see figs. 2.12, 2.13).[3]

1. Bruyn et al., *Corpus of Rembrandt Paintings*, vol. 4, p. 410.

2. On the pursuit of spatial order and harmonious legibility in Rembrandt's work as a function of carefully graded tonal relationships and unity, see Van de Wetering, *Rembrandt: The Painter at Work*, on the concepts of "houding" (pp. 149–70) and "bevriende" (related) colors (pp. 252–53).

3. See Gifford, "Material as Metaphor."

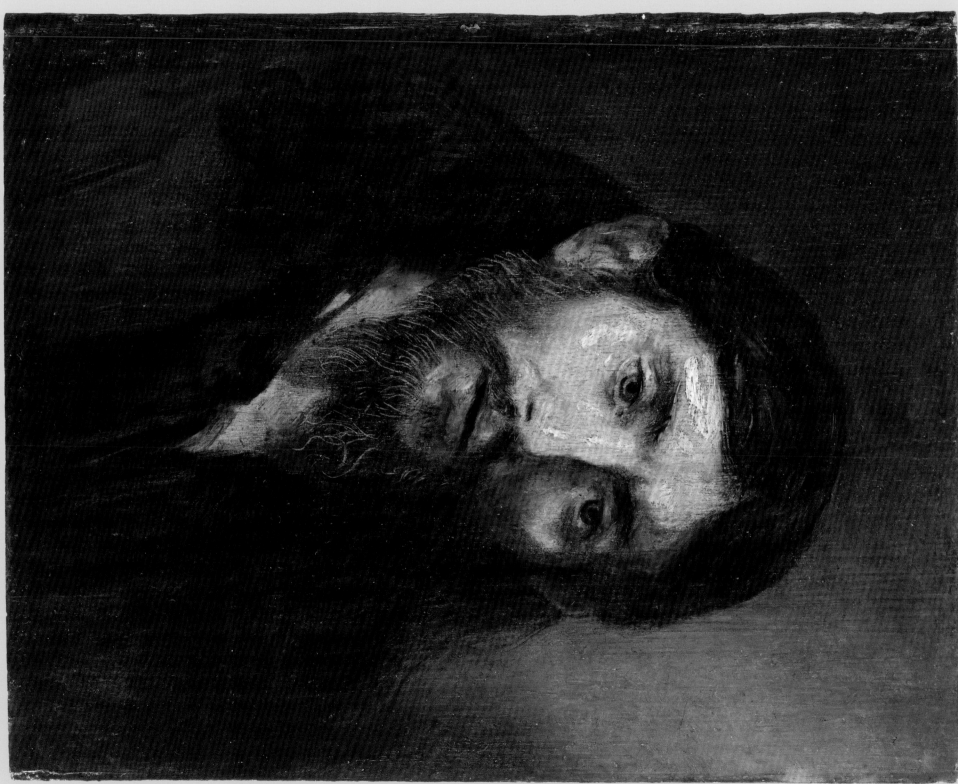

PLATE 2-5 (actual size)

PLATE 2.6

Rembrandt Harmensz. van Rijn

Head of Christ, c. 1648–50

Oil on oak panel, 9 9/16 × 8 7/16 inches (25 × 21.5 cm)

Staatliche Museen Preussischer Kulturbesitz, Gemäldegalerie, Berlin, inv. 811C

Photograph © Bildarchiv Preussischer Kulturbesitz / Art Resource, NY

CAT. 35

The Berlin panel is oak of Baltic/Polish origin and came from the same tree as the similarly sized panel of the Rembrandt studio *Self-Portrait* now in the Museum der Bildenden Künste, Leipzig.[1] The latter panel could be dendrochronologically dated more reliably and so the dating of the Berlin painting was derived from it, giving a plausible creation date from 1645 on. Although the panel shares the vertical format of the others, the grain of the wood is, atypically, horizontal.

The general appearance and technique of working up the finished flesh from a brown monochrome sketch appear typical of the paintings in the Slive group. Also typical is the visual role played by the brown underpaint layer, which is left exposed in parts of the finished face, such as the temple, around the nostril, and around the white of the proper right eye. Only this painting and the Detroit panel (plate 2.7) lack any visible lines drawn into the paint with a hard tool. Still intact are fine touches of brighter red introduced in the later stages of painting, both by blending into wet flesh paint and by adding discrete small strokes on the surface. The conspicuous highlight on the front of the costume is striking and unusual within the group, the most comparable feature being a subtle white highlight in the neckline in the Detroit painting. The X-radiograph of the Berlin painting reveals a larger area of highlight revised to the single emphatic stroke seen in the final painting (see Appendix). The panel has not been cleaned recently, and remnants of a dark material in hollows of the surface, especially within and around impasto, exaggerate the textural aspect of the paint, giving a false roughness to the modeling. The thin darks show some abrasion, especially over ridges in the wood grain, but overall the head, costume, and background appear to be well preserved. That this painting is the most intact of the group has perhaps contributed to the more positive scholarly regard it has elicited. In the fourth volume of the *Corpus* (2006), the Rembrandt Research Project posited that "in style and pictorial quality it approaches his works from the second half of the 1640s. It also displays a feature that appears to be characteristic of Rembrandt, a tendency to shift the eye in the averted half of the face 'outwards' in heads seen in three-quarters profile; compare, for instance, the Virgin in the St. Petersburg *Holy Family* (Br. 570), Asenath in the Kassel *Jacob's Blessing* (Br. 525), and the woman in the Amsterdam *Jewish Bride* (Br. 416)."[2] This feature, so expressive of abstracted contemplation, occurs not only in the Berlin panel, but also in the *Head of Christ* in a private collection (plate 2.4).

1. Bruyn et al., *Corpus of Rembrandt Paintings*, vol. 4, pp. 378–84. 2. Ibid., pp. 381–82.

PLATE 2.6 (actual size)

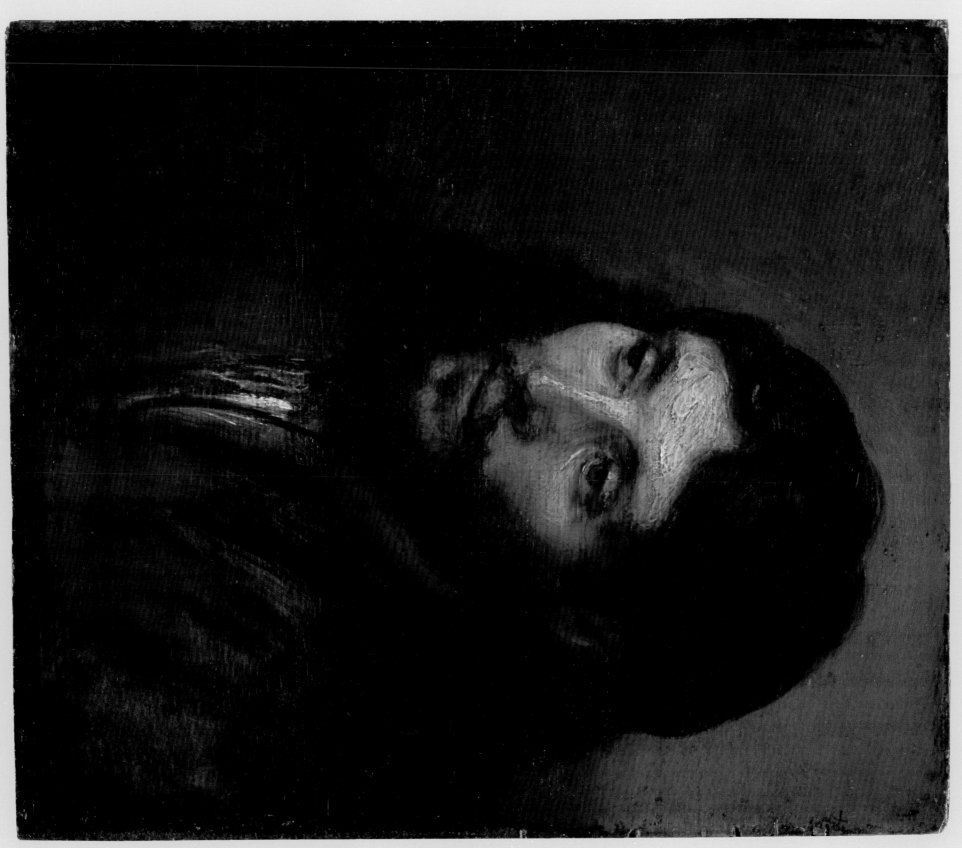

PLATE 2.7

Attributed to Rembrandt Harmensz. van Rijn

Head of Christ, c. 1648–54

Oil on oak panel, 10 × 8⅜ inches (25.4 × 21.3 cm)

Detroit Institute of Arts, Founders Society Purchase, 30:370

CAT. 37

Dendrochronology has established that the oak of the Detroit panel, like that of the panel in a private collection (plate 2.4), came from the Netherlands or western Germany. The youngest heartwood ring of the panel was dated to 1642, corresponding to an earliest possible creation date of 1651, or a more statistically plausible creation date from 1661 on, under standard assumptions for wood from western Europe.

The appearance of the materials and general technique are consistent with the other panels in the group. This painting is, however, notable for the number of significant changes made during its execution. The reflected infrared photograph shows that the outline of the figure against the right background was lowered so that the axis of the shoulders, conceived in an earlier state as sloping sharply upward to the right, was made to slope slightly downward to that side (see Appendix). This change in the relationship of the head to the body altered the initial oblique, hunched pose to a more symmetrical, upright one. The X-radiograph reveals that the eyes, which now meet the viewer's, were originally upturned (see Appendix)—a further alteration from an earlier state toward the present frontal and directly engaging aspect of the figure. The sketchy treatment of the proper right forearm and hand at the bottom of the painting was a change, most likely made by the artist, from a first idea to include both hands.[1] Another change was the conversion of an earlier rounded neckline of the garment to the present "V" shape.[2]

The correspondence between the lights of the flesh as they appear in the finished face and the areas of high density in the X-radiograph is not as consistent throughout as that seen in the other panels—though this is partly due, no doubt, to the inherently lower contrasts of light and shade that accompany the nearly frontal illumination of the face. These pentimenti, along with the way the modeling was developed, as indicated by the X-radiograph, suggest a more searching and experimental approach than is evident in the other panels in the group. Though not handled timidly by the artist, the paint of the face was mixed and worked in a way that produced an overall smoother surface, with less brush-marking, that most closely resembles the texture of the Amsterdam panel (plate 2.3). A final point of handling that diverges from that of the other paintings is the treatment of background, which presents a generally unified appearance in normal light but in the reflected infrared image reveals a more broadly heterogeneous alternation of opaque and translucent tones. The tonal balance of the painting is interrupted by blanching in darkly painted areas. As in the panels in Philadelphia and The Hague (plates 2.2, 2.8), this phenomenon appears to result from degradation of the paint layers rather than from the overlying varnish; in this case, however, it occurs as broader areas of lightened paint, rather than as the fine lines or spots of blanching observed in the other paintings.

The face of Christ in Rembrandt's *Supper at Emmaus* painting in the Louvre (see figs. 2.2, 6.1) bears obvious general similarities to those in the sketches, but the specific similarities to the

PLATE 2·7 (actual size)

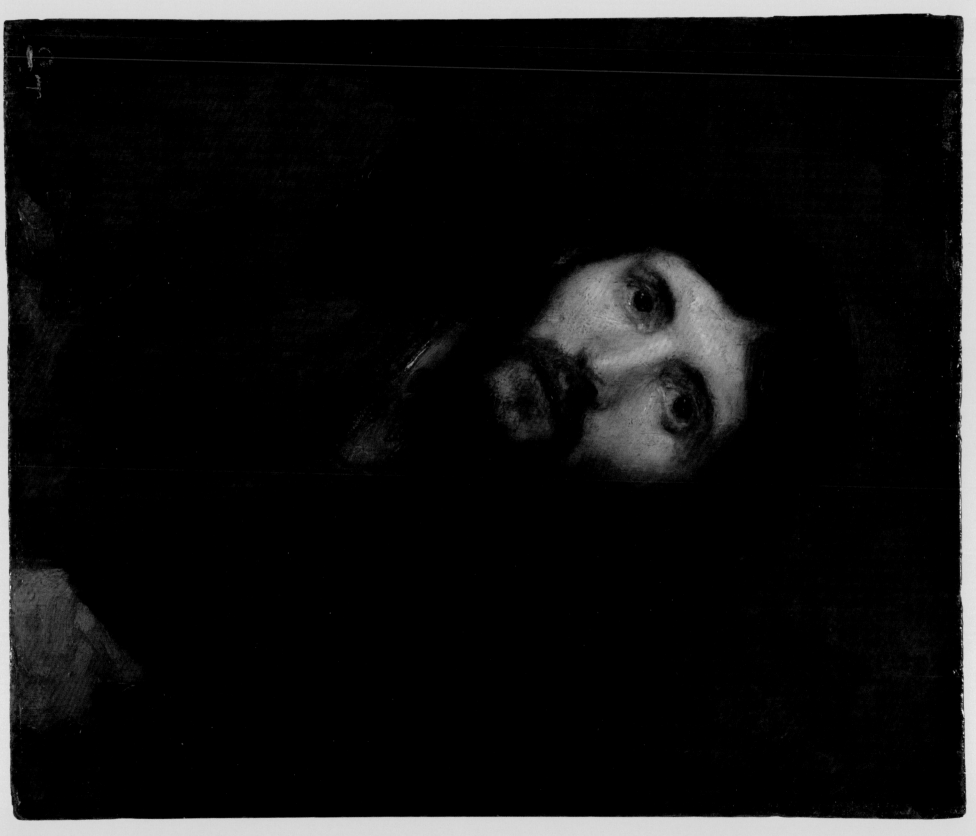

Detroit panel are striking. Although the face is far smaller and much of the sketchy quality is absent, for obvious reasons, from this finished narrative painting, the head is similarly tilted, the mouth is slightly opened, and the eyes are upturned, as they were in the original composition of the Detroit panel.

1. George S. Keyes et al., *Masters of Dutch Painting: The Detroit Institute of Arts* (Detroit: Detroit Institute of Arts; London: D. Giles Ltd., 2004), p. 177.

2. This change was brought to our attention by Alfred Ackerman, Conservator of Paintings at the Detroit Institute of Arts.

PLATE 2.8

Rembrandt Harmensz. van Rijn

Head of Christ, c. 1648

Oil on oak panel, 10 1/16 × 8 1/4 inches (25.5 × 21 cm)
Museum Bredius, The Hague, 94-1946
Photograph © The Bridgeman Art Library International

CAT. 30

The youngest heartwood ring of the Baltic/Polish oak panel of the painting in the Museum Bredius, The Hague, was dated by dendrochronology to 1630, corresponding to an earliest possible creation date of 1641, or a more statistically plausible creation date from 1647 on. The painting's technique appears typical of the group. More extensive use was made of a tool to draw lines into the wet paint here than in any except the Cambridge panel (plate 2.5). The lines were incised into the dark opaque paint during the working up of the hair and then partly covered by subsequent paint applications.

The thinly brushed background, the cursory treatment of the garment with opaque paint worked in over translucent underlayers to suggest texture and the fall of light, and the roughly blocked-in hand are typical of the core group of panels. The buildup of paint in the face and hair appears to conform to the process seen throughout the group, from a thin monochrome sketch through the application of opaque tones and, in the flesh, textured light tones, with the addition of brighter touches of color and loaded highlights to finish the face.

The correspondence between surface modeling and densities in the X-radiograph (see Appendix) is generally close, with the exceptions of the X-radiograph's recording of a light area in the proper right cheek that falls lower on the face than the surface image's built-up cheekbone and associated highlights, suggesting some reworking in this area.

Modeling transitions in the shaded side of the face appear disrupted and hardened due to cleaning abrasion, as described in connection with the Philadelphia panel (plate 2.2). Fine touches of color on and within illuminated flesh could be seen on close examination, however, indicating a good state of preservation in these areas. Slive mentioned "a rather large loss on the right sleeve," but our examination revealed no sign of damage on the surface, in the X-radiograph, or in the reflected infrared photograph (see Appendix). Rather, it appears that the contrast in tone of this more opaquely painted part of the costume (as well as the forearm at the bottom) has been heightened by abrasion of the adjacent, more thinly executed part of the drapery. There are clear signs

PLATE 2.8 (actual size)

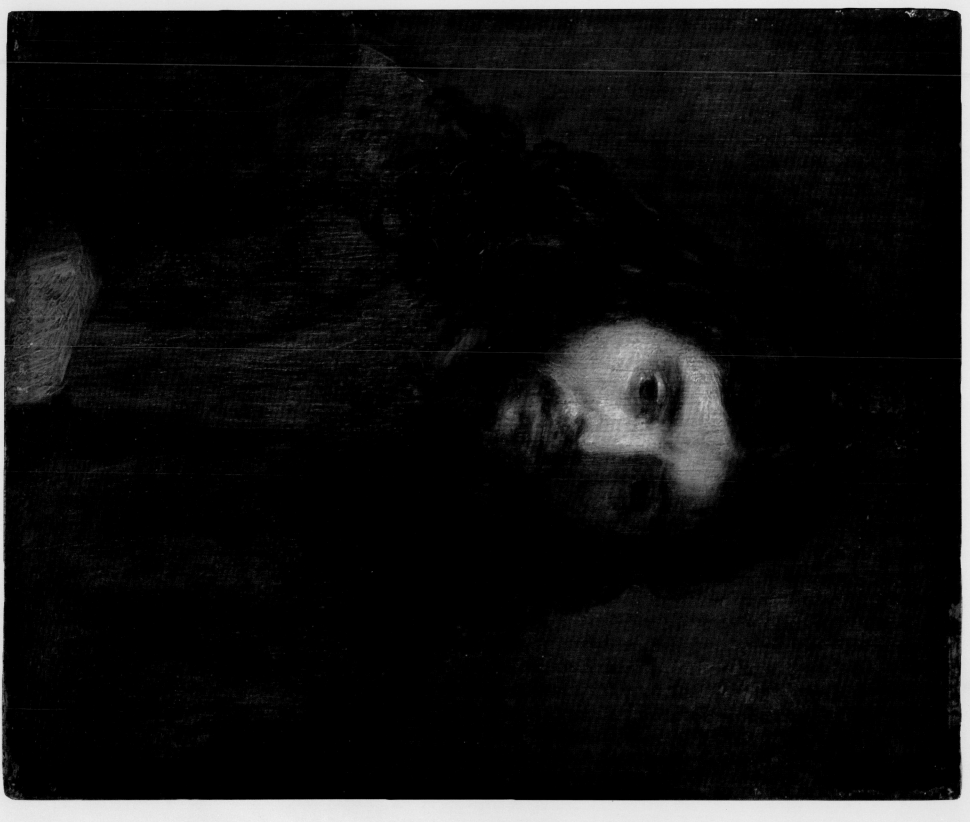

of a general abrasion interrupting translucent brushstrokes in the part of the costume adjacent to the sleeve in question. Note that the short, dark, hatched strokes across the shoulder seam of the sleeve occur also in the inner fold of the elbow in the costume of the figure in the Detroit panel (plate 2.7). Some blanching is evident in the paint of the mid-tones of the face, occurring primarily in raised strokes of impasto, similar to the phenomenon observed in the Philadelphia panel.

The figure in the Bredius panel is the smallest in scale of the group. In contrast to the panels that depict head and shoulders only (Berlin, Cambridge, Amsterdam, and Philadelphia in its pre-enlarged state), the reduced scale of the Bredius and Detroit figures allowed the inclusion of forearms and hands.

The fixed gaze of the figure and the stable, simple pyramidal composition of the painting make the Bredius panel the most iconic of the group. As demonstrated by the organizers of the 2009 exhibition *Rembrandt gespiegeld* (Rembrandt Reflected) at the Museum het Rembrandthuis, Amsterdam, the head of Jesus in *The Hundred Guilder Print* (see plate 1.2) as conceived on the copper plate (rather than as seen in reverse in the finished etching) is most closely related to the face in the Bredius panel.

STUDIO COPIES AFTER THE HEADS OF CHRIST

PLATE 2.9

Studio copy after Rembrandt Harmensz. van Rijn

Head of Christ, c. 1648–56

Oil on oak panel, 9⁵⁄₁₆ × 8¼ inches (23.7 × 21 cm) oval

Bob Jones University Museum and Gallery, Greenville, South Carolina. Acq. Julius Weitzner, London, in 1963, P. 63;330.27

CAT. 43

A copy of the painting in the Museum Bredius (plate 2.8) now in the Bob Jones University Museum and Gallery, Greenville, South Carolina—the only known copy of one of Slive's core group of panels—may belong to what the Rembrandt Research Project refers to as "satellites" of more accepted works.[1] The painting, possibly of seventeenth-century origin, lacks the more emphatically loaded highlights of the original and the other paintings in the Slive group, and does not integrate exposed ground tone or sketch modeling in the surface image to the same extent. As Slive noted, "It shows a heavier touch and lacks the finer tonal gradations." It also lacks the lines drawn into the wet paint of the hair, which here is painted far more smoothly and opaquely, consistent with modeling that is softer overall and handling that is texturally more muted and uniform. The palette and general style of the Greenville painting are consistent enough with the original to suggest a studio copy, though it is clearly outside the core group of panels considered here in points of execution and final effect.

1. There was a second copy or version as well, formerly with a certain De Wildt, a photograph of which is on file at the Rijksbureau voor Kunsthistorische Documentatie in The Hague. Bruyn et al., *Corpus of Rembrandt Paintings*, vol. 4, pp. 381–82.

2. Slive also commented on the conspicuously disrupted appearance of the proper left eye, noting rightly that "it has not gained in the course of later restorations." Slive, "An Unpublished *Head of Christ*," p. 47.

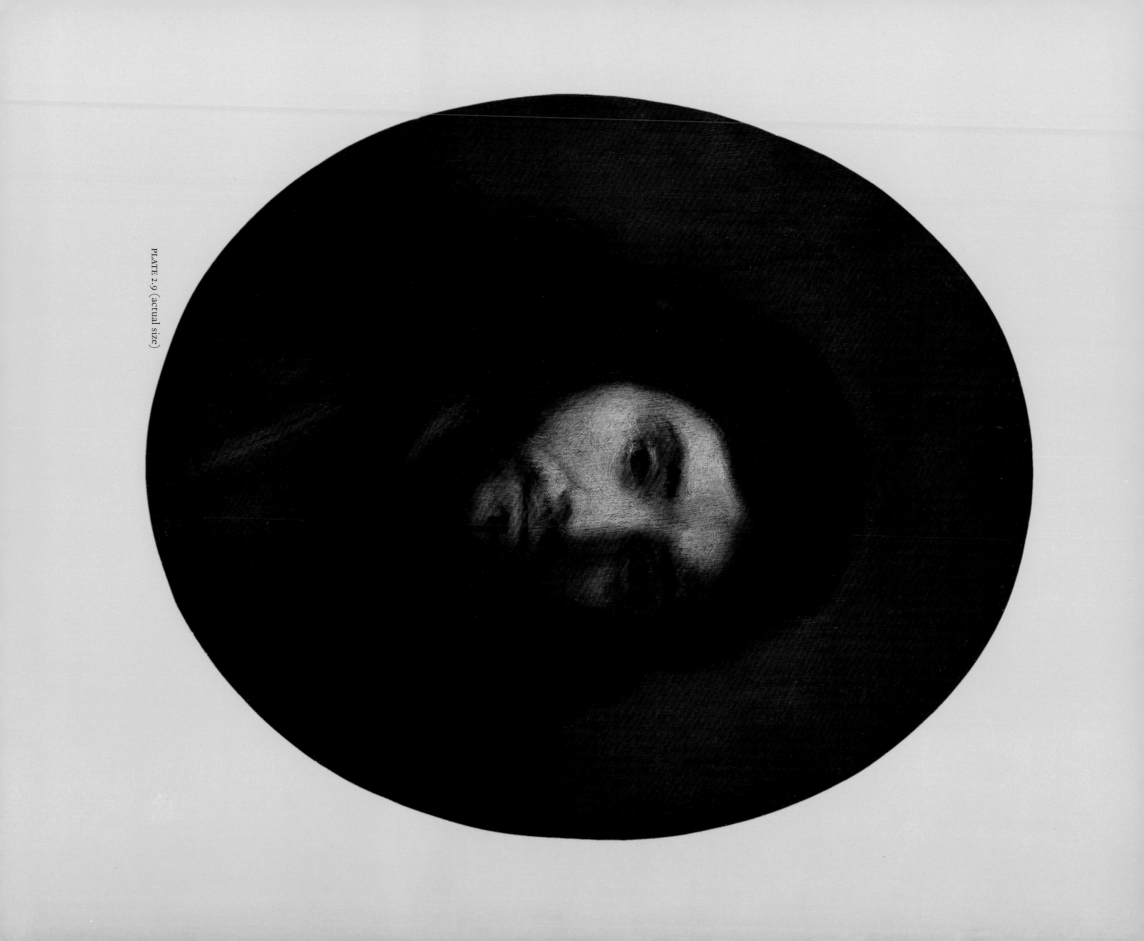

PLATE 2.10

Studio of Rembrandt Harmensz. van Rijn,
probably a copy after a lost painting by Rembrandt

Head of Christ, c. 1648–55

CAT. 38

Oil on oak panel, 23¾ × 19 inches (60.3 × 48.3 cm)

Museum of Art at Brigham Young University, Provo, Utah, Gift of Vivian Hotchkiss Leonis Vicondo, inv. no. 040280000

Two further paintings of the head of Christ executed in Rembrandt's circle, one on panel and one on canvas, are nearly identical to each other in conception. The panel now in the Museum of Art at Brigham Young University, Provo, Utah, shows the same model, costume, and general composition as the Slive group, and its focus on the face of Jesus is consistent with the other panels. It especially resembles the panels in the Museum Bredius (plate 2.8) and the Fogg Art Museum at Harvard University (plate 2.5). Although the palette appears consistent with the other Jesus sketches, this panel was created in a larger format, suggesting that a pupil or associate sought to copy a now-lost sketch as a finished work of art on the scale of a Rembrandt *tronie*. The figure is shown in the same pose and lighting conditions as in the Museum Bredius panel, but here the stable pose and direct gaze have been replaced by a right-turned, slightly tilted head that suggests a more personal, sympathetic demeanor. This composition also resembles Christ in the Cambridge panel (plate 2.5), but significantly more of the right side of the face is in darkness, and Christ's unfocused eyes and hand tucked into the cloak over his chest indicate a state of contemplation rather than of engagement.

At the time of our examination, the Provo panel exhibited ragged, hardened edges of opaque paint that originally blended smoothly onto the sketch shadow zones. (See the discussion of this phenomenon in relation to the Philadelphia painting [plate 2.2].) The sketch shadow tone itself has suffered significant losses, down to the ground in many areas, producing confusing value reversals whereby former areas of deep shade are now lighter than the adjacent illuminated flesh.

PLATE 2.10

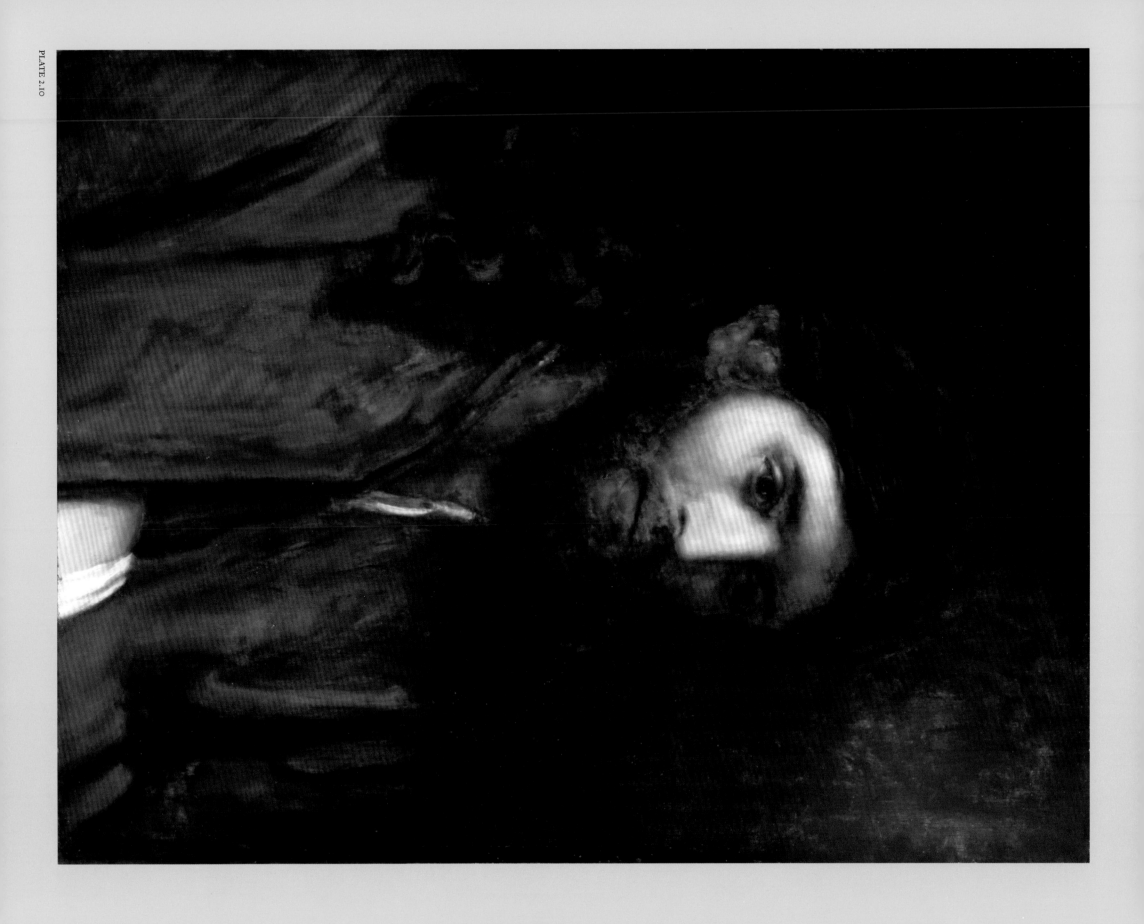

PLATE 2.11

Studio of Rembrandt Harmensz. van Rijn,
probably a copy after a lost painting by Rembrandt

Head of Christ, c. 1650

Oil on canvas; 16¾ × 13½ inches (42.5 × 34.3 cm); with added strips 18⅝ × 14⅝ inches (47.3 × 37.1 cm)
The Metropolitan Museum of Art, New York, Mr. and Mrs. Isaac D. Fletcher Collection,
Bequest of Isaac D. Fletcher, 1917 (17.120.222)
Photograph © The Metropolitan Museum of Art / Art Resource, NY

CAT. 46

A free copy of the Provo panel's composition, now in the Metropolitan Museum of Art, is a fragment on canvas that shows the same head at the same scale, and may originally have been the same size as the Provo panel (plate 2.10). It was painted in Rembrandt's style of the 1660s and may therefore be a copy of either the Provo panel or a lost original, suggesting that one of the latter was still in Rembrandt's house in the 1660s. Like the composition in the Museum Bredius panel (of which the Greenville panel [plate 2.9] is a faithful and sensitive studio copy), this lost original, if it existed, stood out enough to have been worthy of copying by artists who had access to one of the panels in the group, and may bear witness to the phenomenon, noted by Michiel Francken, of students copying originals in Rembrandt's atelier.[1]

1. Francken, "Copying Paintings in Rembrandt's Workshop,"
pp. 169–70.

PLATE 2.II

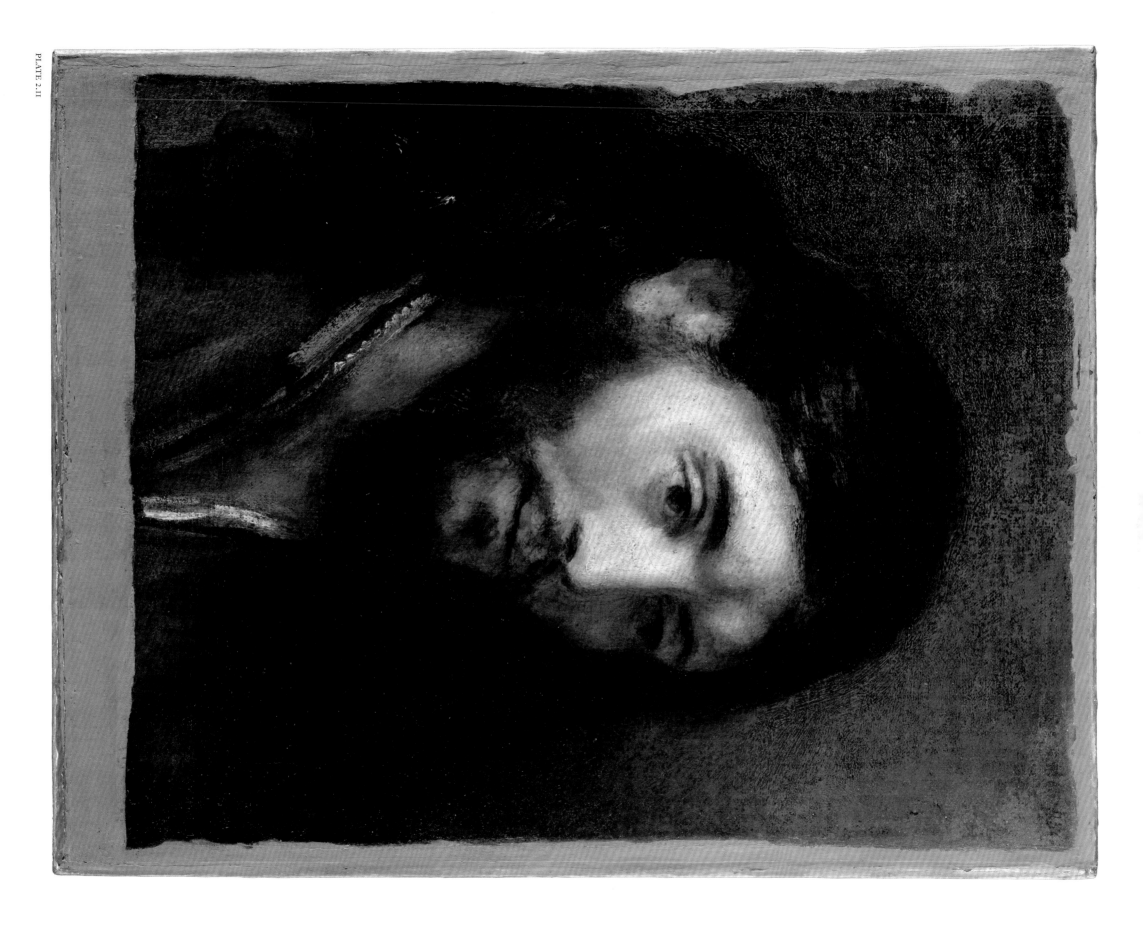

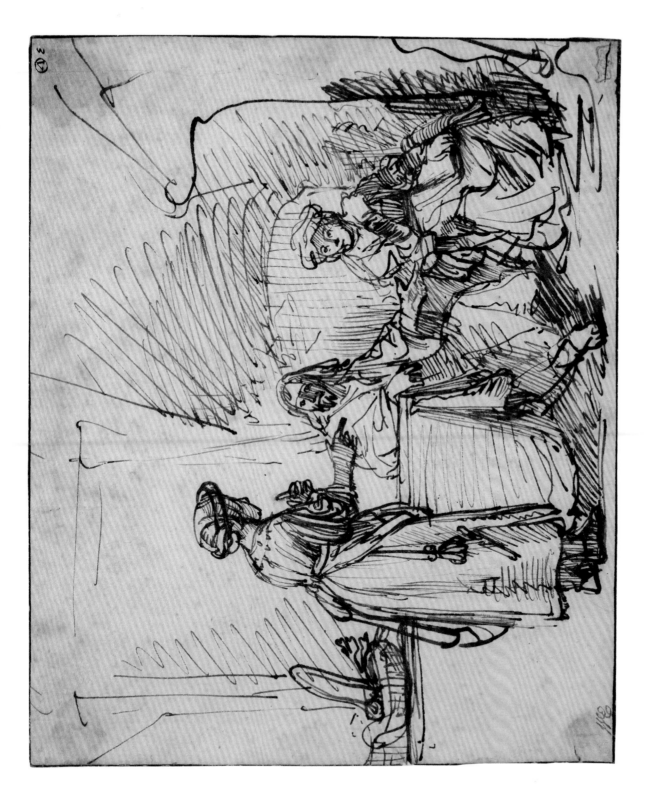

PLATE 3.1

Rembrandt Harmensz. van Rijn

Christ in the House of Mary and Martha, 1632–33

Pen and brown ink on paper, 6¼ × 7⅝ inches (15.8 × 19.4 cm)
Teylers Museum, Haarlem, O*46

CAT. 12

Rembrandt's Jesus

Larry Silver and Shelley Perlove

This essay was drawn largely from Shelley Perlove and Larry Silver, *Rembrandt's Faith: Church and Temple in the Dutch Golden Age* (University Park: Pennsylvania State University Press, 2009).

Rembrandt took a distinctive approach to religious narrative, often combining different moments from the Bible into a single image, and sometimes distilling a holy figure into a portrait-like representation. This particular, personalized imagery emerges most succinctly in the artist's powerful depictions of the adult Jesus on his mission, based on Rembrandt's careful reading of the Gospels, particularly through the new translation with marginal notes in the official Dutch *Statenbijbel* (States Bible; published 1637).[1] Over the course of his career his visual characterization of the role of Jesus shifted decisively, and his depiction of biblical events changed from a dramatic emphasis on crowded miracle narratives toward smaller groups in thoughtful contemplation—even for the same subjects.

SUPPER AT EMMAUS

Rembrandt's interpretations of the Supper at Emmaus span his full career—five works over the course of twenty-five years (1629–54), as well as a painting produced by his studio around 1660 that derives largely from his later etching of 1654 (see plates 3.3, 3.5)—offering a poignant example of his changing treatment of the figure of Jesus. In this Gospel event (Luke 24:13–31), a pair of disciples on pilgrimage—only one, Cleopas, is identified—encounter a stranger, who joins them at table for dinner. Only when their companion blesses the shared bread do the disciples suddenly recognize him as the resurrected Christ, who then disappears. In the process, they distinguish themselves as an insider community of the faithful;[2] thus, the story dramatizes the spiritual journey of the Christian pilgrim from skepticism to faith.

In his earliest *Supper at Emmaus*, painted about 1629 and now in the Musée Jacquemart-André, Paris (see plate 4.1), Rembrandt uses a hidden candle to provide a vivid profile silhouette of the seated Christ—a naturalistic device that suggests the miraculous revelation, in literal enlightenment, of personal recognition. Near the right edge, a bearded, long-haired Jesus leans back with hands clasped; in the center, a humbly dressed, coarse-featured disciple raises his hands as he stares in open-mouthed wonder at the figure he now recognizes as Christ. Only the upper right of the composition is illuminated by that personal glow, leaving the rest of the image in darkness, broken only by a distant light for a kitchen maid at left; she, like Martha in Luke 10:38–42 (plate 3.1), is preoccupied and fails to take note of the unfolding miracle.[3]

This early painting shows Rembrandt vying with the leading contemporary Utrecht religious artists, including such Caravaggist painters as Hendrick ter Brugghen (1588–1629) and Gerrit van Honthorst (1592–1656),[4] and also drawing upon the lighting and space of Adam Elsheimer (1578–1610), for example, in his painting *Jupiter and Mercury in the House of Philemon and Baucis* of

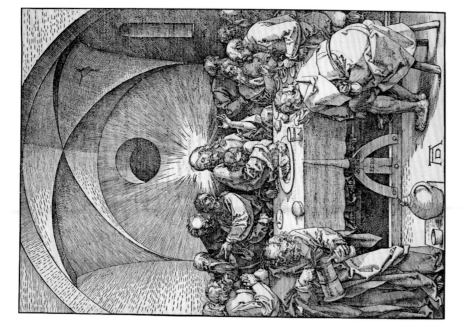

1608–9 (Gemäldegalerie Alte Meister, Dresden).⁵ Rembrandt, however, makes light versus darkness the central subject in order to underscore the sudden revelation of Jesus's divine nature.

Rembrandt's *Supper at Emmaus* panel of 1648, now in the Louvre (see plate 1.1), follows visual tradition in showing the moment in which the disciples recognize Christ at the table, while the waiter obliviously pursues his mundane task of bringing food. The quiet and dignified, if modest, table setting is placed within a high stone vault, a majestic niche-like recess that gives prominence to the humble figure of Christ. Christian Tümpel has noted that the niche and table recall a church chancel and altar, and thus evoke the ritual of Communion.⁶ This meal, then, suggests the early Christian practice of celebrating the Lord's Supper by eating a sacred meal in a dining-room setting. Albrecht Dürer also used a stone-vaulted setting in his *Last Supper* woodcut from the *Large Passion* of 1510 (fig. 3.1), but Rembrandt's architecture is much more austere. Such architectural sobriety may evoke the ideals of the early apostolic church at Jerusalem as described in Acts, viewed as a model for reform by Protestant sects in the sixteenth and seventeenth centuries, including the Calvinist Reformed Church into which Rembrandt was born, and the dominant denomination in the Dutch Republic. In performing the Jewish custom of blessing and breaking bread, Rembrandt's *Supper at Emmaus* also recalls the rituals of the primitive church: "And they were persevering in the doctrine of the Apostles, and in the communion, and in the breaking of bread . . . from house to house they did eat together with rejoicing and simplicity of heart" (Acts 2:42, 46). Rembrandt's preference for this subject thus connects with his ongoing efforts to recapture the spirit of the apostolic church and of Saint Paul, so revered by contemporary Protestants.

The loaf that Christ blesses in the Louvre painting is a braided challah, an egg-based Jewish bread used for Sabbath and holidays. Jesus has torn off the end braid, as is typically done by

the host in a Jewish home to this day. The artist may have been inspired by the *Statenbijbel*, which explains that Christ in Emmaus broke the bread "after the manner of the Jews in the beginning of their meals whose loaves were so baked, that they could conveniently be broken."[7] Rembrandt would have known about challah from his contacts with Jewish neighbors and acquaintances, and its inclusion here suggests the artist's acknowledgment of Jesus's Jewish heritage and his emphasis on the continuity between Old and New Testament.

In this mature work by Rembrandt, the gestures of recognition and reaction by the two disciples are restrained and modest, as if they, like the viewer, have only just realized the identity of the stranger in their midst. Dutch scholar Hugo Grotius (1583–1645), whose writings are important for Rembrandt's religious works, asserted in a 1642 treatise that the confirmation of the miracle of Christ's resurrection by sufficient witnesses was crucial to the propagation of the Christian faith.[8]

As if to underscore this process of recognition, Rembrandt's larger 1648 *Supper at Emmaus*, probably produced with his workshop, and now in the Statens Museum for Kunst, Copenhagen (plate 3.2), includes a parted curtain as a device for viewer revelation. As in *Holy Family with a Curtain* of 1646 (fig. 3.2), Rembrandt here uses a curtain to unveil a sacred subject, in accord with the text of the Emmaus event: "And their eyes were opened, and they knew him" (Luke 24:31).[9] The curtain also literally depicts Paul's message in 2 Corinthians 3:15–16: "But even to this day, when Moses is read, a veil lies on their heart. Nevertheless when one turns to the Lord, the veil is taken away." Of course, the main reference here is to the Jerusalem Temple veil itself, which obscured the Holy of Holies, but which tore open at the death of Jesus (Matthew 27:51; Mark 15:38; veil described in Exodus 26:31). This connection implies the crucial transition between the Old and New Testament in the painting.

In the larger Copenhagen *Supper at Emmaus* of 1648, both Jesus and the two apostles pose and gesture as in the Louvre panel; however, Christ's aura of holiness is less enveloping, replaced

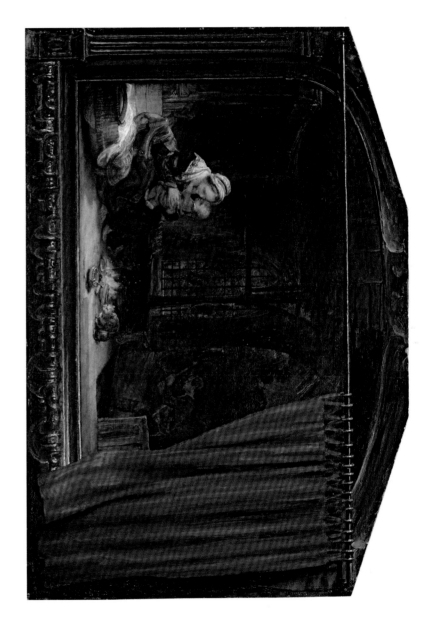

Fig. 3.2. Rembrandt Harmensz. van Rijn, *Holy Family with a Curtain*, 1646. Oil on wood, 18¼ × 27⅛ inches (46.5 × 69 cm). Staatliche Kunstsammlungen, Kassel, Germany

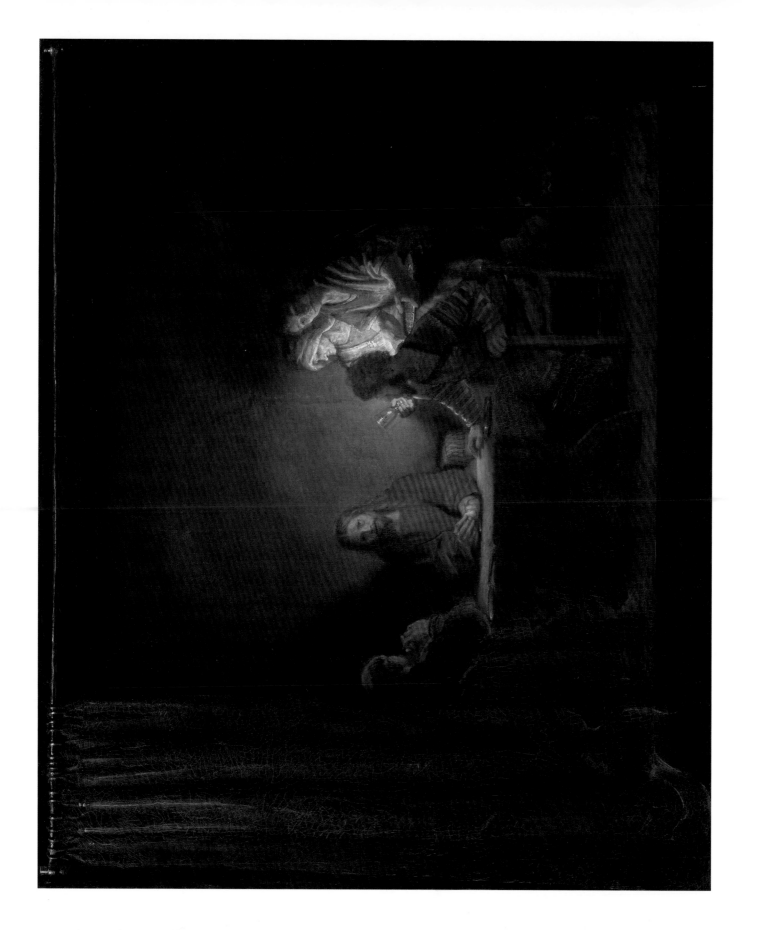

PLATE 3.2

Studio of Rembrandt Harmensz. van Rijn

Supper at Emmaus, 1648

Oil on canvas, 35¼ × 43⅞ inches (89.5 × 111.5 cm)
Statens Museum for Kunst, Copenhagen, KMSSP405

CAT. 28

(as in the 1629 panel) by the artifice of a hidden candle, here carried by the unbelieving servant. Notably, Rembrandt downplays the role of wine in both 1648 paintings, probably to stress the spiritual and symbolic meaning of the blessing, while avoiding associations with the Roman Catholic Mass.

Rembrandt's 1654 etching *Christ at Emmaus: The Larger Plate* (plate 3.3) offers an entirely different image of the Christian redeemer. Enthroned beneath a large baldachin like a king, here Christ appears more ethereal and transcendent than the quietly suffering Jesus of the Louvre *Emmaus*. The etching further underscores the moment of revelation, marked by brilliant, supernatural light around the seated central figure, whose posture and regal dignity recall Christ in Leonardo's *Last Supper* (begun c. 1495). Rembrandt knew Leonardo's mural from prints and adapted it for a red chalk drawing around 1635 (plate 3.4); the baldachin in Rembrandt's etching recalls the one in the drawing, as Clifford Ackley has noted.[10]

Scholars justly consider this *Emmaus* etching a reduced version of the Last Supper, where Christ breaks bread with his disciples. Thematically, its dramatic moment of revelation also distinguishes the Christian community as insiders (and all others as outsiders), just as Judas in the Last Supper is isolated from the rest of the disciples. The connection to the Last Supper is reinforced by the large wine goblet and the lamb, invoking the pure white Paschal lamb sacrificed by the Temple priest at Passover, interpreted in the New Testament as a type for Christ as the lamb of God who takes away sin (see, e.g., 1 Peter 1:19; 1 Corinthians 5:7; John 1:36).[11] Positioned beside the lamb, which invokes the bloody sacrifice, the wine glass recalls the words spoken by Jesus at the Last Supper (Luke 22:20): "This cup is the new Testament in my blood." Rather than breaking challah, as in the Louvre painting, Jesus proffers two pieces of bread: one to the apostle on the left, a believer, the other to the figures on the right, including the waiter, a nonbeliever.

The two disciples in the 1654 etching—as well as in the canvas based upon it that was produced by Rembrandt's studio around 1660 (plate 3.5)—react theatrically to Christ's appearance, especially the one on the left, who rises from his chair with his hands clasped in prayer to offer praise to the Lord. His actions evoke Isaiah 60:1: "Arise, shine: for thy light cometh and the glory of the Lord is risen upon thee." The *Statenbijbel* explains that God speaks in this verse to his Church, which will be enlightened "like a bright, shining sun" by God's glory that will spread through the earth, like the Heavenly Jerusalem of the End of Days (citing Revelation 21:11). Significantly, Christ in Rembrandt's print is imbued with an intense aura that illumines the entire space, while the branch with flowers at the far right seems to promise new life. All figures in the etching gaze at Christ; even the waiter descending the staircase turns to look at him.

Rembrandt's interpretation of the Emmaus subject in this print is unusual in having Christ gaze upon and offer bread to the unbelieving waiter, who resembles an Ashkenazi tradesman, much like the coarse, rotund, central figure in *Christ Disputing with the Doctors* (fig. 3.3), etched the same year. Ashkenazi Jews had come to Amsterdam in the mid-1600s to escape persecution in Poland and central Europe, and Rembrandt began to incorporate figures wearing their distinctive garb into his religious art (see also plates 3.9, 3.13). The *Emmaus* waiter, poised between Christ and the fleshly stores of the food cellar (toward which a carnal dog looks with animal longing), embodies the crucial choice open to the unconverted: either reject the "free gifts and the calling of God" (Romans 11:29) and continue to descend the staircase, or turn openly toward Christ. Surely this Jewish

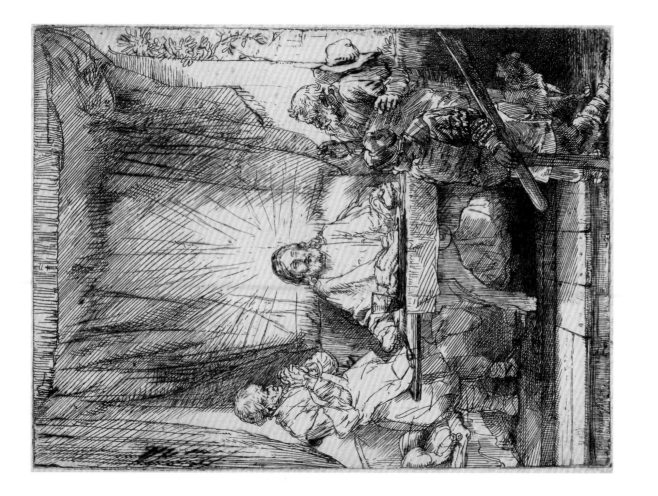

PLATE 3.3

Rembrandt Harmensz. van Rijn

Christ at Emmaus: The Larger Plate, 1654

Etching, engraving, and drypoint on paper; sheet (trimmed to plate mark) 8⅜ × 6⅜ inches (21.2 × 16.2 cm)
National Gallery of Art, Washington, DC, Gift of W. G. Russell Allen, 1955.6.7

CAT. 55A

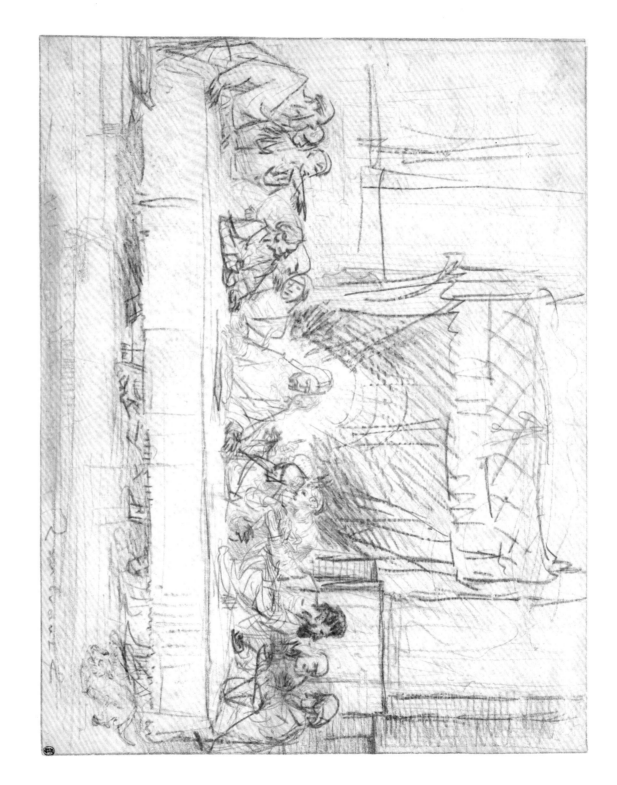

PLATE 3.4

Rembrandt Harmensz. van Rijn

The Last Supper, after Leonardo da Vinci, 1634–35

Red chalk on paper, 14¼ × 18⅞₆ inches (36.2 × 47.5 cm)

The Metropolitan Museum of Art, New York, Robert Lehman Collection, 1975 (1975.1.794)

Photograph © The Metropolitan Museum of Art / Art Resource, NY

CAT. 16

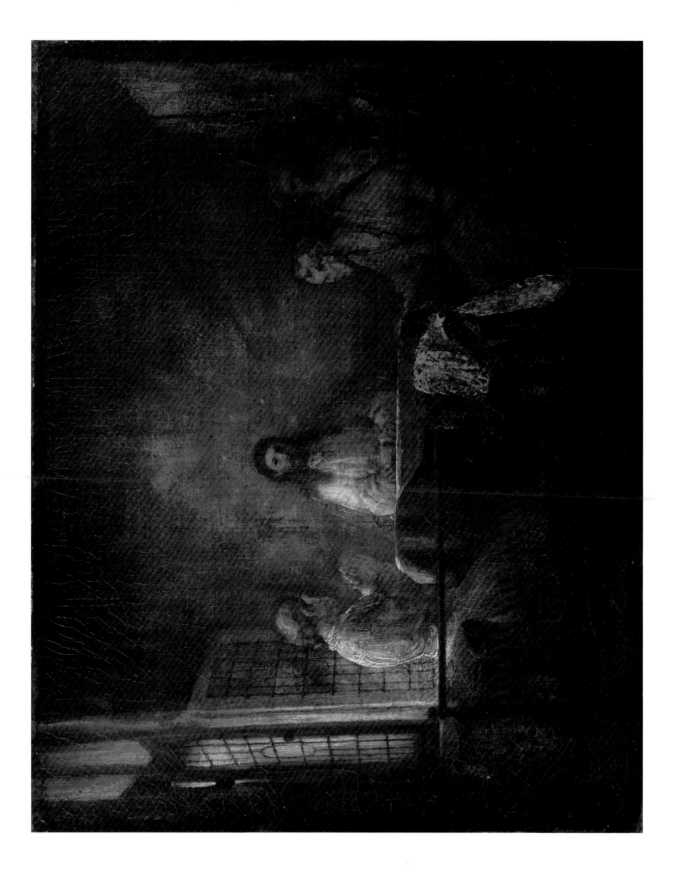

PLATE 3.5

Studio of Rembrandt Harmensz. van Rijn

Supper at Emmaus, c. 1660

Oil on canvas, 19¹¹/₁₆ × 25³/₁₆ inches (50 × 64 cm)
Musée du Louvre, Paris, inv. 1753
Photograph © Réunion des Musées Nationaux / Art Resource, NY

CAT. 67

82

figure, on the brink of either embracing or rejecting Christ, would have been especially topical for the Christian millenarians who endeavored to convert Jews in preparation for the Second Coming, anticipated to occur around 1655 or 1656. According to Hugo Grotius and others, Christ came to suffer on earth in his first advent, but would return in glory as a king in the second. Rembrandt's Christ in the 1654 etching foreshadows this anticipated redeemer of the Second Coming. While the Jews had failed to recognize Jesus as the Messiah because he had suffered and was not the king they expected, Christian reformers believed that the Jews would acknowledge Jesus in the Second Coming because then Christ would come in glory as a king.

The clear split between the witnesses in the *Emmaus* etching corresponds to the division between Christ's community of followers and the unbelievers, reprising in microcosm the basic theme of Rembrandt's etched sermon imagery, where an audience/congregation including both types attends to the Gospel message, as in *The Hundred Guilder Print* (see plate 1.2) and *Christ Preaching* ("*La Petite Tombe*") (see plate 3.9). Most importantly, Christ in these images of the Supper at Emmaus is revealed in relation to his Judaic background. Rembrandt's Paris *Emmaus* alludes to Christ's blessing of bread in the Jewish manner and the continuity of this practice within the primitive church. His 1654 etching associates Christ with the Paschal lamb of the Old Testament Passover, as in traditional representations of the Last Supper, and in the cup also invokes the blood of the New Testament covenant. Its message of salvation, offered even to unbelievers, ultimately augurs the glorified Messiah king of the Jewish tradition. Thus Rembrandt's *Emmaus* etching may be viewed as the artist's culminating mystical statement on a biblical story that occupied his attention for a quarter of a century.

CHRIST AND THE ADULTERESS

Rembrandt's depictions of Christ and the Woman Taken in Adultery, particularly the panel of 1644 now in the National Gallery, London (plate 3.6), explore the complex and often contentious relationships between Jesus and Jewish Temple scribes, Pharisees,[12] and priests.

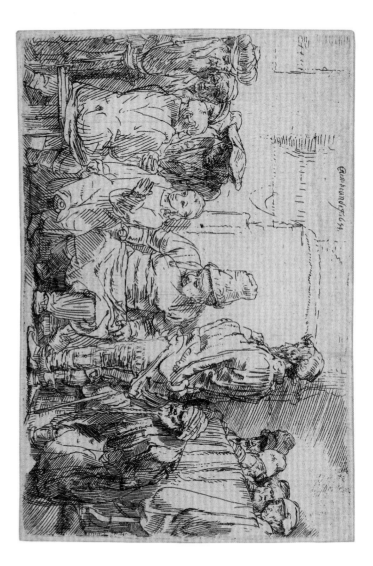

PLATE 3.6

Rembrandt Harmensz. van Rijn

Christ and the Woman Taken in Adultery, 1644

Oil on oak panel, 33 × 25¾ inches (83.8 × 65.4 cm)
The National Gallery, London, NG 45
Photograph © National Gallery, London / Art Resource, NY

CAT. 25

Like his earlier *Simeon's Song of Praise* of 1631 (Mauritshuis, The Hague), Rembrandt's London *Woman Taken in Adultery* presents meticulously rendered details, a style that led to the highly polished finish of later Leiden painting (*fijnschilderij*), in order to situate a large crowd within a towering, dark, and glittering Temple Court.[13] Portraying the story of the adulteress brought before Christ for judgment (John 8:2–11), the painting explores the subject's implicit ironic undertones to convey New Testament themes of grace, repentance, forgiveness, and redemption in relation to Mosaic law and Temple authority. The scribes and Pharisees remind Jesus that Mosaic law decrees death by stoning for a woman caught in the act of adultery, yet their real motivation is to trap Christ "that they might have something with which to accuse him" (8:6). Jesus responds by writing in the dirt and exhorting only the sinless among them to throw the first stone. Hearing this, they withdraw, abashed, "convicted by their own conscience" (8:9). With no one remaining to accuse her, Christ releases the woman and tells her to "sin no more" (8:10–11). In the pictorial tradition of this subject, Jesus is most often shown writing on the ground while the Pharisees flee the scene.[14] Rembrandt focuses instead upon the initial confrontation with the Temple officials, when they present both the adulteress and the law to Jesus in an attempt to trap him. Rembrandt described the emotions of the deceitful Pharisees in a note on a later drawing of the same subject now in the Staatliche Graphische Sammlung, Munich: "They were so anxious to make Jesus contradict himself that they could hardly wait for his answer."[15]

In his compositions of this theme, Rembrandt places two main groups of figures around the fulcrum of Christ and the adulteress. In doing so, he juxtaposes Temple justice, based on outward ceremonies and laws, with Christ's gift of grace, contrasting the duplicity, arrogance, and corruption of the Pharisees and priests with the wisdom, humility, and purity of Jesus. In a drawing from about 1655 (plate 3.7), likely the work of a pupil (perhaps Willem Drost [1633–1659]), Jesus stands in the center above a kneeling, penitent adulteress, while flanked on his right by apostles and on his less favorable left by her accusers. Another rendition of the same subject (plate 3.8), boldly drawn by Rembrandt with a reed pen, shows the climax of the story, where Jesus writes in the dust his admonition that those who are without sin should cast the first stone; in this case, his bowing is echoed by the attentive observers, who lean over to read what he writes, even as the adulteress stands upright and weeps.

Rembrandt's London painting explicitly relates the law of Moses to the grace of Christ by juxtaposing the foreground Gospel scene with the background Temple ceremonies led by the High Priest in the upper right. The priest in black lifts the veil of the accused woman to expose her sin to Jesus. This ritual accusation of the Old Testament (see Numbers 5:12–31) is juxtaposed with the new religion of grace to compare dispensations and to emphasize the role of Christ, bathed in light, as the new High Priest. Even the figure group around Jesus contrasts sharply with the Pharisees at right. The simple, drab, monochrome brown garments of the disciples and the white robes of the kneeling woman distinguish them from the onlookers standing directly below the Temple ritual, including a Pharisee in golden robes, a soldier in shiny armor, and a pair of older men on the right, whose rich dress connotes privilege and power in counterpoint to the humility of Christ.[16] The priest in black accuses the adulteress, in pure white. She wipes her tears with one end of her veil while the soldier firmly grips its other end, holding her captive.

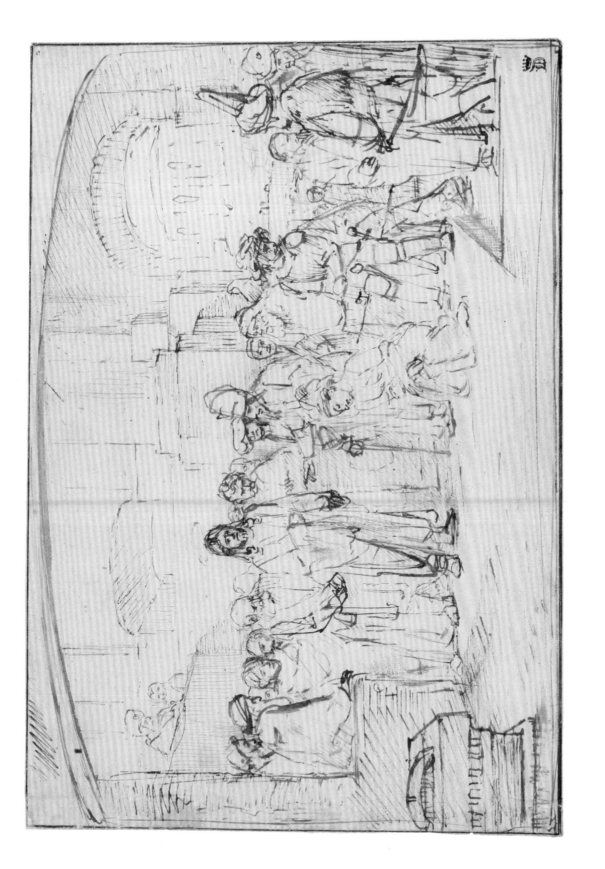

PLATE 3.7

Pupil of Rembrandt Harmensz. van Rijn,
possibly Willem Drost (Dutch, 1633–1659)

Christ and the Woman Taken in Adultery, c. 1655

Pen and brown ink on paper, white correction at bottom right; 7⅝ × 11⅛ inches (19.4 × 28.3 cm)
Museum Boijmans Van Beuningen, Rotterdam, R. 37

CAT. 61

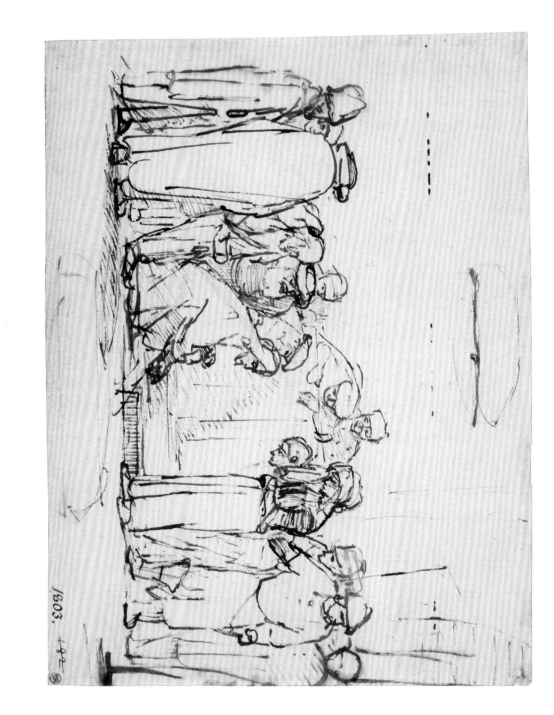

PLATE 3.8

Attributed to Rembrandt Harmensz. van Rijn

Christ and the Woman Taken in Adultery, c. 1650–55

Pen and brown ink on paper, 7⅜ × 9⅞ inches (18.9 × 25 cm)

Nationalmuseum, Stockholm, NMH 1998/1863

Photograph © Nationalmuseum, Stockholm

CAT. 49

The woman's true repentance is signified by her tears, which seventeenth-century theologians identified as a sign of real contrition.[17] Against the sincere penitence of the adulteress, her accuser self-righteously fails to recognize his own sins. Standing near the throne at the upper right, with his back toward the viewer, the *sagan* (second High Priest) holds a crosier in one hand, a censer in another in his role within the large Temple priesthood. Ironically, in the biblical narrative this moment occurs just before Christ indicts the priests and Pharisees by charging anyone without sin to cast the first stone, which causes them to leave.

While the atonement ritual in the upper part of the painting is dimly lit, Christ and the adulteress in the foreground are bathed in a pool of light that leaves the Pharisees, scribes, and Temple priests on its periphery. This light, unnatural and divine, suggests Christ's forgiveness and his declaration after the Pharisees depart: "I am the light of the world. He that follows me shall not walk in darkness but shall have the light of life" (John 8:12). Permeated with light, the adulteress, dressed in white, has been cleansed of sin by Jesus and will be saved (cf. Revelation 3:5: "He that overcometh shall be clothed with white garments: And I will in no wise blot out his name in the book of life").[18]

As viewed by John Calvin's followers, including Rembrandt's Reformed patrons, the adulteress in the painting has earned salvation not by performing works—that is, rituals or good deeds—but by the free election of Christ's mercy. Rembrandt's painting especially establishes this gift of unmerited grace as being superior to Temple rituals. Calvin said that faith and true repentance may only be achieved through God's grace: "A man cannot earnestly apply himself to repentance, unless he know himself to be of God: but no man is truly persuaded that he is of God, but he that hath first received his grace."[19] In Rembrandt's picture, the strong light falling on the adulteress invokes the power of divine grace and forgiveness.

Fierce religious polemics over the role of good works in salvation had proliferated since the dawn of the Reformation in the early sixteenth century and continued into Rembrandt's day. Ulrich Keller has plausibly associated Temple rituals in Rembrandt's painting with critique of the "idolatrous" ceremonies of Catholicism.[20] In 1644, the year of the painting, the consistory (governing body) of the Reformed Church in Amsterdam implored the burgomasters to rid the city of Catholic "spiritual whoredom which especially angers God."[21] Similar complaints were voiced in meetings of the Reformed Church in Gouda (1643), Haarlem (1644), and Amsterdam (1645).[22] The painting's negative reference to good works, however, may have been directed at contemporary Protestant dissenters from strict Calvinist doctrine in Holland: Remonstrants, Mennonites, Puritans, and Socinians, who stressed the saving power of righteous deeds and the love of God and were viewed by the Reformed as equally dangerous heretics. Any reference to Catholicism, in this case, would have implicated these other denominations, who were customarily likened to Roman Catholics by the Reformed Church. Rembrandt's painting celebrates God's mercy as a gift conferred to the repentant sinner, irrespective of good works.

CHRIST PREACHING

Rembrandt's fascination with the role of preaching in Christ's mission began in the mid-1640s and early 1650s with prints of Jesus enacting healing miracles and sermons. Chief among these are *The Hundred Guilder Print* (*Christ Preaching; Bring Thy Little Children unto Me*), completed about 1649 (see plate 1.2), and *Christ Preaching* ("*La Petite Tombe*") of about 1652 (plate 3.9). For these etchings,

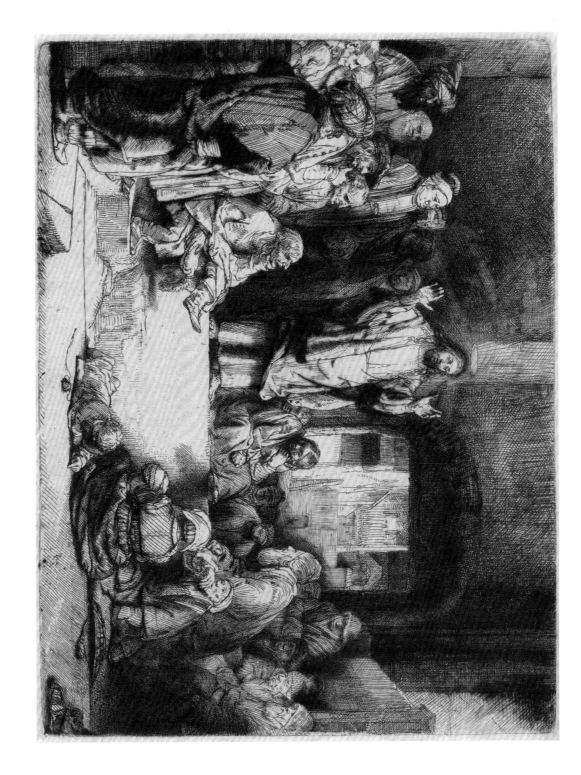

PLATE 3.9

Rembrandt Harmensz. van Rijn

Christ Preaching (*"La Petite Tombe"*), c. 1652

Etching, engraving, and drypoint on paper; plate 5⅞ × 8⅛ inches (15.4 × 20.7 cm); sheet 6¼ × 8⅜ inches (15.9 × 21.1 cm)
National Gallery of Art, Washington, DC, Gift of W. G. Russell Allen, 1955.6.5

CAT. 53A

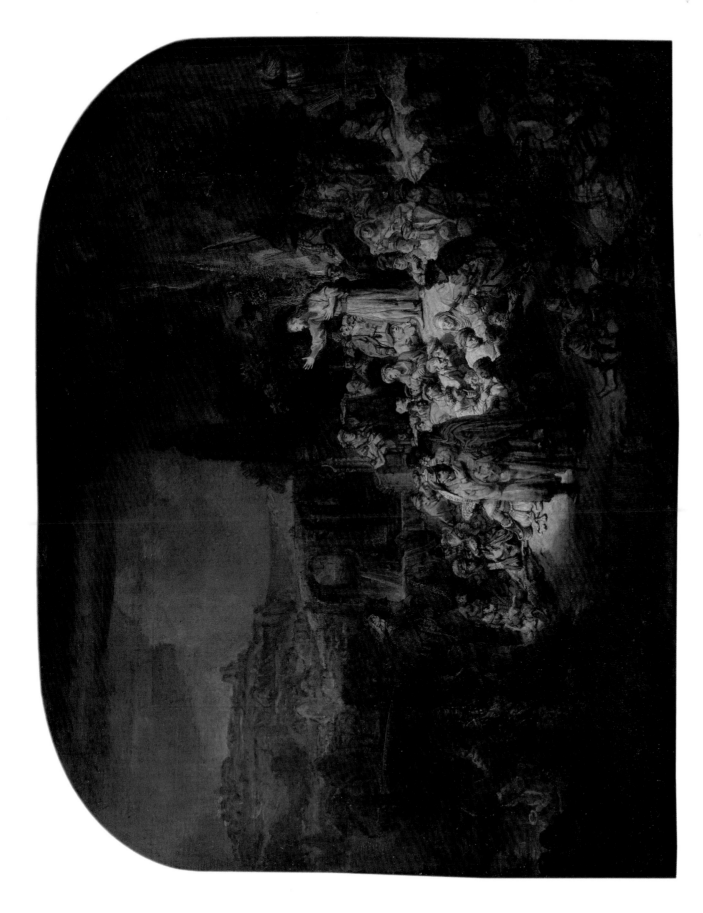

Rembrandt pursued a contrast previously explored in *Christ and the Woman Taken in Adultery*: dramatic confrontation between Christ's public mission and his unsympathetic opponents, distinguished by dress as Jewish.

Christ's audience in these two etchings, as in Rembrandt's grisaille of *John the Baptist Preaching* of about 1634 (fig. 3.4),[23] encompasses all ages and both sexes as well as a full range of character types, from rich to poor and, significantly, composed of different ethnicities. Some figures, dressed in turbans, suggest contemporary Jews. For the artist, Christ's sermons present the case to anyone who has ears to listen. In both *The Hundred Guilder Print* and *Christ Preaching*, the viewer takes his or her place among the varied listeners and, like the disciples at Emmaus, is given the option of recognizing both the person of Jesus and the message. But the possibility also remains that the onlooker could fail to hear or adhere to Christ's words.

Rembrandt's *Hundred Guilder Print* is unusual because it depicts multiple events from Matthew 19, where Christ preaches, disputes, and works miracles.[24] Most visual representations based

on this text focus solely upon Christ's blessing of the children, with crowds of youngsters and parents gathering about the redeemer.[25] Rembrandt's etched Jesus, however, closely related to the study heads in this exhibition (see plates 2.2–2.8), is distinguished from the crowd through his central placement, his greater height, and the aura of radiant light that emerges against the darkness behind him.[26] At the right are the abject poor—sick, frail, elderly, and lame—who beseech Jesus to heal them (Matthew 19:2). Rembrandt's preparatory sketch for these figures (plate 3.10) demonstrates his effort to convey the depths of their suffering. The woman's prayerful gesture imprinted in silhouette on Christ's robe in the etching underscores the desperation of the needy, as well as Christ's compassion.[27] On the left, a group of Pharisees—depicted in a study drawing (plate 3.11)—turn away from Jesus and engage in their own disputations, where they "tempt" Christ and try to trick him on the issue of divorce (19:3–12).

Before Christ, a pair of mothers advance with their infants against the restraint of Saint Peter, closest to Jesus, a scene that results in the declaration, "Let the little children alone, and hinder them not to come to me" (Matthew 19:13–15). Between the mothers sits a wealthy, young man, lost in thought—surely a reference to Christ's admonition that it is easier for a camel (shown at right under the gateway) to pass through the eye of a needle than for a rich man to enter heaven (19:16–24).[28] Another rich man, shown from the back conversing with some Pharisees, is a character type, an imperious onlooker who appears in many of Rembrandt's New Testament subjects, such as *Christ and the Woman Taken in Adultery*.

Rembrandt's virtuoso control of rich, dark shadows and lighting highlights, including Christ's halo shining forth, helps the viewer distinguish the character types and their significance. Notably, the Pharisaic figures at the left edge are differently rendered, reduced to a mere outline in comparison to the fully modeled followers of Jesus as they engage in debate with Christ over the legality of divorce.[29] The Pharisees challenge Christ by asking if it is lawful for a man to forsake his wife for "all manner of causes." Jesus explains that Moses granted leniency concerning divorce because of the "hardness of your hearts" (19:8), but "whoso forsakes his wife, otherwise than for fornication, and marries another, commits adultery" (19:9). Obviously, this declaration also relates to discussions of law prompted by the adulterous woman in that narrative.

As in the grisaille of *John the Baptist*, Rembrandt deliberately contrasts the Gospel message with Mosaic law, just as Jesus does in Matthew 23, when he castigates his opponents as "hypocrites," "blind guides" who do not even follow their own precepts (23:24). Attesting to the hypocrisy of the disputants, a bearded man in a large hat arrogantly leans on the table and proudly displays the phylacteries wound about his hand, according to the Sadducean[30] custom (Pharisees tied them above the elbow).[31] This Sadducee has followed the letter of the law in an open display of piety, which recalls Christ's critical words in Matthew 23:5–6: "And all their works they do to be seen by men. They make their phylacteries broad and enlarge the borders of their garments. They love the best places at feasts, the best seats in the synagogues." In this context, this ritual object worn by the Sadducee, a reminder of a Jew's duty to love God and obey the law, evinces only an outward show of false devotion. Other figures in the print also signify spiritual blindness, such as the elderly, bearded Jewish man standing before the table with his hat over his eyes. In contrast, the African woman at right, whose eyes are also covered by a cap, nevertheless joins the throng beseeching Christ. She suggests the converted African natives whom Rembrandt invoked throughout his

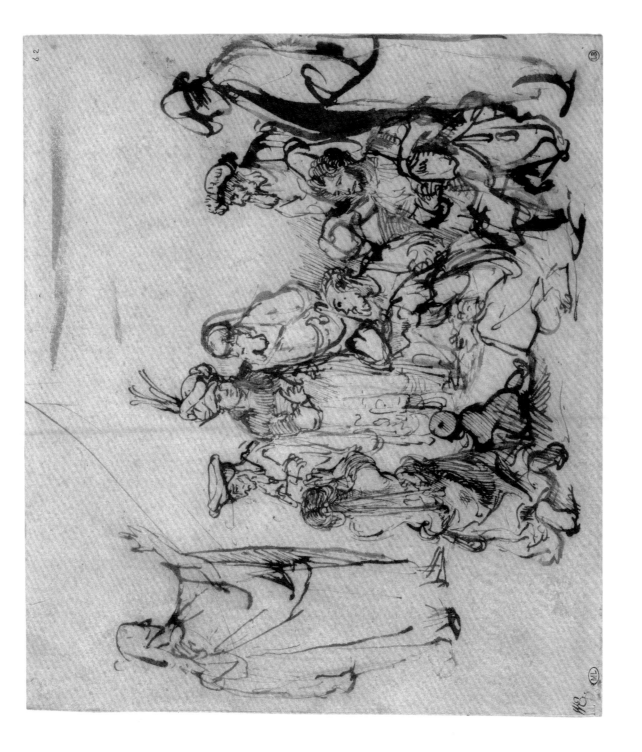

PLATE 3.10

Rembrandt Harmensz. van Rijn

Christ Preaching, c. 1643

Pen and brown ink on paper, 7⅞ × 9⅟₁₆ inches (19.8 × 23 cm)
Musée du Louvre, Paris, L. Bonnat Bequest 1919, RF 4717
Photograph © Réunion des Musées Nationaux / Art Resource, NY

CAT. 24

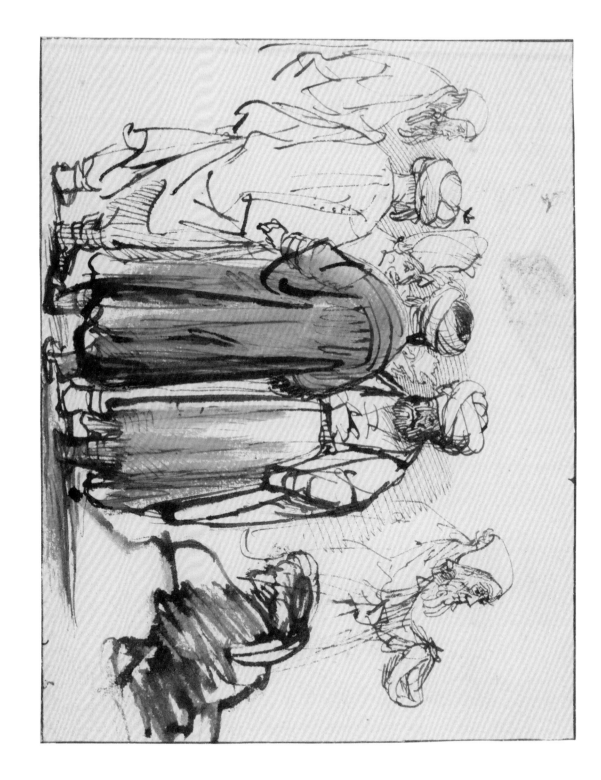

PLATE 3.11

Rembrandt Harmensz. van Rijn

Men in Oriental Apparel and Two Half-Length Studies of a Beggar, c. 1641–42

Pen, brush, brown ink, and wash on paper; 5⅝ × 7⅜ inches (14.3 × 18.6 cm)

The Print Room, University of Warsaw Library, inv. zb.d.485

Photograph © University of Warsaw Library

CAT. 22

career in paintings such as *Baptism of the Eunuch* of 1626 (Catherine Convent, Utrecht) and *John the Baptist Preaching* (see fig. 3.4), and in the 1652 etching *Christ Disputing with the Doctors*.[32]

In opposition to the hostile Pharisees and Sadducees stand the mothers with children, to whom Christ gives his blessing. Not only does the trusting faithfulness of children exemplify the condition that Christ seeks ("for such is the kingdom of heaven"; Matthew 19:14), but it also provides a biblical basis for arguing either for or against infant baptism, especially since the Bible is silent on this issue. Members of the Reformed Church employed this passage "as a shield against the Anabaptists," who forbade infant baptism.[33] Calvin argued that this "laying on of hands" was not an empty sign, since through the gesture infants and children "were renewed by the Spirit to the hope of salvation."[34] On the other hand, Mennonites used the same passage to justify *not* baptizing children.[35]

Rembrandt's subsequent etching *Christ Preaching* (see plate 3.9) suggests Matthew 18:1–14, where the humility of children serves as a model for conversion. Jesus, marked by a halo, again occupies the topmost central position. His hands are raised in a traditional priestly gesture of gentle blessing, already used by Rembrandt in *Simeon and Hannah in the Temple* of 1628 (Kunsthalle, Hamburg) and the *Ascension* of 1636 (Alte Pinakothek, Munich). Significantly, this gesture was also employed by Calvinist ministers to bless congregants.[36]

The group on the right includes a seated youth listening intently at Christ's feet, a seated woman holding a baby, and several wizened and seemingly poor men. Notably set apart, a distracted young boy in the foreground reclines beside a toy top and draws aimlessly in the dust with his finger—too young to understand the sermon, but still the very object of Jesus's benevolent gaze. The idea that children are incapable of comprehending spiritual matters was also conveyed by Rembrandt in two earlier etchings of the Presentation in the Temple: in the 1630 version,[37] a little girl is distracted by a walking lame man; in the 1629 print,[38] another girl watches a dog scratch himself in the foreground. Again, the implication is that such innocents will nonetheless inherit heaven.

Rembrandt's images of Christ teaching in the presence of children may also reflect the great emphasis that contemporary Protestant reformers placed on incorporating children into their religious communities.[39] The boy playing in the dirt at Jesus's feet in *Christ Preaching* especially suggests this concern. Unlike this child, many of the adults in Rembrandt's print listen raptly to Christ's sermon—especially the group of men at the left, which includes a seated, contemplative figure who has respectfully removed his cap in recognition of the redeemer.[40] Several of these men wear turbans of various kinds and one sports a distinctive Ashkenazi *streimmel* (soft fur hat) with caftan. As noted above, Ashkenazim came to Amsterdam around this time under great privation from persecution in Poland and central Europe; they were also the object of intense proselytizing on the part of Dutch Protestants. Compared to either the *John the Baptist* grisaille or *The Hundred Guilder Print*, this etching of *Christ Preaching* seems to encompass a diverse but potentially cohesive Christian community in formation.

THE RAISING OF LAZARUS

The major shift in Rembrandt's treatment of religious narratives—from early works that focus on dramatic action to his mature, contemplative scenes—is also on display in his depictions of the Raising of Lazarus (John 11:1–44). In two early works—a large, vertical painting of about 1630

(fig. 3.5) and an etching of about 1632 (plate 3.12), both produced in rivalry with his colleague Jan Lievens (1607–1674) in Leiden—Rembrandt visualizes this resurrection as a sudden movement, a corpse arising from its tomb in response to the uplifted hand of Jesus.[4] Rembrandt's painting emphasizes the standing Jesus, whose brightly illuminated arm and rigidly extended fingers invoke the divine power of the miracle. Beneath his arm huddle the disciples, whose surprise and fear are rendered in melodramatic gestures. Eyes wide open, they crane their necks to observe the pale, shrouded Lazarus, who rises from his open tomb in the lower right. As in the later images of Jesus

Fig. 3.5. Rembrandt Harmensz. van Rijn, *The Raising of Lazarus*, c. 1630. Oil on panel, 37⅞ × 32 inches (96.4 × 81.3 cm). Los Angeles County Museum of Art, M.72.67.2. Digital image © Museum Associates / LACMA / Art Resource, NY

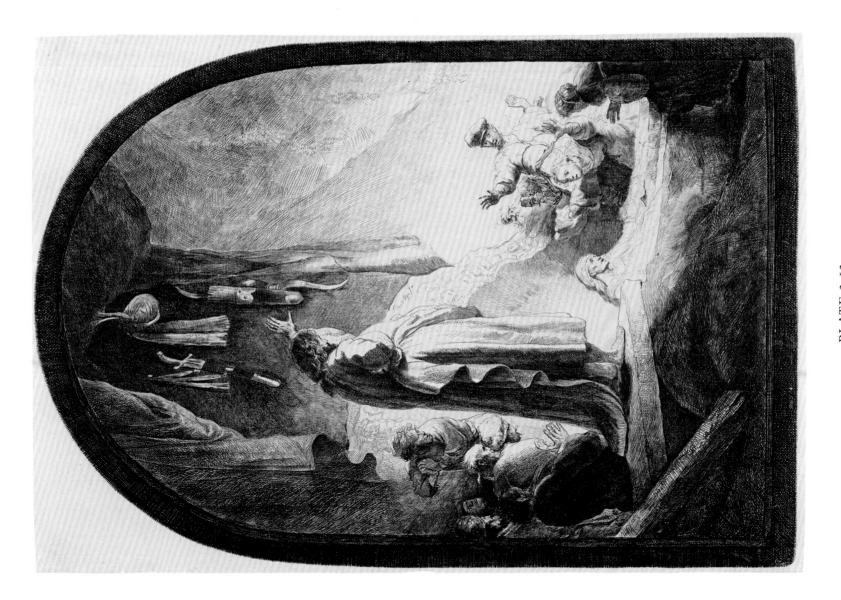

PLATE 3.12

Rembrandt Harmensz. van Rijn

The Raising of Lazarus: The Larger Plate, c. 1632

Engraving and etching on paper; plate 14½ × 10⅟₁₆ inches (36.8 × 25.5 cm); sheet 14⅝ × 10⅟₁₆ inches (37.2 × 25.9 cm)
The Metropolitan Museum of Art, New York, Gift of Henry Walters, 1917 (17.37.195)
Photograph © The Metropolitan Museum of Art / Art Resource, NY

CAT. 11A

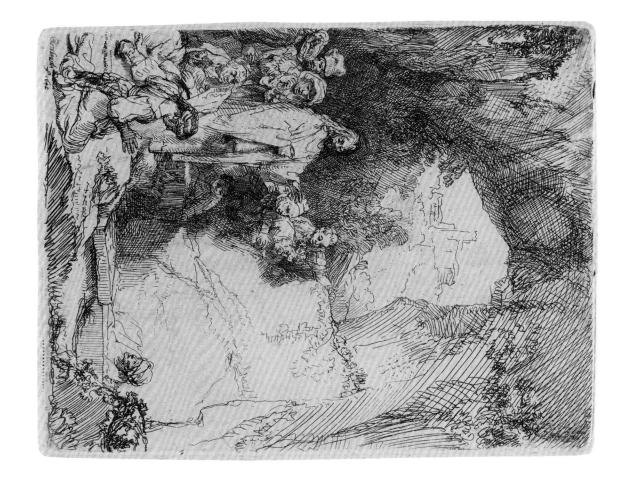

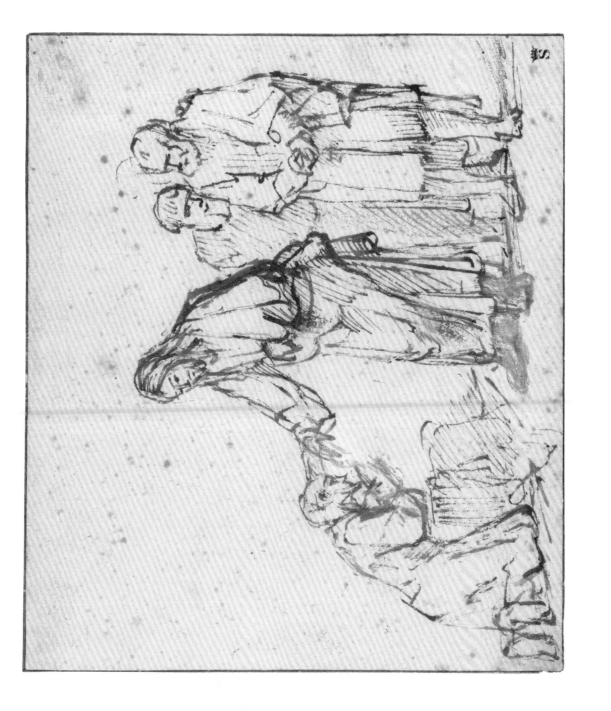

PLATE 3.14

Rembrandt Harmensz. van Rijn

Christ Healing a Leper, c. 1650–55

Reed pen, brown ink, and wash with white gouache on paper; 5¾₆ × 6⅞₆ inches (14.7 × 17.7 cm)
Rijksmuseum, Amsterdam, gift of M. C. Hofstede de Groot, RP-T-1930-24

CAT. 48

preaching, this dense group of diverse figures features young women—Lazarus's sisters, Mary and Martha—as well as bearded elders.

Rembrandt's large etching of about 1632 is even more dramatic. Christ stands in the center of the tall, rounded arch composition, his commanding gaze again directed toward Lazarus. (The orientation in the etching is reversed to show Jesus gesturing with his left hand instead of his favorable right.) Seen at an angle from behind, his profile almost lost to view, Christ's figure is divided vertically between deep black shadows behind and brilliant light in front. The bright figure of the rising Lazarus below is succeeded by a dense, sharply modeled cluster of disciples, who recoil with outstretched arms in surprise and horror. The two women reappear here, Mary in the group on the right, Martha in dark silhouette at the lower right corner. Behind the towering figure of Jesus a group of scruffy disciples also reacts theatrically under a shadowy cover of darkness, only partially lit by the mouth of the cave.

Rembrandt's etching *The Raising of Lazarus: Small Plate* of 1642 (plate 3.13) renders the resurrection more as a quiet healing act than as a turning-point miracle, giving this work a kinship with his *Hundred Guilder Print* and two later drawings of Christ Healing a Leper (plate 3.14; fig. 3.6).[4] The staging of the event moves diagonally from Jesus in the upper left to the head of Lazarus emerging from the coffin in the lower right, with a large gap between them. The arched cave setting towering over all the figures, however, unites them in a generally even light. The Jerusalem Temple Mount appears in the distance through the cave opening. By associating the miracle performed by Christ with the Jerusalem Temple, Rembrandt suggests Christ's role as the High Priest "after the order of Melchizedek" (Hebrews 7:11–25). In this passage, Paul praises Christ, who, unlike the Temple priests, remains "able perfectly to save those who come to God through him, since he always lives to make intercession for them" (7:25).

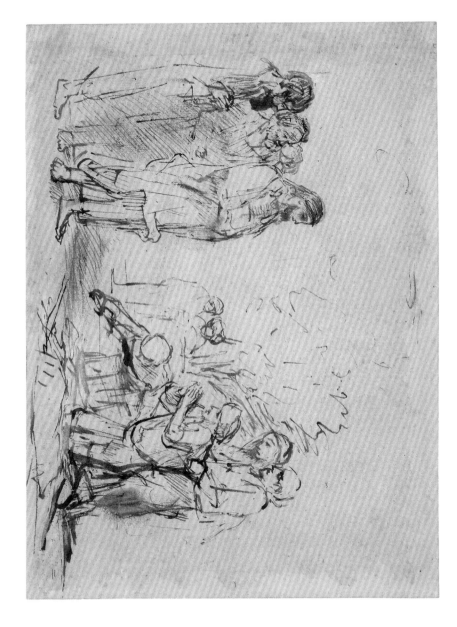

Fig. 3.6. Rembrandt Harmensz. van Rijn, *Christ Healing a Leper*, 1656–57. Pen and brown ink on paper, corrected with white body color. 7⁄16 × 9⁄16 inches (18 × 24.7 cm). Staatliche Museen zu Berlin, Kupferstich-kabinett, inv. KdZ 5247. Photograph © Bildarchiv Preussischer Kulturbesitz / Art Resource, NY

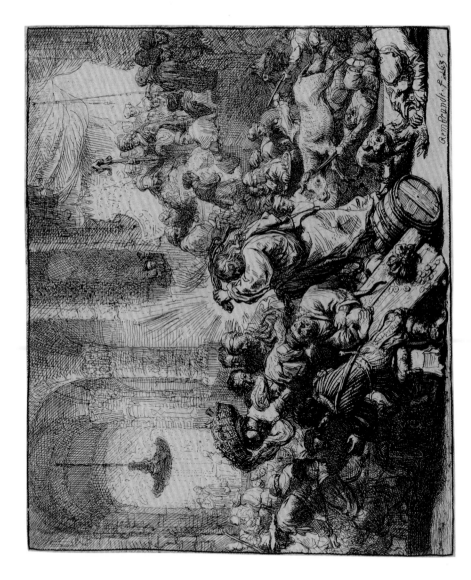

Fig. 3.7. Rembrandt Harmensz. van Rijn, *Christ Driving the Money Changers from the Temple*, 1635. Etching on paper, 5⅞ × 6⅞ inches (13.8 × 17 cm). British Museum, London. Bequeathed by Clayton Mordaunt Cracherode, 1973, U.863. Photograph © Trustees of the British Museum

The witnesses to the miracle in Rembrandt's *Raising of Lazarus* etching surround and frame Jesus like the petitioners in *The Hundred Guilder Print*, but their gazes direct the viewer to the lone, dazed figure of Lazarus rising from the grave rather than to Jesus, who stands well left of center. Christ's somber demeanor and quiet gesture suggest speech more than action. The biblical text explains that Jesus was deeply troubled by Mary and Martha's initial lack of faith and was reluctant to perform the miracle (John 11:41–42). Calvin's commentary on the Lazarus narrative offers an explanation for Jesus's reticence in the etching: "Christ's divine power is better shown by the fact that he did not touch with the hand but only cried with his voice. . . . He commends to us the secret and wonderful efficacy of his Word."[43]

The spectators in the print, however, are awed by the sight of the miracle, rather than by the words. A seated figure in the lower left corner scratches his chin in puzzlement, like the contemplative rich young man in *The Hundred Guilder Print*. The other witnesses, dressed in widely diverse costumes, dating from the biblical Roman period to the contemporary—including a figure in a tall Ashkenazi cap—stare before them in quiet amazement, subdued rather than theatrical in expressing their reactions. Here heartfelt faith predominates ("He who believes in me, though he may die, he shall live"; John 11:25).

Not all the figures in the etching are convinced by the miracle of Lazarus. The man in the tall, eastern European hat is clearly distressed. According to the Gospel, this miracle precipitated momentous changes. It successfully attracted converts from "many of the Jews . . . who had seen the things Jesus did" (John 11:45), but it also provoked a hostile response from Caiaphas, the High Priest, and the Pharisees, who initiated the events that would culminate in Christ's death. The Gospel relates, "But some of them went away to the Pharisees and told them the things Jesus did. . . Then, from

that day on, they plotted to put him to death" (11:46, 53). Their fear, the Gospel claims, lay precisely in Jesus's power to proselytize and win converts, including the Gentiles: "not only for that people, but that he also should gather together into one the children of God who were scattered abroad" (11:52).

Another event that led the chief priests and scribes to conspire against Jesus was his cleansing the Temple of money changers and merchants (Matthew 21:12–17; Mark 11:15–19; Luke 19:45–48; John 2:13–25). In Rembrandt's 1635 etching of this subject (fig. 3.7), Christ's violent purging of the Temple takes place, unconventionally, near a gathering of priests and Pharisees who plot his death when Jesus tells them he will destroy the Temple and build it up in three days. Thus, Rembrandt consistently emphasizes both the positive and negative reactions of varied witnesses to acts performed by the Christian redeemer.

"THEN FACE TO FACE"

In the early 1660s, like many of his contemporaries, Rembrandt radically altered the focus of his religious imagery, turning away from the physical, external notion of the Temple and its successor, the Christian church as an institution, to concentrate on an internalized "church" in the heart of the pious worshiper. Many of the religious works produced in his final decade focus on single figures, represented in close-up, half-length, portrait-like conventions as contemplative or even spiritually conflicted individuals. They model for the viewer a new encounter with the divine—at once intimate, internal, and transformative.

Rembrandt produced several smaller late paintings that offer moving and direct images of the adult Christ. These extend his previous portrait-like heads (tronies) of a deeply human Jesus, as well as his etchings of the 1640s and his Louvre Emmaus, as seen above. The Risen Christ of 1661 (see plate 4.2) accords with other solo images of holy figures made during the same period.[4] Unlike the oblique study heads of Jesus, this frontal half-length figure directly confronts the viewer, his nude torso loosely adorned by a white cloak. This traditional image shows the resurrected Christ, combining his suffering in the Passion (through the suggestion of the side wound, but without a crown of thorns as in images of the Man of Sorrows) with his regal dignity. The painting's overall effect, however, conveys a human vulnerability and physical fleshliness, highlighted by the strong illumination. Similar figures, originating in biblical narratives situated between the Resurrection and the Last Judgment, appear in woodcuts by Albrecht Dürer (e.g., the Small Woodcut Passion, issued 1511) and engravings by Lucas van Leyden (1494–1533), suggesting that Rembrandt's late images of Christ retained some aspects of traditional religious imagery, surely well known to the artist and possibly in his personal collection of prints.

Rembrandt may have had a verbal source for both the features and the gaze of his Risen Christ. In his 1678 treatise on painting, Samuel van Hoogstraten (1627–1678)—Rembrandt's pupil in the mid-1640s, when the bust of Christ prototype originated—quoted a celebrated (albeit forged) letter, allegedly written by Publius Lentulus during Christ's own lifetime, which describes Christ's features, and which Rembrandt likely consulted for his earlier study heads of Jesus. Rembrandt's Risen Christ may also have been based upon a contemporary Jewish model (see DeWitt, this volume). In either case, this portrait-like depiction reasserts Jesus's earthly ancestry. It also places the viewer in the same position as the apostles after the Resurrection, either to affirm faith or to give way to doubt or skepticism, as Thomas did (see the late etching Christ Appearing to the Apostles; plate 3.15).

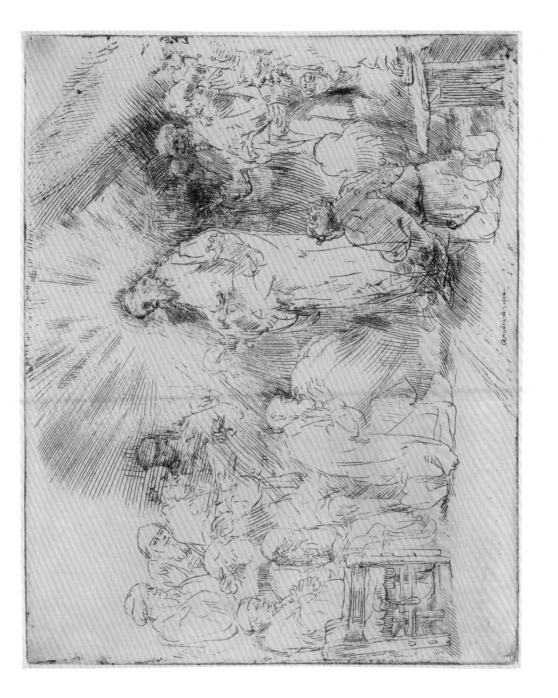

PLATE 3.15

Rembrandt Harmensz. van Rijn

Christ Appearing to the Apostles, 1656

Etching on paper; plate 6⁷⁄₁₆ × 8³⁄₁₆ inches (16.4 × 20.8 cm); sheet 6⅝ × 8⅜ inches (16.8 × 21.2 cm)
The Metropolitan Museum of Art, New York, Gift of Felix M. Warburg and his family, 1941 (41.1.43)
Photograph © The Metropolitan Museum of Art / Art Resource, NY

CAT. 65A

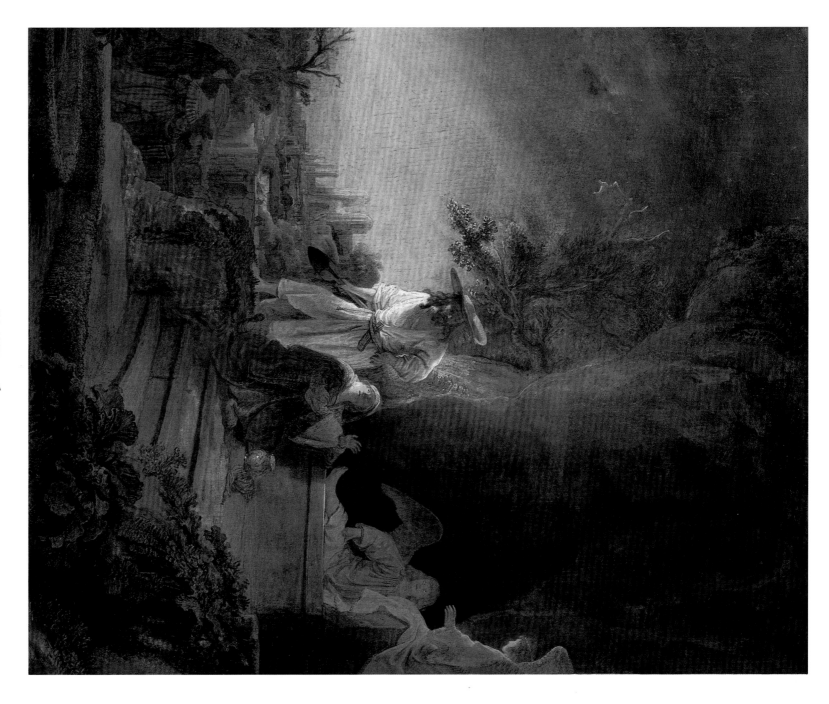

PLATE 3.16

Rembrandt Harmensz. van Rijn

Christ as Gardener Appearing to the Magdalene, 1638

Oil on panel, 24 × 19½ inches (61 × 49.5 cm)
Her Majesty Queen Elizabeth II, The Royal Collection, London, RCIN 404816
Photograph © 2011 Her Majesty Queen Elizabeth II

CAT. 18

All of these responses are elicited by the compassionate, steady gaze of Jesus himself[45]—a look that suggests unmediated assertion, and affirmation, of the Resurrection. The risen Christ here confronts the viewer, just as he manifested himself to the pilgrims at Emmaus, as well as the doubting Thomas (see plate 4.5) and Mary Magdalene (see plate 3.16) in earlier paintings by Rembrandt.[46]

At just this period, the famous poet Jeremias de Decker, Rembrandt's former associate, wrote verses in response to the artist's *Risen Christ Appearing to Mary Magdalene at the Tomb*— presumably the 1638 painting of the Noli Me Tangere (John 20:14–17) now in the Royal Collection, London (plate 3.16). These lines, reflecting on Mary Magdalene's encounter with the risen Christ, celebrate the importance of envisioning Jesus within the mind and heart: "Believing, though not yet with all her heart and mind, she / Seems poised between her joy and grief, her hope and fear."[47] These sentiments were echoed by Calvinists such as Richard Sibbes (1577–1635), who believed that implanting the features of Christ within one's heart was a spiritual goal, in adherence to the doctrine that "in the Gospel we behold, by the Holy Spirit, the glory of God in the face of Christ and are thereby changed into his image."[48]

The evolution of Rembrandt's career-long engagement with the figure of Jesus increasingly exemplifies this spiritual goal, as his approach steadily evolved from early representations of dramatic biblical events, especially miracles, told through emphatic gestures under stark lighting with deep shadows, to a more intimate and personal depiction of Christ. By the time of his several mid-career narratives of the Supper at Emmaus and Christ Preaching, Rembrandt had moved toward a quieter process of communication, with a portrait-like human Jesus—based on carefully studied *tronies*—preaching before a diverse congregation that sits in rapt attention, except for a defiant cluster of resistant Jews. In his final decade of work, the artist concentrated fully and exclusively on Christ, particularly the risen Christ, as the redeemer who suffered for humanity yet retained his merciful compassion. Ultimately, the personal and private interaction between the artist and his savior crystallized into a direct and personal relationship, as if in echo of the words of Paul (for whose visage Rembrandt painted his own features, in the *Self-Portrait as the Apostle Paul*, 1661; Rijksmuseum, Amsterdam): "For we know in part and we prophesy in part. But when that which is perfect has come, then that which is in part will be done away. . . . For now we see in a mirror, dimly, but then face to face" (1 Corinthians 13:10, 12).

1. Biblical quotations in this text are based on Theodore Haak's English translation of the *Statenbijbel*, published in 1657 as *The Dutch Annotations upon the Whole Bible, or, All the Holy Canonical Scriptures of the Old and New Testament . . .* (London: Printed by Henry Hill, for John Rothwell, Joshua Kirton, and Richard Tomlins), though some translations have been modified to eliminate archaisms.

2. Wolfgang Stechow, "Rembrandts Darstellungen des Emmausmahles," *Zeitschrift für Kunstgeschichte*, vol. 3 (1934), pp. 329–41. See also Stechow, "Emmaus," in *Reallexikon zur deutschen Kunstgeschichte*, vol. 5, ed. Karl-August Wirth (Stuttgart: Alfred Druckenmüller, 1967), cols. 228–42; J. Q. van Regteren Altena, "Rembrandt's Way to Emmaus," *Kunstmuseets Årsskrift*, vols. 35–36 (1948–49), pp. 1–26.

3. For the Mary and Martha story, a favorite subject in sixteenth-century Antwerp painting, see Kenneth Craig, "*Pars ergo Marthae Transit*: Pieter Aertsen's 'Inverted' Paintings of Christ in the House of Martha and Mary," *Oud Holland*, vol. 97 (1983), pp. 25–39.

4. See Honthorst's *Denial of St. Peter* (1620–25; Minneapolis Institute of Arts), in Joaneath Spicer and Lynn Federle Orr, *Masters of Light: Dutch Painters in Utrecht during the Golden Age*, exh. cat. (Baltimore: Walters Art Gallery; San Francisco: Fine Arts Museums of San Francisco, 1997), pp. 164–67, no. 12; see Albert Blankert and Leonard J. Slatkes, *Holländische Malerei in neuem Licht: Hendrick ter Brugghen und seine Zeitgenossen*, exh. cat. (Braunschweig: Herzog Anton Ulrich-Museum, 1986), pp. 276–302. This subject was depicted twice by Caravaggio himself; see Silvia Cassani et al., *Caravaggio:*

The Final Tears, exh. cat. (London: National Gallery, 2005), pp. 98–103, nos. 1, 2.

5. Gary Schwartz, Rembrandt: His Life, His Paintings (New York: Viking, 1985), p. 51, fig 33.

6. Noted, without elaboration, in Christian Tümpel, Rembrandt: All Paintings in Colour (Antwerp: Fonds Mercator, 1993), pp. 248–49.

7. Dutch Annotations upon the Whole Bible, note to Luke 24:30.

8. Hugo Grotius, His Discourses, I. Of God and Providence. II. Of Christ, His Miracles and Doctrine (London: James Flesher, 1652), pp. 43–49.

9. Wolfgang Kemp, Rembrandt, die Heilige Familie, oder, Die Kunst, einen Vorhang zu lüften (Frankfurt: Fischer Taschenbuch, 1986), esp. pp. 55–67, fig. 12, for the Copenhagen picture; see also fig. 29 for a Crispijn de Passe (1564–1637) engraving after Herman van Vollenhoven (fl. 1611–1627) of another Emmaus scene with curtain. For a fifteenth-century precedent, see Hugo van der Goes (c. 1440–1482), Adoration of the Shepherds (c. 1480; Gemäldegalerie, Berlin), in ibid., fig. 24; and Barbara Lane, "'Ecce Panis Angelorum': The Manger as Altar in Hugo's Berlin Nativity," Art Bulletin, vol. 57, no. 4 (1975), pp. 476–86. A similar curtain appears in Raphael's Sistine Madonna (1512–14; Gemäldegalerie Alte Meister, Dresden); see Johann Eberlein, "The Curtain in Raphael's Sistine Madonna," Art Bulletin, vol. 65, no. 1 (March 1983), pp. 61–77, who associates the curtain with the revelation of Christ's Incarnation while citing a long lineage of medieval precedents.

10. Clifford S. Ackley et al., Rembrandt's Journey: Painter, Draftsman, Etcher, exh. cat. (Boston: MFA Publications, 2003), pp. 67–79, 238–39, nos. 6, 159.

11. The Quaker Samuel Fisher (1605–1665) wrote the following about the Paschal lamb: "The Pascal lamb without blemish, a bone of which was not to be broken, did not only signifie, but lively resemble also Agnum immaculatum exhibitum, that lamb Christ Jesus, which was once to be offered without spot to God, and not a bone of him to be broken, also the supper that came after it doth not onely signifie, but resemble also Agnum exhibitum, Christ crucified, that immaculate lamb now offered, whose body was broken and blood shed, by bread broken and wine powred forth." Samuel Fisher, Baby-baptism meer babism, or, An answer to nobody in five words to every-body who finds himself concern'd in't by Samuel Fisher (London: Henry Hills, 1653).

12. Pharisees were members of a Jewish sect known for its strict observance of Mosaic law.

13. This work is listed in the 1657 estate of the art dealer Johannes de Renialme with an appraised value of 1,500 guilders, the highest valuation for a single history painting by Rembrandt. Schwartz suggests that Renialme and the artist may have intended to have Woman Taken in Adultery copied for profit. See Schwartz, Rembrandt, p. 228.

14. See, for example, the following prints: Pieter Perret, after Pieter Bruegel the Elder, Christ and the Adulteress of 1565 (René van Bastelaer, Les estampes de Peter Bruegel l'ancien [Brussels: G. van Oest et Cie, 1908], no. 111); Philips Galle, after Antonius Blocklandt, Christ and the Woman Taken in Adultery, from the series Christ and Women from the Gospels

(Adam Bartsch et al., The Illustrated Bartsch [New York: Abaris Books, 1978–], 5601.0335); Georg Pencz, Christ and the Adulterous Woman (Adam Bartsch, Le Peintre graveur [Vienna: J. V. Degen, 1803–21], vol. 8, p. 338, no. 55); Daniel Hopfer (Bartsch, Le Peintre graveur, vol. 8, p. 474, no. 7); and Master BR with the Anchor (Bartsch et al., Illustrated Bartsch, 0919.003).

15. Otto Benesch and Eva Benesch, The Drawings of Rembrandt: A Critical and Chronological Catalogue, 6 vols. (London: Phaidon, 1973), no. 1047; cited in Tümpel, Rembrandt, p. 237.

16. Ulrich Keller notes the contrasts in color between the apostles and the Pharisees. See Ulrich Keller, "Knechtschaft und Freiheit: Ein neutestamentliches Thema bei Rembrandt," Jahrbuch der Hamburger Kunstsammlungen, vol. 24 (1979), p. 82.

17. See, for example, William Est, The Triall of True Teares: Or the summons to repentance whereby the secure sinner is taught how to escape the terrible sentence of the supreme iudge (London: Thomas Creede, 1613). Thomas Watson (d. 1686) wrote: "There's no rowing but upon the stream of repenting tears." Watson, The Doctrine of Repentance, Useful for these Times (London: Thomas Parkhurst, 1668?), p. 82.

18. According to Jewish tradition (Daniel 12:1), the book of life records the names of those who will be saved.

19. John Calvin, Institutes of the Christian Religion, trans. Henry Beveridge (Edinburgh: Calvin Translation Society, 1845–46), 3.3.1, 2.

20. Keller, "Knechtschaft und Freiheit," p. 83.

21. The members of the consistory invoked biblical history, claiming that when the Israelites conquered land, God commanded them to destroy idols. See Christine Kooi, "A Serpent in the Bosom of Our Dear Fatherland: Reformed Reaction to the Holland Mission in the Seventeenth Century," in The Low Countries as a Crossroads of Religious Beliefs, ed. Arie-Jan Gelderblom, Jan L. De Jong, and Marc Van Vaeck (Leiden: Brill, 2004), p. 169 n. 12.

22. Ibid., pp. 170–73.

23. Christopher Brown, Jan Kelch, and Pieter van Thiel, eds., Rembrandt: The Master and His Workshop, vol. 1, Paintings (New Haven: Yale University Press; London: National Gallery Publications, 1991), pp. 178–80, no. 20.

24. Christian Tümpel and Astrid Tümpel, Rembrandt: Mythos und Methode (Königstein: Langewiesche, 1986), pp. 255–61; Ackley, Rembrandt's Journey, pp. 204–8, no. 135.

25. See works illustrated in William H. Halewood, Six Subjects of Reformation Art: A Preface to Rembrandt (Toronto: Toronto University Press, 1982), including paintings by Nicolaes Maes (fig. 38), Hieronymus Francken the Elder (fig. 41), Werner van den Valckert (fig. 42), Vincent Sellaer (fig. 43), Cornelis Cornelisz. van Haarlem (fig. 44), and Adam van Noort (fig. 45). The theme of Christ Blessing the Children enjoyed considerable popularity as an image of childlike faith for sixteenth-century Lutherans and was repeatedly painted by the Lucas Cranach workshop in Wittenberg. See Bodo Brinkmann, ed., Cranach, exh. cat. (London: Royal Academy of Arts, 2007), pp. 214–15, no. 50; see also ibid., pp. 212–13, no. 49, for the Woman Taken in Adultery as a Cranach theme.

26. For a full discussion of the drawings and changes Rembrandt made, see Christopher White, *Rembrandt as an Etcher: A Study of the Artist at Work*, 2d ed. (New Haven: Yale University Press, 1999), pp. 54–64. One of the earliest preparatory drawings for the print, now in the Louvre, emphasizes the diverse and exotic costumes as well as class differences in the etching, in reversed presentation for orientation on the plate. Clearly Rembrandt was thinking about such distinctions from his earliest planning of *The Hundred Guilder Print*. See Martin Royalton-Kisch, "The Role of Drawings in Rembrandt's Printmaking," in *Rembrandt the Printmaker*, ed. Erik Hinterding, Ger Luijten, and Martin Royalton-Kisch, exh. cat. (London: British Museum; Amsterdam: Rijksmuseum, 2000), pp. 76–78 n. 15 (discussing controversies about its attribution), and p. 257, no. 61.

27. See discussion of the drawings in White, *Rembrandt as an Etcher*, pp. 57–62.

28. This figure may have been a later addition; see ibid., p. 63.

29. The Italian critic Filippo Baldinucci in 1686 noted the broad areas of light and shadow in this work. See Seymour Slive, *Rembrandt and His Critics, 1630–1730* (The Hague: M. Nijhoff, 1953), pp. 105–6.

30. The Sadducees were a priestly group associated with the leadership of the Temple in Jerusalem.

31. Thomas Godwyn reported that phylacteries were worn on the left hand, and that the Sadducees wound them about the hand while the Pharisees tied them above the elbow and close to the heart. Thomas Godwyn, *Moses and Aaron and Ecclesiastical Rites* (London: Green Dragon and Crown, 1655), p. 42.

32. Adam Bartsch, *Catalogue raisonné de toutes les estampes qui forment l'oeuvre de Rembrandt et ceux de ses principaux imitateurs* (Vienna: A. Blumauer, 1797), no. 65.

33. John Calvin, *Commentary on a Harmony of the Evangelists*, trans. William Pringle (Edinburgh: Calvin Translation Society, 1845), p. 390 (on Matthew 19:14). This is echoed by Francis Johnson, pastor of the English church in Amsterdam, who argued "that by Christ's owne testimonie and practice here, little children are partakers of his spiritual graces, and of the outward signes and declarations thereof. Of his spiritual graces, as namely, of his blessing, and the kingdome of heaven." Francis Johnson, *A Christian Plea; conteyning three treatises* (Leiden: William Brewster, 1617), p. 22.

34. Calvin, *Commentary on a Harmony*, p. 391 (on Matthew 19:14).

35. William Echard Keeney, *The Development of Dutch Anabaptist Thought and Practice from 1539–1564* (Nieuwkoop: De Graaf, 1968), p. 82, citing Dirck Philips, *Enchiridion oft Handboecxken van de Christelijken Leere ende Religion . . .* (1564), in *Bibliotheca Reformatoria Neerlandica*, ed. Fredrik Pijper and Samuel Cramer (The Hague: M. Nijhoff, 1914), vol. 10, p. 37.

36. John Weemse reports that the Temple priests blessed the people by lifting up their arms. Weemse, *Christian Synagogue, Customs of Hebrews and Proselytes* (London: Thomas Cotes, 1630), p. 311. For the influence of Raphael's *Parnassus* and *Disputà* of the Stanza della Segnatura of the Vatican for this print, see White, *Rembrandt as an Etcher*, pp. 65–67.

37. Bartsch, *Catalogue raisonné*, no. 51.

38. Ibid., no. 49.

39. Many catechisms were produced in the sixteenth century toward this goal: Luther's Kleine Katechismus (Small Catechism; 1520); the Calvinist Heidelberg Catechism, translated into Dutch in 1563 and revised by the Synod of Dort (1618–19); and, among the Mennonites, either Balthasar Hubmaier's 1526 catechism or the Dordrecht Confession of 1632. The Heidelberg Catechism is bound with Abraham Hellenbroek, *Specimen of Divine Truth . . .* (New York: Samuel Loudon, 1784). The Dordrecht Confession is reprinted in John C. Wenger, *Glimpses of Mennonite History* (Scottdale, PA: Mennonite Publishing House, 1940), pp. 84–111.

40. The removal of a hat in recognition of the Messiah is a well-known motif in northern European art. See, for example, Albrecht Dürer's woodcut *The Adoration of the Shepherds* from the series *Life of the Virgin*; Bartsch, *Le Peintre graveur*, vol. 7, p. 132, no. 85.

41. The sequence of works produced by Rembrandt and Lievens in this rivalry is well charted in Schwartz, *Rembrandt*, pp. 8–87, figs. 72–76.

42. Ackley, *Rembrandt's Journey*, pp. 198–99, no. 129.

43. Robert Baldwin, "Rembrandt's New Testament Prints: Artistic Genius, Social Anxiety, and the Marketed Calvinist Image," in *Impressions of Faith: Rembrandt's Biblical Etchings*, ed. Shelley Perlove, exh. cat. (Dearborn: University of Michigan–Dearborn, Mardigian Library, 1989), p. 29, quoting John Calvin, *The Gospel According to Saint John*, 2 vols., trans. T. H. L. Parker (Grand Rapids, MI: William B. Eerdmans, 1959–61), vol. 1, p. 16 (on John 11:43).

44. Arthur Wheelock, Jr., et al., *Rembrandt's Late Religious Portraits*, exh. cat. (Washington, DC: National Gallery of Art; Chicago: University of Chicago Press, 2005), pp. 88–92, no. 6, Beverly Brown and Arthur Wheelock, Jr., *Masterworks from Munich*, exh. cat. (Washington, DC: National Gallery of Art, 1988), pp. 158–60, no. 39. Claims that the picture has been cut down and might once have held the staff and cross or banner of the Resurrection are denied by Wheelock on physical grounds, since thread distortions on the edges suggest that the original format was too small to accommodate this additional motif.

45. The facial features and strong shadow on one side of the face closely resemble those of Rembrandt's contemporary, and probably uncommissioned, *Bust of a Young Jew* of 1663 (see plate 4.7).

46. One other work of the 1660s, which has been called a Rembrandt but is probably (at least in part) the work of a follower (Aert de Gelder?), is *Christ with a Staff* (see plate 4.8). See Wheelock et al., *Rembrandt's Late Religious Portraits*, pp. 110–13, no. 12 (there reinterpreted as the apostle James Minor[?]); Walter Liedtke et al., *Rembrandt / Not Rembrandt in the Metropolitan Museum of Art: Aspects of Connoisseurship*, exh. cat. (New York: Metropolitan Museum of Art, 1995), vol. 2, pp. 128–29, no. 37. The blonde hair of the figure and the loose handling show the discrepancy with the authentic work in Munich, but the same steady gaze and frontal presentation at half-length link the two ("completely consistent in type and expression [if not execution] with his *Risen Christ*," according to Liedtke, p. 128). The traveler's cloak and staff suggest that

this is Christ after the Resurrection, disguised en route to Emmaus and subject to viewer recognition like the revelation of Christ's underlying divine nature to his apostles. A final half-length *Christ* of about 1657–61 (see plate 4.3) seems authentic but has been gravely dismembered at its edges. Wheelock et al., *Rembrandt's Late Religious Portraits*, pp. 120–25, no. 15. While not expressly situated in either the teaching mission or the post-Resurrection narratives, it still shows an intimate exchange of glances between a portrait-like Christ and the beholder.

47. Schwartz, *Rembrandt*, p. 182, fig. 190; Willem Adolph Visser 't Hooft, *Rembrandt and the Gospel* (London: SCM Press, 1957),

pp. 91–92. Rembrandt twice painted the Noli Me Tangere with Mary Magdalene: an early work with brighter colors (1638; see plate 3.16) and a later work with figures glowing against darkness (1651; see plate 4.11).

48. Richard Sibbes, *The Complete Works of Richard Sibbes*, ed. Alexander Balloch Grosart (Edinburgh: Banner of Truth, 1973), vol. 4, pp. 200–305, 312–49. This passage appeared in a treatise that Sibbes wrote in 1639, under the supervision of Thomas Godwyn and Philip Nye. See Richard W. Daniels, *The Christology of John Owen* (Grand Rapids, MI: Reformation Heritage Books, 2004), p. 92.

PLATE 4.1

Rembrandt Harmensz. van Rijn

Supper at Emmaus, c. 1629

Oil on paper, attached to panel; 14¾ × 16⅝ inches (37.4 × 42.3 cm)
Institut de France, Musée Jacquemart-André, Paris, MJAP-P 848
Photograph © Scala / Art Resource, NY

CAT. 6

Testing Tradition Against Nature

REMBRANDT'S RADICAL
NEW IMAGE OF JESUS

Lloyd DeWitt

The year 1648 marked the end of eight decades of war between the Netherlands and Spain, and the latter's unprecedented recognition of the United Provinces, as the fledgling Dutch Republic was then known. In Amsterdam, Rembrandt van Rijn marked an equally radical shift in his oeuvre that year with his *Supper at Emmaus* (see plate 1.1). Around this time a modest but closely related project was started in his studio: a series of small oil sketches on oak panels of a young man in a white tunic and simple brown cloak, in different poses and expressions and under different lighting conditions. His long hair is parted in the center, and he has a short beard; several panels also include his folded hands.[1] Although the figure lacks other identifying attributes or symbols, it was clear to Rembrandt's contemporaries that these sketches were intended as depictions of Christ. Less obvious, perhaps, was the extent to which these works marked a radical change not only in Rembrandt's own work but in the entire tradition of Christian art.

Apparently Rembrandt's use of a live model for Christ was well known. In July 1656, with Rembrandt in bankruptcy, the anonymous clerk of the Amsterdam Desolate Boedelskamer (Chamber of Insolvent Estates) who catalogued the possessions in the artist's house on Jodenbreestraat listed three paintings as heads of Christ. One of them, located in a bin whose contents included ancient textiles, crossbows, foot-bows, stringed instruments, sculptures, antlers, helmets, plaster casts, and two other small paintings, was given the curious description "head of Christ, after life" (*Cristus tronie nae 't leven*).[2] As Seymour Slive noted in his seminal 1965 article on the Christ sketches, the author who first published the inventory in 1834 added a question mark after this entry, perhaps puzzled by how Rembrandt managed to portray the head of Jesus from life.[3] The other two examples, listed in the inventory as "Head of Christ, by Rembrandt," were found in the artist's bedroom.

These three works likely belonged to the series of seven small panel paintings of Jesus now in museums and private collections in Europe and the United States, which form the core of this exhibition and catalogue (see plates 2.2–2.8).[4] The artist and biographer Arnold Houbraken (1660–1719) noted that one of Rembrandt's peculiar practices was his habit of sketching the same subject frequently and from many angles.[5] A drawing in the Morgan Library (fig. 4.1) shows three sketches for the head of the dead Christ on a single sheet, using different models. The heads of Christ, which

Fig. 4.1. Rembrandt
Harmensz. van Rijn,
*Three Studies for a "Descent
from the Cross*," c. 1653–54.
Quill and reed pen in
brown ink on paper,
7¹¹⁄₁₆ × 8¹⁄₁₆ inches (19 ×
20.5 cm). The Pierpont
Morgan Library, New
York, EVT 148

Fig. 4.2. Rembrandt
Harmensz. van Rijn,
*The Entombment, over a
Sketch of an Executioner*,
1640–41. Pen and brown
ink on paper, 6⅛ × 7⁷⁄₁₆
inches (15.6 × 20.1 cm).
Rijksmuseum,
Amsterdam,
RP-T-1930-28

Rembrandt probably began as models for his *Supper at Emmaus* panel of 1648, stand out as the largest such group among his many small oil sketches, suggesting that the project to develop a new model of Jesus "after life" expanded once underway. Like many of his sketches and drawings, they were not intended for the market, and few are signed or completed.[6] The placement of two of these small, intimate portraits in the personal space of Rembrandt's bedroom may indicate that the series had taken on personal significance for the artist.[7]

Making innovative images of Christ had been a focus of Rembrandt's ambition from early in his career. By the time these sketches were executed, he had already painted, drawn, and etched Christ in a great many compositions. Following the path of his master, the Amsterdam artist Pieter Lastman (1583–1633), Rembrandt had built an astonishingly broad repertoire of biblical subjects, as well as a formidable reputation as a history painter, the most honored rank in the hierarchy of specializations. In addition to his dramatic, groundbreaking early *Supper at Emmaus* of about 1629 (plate 4.1), with Christ shown entirely in silhouette, and his theatrical *Raising of Lazarus* of about 1630 (see fig. 3.5), Rembrandt had also painted a Passion of Christ series (1633–39) for Frederik Hendrik, the stadtholder of the United Provinces. The face of Christ in a key work connected to the development of that series, *Christ on the Cross* of 1631 (fig. 4.3), already shows Rembrandt seeking to break from tradition. The face, with its coarse features and defiant expression, bears no small resemblance to Rembrandt's 1630 print *Self-Portrait with Open Mouth* (fig. 4.4). A slightly later drawing of the Entombment (fig. 4.2) shows the face of the dead Christ with the kind of graphic realism for which Rembrandt was known.

The sketches of the late 1640s represent a more decisive break in the iconography of Christ, which becomes especially clear when we compare them to the work of Rembrandt's predecessors. The face of Christ in almost all early Netherlandish paintings, from those of Jan van Eyck (c. 1390–1441) to Pieter Bruegel the Elder (c. 1525/30–1569), was not taken from life but consciously derived from authoritative models and descriptions thought to have been passed down from antiquity. Not only did Rembrandt abandon these traditional sources, but as many scholars have persuasively proposed, and visual and circumstantial evidence consistently supports, he used as his model a young Sephardic Jew from the neighborhood in which he lived and worked. Both his 1656 inventory and an inscription about Christ on an impression of *The Hundred Guilder Print* (Bibliothèque

Fig. 4.3. Rembrandt Harmensz. van Rijn, *Christ on the Cross*, 1631 (detail of plate 7.1). Oil on canvas, glued to panel. Collegiate Church of St. Vincent, Le Mas d'Agenais, France

Fig. 4.4. Rembrandt Harmensz. van Rijn, *Self-Portrait with Open Mouth*, 1630. Etching, 2⅞ × 2 7/16 inches (7.3 × 6.2 cm). Staatliche Museen zu Berlin, Kupferstichkabinett, inv. 82-1887. Photograph © Bildarchiv Preussischer Kulturbesitz / Art Resource, NY

Nationale, Paris) by the Amsterdam poet and nurse H. F. Waterloos (d. 1664) specified that Rembrandt worked "na 't leeven."[8] These Jewish émigrés, expelled from Spain and Portugal, had begun arriving in Amsterdam in the late sixteenth century, and many had settled in the area around Jodenbreestraat, where Rembrandt bought a house in 1639.[9]

The sketches made their mark in Rembrandt's studio—forming the basis for his depictions of Christ in biblical narrative paintings and prints of the 1640s (see plates 1.1, 1.2), as well as in his later images (plates 4.2, 4.3)—but then faded from view and had little immediate impact on understanding of Rembrandt's iconography of Christ until the early twentieth century.[10] Most of his students and followers, such as Samuel van Hoogstraten (1627–1678) and Gerbrand van den Eeckhout (1621–1674), reverted to more canonical representations of Christ. It was only early in the twentieth century, as Albert Blankert has noted, that the sketches, especially the painting in the Museum Bredius (see plate 2.8), were published and became widely known. As George Keyes explains in his essay in this catalogue, Abraham Bredius and Wilhelm Valentiner guided several American museums and collectors in their purchase of sketches from this series in the early decades of the century.[11] The status of these works was again altered with the advent of the Rembrandt Research Project in 1968,[12] which at one point rejected all seven panels from Rembrandt's corpus and has recently readmitted only the example in Berlin (see plate 2.6) as possibly authentic. The authority of the series, the innovation it embodies, and the identity of the face of Rembrandt's Jesus have, therefore, all been highly contested. The essay by Tucker, DeWitt, and Sutherland in this volume has laid out how these works form a consistent group and belong to the same moment; this essay will explore the meaning of the innovations that appear in them.

FROM ICON TO NARRATIVE: CONFRONTING TRADITION

This essay traces the reception and transmission of the canonical image of Jesus in northern European art to assess how Rembrandt transformed—or "corrected"—it, as well as how his use of an ethnographically correct model changed its meaning and status. The sketches lack the light-brown hair, shallow features, thin lips, and especially the distinctly large, high, round forehead and elongated nose of earlier Netherlandish examples like those by Van Eyck (fig. 4.5) and Robert Campin (c. 1375/9–1444; fig. 4.6), which were inspired by well-known Byzantine icons such as the Mandylion (discussed below). Rembrandt's early images of Christ are faithful to this model: in the *Supper at Emmaus* of about 1629 (see plate 4.1) the contour of Jesus's face shows the long nose and shallow, feminine features of the canonical type, more clearly distinguished in the studio drawing of this composition from about 1633 (see plate 1.4). The same features appear in the elaborate finished drawing *Jesus and His Disciples* of 1634 (plate 4.4) and the closely related panel of *The Incredulity of Thomas* (plate 4.5) of the same year. *Christ on the Cross* of 1631, in which Rembrandt uses what appears to be his own face for that of the suffering Jesus, is a remarkable document in Rembrandt's path to a new image of Christ (see fig. 4.3; plate 7.1).[13] The heads of Christ produced in Rembrandt's studio beginning in the late 1640s, however, show a young man with darker skin, black hair, lower hairline, and a more realistically proportioned forehead. This new Jesus has the same broad face, heavy eyelids, and round lips as the younger subjects in Rembrandt's portraits of anonymous Jews (plates 4.6, 4.7).[14] The face in all of the Jesus sketches is considerably more specific, natural, and common than that of older Netherlandish examples, such as the one purportedly originated by Van Eyck (see fig. 4.5). In the 1661 *Christ*

with a Staff (plate 4.8) these distinctive features once again appear, perhaps even based on the Bredius panel (see plate 2.8) or a lost panel that is reflected in two copies (see plates 2.10, 2.11).

Depicting the face of Christ had always been a contentious practice in Christian art, as from the beginning the Second Commandment prohibition against idolatry clashed with the image-loving culture of the ancient Roman world. The legality of religious art was a core issue of the Protestant Reformation, and portraying Christ would remain a fraught practice in Rembrandt's time and beyond. The early Church Fathers Justin, Tertullian, and Clement of Alexandria all nevertheless had speculated about Christ's physical appearance, but concluded that he was probably unremarkable in this regard. Not until the third century, according to Hans Belting, did a Gnostic-influenced idea begin to prevail in which Jesus was ascribed a measure of youthful beauty and bodily perfection (even at birth) more appropriate to his divine status.[15] This youthful type persisted until it was displaced by that of the philosopher with beard, parted hair, and averted gaze found on the earliest surviving portable icons, such as those at Saint Catherine's Monastery at Mount Sinai in Egypt.[16]

Complicating the representation of Christ was the fact that, since nearly all Christians confess the divinity of Jesus, the very practice of depicting him was seen as conflicting with the Law of Moses, which forbids making images of God. Two early portraits of Jesus, however—the Mandylion of Edessa, which was well known in the Byzantine East (Orthodox) world, and the Sudarium (or Veil of Veronica), familiar in the Latin West (Roman Catholic) world, and the Mandylion of Edessa, which was well known in the Byzantine East (Orthodox) world—were purported to have been produced by the body of Christ itself, imprinted on cloth pressed to his face, and thus, like the Shroud of Turin, were considered *acheiropoieta*—sacred icons made without human hands—and not idols or man-made works of art.[17] The Sudarium was thought to be the veil that a young woman named Veronica pressed to Christ's face to relieve his suffering on the road to Calvary. The Mandylion, according to a fifth-century account, was a likeness miraculously imprinted on a cloth that Jesus held to his face, and which he sent to Edessa (in present-day Turkey) to heal its king, Abgar.[18]

Fig. 4.5. Artist unknown, *Head of Christ.* Copy after a lost painting of 1438 by Jan van Eyck (Dutch, c. 1390–1441). Oil on panel, 17³⁄₈ × 12⁵⁄₈ inches (44 × 32 cm). Staatliche Museen Preussischer Kulturbesitz, Gemäldegalerie, Berlin, inv. 528. Photograph © Bildarchiv Preussischer Kulturbesitz / Art Resource, NY

Fig. 4.6. Robert Campin (Netherlandish, c. 1375/9–1444), *Christ and the Virgin,* c. 1430–35. Oil and gold on panel, 11¼ × 17¹⁵⁄₁₆ inches (28.6 × 45.6 cm). Philadelphia Museum of Art, John G. Johnson Collection, cat. 332

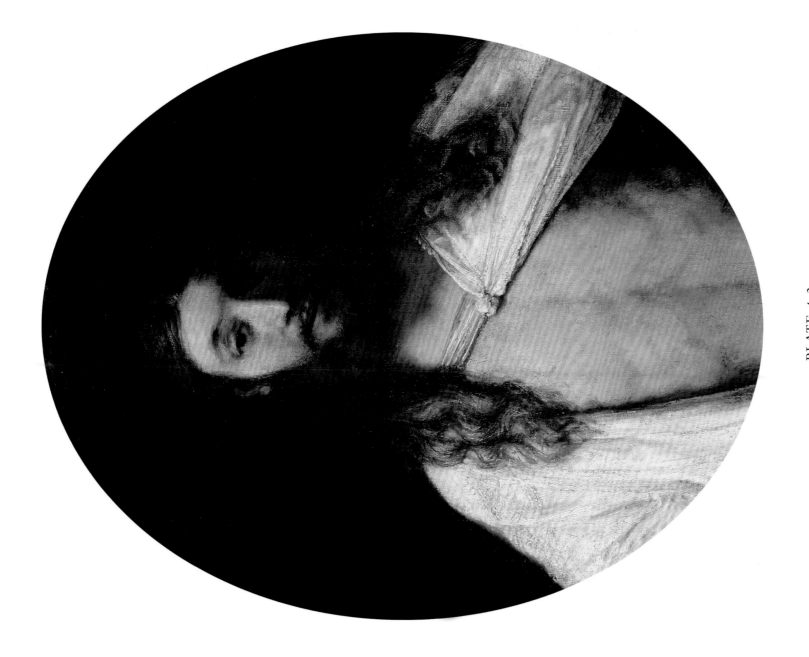

PLATE 4.2

Rembrandt Harmensz. van Rijn

The Risen Christ, 1661

Oil on canvas, 30⅞ × 24¹⁵⁄₁₆ inches (78.5 × 63 cm)
Bayerische Staatsgemäldesammlungen, Alte Pinakothek, Munich, 6471
Photograph by Erich Lessing / Art Resource, NY

CAT. 68

114

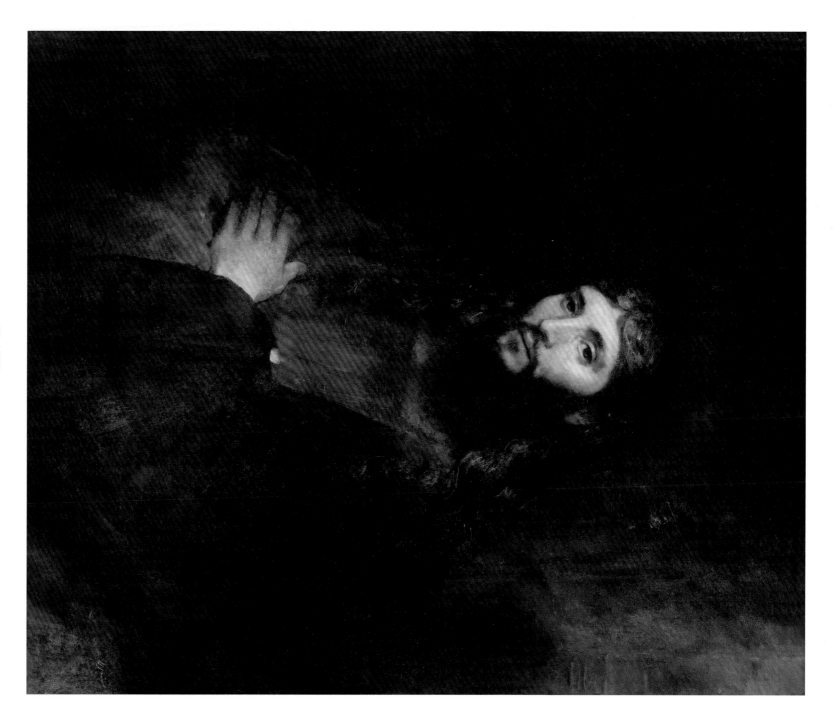

PLATE 4·3

Rembrandt Harmensz. van Rijn

Christ with Arms Folded, c. 1657–61

Oil on canvas, 43 × 35½ inches (109.2 × 90.2 cm)
The Hyde Collection, Glens Falls, New York, 1971.37

CAT. 66

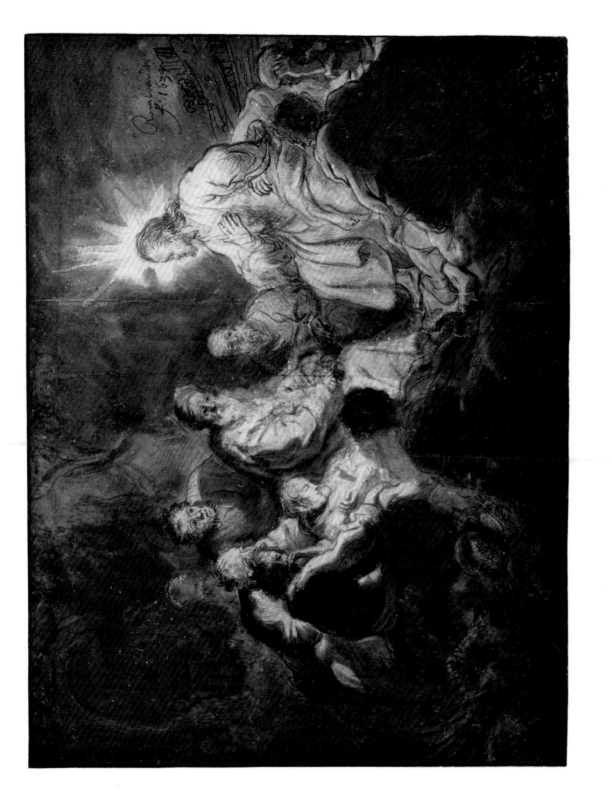

PLATE 4.4

Rembrandt Harmensz. van Rijn

Jesus and His Disciples, 1634

Black and red chalks, pen and brown ink, and various washes on paper; 14⅟₁₆ × 18⅞ inches (35.7 × 47.8 cm)

Teylers Museum, Haarlem, O* 47

CAT. 15

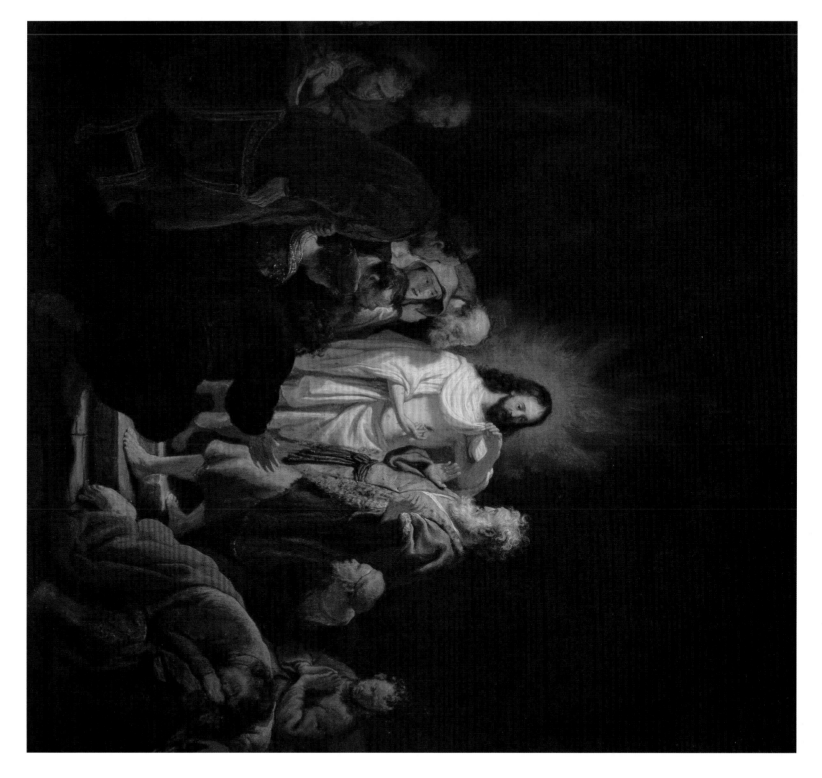

PLATE 4·5

Rembrandt Harmensz. van Rijn

The Incredulity of Thomas, 1634

Oil on panel, 20⅞ × 19⅞ inches (53.1 × 50.5 cm)
Pushkin State Museum of Fine Arts, Moscow, 2619
Photograph © Scala / Art Resource, NY

CAT. 14

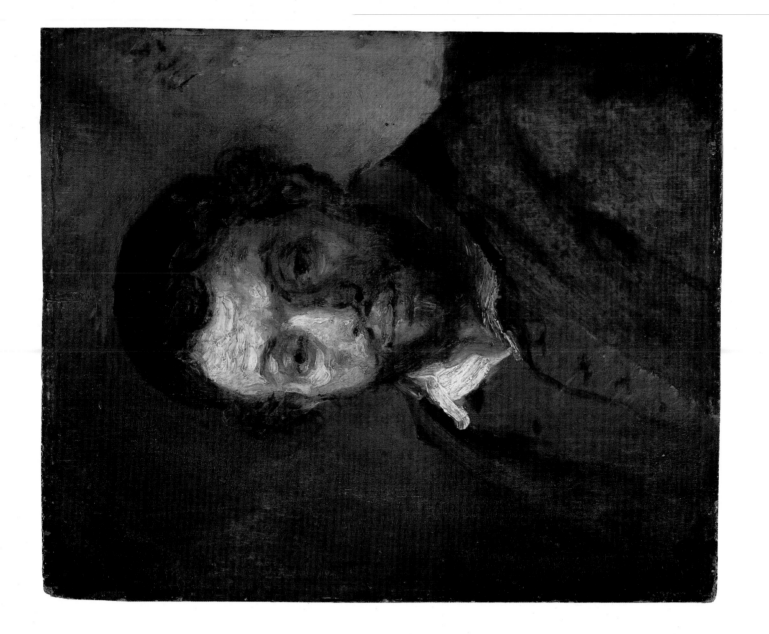

PLATE 4.6

Rembrandt Harmensz. van Rijn

Portrait of a Young Jew, c. 1648

Oil on panel, 10 × 8⁹⁄₁₆ inches (25.4 × 21.7 cm)

Staatliche Museen Preussischer Kulturbesitz, Gemäldegalerie, Berlin, inv. 828M

Photograph © Bildarchiv Preussischer Kulturbesitz / Art Resource, NY

CAT. 31

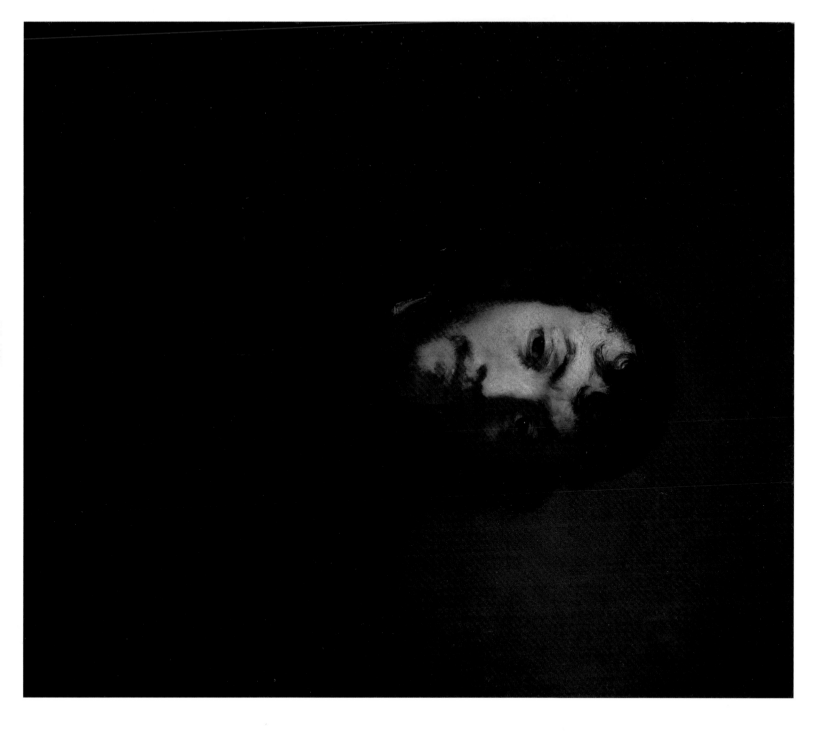

PLATE 4·7

Rembrandt Harmensz. van Rijn

Bust of a Young Jew, 1663

Oil on canvas, 25⅞ × 22⅝ inches (65.8 × 57.5 cm)
Kimbell Art Museum, Fort Worth, Texas, AP 1977.04
Photograph © Kimbell Art Museum, Forth Worth / Art Resource, NY

CAT. 70

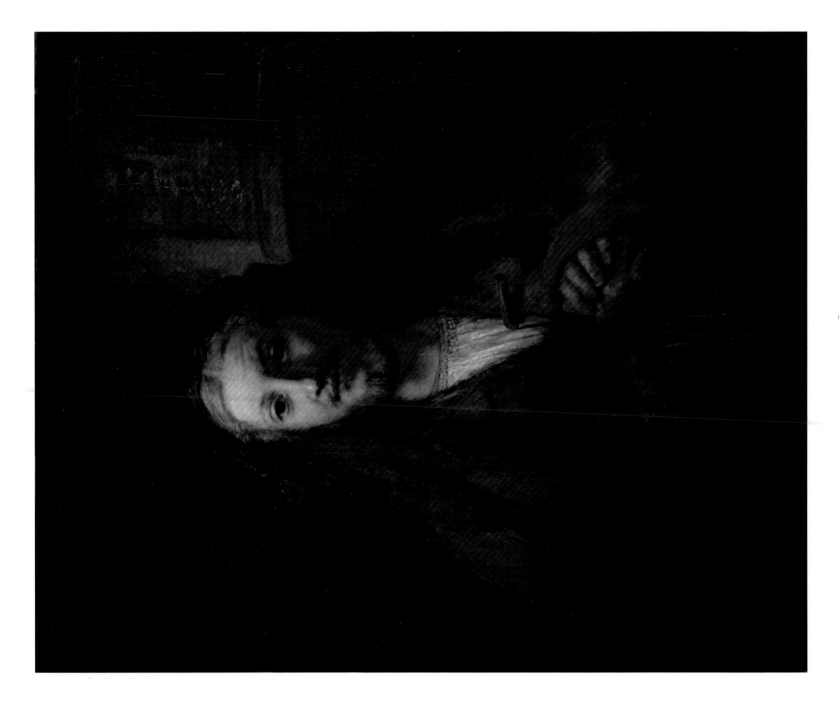

PLATE 4.8

Studio of Rembrandt Harmensz. van Rijn

Christ with a Staff, 1661

Oil on canvas, 37½ × 32½ inches (95.3 × 82.6 cm)

The Metropolitan Museum of Art, New York, The Jules Bache Collection, 1949 (49.7.37)

Photograph © The Metropolitan Museum of Art / Art Resource, NY

CAT. 69

The more influential of the two for Netherlandish art was the Mandylion. This image-bearing cloth survived two periods of official iconoclasm in the Byzantine Empire, 726–87 and 815–43, before it was brought to Constantinople in 944.[19] The Mandylion's cult blossomed all the more following its loss during the sack of that city during the Fourth Crusade in 1204. For centuries, Flanders had maintained links to the Byzantine Empire that belied their physical separation, and these ties only grew after the sack of Constantinople. The counts of Flanders ruled the empire until 1284, and Byzantine icons, including copies of the Mandylion, began to find their way north.[20] One such copy, the thirteenth-century Serbian icon known as *The Holy Face of Laon*, was brought (as the original Mandylion) to northern France in 1249, where it now resides in the Laon Cathedral (fig. 4.7).[21] The heavily stylized face in that painting was seen as establishing the object's antiquity, while its meticulously smooth, painted surface reinforced its claim to be a miraculous image not made by human hands.

These icons became the most authoritative and influential portraits of Jesus and were the models most often used in early Netherlandish painting. Even as Flemish painters in the fifteenth century became obsessed with illusionism and employed ever more microscopic levels of detail in their oil paintings, their depictions of the face of the mature Jesus largely remained faithful to such Byzantine models. The imperial face of Jesus in Campin's *Christ and the Virgin* of about 1430–35 (see fig. 4.6) is a key example of the Byzantine type as transmitted to the Low Countries; its frontally posed face with averted gaze is essentially a repetition of images such as *The Holy Face of Laon*.[22] Campin's adherence to models purportedly made without human hands does not seem, incidentally, to have protected the face in his painting from being damaged in the manner of iconoclasm, an act perhaps provoked by its startling realism.[23]

The authority of the Byzantine image of Jesus in northern Europe was further propagated through an apocryphal written source called the "Lentulus letter," a description of the physical

Fig. 4.7. Artist unknown, *The Holy Face of Laon*, c. 1249. Tempera on primed cedar panel, 17⅜ × 14¾ inches (44.1 × 40.1 cm). Treasury, Laon Cathedral, France. Photograph © DeA Picture Library / Art Resource, NY

Fig. 4.8. Hans Burgmaier (German, 1473–1531), *Lentulus Letter with Christ in Profile*, 1512. Woodcut, sheet 10 × 6⅝ inches (25.4 × 16.9 cm). Staatliche Graphische Sammlung, Munich, inv. 6784D

Fig. 4.9. Jacob Matham (Dutch, 1571–1631) after Abraham Bloemaert (Dutch, 1566–1651), *Veronica's Veil*, 1605. Engraving, 16⅞ × 12⅝ inches (42.8 × 32.1 cm). British Museum, London, 1856,0209.274. Photograph © The Trustees of the British Museum

appearance of Jesus that, according to legend, was sent by a certain Publius Lentulus to the Roman senate during Christ's lifetime. The letter observed the following about Jesus:

> His hair is the color of a ripe hazelnut, parted on top in the manner of the Nazirites [Hebrew ascetics], and falling straight to the ears but curling further below, with blonde highlights and fanning off his shoulders. He has a fair forehead and no wrinkles or marks on his face, his cheeks are tinged with pink, . . . his beard is large and full but not long, and parted in the middle. His glance shows simplicity adorned with maturity, his eyes are clear and commanding, never apt to laugh, but sooner inclined to cry; he has straight hands and his arms are very pleasing, He speaks sparingly and is very polite to all. In sum, he is the most beautiful of all mortals.[24]

The text of this letter was well known, appearing in the fourteenth-century *Vita Christi* by Ludolf of Saxony, in a 1512 engraving by Hans Burgmaier (fig. 4.8), and even copied onto a Netherlandish diptych wing of about 1499 (Museum Catharijneconvent, Utrecht), facing a profile portrait with corresponding features.[25]

During the sixteenth century, Dutch Protestants became increasingly wary of the veneration of saints and the propriety, not just of Christ images, but of any statues and paintings purported to work miracles or otherwise deemed to take on the characteristics of idols. Beginning in the summer of 1566, these tensions finally exploded in episodes of iconoclasm, resulting in the destruction of a staggering number of religious paintings and sculpture in the Netherlands.

Rembrandt worked less than a century after iconoclasts had removed religious images from churches throughout the Netherlands and triggered the political revolt that led to the independence of the United Provinces. These events forever changed the Dutch art market, especially for religious art. In the post-Reformation Dutch Republic, most artists worked in secular genres such as portraiture, still life, and landscape, all of which blossomed to fill the demands of a nation of burgeoning wealth and growing taste for luxury goods. During this period, known as Holland's Golden Age, which roughly spanned the seventeenth century, religious painting became a marginal aspect of art production, both because the Church had ceased to function as major patron and because the predominantly Protestant population remained averse to even the perception of idolatry. Nevertheless, the image of Jesus continued to be the subject of much debate in Rembrandt's time. For example, Jan Victors (1619–1676), one of Rembrandt's more devoutly Protestant pupils, painted only Old Testament subjects and not a single painting of Christ precisely because of his beliefs concerning idolatry.[26]

Yet even during this period, Dutch artists continued to produce images of Christ, using the Byzantine-inspired models. In spite of restrictions on the activity of the Catholic Church in the Protestant-controlled United Provinces, prominent Catholic artists such as Abraham Bloemaert (1566–1651), Jan Steen (1626–1679), and Johannes Vermeer (1632–1675), and even some Protestant artists like Joachim Wtewael (1566–1638), produced altarpieces and images of Christ for ecclesiastical and private devotional uses.[27] In 1605, for example, the Utrecht-based Bloemaert actively supported the cause of the Counter-Reformation through an influential print of the Sudarium (fig. 4.9).[28] Right up to Rembrandt's day, and in his own early work, therefore, the authority of those original models was still being asserted by leading artists in the northern Netherlands.

THE NEW ICON IN USE

While the genesis of Rembrandt's project of finding a new means to depict Jesus is unclear, two drawings he made around 1648 (plates 4.9, 4.10) of a young man seated on a chair with his hat in his hands may offer us a glimpse of its inception. As Peter Schatborn and Martin Royalton-Kisch have indicated, out of all the known drawings attributed to Rembrandt, only these two seem to show the same model as the sketches of Christ.[29] The long hair, short beard, and nose all correspond to the sketches, as do the shape of the eyebrows and the high cheekbones. The modern dress of the figure in the drawings—particularly his flat collar and coat, and possibly the hat on his lap—does not correspond to the more ancient garments in the oil sketches, but his pose is quite similar, down to the hands folded over his hat. This was typical of Rembrandt's process of refining the pose and expression of his subject over successive sketches, suggesting that these drawings represent an initial stage in the development of this model into the sketches of Christ.[30]

As discussed elsewhere in this catalogue (see Tucker, DeWitt, and Sutherland), several technical features of the heads of Christ indicate that they too were taken from life, particularly their sketch-like quality, mainly wet-in-wet paint handling, and consistent level of immediacy with the subject. The vignette-like dropping-off of finish toward the edges makes sense if the panels were indeed studies of facial expression and pose, and the tonal palette typical of Rembrandt's mature work enhances the refinements in chiaroscuro so critical to their function as studies.

The heads of Christ lack the archaic halo or radiance that Rembrandt revived as a distinctive marker of the risen Christ in paintings such as the Louvre *Supper at Emmaus* (see plate 1.1),

PLATE 4.9

Rembrandt Harmensz. van Rijn

Seated Man, Half-Length, at Work, c. 1648

Black chalk on paper, 5 × 4 inches (12.7 × 10.2 cm)
Private collection, New York

CAT. 32

PLATE 4.10

Rembrandt Harmensz. van Rijn

Seated Man with Long Hair, Hands Folded, c. 1648

Black chalk on paper, 5⁵⁄₁₆ × 3⁷⁄₁₆ inches (13.5 × 9.6 cm)

Collection of Bob P. Haboldt, Paris

CAT. 33

The Risen Christ Appearing to the Magdalene (*Noli Me Tangere*) of 1651 (plate 4.11), and *The Risen Christ* of 1661 (see plate 4.2), as well as in numerous prints and drawings.[31] This difference is another sign that these works were intended to look like sketches based on an anonymous model from life, rather than an identifiable figure taken from the artist's imagination. The radiant figure in the earlier *Christ as Gardener Appearing to the Magdalene* of 1638 (see plate 3.16), for example, was praised for this quality in Jeremias de Decker's *Goede Vrydag* (Good Friday; 1651): "But if you were not blind through envy or lack of faith, / You would see more shine forth from him than Human frailty, / Even through the midst of torment."[32] On one level, the oil sketches of Jesus resemble the canonical models in that they draw their affective power partly from the religious understanding of the believer, which leads to a new conundrum: The lack of symbols, attributes, or narrative context makes these refined studies of emotion and expression seem like disembodied types, even as they make Jesus more human than previous imagery did. The body of Christ the studies portrayed was believed to have been the same body that was resurrected from the dead, glorified, and ascended into heaven in order to appear again on the Last Day in triumph and judgment. Yet the sketches differ dramatically from the *acheiropoieta*, which, because they supposedly had touched Christ's body, reference the miracle of incarnation, in which God takes the form of a man.[33] Rembrandt, on the other hand, gave a graphically human character to his Christ by referring to Jesus's earthly Jewish parentage, his realistic and specific appearance, and his very human emotions. In further contrast to stylized iconic images such as *The Holy Face of Laon*, in the oil sketches the artist's hand is everywhere evident, in the loose execution, scratches with tools, and unfinished quality. The project dictated, and Rembrandt and his studio produced, a series of specific poses and expressions that corresponded to their use in his narrative art. The face of Christ, turned to the side with his eyes closed, in the panel in the Bijbels Museum, Amsterdam (see plate 2.3), for instance, seems to show the kind of mournful supplication that would be appropriate to a composition of Christ on the Mount of Olives, such as Rembrandt's heart-rending drawing of the subject now in the Kunsthalle, Hamburg (plate 4.12). Rembrandt's ability to specify what John Nash has called "the nuanced subtlety of a living human physiognomy" in his sketches of Christ is moreover crucial to their success, and their connection to the Louvre *Supper at Emmaus* panel of 1648 (see plates 1.1, 2.7) and *The Hundred Guilder Print* (*Christ Preaching; Bring Thy Little Children unto Me*) etching he produced about a year later (see plates 1.2, 2.8).[34] Rather than continuing to refine the generic or iconic type of Christ—eternal, unchanging, and detached—as used by Northern artists ranging from Campin (see fig. 4.6) to "pre-Rembrandtist" Amsterdam history painters such as Jan Pynas (c. 1583–1631; fig. 4.10), Rembrandt envisioned a variety of purposes for his sketches that involved Christ's engagements with particular narratives or with his followers.

While Rembrandt's process of reconceptualizing his image of Christ was his own, his desire for a new image that challenged tradition was shared by many.[35] Peter Paul Rubens (1577–1640), in his Antwerp Cathedral *Raising of the Cross* of 1610–11, employed a robust, muscular figure with larger-than-life proportions that emphasized Jesus's divinity by reference to a heroic ideal as expressed in ancient sculpture such as the Farnese Hercules.[36] Hendrick Goltzius of Haarlem (1558–1617), who produced an engraving of the Farnese Hercules in 1591, adopted a similarly muscular and idealized figure for his depictions of Christ. Rubens and Goltzius sought to reform the image of Jesus by emphasizing aspects of his nature not seen in older iconography. It could

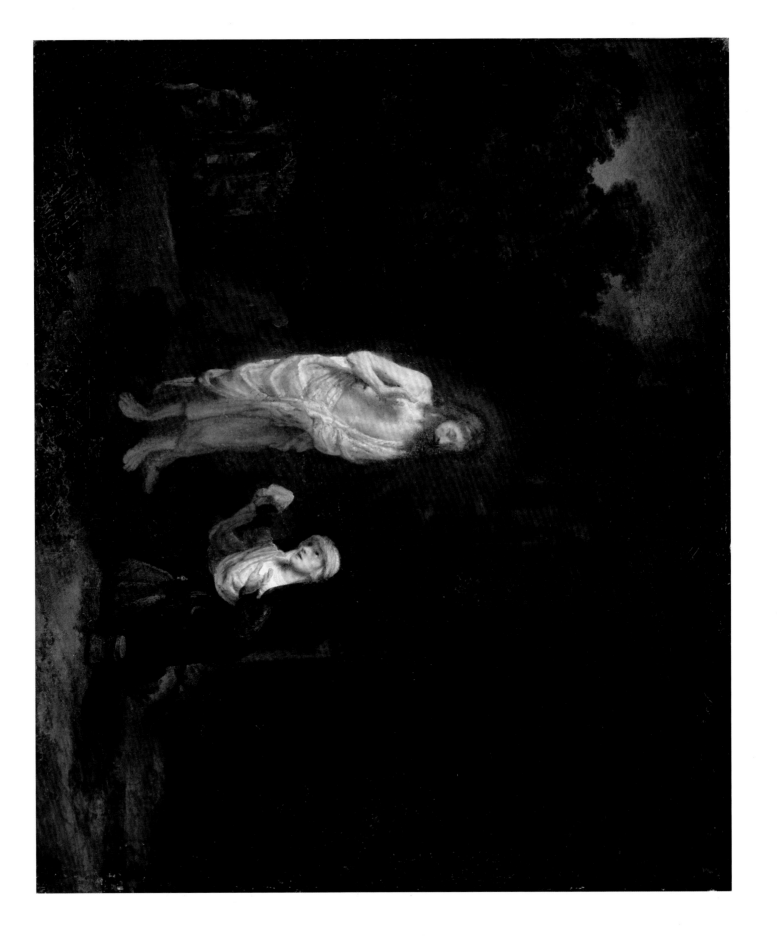

PLATE 4.11

Rembrandt Harmensz. van Rijn

The Risen Christ Appearing to the Magdalene (Noli Me Tangere), 1651

Oil on canvas, 25⅝ × 31⅛ inches (65 × 79 cm)

Herzog Anton Ulrich-Museum, Braunschweig, GG 235

CAT. 51

127

PLATE 4.12

Rembrandt Harmensz. van Rijn

Christ on the Mount of Olives, c. 1655

Pen and brush with brown ink, traces of body color on laid paper; 7¼ × 11¹³⁄₁₆ inches (18.4 × 30 cm)
Kunsthalle, Hamburg, Kupferstichkabinett, inv. 22413

CAT. 59

be that Rembrandt, in developing a specifically Jewish Jesus, was consciously challenging not only traditional Byzantine iconography but also the classical ideals about divine physicality represented in the works of his immediate predecessors.

The panels of the face of Jesus may go further than simply emphasizing Christ's humanity. The use of a model from a marginalized community lends support to William Halewood's contention that Rembrandt sought to emphasize Christ's humanity through his humble appearance in the etching *Christ Preaching* (*"La Petite Tombe"*) of about 1652 (see plate 3.9).[37] Rembrandt was repeatedly admonished by artists and critics for associating with people of low station, which they saw as a negative influence on his work, and for insisting on naturalism at the expense of decorum.[38]

However groundbreaking his innovation, Rembrandt failed to convince even some of his own pupils of the validity of his new model. In Van Hoogstraten's 1649 painting *The Incredulity of Thomas* (fig. 4.11), Jesus retains the high forehead and shallow, feminine features found in Rembrandt's 1634 panel of this subject (see plate 4.5), as well as in his *Christ and the Woman Taken in Adultery* of 1644 (see plate 3.6) and several drawings (plates 4.4, 4.13). Although Van Hoogstraten was skeptical about the authenticity of the Lentulus letter, in his 1678 treatise *Inleyding tot de hooge schoole der schilderkonst* (Introduction to the academy of painting) he nonetheless recommended it as the best available literary source for young artists to follow. "Be it real or fiction," he wrote, "we will

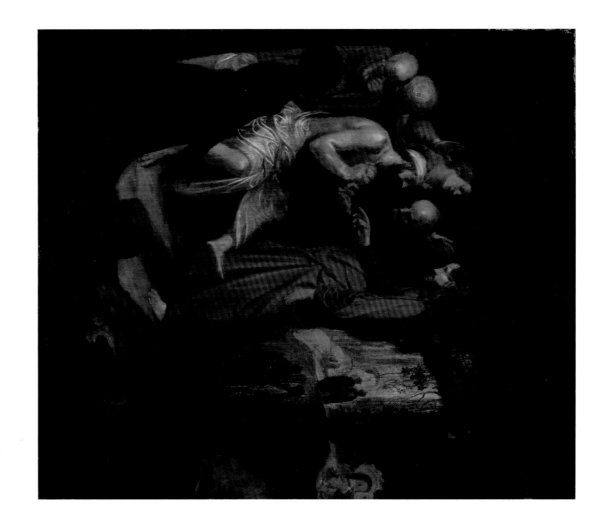

Fig. 4.10. Jan Symonsz. Pynas (Dutch, 1583–1631), *The Raising of Lazarus*, c. 1615. Oil on panel, 22¾ × 19⅞ inches (57.8 × 50.5 cm). Philadelphia Museum of Art, John G. Johnson Collection, cat. 471

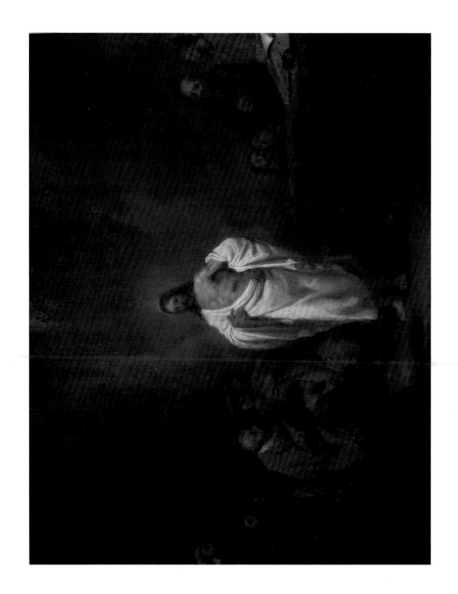

Fig. 4.11. Samuel van Hoogstraten (Dutch, 1627–1678), *The Incredulity of Thomas*, 1649. Oil on panel, 18½ × 23⅝ inches (47 × 60 cm). Landesmuseum, Mainz, inv. 1180

restrict ourselves to that which tradition attributes to the Roman Lentulus."[29] His view was typical, and we seldom find Rembrandt's pupils following their master's innovation, with the possible exceptions of Johann Ulrich Mayr (1630–1704), in his imposing *Christ* (plate 4.14), and Govaert Flinck (1615–1660; discussed below). One other, anonymous artist close to Rembrandt also seems to have repeated his experiment with a different young man as model (plate 4.15). These isolated examples aside, however, the Lentulus letter continued to reinforce the authority of the ancient and Byzantine prototypes and their features in Dutch art beyond Rembrandt's time.[40]

THE JEWISH REMBRANDT

In his 1641 speech to the assembly of Leiden painters on their patron saint's feast day, the artist Philips Angel (c. 1618–1664) praised Rembrandt and his friend Jan Lievens (1607–1674) for making use of the works of the ancient Jewish writer Flavius Josephus (A.D. 37–100), among other sources, to enrich their iconography, saying, "All these good things issue from the source of a desire to read."[41] Rembrandt he commended for his historical veracity, not only for referring to Josephus but also in showing the wedding guests in *Samson's Riddle* reclining on couches rather than seated in chairs.[42] Rembrandt owned 1574 German translations of Josephus's *Antiquities of the Jews* and *The Jewish Wars* illustrated by Tobias Stimmer (1539–1584), which he likely consulted for the appearance of Herod's temple in his 1659 etching *Peter and Paul at the Temple Gate*,[43] as well as for the temple and details of dress in his earlier print *Triumph of Mordecai*, of about 1641.[44] Rembrandt thus used Josephus to make his iconography more accurate and truthful, much in the way he used his Jewish model for Christ.[45]

Rembrandt's relationships with the Jews of his own time, as Gary Schwartz notes, "have been the subject of much sentimental conjecture."[46] The myth of the "Jewish" Rembrandt—the

PLATE 4.13

Rembrandt Harmensz. van Rijn

Christ on the Road to Emmaus, c. 1639

Pen and brush, gallnut ink on paper; 8⅞ × 6⅜ inches (22.6 × 16.1 cm)
National Gallery of Scotland, Edinburgh, D5131

CAT · 19

PLATE 4.14

Johann Ulrich Mayr (German, 1630–1704)

Christ, c. 1648

Oil on canvas, 25⁹⁄₁₆ × 21¼ inches (65 × 54 cm)
Private collection

CAT. 29

PLATE 4.15

School of Rembrandt Harmensz. van Rijn

Portrait of a Jew in Profile, c. 1648–56

Oil on panel, 7⅞ × 5¹¹⁄₁₆ inches (20.2 × 14.5 cm)

Private collection, New York

CAT. 42

view that Rembrandt used Jewish models extensively—is largely a product of the nineteenth-century imagination and has recently undergone considerable revision. In an 1854 article Eduard Kolloff posited that the artist's Old Testament history paintings gained "a strong touch of the Judaic" by his almost archeological exploitation of the Jewish quarter for models.[47] Kolloff's article led other art historians to interpret an excessive number of Rembrandt's figures as Jews. One of the most enthusiastic twentieth-century proponents of the "Jewish" Rembrandt theory, Franz Landsberger, went so far as to distinguish the features of Jesus in the Louvre *Supper at Emmaus* (see plate 1.1) as those of an Eastern European Ashkenazi (rather than Sephardic) Jew, claiming that "the only variation is that here Rembrandt lets the hair fall over the shoulders, and gives a nobler expression to the face."[48] However over-reaching Landsberger's analysis, we should not discount his perceptive identification of Rembrandt's use of an ethnographically correct model.

The level of sympathy the artist exhibited for his Jewish neighbors has also been the subject of considerable debate in the last century, by scholars ranging from Anna Seghers to Erwin Panofsky.[49] In recent decades, books by Schwartz, Michael Zell, and Steven Nadler have brought new documentation to light and added a great deal to our understanding.[50] As Zell notes, sources closer to Rembrandt's time confirm that he indeed sketched the Jews on his street, and details of clothing distinguish some of his subjects as Jewish.[51] Furthermore, Rembrandt's portrayals of Jews evolved over the course of his career from the caricatures common in Netherlandish iconography to more humanized depictions based on his own sketches from life. Two etchings of Christ before Pontius Pilate (Ecce Homo) illustrate this point. As Christian Tümpel noted, Rembrandt's etching of 1636 (plate 4.16) held to the tradition of portraying the members of the crowd mocking Jesus with stereotypical "Jewish" features. This changed considerably in his 1655 etching of the theme (plate 4.17), in which the same figures seem to be sympathetic characters drawn from life. This shift is consonant with the rapport between artist and subject evident in two oil sketches of what appear to be young Jewish men, now in Berlin and Fort Worth (see plates 4.6, 4.7).[52]

Amsterdam's Jewish community provided Rembrandt not only with subjects but also with patrons, who commissioned him to produce portraits and book illustrations. His work for the Portuguese-born rabbi and scholar Menasseh ben Israel (1604–1657) is well known. In 1655 Rembrandt etched four biblical episodes as illustrations for Menasseh's book *Piedra Gloriosa* (fig. 4.12): the colossus in the dream of Nebuchadnezzar, Jacob's dream, David slaying Goliath, and Daniel's vision of the four beasts (in which Rembrandt includes an anthropomorphic figure of God!). Menasseh was a key figure in the discourse today known as Philosemitism, an extraordinary dialogue between Jewish and Protestant theologians.[53] In the past Menasseh has been credited for many of the Hebraic motifs in Rembrandt's work, and he must have been responsible for at least the Hebrew inscription in *Belshazzar's Feast* of about 1636–38 (fig. 4.13), which was even corrected during execution, indicating a sensitive advisor.[54] However influential Menasseh may have been in the larger society, as Zell reminds us, he stood at the edge of the Sephardic community.[55] Nevertheless, through his connection to Menasseh, Rembrandt participated in an extraordinary project of Jewish-Christian rapprochement taking place in Amsterdam in the seventeenth century, one that finds an echo in the heads of Christ.[56]

Some scholars have pointed to Rembrandt's disputes with Jewish clients and neighbors to argue that he harbored a "typically Calvinist" lack of sympathy toward the Jewish community. It

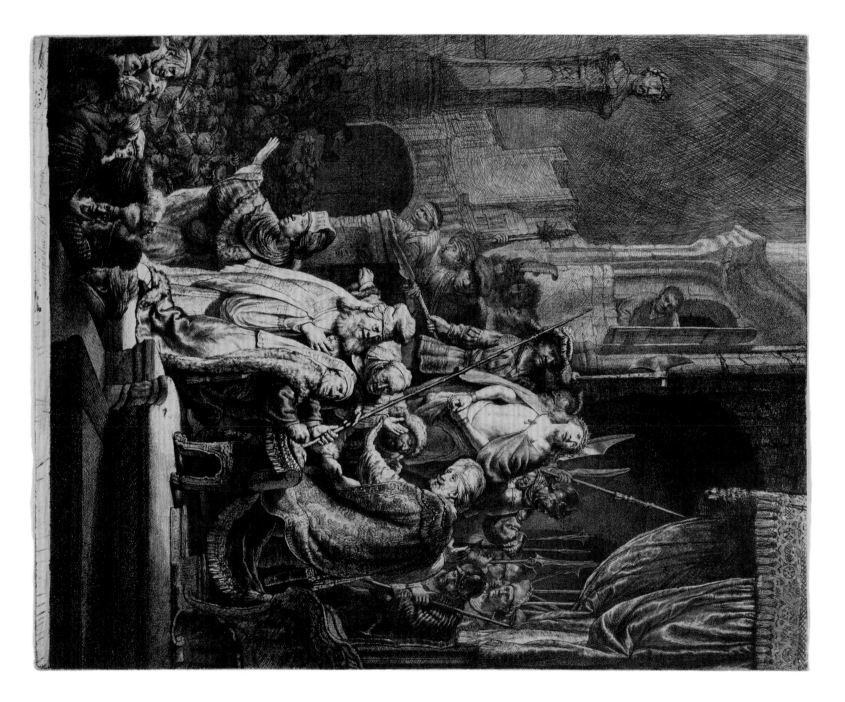

PLATE 4.16

Rembrandt Harmensz. van Rijn

Christ before Pilate: Large Plate, 1636

CAT. 17A

Etching on paper, sheet (trimmed to plate mark) 21¾ × 17¹¹⁄₁₆ inches (55.2 × 44.9 cm)
National Gallery of Art, Washington, DC, Rosenwald Collection, 1943.3.7175

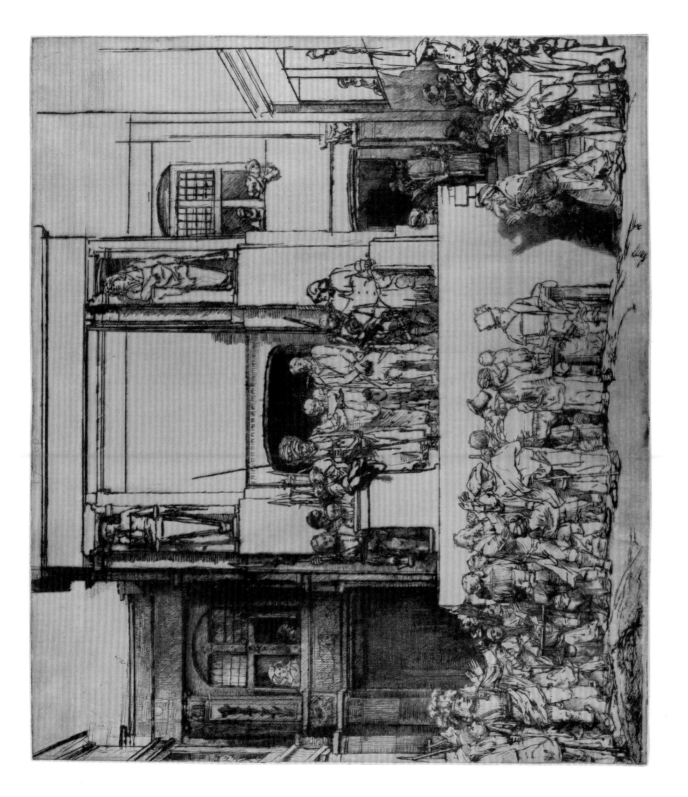

PLATE 4.17

Rembrandt Harmensz. van Rijn

Christ Presented to the People (*Ecce Homo*), 1655

Drypoint on japan paper, plate 15⅛ × 17¹¹⁄₁₆ inches (38.4 × 44.9 cm)
The Metropolitan Museum of Art, New York, Gift of Felix M. Warburg and his family, 1941 (41.1.34)
Photograph © The Metropolitan Museum of Art / Art Resource, NY

CAT. 58A

136

is not clear, however, that such disagreements arose more often with Jewish clients and neighbors than with non-Jewish ones.[57] It is clear that Rembrandt was far from the only Dutch artist of his time to engage with the Jewish community. Jacob van Ruisdael (1628/9–1682), who has himself been suspected of being Jewish, included in two key paintings striking portrayals of Beth Chaim, the Jewish cemetery at Ouderkerk aan de Amstel, near Amsterdam.[58] Others, like Emanuel de Witte (1617–1692) and Romeyn de Hooghe (1645–1708), recorded the monuments and rituals that marked the Jewish community's activity in the city of Amsterdam.[59] Unlike these other artists, however, Rembrandt's engagements with his Jewish neighbors were integrated into his artistic practice, especially in refining his biblical iconography. As Silver and Perlove discuss in their essay in this volume, his body of history paintings shows an extraordinary fascination with the Old Testament, as well as with Jewish types and models, and even the beggars and cripples in his etchings are often thought to be based on sketches of impoverished Ashkenazi refugees. Schwartz's notion

Fig. 4.12. Rembrandt Harmensz. van Rijn, *Four Illustrations for the Piedra Gloriosa: Nebuchadnezzar's Dream, Jacob's Ladder, David and Goliath and Daniel's Vision of the Four Beasts* (uncut sheet), 1655. Etching, drypoint, and engraving on Japanese paper; 9⁹⁄₁₆ × 6⁵⁄₁₆ inches (24 × 16.1 cm). Rijksmuseum, Amsterdam, RP-B-OB-65

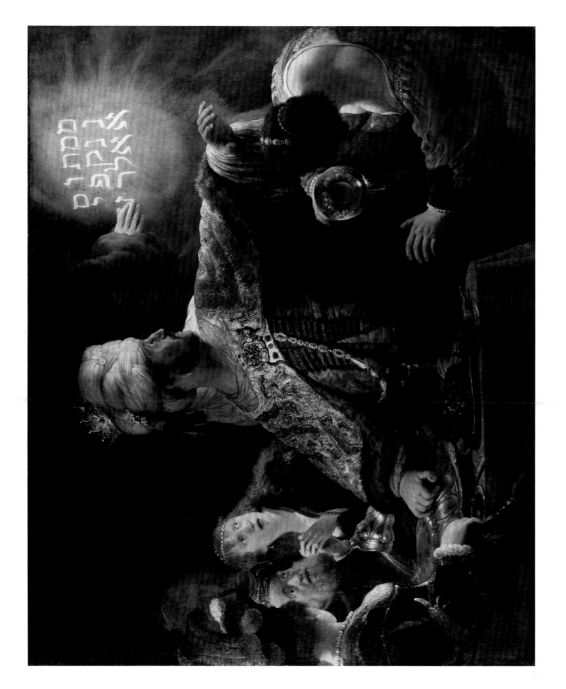

Fig. 4.13: Rembrandt Harmensz. van Rijn, *Belshazzar's Feast*, c. 1636–38. Oil on canvas, 66 × 82⅜ inches (167.6 × 209.2 cm). The National Gallery, London, NG6350. Photograph © National Gallery, London / Art Resource, NY

that "nothing we know about Rembrandt suggests he was a friend of the Jews"[60] does little to explain the artist's unusually close connections to Amsterdam's Jewish community and the Philosemitic movement, as well as his use of Jewish models, literary and theological sources, and biblical imagery.

THE FATE OF THE JEWISH JESUS

The idea that a Jewish man would knowingly pose for Jesus as Messiah may seem difficult to accept. And yet, all evidence points to Rembrandt having based his heads of Christ series on a Jewish model. We also have literary evidence that Rembrandt's student Govaert Flinck, like his teacher, made an image of Christ using a Jewish model. The poet Jan Vos (1612–1667) wrote a verse called "Christ Painted for Joris de Wijze by Govaert Flinck, after a Jew":

All that lacks is speech, but
Govaert Flinck refused
To paint an open mouth,
Despite de Wijze's plea
For this Christ would not
Speak of Christ except in
blasphemy.

While this poem indicates some of the cultural tensions inherent in using a Jewish model to portray Christ, it also underscores the radical nature of Rembrandt's reimagined Christ. Whereas Vos claimed that Flinck deliberately stopped the mouth of this Jewish man to keep him from cursing Christ, in nearly all of the oil sketches Christ has slightly parted lips suggesting speech, and two of the sketches were employed in compositions in which Christ speaks.

Rembrandt made no effort to exaggerate the features of his Jesus to make them unambiguously Jewish or Byzantine per se. Rather, his radical gesture was to challenge and correct the received prototype by comparing it to reality close at hand. This desire to take Scripture at its word occurs as well in his radical rethinking of the Supper at Emmaus in which he shows Christ as having disappeared before the disciples' eyes, as the text specifies. This painting, now lost, was copied in a sketch now in the Fitzwilliam Museum (see plate 1.14) and a reproductive engraving by Houbraken (fig. 4.14), who included it in his volumes of artist biographies of 1718–21, *De groote schouburgh der neder-lantsche konstschilders en schilderessen* (The great theater of Netherlandish painters and paintresses) as the only illustration of a work of art in addition to the artist's portrait. As Houbraken recognized, the empty chair was an unprecedented and radical way of showing Christ's miraculous nature while using what was otherwise roughly the same composition as in the 1629 painting (see plate 4.1).

Such daring is also visible in a drawing of *Christ in the House of Mary and Martha* (plate 4.18) now in Paris, in which Martha, the sister who had chosen to carry on her tasks while Christ taught in her house, was deliberately and expressively rendered by Rembrandt as a dark smudge, the result

*The heart is not reflected by
the face that shines at you.
You ask how come? Because
the model was a Jew.*[61]

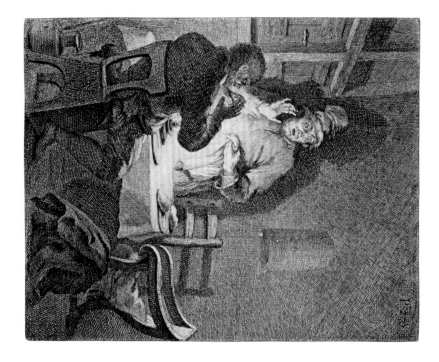

Fig. 4.14. Arnold Houbraken (Dutch, 1660–1719), *Supper at Emmaus*, c. 1718. Engraved copy after a lost painting by Rembrandt, as published in *De groote schouburg der nederlantsche konstschilders en schilderessen* (Amsterdam, 1718–21).

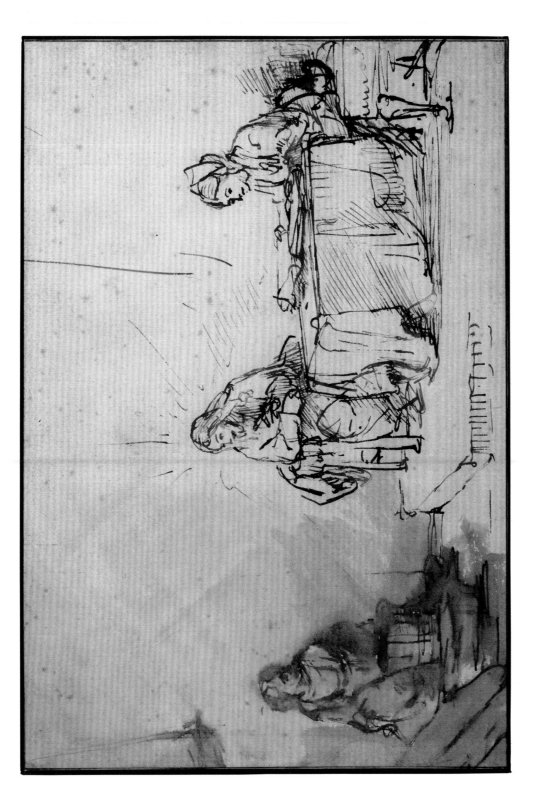

PLATE 4.18

Rembrandt Harmensz. van Rijn

Christ in the House of Mary and Martha, c. 1648–50

Pen and wash in brown ink on paper, 7 × 10½ inches (17.8 × 26.7 cm)

Petit Palais, Musée des Beaux-Arts de la Ville de Paris, DDUT 0104

Photograph © Réunion des Musées Nationaux / Art Resource, NY

CAT. 36

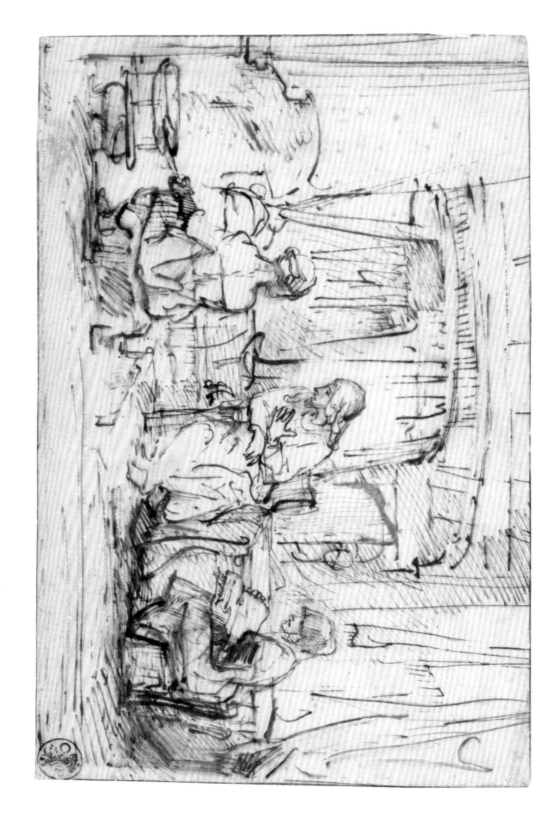

PLATE 4.19

Attributed to Rembrandt Harmensz. van Rijn

Christ in the House of Mary and Martha, c. 1645–50

Pen and brown ink on paper, 7 × 10½ inches (17.8 × 26.6 cm)

Staatliche Graphische Sammlung, Munich, 1416 z

CAT. 26

of the artist partially dissolving the figure in dark wash. In contrast, in the drawing of the same scene now in Munich (plate 4.19), both figures are carefully rendered in a conventional and readable way; Martha, seen from behind in the foreground, takes on additional importance, whereas Rembrandt maintains the centrality of the figure of Christ in the Paris drawing.

Rembrandt's sketches of Christ, with their multipurpose poses and highly refined expressions, emphasize the immediacy, directness, and narrative contexts of the encounter between Jesus and the viewer, in contrast to the permanency and distance enshrined in the traditional Byzantine and early Netherlandish images. As W. A. Visser t'Hooft remarked about the heads of Christ:

At first glance the portrait seems to be of a Jewish rabbi—the deepest and most delicate portrait possible. But then you feel there is a mystery. This Christ is far from impressing us by his majesty. On the contrary, he is "without form nor beauty," he "does not raise his voice"; but he asks us a question, a commanding question.[62]

Rembrandt's reformation of the image of Jesus was by no means a declaration of solidarity with any particular religious faction in Amsterdam; indeed, he left no evidence of religious affiliation.[63] Nor was it primarily offered as a token of sympathy with the Jewish community. Rather, as theologian Christopher Joby has argued, Rembrandt's choice of a live model ethnographically closer to Christ was primarily a rejection of both tradition and idolatry through the use of realism.[64] The subsequent "Protestant icons" of William Holman Hunt (1827–1910) in nineteenth-century Britain and Warner Sallman (1892–1968) in twentieth-century United States did not, in their quest for universality, present so radical a shift in iconography as did Rembrandt's project in the seventeenth century.[65] His gesture of testing tradition against nature did not, in the end, change the history of art as much as trace the intense and personal nature of Rembrandt's engagement with Jesus.

1. Christ's hands in the panel in the Johnson Collection (see plate 2.2) were overpainted, likely when the panel was reduced in size.

2. Walter L. Strauss and Marijon van der Meulen, *The Rembrandt Documents* (New York: Abaris, 1980), p. 383. The level of detail was typical for a bankruptcy inventory.

3. Seymour Slive, "An Unpublished *Head of Christ* by Rembrandt," *Art Bulletin*, vol. 47, no. 4 (December 1965), p. 407.

4. The paintings in the Museum of Art at Brigham Young University, Provo, Utah (see plate 2.10) and the Metropolitan Museum of Art in New York (see plate 2.11) seem to copy a lost eighth panel that belonged to the group. See Tucker, DeWitt, and Sutherland, this volume.

5. Arnold Houbraken, *De groote schouburg der nederlantsche konstschilders en schilderessen* (Amsterdam, 1718–21); cited in Charles Ford, *Lives of Rembrandt* (London: Pallas Athene, 2007), p. 60.

6. Slive, "An Unpublished *Head of Christ*," p. 409.

7. According to the 1656 inventory, a preponderance of the religious paintings in Rembrandt's possession were kept in this room, including an Ecce Homo, a Crucifixion by Lelio

Orsi da Noverella, a Sacrifice of Isaac by Jan Lievens, a Madonna purportedly by Raphael, as well as a large Christ and the Samaritan Woman, an Entombment, and a Resurrection by Rembrandt himself. Strauss and Van der Meulen, *Rembrandt Documents*, pp. 361–63. The placement of the panels of Christ in Rembrandt's bedroom also brings to mind paintings of Christ Pantokrator depicted on the wall of the Virgin's bedchamber in works by Netherlandish artists, including panels of the Annunciation by Jean Hey (also known as the Master of Moulins; c. 1475–1505) in 1490/95 (now in the Art Institute of Chicago) and by the workshop of Rogier van der Weyden (c. 1399–1464) in about 1425–50 (now in the Musée du Louvre, Paris). See also the diptych painting of Christ and the Virgin on the wall of the *Diptych of Christian de Hondt* by the Bruges Master of 1499 (Koninklijke Museum voor Schone Kunsten, Antwerp).

Sixten Ringbom, *Icon to Narrative: The Rise of the Dramatic Close-up in Fifteenth-Century Devotional Painting* (Turku, Finland: Åbo Akademi, 1965), p. 38.

8. Slive, "An Unpublished *Head of Christ*," pp. 407–8; Blankert et al., *Rembrandt: A Genius and His Impact*, exh. cat. (Melbourne: National Gallery of Victoria; Sydney: Art Exhibitions Australia; Zwolle, Netherlands: Waanders, 1997), pp. 197–98; Gary Schwartz, *The Rembrandt Book* (New York: Abrams,

2006), p. 325. Although Waterloos seems to have known about Rembrandt's use of a living model, there is no evidence that Rembrandt knew Waterloos, as Schwartz suggests.

9. Jodenbreestraat had been the artists' neighborhood, and Rembrandt had worked on this same street when apprenticed to Pieter Lastman around 1625–26. The Sephardim may have favored it because they, too, often traded in luxury goods. See Steven Nadler, *Rembrandt's Jews* (Chicago: University of Chicago Press, 2003), pp. 9–10.

10. Only Govaert Flinck and Johann Ulrich Mayr (see plate 4.14) seem to have occasionally used Rembrandt's new type of Christ in their works. See Werner Sumowski, *Gemälde der Rembrandt-Schüler* (Landau: Pfälzische Verlagsanstalt, 1983), vol. 3, p. 2184, and note 35.

11. Albert Blankert, "Controverses autour de Rembrandt," in *Rembrandt et la nouvelle Jérusalem: Juifs et Chrétiens à Amsterdam au siècle d'or*, ed. Laurence Sigal-Klagsbald and Alexis Merle du Bourg, exh. cat. (Paris: Panama musées; Musée d'art et d'histoire du Judaïsme, 2006), pp. 85–86.

12. The Rembrandt Research Project was formed in 1968 and has since become an influential authority on determining the authenticity of works attributed to Rembrandt.

13. Schwartz, *The Rembrandt Book*, p. 289. Albrecht Dürer (1471–1528) had famously painted himself in the mode of an icon of Christ in 1500 (Alte Pinakothek, Munich). Rembrandt would later paint himself as one of the executioners raising the cross (*Crucifixion*, c. 1633; Alte Pinakothek, Munich), just as Rubens had done some years earlier (*The Raising of the Cross*, 1610–11; Antwerp Cathedral).

14. Slive, "An Unpublished *Head of Christ*," p. 410.

15. Philip Schaff, *The New Schaff-Herzog Encyclopedia of Religious Knowledge*, 13 vols. (Grand Rapids, MI: Baker, 1953), vol. 6, pp. 169–70.

16. Hans Belting, *Likeness and Presence* (Chicago: University of Chicago Press, 1994), pp. 133, 136.

17. For an overview of the stories of the Mandylion and Sudarium, see Neil MacGregor, *Seeing Salvation: Images of Christ in Art* (New Haven: Yale University Press, 2000), pp. 85–115.

18. The story of the Mandylion stems from a conflation of the *Doctrina Addai* (Doctrine of Addai), an early written account in which Abgar's archivist Hanan does return to Edessa with a miracle-working portrait for his sovereign, with another by Eugarius (544–794) of the *acheiropoieton* Mandylion being sent instead of a painting after the archivist had been disabled by the blinding glory of Jesus in the painting. Han J. W. Drijvers, "The Image of Edessa in the Syriac Tradition," in *The Holy Face and the Paradox of Representation: Papers from a Colloquium Held at the Bibliotheca Herziana, Rome and the Villa Spelman, Florence*, ed. Herbert L. Kessler and Gerard Wolf (Bologna: Nuovo Alfa, 1998), pp. 14–40. See also Ducos, "The Orient and Rembrandt's Redefinition of Christ Iconography," this volume.

19. Herbert L. Kessler and Gerhard Wolf, "Introduction," in *The Holy Face*, p. ix.

20. On indulgenced images—that is, ones purported to offer specific benefit or indulgence for prayer and devotion—see John Oliver Hand, "Salve sancta facies: Some Thoughts on the Iconography of the 'Head of Christ' by Petrus Christus," *Metropolitan Museum Journal*, vol. 27 (1992), pp. 7–18. On the dissemination of Byzantine imagery in the North, see Maryan W. Ainsworth, "À la façon grèce': The Encounter of Northern Renaissance Artists with Byzantine Icons," in *Byzantium: Faith and Power*, ed. Helen C. Evans, exh. cat. (New York: Metropolitan Museum of Art, 2004), pp. 545–54.

21. Annamarie Weyl Cahn, "The Holy Face of Laon," in *Byzantium: Faith and Power*, pp. 274–75.

22. Ringbom, *Icon to Narrative*, pp. 69–71, fig. 25. The earliest northern European illustration of the Sudarium, in Matthew Paris's (c. 1200–1259) illumination in Corpus Christi College, Cambridge University (MS.26), shows the neck of Christ.

23. The eyes of Christ and parts of the face of the Virgin were gouged out at some point prior to 1805, in the same manner that images were typically defaced during the iconoclastic riots of 1566 in Flanders and Holland.

24. Gary Schwartz, *Rembrandt: His Life, His Paintings* (New York: Viking, 1985), p. 284. The original Latin text of the letter reads: "Temporibus octouiani Cesaris Cum ex uniusis mudi / Partibus hii. Qui pro senatu populoq Romano preer-ant / Prouiciis, scriberent Senatoribus qui rome errant, novitates / Que occurrebant per mudi climata publius lentulus / In Iudea preses senatui populoq Romano. Eplam hanc / Misit cuius verba hec sunt videlicet / Apparuit temporibus nris et ad huc est homo magnae / Virtutis, Cui nomen est Cristus Jhesus, Qui dicitur a / Gentibus propheta veritatis, Quem eius discipuli / vocant filiu dei. Suscitans mortuos, Et sanans / Languores. Homo quidem statura procerus, Et. / Spectabilis,vultum habens venerabilem, Quem / Intuentes possunt diligere et formidare, Capillos habens nucis auellane pmature. Et / planos fere usq ad aures, Ab aurib vero crispos aliquatulum. / Ceruliores, Et fulgenciores ad humeris, Uentilantes. / Discrimen habens in medio capitis, iuxta morem. / Nasarenoru. Frontem planam. Et serenissima. / In facie sine ruga et macula aliqua. Qua rubor / Moderatus venuscat. Nasi et oris multa prors pre / hensio, Barbam ipus copiosam et capill concolorem / Non longa,sed in medio befurcata. Aspectu simplice / Et maturu. Ocul glaucis et claris existetib, Increpatioc terribilis. Et amonitione placid vis et amabil. Ylaris servata gravitate. qui nuq vis e ride.flere / Aute sic. In statura corporis ppagat et rect. Man / Hns et brachia visui delectabilia. In colloquio gravis / Rarus. Et modestus. Speciosus forma pfiliis homi. Hec epla in annalibus romanoru comperta est." See John Oliver Hand, Catherine A. Metzger, and Ron Spronk, *Prayers and Portraits: Unfolding the Netherlandish Diptych* (Washington, DC: National Gallery of Art, 2006), pp. 200–205 n. 1.

25. Hand, Metzger, and Spronk, *Prayers and Portraits*, pp. 202–3.

26. Holm Bevers recently attributed several drawings of New Testament subjects to Victors; see Bevers, "Drawings by Jan Victors: The Shaping of an Oeuvre of a Rembrandt Pupil," paper presented at the symposium *Drawings by Rembrandt and His Pupils: Telling the Difference*, J. Paul Getty Museum, Los Angeles, February 2, 2010. For Victors's career, see Debra Miller, "Jan Victors" (Ph.D. diss., University of Delaware, 1985).

27. Volker Manuth, "Denomination and Iconography: The Choice of Subject Matter in the Biblical Paintings of the Rembrandt Circle," *Simiolus* 22 (1993–94), pp. 235–52.

28. Walter Melion, "Pictorial Artifice and Catholic Devotion," in *The Holy Face and the Paradox of Representation*, p. 334.

29. See Peter Schatborn's entries in Christie's London, July 8, 2003, no. 100, and January 24, 2008, lot 144. Our thanks to Martin Royalton-Kisch for pointing these drawings out to us.

30. Martin Royalton-Kisch has suggested that the figure is playing cards in these drawings, although in the Habolt version his block-like hands, in the identical pose, are more clearly folded on an object in his lap. Remarks made at the symposium *Drawings by Rembrandt and His Pupils: Telling the Difference*, J. Paul Getty Museum, Los Angeles, February 2, 2010.

31. H.-M. Rotermund, "The Motif of Radiance in Rembrandt's Biblical Drawings," *Journal of the Warburg and Courtauld Institutes*, vol. 15, nos. 3 and 4 (1952) pp. 101–21.

32. "Jeremias de Decker," www.dbnl.nl/auteurs/auteur.php?id=deck001 (accessed January 31, 2009).

33. Belting, *Likeness and Presence*, pp. 1–2.

34. John Nash, "The Presentation of 'Soul' by Rembrandt," in *Presence: The Inherence of the Prototype within Images and Other Objects*, ed. Rupert Shepherd and Robert Maniura (Aldershot, UK: Ashgate, 2006), p. 198. See also Gottwald, this volume.

35. Ironically, the sixth-century Christian historian Theodorus Lector recounted the story of a painter who had sought to give Christ the features of Zeus, whereupon his hand withered. Belting, *Likeness and Presence*, p. 134.

36. W. A. Visser t'Hooft, *Rembrandt and the Gospel* (Philadelphia: Westminster Press, 1957), p. 31.

37. William H. Halewood, "Rembrandt's Low Diction," *Oud Holland*, vol. 107 (1993), p. 293.

38. Seymour Slive, *Rembrandt and His Critics, 1630–1730* (The Hague: M. Nijhoff, 1953) pp. 91, 92, 99, 112–13.

39. Samuel van Hoogstraten, *Inleyding tot de hooge schoole der schilderkonst* (Amsterdam, 1678), p. 105. Van Hoogstraten instructed his readers to combine all of Christ's virtues in their images, very much in the spirit of the Lentulus description that follows his advice in this text.

40. Recently, some authors have gone so far as to claim that Rembrandt himself followed the Lentulus description entirely, without reference to a living model. However, the hair in the sketches shows no trace of the red or blonde highlights specified in the letter, Christ's beard is neither large nor full, his skin and forehead show no evidence of ever having been fair, and his eyes are not particularly commanding, but rather sympathetic. See Mirjam Alexander-Knotter, Jasper Hillegers, and Edward van Voolen, *De 'Joodse' Rembrandt: de mythe ontrafeld*, exh. cat. (Amsterdam: Joods Historisch Museum, 2006), pp. 54–55; Schwartz, *The Rembrandt Book*, p. 303. Schwartz surmised that Rembrandt was using Jews to model Christ "as a tool to approximate the description of Christ in a famous historical fraud that was still believed in his time, the letter of Lentulus." See also Teresa P. Kubissa, "Cabeza de Cristo," in *Rembrandt, pintor de historias*, ed. Alejandro Vergara, exh. cat. (Madrid: Museo del Prado, 2008), p. 182; and Arthur Wheelock, Jr., et al., *Rembrandt's Late Religious Portraits*, exh. cat. (Washington, DC: National Gallery of Art; Chicago: University of Chicago Press, 2005), p. 91. On the tradition of using the letter in early Northern art, see Hand, Metzger, and Spronk, *Prayers and Portraits*, pp. 200–205.

41. "Alle deze aerdigheden vloeyen uyt de fonteyne der lees gierigheyts." Philips Angel, *Lof der schilderkonst* (Leiden, 1642), p. 48 (translation mine).

42. Ibid., pp. 45–46.

43. Franz Landsberger, "Rembrandt and Josephus," *Art Bulletin*, vol. 36, no. 1 (March 1954), p. 62. Rachel Wischnitzer suggested that Rembrandt was unable to read the text and only used the plates. Rachel Wischnitzer, "Rembrandt, Callot and Tobias Stimmer," *Art Bulletin*, vol. 39, no. 3 (September 1957), p. 230.

44. Shelley Perlove, "An Irenic Vision of Utopia: Rembrandt's 'Triumph of Mordecai' and the New Jerusalem," *Zeitschrift für Kunstgeschichte*, vol. 56, no. 1 (1993), pp. 41–46.

45. In using optics and lenses, Johannes Vermeer also sought to make his art more truthful to nature. See Arthur K. Wheelock, Jr., and Cees Kaldenbach, "Vermeer's 'View of Delft' and His Vision of Reality," *Artibus et Historiae*, vol. 3, no. 6 (1982), p. 17. See also Arthur K. Wheelock, Jr., *Perspective, Optics, and Delft Painters around 1650* (New York: Garland, 1977).

46. Schwartz, *Rembrandt: His Life, His Paintings*, p. 284; see also Schwartz, *The Rembrandt Book*, p. 100.

47. Eduard Kolloff, "Rembrandt's Leben und Werke, nach neuen Actenstücken und Gesichtspunkten geschildert," *Historisches Taschenbuch*, vol. 5 (1854), pp. 401–582; cited in Michael Zell, *Reframing Rembrandt: Jews and the Christian Image in Seventeenth-Century Amsterdam* (Berkeley: University of California Press, 2002), p. 43.

48. Franz Landsberger, *Rembrandt, the Jews, and the Bible*, trans. Felix N. Gerson (Philadelphia: Jewish Publication Society of America, 1946), p. 118.

49. Erwin Panofsky, "Rembrandt und das Judentum" (1920), reprinted in *Jahrbuch der Hamburger Kunstsammlungen*, vol. 18 (1973), pp. 98–99. Panofsky felt that the Jesus sketches grasped something divine in the collective unconscious. Anna Seghers was drawn to the humanity of the figures and saw them as portraits. See Netty Reiling (Anna Seghers), *Jude und Judentum im Werke Rembrandts* (1933; reprint, Leipzig: Reclam, 1983), cited in Helen Fehervary, *Anna Seghers: The Mythic Dimension* (Ann Arbor: University of Michigan Press, 2001), p. 60.

50. Zell, *Reframing Rembrandt*; Schwartz, *Rembrandt: His Life, His Paintings*; Nadler, *Rembrandt's Jews*.

51. Zell, *Reframing Rembrandt*, pp. 47–48. A 1719–20 biography of the painter Adriaen van der Werff (1659–1722), written by his son-in-law, for example, notes that Rembrandt sketched the Jews on his street.

52. Christian Tümpel and Astrid Tümpel, *Rembrandt: Mythos und Methode* (Königstein: Langewiesche, 1986), p. 106.

53. Zell, *Reframing Rembrandt*, pp. 86–88. Zell notes the dominance of the Christian vision of Messianism in this dialogue.

54. Ibid., p. 60.

55. Menasseh's book *The Hope of Israel* (London, 1650) posited that the Jewish colonization of all corners of the earth would bring about the coming of the Messiah, and he personally set about negotiating with Oliver Cromwell and the British Parliament the establishment of a colony in London, where Jewish immigration had to that point been banned. Zell, *Reframing Rembrandt*, p. 95.

56. Nadler, *Rembrandt's Jews*, pp. 144–46.

57. The oft-cited dispute between Rembrandt and his Jewish neighbor Daniel Pinto, for example, differs little from his interactions with many of his clients during this period. As Paul Crenshaw recounts in his study of Rembrandt's bankruptcy, in 1653 Pinto began the process of leveling the foundation walls of his home. The procedure, an inescapable aspect of a city built on pilings, was usually undertaken jointly by owners of buildings with shared walls. Rembrandt, however, was in severe financial difficulty at this time, brought on mostly by his profligate collecting of art and curiosities, and had not contributed a payment to his mortgage in four years. He was unable to pay for his share of the costs, and Pinto eventually sued him, having failed to secure the contribution from the holder of Rembrandt's mortgage, Christophel Thijs, who then called the loan from Rembrandt. Meanwhile, Pinto continued to rent Rembrandt's cellar for storage; evidence that their dispute remained a financial one. It was Cornelis Witsen, from whom Rembrandt eventually secured a loan whose conditions he could not meet, who forced the artist into bankruptcy in 1656, not Pinto. See Christian Tümpel, "Traditional and Groundbreaking: Rembrandt's Iconography," in Ernst van de Wetering et al., *Rembrandt: Quest of a Genius*, exh. cat. (Amsterdam: Museum het Rembrandthuis,

2006), pp. 128–34; Paul Crenshaw, *Rembrandt's Bankruptcy* (Cambridge: Cambridge University Press, 2006), pp. 50, 51.

58. See Menachem Wecker, "Jacob van Ruisdael Is Not Jewish," *Forward*, October 21, 2005, archived at www.forward.com/articles/2116/ (accessed January 5, 2009).

59. Zell, *Reframing Rembrandt*, p. 40. The group that met in Menasseh's Amsterdam home in December 1674 included the Walloon Protestant minister Petrus Serrarius and the Bohemian Protestant theologian D. Paul Felgenhauer. Their dialogue about the messianic future was published as *Bonum Nuncium Israeli*, which appeared a few months before Menasseh's *Piedra*.

60. Schwartz, *The Rembrandt Book*, p. 304.

61. Jan Vos, *Alle de gedichten van Jan Vos*, vol. 1 (Amsterdam, 1672), p. 326, quoted in Zell, *Reframing Rembrandt*, p. 57. As Schwartz, *Rembrandt: His Life, His Paintings*, p. 284, notes, the notary de Wijze was an art collector.

62. Visser t'Hooft, *Rembrandt and the Gospel*, p. 15.

63. Ibid., pp. 60–70.

64. Christopher Richard Joby, *Calvinism and the Arts: A Reassessment* (Leuven: Peeters, 2007), pp. 145–52.

65. Erika Doss, "Making a 'Virile, Manly Christ': The Cultural Origins and Meanings of Warner Sallman's Religious Imagery," in *Icons of American Protestantism: The Art of Warner Sallman*, ed. David Morgan (New Haven: Yale University Press, 1996), pp. 61–94. See also Judith F. Dolkart, *James Tissot: The Life of Christ* (Brooklyn: Brooklyn Museum of Art, 2009), p. 20.

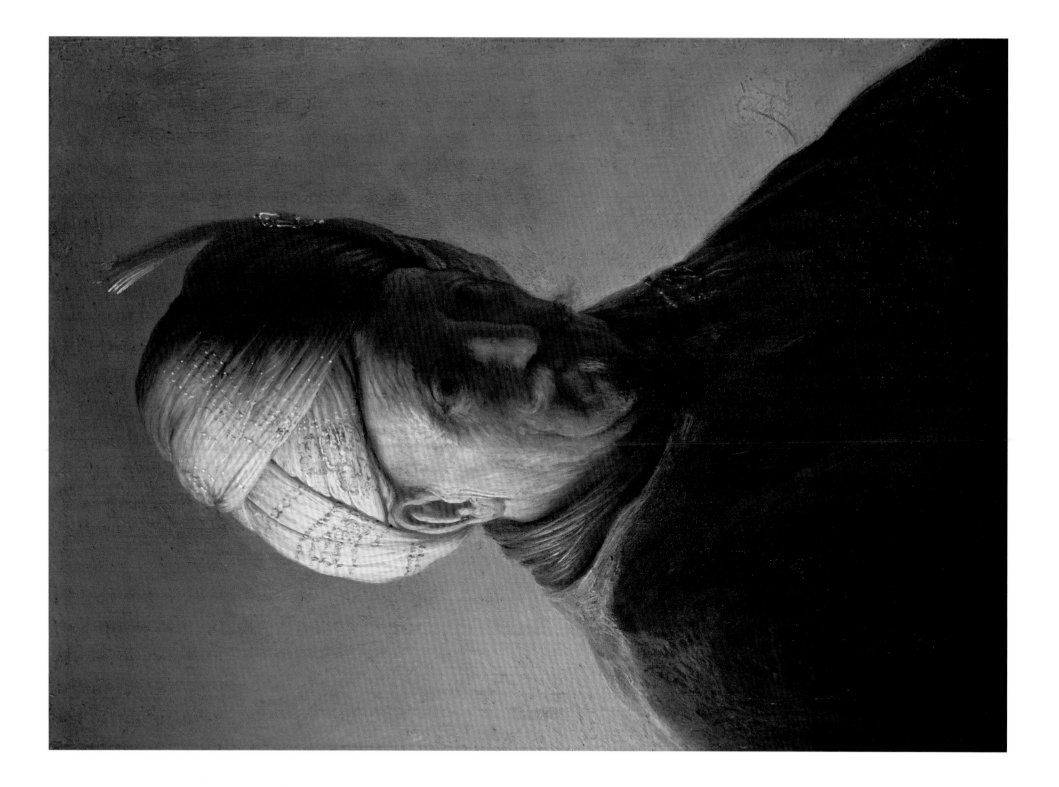

The Heads of Christ in the Context of the *Tronie*

Franziska Gottwald

The two entries for a "Cristus tronie van Rembrant" (head of Christ by Rembrant) as well as one for a "Cristus tronie nae 't leven" (head of Christ from life) in Rembrandt's inventory of 1656 have long been linked by art historians to the group of head studies of Christ produced by Rembrandt and his circle beginning in the second half of the 1640s (see plates 2.2–2.8).[2] The contemporary designation of the single-figured heads and busts of Christ as *tronies* raises the question of whether these panels should be assigned to the Dutch painting genre of the same name, with which these works share intriguing parallels.

The word *tronie* meant "head" or "face" in seventeenth-century Dutch and was used in other inventories from the period to describe paintings that showed a single head or bust. Its current use in the art-historical context to refer to an independent genre dates to the 1960s, when Justus Müller Hofstede began to designate as *tronies* oil studies of heads made by Peter Paul Rubens (1577–1640) in preparation for large history paintings.[3] Albert Blankert, in his 1982 book on Rembrandt's pupil Ferdinand Bol (1616–1680), applied the term to the "Character- or Fantasy-heads"—independent depictions of heads and busts in costume—made by Rembrandt and his pupils and followers for sale on the open market.[4] Thus, the term *tronie* has been applied both to head studies made in preparation for history paintings and to a distinct, autonomous pictorial type produced by Rembrandt (fig. 5.1), his pupils, and his followers.[5] The single-figured representations of Christ discussed here illuminate this semantic problem, which in turn has implications for whether we interpret these panels as oil studies for larger paintings or as independent works of art.

To address this question, we must first define the pictorial type known as the "character head," or *tronie*. Paintings designated as *tronies* in the art-historical literature typically are based on a live model and concentrate on the human face, thus fulfilling two criteria of portraiture; however, rather than being a portrait of a specific individual, these works are intended to represent an established character type, costume, or emotional state, and thus relate to the practice of narrative or history painting.[6] With its focus on the human head, the *tronie* descended from sixteenth-century Flemish head studies produced as *modelli*, small-scale preparatory paintings to be worked into the compositions of history paintings.[7] But while these Flemish precedents functioned as tools in the production process, the *tronies* of the seventeenth century form an independent genre. Rembrandt, together with his compatriot of the Leiden years, Jan Lievens (1607–1674), can be

Fig. 5.1. Rembrandt Harmensz. van Rijn, *Head of an Old Man with Turban*, c. 1627–28. Oil on panel, 10⁷/₁₆ × 7⁷/₈ inches (26.5 × 20 cm). Collection Fondation Aetas Aurea

Fig. 5.2. Peter Paul Rubens (Flemish, 1577–1640), *Head of a Youth*, c. 1601–2. Oil on paper, mounted on panel; 13¾ × 9⁵⁄₁₆ inches (34.9 × 23.4 cm). Blanton Museum of Art, University of Texas at Austin, The Suida-Manning Collection

Fig 5.3. Jan Lievens (Dutch, 1607–1674), *Young Man Wearing a Beret*, c. 1627–29. Oil on oak panel, 19⅜ × 14⅞ inches (49.2 × 37.8 cm). North Carolina Museum of Art, Raleigh, Gift of Mr. Benjamin Katz, G.57.28.1

credited with converting the Flemish head study into this distinct pictorial type. It was Lievens who adopted Rubens's head studies (fig. 5.2) as a direct model for his own depictions of heads and busts (fig. 5.3). The broad brushwork that characterizes Lievens's early *tronies* is still reminiscent of the Flemish model, while the high degree of completeness and careful composition—for example, the positioning of the figure in the pictorial frame, the evocation of light, and the background conjuring depth—already indicate the independent nature of the picture.[8] Rembrandt, who after studying with Pieter Lastman (1583–1633) aligned himself with the more experienced Lievens, began to apply specific narrative elements such as an elaborate costume or the evocation of a mental state, or both, to his *tronies* (see fig. 5.1), expansions that definitively liberated this pictorial type from the oil sketch. Unlike Flemish oil studies, the *tronies* in Rembrandt's oeuvre are finished and, in most cases, signed depictions of heads or busts that did not remain in the studio, as head studies generally did.

Instead, like the many other painting genres that developed in the Netherlands in the first half of the seventeenth century, the single-figured *tronie* was bought and sold on the open market.[9] As Ernst van de Wetering has made clear, over the course of the century the interpretive significance of these images increasingly took a subordinate role, as patrons often purchased *tronies* on the basis of the artist's fame and as evidence of their own elevated connoisseurship.[10] With a *tronie* by Rembrandt, a so-called *liefhebber van de schilderkonst* (lover of the art of painting) could acquire a

work of art that brought together various qualities of the painter's other works—the naturalistic representation of the human face, the careful and elaborate rendering of a costume or an emotional state—but, as a single-figured and often small-format piece, was typically lower in price than a history painting or portrait.[11] Furthermore, because of its origins in the oil study, a *tronie* could be carried out in a rather loose, sketchy style that lent the picture a more informal, immediate quality.

This essay discusses Rembrandt's heads of Jesus in the context of the genre of the seventeenth-century Dutch *tronie*. Like these "character heads," the small panels of Christ produced by Rembrandt and his studio were probably based on a live model[12]—as is demonstrably the

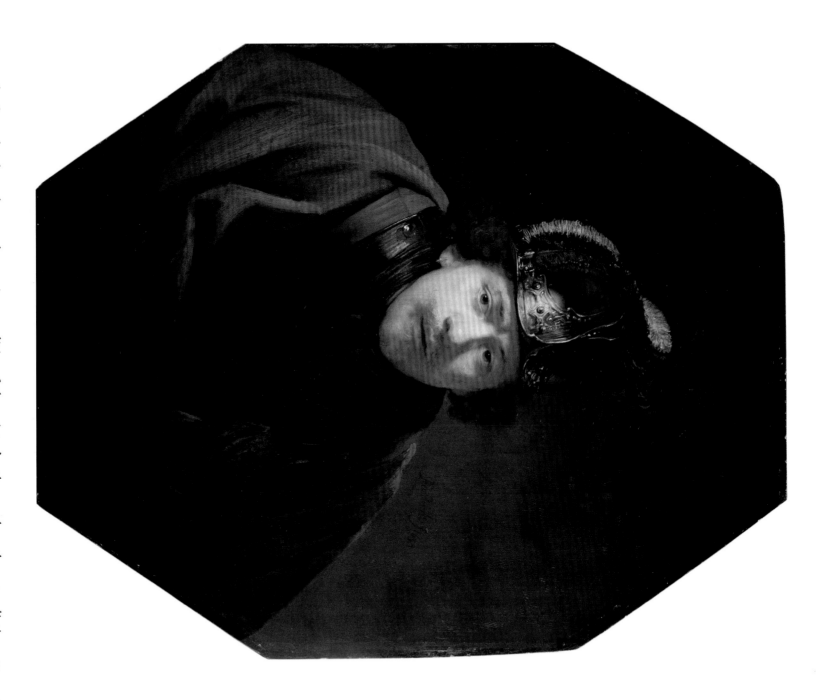

Fig. 5.4. Rembrandt Harmensz. van Rijn, *Self-Portrait with Helmet*, 1634. Oil on panel, 31¾ × 26 inches (80.5 × 66 cm). Staatliche Museen Kassel, Gemäldegalerie Alte Meister

THE *TRONIE* AS PAINTING GENRE

The meaning of the word *tronie* in the context of Netherlandish visual arts in the sixteenth and seventeenth centuries has been studied thoroughly and calls for only a brief summary here.[13] The term comprises the oldest known designation in Dutch for "head" and "face," as well as for "facial expression."[14] While in the literature—for example, in Karel van Mander's *Schilder-Boeck* (1604)[15]—*tronie* indicates the human head and face, in probate inventories from this period the term also describes the subject matter of paintings. The entry "Een out mans tronie, sijnde 't conterfeytsel van de vader van Mr Rembrandt" (A head of an old man, the likeness of Mr. Rembrandt's father)[16] in a Leiden inventory from 1644 thus indicates that the painting in question is not a portrait, but a rendering of a head *based upon* the appearance of the artist's father. In some cases, such descriptions may not tell us to which genre the work belongs. "Een tronie van Maria" (A head of Mary),[17] for example, could refer to a head study for a multi-figured history painting, or to a single-figured painting of the Mother of God. A similar ambiguity is presented by the designation "head of Christ" given to the three works in the 1656 inventory of Rembrandt's insolvent estate. There we find two panels called "head of Christ by Rembrandt" and a third labeled as "head of Christ from life." While these entries mention the subject, they say nothing about whether the works are traditional icon-like images of Jesus or oil sketches.[18]

As noted, only recently have art historians used the term *tronie* to distinguish a genre of works created by Rembrandt and his circle.[19] Counted among these are single-figured depictions of human heads or busts that cannot clearly be assigned to portraiture, narrative or history painting, or the category of "study heads."[20] Because the *tronie* shares traits with all of these genres, it is not always easy to make a definitive categorization. Consider, for example, Rembrandt's *Head of an Old Man with Turban* of about 1627–28 (see fig. 5.1), the earliest known *tronie* by the master. The detailed and convincing rendering of the tightly framed, wrinkled face attracts immediate notice, clearly indicating that the work was painted "from life," that is, from a model directly in front of Rembrandt. As Rembrandt's early admirer Constantijn Huygens (1596–1687) noted, a "head of a Dutchman" formed the basis for this *tronie* as well as others representing the same old man, regularly taken to be the artist's father.[21] Its evidently realistic depiction of facial features also fulfills one of the most important criteria of portrait painting, namely, a memorializing likeness of the subject.[22]

Despite its use of a live model and focus on the face, the *Head of an Old Man with Turban* is clearly not a commissioned portrait, as is obvious from three other compositional characteristics. First, the man has a downward-directed gaze, rather than the portrait sitter's customary glance toward the viewer.[23] Second, the Oriental costume, including a turban of light gold embroidery and translucent material, as seen in various Old Testament scenes by Rembrandt, points to a narrative connection. The same applies to Rembrandt's casting of the face in complete shadow, instead of

case with the old man depicted in Rembrandt's earliest known *tronie* (see fig. 5.1). In the panels of Christ the figure is also shown with an engaged facial expression—a slightly opened mouth (see, e.g., plates 2.2, 2.3, 2.5, 2.6) or an averted or unfixed gaze (see, e.g., plates 2.2, 2.7, 2.8, 2.10) as in other *tronies* by the master, such as the so-called *Self-Portrait with Helmet* (fig. 5.4). However, a closer examination reveals that these heads of Christ by Rembrandt do not possess all of the criteria of the *tronie*, as will be explained below.

depicting readily recognizable features, thereby suggesting a narrative context that calls for an expressive fall of light. Van de Wetering has posited that the *Head of an Old Man with Turban* was created in connection with Rembrandt's 1629 history painting *Judas Returning the Thirty Pieces of Silver* (fig. 5.5).[24] Nonetheless, it is not a head study in the classical sense of a sketch or *modello* (see fig. 5.2) but rather a finely executed, finished, and signed virtuoso work that must have been intended for sale.[25] Because the figure in a *tronie* is not decisively identified with a specific historical personage, it can be interpreted as a vehicle to convey a typological allusion such as Youth, Old Age, Wisdom, Sorrow, Faith, or even Transience, as Van de Wetering has proposed.[26] The artist might also employ the costumed figure in a *tronie* to elicit an exotic or military tone, or simply to foreground the painterly performance of its execution.[27]

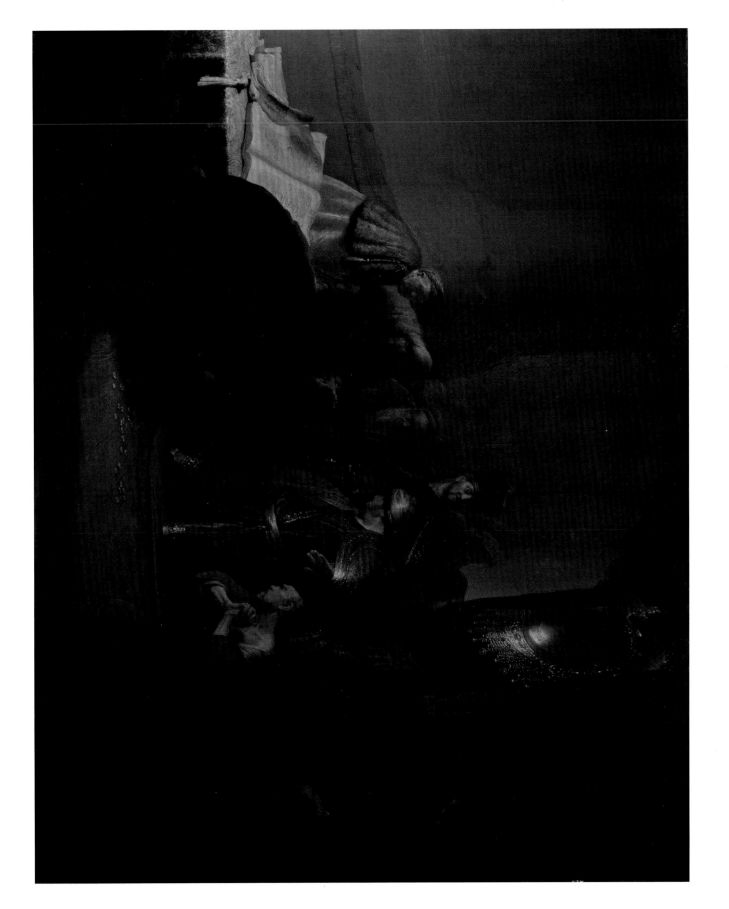

Fig. 5.5. Rembrandt Harmensz. van Rijn, *Judas Returning the Thirty Pieces of Silver*, 1629. Oil on panel, 31¹¹⁄₁₆ × 40⁵⁄₁₆ inches (79 × 102.3 cm). Private collection

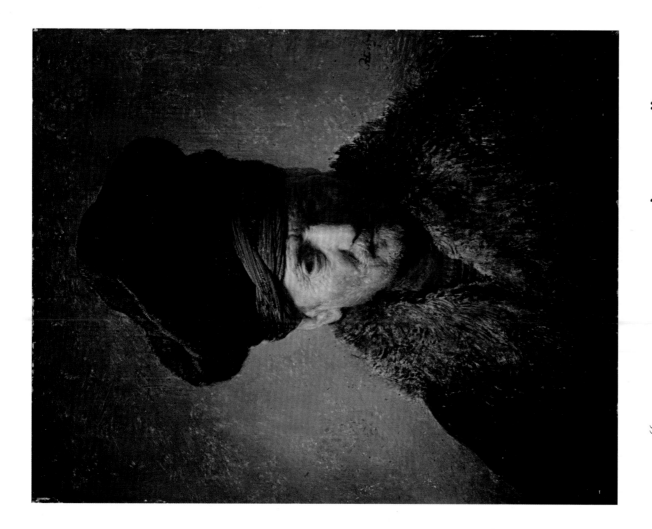

Fig. 5.6. Rembrandt Harmensz. van Rijn, *Bust of an Old Man in a Fur Cap*, 1630. Oil on panel, 8¾ × 6⅞ (22.2 × 17.7 cm). Tiroler Landesmuseum Ferdinandeum, Innsbruck

"CRISTUS TRONIE NAE 'T LEVEN"

The single-figured depictions of Christ (see plates 2.2–2.11) at first appear to follow the three criteria for the *tronie* discussed above: a tight framing of the face, an averted or unfixed gaze, and a connection to narrative or history painting. In a comparison of the panel in the Museum Bredius, The Hague (see plate 2.8), with one of Rembrandt's early *tronies*—*Bust of an Old Man in a Fur Cap* of 1630 (fig. 5.6)—the formal similarities become clear: the paintings have nearly the same format; the figures are both busts that fill the frame; and the heads are turned and lean slightly forward. Furthermore, the unfocused gaze of both figures suggests immersion in thought, or a kind of interiority. The figure in Rembrandt's *tronie* of 1630 is, moreover, outfitted with a cloak with a fur collar and a tall fur hat, the latter resembling the *kolpak* worn by Polish Jews for centuries.[28] A comparable head covering appears in his *Judas Returning the Thirty Pieces of Silver* (see fig. 5.5), underscoring the connection between the *tronie* and history painting. Much the same can be said for the heads of Christ: the simple brown or reddish-brown garment worn in all examples can be found in at least two painted biblical scenes by Rembrandt: *The Supper of Emmaus* of 1648 (see plate 1.1) and *Christ and the Woman Taken in Adultery* of 1644 (see plate 3.6).

At this point, however, differences begin to emerge that clearly distinguish Rembrandt's heads of Christ from his *tronies* such as *Bust of an Old Man in a Fur Cap*. While the costume in the 1630 *tronie* does not point to a recognizable historical figure, Jesus is identifiable in the later panels by his beard, hairstyle, and sober and primitive costume, which tap into the traditional iconography of Christ.[29] Moreover, details in *tronies* are typically rendered with care and lend a *schilderachtig*,[30] or picturesque, quality to these finished works of art; this can be seen in the old man's face in the 1630 work, where the signs of age are rendered with a precision that underscores the special mastery of the artist. No such meticulousness is manifested, however, in the broad and, in parts, sketchy execution of the costume and especially of the face of Christ in the panels. In the youthful visage of

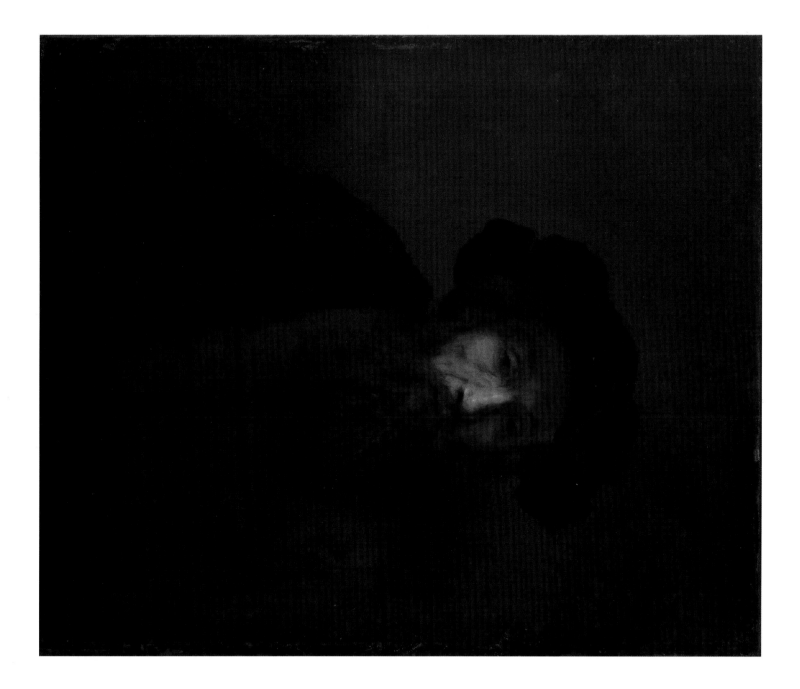

Fig. 5.7. Rembrandt Harmensz. van Rijn, *A Bearded Man in a Cap*, c. 1655. Oil on canvas, 30¹⁵/₁₆ × 26¼ inches (78 × 66.7 cm). The National Gallery, London, NG190. Photograph © National Gallery, London / Art Resource, NY

Jesus, the even features are formed with a broad, thick application of paint typical of Rembrandt's later finished work, as well as his studies.[31] In contrast, even in a *tronie* from about 1655 (fig. 5.7), only slightly later than the heads of Christ, and carried out with a broader brush handling than the earlier examples of the genre, the velvet beret, cloak, and simple undergarment, along with the beard and facial topography, are more solidly modeled and give a stronger impression of form and surface.

It is also useful to compare the heads of Christ to Rembrandt's later single-figured depictions of Christ, such as the examples now in the Alte Pinakothek in Munich and the Hyde Collection in Glens Falls, New York (see plates 4.2, 4.3). These half-length representations, both from around 1661, are much more completely finished than the heads of Christ from the 1640s and 1650s, probably because the former are history paintings[32] for which three of the "heads" could have served as studies—a fact that once again clarifies the difference between the heads of Jesus and the *tronie*. The physiognomy of the Munich Christ, for example, may have been based on the panel in the Museum Bredius (see plate 2.8), while the image of Jesus in the Hyde Collection relates both to the bust of Christ in the Berlin Gemäldegalerie and, in its composition and pose, to the head of Jesus in Detroit (see plates 2.6, 2.7).

As noted by Lloyd DeWitt, the heads of Christ are painted with a range of sketchy handling and vary only slightly with respect to composition. It is therefore likely that these pictures are studies that Rembrandt completed with single- or multi-figured history paintings in mind (see plates 1.1, 2.7, 4.2).[33] Herein lies the explanation for their formal similarities to the *tronie*, whose development, as noted, can be traced to Flemish head studies of the previous century. A preparatory oil study such as the *Head of a Youth* (see fig. 5.2) by Rubens likewise displays rough and broad brushstrokes, with the face finished with greater clarity than the vaguely indicated mantle. Rubens painted his studies after models, who were likely selected with a particular narrative connection in mind, and whose appearance was in the process adjusted to fit an existing iconographic type. This figure served as a template for the boy who appears to turn around spontaneously in the large-format painting *The Mocking of Christ* of 1601–2 (Cathédrale Notre-Dame du Puy, Grasse). The boy's appearance is probably based on an Italian model whose features have been transformed according to the Caravaggesque style of Rubens's early years in Italy.[34]

A comparable process can be reconstructed in Rembrandt's practice. The existence of a drawing (see plate 4.9) of a figure similar to the one in the panels of the head of Christ, in bust length and with head inclined forward, strongly suggests that he used a model for both the drawings and the panels.[35] Peter Schatborn has suggested a date of the early 1650s for the drawing,[36] slightly later than the paintings under discussion. Even so, Rembrandt may have used the same model as a point of departure for his images of Jesus. This downturned face appears in the heads of Christ in the Fogg and Bredius museums (see plates 2.5, 2.8), as well as turned in the opposite direction in the examples in Philadelphia and Berlin (see plates 2.2, 2.6). Furthermore, the outward appearance of the roughly sketched figure in the drawing, with its long, wavy hair and short, dense beard, corresponds with that of the figure in all of the Christ sketches by Rembrandt and his pupils and followers. At the same time, however, the face in the drawing is indicated with only a few chalk strokes, so that it remains uncertain whether Rembrandt drew on a living model for his physiognomy of Jesus.

Because of the listing of a "Cristus tronie nae 't leven" (head of Christ from life) in the inventory of 1656, many art historians have assumed that Rembrandt's heads of Christ must have

been based on a model.[37] A closer look at the inventory, however, reveals a distinction between this "head"—the only one described as being from life—and the other two referenced there. The inventory lists objects according to their location in the house. While the other two "heads of Christ" are included with paintings in the larger spaces,[38] the "head of Christ from life" was found in the "small studio, . . . in the fifth bin," among objects that were primarily sculptures or casts either from living models ("17 hands and arms, cast from life") or from antique statues, such as a "plaster cast of a Greek antique" or a "satyr's head [*tronie*] with horns."[39] That the Dutch word *tronie* could indicate not only a two-dimensional work but also a sculpture is demonstrated by an Amsterdam inventory entry from the year 1665: "A head [*tronie*] of plaster."[40] The "head of Christ from life" in the small studio thus could have been a sculpture done after a model as much as it could have been a painted study. However, it appears unlikely that a plaster head of Jesus would be described as made "from life," raising the question of whether the entry can even serve as evidence for or against the use of a model for the oil sketches of Christ.

Yet another reason that this inventory entry is important for the connection between study and *tronie* is the fact that the descriptor "nae 't leven" (from life) was added, but not the qualification "by Rembrandt" (as with the two other studies). This clearly indicates that the representation in question was a study that was either not executed by the master or not intended for sale, and that its authorship played no role in its evaluation for the purpose of the inventory. Furthermore, this "Cristus tronie" was not displayed like a *tronie* in the sense of a virtuoso head, but rather was included in a bin with other tools of the trade that Rembrandt deployed to enhance the authenticity of his depictions,[41] and thus was most likely a sketch that served as a departure point for larger compositions.

Let us look once more at both of the early *tronies* by Rembrandt mentioned above (see figs. 5.1, 5.6). In executing these paintings, the artist was especially careful in rendering the topography of the face, as he saw it in front of his eyes. Even though Rembrandt likely used a model for his representations of Christ, he seems to have slightly idealized the features compared to those in his *tronies*. This difference can be explained by both the rougher brushwork and the youthfulness of the figure of Jesus, which the artist rendered using long, thin brushstrokes. As DeWitt has demonstrated (this volume), Rembrandt's heads of Christ constitute a radical break with tradition: the artist adopted neither the influential (though apocryphal) description of Jesus in the so-called Lentulus letter, nor the frontal, iconic pose of early Netherlandish painting. Precisely in the core group of Christ sketches (see plates 2.2–2.8), the figure appears subtly enlivened in that it is turned on its axis in the one case (see plate 2.6), and shown with slightly opened mouth and inwardly directed gaze in the other (see plate 2.5). While these aspects indeed point to the use of a live model, we cannot overlook the simple costume, hair, and beard, all of which largely follow the tradition for representing Jesus.[42]

It is this idealization of Christ, however restrained or limited, that marks the decisive distinction between the head study and the *tronie*—namely, that the *tronie* offers the appearance of a model, while the head study nearly always follows the established iconography and types of narrative or history painting.[43] Because Rembrandt did not exclusively render the individualized features of a model for his heads of Christ, but rather drew on an iconographic tradition by which the figure became recognizable as Jesus, these works cannot be regarded as *tronies*, even though they

share characteristics of the genre, such as a smaller scale, a tight framing of the head or bust, an unfixed gaze, and a connection to history painting. These commonalities can be explained by the origins of the *tronie* in the head study, and they make clear that despite his role in developing this new pictorial category, when inventing types for history paintings, such as the heads of Christ, Rembrandt continued to adhere to conventional studio practice.

REMBRANDT'S OIL STUDIES

The sketches in oil that Rembrandt completed for finished paintings or etchings constitute a small and little-discussed group within the oeuvre of the artist.[44] They include a few heads and half-length figures that, as in Flemish workshops of the sixteenth and early seventeenth centuries, served as preparations for figures in large compositions. The process by which these head studies were produced remains elusive, as the autograph pictures cannot always be distinguished from the studio copies. Furthermore, as Van de Wetering has reconstructed, some of the heads and busts that can be connected to finished paintings by Rembrandt were in fact partial copies of compositions by the master made by his students as part of their instruction.[45]

It is not always obvious whether such sketches were produced as "workshop tools" for the production process, as the heads of Christ demonstrate. Only with a more precise analysis can some of these preparatory heads and busts be definitively distinguished from Rembrandt's *tronies*. Although the panels of Christ by Rembrandt and his studio are today referred to as head studies, it is evident that none were translated directly into figures in finished paintings—as were, for example, works produced in Rubens's studio—and often no connection to a completed composition can be found. Even the preparatory studies that Rembrandt made for his portraits were transformed substantially on the way to the finished painting.[46] It is thus possible to relate the so-called *Falconer (St. Bavo)* of about 1661 (Konstmuseum, Gothenburg), which can be called a *portrait histo-rié*, to a loosely painted representation of the same man (Statens Museum for Kunst, Copenhagen) that differs in composition and execution from the end product. In the study, not only is the figure sketched in broader and more fluid brushstrokes than in the finished painting, but the three-quarter angle is "turned" into a view *en face*. Whereas a portrait sketch needed primarily to record the appearance of the sitter, other paintings by Rembrandt that have been termed head studies served to solve painterly problems, in large part by simulating a complicated and difficult lighting scenario. The unsigned *Lighting Study of an Old Man in Profile* (Agnes Etherington Art Centre, Kingston, Ontario), for example, executed wet-in-wet, has been interpreted by Van de Wetering as a simulation of the organization of light and shadow for two figures in profile and lit from behind in *The Circumcision in the Stable* of 1661 (National Gallery of Art, Washington, DC).[47]

A similar practice should be understood for the heads of Christ. The panel in Berlin (see plate 2.6), for example, could have served to establish the appearance of the figure of Christ, developed from a drawing of a live model, including its specific facial expression (reflective and turned inward). On the other hand, the study simulates a lighting scenario that draws the inverted-triangular facial surface out of the surrounding dark beard and hair. While the Hyde Collection painting (see plate 4.3), for which the Berlin painting may have served as a study, shows a different position of the head, nonetheless the face and its inwardly turned expression are brought forward by a strong frontal light source that contrasts sharply with the dark hair. This relationship to the

finished work distinguishes the studies by Rembrandt from those by the Flemish masters. While the Flemish oil studies were primarily made to be copied into compositions by assistants and pupils, Rembrandt's were designed to address painterly problems, leaving the master greater freedom in the translation to the larger composition.

The proximity of the studies of Christ to the *tronie*, observed primarily in the immediacy of the representation and the element of painterliness, must also have been noted by the artist's contemporaries. Not only did two "Cristi tronie van Rembrant" decorate Rembrandt's private space (see DeWitt, this volume), but two other Dutch painters, Jan van de Cappelle (1626–1679) and Cornelis Dusart (1660–1704), had heads of Christ by Rembrandt registered among their possessions.[48]

1. Walter L. Strauss and Marjon van der Meulen, *The Rembrandt Documents* (New York: Abaris Books, 1979), pp. 361 (docs. 115, 118) and 383 (doc. 326).

2. While the Rembrandt Research Project has rejected all of the heads of Christ as authentic paintings by Rembrandt, some scholars have argued that the panel in Berlin (see plate 2.6) was painted by Rembrandt. The attribution of the core group of panels remains the subject of debate among Rembrandt scholars. See Tucker, DeWitt, and Sutherland, this volume. See also Walter Liedtke et al., *Rembrandt / Not Rembrandt in the Metropolitan Museum of Art: Aspects of Connoisseurship*, exh. cat. (New York: Metropolitan Museum of Art, 1996), vol. 2, p. 122, cat. 35; Albert Blankert et al., *Rembrandt: A Genius and His Impact*, exh. cat. (Melbourne: National Gallery of Victoria; Sydney: Art Exhibitions Australia; Zwolle, Netherlands: Waanders, 1997), p. 197, cat. 31; and Ernst van de Wetering et al., *Rembrandt, ein Genie auf der Suche*, exh. cat. (Berlin: Gemäldegalerie, Staatliche Museen zu Berlin, 2006), pp. 356–57, cat. 57 (entry by Katja Kleinert).

3. Justus Müller Hofstede, "Eine Kreidestudie von Rubens für den Kreuzaufrichtungsaltar," *Pantheon: Internationale Zeitschrift für Kunst*, vol. 25 (1967), pp. 35–43.

4. Albert Blankert, *Ferdinand Bol (1616–1680): Rembrandt's Pupil* (Doornspijk, Netherlands: Davaco, 1982), pp. 26–27.

5. In the text that follows, only these autonomous representations will be designated as *tronies*.

6. About the *tronie*, see Frederic Schwartz, "The Motions of the Countenance: Rembrandt's Early Portraits and the Tronie," *Res: Journal of Anthropology and Aesthetics*, vols. 17 and 18 (1989), pp. 89–116; Lyckle de Vries, "Tronies and Other Single-Figured Paintings," *Leids Kunsthistorisch Jaarboek (Nederlandse Portretten. Bijdragen over de portretkunst in de Nederlanden uit de 16de, 17de en 18de eeuw)*, vol. 8 (1989), pp. 185–202; Jaap van der Veen, "Faces from Life," in Blankert et al., *Rembrandt: A Genius and His Impact*, pp. 69–80; Yoriko Kobayashi-Sato, "Roles of Tronies in the History Paintings of Rembrandt," *Rembrandt and Dutch History Painting in the 17th Century* (Tokyo: National Museum of Western Art, 2004), pp. 95–109; Dagmar Hirschfelder, *Tronie und Porträt in der niederländischen Malerei des 17. Jahrhunderts* (Berlin: Gebr. Mann Verlag, 2008); Franziska Gottwald, "The Leidingen des Gemoeds: Towards an Interpretation of Rembrandt's Tronie Prints as 'Pictures-within-Pictures'" in Still Lifes by Sebastian Stoskopff and Johan de Cordua," in *Rembrandt 2006: Essays about Rembrandt*, ed. Michiel Roscam Abbing (Leiden: Foleor, 2006), pp. 155–72; and Franziska Gottwald, *Das Tronie: Muster – Studie – Meisterwerk. Die Genese einer Gattung der Malerei vom 15. Jahrhundert bis zu Rembrandt* (Munich and Berlin: Deutscher Kunstverlag, 2011).

7. For Flemish head studies, see Müller Hofstede, "Eine Kreidestudie von Rubens," pp. 35–43; Julius S. Held, "Einige Bemerkungen zum Problem der Kopfstudie in der flämischen Malerei," *Wallraf-Richartz-Jahrbuch*, vol. 32 (1970), pp. 28–95; and Gottwald, *Das Tronie*, pp. 57–92.

8. Gottwald, *Das Tronie*, pp. 94–108.

9. Hirschfelder, *Tronie und Porträt*, pp. 229–41; and Gottwald, *Das Tronie*, pp. 108–13.

10. Ernst van de Wetering, "The Multiple Functions of Rembrandt's Self Portraits," in *Rembrandt by Himself*, ed. Christopher White and Quentin Buvelot, exh. cat. (London: National Gallery; The Hague: Het Mauritshuis, 1999), p. 26.

11. See Van der Veen, "Faces from Life," p. 71; and Michael Montias, *Art at Auction in 17th Century Amsterdam* (Amsterdam: Amsterdam University Press, 2002), pp. 141–42.

12. See DeWitt, this volume.

13. Lydia de Pauw-de Veen, *Bijdrage tot de studie van de woordenschat in verband met de schilderkunst in de 17de eeuw* (Ghent: Secretarie der Koninklijke Vlaamse Academie, 1957); Lydia de Pauw-de Veen, "Tronies toegeschreven aan Pieter Bruegel (I)," *De zeventiende eeuw*, vol. 17, no. 2 (2001), pp. 174–204; Jan Muylle, *De begrippen "schilder," "schilderij" en "schilderen" in de zeventiende eeuw* (Brussels: Paleis der Academiën, 1969).

14. Jan Hendrik van Dale, *Etymologisch woordenboek* (Utrecht and Antwerp: Van Dale Lexicografie, 1986), p. 767; Jan de Vries and F. de Tollenaere, *Nederlands etymologisch woordenboek* (Leiden: Brill, 1991), p. 383.

15. Karel van Mander, *Schilder-Boeck: waer in Voor eerst de leerlustighe Iueght den grondt der Edel Vry Schilderconst in Verscheyden deelen Wort Voorghedraghen* (Haarlem, 1604).

16. Strauss and Van der Meulen, *Rembrandt Documents*, p. 240.

17. Inventory of Jan Arentsz. van Naerden, December 11, 1637, Gemeentearchief, Amsterdam, catalogued on *The Getty Provenance Index Database*, Archival Document N-2296 (item 0054b), http://piprod.getty.edu/starweb/pi/servlet.starweb?path=pi/pi.web (accessed November 27, 2009).

18. Strauss and Van der Meulen, *Rembrandt Documents*, pp. 351–61, 379, 383. See also DeWitt, this volume.

19. See note 3 above.

20. The term *tronie* is occasionally applied to half-length or full-length depictions showing a particular character type or fanciful costume. See Walter A. Liedtke, *Dutch Paintings in the Metropolitan Museum of Art* (New Haven: Yale University Press, 2007), vol. 2, p. 562; and Gottwald, *Das Tronie*, pp. 12–13.

21. "Est apud Principem meum Turcici quasi Ducis effigies, ad Batavi cuiuspiam caput expressa"; J. A. Worp, "Constantyn Huygens over de schilders van zijn tijd," *Oud Holland*, vol. 9 (1891), p. 128. This passage is linked to Jan Lievens's painting *Man in Oriental Costume ("Sultan Soliman")* of about 1629–31 (Stiftung Preussische Schlösser und Gärten, Berlin-Brandenburg; see fig. 6.4). See Liedtke, *Dutch Paintings in the Metropolitan Museum of Art*, pp. 556–60.

22. Hirschfelder, *Tronie und Porträt*, pp. 81–86.

23. Schwartz, "The Motions of the Countenance," p. 105.

24. Van de Wetering and Schnackenburg, eds., *The Mystery of the Young Rembrandt*, pp. 226–29, cat. 33 (entry by Bob van den Boogert).

25. Autonomous depictions of heads by Rembrandt appear in early inventories, including the "Een klein Tronijtgen van Rembrandt" (a small head by Rembrandt) listed in a 1629 inventory. C. Hofstede de Groot, *Die Urkunden über Rembrandt (1575–1721)* (The Hague: M. Nijhoff, 1906), p. 291.

26. Van de Wetering, "The Multiple Functions of Rembrandt's Self Portraits," p. 21.

27. Liedtke, *Dutch Paintings in the Metropolitan Museum of Art*, p. 562; Hirschfelder, *Tronie und Porträt*, pp. 309–20; and Gottwald, *Das Tronie*, p. 9.

28. Michael Zell, *Reframing Rembrandt: Jews and the Christian Image in Seventeenth-Century Amsterdam* (Berkeley: University of California Press, 2002), pp. 46–48. Zell assumes that Rembrandt must have recognized the hat as "characteristic of Jewish dress"; ibid., p. 46.

29. On the iconography of Christ, see DeWitt, this volume.

30. The Dutch term *schilderachtig* indicated both a realistic depiction and a masterful manner of painting, but was also used in connection with an old face. See Boudewijn Bakker, "*Schilderachtig*; discussies over term en begrip in de zeventiende eeuw," in *Het schilderachtige. Studies over het schilderachtige in de Nederlandse kunsttheorie en architectuur, 1650–1900*, ed. C. van Eck, J. Van den Eynde, and W. Van Leeuwen (Amsterdam: Architectura & Natura Publishers, 1994), pp. 11–24; Hirschfelder, *Tronie und Porträt*, pp. 337–40; and Gottwald, *Das Tronie*, pp. 137–38.

31. Ernst van de Wetering, *Rembrandt: The Painter at Work* (Berkeley: University of California Press, 2000), pp. 156–69.

32. About the painting, see Markus Dekiert, *Alte Pinakothek: holländische und deutsche Malerei des 17. Jahrhunderts* (Ostfildern: Hatje Cantz, 2006), p. 179.

33. See DeWitt, this volume.

34. Gottwald, *Das Tronie*, pp. 72–74.

35. The drawing was first published by Werner Sumowski, who noted that the model was used initially in 1648 for Rembrandt's paintings of the head of Christ. Werner Sumowski, "Rembrandt Zeichnungen," *Pantheon*, vol. 29 (1971), pp. 129–32, fig. 9.

36. Peter Schatborn, "Lot Notes" for *Seated Man, Half Length, at Work*, Christie's, Lot 144, Sale 1961, http://www.christies.com/LotFinder/lot_details.aspx?intObjectID=5032108 (accessed December 8, 2009). See also DeWitt, this volume.

37. See, for example, Blankert et al., *Rembrandt: A Genius and His Impact*, pp. 197–99, cat. 31; Christian Tümpel and Astrid Tümpel, *Rembrandt: Images and Metaphors* (London: Haus, 2006), pp. 112–13; and Van de Wetering et al., *Rembrandt, ein Genie auf der Suche*, pp. 356–57, cat. 57 (entry by Katja Kleinert). See also DeWitt, this volume.

38. Strauss and Van der Meulen, *Rembrandt Documents*, p. 361 (docs. 115, 118).

39. "17 handen en armen, op 't leven afgegoten" (17 hands and arms, cast from life); "Een pleijster gietsel van een Grieks anticq" (a plaster cast of a Greek antique); and "Een Saters tronie met hooren" (a satyr's head with horns). Ibid., p. 383 (docs. 317, 323, 327).

40. "Een tronij van pleijster" (a head of plaster). *The Getty Provenance Index Database*, Archival Document N-2349 (item 0045), http://piprod.getty.edu/starweb/pi/servlet.starweb (accessed November 27, 2009).

41. For example, for his depictions of Old Testament figures Rembrandt used "antieckse hoeden en schilden" (antique hats and shields), which are mentioned as being in the same bin as one of the heads of Christ (Strauss and Van der Meulen, *Rembrandt Documents*, p. 361, doc. 320). See Ben Broos, "Rembrandt en zijn schilderachtig universum. De collectie van de kunstenaar als bron van inspiratie," in Bob van den Boogert et al., *Rembrandts schatkamer* (Amsterdam: Museum het Rembrandthuis, 1999), p. 124.

42. See Van de Wetering et al., *Rembrandt, ein Genie auf der Suche*, p. 356; DeWitt, this volume.

43. See Gottwald, *Das Tronie*, pp. 80–84.

44. On Rembrandt's oil studies, see Ernst van de Wetering, "Rembrandt's Oil Studies. New Light on an Old Problem," in Ernst van de Wetering et al., *Rembrandt: Quest of a Genius* (Zwolle, Netherlands: Waanders; Amsterdam: Museum het Rembrandthuis, 2006), pp. 179–207.

45. See, for example, the panel *Head of a Girl* of about 1645 by an unknown artist (private collection), which was identified by Ernst van de Wetering as a partial copy of Rembrandt's *The Holy Family with Angels* of the same year (State Hermitage Museum, St. Petersburg). Van de Wetering et al., *Rembrandt: Quest of a Genius*, p. 179. About partial copies, see Michiel

Franken, "Learning by Imitation: Copying Paintings in Rembrandt's Workshop," in Van de Wetering et al., *Rembrandt: Quest of a Genius*, pp. 169–75.

46. See Van de Wetering, "Rembrandt's Oil Studies," pp. 204–7.

47. Ibid., pp. 182–86.

48. Van de Cappelle's inventory lists "Een Christus trony van ditto [Rembrandt]" (a head of Christ by Rembrandt); quoted in Abraham Bredius, "De schilder Johannes van de Cappelle," *Oud Holland*, vol. 8 (1892), p. 33 (doc. 56). Dusart's inventory includes "een cristus beelt van Rembrant" (a picture of Christ by Rembrandt); see *The Getty Provenance Index Databases*, Archival Document N-5636, http://piprod.getty.edu/starweb/pi/servlet.starweb (accessed June 20, 2010). The inventory of Gerrit Reijersz Elias, Amsterdam, January 7–8, 1676, mentions "Een schilderijtje, sijnde een copye: Christus trony, van Rembrant" (a painting, a copy of a head of Christ by Rembrandt); see *The Getty Provenance Index Databases*, Archival Document N-2062 (NAA 2410, omslag 23, [film 2551], ff.10–28), http://piprod.getty.edu/starweb/pi/servlet.starweb (accessed April 14, 2010).

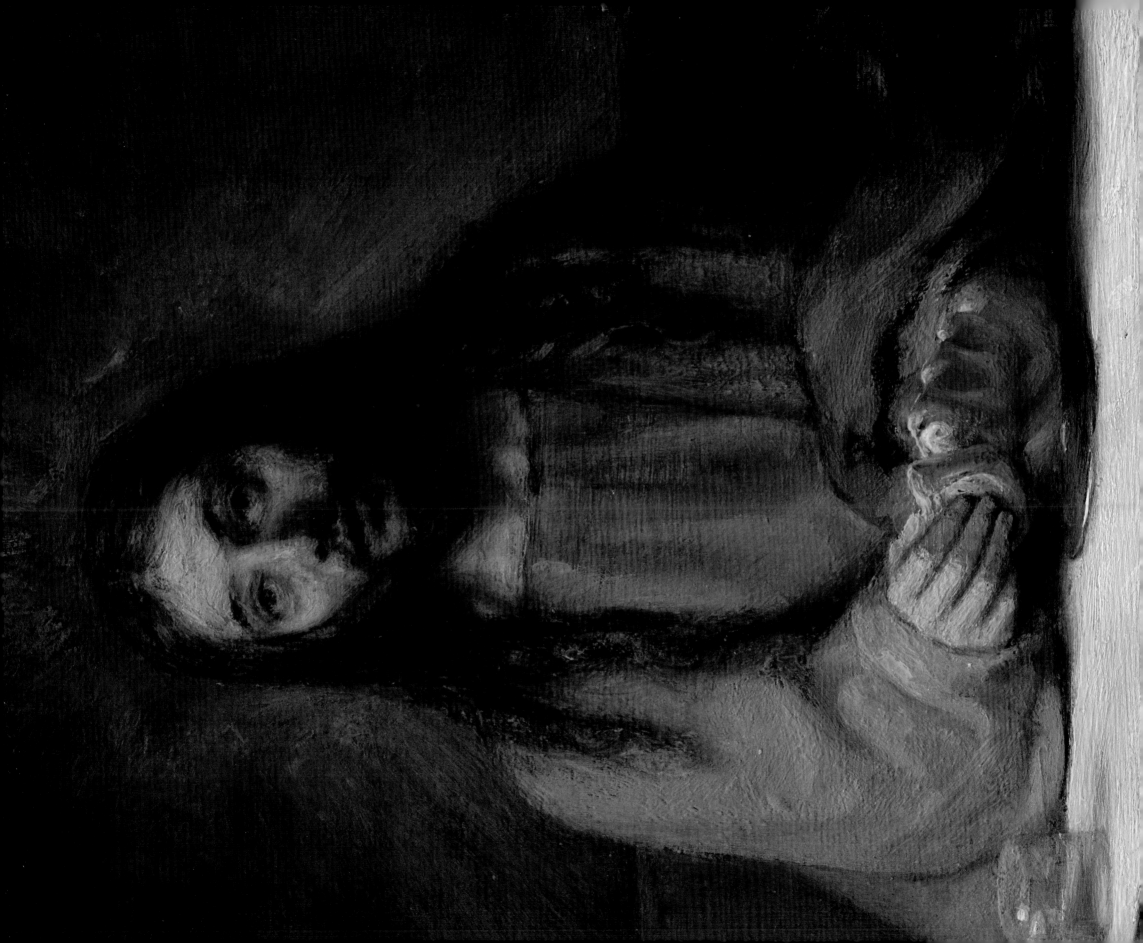

The Orient and Rembrandt's Redefinition of Christ Iconography

Blaise Ducos

Au siècle de Louis XIV on était helléniste, maintenant on est orientaliste.

[During the century of Louis XIV one was a Hellenist, now one is an Orientalist.]

—Victor Hugo, Preface to *Les Orientales* (1829)

In January 1829, brushing aside any nuanced opinion, Victor Hugo fully embraced the contemporary infatuation with the Orient. His goal was to situate his collection of poetry, *Les Orientales*, at the forefront of European Romantic culture; writing at the beginning of the nineteenth century, he sensed in the Orient some new inspirational material and skillfully pushed the contrasts with preceding eras to cast the current exoticism in relief. Contemporary scholarship about what people under the Ancien Régime actually knew of the Orient essentially tends to prove Hugo false.[1] In reality, the Levant formed a major subject of European preoccupation in the classical era: knowledge of the Orient had long circulated there through the routes traced by Mediterranean commerce, missionary voyages, bills of exchange, and slave raids. The following essay generally considers the impact of the Orient—seen above all as centered on the Levant—on the European collective consciousness, particularly as it was envisioned by the Dutch.

The Netherlands constituted the economic heart of Europe during the seventeenth century, and is thus recognized as one of the principal centers of knowledge about the Near East—both ancient and modern. This much is known. However, it seems that the omnipresence of the Orient in Dutch society at the time, and notably its reverberation among artists, was until recently treated in a marginal fashion. The very notion of the "source of inspiration" was likely at the origin of this bias: it conveyed the idea that the Orient was nothing more than a range of decorative forms to be borrowed. Could Rembrandt therefore have seen in the Orient something other than a subject of *curiosity*? The question that occupies us here is to understand whether Rembrandt had an interest—an artistic interest—in utilizing the Orient when he painted. In the case of the figure of Christ, we will see that this interest must have been immense.

Fig. 6.1. Rembrandt Harmensz. van Rijn, *The Supper at Emmaus*, 1648 (detail of plate 1.1). Oil on mahogany panel. Musée du Louvre, Paris

IN LIMINE: JEWS, MEDICINE, AND THE ORIENT UNDER DUTCH EYES

The philosopher Baruch Spinoza (1632–1677), born in Amsterdam's Sephardic Jewish community,[2] was at one time sought by the University of Heidelberg for appointment as a professor.[3] The gradual admission of Jews to universities in Germany and the northern Netherlands in the seventeenth century was a slow and hard-won process. For Jews wishing to study medicine, Netherlandish universities were remarkable for their relative, though exceptional, openness. As early as 1624, Benedict de Castro (1597–1684) of Hamburg was allowed to matriculate in medicine at the University of Franeker, where he became the first Jew in the United Provinces to earn the precious doctoral diploma. Other university centers—especially Leiden, Utrecht, and, later in the century, Harderwijk—were notable for the progressive entrance of Jews into the medical profession.[4]

Could the great Northern tradition of medical studies (consider, for example, anatomy) assimilate the contribution of Jews, even those trained in its midst? Could the pragmatic Dutch—extremely tolerant toward the Jewish community in the Brazilian colonies governed by the Dutch West India Company, even encouraging there the "emergence of a new kind of Sephardic Jewish society"[5]—grant Jews such professional status at home? We need only recall that Amsterdam, where many Sephardim settled after fleeing the Inquisition, suffered the plague several times during the seventeenth century to grasp how vitally important the medical corps and its recruitment were for the Dutch.[6] And yet, although some writers did defend Jewish physicians, they were the exception until the Enlightenment. The issue at stake for Dutch Christians was the relation of a perceived malignant Other to the body. The fact that Jews could examine, palpate, and tend to the bodies of Christians provoked extremely brutal reactions, including numerous writings denouncing Jewish physicians as charlatans and as unclean.[7] Quack doctors were a favorite subject of painters such as Jan Steen (1626–1679), who were fond of depicting their hoaxes, so we can easily imagine the difficulties a Jew, even with a diploma, would encounter in striving to build a practice among an already suspicious and hostile public. Rembrandt's 1647 portrait of the Jewish physician Ephraïm Bueno (fig. 6.2) gives us a glimpse into a world of tensions between Jews and Christians with the body as its stake. What Rembrandt puts forward with Bueno's likeness is far more than picturesque documentary evidence. It is a statement about the Jews, medical proficiency, and tolerance in Amsterdam. It also attests to Rembrandt's positive stance toward the Jews and their ability to minister to the needs of a Christian body.

These tensions within Dutch society reflect the paradox facing the intellectual elites of the young republic. While their supreme ambition with regard to the Jews was to convert them to Protestant Christianity, Dutch elites were becoming increasingly familiar with Hebraic culture. Indeed, the return to manuscript sources—that great Renaissance current then renewing European learning—required comprehension of various ancient languages (strikingly illustrated by the making of polyglot Bibles), the first and foremost being Hebrew.[8] In introducing the Orient into the Dutch orbit, especially in Amsterdam, this scholarly concern went hand-in-hand with the economic incentive to understand the amazingly wide-ranging international trade networks facilitated by Jews, including importing cane sugar from Brazil and even wines and liquors from the Loire delta.[9]

Although Sephardic communities existed in the Philippines, Indonesia, and China, the "Orient" involved here, with few exceptions, was the Near East—the Levant—as well as North

Africa's Maghreb coast. As Jonathan Israël has pointed out, the reconfiguration of relations among the Western maritime empires (Spain, England, the United Provinces, and France), but also between those empires and the Eastern powers (Ottoman Empire, Persia), in the sixteenth and seventeenth centuries aided the advancement of the exiled Sephardic communities. Many Sephardim had been forced to convert to Christianity during the Spanish Inquisition, but their ties with the Mosaic cult survived.[10] Their settlement in northern Europe from the outset of the Golden Age, their influence on Amsterdam in particular, as well as their frequently difficult relations with the Ashkenazi Jews who immigrated from Central Europe to Holland, have been the subjects of recent studies.[11]

The Sephardim forced to flee Spain came to northern Europe by way of the Ottoman Empire, where they supplanted the other potential commercial go-betweens with the Ottomans—particularly Greeks and Armenians—mainly owing to the international dimension of the Sephardic network.[12] Thus, a Sephardic Jew residing in Amsterdam in the mid-seventeenth century represented a community with affiliations ranging from Brazil to North Africa, from the Guyanas to the Indian coast, but also—or maybe first of all?—to the Mediterranean. In the palimpsest of identities of an Amsterdam Sephardic Jew, the Mediterranean East appears to have been crucial. Mediterranean trade and the Sephardim's role in its vitality cannot be overemphasized in relation to the development of Dutch circumnavigation. With their outstanding knowledge of local cultures and the expediency of their networks, Jews were the apt facilitators of the latter. Added to this is the

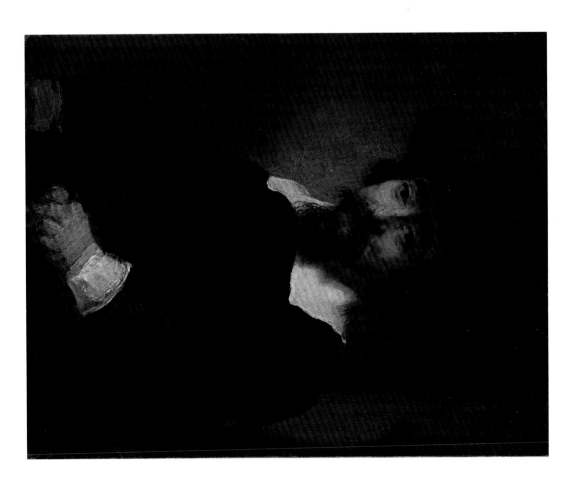

Fig. 6.2. Rembrandt Harmensz. van Rijn, *Dr. Ephraim Bueno, Jewish Physician and Writer*, 1647. Oil on panel, 7½ × 5⅞ inches (19 × 15 cm). Rijksmuseum, Amsterdam, SK-A-3982

antiquity of Sephardic settlements all around the Mediterranean,[13] as well as the binding role a common language (Portuguese) played in forming and perceiving an identity. Israël's idea that Sephardic Jews are a unique case of a community able to form a bond between the different religious groups as well as the maritime empires and the continents should not eclipse the fact that in seventeenth-century Amsterdam "Sephardic" implied an Oriental filiation.[14]

In the seventeenth-century Dutch world, conditions of trade to and from the Orient (in which Sephardim were the principal agents) probably combined with the recent assertiveness of Sephardic culture to make the Jews a subject of great interest to their Dutch Christian contemporaries. For a history painter working in Golden Age Amsterdam—particularly a free-spirited artist drawn to the biblical past—the presence of a minority rooted in what would have been perceived as the truth of that past must have offered great opportunities, especially if that painter was profoundly original. And with Rembrandt, originality is the whole point.

ORIENTAL STUDIES AS A BACKDROP TO REMBRANDT'S CREATION

Rembrandt's connection with the Orient is sometimes presented as a play of the imagination, an aesthetics drawn from various sources, always reworked. Gorgeous costumes and fabulous turbans, dazzling pictorial effects evocative of Eastern lavishness—supposedly the various Oriental figures he left us were essentially creations of his fancy (see figs. 5.1, 6.5). In this view, the Amsterdam master's taste for the decorative, in addition to his desire to shun Calvinist rigorism, led him to revive an ancient *topos* positing that *varietas delectat*.[15] The art market prospered from this delectation, with Oriental subjects common among the *tronies* that the Dutch were so fond of in the wake of Jan Lievens's (1607–1674) and Rembrandt's innovations (see Gottwald, this volume).

From this point of view, Rembrandt's oeuvre is considered extraneous to Oriental studies, that great current of intellectual curiosity that arose in Europe in the sixteenth century. And yet, the profusion of Dutch paintings presenting Old Testament scenes in an Oriental setting—including some thirty by Rembrandt himself—can scarcely be understood apart from this lively interest.[16] Golden Age Holland provided extremely favorable soil for Oriental studies, and indeed the United Provinces were a major hub of scholarly activity. This was due foremost to the profusion of Protestant biblical studies, which focused attention on the Mediterranean East as the main stage of the events recorded in the Scriptures.[17] Among the many Orientalist scholars in Leiden at that time were Thomas Erpenius (1584–1624), best known for introducing Arabic studies in Europe but an eminent scholar of Hebrew as well; Daniel Heinsius (1580–1655), a Hellenist familiar with Oriental languages, including Hebrew; and young Hiob Ludolf (1624–1704), who in 1645 studied Ethiopian in the ancient collections left in the city by the philologist and historian Joseph Justus Scaliger (1540–1609). At the University of Franeker and then in Leiden, the polyglot German theologian Johannes Coccejus (1603–1669), who knew Arabic, Greek, Hebrew, Chaldean, and Syriac, among other languages, was reputed for his exegesis of the Quran and Latin translations of the Talmud.[18] Étienne Morin (1624/25–1700), a French Protestant clergyman and expert in Oriental languages, subsequently came to Amsterdam, having fled France following the 1685 revocation of the Edict of Nantes, which had protected Calvinist Protestants living there.[19] A Dutch translation of the account of Pietro della Valle's (1586–1652) journey to Mesopotamia was printed in Amster-

dam in 1664, but people in the Low Countries certainly were aware of his travels prior to this publication.[20] The French man of letters Nicolas Fabri de Peiresc (1580–1637), whose network of correspondents extended all the way to Smyrna and Jerusalem, had epistolary interlocutors in the United Provinces.[21] In short, in the Golden Age the elite of the United Provinces, spurred by an encyclopedic form of intellectual curiosity, was deeply committed to the study of the Old Testament and its Eastern roots.

Moreover, Holland was a publishing center that attracted manuscripts from scholars seeking tolerant printers not subject to the censorship of other European states. Some of these works directly concerned the interpretation of the Bible as well as its authority: it was in Amsterdam in 1655 that a dangerous book by the French theologian Isaac de la Peyrère (1596–1676) appeared that challenged biblical chronology.[22] The previous year, poems by the thirteenth-century Persian poet Saadi were published in Jan van Duisberg's translation.[23] Alongside the printed works, a bustling trade in manuscripts thrived as academics such as Jacobus Golius (1596–1667) of Leiden traveled to the Levant and acquired works in Turkish, Arabic, and Persian. Throughout the seventeenth century, the University of Leiden was actively collecting Oriental manuscripts,[24] those rare and precious articles that helped make Golden Age Holland a center of the budding scholarship focused on the Near East.

Oriental studies also flourished in the Netherlands due to Amsterdam's role—unprecedented in modern history—as a trade partner with cities such as Istanbul and Aleppo, as well as an importer of wares, often luxury items such as Oriental rugs, from these and other centers in Egypt, Persia, and the East Indies.[25] The importance of Dutch trade with the Levant was such that in 1625 a group of Amsterdam tradesmen founded a Levant directorate (managed by "Directeuren van den Levantschen handel en navigatie in de Middellandsche Zee" [Directors of Levantine Trade and Navigation in the Mediterranean]).[26] "De Oisterische Natie" (the Eastern Nation) was the expression used in Amsterdam to designate tradesmen from Persia or Armenia, who often settled in the Boomsloot district.[27] The oft-cited arrival in The Hague of Musa Beg, Persian ambassador from the city of Isfahan, in 1626–27, must have produced the impression of an Oriental epiphany under Batavian skies: it left its mark in Dutch memories.[28] We should also not forget that Holland, in the person of its stadtholder, Maurice of Nassau (1567–1625), had early in the Golden Century sought to form an alliance with the Muslim state of Morocco, hoping to rival Spain's economic might in the Mediterranean.[29]

Another significant current feeding the stream of Oriental studies in Holland was the importance given to exotic artifacts, as demonstrated by the proliferation of cabinets of *naturalia* brought back from the far-flung colonies. This is something unique to the Dutch: Portugal and Spain, with their considerable colonial empires, never had such a boom in natural history cabinets containing both curiosities and items of scientific interest. Examples include the collections of the physician and botanist Bernardus Paludanus (1550–1633) at Enkhuizen, famous even outside of Holland long after his death, or the insects collected by Johannes Swammerdam (1637–1680). Generally speaking, Dutch natural history cabinets differed from their other European counterparts by their greater number of items from other continents.[30] Rembrandt's love of nature, as well as his famous refusal to travel to Italy, might find their roots in the wealth of natural artifacts Amsterdam offered for the eye and the mind.

Amid all this activity, the recent arrival in Amsterdam of a Jewish community further stimulated interest in the Orient insofar as this group was widely seen as descending from the inhabitants of Palestine of the time of the early Christian church.[31] This sizable Jewish community, in its Sephardic and Ashkenazi components, attained its greatest prosperity around 1647–48, when the Eighty Years' and the Thirty Years' Wars were coming to a close—and, not coincidentally, precisely the time when Rembrandt and his studio created the works that lie at the center of this exhibition and catalogue.[32]

How could we imagine that an artist like Rembrandt could be indifferent to all of this cultural, intellectual, and commercial activity? If we consider Rembrandt's work apart from the *translatio studii et commercii* taking place in the first half of the Golden Age from Rome to northern Europe, are we not liable to overlook the impact of this profound Eastern current on his art?[33] This is not to make Rembrandt out as an antiquarian, or as a representative of a universal culture stemming from Renaissance Humanism. Nor is it an attempt to cast him as an expert in "historical erudition, biblical criticism and textual scholarship," qualities of Dutch Golden Age universities as described by Anthony Grafton—even if we do know that Rembrandt frequented several scholarly circles in Amsterdam.[34] But how could we fail to be struck by the fact that the Louvre's *Supper at Emmaus* (see plate 1.1; fig. 6.1) and the series of heads of Christ (see plates 2.2–2.8) were painted in or around 1648, precisely when Dutch trade with the Mediterranean was booming?[35] In short, an examination of Rembrandt's corpus reveals a constant interest in both the biblical Orient (in history paintings) and the contemporary Orient, whether Turkish, Persian, or even Polish (as in several fanciful figures depicted in his *tronies*). However, his artistic production of such subjects has not been sufficiently appraised for its contribution to the scholarly curiosity toward the Orient flourishing in the United Provinces at the time.

ORIENTALS AND JEWS IN REMBRANDT'S ARTISTIC QUEST

As noted above, in the course of his career Rembrandt produced some thirty paintings inspired by the Old Testament.[36] This number inclines us to place these works at the center of the maelstrom of Dutch paintings illustrating the first books of the Bible. Above all, it invites us to reflect on the place they occupy in Rembrandt's artistic quest. If the story and the pictorial devices used to stage it are essential to Rembrandt's artistic endeavor, what role can we assign to the biblical Orient in this conception? And how can we assess the contribution of Oriental figures to Rembrandt's art?

The truth is that the biblical Orient and the modern Orient converge in Rembrandt's painting primarily to enhance the narration on the formal or stylistic level. The Indian (Mughal) miniatures that Rembrandt owned and had to part with at the time of his insolvency in 1656 may have helped the painter in his striving to distill the story or, if you prefer, the action represented.[37] The sobriety of the Oriental line would have been especially influential. His etching of *Abraham Entertaining the Angels* of 1656 (fig. 6.3) has a spirit and manner that appear inspired by Mughal models.[38] Could Muslim art be the source of this distillation in Rembrandt's style?

And then there is the issue of emulation, especially with regard to Rembrandt's fellow painter Jan Lievens, with whom he may have shared a studio after he settled in Leiden in 1625. Constantijn Huygens (1596–1687) records in his autobiography of 1630–31 that during a visit to the stadtholder's collection, he marveled at seeing a painting of an Oriental by Lievens. Laconically,

Huygens observed that a Dutchman sat for this likeness of a Turkish prince. The picture has now been identified as the one held at the castle of Sanssouci, in Potsdam, known as *Sultan Soliman* (fig. 6.4) and dated to the early 1630s.[39] Should this be interpreted as an "ideal portrait"[40] or, conversely, as an artistic attempt to confer presence and actuality on this figure of an outsider from a remote land by using a model close at hand? Dagmar Hirschfelder recently suggested that this painting could be a recomposed figure, or *tronie*, that was nonetheless perceived by contemporaries as an authentic representation of a powerful Muslim prince.[41] What Lievens offers us here is not at all a normalized exoticism, but rather a masterly figure. That the model was not a genuine Ottoman does not mean that the painter was not seeking a form of verisimilitude. In producing such a work, Lievens documents the Dutch interest in the Orient. Above all, this painting demonstrates the competition (reciprocal imitation, emulation) that existed between the two young painters, as evidenced, for example, by Rembrandt's figure of an Oriental, dated 1627–28, now in the Fondation Aetas Aurea (see fig. 5.1), as well as the one now in the Alte Pinakothek in Munich (fig. 6.5). When the two artists subsequently parted ways, and Lievens became less influential in Rembrandt's artistic life, the latter continued to paint Orientals. A biblical patriarch, a Persian potentate, a prince of the ancient Mediterranean: it is indeed because these isolated figures are not portraits but *tronies*—independent works with their own merit, and as such, intended for the market—that they do not seem devoid of narrative merit. Conversely, everything about them speaks of history, of stories. In these works we can read the history of the Mediterranean basin, cradle of the early Church, immersing the beholder in a suggestive ancient geography that the Dutch East India Company's

Fig. 6.3. Rembrandt Harmensz. van Rijn, *Abraham Entertaining the Angels*, 1656. Etching and drypoint on paper; plate 6¼ × 5⁹⁄₁₆ inches (15.9 × 13.2 cm); sheet 6⅜ × 5⁵⁄₁₆ inches (16.2 × 13.5 cm). National Gallery of Art, Washington, DC. Rosenwald Collection, 1943.3.7160

Fig. 6.4. Jan Lievens (Dutch, 1607–1674), *Man in Oriental Costume ("Sultan Soliman")*, c. 1629–31. Oil on canvas, 53⅛ × 39⁹⁄₁₆ inches (135 × 100.5 cm). Stiftung Preussische Schlösser und Gärten Berlin-Brandenburg

daring and the proliferation of modern atlases at last made true. We also see in them biblical stories in which the figures, though recognized by contemporary viewers as imaginary, nonetheless incarnate a king, a hero, a judge. Therein lies the prestige of these images produced by Lievens and Rembrandt, which belong to a subsection of the *tronie* genre. Rembrandt's Oriental *tronies* possess a narrative dimension (developed in the rivalry with Lievens): they emanate a singular, undeniable ascendancy that belongs to the Orient.

Still speaking of emulation, the legends of the holy images of Christ's face have largely been overlooked as a possible influence on Rembrandt's art. These legends had an Oriental origin, being linked to Jesus's miraculous manifestations to the first communities of believers. For a history painter active in Golden Age Amsterdam, most of these legends certainly could not inspire belief: the fact that Paris, Turin, Rome, and Genoa all claimed to possess the relic of the Holy

Face raised countless historical problems noted by Protestants—chiefly that of the authenticity of the ancient testimonies supporting these tales.[+] Even so, the thesis that the Mandylion (according to tradition, the first icon, an image "not made by the human hand" showing Christ's face) could be identified with the shroud preserved in the Church of St. Bartholomew of the Armenians in Genoa was widespread in Holland (see DeWitt, this volume).[+] In fact, this claim, brought from the East, appears in the *Historia Christi* by Jérôme Xavier, published in 1639 in Leiden by Elzevier.[+] Recent studies have noted that Genoa and Amsterdam enjoyed privileged relations during the Thirty Years' War.[+] The legend of the Mandylion thus would have been well known among Dutch painters; Arnold Houbraken (1660–1719) cited it as a commonplace in the early eighteenth century.[46] Rembrandt would have had to take a side in the discussion regarding this Oriental tradition. Not only would the latter have formed part of the repertoire the painter had at his

Fig. 6.5. Rembrandt Harmensz. van Rijn, *Portrait of a Man in Oriental Costume*, 1633. Oil on panel, 33¾ × 25⅛ inches (85.8 × 63.8 cm). Alte Pinakothek, Munich. Photograph © Alte Pinakothek, Munich. Bridgeman Art Library / Giraudon

command—Rembrandt would have been able to use it as a *repoussoir* in order to develop his own Christ iconography.

Rembrandt's fascination with the Orient included but went far beyond collecting weapons, shells,[47] and other curiosities to be rendered in history paintings, such as the kris (Indonesian dagger) in *The Blinding of Samson by the Philistines* of 1636, now in the Städelsches Kunstinstitut, Frankfurt. Certainly it is tempting to interpret Rembrandt's interest in the Orient as a mere reflection of Netherlandish tastes, but his approach is not that of someone like Romeyn de Hooghe (1645–1708)—a brilliant but, in the long run, rather superficial chronicler of contemporaneous events.[48] As a matter of fact, somewhat in the manner of the polyglot Bibles, Rembrandt's paintings illustrating Old Testament episodes give tangible reality to the fact that biblical history coincides with the history of the ancient Orient.[49] Rembrandt's work is steeped through and through in the Orient.

This being the case, the series of heads of Christ at the center of this exhibition is remarkable not only because it constitutes an impressive ensemble of images of (the resurrected?) Jesus, but also because, by using a model who in all likelihood belonged to the Amsterdam Jewish community, Rembrandt is connecting to a major cultural movement that he could not overlook. Biblical research—a combination of exegetical questioning and a thirst for accumulation (of manuscripts, but also university positions)—progressed by including henceforth the ancient Oriental languages, creating a greater awareness of the reality of the Orient, and contributing to the dwindling of historical prejudice against the inhabitants of Jerusalem, Smyrna, or Damascus in the time of the early Church. The works produced by Rembrandt and his workshop reflect this new perception of the Orient, now seen not as a hostile Other but as a source of historical and pictorial truth —and, therefore, of inspiration. The idea that Rembrandt could not have had close ties to the Jewish community because anti-Semitism still ruled Dutch society ignores the new cultural drift of which the artist was a part.[50] While many Protestant theologians and ministers in Holland (perhaps the most multi-denominational area in Europe at the time) doubtlessly behaved with hostility toward the Jews, especially those living in Holland, their attitudes should be considered alongside the tendencies stirring within Dutch scholarly circles at the time.

As we have seen, seventeenth-century Holland was one of the leading centers of Orientalist scholarship. We should not underestimate the consequences of this situation. The mainspring of these studies was the authentication and interpretation of biblical texts, and therefore scholars were increasingly turned toward the Levant, a fact that constituted a remarkable force for assimilating non-Christian historic reality, be it Hebraic, Persian, or Arabic. Could the vitality of Dutch scholarship and its effects on other spheres of Golden Age Dutch culture, notably painting, counter the hostility (at times violent) of the time toward the Jews? This certainly was not possible in a non-secular society that could not conceive of a truly neutral public space. In this sense, the notion of a "Philosemitism" in Rembrandt appears rather fanciful, and it is right to reposition Rembrandt the man at the center of the Christianity of his day, scarcely receptive to dialogue between the religions of the Book.[51] But does this reasoning apply to his art as well?

We tend here to insist on the specificity of artistic creation, in that it is driven by different goals and must adopt a position toward a set of rules claiming to define art. Since the publication of Jan Emmens's *Rembrandt en de Regels van de Kunst* (Rembrandt and the rules of art) in 1968, the master's relations with classical artistic precepts have become a frequent theme.[52] The idea that

the very nature of Rembrandt's painting lies in a relationship with the normative rules of art (arisen from Italian practices and doctrines forming the framework of connoisseurs' and artists' appreciation in seventeenth-century Amsterdam) is essential for understanding his pictorial quest. By breaking free from the love of the antique dear to the Italian Renaissance, and reworking the inventions—known by prints—of geniuses such as Raphael or Carracci, Rembrandt was already in the 1630s and 1640s different from painters like Jacob van Loo (1614–1670) or even Jacob Backer (1608–1651).[53] It does seem that the master jettisoned the classical rules while developing an interest in the Orient. We might even claim that his interest in the Orient was itself a turning point in his work and a deviation from the classical rules. Jews and other Orientals are more than characters in Rembrandt's pictures: they embody the nonclassical conception of his art turned toward nature. We should note, however, that this does not mean the painter created without references to his predecessors: his emulation of Titian, the interpreter of the figure of Christ whose compositions circulated by prints, surely played a role in forming the new imagery Rembrandt sought.

REMBRANDT'S *SUPPER AT EMMAUS* AND THE ORIENT

It is odd that the ambition of *The Supper at Emmaus* panel of 1648 has not been put in perspective with the revival of Dutch painting in the second half of the 1640s. With the end of the wars that had long scourged the United Provinces, the country entered the final phase of its command of world maritime trade, while its painting, as Israël asserts in a daring synthesis, turned once again to "grandeur, complexity and opulence." Israël points out that all the genres of Dutch painting were transformed by the radical changes in economic conditions.[54] In the instance of *The Supper at Emmaus*, Rembrandt's ambition to create a painting faithful to historical veracity (in representing Christ's deeds) can be understood within this very aspiration to greater grandeur and complexity. The Louvre painting can be considered a breakthrough in this respect—first, because it seems to benefit from the maturation of the Dutch school of Oriental studies; second, because we can see it as an artistic echo of Holland's intense dealings with the Mediterranean; and third, because we can interpret the presence of a Jewish model behind his creation as a distinctive feature of the only European society then willing to provide a position (albeit not equal) for Jewish immigrants fleeing persecution and death. With *The Supper at Emmaus* Rembrandt becomes the brilliant stage director of a biblical Orient brought back to life by contemporary events.

While this explanation is appealing, it is only part of the story: it does not account for Rembrandt's uniqueness. As Paul Veyne observed—not coincidentally, in relation to the rise of Christianity in the ancient pagan world—historians should be able to acknowledge innovation, novelty, and creation. We cannot explain every historical event by the past or context.[55] This far-reaching methodological observation implies an acknowledgment of the innovative capacity of a creator like Rembrandt. The Louvre's *Supper*, like the series of heads of Christ, may well be elucidated by the history of trade, scholarship, or the Jewish diaspora, but these paintings should be understood first of all as exemplifying artistic innovation.

The sketches of the head of Christ, it will be said, are linked to some of Rembrandt's earlier paintings: *Christ on the Cross* of 1631, at Le Mas d'Agenais in Lot-et-Garonne, France (see plate 7.1), already provided a study of the suffering of Jesus of Nazareth. In the small sanctuary in which it is displayed, this pain-wracked face stirs in the beholder an incomparable empathy: anatomical

work from life and a renewed conception of emotion converge in a re-creation of biblical times in Zion. Could this be the first stage in Rembrandt's interest in a genuinely Jewish, Mediterranean, Oriental Christ?[56]

Most of the sketches of the head of Christ are not autograph works, but this does not alter the fact that they are inconceivable without the master's inspiring influence. They are also meaningful in their relation with two drawings depicting a model, certainly from life, posing for Rembrandt himself (see plates 4.9, 4.10; today the drawings are accepted as by the artist's hand).[57] Although it is tempting to say that the heads were preparatory for *The Supper at Emmaus*, most are more likely the reflection of an invention by the master assimilated by his studio.

It is difficult to prove irrefutably that the model for the heads, and consequently for Christ in *The Supper at Emmaus*, was an Amsterdam Jew, but the objections to this idea stem essentially from the recent criticisms of the historiographic tradition that Rembrandt had privileged relationships with several Jews. The insistence of some scholars on demolishing the evidence for such relations—by arguing that Rembrandt was not a friend of the influential rabbi and scholar Menasseh ben Israel, that he turned to Christian scholars rather than Jews for the Hebraic writing in his paintings, that he never etched the synagogue as such, and so on—and thus to taint Rembrandt's artistic identity with a hint of anti-Semitism (and thereby reintegrate him in the Christian *doxa* of his time), probably pertains to the reticence, cited by Veyne, to give novelty its due place in history.[58] Rembrandt's novelty is all the more remarkable for being short-lived: the influence of his innovation seems to have ended shortly after his death. Samuel van Hoogstraten (1627–1678), a former pupil of Rembrandt's, describes with tantalizing indulgence the barely veiled nudity of young Turkish women in his 1678 treatise *Inleyding tot de Hooge Schoole der Schilderkonst* (Introduction to the academy of painting). How different his sensibility from his master's in depicting the Orient![59] Rembrandt's quest for historic depth and verisimilitude has been transformed into a pre-rococo cliché. Generally speaking, using a model from the Jewish community of Amsterdam would seem to be consistent with Rembrandt's artistic conception—above all, an aspiration to the truth of nature. We could even argue that this innovation provided an answer to the problem that had bedeviled the painter during the 1640s: if painting cannot be practiced as the art of trompe-l'oeil (even to perfection) yet must follow nature and nature alone, then employing contemporary models evocative of the biblical truth could be an ingenious resolution of an apparent artistic *aporia*.[60]

CONCLUSION

Today, Rembrandt's interest in the Orient has become a theme of studies on the painter. Leonard Slatkes's 1983 book *Rembrandt and Persia* spread the idea that Ottoman or Persian works could have been sources for some of Rembrandt's creations. The presence in the artist's private collection of items from the Orient confirms his interest in the subject.[61] Some of his *tronies*—figures of Orientals where imagination vies with ostentation—complete the picture of a painter using the Orient as a motif of his repertoire. In this way, Rembrandt appears to have been responding with brio to the taste of seventeenth-century Europeans for Middle Eastern splendors.

It is difficult to extricate reflections on the connection between Rembrandt and the Orient from a traditional view of exoticism. Aside from the fact that for a great innovator like Rembrandt—and when innovation is the very point in discussion—identifying shallow behavior (such as pro-

ducing works simply to satisfy a public taste for the Orient) is always questionable, it is nonethe- less tricky, in the terms in which the problem is posed, to pinpoint Rembrandt's originality in his relations with the Orient. This changes entirely, however, if we divest Rembrandt's Oriental inter- est of its usual exotic interpretation and attempt, on the one hand, to resituate it in the intellec- tual debate animating the Dutch republic of letters at the time, and, on the other hand, to place it at the heart of his artistic approach. If we interpret the Orient as material for Rembrandt's cre- ativity to assimilate, it becomes not only a source of inspiration for Old Testament scenes, but also one of the powers called upon in his striving to break free from the artistic rules commonly accepted by the *liefhebbers*, the circles of connoisseurs, patrons, and art lovers of Amsterdam. And this Orient is essentially biblical (revived by its contemporary Ottoman elements). Does not Rembrandt's *Bathsheba Holding King David's Letter* (fig. 6.6), a painting dated 1654, represent a large nonclassical female nude whose rendering reinvents the very conception of the biblical heroine? Indeed, in this canvas Rembrandt renders an emotion as yet unknown in the painting of his time—that of a grieving young woman, victim of an abuse of power, whose moral despondency and foreboding of tragedies are reflected in her pose, or, as Kenneth Clark wrote, in "the naked

Fig. 6.6. Rembrandt Harmensz. van Rijn, *Bathsheba Holding King David's Letter*, 1654. Oil on canvas, 55⅞ × 55⅞ inches (142 × 142 cm). Musée du Louvre, Paris, Dr. Louis La Caze bequest, 1869, M.I. 957. Photograph © 2007 Musée du Louvre / Angèle Dequier

body permeated with thought."[62] The extreme novelty of this creation—the introduction of a precisely feminine emotion through a new conception of the body—is one of Rembrandt's fundamental contributions to the art of painting, as well as to the palette of impressions of women an artist could achieve. Equally, however, it represents a transgression of the ancient canon (based on beautiful and rigid proportions) and the classical theory of passions (utterly irreceptive to feminine sensibility and its hues). Such an ambition, it should be underscored, cannot be separated from the ambition to emulate the great Renaissance masters.[63] Here, breaking free from the rules of art goes hand-in-hand with the surge of a new emotion in the painting. Is it not obvious, in the iconography of Christ, that the main issue is the emotion, the pathos aroused by the sight of the one who experienced the Passion and Resurrection?

A final determining element for appraising the Orient in Rembrandt's reinvention of Christ imagery is his use of a living model. Eric Jan Sluijter claims that considering the incoherence of the numerous anatomical details in *Bathsheba*, it is inconceivable that a real woman could have posed for the master.[64] This may be true, but one should not forget the abyss that exists between Rembrandt's depiction of the human body and that of some Italian and French painters who recomposed *female* bodies from *male* models and canonical examples borrowed from antiquity and the High Renaissance—without ever having drawn a female model from life.[65] If we imagine the abhorrence of contact with Jewish bodies felt by some of Rembrandt's contemporaries, we can begin to understand how radical it was for him to have a Jewish model pose in his studio.

It may at first seem a surprising notion that we would see a connection between Rembrandt's transgression of classical rules and his embrace of the Orient. It is only by treating the Orient as exterior to Rembrandt's artistic undertaking, however, that we fail to dissipate this surprise. If instead we are willing to place the Orient at the heart of Rembrandt's art and his love of nature, then we can understand that his innovative treatment of Oriental themes enables him to rival or even surpass the ancient masters. The series of heads of Christ by Rembrandt and his pupils, from this viewpoint, occupies a privileged position. Rembrandt here returned to the experiment he attempted in the Mas d'Agenais *Christ on the Cross*, except that this time he was not content to imbue the figure of Christ with a new emotion. By using a Jewish model—that is, for an Amsterdammer of the 1640s, a man whose ascendance was bound to the biblical Orient—Rembrandt introduced in Christ's figure an element of truth, of historical verisimilitude, whereby the image attains a dimension that no Christ by Albrecht Dürer, Martin Schongauer, Lucas van Leyden, or even Titian ever achieved. By transgressing the classical rules that a Rubens never broke, Rembrandt renewed Christ's iconography.

This glorious pictorial breakthrough places Rembrandt in a singular position within the inquiry on the Orient in which his country played a distinguished role in Europe. If we keep in mind that, for the Netherlands of the Golden Age, the Orient—historical theater of biblical events, but also magnet for Mediterranean trade—was a commercial, intellectual, scholarly, and political center of attraction of the utmost importance, then Rembrandt's enterprise of artistic transcendence by iconographic transcendence assumes all its originality while attaining historical coherence. When all is said and done, what figure could be more beautiful than Christ's for achieving a pictorial reform that would warrant its author preeminence in the art of painting?

Translated from the French by Susan Wise

1. Nicholas Dew, *Orientalism in Louis XIV's France* (Oxford: Oxford University Press, 2009).

2. Although the term *Marrano* is often applied to Jews from the Iberian peninsula (including Spinoza) who were required to convert to the Christian faith, we will refrain from using it here, since it was already considered pejorative in the seventeenth century; Randle Cotgrave, in his 1611 dictionary, defines it thus: "A Renegado, or Apostata; a peruerted, or circumcised Christian; a Christian turned Turke, or Iew; also, a conuerted, or baptized Moore, Turke, or Iew; one that turnes Christian for feare rather then of deuotion; also, a Iewish, cruell, hard-hearted, or hollow-hearted fellow." See also, along the same lines, the dictionaries of Antoine Furetière (1690) and Thomas Corneille (1694).

3. Manfred Komorowski, *Bio-bibliographisches Verzeichnis jüdischer Doktoren im 17. und 18. Jahrhundert* (Munich: Saur, 1991), p. 7. In 1673, under the auspices of the German prince Charles Louis of Palatinate, Spinoza's appointment to the University of Heidelberg seemed about to be confirmed but then failed to materialize; see Monika Richarz, *Der Eintritt der Juden in die akademischen Berufe. Jüdische Studenten und Akademiker in Deutschland 1678–1848* (Tübingen: J. C. B. Mohr, 1974), p. 33.

4. See Hindle S. Hes, *Jewish Physicians in the Netherlands, 1600–1940* (Assen: Van Gorcum, 1980).

5. Jonathan Israël describes this "new kind of Sephardic Jewish society" as "one based on a wide range of trade and finance linked to tropical agriculture and a slave economy." See Jonathan Israël and Stuart B. Schwartz, *The Expansion of Tolerance: Religion in Dutch Brazil (1624–1654)* (Amsterdam: Amsterdam University Press, 2007), p. 27. This approach has the advantage of providing a glimpse, behind figures like Isaac Aboab da Fonseca, the first rabbi in the New World, of a socio-economic network that eluded traditional patterns.

6. Jan Gerard Dijkstra, *Een epidemiologische beschouwing van de nederlandsche pest-epidemieën der XVIIde eeuw* (Amsterdam: Volharding, 1921), p. 36.

7. Komorowski, *Bio-bibliographisches Verzeichnis jüdischer Doktoren*, pp. 9, 111 n. 2. The idea of an authentically Jewish thaumaturgic virtue would be staged much later by Walter Scott in *Ivanhoe* with lovely Rebecca. See Ingrid Kästner, "Das Bild der heilkundigen Jüdin bei Walter Scott," in *Medizin und Judentum*, ed. Albrecht Scholz and Caris-Petra Heidel (Frankfurt: Mabuse, 2005), pp. 90–97.

8. Christiane Berkvens-Stevelinck, "En relatif dialogue: Juifs et remonstrants à Amsterdam au dix-septième siècle," in *L'Antisémitisme éclairé. Inclusion et exclusion depuis l'époque des Lumières jusqu'à l'Affaire Dreyfus*, ed. Ilana Y. Zinger and Sam W. Bloom (Leiden: Brill, 2003), pp. 31–41.

9. See Henriette de Bruyn Krops, *A Spirited Exchange: The Wine and Brandy Trade between France and the Dutch Republic in Its Atlantic Framework, 1600–1650* (Leiden: Brill, 2007).

10. These remarks are founded on Jonathan Israël, "Diasporas Jewish and Non-Jewish and the World Maritime Empires," in *Diaspora Entrepreneurial Networks: Four Centuries of History*, ed. Ina Baghdiantz McCabe, Gelina Harlaftis, and Ioanna Pepelasis Minoglou (Oxford: Berg, 2005), pp. 3–26.

11. See Steven Nadler, *Rembrandt's Jews* (Chicago: University of Chicago Press, 2003); Laurence Sigal-Klagsbald and Alexis Merle du Bourg, eds., *Rembrandt et la nouvelle Jérusalem: Juifs et Chrétiens à Amsterdam au siècle d'or* (Paris: Panama musées; Musée d'art et d'histoire du Judaisme, 2007).

12. The shift of the center of gravity of Armenian activity toward Iran equally made way for the emergence of Sephardim as the leading go-betweens; Israël, "Diasporas Jewish and Non-Jewish," p. 9.

13. On the vitality of Mediterranean trade in the seventeenth century, see Fernand Braudel, *La Dynamique du capitalisme* (1985; reprint, Paris: Flammarion, 2008).

14. "Only one particular subsection of the Jewish people, the western Sephardic diaspora in combination with their forcibly converted (i.e., *converso*) relatives and associates in the Hispanic world contrived for some two centuries to span in structurally crucial ways all the great religious blocs with exclusive aims (i.e. Catholicism, Protestantism, Orthodoxy and Islam), all the western empires and all the continents"; Israël, "Diasporas Jewish and Non-Jewish," p. 10. Moors, whose state-enforced emigration was parallel to that of Sephardim, could not play this role as go-betweens; see Michel Cassan, ed., *Les Sociétés anglaise, espagnole et française au XVIIe siècle* (Paris: Armand Colin, CNED/SEDES, 2006), pp. 18ff.

15. See Kristin Bahre, "Orientalisierende Motive im Werk Rembrandts," in Ernst van de Wetering et al., *Rembrandts, ein Genie auf der Suche*, exh. cat. (Cologne: DuMont, 2006), pp. 138, 143 n. 24.

16. Christian Tümpel, "Alttestamentliche Historienmalerei im Zeitalter Rembrandts," in *Im Lichte Rembrandts. Das alte Testament im goldenen Zeitalter der niederländischen Kunst*, exh. cat. (Munich: Klinkhardt und Biermann, 1994), pp. 8, 9, 23. Examples include Jan Victors (1619–1676), Aert de Gelder (1645–1727), Jan Lievens, and Gerbrand van den Eeckhout (1621–1674). Tümpel points to the importance in Dutch theater of plays directly inspired by the Old Testament.

17. Hans-Joachim Kraus, *Geschichte der historisch-kritischen Erforschung des Alten Testaments* (1956; reprint, Neukirchen-Vluyn: Neukirchener Verlag, 1969).

18. Among many other examples, see Mathieu Delvenne, *Biographie du royaume des Pays-Bas, ancienne et moderne* (Liège: Vve J. Desoer, 1828–29), s.v. "Erpenius"; Académie Royale des Sciences, des Lettres et des Beaux-Arts de Belgique, *Biographie nationale* (Brussels: Thiry, 1884–85), s.v. "Heinsius"; Herrmann Jungraithmayr and Wilhelm J. G. Möhlig, eds., *Lexikon der Afrikanistik. Afrikanische Sprachen und ihre Erforschung* (Berlin: Reimer, 1983), s.v. "Ludolf, Hiob"; *Levensbeschryving van eenige voorname meest Nederlandsche mannen en vrouwen* (Amsterdam, 1776), s.v. "Coccejus, Johannes" (this eighteenth-century dictionary dwells on Coccejus's talent as an Orientalist).

19. Morin delivered his *Oratio de utilitate linguarum orientalium* (Speech on the usefulness of Oriental languages) in Amsterdam in 1686; see Abraham van der Aa, *Biographisch woordenboek der Nederlanden* (Haarlem, 1869), s.v. "Étienne Morin." Hugo Grotius (1583–1645), who was forced to flee Holland in 1621, was also among the Netherlandish scholars versed in the study of languages.

20. *De Volkome beschryving der voortreffelijcke reizen van . . . Pietro della Valle, . . . in veel voorname gewesten des werrelts sedert het jaer 1615 tot in 't jaar 1626 gedaan, uit zijn schriften, aan Mario Schipiano geschreven, door J. H. Glazemaker vertaald, en in zes deelen onderscheiden, met 25 . . . kopere platen en een register verziert*, 6 vols., trans. Jan Hendrik Glazemaker (Amsterdam, 1664). Glazemaker was famed for his works in several languages.

21. Peter N. Miller, *Peiresc's Europe: Learning and Virtue in the Seventeenth Century* (New Haven: Yale University Press, 2000), p. xvi.

22. Isaac de la Peyrère, *Praeadamitae. Sive Exercitatio super versibus duodecimo, decimotertio et decimoquarto capitis quinti Epistole D. Pauli ad Romanos. Quibus inducuntur primi homines ante Adamum conditi* (Amsterdam: Elzevier, 1655). This is not to mention the presses that, using new fonts of Arabic characters, published books in the language of Mahomet in the heart of Christian Europe. See Eva Hanebutt-Benz et al., *Sprachen des Nahen Ostens und die Druckrevolution* (Westhofen: WVA-Verlag Skulima, 2002). On the freedom of gazettes and other newspapers, see H. A. Enno van Gelder, *Getemperde vrijheid. Een verhandeling over de verhouding van Kerk en Staat in de Republiek der Verenigde Nederlanden en de vrijheid van meningsuiting in zake godsdienst, drukpers en onderwijs gedurende de 17e eeuw* (Groningen: Wolters-Noordhoff, 1972), chap. 4, "De Drukpers."

23. *Persiaansche roosengaard* (Amsterdam, 1654). Since Van Duisberg died in 1638, we can assume that the translations around this immensely famous book had already made quite a stir in the first third of the seventeenth century. See Christien Dohmen, *In de schaduw van Scheherazade. Oosterse vertellingen in achttiende-eeuws Nederland* (Nijmegen: Vantilt, 2000), p. 10.

24. Jan Schmidt, "Between Author and Library Shelf: The Intriguing History of Some Middle Eastern Manuscripts Acquired by Public Collections in the Netherlands Prior to 1800," in *The Republic of Letters and the Levant*, ed. Alastair Hamilton et al. (Leiden: Brill, 2005), pp. 27–51; Josée Balagna, *L'Imprimerie arabe en Occident, XVIe, XVIIe et XVIIIe siècles* (Paris: Maisonneuve et Larose, 1984).

25. Onno Ydema, *Carpets and Their Datings in Netherlandish Paintings, 1540–1700* (Zutphen: Walburg Press, 1991), p. 208, gives an idea of the extraordinary attraction Muslim textile art held for Dutch buyers, as well as for the country's painters. The Dutch opened a trading post in Aleppo in 1613; see André Raymond, *Grandes villes arabes à l'époque ottomane* (Paris: Sindbad, 1985), p. 110.

26. This directorate was active for decades; see Mehmet Bulut, *Ottoman-Dutch Economic Relations in the Early Modern Period, 1571–1699* (Hilversum: Verloren, 2001), pp. 138ff.

27. Juliusz Chrościcki, *Oriental Motifs in the Works of Rubens, Rembrandt, and Their Pupils* (Washington, DC: National Gallery of Art, 1987), pp. 47–48.

28. Hermann Goetz, "Persians and Persian Costumes in Dutch Painting of the Seventeenth Century," *Art Bulletin*, vol. 20 (1938), pp. 282–83.

29. A commercial treaty was signed with Morocco in 1610. A Dutch embassy was established in Istanbul in 1612. Naturally, the 1609 truce with Spain postponed the Iberian threat to Holland by a few years. See A. H. de Groot, *The*

Ottoman Empire and the Dutch Republic: A History of the Earliest Diplomatic Relations, 1610–1630 (Leiden: Nederlands Historisch-Archaeologisch Instituut, 1978), pp. 83ff.

30. Jelle Banga, *Geschiedenis van de geneeskunde en van hare beoefenaren in Nederland* (Leeuwarden, 1868), s.v. "Paludanus"; ibid., s.v. "Swammerdam."

31. The fact that in Amsterdam in the 1630s and 1640s a distinct Ashkenazi Jewish community was formed that ended up outnumbering the Sephardic community in no way changes the fact that Jews, generally speaking, were seen by seventeenth-century Christians as the people of the Old Testament. See Nadler, *Rembrandt's Jews*. The reticence of many Dutch cities to welcome the immigrant Jews explains their privileged settlement in Amsterdam.

32. Israel insists that the stages of the development of the Jewish community in Amsterdam coincide more or less with those of the economic boom of the young Dutch republic. See Jonathan Israel, "The Republic of the United Netherlands until about 1750: Demography and Economic Activity," in *The History of the Jews in the Netherland*, ed. J. C. H. Blom, R. G. Fuks-Mansfeld, and I. Schöffer (Oxford: Littman Library of Jewish Civilization, 2002), p. 87.

33. See Peter N. Miller, "Making the Paris Polygot Bible," in *Die europäische Gelehrtenrepublik im Zeitalter des Konfessionalismus*, ed. Herbert Jaumann (Wiesbaden: Harrassowitz, 2001), p. 62.

34. Anthony Grafton, *Defenders of the Text: The Traditions of Scholarship in an Age of Science, 1450–1800* (Cambridge: Harvard University Press, 1991), p. 10. See also Amy Golahny, *Rembrandt's Reading: The Artist's Bookshelf of Ancient Poetry and History* (Amsterdam: Amsterdam University Press, 2003), pp. 72–74.

35. As Israel notes, "from the late 1640s onwards . . . Dutch trade with the Mediterranean had strongly revived." Jonathan Israel, "Adjusting to Hard Times: Dutch Art during Its Period of Crisis and Restructuring (c. 1621–c. 1645)," *Art History*, vol. 20, no. 3 (1997), p. 465.

36. Tümpel, "Alttestamentliche Historienmalerei im Zeitalter Rembrandts," p. 17 ("Von Rembrandt selbst sind nur ca. 32 eigenhändige alttestamentliche Historien bekannt"). The heads of Christ are naturally not included in this account.

37. Heinrich Schmidt, "Rembrandt, der islamische Orient und die Antike," in *Aus der Welt der islamischen Kunst: Festschrift für Ernst Kühnel zum 75. Geburtstag am 26.10.1957*, ed. Richard Ettinghausen (Berlin: Mann, 1959), pp. 336–49. Rembrandt copied these miniatures, and some of these drawings survive. If we cannot locate with certainty the miniatures in question, they are nonetheless comparable to those that can be seen at Schönnbrunn, near Vienna. See Bahre, "Orientalisierende Motive im Werk Rembrandts," p. 140.

38. See Chrościcki, *Oriental Motifs in the Works of Rubens, Rembrandt, and Their Pupils*, pp. 47–48. Chrościcki, in this instance, agrees with Leonard Slatkes, who claimed he could identify several Oriental manuscripts as direct sources of works by Rembrandt; see Leonard Slatkes, *Rembrandt and Persia* (New York: Abaris, 1983), pp. 28, 55.

39. The painting is dated to c. 1629–31 in Arthur K. Wheelock et al., *Jan Lievens: A Dutch Master Rediscovered*, exh. cat.

(Washington, DC: National Gallery of Art; Milwaukee: Milwaukee Art Museum; Amsterdam: Museum het Rembrandthuis, 2008), p. 118 n. 19.

40. Bahre, "Orientalisierende Motive im Werk Rembrandts," p. 134, uses the term *Idealbildnis* in this way.

41. Dagmar Hirschfelder, *Trone und Porträt in der niederländischen Malerei des 17. Jahrhunderts* (Berlin: Mann, 2009), p. 255.

42. Richard Adelbert Lipsius, *Die edessenische Abgar-Sage kritisch untersucht* (Brunswick: Schwetschke, 1880), p. 7.

43. Hans Belting observes that it is a canvas mounted on wood, approximately 15¾ × 11⅜ inches (40 × 29 cm). Hans Belting, *Bild und Kult. Eine Geschicte des Bildes vor dem Zeitalter der Kunst* (Munich: Beck, 1990), p. 235.

44. *Historia Christi persice conscripta simulque multis modis contaminata, a P. Hieronymo Xavier* (Ludguni Batavorum: ex officina Elseviriana, 1639). See Martin Illert, *Die Abgarlegende. Das Christusbild von Edessa* (Turnhout: Brepols, 2007), p. 98 n. 439. The name of the church, San Bartolomeo degli Armeni, emphasizes an Oriental filiation in the transmission of the sacred image.

45. Julia Zunckel, *Rüstungsgeschäfte im Dreissigjährigen Krieg. Unternehmerkräfte, Militärgüter und Marktstrategien im Handel zwischen Genua, Amsterdam und Hamburg* (Berlin: Duncker and Humblot, 1997).

46. Arnold Houbraken, *De groote schouburgh der nederlantsche konstschilders en schilderessen* (Amsterdam, 1718–21), vol. 2, pp. 228–29. Houbraken trained with Samuel van Hoogstraten, himself a former pupil of Rembrandt.

47. See, in particular, on shells, Paul Crenshaw, *Rembrandt's Bankruptcy: The Artist, His Patrons, and the Art Market in Seventeenth-Century Netherland* (Cambridge: Cambridge University Press, 2006), pp. 94–95.

48. The spectacular prints that Romeyn de Hooghe produced in the 1670s illustrating the Netherlandish colonial victories give an idea of the spirit of the time. See Michiel van Groesen, "De geplukte Tapecier," in *Romeyn de Hooghe: de verbeelding van de late Gouden Eeuw*, ed. Henk van Nierop et al. (Zwolle: Waanders, 2008), pp. 58ff.

49. The polyglot Bibles were made in Alcalá and Antwerp in the sixteenth century, and in Paris and London in the seventeenth; they represent one of Humanism's great achievements.

50. Gary Schwartz, "Rembrandt's Hebrews," in *Rembrandt. Wissenschaft auf der Suche*, ed. Holm Bevers et al. (Berlin: Mann, 2009), pp. 33–38.

51. Schwartz insists on this point; ibid.

52. See, e.g., J. A. Emmens, *Rembrandt en de regels van de kunst* (Utrecht: Dekker and Gumbert, 1968).

53. See Eric Jan Sluijter, *Rembrandt and the Female Nude* (Amsterdam: Amsterdam University Press, 2006). See also Eric Jan Sluijter, "Rembrandt and the Rules of Art Revisited," in *Rembrandt. Wissenschaft auf der Suche*, ed. Holm Bevers et al. (Berlin: Mann, 2009), pp. 121–29, where the author underlines the precocity, in the seventeenth century, of the opposition between the so-called classical conception and that of Rembrandt.

54. Israël links "the reversion to grandeur, complexity and opulence in art in the period 1646–1672 with the culminating epoch of Dutch primacy in world trade at precisely this time"; Israël, "Adjusting to Hard Times," p. 472; see also p. 469: "All the genres of Dutch art were fundamentally influenced by these structural changes in the Dutch maritime economy and the art market."

55. Paul Veyne, *Quand notre monde est devenu chrétien* (Paris: Le Grand Livre du Mois, 2007). See also the lecture given by Veyne at the conference *Les origines du christianisme en Occident*, April 17, 2008, at the Bibliothèque nationale de France, Paris, available online at www.bnf.fr/fr/evenements_et_culture/anx_conferences/a.c_080417_veyne.html.

56. The harmony seems so perfect when standing before this picture that we might almost say that the conception of the art of painting from life (*naar het leven*) merges here with the purely intellectual, recomposed one (*uit de gheest*).

57. The small number of assistants Rembrandt may have had—notably in the late 1640s, the likely date of the execution of this group of sketches—would make us tend to think that the heads of Christ were not done at the same time; see Walter Liedtke, "Rembrandt's 'Workshop' Revisited," *Oud-Holland*, vol. 117, nos. 1 and 2 (2004), pp. 48–73. This said, the set of sketches is limited and they are all small-format works.

58. Schwartz, "Rembrandt's Hebrews," pp. 33–38.

59. Van Hoogstraten describes "young Turkish women" who imitate the manner of Venus revealing her body under diaphanous garments "so successfully that those who come to see them make out their body through their thin apparel as though you might say they were nude"; Samuel van Hoogstraten, *Inleyding tot de hooge schoole der schilderkonst* (Rotterdam: François van Hoogstraeten, 1678), vol. 4, p. 149.

60. Ernst van de Wetering, "Rembrandt as a Searching Artist," in *Van de Wetering et al., Rembrandt: Quest of a Genius* (Zwolle: Waanders, 2006), esp. pp. 100, 115.

61. See Michiel Roscam Abbing, *The Treasures of Rembrandt* (London: Deutsch, 2006).

62. Kenneth Clark, *The Nude: A Study of Ideal Art* (1956; reprint, London: Penguin, 1964), p. 330. Eric Jan Sluijter's idea that Bathsheba is the "the passive victim of her own fateful beauty" seems to reflect a widespread point of view in Rembrandt's day rather than the innovation accomplished in this painting. See Sluijter, *Rembrandt and the Female Nude*, p. 365; and Blaise Ducos, *Rembrandt. Bethsabée tenant la lettre du roi David* (Paris: Réunion des Musées Nationaux, 2006).

63. *Bathsheba* corresponds to compositions by Tintoretto, Rubens, and Cornelis Cornelisz. van Haarlem.

64. As Sluijter notes, the structure and proportions of the torso and legs "make emphatically clear that Rembrandt did not have a model posing in this attitude before his eyes when he conceived of this nude"; Sluijter, *Rembrandt and the Female Nude*, p. 356.

65. See Carl Goldstein, *Teaching Art: Academies and Schools from Vasari to Albers* (Cambridge: Cambridge University Press, 1996).

PLATE 7.1

Rembrandt Harmensz. van Rijn

Christ on the Cross, 1631

Oil on canvas, glued to panel; 39⅜ × 28¾ inches (100 × 73 cm)
Collegiate Church of St. Vincent, Le Mas d'Agenais, France
Photograph © The Bridgeman Art Library International

CAT. 10

The Impassibility of the Gods: Rembrandt and Christ

Blaise Ducos

When Giotto painted Christ on the cross in the early fourteenth century, he chose to depict the body of Jesus against a background that explicitly evoked a type of Islamic woodwork of his time—the geometric, skillfully cut designs that were the specialty of Mamluk workshops in Cairo (figs. 7.1, 7.2). These visually appealing Islamic motifs had also been used in other Italian works, notably marble decorations in Tuscan churches.¹ The parallels between the rare, exotic rosewood and *padouk* (varieties of African wood that, when freshly cut, have a striking red color)² and the martyred, bloodied body of Christ are multi-layered: the wood of the cross and that of the background; Jesus's Near Eastern origins and the Mediterranean-style craftsmanship in the Islamic decorative motifs; the body of Christ as a balm for the wounded soul and the precious wood that is also used as a base for herbal medicines. Giotto's depiction of the Crucifixion thus evokes both the Mediterranean origins of Christianity and the supreme moment of the Passion.

Giotto's innovation suggests that the supremely codified theme of the Crucifixion was not without immense poetic possibilities. The visual metaphors (if the geometric background in his painting is to be given more than superficial relevance) serve as a repeated commentary on the body of Christ. In the example in the Louvre, the staging is completed by the apostle John and the Virgin, so that Christ's body becomes part of an ensemble—much like a soloist whose performance can only receive its full expression in relation to the choir. Giotto's notion of a dialogue of suffering between Jesus and his loved ones is absent from certain particularly forceful and bare seventeenth-century Crucifixions, which show the Christ figure alone, emerging from a dark, somber sky amid a profound silence.

Among these seventeenth-century paintings of Christ on the cross, three seem close to one another. Produced in the early 1630s by artists who were still very young—Rembrandt van Rijn, Jan Lievens (1607–1674), and Jacob Backer (1608/9–1651)—they have recently been compared by Peter van den Brink.³ All three paintings show Jesus on the cross, bloodless, against an overcast sky in greenish (Rembrandt) or reddening tones (Lievens and Backer). Rembrandt's Crucifixion (Collegiate Church of St. Vincent, Le Mas d'Agenais; plate 7.1) and that of Lievens (plate 7.2) are from the same year (1631); Backer's painting (plate 7.3) is in all likelihood from around the same time, definitely before 1635.⁴ The model provided by Peter Paul Rubens (1577–1640) is rightfully believed to be the source for both Lievens's and Backer's paintings; the engraving by Schelte

Adamsz. Bolswert (c. 1586–1659) after Rubens was, in fact, a precursor to these works (plate 7.4).[5] which offer contrasting visions of the Passion. Lievens depicts a powerful, athletic Christ who is beautiful in death, while Backer opts for a slender body with morbid flesh. A dying Christ, on the verge of unconsciousness and succumbing to the darkness that is already enveloping him (Backer), succeeds a Christ who is arrested and magnified in death (Lievens). In depicting Christ with mouth half-open, eyes half-closed, and pallid flesh, both painters display a fascination with the moment of death—be it imminent (Backer) or just past (Lievens). Seemingly suspended in time, the paintings are in fact extended by their underlying messages. In them is contained, *in nuce*, what has happened (the Passion, as well as the entire ministry of Christ) and also what is to come (the Resurrection and scenes of recognition).

These are Lievens's and Backer's solutions to a classic conundrum in history painting: how to depict the passions of the gods. How does one portray the intense emotions of beings who are suprahuman? Giotto's genius, as we have seen, was to refocus the problem by transforming a scene of enormous expressionistic potential into a dolorist polyphony, a marvelous labyrinth of metaphors.

The challenge of depicting divine pathos is deeply rooted outside Christianity. The *impassibility* of the gods—that is, their radiant, harmonious, and enduring beauty—is a recurring theme

Fig. 7.1. Giotto di Bondone (Italian, c. 1267–1337). *Crucifix*, c. 1315. Oil on panel, 109 × 88⅝ inches (277 × 225 cm). Musée du Louvre, Paris, M.I. 357. Photograph © Louvre, Paris / Giraudon / The Bridgeman Art Library International

Fig. 7.2. Detail of a door leaf from the al-Maridani Mosque, Cairo, 1337–39. African or Asian Padouk wood, Brazilian rosewood, carved decoration with bone inlays, traces of gilt. Musée du Louvre, Paris, OA 4064. Photograph © 2006 Musée du Louvre / Etienne Revault

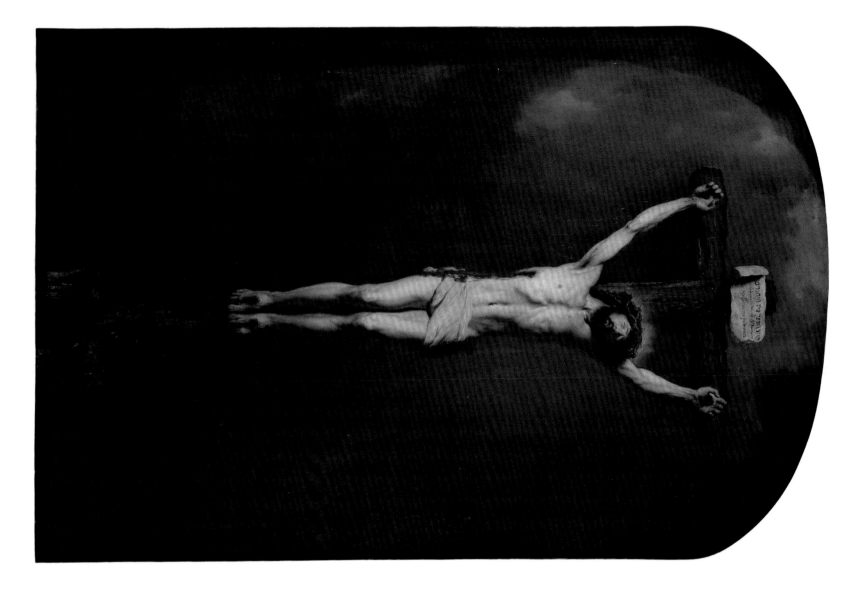

PLATE 7.2

Jan Lievens (Dutch, 1607–1674)

Christ on the Cross, 1631

Oil on canvas, 50�⁄₁₆ × 33¹⁵⁄₁₆ inches (129 × 84 cm)
Musée des Beaux-Arts, Nancy, no. 94

CAT. 9

181

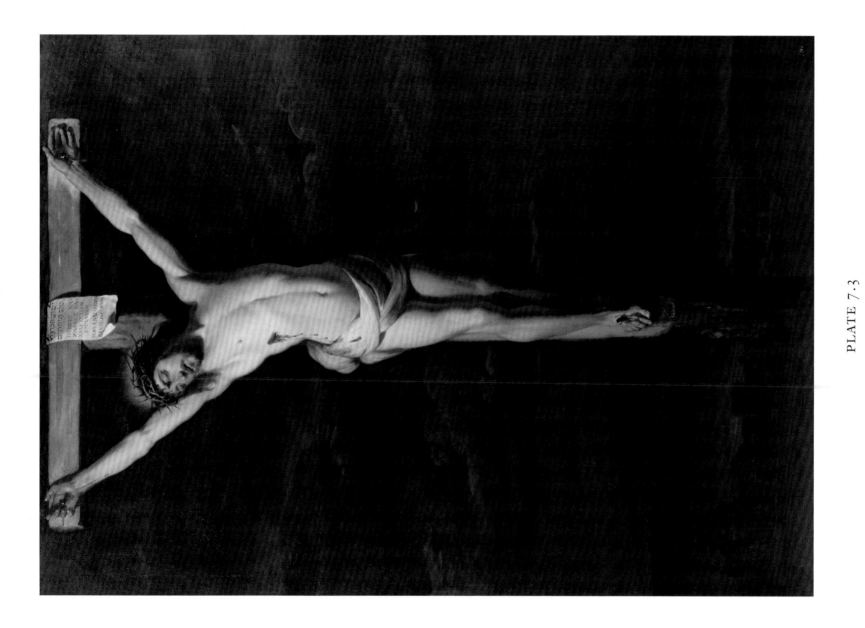

PLATE 7.3

Jacob Adriaensz. Backer (Dutch, 1608/9–1651)

Christ on the Cross, 1631

Oil on canvas, 63 × 45¼ inches (160 × 115 cm)
Pavlovsk Palace Museum, Russia, ZH-1660-III

CAT. 8

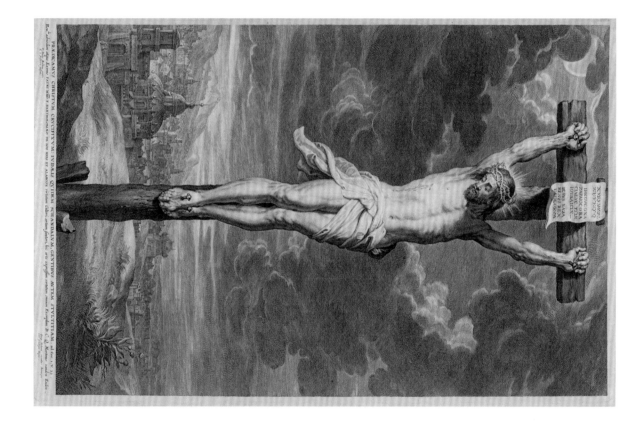

PLATE 7.4

Schelte Adamsz. Bolswert (Flemish, 1586–1659)
after Peter Paul Rubens (Flemish, 1577–1640)

The Crucifixion, after 1630

Engraving on paper, 21⅞ × 14⅛ inches (54.4 × 35.9 cm)
Bibliothèque Nationale de France, Paris, Rés. EC-74c

CAT. 45

in Greek mythology.[6] Plutarch, in his *Life of Alcibiades*, echoes an ancient tradition according to which the first divine being to try out Pan's flute (the syrinx) was Athena. When she realized that blowing on the instrument made her cheeks puff out, she flung it aside.[7] The Greek gods may have interfered in human affairs (love, war, the building of cities, etc.) and shared their passions, but they were also exemplars. Athena's deeds are multifaceted; what is important to note here is that the beauty of the Greek gods (as a late author like Plutarch chose to portray it) lay in an ideal of impassibility. Plutarch's works were known in seventeenth-century Holland: Reinier Telle (1558–1618) gave a translation of selected passages (published 1624), titled *Eenighe morale of zedige werken van Plutarchus*.[8] We also know that Rembrandt closely studied Plutarch, along with Ovid, Homer, Aulus Gellius, Josephus, and Tacitus.[9]

The term *impassible* features prominently in seventeenth-century European texts describing Christ and his body. An example is the following entry in an advance edition of the *Dictionnaire de l'Académie française* from 1687:

GLORIOUS BODY *glorified body. Body of the blessed*, filled with heavenly glory. *The glorious body is impassible, is luminous*, etc.

It is said of the most holy Sacrament of the Eucharist. *The body of* JESUS CHRIST. *The true body. The sacred body. The precious body of our Lord,* JESUS CHRIST. *The true presence of the body of* JESUS CHRIST *in the holy Sacrament of the Altar. Take, receive the body of our Lord*.[10]

Similarly, in the first official edition of the *Dictionnaire* (1694), we find the following:

IMPASSIBLE. adj. That which is incapable of suffering. *Glorious bodies are impassible*.[11]

The fact that these are definitions—texts that are at least as normative (oriented to the future) as they are descriptive (echoing practices past and present)—is significant. In this sense, one can imagine that Rembrandt's wretched and truly pitiful Christ, with no glorious halo, was an exception, an iconographic revolution—one that was, as in France, promptly followed by a restoration. The classically inclined Dutch painter and theorist Gérard de Lairesse (1640/41–1711), in his *Groot Schilderboek* (1714), denies Crucifixion painters any latitude or personal interpretation: "As far as possible, one must aim [in portrayals of the Crucifixion] for the truth, uncolored by personal sensibilities or choices."[12] Rembrandt's work is striking not only in comparison with that of contemporary rivals such as Lievens or even Backer, but also with regard to the past (the classical heritage) and subsequent generations of artists.

The *Christ on the Cross* at Le Mas d'Agenais shows a puny, feeble, sickly man nailed to the cross. His eyes are open, and he is gazing heavenward. Fully conscious, he speaks to God as the only one with whom he can still communicate. Even Lievens's Christ figure is less striking. In the Rembrandt work, one sees Jesus devoid of all grace: it is a painting of abandonment, which the artist has chosen to convey through a personalized face. Where Lievens and Backer present an archetypal Christ with majestic features (monumental in the case of the former, delicate in the latter), Rembrandt renders a face that has suffered every possible humiliation.[13]

It is not enough to say that Rembrandt is a major Christian painter because he understood, as Chateaubriand might have put it, the pathos of this religion. Rembrandt is manifestly skeptical of the figure of Christ handed down by tradition: the usual majesty is not for him.

Already, in his *Supper at Emmaus* of about 1629, now in the Musée Jacquemart-André (see plate 4.1), Jesus is backlit and difficult to make out in detail. One senses Rembrandt's appreciation of the formidable task of representing the figure of Christ. He stages the challenge literally, through his use of darkness. It is a well-known technique—to suggest mystery (of an identity, combined in this instance with the mystery of the Resurrection) through shadowy light. The importance of this painting cannot be overestimated when one considers how Rembrandt calls into question the traditional iconography of the risen Christ. His portrayal of Jesus as a silhouette is not simply a display of virtuosity; it is a confirmation that, from the outset, the young painter was grappling with the problem of representing the figure of Christ.

In the 1631 Mas d'Agenais painting, Rembrandt tackles the problem head on by bringing the divine figure to a personal level—through his face. The human depth that is (too?) often the focus of discussions about his art finds a meaning here. One cannot overemphasize Rembrandt's innovation in his *Christ on the Cross*. For one, the Dutch painter set himself apart from the masters of the Northern Renaissance. He was familiar with their engravings, and his art cannot really be understood without reference to these *peintres-graveurs*.[14] Yet, the works of Heinrich Aldegrever (1502–c. 1555), Hans Holbein the Elder (c. 1460–1534), and even Albrecht Dürer (1471–1528; plate 7.5) do not come close to what is portrayed in the Mas d'Agenais painting; a lined, frowning face distorted by suffering, without beauty, gasping for its last breath. Even Martin Schongauer (c. 1430–1491), in his *Carrying of the Cross* (plate 7.6), was careful to keep Christ's features symmetrical and harmonious, as befitting an archetype. This archetype was also respected by the most gifted sixteenth-century Dutch engravers, be it Hendrick Goltzius (1558–1617; plate 7.7) or Lucas van Leyden (1494–1533; plate 7.8)—although the latter was careful to eschew overly classicist canons. Perhaps only Andrea Mantegna (1430/31–1506; plate 7.9)—an artist Rembrandt greatly admired—lent to his portrayals of a humiliated and suffering Jesus a depth comparable to that of the Dutch master.[15] Still, Mantegna's Christ has the body of an athlete. The features of Rembrandt's Christ have lost all composure and the body its sculptural beauty. All that remains is the reality of a man who is suffering and on the verge of dying. It is not a stretch to see in the harsh treatment of the crucified Christ a herald of Rembrandt's future anatomical studies, as well as an evocation of detailed studies of corpses made by Michelangelo to ensure the accuracy of his drawing—made in preparation for a Crucifix sculpture.[16] The isolation of the Christ figure in Rembrandt's composition thus stands in contrast to the variety and density of iconographic references it embodies. The painting goes much further than Rubens's model, known from contemporary Antwerp engravings (fig. 7.3).

Diametrically opposed to the classical impassibility of the gods he would have come across in his readings, at odds with the stylization of the German and Dutch engravers and etchers of previous generations, and in defiance of the classical dictates of lexicographers and art theorists (de Lairesse), the twenty-five-year-old Rembrandt explored in *Christ on the Cross* the most arduous paths of history painting, attempting to render Christ's sublimity through his simple humanity. In the mid-1950s, Hans-Martin Rotermund created a typology of Rembrandt's Christ figures, following the painter's career from the drawings of the 1630s (see, e.g., *Christ with Arms Folded* [plate 4.4]), to the monumental figures of his latter years (see, e.g., *Jews and His Disciples* [plate 4.3]). Had he known of the existence of the Mas d'Agenais painting of 1631 (rediscovered some years later),

PLATE 7.5

Albrecht Dürer (German, 1471–1528)

Holy Face (The Mandylion Carried by Two Angels), 1513

Engraving on paper, 4 × 5⁹⁄₁₆ inches (10.2 × 14.1 cm)
Musée du Louvre, Paris, Rothschild Collection, 531 LR
Photograph © Réunion des Musées Nationaux / Art Resource, NY

CAT. 4

he no doubt would have qualified his idea that Rembrandt's Christ figure—a figure that he, furthermore, saw as "idealizing"—emerged between 1633 and 1634.[7]

On the contrary, the Amsterdam master treated the Christ figure as an object of study, giving it form in a non-linear fashion, drawing on Renaissance precedents in order to more firmly break with them. In this light, the clash between the Christ figures of Backer, Rembrandt, and Lievens takes on a new dimension, underscoring the uniqueness of Rembrandt's creation—one that refused the seductions of a morbid sweetness and strength beyond suffering. To depart from a beautiful Christ figure in the early 1630s was almost unthinkable; Rembrandt took that risk.

Translated from the French by Vanessa Nicolai

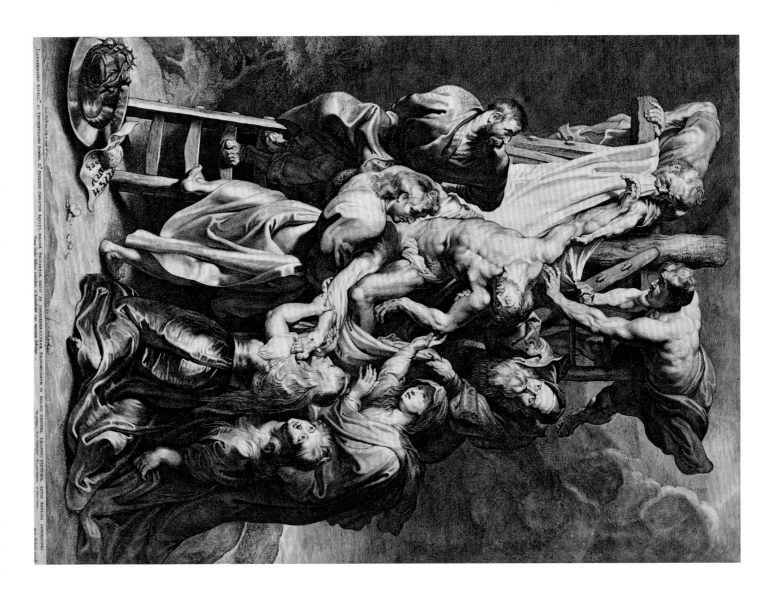

Fig. 7-3. Lucas Vorsterman (Flemish, 1595–1675) after Peter Paul Rubens (Flemish, 1577–1640), *The Descent from the Cross*, 1620. Engraving on paper, 22%6 × 17⅛ inches (58.2 × 43.5 cm). British Museum, London, 1841,0809.22. Photograph © The Trustees of the British Museum

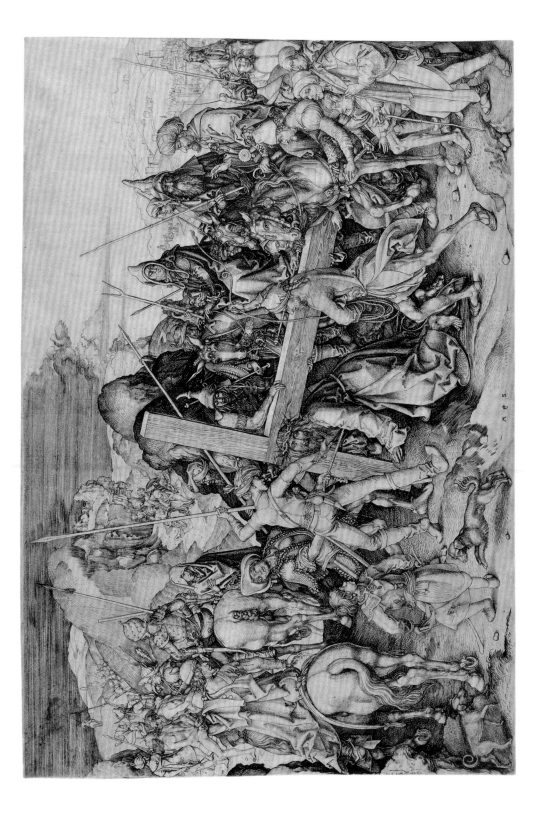

PLATE 7.6

Martin Schongauer (German, c. 1430–1491)

The Carrying of the Cross, c. 1470–80?

Engraving on paper, 11¼ × 16¹⁵⁄₁₆ inches (28.5 × 42.7 cm)
Musée du Louvre, Paris, Rothschild Collection, 204 LR
Photograph © Réunion des Musées Nationaux / Art Resource, NY

CAT. 2

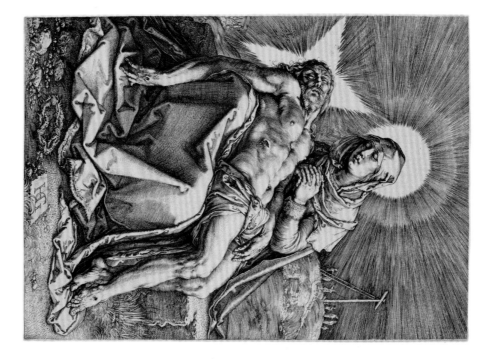

PLATE 7·7

Hendrick Goltzius (Dutch, 1558–1617)

The Dead Christ in the Lap of the Virgin (Pietà), 1596

Engraving on paper, 6⅞₁₆ × 5⁵⁄₁₆ inches (17.7 × 12.8 cm)
Musée du Louvre, Paris, Rothschild Collection, 2552 LR
Photograph © Réunion des Musées Nationaux / Art Resource, NY

CAT. 5

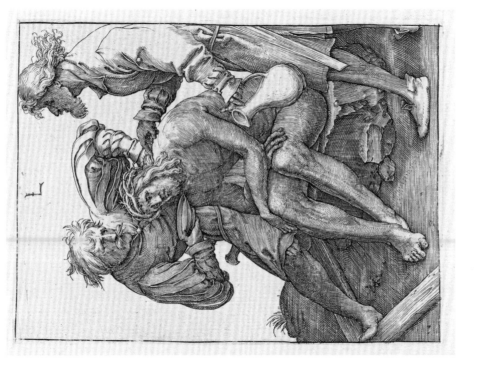

PLATE 7.8

Lucas van Leyden (Dutch, 1494–1533)

Soldiers Giving a Drink to Christ, c. 1512

Engraving on paper, 5³⁄₁₆ × 4¹⁄₁₆ inches (13.1 × 10.3 cm)
Musée du Louvre, Paris, Rothschild Collection, 1742 LR
Photograph © Réunion des Musées Nationaux / Art Resource, NY

CAT. 3

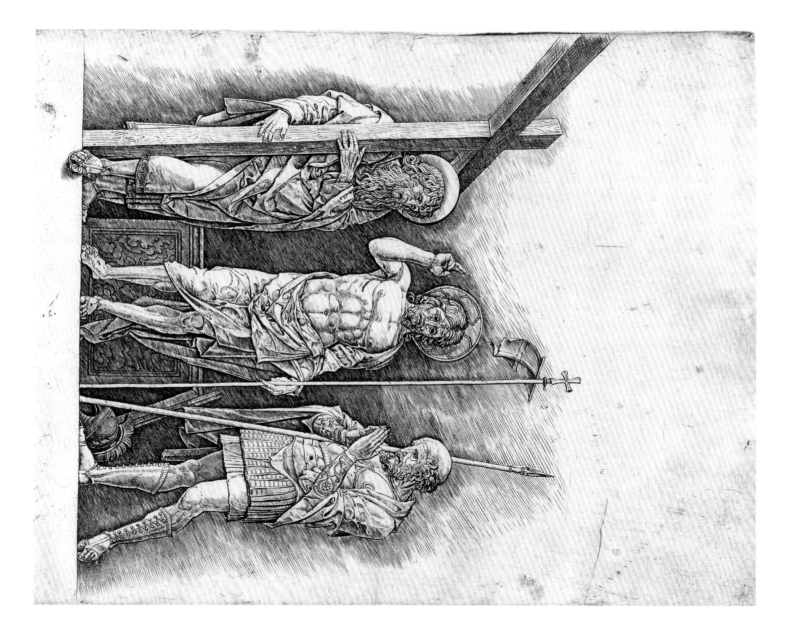

PLATE 7.9

Andrea Mantegna (Italian, 1430/31–1506)

Christ between Saints Andrew and Longinus, c. 1472

Engraving on paper, 16⁹⁄₁₆ × 13⁹⁄₁₆ inches (42.6 × 33.2 cm)
Musée du Louvre, Paris, Rothschild Collection, 3844 LR
Photograph © Réunion des Musées Nationaux / Art Resource, NY

CAT. 1

1. Created by Fra Guglielmo of Pisa (d. 1312 or 1313), a collaborator of Nicola Pisano. See Marco Ciatti and Max Seidel, eds., *Giotto: The Santa Maria Novella Crucifix* (Florence: Edifir Edizioni, 2002), p. 205.

2. See Centre Technique Forestier Tropical, *Bois tropicaux*, 5th ed. (Nogent-sur-Marne: Centre Technique Forestier Tropical, 1983), pp. 123ff.

3. Peter van den Brink et al., *Jacob Backer (1608/9–1651)* (Zwolle: Waanders, 2009), p. 213, no. A22. During a visit to Pavlovsk Palace near St. Petersburg in 2009, Van den Brink also made an impromptu remark about Backer's painting, housed in Pavlovsk, thus drawing my attention to this point.

4. Van den Brink, ibid., p. 43, dates this work to the first half of the 1630s: "Het schilderij is echter zeker van de hand van Backer en dateert mijns inziens uit de eerste helft van de jaren dertig" [However, the painting can certainly be attributed to Backer and dates, according to me, to the first half of the 1630s].

5. Regarding Lievens's painting, Virginia C. Treanor cites the engravings of Paulus Pontius (1603–1658) and Bolswert as models (Pontius's engraving is the more frequently cited of the two). See Arthur Wheelock et al., *Jan Lievens: A Dutch Master Rediscovered* (New Haven: Yale University Press, 2008), pp. 144–45.

6. There was no unified notion of the impassibility of the gods in Hellenistic Greece; classical schools of thought were divided on the issue. My point is simply to underline the importance of the concept in the pagan world, without underestimating its complexity. See Paul Gavrilyuk, *The Suffering of the Impassible God: The Dialectics of Patristic Thought* (Oxford: Oxford University Press, 2004), especially p. 173. See also Paul Veyne, *Quand notre monde est devenu chrétien: 312–394* (Paris: Librairie générale française, 2010).

7. Plutarch, *Life of Alcibiades*, in *Greek Lives*, trans. Robin Waterfield (Oxford: Oxford University Press, 2008), p. 223.

8. Reinier Telle, *Eenighe morale of 'zedige werken van Plutarchus, vertaelt door R. T.* (Amsterdam: H. Maneke, 1634).

9. Amy Golahny, *Rembrandt's Reading: The Artist's Bookshelf of Ancient Poetry and History* (Amsterdam: Amsterdam University Press, 2003), p. 237.

10. *Dictionnaire de l'Académie française*, Advance Edition 3 (1687), s.v. "corps glorieux" [glorious body]: "CORPS GLO-RIEUX *corps glorifié. corps des bienheureux*, remply de la gloire celeste. *Le corps glorieux est impassible, est lumineux* etc. On dit du tres-saint Sacrement de l'Eucharistie. *Le corps de JESUS-CHRIST. le vray corps. le sacré corps. le précieux corps de nostre Seigneur JESUS-CHRIST. la presence réelle du corps de JESUS-*

CHRIST *au saint Sacrement de l'Autel. prendre, recevoir le corps de nostre Seigneur.*"

11. *Dictionnaire de l'Académie française* (Paris: J. B. Coignard, 1694), s.v. "impassible": "IMPASSIBLE. adj. de tout genre. Qui est incapable de souffrir. *Les corps glorieux sont impassibles.*" The French "de tout genre" indicates that the adjective can modify a feminine as well as masculine noun.

12. Gérard de Lairesse, *Groot Schilderboek, waar in de schilderkonst in al haar deelen grondig werd onderweezen, ook door redeneeringen en printverbeeldingen verklaard: met voorbeelden uyt de beste konst-stukken der oude en nieuwe puyk-schilderen, bevestigd: en derzelver wel- en misstand aangeweezen* (Amsterdam: D. Mortier, 1714), p. 299 ("Van Jesus kruyssing"): "Men moet de waarheid, zo veel het mogelyk is, zoeken op te volgen, en niet zyne eigene zinnelykheid of keur." The passage that Samuel van Hoogstraten, in his *Inleyding*, devotes to the appearance of Jesus, following the apocryphal letter of Publius Lentulus, is perhaps better known than the work by Lairesse.

13. It is debatable whether, as Shelley Perlove and Larry Silver argue, Rembrandt represented his own features in the Christ figure. See Shelley Perlove and Larry Silver, *Rembrandt's Faith: Church and Temple in the Dutch Golden Age* (University Park: Pennsylvania State University Press, 2009), p. 296 and note 121. They cite various texts supporting this idea, some of which date back to a study of the painting by the Laboratory of the Louvre in 1960, but neglect to note the problematic place of self-portraits in Rembrandt's oeuvre, as well as the lively debates around the artist's use of his own image in his history paintings. See Ernst van de Wetering, "The Various Functions of Rembrandt's Self-Portraits," in *Rembrandt: Three Faces of the Master*, ed. Benedict Leca (Cincinnati: Cincinnati Art Museum, 2008), pp. 51–72.

14. Christian Tümpel et al., *Rembrandt en de Bijbel. Alle etsen* (Zwolle: Waanders, 2006), pp. 16ff.

15. On the importance of Mantegna in seventeenth-century Amsterdam, and in Rembrandt's studio in particular, see Martin Royalton-Kisch and David Ekserdjian, "The *Entombment of Christ*: A Lost Mantegna Owned by Rembrandt?" *Apollo*, no. 151 (2000), 457, pp. 52–56.

16. Samuel van Hoogstraten, Rembrandt's famous disciple, echoes this tradition regarding Michelangelo. See *Inleyding tot de hooge schoole der schilderkonst* (Rotterdam: François van Hoogstraeten, 1678), p. 53.

17. Hans-Martin Rotermund, "Wandlungen des Christus-Typus bei Rembrandt," *Wallraf-Richartz-Jahrbuch*, vol. 18 (1956), pp. 197–237. On page 197, the author describes "der gleiche idealisierende Christustyp" (the same idealizing Christ-type) with regard to Rembrandt's first works.

Chronology

Mark Castro

Black = Events in Rembrandt's Life
Gray = Events in the United Provinces
Brown = Events in the Jewish Community of Amsterdam

1578

After a bloodless revolution known as the "Alteration," Amsterdam adopts the Reformation and Protestants take control of government and other institutions in the city, expelling their Catholic predecessors.

1579

JANUARY 23. The northern provinces of the Netherlands sign the Union of Utrecht, establishing the Republic of the Seven United Provinces and vowing cooperation against Spain.

1585

Spain re-conquers the port of Antwerp, causing an exodus of Protestants to the United Provinces.

1589

Rembrandt's parents, the miller Harmen Gerritsz. van Rijn (1569–1630) and Neeltgen (Cornelia) Willemsdr. van Zuytbrouck (1568–1640), marry in Leiden. Historically a center of religion and scholarship, Leiden is in the early stages of rapid population growth centered on its textile industry.

1593

After being refused entrance in other Dutch cities, Sephardic Jews and crypto-Jews (those practicing their religion in secret due to persecution) begin to settle in Amsterdam.

1595

The United Provinces blockade Antwerp, diverting international trade to Amsterdam.

1602–3

The Vereenigde Oost-Indische Compagnie (V.O.C.), or Dutch East India Company, is established and trades in Asian spices, porcelain, and fabrics.

The first Sephardic congregation in Amsterdam, Beth Yaakov, is founded, presided over by Jacob Tirado (c. 1540–1620).

Amsterdam authorities recognize the Sephardic community's right to practice its religion privately.

1606

JULY 15. Rembrandt Harmensz. van Rijn is born in Leiden, the ninth of ten or more children.

1608

A second Sephardic congregation, Neveh Shalom, is founded in Amsterdam.

1609

Spain and the United Provinces sign the Twelve Years' Truce; the treaty is a de facto recognition of the Dutch Republic by Spain.

ABOUT 1613–15

Rembrandt presumably attends Latin school in Leiden.

1614

One hundred sixty-four Jewish families are documented in Amsterdam. A Jewish cemetery is established at Ouderkerk.

AUGUST 22. Jews are massacred in Frankfurt and the survivors expelled from the city.

1615

The Dutch jurist Hugo Grotius (1583–1645) releases his *Remonstratie*, a report calling for Jews to be welcomed compassionately to the United Provinces, as long as they declare their faith openly and are willing to live under restrictions.

1616

Amsterdam authorities recognize the presence of the "Jewish nation," as the Sephardic community is known, but prohibit Jewish writings or statements detrimental to the Christian religion, proselytism, and carnal relations with Christians. Jews are also excluded from artisans' and merchants' guilds.

1618

The Thirty Years' War begins in Germany.

The Dutch Reform Church convenes the Synod of Dordrecht to confront the rise of the Arminians (also called Remonstrants), followers of the Dutch theologian of Jacobus Arminius (1560–1609) who rejected some of the basic tenets of Calvinism.

Arminian riots break out in Leiden.

A third Sephardic congregation, Beth Israel, is founded in Amsterdam, under the authority of the rabbi and merchant Joseph Pardo (d. 1619).

1619

Province of Holland adopts a policy of tolerance of Jewish settlement and worship in its cities.

1620

MARCH 20. Rembrandt enrolls in the University of Leiden but leaves after a year to pursue a career as a painter.

The first German Jewish (Ashkenazi) refugees from the Thirty Years' War arrive in Amsterdam.

1621

Spain imposes an embargo on the United Provinces, ending the twelve-year truce.

The Spanish embargo devastates Amsterdam's Sephardic merchants, many of whom imported products from the Portuguese colonies. About a quarter of the city's Jewish population (between 300 and 500 people) leaves for Hamburg.

The Geoctroyeerde Westindische Compagnie, or Dutch West India Company, is created to develop trade with the Americas and the African coast.

ABOUT 1621–24

Undertakes a three-year apprenticeship in Leiden with Jacob Isaacsz. van Swanenburgh (1571–1638), a painter known for his dramatically illuminated scenes of hell.

1624

Spends six months in Amsterdam as an apprentice to Pieter Lastman (1583–1633), painter of biblical, mythological, and historical subjects.

1625

Working as an independent master in Leiden; paints *Stoning of St. Stephen* (Musée des Beaux-Arts, Lyon), his earliest known dated painting.

Stadtholder Maurice of Nassau (1567–1625), Prince of Orange, dies and is succeeded by his half-brother Frederik Hendrik (1584–1647), who centralizes civil and military powers under his control.

ABOUT 1626

Engages in a friendly rivalry with Jan Lievens (1607–1674), another student of Lastman.

Begins to make his own etchings.

1627

The first Hebrew-language printing press is established in Amsterdam by Menasseh ben Israel (1604–1657).

1628

Produces his first dated etchings, studies of a woman traditionally identified as his mother.

Takes on his first pupils, Gerrit Dou (1613–1675) and Isaac Jouderville (1613–1648). Over the years, Rembrandt will have more than fifty students.

ABOUT 1628–29

Constantijn Huygens (1596–1687), connoisseur of the arts and private secretary to Stadtholder Frederik Hendrik, writes admiringly of Rembrandt's and Lievens's art in his unpublished memoir.

1629

Paints and etches his earliest dated self-portrait (Alte Pinakothek, Munich).

ABOUT 1629

Paints his first canvas of *Supper at Emmaus* (Musée Jacquemart-André, Paris; see plate 4.1).

1630

Harmen van Rijn, Rembrandt's father, dies.

Begins collaboration with the printmaker Jan van Vliet (1610–d. after 1635).

1631

Rembrandt and Lievens part ways; Lievens goes to England, while Rembrandt moves to Amsterdam, where he establishes ties with the art trade.

Paints *Nicolaes Ruts* (Frick Collection, New York), his first known portrait of an Amsterdam patron.

1631–34

Paints in the Amsterdam workshop of prominent art dealer Hendrick Uylenburgh (1584–1661), primarily producing portraits of middle-class scholars, preachers, artisans, and small businessmen, as well as depictions of biblical and mythological subjects.

Continues his printmaking activities, apparently in Leiden.

1632

The inventory of the collection of Stadtholder Frederik Hendrik includes paintings by Rembrandt.

The first part of Menasseh ben Israel's *El Conciliador*—in which he attempts to resolve all apparent contradictions in the Hebrew Bible—is published in Amsterdam.

1633

Rembrandt's painting *Self-Portrait with Beret and Gold Chain* (Walker Art Gallery, Liverpool) is recorded in the collection of King Charles I of England (1600–1649), as a gift from Sir Robert Kerr (c. 1578–1654), ambassador to the Netherlands.

ABOUT 1633

Completes two paintings of Christ's Passion for Stadtholder Frederik Hendrik: *The Raising of the Cross* and *The Descent from the Cross* (Alte Pinakothek, Munich).

1634

Becomes a citizen of Amsterdam and joins the painters' Guild of St. Luke.

JUNE 22. Marries Saskia van Uylenburgh (1612–1642).

1635

Rents a house in the fashionable Nieuwe Doelenstraat. Apparently working independently of Hendrick Uylenburgh.

First child, son Rombertus (named after Saskia's father), is born.

1636

Rombertus dies.

Rembrandt corresponds with Huygens about the Passion series for Stadtholder Frederik Hendrik and completes another picture for it.

Ferdinand Bol (1616–1680) becomes Rembrandt's pupil.

1637

Moves to rented house on Binnen-Amstel.

The Statenbijbel, the official translation of the Bible into Dutch, is published.

1638

Daughter Cornelia is born and dies.

NOVEMBER 24. The philosopher Baruch Spinoza (1632–1677), son of a Jewish Portuguese merchant, is born in Amsterdam.

1639

Buys a large house for 13,000 guilders on the Sint Anthoniesbreestraat (today the Museum het Rembrandthuis), in the Jewish quarter of Amsterdam.

Produces *Self-Portrait at a Stone Sill*, his last self-portrait etching until 1648.

Again corresponds with Huygens about Passion paintings for Stadtholder Frederik Hendrik. Seeks payment and completes two further pictures for series.

OCTOBER 21. The Dutch defeat the Spanish fleet at the Battle of the Downs, cementing the United Provinces' maritime power.

The three Sephardic Portuguese communities in Amsterdam unite under the name Talmud Torah. An Ashkenazi community is formally established in the city.

1640

Second daughter, Cornelia, is born and dies.

Rembrandt's mother, Neeltgen (Cornelia) van Rijn, dies.

Samuel van Hoogstraten (1627–1678) becomes Rembrandt's pupil.

1641

Son Titus is born, the only child of Rembrandt and Saskia to survive infancy. Saskia becomes sick, likely with tuberculosis.

Jan Jansz. Orlers (1570–1646) publishes the first brief biographical sketch of Rembrandt, in a book about Leiden.

The painter and art critic Philips Angel (1618–1664) praises Rembrandt's 1638 canvas of *The Wedding of Samson* (Gemäldegalerie Alte Meister, Dresden) in a lecture to artists in Leiden. The text is published the following year as *Lof der Schilderkunst* (In Praise of Painting).

1642

Saskia dies.

Amsterdam's Ashkenazi community acquires a cemetery in the nearby town of Muiden.

The Queen of England, Henrietta Maria (1609–1669), visits Amsterdam.

ABOUT 1642

Geertje Dircx (1610/15–after 1656), a widow, is employed as a nurse for Titus and becomes Rembrandt's mistress.

1642–49

At the request of the Dutch theologian and Hebrew scholar Adam Boreel (1603–1667), Jacob Judah Aryeh Leon Templo (1603–c. 1675) draws a plan of the Temple of Solomon.

1643

The Keter Torah school is founded in Amsterdam.

1646

Stadtholder Frederik Hendrik pays Rembrandt 2,400 guilders for two paintings, to be added to the Passion series, on the infancy of Christ.

1647

Etches portrait of Jan Six (1618–1700), one of his most significant and socially prominent patrons.

MARCH 14. Stadtholder Frederik Hendrik of Nassau dies and is succeeded by his son, William II (1626–1650).

ABOUT 1647

Hendrickje Stoffels (c. 1625–1663) is employed as a live-in servant and presumably becomes Rembrandt's mistress.

1648

Rembrandt etches his self-portrait as a working artist.

JANUARY. Geertje Dircx makes a will, leaving her possessions to Titus van Rijn.

Rembrandt Paints *Supper at Emmaus* (Musée du Louvre, Paris; see plate 1.1).

Treaty of Munster is signed. Spain officially recognizes the independence of the United Provinces.

Polish Jews arrive in Amsterdam following widespread massacres at the hands of Kossack rebels led by Bogdan Chmielnitzki.

1649

Geertje Dircx sues Rembrandt for breach of marital promise. The Chamber of Marital Affairs orders him to pay her an annual allowance of 200 guilders, slightly more than Rembrandt had previously offered.

ABOUT 1649

Completes *Christ Preaching*, known since the seventeenth century as *The Hundred Guilder Print* (see plate 1.2).

1650

Rembrandt pays to have Geertje committed to the Spinning House (women's house of correction) in Gouda.

Stadtholder William II marches on Amsterdam, which opposes his attempt to create a hereditary monarchy. He fails and dies shortly after. His son, William III (1650–1702), is born after his death.

Menasseh ben Israel publishes *Miqveh Israel* in Amsterdam. It is translated into English and published in London the same year.

1652

The States General, the representative governing body of the provinces, reduces the powers of the Stadtholder and makes its own appointee, the Grand Pensionary, the highest authority in the United Provinces.

The Dutch colony Cape of Good Hope is founded in Africa.

1652–54

England's Navigation Act, aimed at dismantling the maritime commerce of the United Provinces, results in the first Anglo-Dutch war. Peace is restored in 1654 by the Treaty of Westminster, signed by Jan de Witt (1625–1672), Grand Pensionary of Holland, and Oliver Cromwell (1599–1658).

1653

Rembrandt borrows heavily to pay off the 8,470-guilder debt, interest, and taxes for his Sint Anthoniesbreestraat house.

Executes his large drypoint *Christ Crucified* (*The Three Crosses*).

1654

Hendrickje is denied communion by the Reformed Church Council when she is found to be pregnant with Rembrandt's child. Hendrickje gives birth to Cornelia, Rembrandt's only daughter to survive infancy.

The United Provinces vote to further limit the powers of Stadtholder William III.

The Dutch lose their territory in northeastern Brazil to the Portuguese.

1655

Radically transforms his large drypoint of *Christ Presented to the People* (*Ecce Homo*; see plate 4.17).

Geertje Dircx is released from the Spinning House.

Rembrandt auctions art from his collection, and perhaps his own work as well. The results are unknown.

Menasseh ben Israel visits London and is received by Cromwell.

Lithuanian Jews arrive in Amsterdam after the Swedish invasion; 1,700 refugees receive assistance from the *mahamad*, leaders of the Sephardic community.

1656

Transfers ownership of his house to Titus to protect it from creditors.

Applies for and receives a declaration of bankruptcy.

An inventory is made of his possessions not sold the previous year. This list, which reveals him to be a voracious collector of works of art, weapons, and curios both natural and man-made, includes three works described as "Head [or face] of Christ."

JULY 27. Spinoza is excommunicated by the *mahamad*.

1656–58

Rembrandt's possessions are sold in a series of six auctions, yielding a disappointing 5,044 guilders.

1657

JULY 17. A resolution of the States General grants Jews in the United Provinces the status of subjects.

NOVEMBER 20. Menasseh ben Israel dies in Middelburg while conveying his son Samuel's body there for burial.

1658

Titus's ownership of the Sint Anthoniesbreestraat house is voided. The Chamber of Insolvent Estates auctions the house for 13,600 guilders, but the buyer does not pay.

In an attempt to avoid the artist's creditors, Hendrickje and Titus begin to act as Rembrandt's employers and sell his work.

ABOUT 1658

Rembrandt moves with Hendrickje, Titus, and Cornelia to a much smaller rented house on the Rozengracht, in the Jordaan section of Amsterdam, where he lives for the rest of his life.

ABOUT 1659

The Sint Anthoniesbreestraat house is re-auctioned for 12,000 guilders, but again the buyer does not pay. Arent (Aert) de Gelder (1645–1727) becomes one of Rembrandt's pupils.

1660

Hendrickje and Titus formalize their art-dealing partnership, thus relieving Rembrandt of all financial responsibility for his debts.

ABOUT 1660

The Sint Anthoniesbreestraat house is auctioned a third time. The buyer pays 11,218 guilders.

1661

Executes a series of apostle paintings, including the studio work *Christ with a Staff* (Metropolitan Museum of Art, New York; see plate 4.8).

1662

Receives major commissions for portraits and other works, including some from the wealthy Trip family.

Sells Saskia's grave.

1663

Plague strikes Amsterdam.

Hendrickje dies (probably a victim of the plague) and is buried in a rented grave in the Westerkerk.

1665

Rembrandt makes his last print, a commissioned posthumous portrait of the physician Johannes Antonides van der Linden. The publisher rejects the plate as not suitable for extended printing.

1665–67

The second Anglo-Dutch war results in the loss of New Amsterdam. In response, the Dutch advance up the Thames to the gates of London and destroy the shipyards of the British fleet.

1666

Rembrandt gives Titus full power of attorney.

1667

JULY. The Treaty of Breda ends the war.

A Bible developed jointly by the Protestant theologian Johannes Leusden (1624–1699) and the first Jewish printer, Joseph Athias (c. 1635–1700), is published in Amsterdam.

Florentine duke Cosimo III de'Medici (1642–1723) meets Rembrandt and other artists in Amsterdam during his first European tour.

1668

Titus marries and dies seven months later. He is buried in the Westerkerk.

1669

Titus's daughter, Titia, is born.

Rembrandt paints three self-portraits (National Gallery, London; Galleria degli Uffizi, Florence; Mauritshuis, The Hague).

OCTOBER 4. Rembrandt dies and is buried four days later in a rented grave in the Westerkerk.

Appendix

REFLECTED INFRARED AND X-RADIOGRAPHIC IMAGES OF THE HEAD OF CHRIST PANELS

For discussion of the following images, see the general essay and individual entries on the paintings in "The Heads of Christ: A Technical Survey" on pp. 31–73. All of the images are reproduced at actual size.

PLATE 2.2A, B Rembrandt Harmensz. van Rijn and Studio, *Head of Christ*, c. 1648–56 Philadelphia Museum of Art, John G. Johnson Collection, cat. 480

page 200: Reflected infrared photograph, Nikon D90 camera with a #87 gelatin filter, by J. Mikuliak, Conservation Department, Philadelphia Museum of Art

page 201: X-radiograph by J. Mikuliak, Conservation Department, Philadelphia Museum of Art

PLATE 2.3A, B Attributed to Rembrandt Harmensz. van Rijn and Studio, *Head of Christ*, c. 1655 Netherlands Institute for Cultural Heritage, NK774, on loan to Bijbels Museum, Amsterdam

page 202: Reflected infrared photograph, Nikon D90 camera with a #87 gelatin filter, by M. Tucker, Conservation Department, Philadelphia Museum of Art

page 203: X-radiograph provided by Netherlands Institute for Cultural Heritage Research

PLATE 2.4A Rembrandt Harmensz. van Rijn, *Head of Christ*, c. 1648–56 Private collection

page 212: Reflected infrared photograph, Sony F 747 with infrared filter, by Michel van de Laar, Amsterdam

PLATE 2.5A, B Rembrandt Harmensz. van Rijn, *Head of Christ*, c. 1648–56 Harvard Art Museum/Fogg Museum, Cambridge, Massachusetts, 1964.172

page 204: Reflected infrared photograph provided by Harvard University Art Museums

page 205: X-radiograph provided by Harvard University Art Museums

PLATE 2.6A, B Rembrandt Harmensz. van Rijn, *Head of Christ*, c. 1648–50 Staatliche Museen Preussischer Kulturbesitz, Gemäldegalerie, Berlin, inv. 811C

page 206: Reflected infrared photograph provided by Gemäldegalerie, Berlin

page 207: X-radiograph provided by Gemäldegalerie, Berlin*

PLATE 2.7A, B Attributed to Rembrandt Harmensz. van Rijn, *Head of Christ*, c. 1648–54 Detroit Institute of Arts, Founders Society Purchase, 30.370

page 208: Reflected infrared photograph by Paul Cooney, provided by the Detroit Institute of Arts

page 209: X-radiograph provided by the Detroit Institute of Arts*

PLATE 2.8A, B Rembrandt Harmensz. van Rijn, *Head of Christ*, c. 1648 Museum Bredius, The Hague, 94-1946

page 210: Reflected infrared photograph, Nikon D90 camera with a #87 gelatin filter, by M. Tucker, Conservation Department, Philadelphia Museum of Art

page 211: X-radiograph provided by the Rijksbureau voor Kunsthistorische Documentatie. The X-radiograph was taken with the panel in its frame; the outlines of nails seen at top and left and the plate at bottom are related to the frame, not the panel.*

*These X-radiographs also show wooden cradles that were attached to the backs of the panels at a later date.

199

PLATE 2.2A (INSET PORTION) REFLECTED INFRARED PHOTOGRAPH

200

PLATE 2.2B (INSET PORTION) X-RADIOGRAPH

201

PLATE 2.3A REFLECTED INFRARED PHOTOGRAPH

202

PLATE 2·3B X-RADIOGRAPH

203

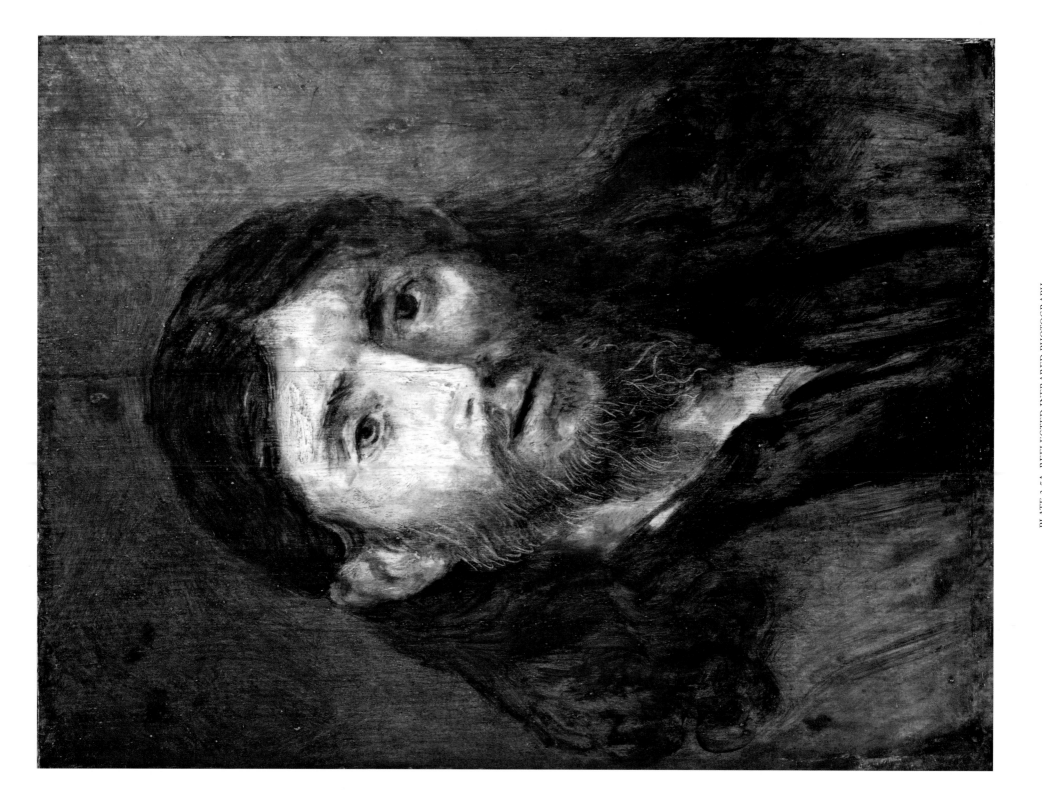

PLATE 2.5A REFLECTED INFRARED PHOTOGRAPH

204

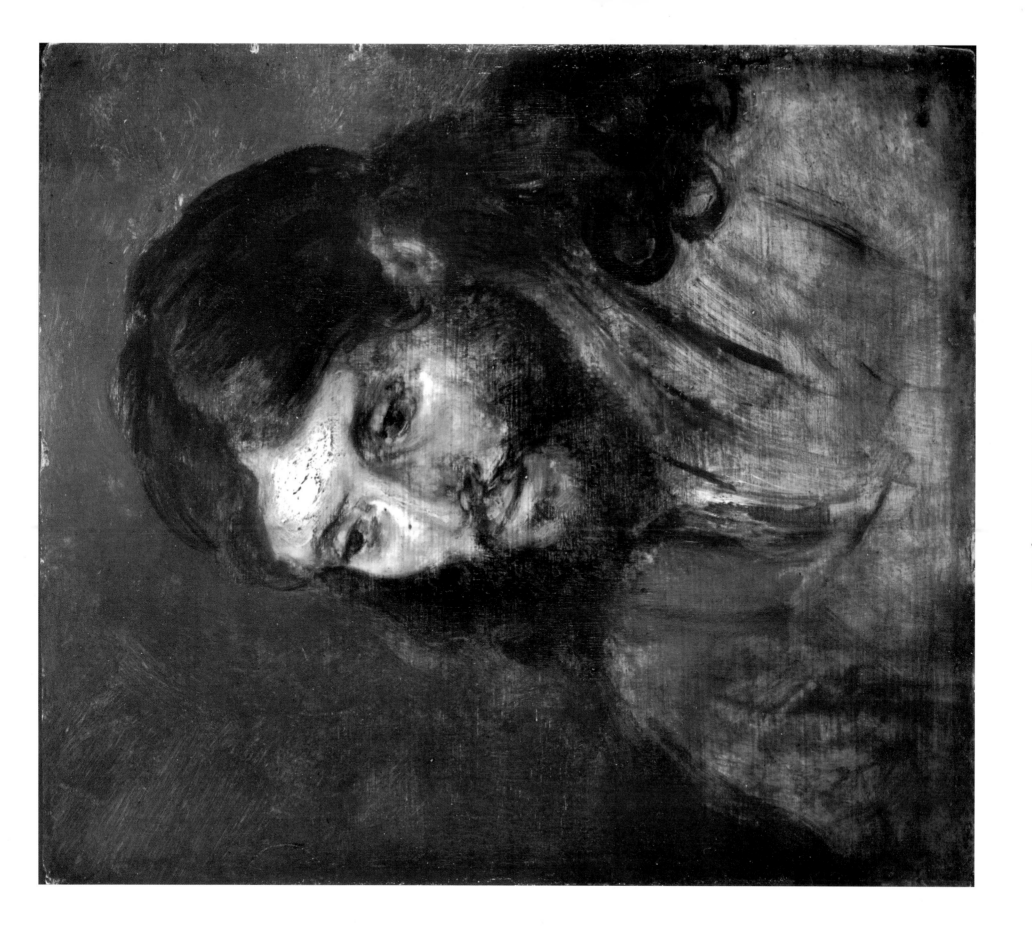

PLATE 2.6A REFLECTED INFRARED PHOTOGRAPH

206

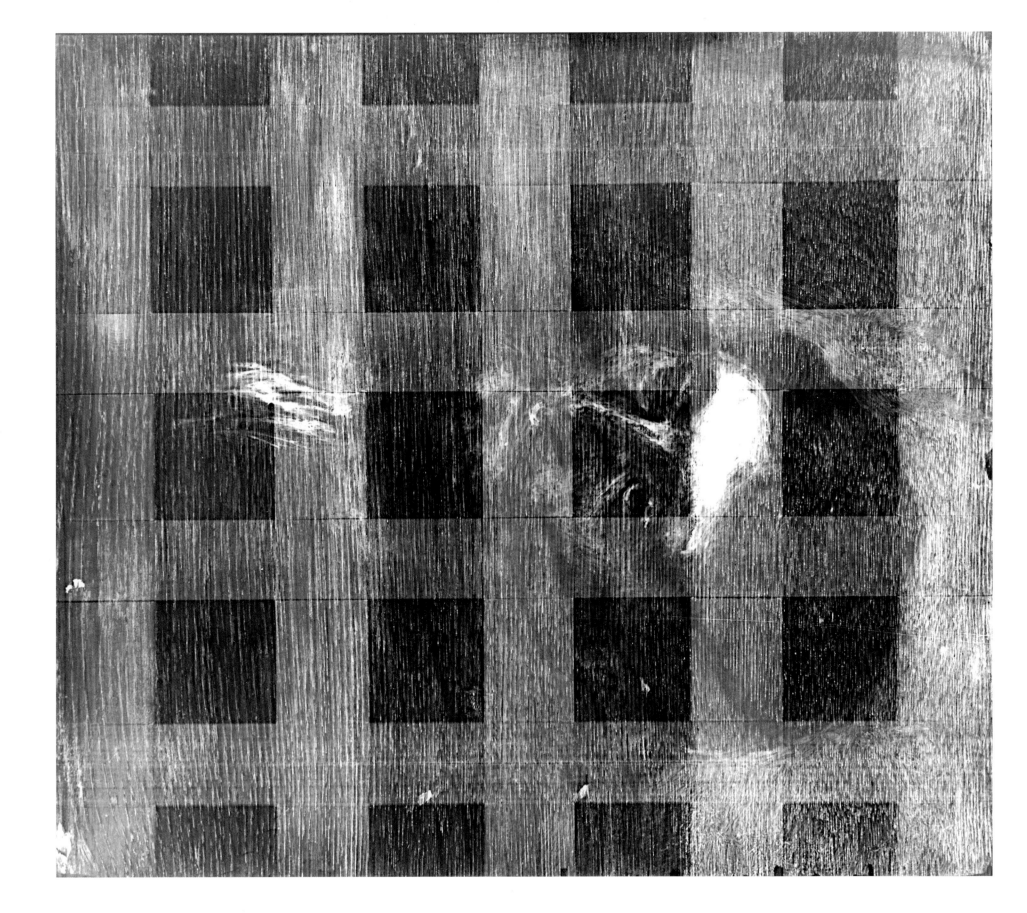

PLATE 2.6B X-RADIOGRAPH

207

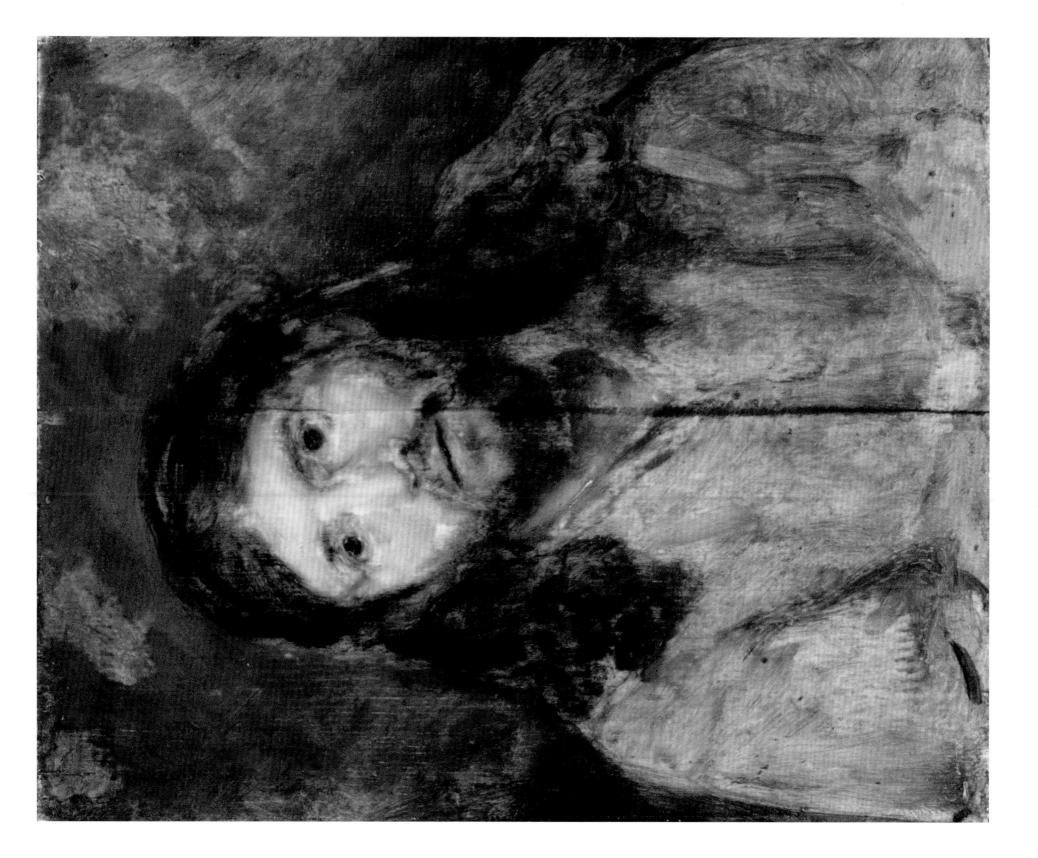

PLATE 2.7A REFLECTED INFRARED PHOTOGRAPH

208

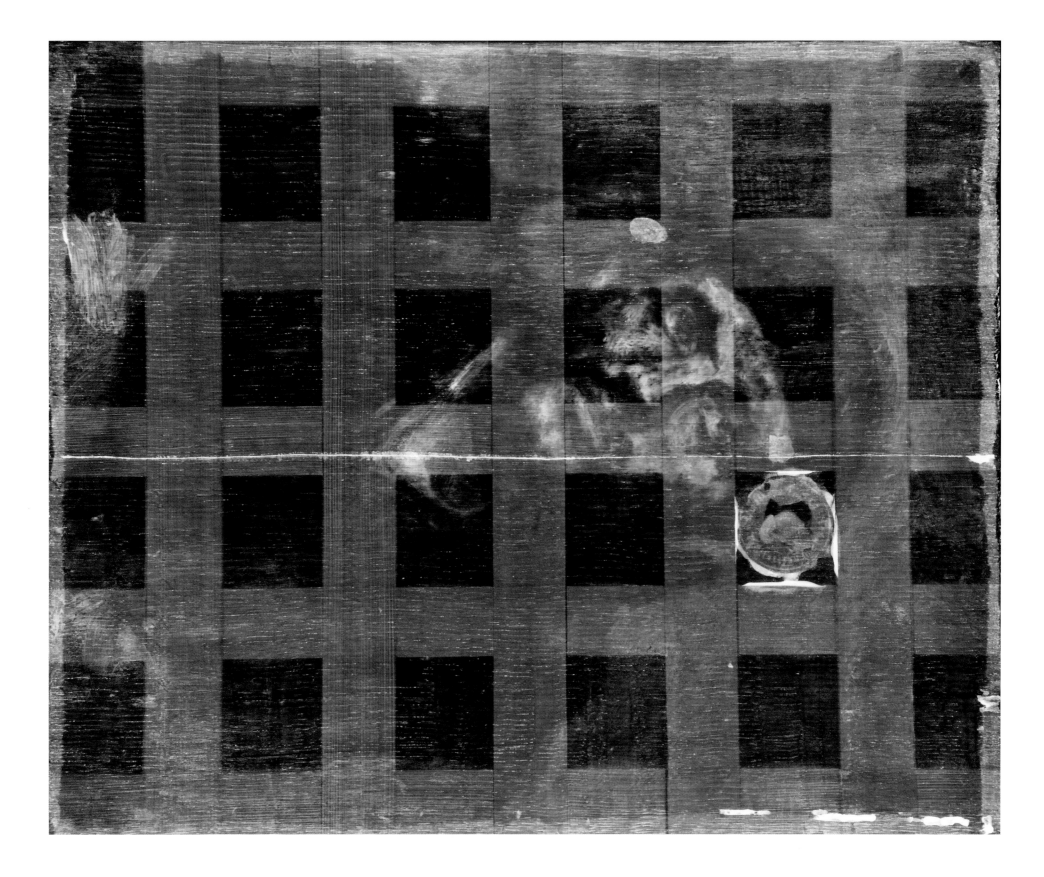

PLATE 2.7B X-RADIOGRAPH

209

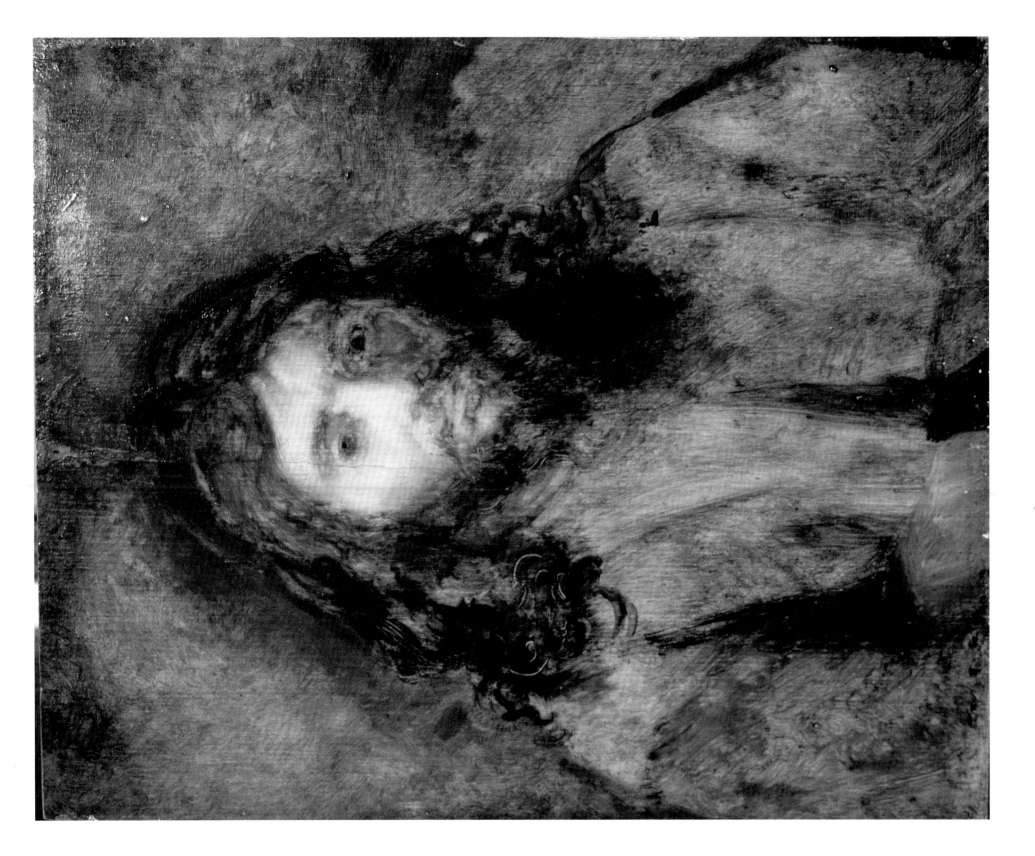

PLATE 2.8A REFLECTED INFRARED PHOTOGRAPH

210

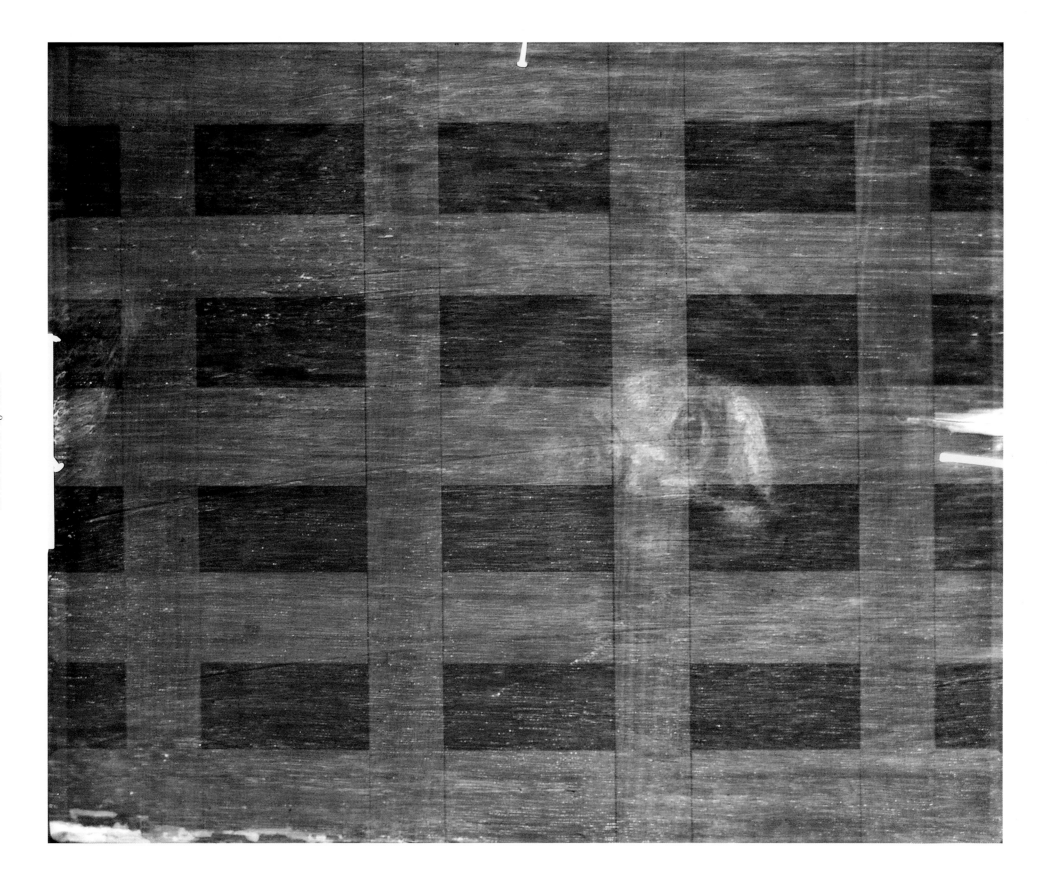

PLATE 2.8B X-RADIOGRAPH

211

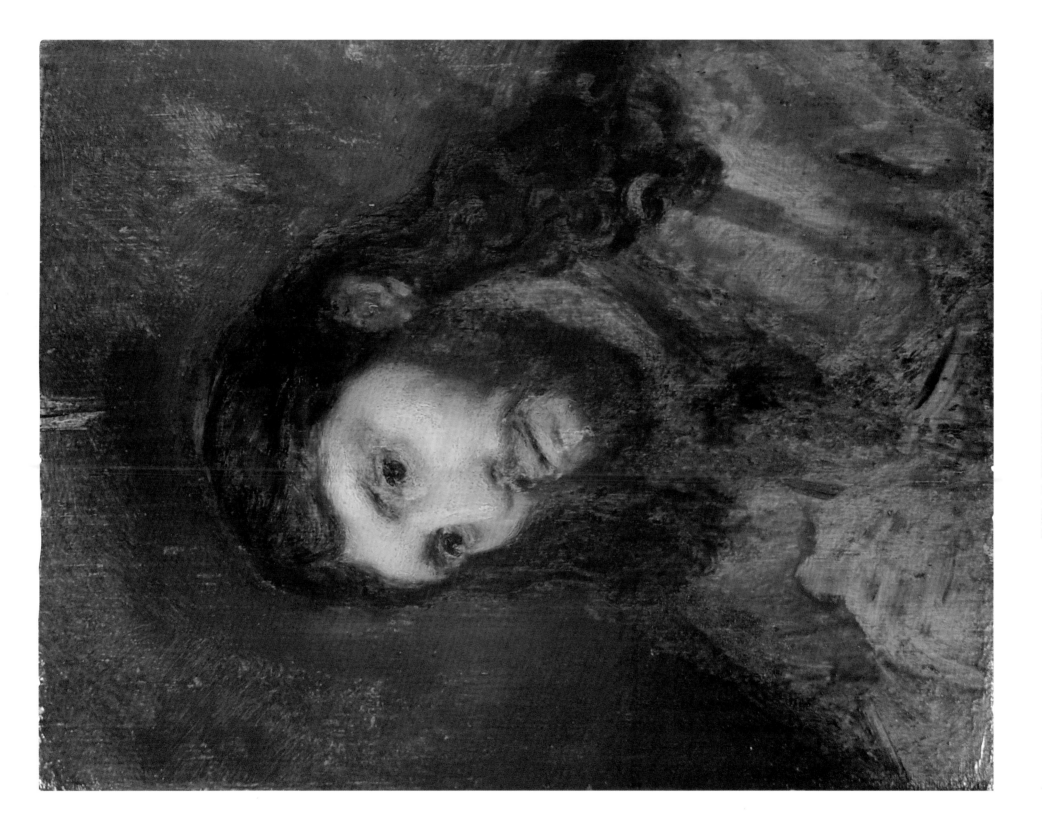

PLATE 2.4A REFLECTED INFRARED PHOTOGRAPH

212

SELECTED BIBLIOGRAPHY

Ackley 1980
Ackley, Clifford S. *Printmaking in the Age of Rembrandt*. Exh. cat. Museum of Fine Arts, Boston, October 28, 1980–January 4, 1981; Saint Louis Art Museum, February 19–April 12, 1981. Boston: Museum of Fine Arts.

Ackley et al. 1989
Ackley, Clifford, et al. *From Michelangelo to Rembrandt: Master Drawings from the Teyler Museum*. Exh. cat. The Pierpont Morgan Library, New York, February 10–April 30; The Art Institute of Chicago, May 13–July 30. New York: The Pierpont Morgan Library.

Ainsworth et al. 1982
Ainsworth, Maryan W., et al. *Art and Autoradiography: Insights into the Genesis of Paintings by Rembrandt, Van Dyck, and Vermeer*. New York: The Metropolitan Museum of Art.

Alexander-Knotters, Hillegers, and Van Voolen 2006
Alexander-Knotters, Mirjam, Jasper Hillegers, and Edward van Voolen. *De 'joodse' Rembrandt: de mythe ontrafeld*. Exh. cat. November 10, 2006–February 4, 2007. Amsterdam: Joods Historisch Museum.

Alexandre 1929
Alexandre, Arsène. "L'art hollandais à la Royal Academy." *La Renaissance*, vol. 12 (March), pp. 11–30.

Allard and Lyman 1942
Allard, Louis, and John Lyman. *Loan Exhibition of Masterpieces of Painting under the Distinguished Patronage of His Excellency the Earl of Athlone, Governor General of Canada, and H.R.H. The Princess Alice, Countess of Athlone; for the benefit of the Men of the Allied Merchant Navies*. Exh. cat. February 5–March 8. Montreal: Art Association of Montreal.

Allen 1945
Allen, Josephine L. "The Museum's Rembrandts." *Metropolitan Museum of Art Bulletin*, vol. 4 (November).

Alpers 1988
Alpers, Svetlana. *Rembrandt's Enterprise: The Studio and the Market*. Chicago: University of Chicago Press.

Alsteens 2004
Alsteens, Stijn. *Regards sur l'art hollandais du XVIIe siècle: Frits Lugt et les frères Dutuit, collectionneurs*. Paris: Adam Biro.

Anderberg, Larsen, and Bjerkhof 2005
Anderberg, Birgitte, Peter Norgaard Larsen, and Sven Bjerkhof. *SMK Highlights*. Copenhagen: Statens Museum for Kunst.

Andrews 1985
Andrews, Keith. *Catalogue of Netherlandish Drawings in the National Gallery of Scotland*. 2 vols. Edinburgh: Trustees of the National Galleries of Scotland.

Angel 1996
Angel, Philips. "Praise of Painting." Translated by Michael Hoyle. *Simiolus: Netherlands Quarterly for the History of Art*, vol. 24, nos. 2 and 3, pp. 227–58.

Anonymous 1917
Anonymous. "Obituary for Isaac D. Fletcher." *American Art News*, vol. 15 (May 5) p. 4.

Anonymous 1929a
Anonymous. "The Dutch Art Exhibition." Supplement to the *Illustrated London News* (January 5).

Anonymous 1929b
Anonymous. *Illustrated London News* (January 12), cover.

Art Association of Montreal 1933
Art Association of Montreal. *Exhibition: A Selection from the Collection of Paintings of the Late Sir William Van Horne, K.C.M.G., 1843–1915*. Exh. cat. October 16–November 5. Montreal: Art Association of Montreal.

Bache 1929
Bache, Jules Semon. *A Catalogue of Paintings in the Collection of Jules S. Bache*. New York: Privately printed.

Bache 1937
Bache, Jules Semon. *A Catalogue of Paintings in the Bache Collection, with Sixty-four Illustrations*. New York: William Bradford Press.

Bache 1943
Bache, Jules Semon. *A Catalogue of Paintings in the Bache Collection, with Sixty-four Illustrations*. Rev. ed. New York: William Bradford Press.

Bacou 1967
Bacou, Roseline. *Le Cabinet d'un grand amateur, P. J. Mariette*. Exh. cat. Musée du Louvre, Paris. Paris: Éditions des musées nationaux.

Bacou et al. 1970
Bacou, Roseline, et al. *Rembrandt et son temps – Dessins des collections publiques et privées conservées en France*. Exh. cat. Musée du Louvre, Paris, February 3–April 27. Paris: Éditions des musées nationaux.

Baer et al. 2003
Baer, Ronnie, Clifford Ackley, Tom Rassieur, and William W. Robinson. *Rembrandt's Journey: Painter, Draftsman, Etcher*. Exh. cat. Museum of Fine Arts, Boston, October 26, 2003–January 18, 2004; The Art Institute of Chicago, February 14–May 9, 2004. Boston: Museum of Fine Arts.

Baker 1993
Baker, Christopher. *Rembrandt*. Secaucus, NJ: Chartwell Books.

Bartsch 1797
Bartsch, Adam. *Catalogue raisonné de toutes les estampes qui forment l'œuvre de Rembrandt et ceux de ses principaux imitateurs*. 2 vols. Vienna: A. Blumauer.

Bartsch 1803–21
Bartsch, Adam. *Le peintre graveur*. 21 vols. Vienna: Degen.

Basan 1767
Basan, François. *Catalogue des estampes gravées d'après Rubens*. Liège: Jean Dessain.

Basan 1772
Basan, François. *Catalogue des tableaux du cabinet de feu M. Louis Michel Vanloo, Ecuyer, Chevalier de L'Order Du Roy*. Paris: Imprimerie de Prault.

Batowski 1928
Batowski, Zygmunt. *Zbiór graficzny w Uniwersytecie Warszawskim*. Warsaw: Nakt. Universytetu.

Bauch 1926
Bauch, Kurt. *Jakob Adriaensz Backer: Ein Rembrandtschüler aus Friesland*. Berlin: G. Grote.

Bauch 1960
Bauch, Kurt. *Der frühe Rembrandt und seine Zeit; Studien zur geschichtlichen Bedeutung seines Frühstils*. Berlin: Gebr. Mann.

Bauch 1962
Bauch, Kurt. "Rembrandts Christus am Kreuz." *Pantheon*, vol. 20, pp. 137–44.

Bauch 1966
Bauch, Kurt. *Rembrandt Gemälde*. Berlin: W. de Gruyter.

Baudiquey, Osty, and Trinquet 1979
Baudiquey, Paul, Émile Osty, and Joseph Trinquet. *Rembrandt et la Bible: Texte intégral de L'Ancien et du Nouveau Testament.* Paris: Desclee De Brouwer.

Beck 1957
Beck, Will. *An Inaugural Exhibition of Six Great Painters: El Greco, Rembrandt, Goya, Van Gogh, Cézanne, and Picasso.* Exh. cat. September 12–October 20. Milwaukee: Milwaukee Art Center.

F. Becker 1923
Becker, Felix. *Handzeichnungen holländischer Meister aus der Sammlung Dr. C. Hofstede de Groot im Haag.* Leipzig: B. Tauchnitz.

W. Becker 1909
Becker, Willy. *Das Poetische in den biblischen Darstellungen Rembrandts: ein Ergänzungskapitel zu Lessings Untersuchungen über die Grenzen der Malerei und Poesie.* Leipzig: Klinkhardt.

Bell 1899
Bell, Malcolm. *Rembrandt van Rijn and His Work.* London: G. Bell.

Belting 1998
Belting, Hans. *Likeness and Presence.* Chicago: University of Chicago Press.

Bénédite 1921
Bénédite, Léonce. *Exposition hollandaise, tableaux, aquarelles et dessins anciens et modernes.* Exh. cat. Galerie Nationale du jeu de Paume, Paris, April–May. The Hague: Impr. de Mouton.

Benesch 1925
Benesch, Otto. *Rembrandt's Vermächtnis.* Vienna: Krystallverlag.

Benesch 1935
Benesch, Otto. *Rembrandt. Werk und Forschung,* Vienna: Gilhofer and Ranschburg.

Benesch 1947
Benesch, Otto. *Rembrandt: Selected Drawings.* London: Phaidon.

Benesch 1954–57
Benesch, Otto. *The Drawings of Rembrandt.* 6 vols. London: Phaidon.

Benesch 1956a
Benesch, Otto. *Rembrandt: Ausstellung im 350 Geburtsjahr des Meisters.* Exh. cat. Vienna: Graphische Sammlung Albertina.

Benesch 1956b
Benesch, Otto. "Worldly and Religious Portraits in Rembrandt's Late Art." *Art Quarterly,* vol. 19 (Winter), pp. 334–55.

Benesch 1957
Benesch, Otto. *Rembrandt: Biographical and Critical Study.* New York: Skira.

Benesch 1960
Benesch, Otto. *Rembrandt as a Draughtsman: An Essay.* London: Phaidon.

Benesch 1964
Benesch, Otto. "Neuentdeckte Zeichnungen von Rembrandt," *Jahrbuch der Berliner Museen,* vol. 6, pp. 105–60.

Benesch 1970–73
Benesch, Otto. *Collected Writings.* 4 vols. London: Phaidon.

Benesch and Benesch 1973
Benesch, Otto, and Eva Benesch. *The Drawings of Rembrandt.* 6 vols. Enlarged ed. London: Phaidon.

Bergström 1969
Bergström, Ingmar. "Oeuvres de jeunesse de Rembrant." *L'Oeil,* vol. 173 (May), pp. 2–9.

Bernard, Bénédite, and Demonts 1921
Bernard, Edmond, Léonce Bénédite, and Louis Demonts. *Les dessins de Rembrandt: recueil de quarante dessins en fac-simile.* Paris: Éditions d'Art de l'illustration.

Bernhard 1976
Bernhard, Marianne. *Rembrandt.* 2 vols. Munich: Südwest Verlag.

Bertram 1955
Bertram, Anthony. *Rembrandt.* London: Studio.

Bevers et al. 2010
Bevers, Holm, et al. *Drawings by Rembrandt and His Pupil: Telling the Difference.* Exh. cat. December 8, 2009–February 28, 2010. Los Angeles: J. Paul Getty Museum.

Bikker 2005
Bikker, Jonathan. *Willem Drost (1633–1659): A Rembrandt Pupil in Amsterdam and Venice.* New Haven: Yale University Press.

Bjurström 1969
Bjurström, Per. *Drawings from Stockholm: A Loan Exhibition from the Nationalmuseum.* Exh. cat. The Pierpont Morgan Library, New York; Museum of Fine Arts, Boston; The Art Institute of Chicago. New York: The Pierpont Morgan Library.

Blanc 1859
Blanc, Charles. *L'œuvre complet de Rembrandt.* Paris: Gide.

Blankert 1978
Blankert, Albert. *Museum Bredius: catalogus van de schilderijen en tekeningen.* The Hague: Diest voor Schone Kunsten der Gemeente s'Gravenhage.

Blankert 1982
Blankert, Albert. *Ferdinand Bol (1616–1680): Rembrandt's Pupil.* Doornspijk: Davaco.

Blankert 2000
Blankert, Albert. *Jezus in de Gouden Eeuw.* Exh. cat. September 9, 2000–January 7, 2001. Rotterdam: Kunsthal.

Blankert et al. 1997
Blankert, Albert, et al. *Rembrandt: A Genius and His Impact.* Exh. cat. National Gallery of Victoria, Melbourne, October 1–December 7, 1997; National Gallery of Australia, Canberra, December 17, 1997–February 15, 1998. Melbourne: National Gallery of Victoria.

Blankert, Barnouw-de Ranitz, and Stal 1991
Blankert, Albert, Louise Barnouw-de Ranitz, and C. J. J. Stal. *Museum Bredius: catalogus van de schilderijen en tekeningen.* Zwolle: Waanders.

Blankert and Broos 1983
Blankert, Albert, and Ben Broos. *The Impact of a Genius: Rembrandt, His Pupils and Followers in the Seventeenth Century: Paintings from Museum and Private Collections.* Exh. cat. Waterman Gallery, Amsterdam; Groninger Museum, May 22–June 19. Amsterdam: K. and V. Waterman.

Blum 1949
Blum, André. "La Pièce aux Cent Florins." *Gazette des Beaux-arts,* ser. 6, vol. 35, pp. 137–60.

Blunt 1948
Blunt, Anthony. *Masterpieces of the Dutch School from the Collection of His Majesty, the King of England.* Exh. cat. August 6–September 26. The Hague: Mauritshuis.

Bock, Rosenberg, and Friedländer 1931
Bock, Elfried, Jakob Rosenberg, and Max J. Friedländer. *Die niederländischen Meister: Beschreibendes Verzeichnis Sämtlicher Zeichnungen.* 2 vols. Frankfurt: Prestel-verlag.

Bolten 1981
Bolten, J., ed. *Rembrandt and the Incredulity of Thomas: Papers on a Rediscovered Painting from the Seventeenth Century.* Leiden: Aliotta and Manhart.

Bolten, Bolten-Rempt, and Adkinson 1977
Bolten, J., H. Bolten-Rempt, and Danielle Adkinson. *The Hidden Rembrandt.* Chicago: Rand McNally.

Bomford et al. 2006
Bomford, David, et al. *Rembrandt: Art in the Making.* London: The National Gallery.

Bomford, Brown, and Roy 1988
Bomford, David, Christopher Brown, and Ashok Roy. *Art in the Making: Rembrandt.* London: The National Gallery.

Bonnier 1969
Bonnier, Henry. *L'univers de Rembrandt.* Paris: H. Scrépel.

Boon 1970
Boon, Karel G. *Rembrandt, trentatto disegni*. Exh. cat. Pinacoteca di Brera, Milan, November 6–December 16. Milan: Centro Di.

Boon et al. 1961
Boon, Karel G., et al. *Hollandse Tekeningen uit de gouden eeuw / Holländische Zeichnungen der Rembrandt-Zeit*. Exh. cat. Albert I-Bibliotheek, Brussels, April 22–June 24; Kunsthalle, Hamburg, September 8–October 15; Brussels: Albert I-Bibliotheek; Hamburg: Kunsthalle.

Borenius 1946
Borenius, Tancred. *Rembrandt: Selected Paintings*. London: Phaidon.

Borenius 1923
Borenius, Tancred. *Four Early Italian Engravers: Antonio Del Pollaiuolo, Andrea Mantegna, Jacopo De' Barbari, Giulio Campagnola*. London: Medici Society.

Both de Tauzia 1888
Both de Tauzia, L., Vicomte. *Musée national du Louvre, dessins, cartons, pastels et miniatures des diverses écoles*. Paris: Librairie des imprimeries réunies.

Bouleau-Rabaud 1955
Bouleau-Rabaud, Wanda. *Rembrandt et son temps: dessins et eaux-fortes de Rembrandt et d'autres maîtres hollandais du XVIIe siècle conservés dans les collections de l'École des beaux-arts*, Paris. Exh. cat. May–June. Paris: École nationale supérieure des beaux-arts.

Bowron 1990
Bowron, Edgar Peters. *European Paintings before 1900 in the Fogg Art Museum: A Summary Catalogue Including Paintings in the Busch-Reisinger Museum*. Cambridge, MA: Harvard University Art Museums.

Brandus 1928
Brandus, Édouard. "La collection des tableaux anciens de M. Jules S. Bache, à New-York." *La Renaissance*, vol. 11 (May), pp. 181–98.

Bredius 1935
Bredius, Abraham. *Rembrandt Gemälde*. Vienna: Phaidon

Bredius 1937
Bredius, Abraham. *The Paintings of Rembrandt*. London: Allen and Unwin.

Bredius and Gerson 1969
Bredius, Abraham, and H. Gerson. *Rembrandt: The Complete Edition of the Paintings*. Edited by Horst Gerson. 3d ed. London: Phaidon.

Bredius and Kronig 1915
Bredius, Abraham, and J. O. Kronig. *Tentoonstelling van oude schilderijen*. Exh. cat. The Hague: Kunstzaal Kleykamp.

Brejon de Lavergnée 1970
Brejon de Lavergnée, Arnauld. *Le siècle de Rembrandt; tableaux hollandais des collections publiques françaises*. Exh. cat. Musée du Petit Palais, Paris, November 17, 1970–February 15, 1971. Paris: Éditions des musées nationaux.

Broos 1977
Broos, Ben. *Index to the Formal Sources of Rembrandt's Art*. Maarssen: Schwartz.

Broos 1985
Broos, Ben. *Rembrandt en zijn voorbeelden*. Exh. cat. November 2, 1985–January 5, 1986. Amsterdam: Museum het Rembrandthuis.

Broos, Buijsen, and Van Leeuwen 1990
Broos, Ben, Edwin Buijsen, and Rieke van Leeuwen. *Great Dutch Paintings from America*. Exh. cat. Mauritshuis, The Hague, September 28, 1990–January 13, 1991; The Fine Arts Museums of San Francisco, February 16–May 5, 1991. Zwolle: Waanders.

Brouwer-Sierdsma 1930
Brouwer-Sierdsma, J. *Verzameling Dr. C. Hofstede de Groot*. Exh. cat. August 16–September 16. The Hague: Gemeentemuseum.

B. L. Brown 1989
Brown, Beverly Louise. *Treasures from the Fitzwilliam Museum: The Increase of Learning and Other Great Objects*. Exh. cat. National Gallery of Art, Washington, DC, March 19–June 18, 1989; Kimbell Art Museum, Fort Worth, TX, November 5, 1989–January 8, 1990. Cambridge: Fitzwilliam Museum.

C. Brown 1976
Brown, Christopher. *Art in Seventeenth Century Holland*. Exh. cat. September 30–December 12. London: The National Gallery.

Brown and Wheelock 1988
Brown, Beverly Louise, and Arthur K. Wheelock. *Masterworks from Munich: Sixteenth- to Eighteenth-Century Paintings from the Alte Pinakothek*. Exh. cat. National Gallery of Art, Washington, DC, May 29–September 5, 1988; Cincinnati Art Museum, October 25, 1988–January 8, 1989. Washington, DC: National Gallery of Art.

Brown et al. 1991
Brown, Christopher, et al. *Rembrandt: The Master and His Workshop*. 2 vols. Exh. cat. Altes Museum, Berlin, September 12–November 10, 1991; Rijksmuseum, Amsterdam, December 4, 1991–March 1, 1992; The National Gallery, London, March 26–May 24, 1992. London: The National Gallery.

Brown, Holzapfel, and Pheysey 2006
Brown, S. Kent, Richard Neitzel Holzapfel, and Dawn Pheysey. *Beholding Salvation: The Life of Christ in Word and Image*. Exh. cat. Brigham Young University Museum of Art, Provo, UT, November 17, 2006–June 16, 2007. Salt Lake City: Deseret Book.

Bruel 1908
Bruel, F. L. "L'exposition des dessins et d'eauxfortes de Rembrandt à la Bibliothèque nationale." *Gazette des Beaux-Arts*, ser. 4, vol. 1, pp. 441–62.

Bruyn et al. 1973
Bruyn, J., J. A. Emmens, E. de Jongh, and D. P. Snoep, eds. *Album amicorum J. G. van Gelder*. The Hague: M. Nijhoff.

Bruyn et al. 1982–2006
Bruyn, J., et al. *A Corpus of Rembrandt Paintings*. 4 vols. The Hague: M. Nijhoff.

Budzińska 1972
Budzińska, Elżbieta. "Tak zwana kolkcja Stanisława Kostki Potockiego w Gabinecie Rycin Biblioteki Uniwersyteckiej w Warszawie." *Biuletyn Historii Sztuki*, vol. 34, no. 2, pp. 161–67.

Bürger 1858
Bürger, Wilhelm. "Les dessins de Rembrandt au British Museum." *Revue Germanique*, vol. 3, pp. 392–403.

Burroughs 1923
Burroughs, Alan. "Rembrandts in the Metropolitan Museum." *The Arts*, vol. 4 (November).

Byrnes 1959
Byrnes, James. *Masterpieces of Art: In Memory of Wilhelm R. Valentiner, 1880–1958*. Exh. cat. April 6–May 17. Raleigh: North Carolina Museum of Art.

Cabanne 1991
Cabanne, Pierre. *Rembrandt*. Paris: Chêne.

California Palace of the Legion of Honor and the M. H. de Young Memorial Museum 1940
California Palace of the Legion of Honor and the M. H. de Young Memorial Museum. *Seven Centuries of Painting: A Loan Exhibition of Old and Modern Masters*. Exh. cat. December 29, 1939–January 28, 1940. San Francisco: M. H. de Young Memorial Museum.

Campbell 1971
Campbell, Colin. "Studies in the Formal Sources of Rembrandt's Figure Compositions." Ph.D. diss., University of London.

Carroll 1981
Carroll, M. "Rembrandt as a Meditative Printmaker." *Art Bulletin*, vol. 63, pp. 58–610.

Cavalli-Björkman, Sidén, and Snickare 2005
Cavalli-Björkman, Görel, Karin Sidén, and Mårten Snickare. *Holländsk guldålder: Rembrandt, Frans Hals och deras samtida*. Exh. cat. September 22, 2005–January 8, 2006. Stockholm: Nationalmuseum.

Cavalli-Björkman and Snickare 1992
Cavalli-Björkman, Görel, and Mårten Snickare. *Rembrandt och hans tid: människan i centrum*. Exh. cat. October 2, 1992–January 6, 1993. Stockholm: Nationalmuseum.

Charrington 1923
Charrington, John. *A Catalogue of the Mezzotints After, or Said to Be After, Rembrandt.* Cambridge: Cambridge University Press.

Cincinnati Art Museum 1959
Cincinnati Art Museum. *The Lehman Collection, New York.* Exh. cat. May 8–July 5. Cincinnati: Cincinnati Art Museum.

Clark 1966
Clark, Kenneth. *Rembrandt and the Italian Renaissance.* The Wrightsman Lectures, no. 1. New York: New York University Press.

Clark 1978
Clark, Kenneth. *An Introduction to Rembrandt.* New York: Harper and Row.

Cormack 1966
Cormack, Malcolm. *Rembrandt and His Circle: An Exhibition of Drawings from the Collection of the Fitzwilliam Museum.* Exh. cat. February–June. Cambridge: Fitzwilliam Museum.

Cortissoz 1920
Cortissoz, Royal. "The Jules S. Bache Collection." *American Magazine of Art*, vol. 21 (May), pp. 245–61.

Courboin, Guibert, and Lemoisne 1908
Courboin, François, Joseph Guibert, and Paul-André Lemoisne. *Exposition d'oeuvres de Rembrandt: dessins et gravures.* Exh. cat. May–June. Paris: École nationale supérieure des beaux-arts.

Crenshaw 2006
Crenshaw, Paul. *Rembrandt's Bankruptcy: The Artist, His Patrons, and the Art Market in Seventeenth-Century Netherland.* Cambridge: Cambridge University Press.

Dacier 1909–21
Dacier, Émile. *Catalogues de ventes et de livrets de Salons illustrés par Gabriel de Saint-Aubin.* 11 volumes in 6. Paris: Au siège de la Société.

Darracott 1979
Darracott, Joseph. *All for Art: The Ricketts and Shannon Collection.* Exh. cat. Fitzwilliam Museum, Cambridge, October 9–December 3. Cambridge: Cambridge University Press.

Dekiert 2006
Dekiert, Marcus. *Alte Pinakothek: holländische und deutsche Malerei des 17. Jahrhunderts.* Ostfildern: Hatje Cantz.

Demonts 1920
Demonts, Louis. "L'album de dessins de Rembrandt donné au . . . Louvre par M. Bonnat." *Gazette des Beaux-arts*, ser. 5, vol. 1, pp. 1–20.

Descamps 1754
Descamps, Jean Baptiste. *La vie des peintres flamands, allemands et hollandois.* 2 vols. Paris: Jombert.

De Tolnay 1943
De Tolnay, Charles. *History and Technique of Old Master Drawings: A Handbook.* New York: H. Bittner.

Detroit Institute of Arts 1949
Detroit Institute of Arts. *Masterpieces of Painting and Sculpture.* Exh. cat. Detroit: Detroit Institute of Arts.

DeWitt 2006
DeWitt, Lloyd. "Evolution and Ambition in the Career of Jan Lievens 1607–1674." Ph.D. diss., University of Maryland, College Park.

Dittrich and Ketelsen 2004
Dittrich, Christian, and Thomas Ketelsen, with K. Bielmeier and C. Melzer. *Rembrandt: die Dresdener Zeichnungen.* Cologne: W. König.

Dodgson 1926
Dodgson, Campbell. *Albrecht Dürer.* London: Medici Society.

Douglas 1948
Douglas, R. Langton. "Three Pictures by Rembrandt from the van Loo Collection." *Art in America*, vol. 36, pp. 69–74.

Drost 1957
Drost, Willi. *Adam Elsheimer als Zeichner: Goudts Nachahmungen und Elsheimers Weiterleben bei Rembrandt, ein Beitrag zur Strukturforschung.* Stuttgart: W. Kohlhammer.

Drost 1960
Drost, Willi. "Eine Handzeichnungsgruppe aus Rembrandt-Werkstatt um 1655." In *Das Werk des Künstlers*, ed. Hans Fegers, pp. 212–29. Stuttgart: Kohlhammer.

Dutuit 1881–88
Dutuit, Eugène. *Manuel de l'amateur d'estampes.* Paris: A. Lévy.

Dutuit 1885
Dutuit, Eugène. *Tableaux et dessins de Rembrandt.* Paris: A. Lévy.

Duveen 1957
Duveen, James Henry. *The Rise of the House of Duveen.* New York: Alfred A. Knopf.

Duveen Brothers 1941
Duveen Brothers. *Duveen Pictures in Public Collections of America: A Catalogue Raisonné with Three Hundred Illustrations of Paintings by the Great Masters, Which Have Passed through the House of Duveen.* New York: William Bradford Press.

E. J. van Wisselingh & Co. 1913
E. J. van Wisselingh & Co. *Catalogue of a Special Exhibition of Paintings, Water-colour Drawings and Original Etchings of the Art of the Netherlands.* Exh. cat. Galleries of the Winnipeg Industrial Bureau, Amsterdam, April–May. Amsterdam: E. J. van Wisselingh & Co.

Egorova, Levitin, and Danilova 1969
Egorova, K. S., E. S. Levitin, and Irina Evgen'evna Danilova. *Vystavka proizvedenii Rembrandta, 1606–1669: k 300-letiiu so dnia smerti khudozhnika* (Rembrandt: An exhibition of his works dedicated to the 300th anniversary of the artist's death). Exh. cat. Moscow: The Pushkin Museum.

Eiskonen et al. 2005
Eiskonen, Satu, Eeva-Kaisa Hakulinen, Olli Immonen, and Jukka Mallinen. *Treasures from the Pavlovsk Palace: The Collecting in Russia in the Time of Catherine II and Paul I.* Exh. cat. Helsinki: Etelä-Karjalan taidemuseo.

Eisler 1927
Eisler, Max. *Der alte Rembrandt.* Vienna: Druck und Verlag der Österreichischen Staatsdruckerei.

Ekkart, Jacob, and Klessmann 1979
Ekkart, Rudolf E. O., Sabine Jacob, and Rüdiger Klessmann. *Jan Lievens, ein Maler im Schatten Rembrandts.* Exh. cat. September 6–November 11. Braunschweig: Herzog Anton Ulrich-Museum.

Elen 2005
Elen, Albert. *Rembrandt in Rotterdam: tekeningen van Rembrandt en zijn kring in het Museum Boijmans Van Beuningen.* Exh. cat. Museum Boijmans Van Beuningen, December 10, 2005–March 5, 2006; Pera Museum, Istanbul, October 17, 2006–January 7, 2007. Rotterdam: Museum Boijmans Van Beuningen.

Emmens 1964
Emmens, Jan A. *Rembrandt en de Regels van de Kunst.* Utrecht: H. Dekker and Gumbert.

Ephrussi and Dreyfus 1879
Ephrussi, Charles, and Gustve Dreyfus. *Catalogue descriptif des dessins de maîtres anciens exposés à l'École des Beaux-Arts.* Exh. cat. May–June. Paris: G. Chamerot.

Errera 1920
Errera, Isabella. *Répertoire des peintures datées.* Brussels: G. van Oest and Cie.

Evans 2004
Evans, Helen C., ed. *Byzantium: Faith and Power (1261–1557).* Exh. cat. March 23–July 4. New York: The Metropolitan Museum of Art.

Fendrich 1990
Fendrich, Herbert. *Rembrandts Darstellung des Emmausmahles.* Frankfurt: Pe-er Lang.

Fleischer and Scott 1997
Fleischer, Roland E., and Susan C. Scott, eds. *Rembrandt, Rubens, and the Art of Their Time: Recent Perspectives.* Papers in Art History from the Pennsylvania State University, vol. 11. University Park: Pennsylvania State University.

Fogg Art Museum 1942
Fogg Art Museum. *Annual Report.* Cambridge, MA: Fogg Art Museum.

Fogg Art Museum 1948a
Fogg Art Museum. *Annual Report*. Cambridge, MA: Fogg Art Museum.

Fogg Art Museum 1948b
Fogg Art Museum. *Rembrandt: Paintings and Etchings*. Exh. cat. October 19–November. Cambridge, MA: Fogg Art Museum.

Fogg Art Museum 1968
Fogg Art Museum. *A Tribute to John Coolidge: Purchases of Two Decades*. Exh. cat. May 28–July 31. Cambridge, MA: Fogg Art Museum.

Ford et al. 2007
Ford, Charles, ed. and trans. *Lives of Rembrandt*. London: Pallas Athene.

Foucart 1982
Foucart, Jacques. *Les peintures de Rembrandt au Louvre*. Paris: Éditions des musées nationaux.

Foucart 2009
Foucart, Jacques. *Catalogue des peintures flamandes et hollandaises du musée du Louvre*. Paris: Musée du Louvre Éditions / Gallimard.

Frederik A. Müller & Co. 1929
Frederik A. Müller & Co. *Dessins anciens provenant d'une collection connue: vente publique le 21 Novembre, à 2½ [very 2½] heures dans la grande salle de ventes de la maison Frederik Müller & Cie.* Amsterdam: Frederik A. Müller & Co.

Freise 1912
Freise, Kurt. "Neue Bilder in holländischen Sammlungen." *Der Cicerone*, vol. 4, pp. 653–63.

Freise 1911
Freise, Kurt. *Pieter Lastman, sein Leben und seine Kunst, ein Beitrag zur Geschichte der Holländ. Malerei im Xvii. Jahrh.* Leipzig: Klinkhardt and Biermann.

Freise, Lilienfeld, and Wichmann 1921–25
Freise, Kurt, Karl Lilienfeld, and Heinrich Wichmann. *Rembrandts Handzeichnungen*. Parchim: H. Freise.

Frerichs and Verbeek 1964
Frerichs, L.C.J., and J. Verbeek. *Bijbelse inspiratie, tekeningen en prenten van Lucas van Leyden en Rembrandt.* Exh. cat. November 18, 1964–February 8, 1965. Amsterdam: Rijksmuseum.

Freylinghuysen 1993
Freylinghuysen, Alice Cooney. *Splendid Legacy: The Havemeyer Collection.* Exh. cat. March 27–June 30. New York: The Metropolitan Museum of Art.

Friedländer 1930
Friedländer, Max J. *Rembrandt.* Exh. cat. February 22–April 6. Berlin: Preussische Akademie der Künste zu Berlin.

Furcy-Raynaud 1912
Furcy-Raynaud, Marc. *Les tableaux et objets d'art saisis chez les émigrés et condamnés et envoyés au Muséum central.* Paris: s.n.

Galerie Goudstikker 1930
Galerie Goudstikker. *Catalogue des nouvelles acquisitions de la Collection Goudstikker.* Exh. cat. April–May. Amsterdam: Galerie Goudstikker.

Galerie Nationale du Jeu de Paume 1911
Galerie Nationale du Jeu de Paume. *Grands et petits maîtres hollandais.* Exh. cat. April 28–July 10. Paris: Galerie Nationale du Jeu de Paume.

Gantner 1964
Gantner, Joseph. *Rembrandt und die Verwandlung klassischer Formen.* Bern: Francke Verlag.

Geluk 1951
Geluk, D. J. A. *Rembrandt tentoonstelling: tekeningen en etsen.* Exh. cat. June 2–September 3. Haarlem: The Vleeshal.

Gerson and Schwartz 1968
Gerson, Horst, and Gary Schwartz. *Rembrandt Paintings.* New York: Reynal.

Gibson 1928
Gibson, William. "The Dutch Exhibition at Burlington House." *Apollo*, vol. 8 (December), pp. 319–22.

Giltaij 2002
Giltaij, Jeroen. *Rembrandt Rembrandt.* Exh. cat. National Museum, Kyoto, November 3, 2002–January 13, 2003; Städelsches Kunstinstitut, Frankfurt, January 31–May 11, 2003. Kyoto: National Museum.

Giltaij 1988
Giltaij, Jeroen. *The Drawings by Rembrandt and His School in the Museum Boymans–van Beuningen.* Rotterdam: The Museum Boijmans Van Beuningen.

Golanska and Sawicka 1976
Golanska, Stefania, and Stanislaw Sawicka. *Rembrandt i jego Krąg.* Exh. cat. March 15–April 30. Warsaw: National Museum.

Gowing 1952
Gowing, Lawrence. *Vermeer.* London: Faber and Faber.

Graul 1906
Graul, Richard. *Rembrandt: Eine Skizze.* Leipzig: E. A. Seemann.

Guillaud and Guillaud 1986
Guillaud, Jacqueline, and Maurice Guillaud. *Rembrandt, la figuration humaine.* Paris: Guillaud.

Haagsche Kunstkring 1902
Haagsche Kunstkring. *Tekeningen van oude hollandsche meesters uit de verzameling van Dr. C. Hofstede de Groot.* Exh. cat. 1902–3. The Hague: Haagsche Kunstkring.

Haak 1969
Haak, Bob. *Rembrandt: His Life, Work and Times.* New York: H. N. Abrams.

Hamann 1948
Hamann, Richard. Berlin: Safari-Verlag.

Hamburger Kunsthalle 1967
Hamburger Kunsthalle. *Hundert Meisterzeichnungen aus der Hamburger Kunsthalle 1500–1800.* Exh. cat. Hamburg: Hamburger Kunsthalle.

Hamburger Kunsthalle 1987
Hamburger Kunsthalle. *Rembrandts hundert Radierungen.* Exh. cat. April 15–June 7. Hamburg: Hamburger Kunsthalle.

Hand 1992
Hand, John Oliver. "Salve sancta facies: Some Thoughts on the Iconography of the 'Head of Christ' by Petrus Christus." *Metropolitan Museum Journal*, vol. 27, pp. 7–18.

Haverkamp-Begemann 1961
Haverkamp-Begemann, Egbert. "Review of Benesch 1954–1957." *Kunstchronik*, vol. 14, pp. 10–28, 50–57, 85–91.

Heil 1929
Heil, Walter. "The Jules Bache Collection." *Art News*, vol. 27 (April 27), pp. 3–4.

Hell 1930
Hell, Hans. *Die Späten Handzeichnungen Rembrandts.* Berlin: W. de Gruyter.

Hendy and Goldscheider 1945
Hendy, Philip, and Ludwig Goldscheider. *Giovanni Bellini.* Oxford: Phaidon.

Henkel 1943
Henkel, M. D. *Catalogus van de Nederlandsche teekeningen in het Rijksmuseum te Amsterdam.* The Hague: Algemeene Landsdrukkerij.

Grant 1908
Grant, J. Kirby. "Mr. John G. Johnson's Collection of Pictures in Philadelphia: Part IV." *The Connoisseur*, vol. 22 (November), pp. 141–52.

Grate 1967
Grate, Pontus. *Holländska mästare i svensk ägo.* Exh. cat. March 3–April 30. Stockholm: Nationalmuseum.

Hertz 1924
Hertz, Peter. *Den kongelige Malerisamlings Tilblivelse.* Copenhagen: Statens Museum for Kunst.

Heseltine 1910
Heseltine, John Postle. *Original Drawings by Old Masters of the Dutch School in the Collection of J.P.H.* London: Chiswick.

Hind 1912
Hind, Arthur Mayger. *Rembrandt, with a Complete List of His Etchings.* London: W. Heinemann.

Hind 1915
Hind, Arthur Mayger. *Catalogue of Dutch and Flemish Drawing in the British Museum.* 3 vols. London: British Museum.

Hind 1923
Hind, Arthur Mayger. *A Catalogue of Rembrandt's Etchings.* 2 vols. 2d ed. London: Methuen.

Hind 1932
Hind, Arthur Mayger. *Rembrandt.* London: Oxford University Press.

Hind 1938
Hind, Arthur Mayger. *Drawings and Etchings by Rembrandt.* Exh. cat. London: British Museum.

Hind 1948
Hind, Arthur Mayger. *Early Italian Engraving: A Critical Catalogue with Complete Reproduction of All the Prints Described.* 7 vols. London: B. Quaritch.

Hind 1967
Hind, Arthur Mayger. *A Catalogue of Rembrandt's Etchings.* 2 vols. 2d ed. Reprint. New York: Da Capo.

Hind and Colvin 1910
Hind, Arthur M., and Sidney Colvin. *Catalogue of Early Italian Engravings Preserved in the Department of Prints and Drawings in the British Museum.* London: Printed by order of the Trustees.

Hinterding 1994
Hinterding, Erik. "A History of Rembrandt's Copperplates, with a Catalogue of Those That Survive." *Simiolus,* vol. 22, no. 4.

Hinterding 2006
Hinterding, Erik. *Rembrandt as an Etcher.* Trans. Michael Hoyle. Ouderkerk aan den IJssel: Sound and Vision.

Hinterding et al. 2000
Hinterding, Erik, Ger Luijten, and Martin Royalton-Kisch, eds. *Rembrandt the Printmaker.* Exh. cat. Rijksmuseum, Amsterdam, July 22, 2000–January 7, 2001; British Museum, London, January 26–April 8, 2001. Zwolle: Waanders.

Hirschfelder 2008
Hirschfelder, Dagmar. *Tronie und Porträt in der niederländischen Malerei des 17. Jahrhunderts.* Berlin: Gebr. Mann Verlag.

Hirschmann 1917
Hirschmann, Otto. "Die Handzeichnungen-Sammlung Dr. Hofstede de Groot im Haag, II." *Der Cicerone,* vol. 9, nos. 1 and 2 (January), pp. 6–22.

Hirschmann 1919
Hirschmann, Otto. *Hendrick Goltzius.* Leipzig: Klinkhardt and Bierman.

Hoekstra 1983
Hoekstra, Hidde. *Rembrandt en de Bijbel: Verhalen uit het Oude en Nieuwe Testament.* 3 vols. Utrecht: Spectrum.

Hoetink and Giltaij 1969
Hoetink, Hendrik Richard, and Jeroen Giltaij. *Tekeningen van Rembrandt en zijn school. Catalogus van de verzameling in het Museum Boymans–Van Beuningen.* Rotterdam: Museum Boijmans Van Beuningen.

Hofstede de Groot 1898
Hofstede de Groot, Cornelis. *De Rembrandt tentoonstelling te Amsterdam.* Amsterdam: Scheltema and Holkema.

Hofstede de Groot 1906a
Hofstede de Groot, Cornelis. *Die Handzeichnungen Rembrandts.* Haarlem: E. F. Bohn.

Hofstede de Groot 1906b
Hofstede de Groot, Cornelis. *Die Urkunden über Rembrandt (1575–1721).* The Hague: M. Nijhoff.

Hofstede de Groot 1908–27
Hofstede de Groot, Cornelis. *A Catalogue Raisonné of the Works of the Most Eminent Dutch Painters of the Seventeenth Century Based on the Work of John Smith.* 10 vols. Edward G. Hawkings, translator and editor. London: Macmillan.

Hofstede de Groot 1916
Hofstede de Groot, Cornelis. *Beschreibendes und kritisches Verzeichnis der Werke der hervorragendsten holländischen Maler des CVII. Jahrhunderts,* vol. 6. Esslingen: P. Neff.

Hofstede de Groot 1922
Hofstede de Groot, Cornelis. *Die holländische Kritik der jetzigen Rembrandt-Forschung.* Berlin: Deutsche verlags-anstalt.

Hollstein 1949–
Hollstein, Friedrich W. H. *Hollstein's Dutch and Flemish Etchings, Engravings, and Woodcuts, Ca. 1450–1700.* Amsterdam: M. Hertzberger.

Hollstein 1954–
Hollstein, Friedrich W. H. *German Engravings, Etchings and Woodcuts 1450–1700.* Amsterdam: Menno Hertzberger.

Houbraken 1976
Houbraken, Arnold. *De groote schouburgh der nederlantsche konstschilders en schilderessen.* 1718–21. Reprint. Amsterdam: B. M. Israël.

Hours 1969
Hours, M. "La Crucifixion du Mas d'Agenais par Rembrandt." *Revue du Louvre et des Musées de France,* vol. 19, pp. 157–60.

Hours-Miedan 1956
Hours-Miedan, Madeleine. *Rembrandt durchleuchtet. Röntgen- und Infrarot-Aufnahmen der Rembrandt-Bilder im Louvre.* Exh. cat. Cologne: Wallraf-Richartz-Museum.

Immerzeel 1841
Immerzeel, Johannes. *Lofrede op Rembrandt.* Amsterdam: Bij. den Schrijver.

Institut Néerlandais 1957
Institut Néerlandais. *Exposition Rembrandt et son école: dessins et estampes.* Exh. cat. March 12–30. Paris: Institut Néerlandais.

Institut Néerlandais 1960
Institut Néerlandais. *Bestiaire bollandais: catalogue du exposition de tableaux, aquarelles, dessins et gravures par des artistes bollandais des XVIIe–XVIIIe siècles et d'un choix de livres de la même période.* Exh. cat. Paris: Institut Néerlandais.

Isarlov 1936
Isarlov, George. *Rembrandt et son entourage.* Exh. cat. Paris: La Renaissance.

Isenstein 1956
Isenstein, Harald. "De tidligste Rembrandt-biografier." *Kunst,* vol. 4.

Jean-Richard 2000
Jean-Richard, Pierrette. *Rembrandt: gravures et dessins de la Collection Edmond de Rothschild et du Cabinet des dessins, Département des arts graphiques du Musée du Louvre.* Exh. cat. Musée du Louvre, Paris, March 16–June 19. Paris: Éditions des musées nationaux, 2000.

Jeromack 1988
Jeromack, Paul. "Être Rembrandt ou ne plus l'être." *Connaissance des Arts,* no. 441 (November).

Joby 2007
Joby, Christopher Richard. *Calvinism and the Arts: A Reassessment.* Leuven: Peeters.

Johnson 1988
Johnson, Graham. *Treasures from the Royal Collection.* Exh. cat. The Queen's Gallery, Buckingham Palace, London, 1988–89. London: Royal Collection.

Johnson, Berenson, and Valentiner 1913
Johnson, John G., Bernard Berenson, and Wilhelm Reinhold Valentiner. *Catalogue of a Collection of Paintings and Some Art Objects.* Philadelphia: J. G. Johnson.

John G. Johnson Collection 1941
John G. Johnson Collection. *John G. Johnson Collection, Catalogue of Paintings.* Philadelphia: John G. Johnson Collection.

John G. Johnson Collection 1953
John G. Johnson Collection. *Johnson Collection: Two Hundred and Eighty-eight Reproductions: Italian, Dutch, Flemish, German, Spanish, French, English and 19th Century Paintings.* Philadelphia: John G. Johnson Collection.

Jones 1968
Jones, Beneth A. *Bob Jones University: Supplement to the Catalogue of the Art Collection: Paintings Acquired 1963–1968.* Greenville, SC: Bob Jones University.

Jordan 2005
Jordan, Stephen C. *Bohemian Rogue: The Life of Hollywood Artist John Decker.* Lanham, MD: Scarecrow Press.

Judson and Haverkamp-Begemann 1969
Judson, J. Richard, and Egbert Haverkamp-Begemann. *Rembrandt after Three Hundred Years.* Exh. cat. The Art Institute of Chicago, October 25–December 7, 1969; The Minneapolis Institute of Arts, December 22, 1969–February 1, 1970; Detroit Institute of Arts, February 24–April 5, 1970. Chicago: The Art Institute of Chicago.

Kai Sass 1953
Kai Sass, Else. *Kunstforstaaelse: Maleri.* Copenhagen: Jespersen og Pio.

Kalamazoo Institute of Arts 1967
Kalamazoo Institute of Arts. *Alfred Bader Collection: 17th Century Dutch and Flemish Painting,* Exh. cat. October 8–November 10. Kalamazoo, MI: Kalamazoo Institute of Arts.

Kauffmann 1922
Kauffmann, Hans. *Rembrandts Bildgestaltung: ein Beitrag zur Analyse seines Stils.* Stuttgart: W. Kohlhammer.

Kauffmann 1926
Kauffmann, Hans. "Zur Kritik der Rembrandtzeichnungen." *Repertorium für Kunstwissenschaft,* vol. 47, pp. 157–78.

Kelleher 1964
Kelleher, Patrick J. "College Museum Notes." *Art Journal,* vol. 24, no. 1 (Autumn), pp. 52–70.

Kemp 1986
Kemp, Wolfgang. *Rembrandt, die Heilige Familie, oder, Die Kunst, einen Vorhang zu lüften.* Frankfurt: Fischer Taschenbuch.

Kessler and Wolf 1998
Kessler, Herbert, and Gerhard Wolf, eds. *The Holy Face and the Paradox of Representation.* Bologna: Nuova Alfa.

Kettlewell 1968
Kettlewell, James K. "Rembrandt's Christ in Thirteen Paintings and One Etching." *Bulletin of the Hyde Collection,* Glens Falls, NY: The Hyde Collection.

Kettlewell 1981
Kettlewell, James K. *The Hyde Collection Catalogue.* Glens Falls, NY: The Hyde Collection.

Keyes et al. 2004
Keyes, George S., et al. *Masters of Dutch Painting: The Detroit Institute of Arts.* Detroit: Detroit Institute of Arts.

Kleinberger Galleries 1911
Kleinberger Galleries. *A Descriptive and Illustrated Catalogue of 150 Paintings by Old Masters of the Dutch, Flemish, German, Italian, Spanish and French Schools from the Kleinberger Galleries.* Paris: Imprimerie générale Lahure.

Kleinmann 1913
Kleinmann, H. *Handzeichnungen alter Meister der holländischen Malerschule.* 4 vols. Leipzig: Deutsche Verlags-Anstalt.

Klessmann 1983
Klessmann, Rüdiger. *Die holländischen Gemälde: kritische Verzeichnis.* Braunschweig: Herzog Anton Ulrich-Museum.

Klessmann 1988
Klessmann, Rüdiger. "Rembrandts 'Noli me tangere' – Mit den Augen eines Dichters gesehen." *Niederdeutsche Beiträge zur Kunstgeschichte,* vol. 27, pp. 89–100.

Knipping 1974
Knipping, John B. *Iconography of the Counter Reformation in the Netherlands: Heaven on Earth.* 2 vols. Nieuwkoop: De Graaf.

Knoedler Galleries 1912
Knoedler Galleries. *Loan Exhibition of Old Masters.* Exh. cat. January 11–27. New York: Knoedler Galleries.

Knüttel 1956
Knüttel, G. *Rembrandt, de meester en zijn werk.* Amsterdam: Ploegsma.

Kozak, Monkiewicz, and Sulerzyska 1993
Kozak, Anna, Maciej Monkiewicz, and Teresa Sulerzyska. *Master European Drawings from Polish Collections.* Exh. cat. The Nelson-Atkins Museum of Art, Kansas City, MO, April 17–June 6, 1993; Milwaukee Art Museum, July 9–August 29, 1993; Museum of Fine Arts, Montreal, October 10–December 5, 1993; Wadsworth Atheneum, Hartford, CT, January 9–March 6, 1994. Washington, DC: Trust for Museum Exhibitions.

Kozak and Tomicka 2009
Kozak, Anna, and Joanna A. Tomicka. *Rembrandt. Rysunki i ryciny w zbiorach polskich. Katalog.* Warsaw: Muzeum Narodowe w Warszawie.

Kristeller and Strong 1901
Kristeller, Paul, and S. A. Strong. *Andrea Mantegna.* London: Longmans, Green.

Kruse and Neumann 1920
Kruse, John, and Carl Neumann. *Die Zeichnungen Rembrandts und seiner Schule im National-Museum zu Stockholm.* The Hague: M. Nijhoff.

Kunze 1931
Kunze, Irene. *Beschreibendes Verzeichnis der Gemälde im Kaiser Friedrich-Museum und Deutschen Museum.* Berlin: W. Buxenstein.

Landsberger 1946
Landsberger, Franz. *Rembrandt, the Jews and the Bible.* Philadelphia: Jewish Publication Society of America.

Landsberger 1954
Landsberger, Franz. "Rembrandt and Josephus." *Art Bulletin,* vol. 36, no. 1 (March), p. 62.

Lawrence 1835
Lawrence, Thomas. *Exhibition: Original Drawings by P. P. Rubens; Ant. Van Dyke; Rembrandt van Rijn; Claude Lorraine; Nicholas Poussin; Il Parmigiano; Correggio; Ludovico, Agostino and Annibal Carracci; Zucchero, Andrea del Sarto, Caravaggio; Fra Bartolomeo; Albert Durer; Titian; Raphael; Michelangelo.* Exh. cat. London: Lawrence Gallery.

Lecaldano 1969
Lecaldano, Paolo. *L'opera pittorica completa di Rembrandt.* Milan: Rizzoli.

Lecaldano, Veinstein, and Foucart 1971
Lecaldano, Paolo, Alain Veinstein, and Jacques Foucart. *Tout l'oeuvre peint de Rembrandt.* Paris: Flammarion.

Leeflang, Luijten, and Nichols 2003
Leeflang, Huigen, Ger Luijten, and Lawrence W. Nichols. *Hendrick Goltzius (1558–1617): Drawings, Prints and Paintings.* Exh. cat. Rijksmuseum, Amsterdam, March 7–May 25, 2003; The Metropolitan Museum of Art, New York; June 25–September 7, 2003; Toledo Museum of Art, Ohio, October 18, 2003–January 4, 2004. Zwolle: Waanders.

Lehrs 1908–34
Lehrs, Max. *Geschichte und kritische Katalog des deutschen, niederländischen und französischen Kupferstichs im XV Jahrhundert.* 9 vols. Vienna: Gesellschaft für vervielfältigende Kunst.

Leymarie 1956
Leymarie, Jean. *Dutch Painting.* Geneva: Skira.

Liedtke 1997
Liedtke, Walter. "Reconstructing Rembrandt and His Circle: More on the Workshop Hypothesis." In *Rembrandt, Rubens and the Art of Their Time: Recent Perspective,* ed. Roland E. Fleischer and Susan Clare Scott, pp. 37–48. University Park: Pennsylvania State University Press.

Liedtke 1998
Liedtke, Walter. "Albert Blankert et al., 'Rembrandt: A Genius and His Impact.'" *Simiolus*, vol. 26, no. 4, pp. 312–17.

Liedtke 2007
Liedtke, Walter. *Dutch Paintings in The Metropolitan Museum of Art.* 2 vols. New York: The Metropolitan Museum of Art.

Liedtke et al. 1995
Liedtke, Walter, Carolyn Logan, Nadine M. Orenstein, and Stephanie S. Dickey. *Rembrandt / Not Rembrandt in the Metropolitan Museum of Art: Aspects of Connoisseurship.* Vol. 2, *Paintings, Drawings, and Prints: Art-Historical Perspectives.* Exh. cat. October 10, 1995–January 7, 1996. New York: The Metropolitan Museum of Art.

Lippmann and Hofstede de Groot 1889–1911
Lippmann, Friedrich, and C. Hofstede de Groot. *Original Drawings by Rembrandt Harmensz. Van Rijn Reproduced in Photo-type.* 4 vols. The Hague: M. Nijhoff.

Ljøgodt 2005
Ljøgodt, Knut. *Fra gullalder til cobra: dansk kunst i 150 år: malerier fra Statens Museum for Kunst i København.* Tromsø, Norway: Nordnorsk Kunstmuseum.

Los Angeles County Museum of Art 1947
Los Angeles County Museum of Art. *Loan Exhibition of Paintings by Franz Hals and Rembrandt.* Exh. cat. November 18–December 31. Los Angeles: Los Angeles County Museum of Art.

Lugt 1921
Lugt, Frits. *Les marques des collections de dessins et d'estampes.* 2 vols. Amsterdam: Vereenigde Druckkerijen.

Lugt 1927
Lugt, Frits. *Les dessins des écoles du nord de la Collection Dutuit au Musée des beaux-arts de la ville de Paris (Petit-palais).* Paris: A. Morancé.

Lugt 1933
Lugt, Frits. *Inventaire général des dessins des Ecoles du Nord T. 3, École hollandaise; Rembrandt, ses élèves, ses imitateurs, ses copistes.* Paris: Éditions des musées nationaux.

Lugt 1949
Lugt, Frits. *Inventaire général des dessins des écoles du Nord.* Paris: Éditions des musées nationaux.

Lugt and Vallery-Radot 1936
Lugt, Frits, and Jean Vallery-Radot. *Inventaire général des dessins des écoles du nord.* Paris: Éditions des Bibliothèques nationales de France.

M. Knoedler & Co. 1933
M. Knoedler & Co. *Loan Exhibition of Paintings by Rembrandt: Held for the Benefit of the Adopt-a-Family Committee of the Emergency Unemployment Relief Fund.* Exh. cat. April 17–29. New York: M. Knoedler & Co.

MacLaren 1960
MacLaren, Neil. *The Dutch School.* 3 vols. London: The National Gallery.

MacLaren and Brown 1991
MacLaren, Neil, and Christopher Brown. *The Dutch School, 1600–1900.* London: The National Gallery.

Madsen 1911
Madsen, Karl. *Billeder af Rembrandt og Hans Elever i den Kgl. Maleri-Samling.* København-Kristiania: Gyldendalske Boghandel-Nordisk Forlag.

Madsen 1920
Madsen, Karl. *Nogle restaurerings-resultater.* Copenhagen: Statens Museum for Kunst.

Manchester City Art Gallery 1957
Manchester City Art Gallery. *Art Treasures Centenary: European Old Masters: Commemorating the Famous Exhibition, The Art Treasures of the United Kingdom, Held at Manchester in 1857.* Exh. cat. October 30–December 31. Manchester: Manchester City Art Gallery.

Marani 2001
Marani, Pietro C. *Il genio e le passioni: Leonardo e il Cenacolo: precedenti, innovazioni, riflessi di un capolavoro.* Exh. cat. Palazzo Reale, Milan, March 21–June 17. Milan: Skira.

Martin 1911a
Martin, Wilhelm. "Ausstellung altholländischer Bilder in pariser Privatbesitz." *Monatshefte für Kunstwissenschaft,* vol. 4.

Martin 1911b
Martin, Wilhelm. "De Tentoonstelling van Oud-Holl. Schilderijen te Paris." *Elsevier's Geïllustreerd Maandschrift,* vol. 21 (July–December).

Martin and Moes 1912
Martin, Wilhelm, and E. W. Moes. *Altholländische Malerei: Gemälde von holländischen und vlämischen Meistern in Rathäusern, kleineren Museen, Kirchen, Stiften, Wäisenhäusern, Senatszimmern, u.s.w., und in Privatbesitz . . . erster Jahrgang.* Leipzig: Klinkhardt and Biermann.

McCall 1942
McCall, George Henry. *Paintings by the Great Dutch Masters of the Seventeenth Century; Loan Exhibition in Aid of the Queen Wilhelmina Fund and the American Women's Voluntary Services.* Exh. cat. Duveen Galleries, New York, October 8–November 7, 1942. New York: William Bradford Press.

McQueen 2003
McQueen, Alison. *The Rise of the Cult of Rembrandt: Reinventing an Old Master in Nineteenth-Century France.* Amsterdam: Amsterdam University Press.

Meder 1932
Meder, Joseph. *Dürer-Katalog: ein Handbuch über Albrecht Dürers Stiche, Radierungen und Holzschnitte, deren Zustände, Ausgaben und Wasserzeichen.* Vienna: Gilhofer and Ranschburg.

Meij 1974a
Meij, A. W. F. M. *Dessins flamands et hollandaise du dix-septième.* Exh. cat. April 25–June 9. Paris: Institut Néerlandais.

Meij 1974b
Meij, A. W. F. M. *Tekeningen van Vlaamse en Hollanse meesters uit de 17e eeuw, uit Belgische en Hollandse Musea en uit het Institut Néerlandais te Parijs.* Exh. cat. The State Hermitage Museum, Leningrad; The Pushkin Museum, Moscow; Museum of Western and Oriental Art, Kiev. Moscow: Sovetskii khudozhnik.

Meldrum 1923
Meldrum, David Storrar. *Rembrandt's Paintings.* London: Methuen.

The Metropolitan Museum of Art 1942
The Metropolitan Museum of Art. *The Unseen Rembrandt.* New York: The Metropolitan Museum of Art.

Michel 1893
Michel, Émile. *Rembrandt, sa vie, son oeuvre et son temps.* Paris: Hachette.

Michel 1894
Michel, Émile. *Rembrandt: His Life, His Work, and His Time.* New York: W. Heinemann.

Michel et al. 1888
Michel, Émile, Wilhelm von Bode, Cornelis Hofstede de Groot, Sidney Colvin, F. S. Haden, J. P. Heseltine, and Friedrich Lippmann. *Zeichnungen von Rembrandt Harmensz. van Rijn.* 4 vols. Leipzig: K. W. Hiersemann.

Miller 1971
Miller, Oliver. *Dutch Pictures from the Royal Collection.* Exh. cat. The Queen's Gallery, Buckingham Palace, London, 1971–72. London: Lund Humphries.

Milner 2006
Milner, Max. *Rembrandt à Emmaüs.* Paris: José Corti.

Moltke and Belkin 1994
Moltke, Joachim Wolfgang, and Kristin Lohse Belkin. *Arent de Gelder: Dordrecht 1645–1727.* Dornspijk, Netherlands: Davaco.

Monrad 1989
Monrad, Kasper. *Hverdagsbilleder: dansk guldalder, kunstnerne og deres vilkår.* Copenhagen: C. Ejler.

Morgenstein and Levine 1982
Morgenstern, Susan W., and Ruth E. Levine. *The Tears in the Age of Rembrandt*. Exh. cat. Hebrew Union College, Skirball Museum, Los Angeles, January 20–March 28; The Maurice Spertus Museum of Judaica, Chicago, April 25–July 4; The Jewish Museum, New York, September 9–December 5. Los Angeles: Hebrew Union College.

Munnings 1946
Munnings, Alfred James. *The King's Pictures: An Illustrated Souvenir of the Exhibition of the King's Pictures at the Royal Academy of Arts, London*. Exh. cat. London: Royal Academy of Arts.

Müntz 1892
Müntz, Eugène. "Rembrandt et l'Art Italien." *Gazette des Beaux-arts*, ser. 3, vol. 7 (March), pp. 196–211.

Müntz 1935
Müntz, Ludwig. "Rembrandts Altersstil und die Barockklassik." *Jahrbuch der Kunsthistorischen Sammlungen in Wien*, new ser. 9, pp. 183–222.

Münz 1957
Münz, Ludwig. "Rembrandt Vorstellung vom Antlitz Christi." In *Festschrift Kurt Bauch's kunstgeschichtliche Beiträge zum 25. November 1957*, ed. Berthold Hackelsberger. Munich: Deutscher Kunstverlag.

Musée du Louvre 1820
Musée du Louvre. *Notices des dessins, peintures, émaux et terres cuites émaillées, exposés au Musée royal, dans la Galerie d'Apollon*. Exh. cat. Paris: Musée du Louvre.

Musée du Louvre 1838
Musée du Louvre. *Notice des dessins placés dans les galleries du Musée royal, au Louvre*. Paris: Musée du Louvre.

Musée du Petit Palais 1986
Musée du Petit Palais, Paris. *Rembrandt: eaux-fortes*. Exh. cat. February 6–April 20. Paris: Édition Paris Musées.

Museum of Ornamental Art 1857
Museum of Ornamental Art. *Art Treasures of the United Kingdom, Collected at Manchester in 1857*. Exh. cat. May 5–October 17. Manchester: Museum of Ornamental Art.

Museum zu Allerheiligen 1949
Museum zu Allerheiligen, Schaffhausen, Switzerland. *Rembrandt und seine Zeit: Zweihundert Gemälde der Blütezeit der holländischen Barockmalerei des 17. Jahrhunderts*. Exh. cat. April 10–October 2. Schaffhausen: Lempen and Cie.

Nacler 2003
Nacler, Steven. *Rembrandt's Jews*. Chicago: University of Chicago Press.

Národní Gallery 1966
Národní Gallery. *Tři stoleti nizozemské kresby, 1400–1700*. Exh. cat. June–July, Prague: Národní Gallery.

National Gallery of Art 1969
National Gallery of Art, Washington, DC. *Rembrandt in the National Gallery of Art*. Exh. cat.

National Gallery of Art 1983
National Gallery of Art, Washington, DC. *Leonardo's Last Supper: Precedents and Reflections*. Exh. cat. December 18, 1983–March 4, 1984. Washington, DC: National Gallery of Art.

Nationalmuseum, Stockholm 1956
Nationalmuseum, Stockholm. *Rembrandt*. Exh. cat. January 12–April 15. Stockholm: Nationalmuseum.

Neipp 2001
Neipp, Bernadette. *Rembrandt et la mort de Jésus: la tendresse d'un regard*. Saint-Maurice: Editions Saint-Augustin.

Neumann 1918
Neumann, Carl. *Aus der Werkstatt Rembrandts*. Heidelberg: C. Winter.

Neumann 1923
Neumann, Carl. *Rembrandt Handzeichnungen*. Munich: R. Piper.

Nicolle 1905
Nicolle, Marcel. "Les récentes acquisitions du musée du Louvre. Département de la peinture 1902–1904." *La Revue de l'Art Ancien et Moderne*, vol. 17, pp. 353–58, 406–8.

Nieuwenhuys 1834
Nieuwenhuys, Christianus J. *A Review of the Lives and the Works of Some of the Most Eminent Painters: With Remarks on the Opinions and Statements of Former Writers*. London: H. Hooper.

Nihon Keizai Shimbun 1968
Nihon Keizai Shimbun. *Rembranto meisaku ten [Masterpieces of Rembrandt]*. Exh. cat. Tokyo National Museum, April 2–May 16; Kyoto National Museum, May 25–July 14. Tokyo: Nihon Keizai Shimbun.

Nilsson 1932
Nilsson, Gerhard. *Notices on All the So-Called Rembrandts, Ruisdels and Titians and on Several So-Called Rubens, Ruisdels and Vrooms in the Danish Galleries*. Stockholm: Gernandts boktryckeri.

Nolan 2001
Nolan, John. *Selected Masterworks from the Bob Jones University Museum and Gallery*. Greenville, SC: Bob Jones University Museum and Gallery.

Ornstein-van Slooten and Schatborn 1984
Ornstein-van Slooten, Eva, and Peter Schatborn. *Rembrandt as Teacher*. Exh. cat. October 26, 1984–January 6, 1985, Amsterdam: Museum het Rembrandthuis.

Palais de la Présidence du Corps Legislatif 1874
Palais de la Présidence du Corps Legislatif. *Explication des ouvrages de peinture exposés au profit de la colonisation de l'Algérie par les Alsaciens-Lorrains*. Exh. cat. April 23. Paris: Impr. de J. Claye.

Panofsky 1973
Panofsky, Erwin. "Rembrandt und das Judentum." *Jahrbuch der Hamburger Kunstsammlungen*, vol. 18, pp. 98–99.

Pauli 1926
Pauli, Gustav. *Zeichnungen alter Meister in der Kunsthalle zu Hamburg: Niederländer, neue Folge*. Frankfurt: Prestel-Verlag.

Pauw-de Veen 1957
Pauw-de Veen, Lydia de. *De begrippen "schilder," "schilderij" en "schilderen" in de zeventiende eeuw*. Brussels: Paleis der Academiën.

Pauw-de Veen 1969
Pauw-de Veen, Lydia de. "De begrippen 'schilder,' 'schilderij' en 'schilderen' in de zeventiende eeuw." Ghent: Secretarie der Koninklijke Vlaamse Academie.

Peck and Robinson 2003
Peck, Sheldon, and Franklin Westcott Robinson. *Rembrandt Drawings: Twenty-five Years in the Peck Collection*. Boston: Pertho Documenta.

Pederson, Ronberg, and Wadum 2006
Pederson, Eva de la Fuente, Lene Bogh Ronberg, and Jorgen Wadum. *Événement l'année Rembrandt*. Dijon: Éditions Faton.

Pederson et al. 2006
Pedersen, Eva de la Fuente, et al. *Rembrandt?: The Master and His Workshop*. Exh. cat. Feburary 4–May 14. Copenhagen: Statens Museum for Kunst.

Perlove and Silver 2009
Perlove, Shelley Karen, and Larry Silver. *Rembrandt's Faith: Church and Temple in the Dutch Golden Age*. University Park: Pennsylvania State University Press.

Perussaux 1962
Perussaux, Charles. *Le Véritable sujet des "Disciples d'Emmaüs" de Rembrandt*. Paris: Gazette des Beaux-arts.

The Pierpont Morgan Library 1939
The Pierpont Morgan Library. *Illustrated Catalogue of an Exhibition Held on the Occasion of the New York World's Fair*. Exh. cat. May–October. New York: Privately printed.

Plietzsch 1956
Plietzsch, Edouard. "Randbemerkungen zur holländischen Interieurmalerei an beginn des 17. Jahrhundert." *Wallraf-Richartz Jahrbuch*, vol. 17.

Plomp 1997
Plomp, Michiel. *The Dutch Drawings in the Teyler Museum*. 2 vols. Ghent: Snoeck, Ducaju and Zoon.

Posada Kubissa, Vergara, and Westermann 2008
Posada Kubissa, Teresa, Alexander Vergara, and Mariët Westermann. *Rembrandt, pintor de historias*. Exh. cat. October 15, 2008–January 6, 2009. Madrid: Museo Nacional del Prado.

Prenen 1952
Prenen, H. L. *Rembrandt en Christus*. Amsterdam: Ploegsma.

Querfurt 1710
Querfurt, Tobias. *Kurtze Beschreibung des Fürstl. Lust-Schlosses Salzdahlum: herausgegeben und dem durchl. Fürsten und Herrn, Herrn Anthon Ulrich, Hertzogen zu Braunschweig und Lüneburg*. Braunschweig: Zilliger.

Quodbach 2007
Quodbach, Esmée. "The Age of Rembrandt: Dutch Paintings in The Metropolitan Museum of Art." *Metropolitan Museum of Art Bulletin*, vol. 65, no. 1 (Summer).

Raaf 1912
Raaf, K. H. de. "Rembrandt's Christus en Maria Magdalena." *Oud Holland*, vol. 30, pp. 6–8.

Reuterswärd 1956
Reuterswärd, Patrick. "Tavelförhänget." *Konsthistorisk Tidskrift*, vol. 25, pp. 97–113.

Reuterswärd 1980
Reuterswärd, Patrick. "Om realismen i holländsk bildtradition." *Konsthistorisk Tidskrift*, vol. 49 (June), pp. 1–16.

Reuterswärd 1991
Reuterswärd, Patrick. *The Visible and Invisible in Art: Essays in the History of Art*. Bibliotheca artibus et historiae. Vienna: IRSA.

Rich 1935
Rich, Daniel Cotton. *Loan Exhibition of Paintings, Drawings and Etchings by Rembrandt and His Circle*. Exh. cat. December 19, 1935–January 19, 1936. Chicago: The Art Institute of Chicago.

Riggs and Silver 1993
Riggs, Timothy A., and Larry Silver. *Graven Images: The Rise of Professional Printmakers in Antwerp and Haarlem, 1540–1640*. Exh. cat. Mary and Leigh Block Gallery, Northwestern University, Evanston, Illinois, May 6–June 3; Ackland Art Museum, University of North Carolina, Chapel Hill, August 15–September 26. Evanston, IL: Mary and Leigh Block Gallery, Northwestern University.

Ringbom 1965
Ringbom, Sixten. *Icon to Narrative: The Rise of the Dramatic Close-up in Fifteenth-Century Devotional Painting*. Turku, Finland: Åbo Akademi.

Robb 1978
Robb, David M., Jr. "Rembrandt's Portrait of a Young Jew." *Apollo*, vol. 107, no. 191 (January), pp. 44–47.

Robinson 1977
Robinson, Franklin Westcott. *Seventeenth-Century Dutch Drawings from American Collections: A Loan Exhibition*. Exh. cat. National Gallery of Art, Washington, DC, January 30–March 13; Denver Art Museum; Kimbell Art Museum, Fort Worth. Washington, DC: The International Exhibitions Foundation.

Röell 1956
Röell, D. C. *Rembrandt tentoonstelling ter herdenking van de geboorte van Rembrandt op 15 Juli 1606*. Exh. cat. Rijksmuseum, Amsterdam, May 18–August 5; Museum Boymans, Rotterdam, August 8–October, 21. Haarlem: J. Enschedé.

Roger-Marx 1960
Roger-Marx, Claude. *Rembrandt*. New York: Universe Books.

A. Rosenberg 1904
Rosenberg, Adolf. *Rembrandt, des Meisters Gemälde*. Stuttgart and Leipzig: Deutsche Verlags-Anstalt.

A. Rosenberg 1906
Rosenberg, Adolf. *Rembrandt, des Meisters Gemälde*. 2d ed. Stuttgart and Leipzig: Deutsche Verlags-Anstalt.

A. Rosenberg 1909
Rosenberg, Adolf. *Rembrandt, des Meisters Gemälde*. 3d ed. Stuttgart and Leipzig: Deutsche Verlags-Anstalt.

J. Rosenberg 1948
Rosenberg, Jakob. *Rembrandt*. Cambridge, MA: Harvard University Press.

J. Rosenberg 1956
Rosenberg, Jakob. *Rembrandt the Draughtsman: With Consideration of the Problem of Authenticity*. Cambridge, MA: Fogg Art Museum.

J. Rosenberg 1959
Rosenberg, Jakob. Review of Otto Benesch, *The Drawings of Rembrandt*, in *Art Bulletin*, vol. 41, pp. 108–19.

J. Rosenberg 1960
Rosenberg, Jakob. *Rembrandt Drawings from American Collections*. Exh. cat. The Pierpont Morgan Library, New York, March 15–April 16; Fogg Art Museum, Cambridge, MA, April 27–May 29. New York: The Pierpont Morgan Library.

J. Rosenberg 1964
Rosenberg, Jakob. *Rembrandt: Life and Work*. Rev. ed. London: Phaidon.

Rotermund 1951
Rotermund, Hans-Martin. "'Habe du nichts zu schaffen mit diesem Gerechten!' Zur Deutung eines sonst bei Rembrandt nicht begegnenden Bildvorwurfs aus dem Themen kreis der Leidensgeschichte." *Oud Holland*, vol. 66, pp. 54–56.

Rotermund 1952
Rotermund, Hans-Martin. "The Motif of Radiance in Rembrandt's Biblical Drawings." *Journal of the Warburg and Courtauld Institutes*, vol. 15, nos. 3 and 4, pp. 101–21.

Rotermund 1952–53
Rotermund, Hans-Martin. "Rembrandt u. die rel. Laienbewegungen in den Niederlande seiner Zeit." *Nederlandsch kunsthistorisch Jaarboek*, vol. 4, pp. 104–92.

Rotermund 1956
Rotermund, Hans-Martin. "Wandlungen des Christus-Typus bei Rembrandt." *Wallraf-Richartz-Jahrbuch*, vol. 18.

Rotermund 1963
Rotermund, Hans-Martin. *Handzeichnungen und Radierungen zur Bibel*. Stuttgart: Ernst Kaufman Lahr und Württembergische Bibelanstalt, Lahr/Schwarzwald: E. Kaufmann.

Rouchès 1937
Rouchès, Gabriel. *Rembrandt, dessins et eaux-fortes*. Exh. cat. Musée de l'Orangerie, Paris. Paris: E. Baudelot.

Rousseau 1952
Rousseau, Theodore, Jr. "Rembrandt." *Metropolitan Museum of Art Bulletin*, vol. 11 (November), pp. 8–92.

Röver-Kann and Ketelsen 2000–2001
Röver-Kann, Anne, and Thomas Ketelsen. *Rembrandt, oder nicht? Zeichnungen von Rembrandt und seinem Kreis aus den Hamburger und Bremer Kupferstichkabinetten*. Exh. cat. Kunsthalle Bremen, October 15, 2000–January 21, 2001. Ostfildern-Ruit: Hatje Cantz.

Royal Academy of Arts 1899
Royal Academy of Arts. *Exhibition of Works by Rembrandt. Winter Exhibition*. Exh. cat. January 2–March 11. London: Royal Academy of Arts.

Royal Academy of Arts 1929
Royal Academy of Arts. *Exhibition of Dutch Art, 1450–1900*. Exh. cat. January 4–March 9. London: Royal Academy of Arts.

Royal Academy of Arts 1952
Royal Academy of Arts. *Dutch Pictures, 1450–1750*. Exh. cat. November 1952–March 1953. London: Royal Academy of Arts.

Royal-on-Kisch 1992
Royal-on-Kisch, Martin. *Drawings by Rembrandt and His Circle in the British Museum.* London: British Museum Press.

Royalton-Kisch 2010
Royalton-Kisch, Martin. *Drawings by Rembrandt and His School in the British Museum.* London, British Museum.

Rudraif 1996
Rudrauf, Lucien. *Le repas d'Emmaüs: étude d'un thème plastique et de ses variations en peinture et en sculpture.* 2 vols. Paris: Nouvelles éd. Latines.

Sawicka 1957
Sawicka, Stanisław. "Na marginesie wystawy Rembrandtowskiej w Warszawie." *Biuletyn Historii Sztuki,* vol. 19, no. 4, pp. 367–74.

Saxl 1908
Saxl, Fritz. "Bemerkungen zu den Münchener Rembrandtzeichnungen." *Repertorium für Kunstwissenschaft,* vol. 31, pp. 531–37.

Scallen 2004
Scallen, Catherine B. *Rembrandt, Reputation, and the Practice of Connoisseurship.* Amsterdam: Amsterdam University Press.

Schaar 1994
Schaar, Eckhard. *Rembrandt und sein Jahrhundert: niederländische Zeichnungen in der Hamburger Kunsthalle.* Exh. cat. Hamburger Kunsthalle, October 21, 1994–January 15, 1995. Heidelberg: Edition Braus.

Schaeffer Galleries 1936
Schaeffer Galleries. *The Great Dutch Masters.* Exh. cat. New York: Schaeffer Galleries.

Schaeffer Galleries 1938a
Schaeffer Galleries. *Exhibition of Paintings by Old Masters: Lent by Schaeffer Galleries Inc., New York.* Exh. cat. San Francisco Museum of Art. New York: Schaeffer Galleries.

Schaeffer Galleries 1938b
Schaeffer Galleries. *Exhibition of Paintings by Old Masters: Lent by Schaeffer Galleries Inc., New York.* Exh. cat. Los Angeles County Museum of Art. New York: Schaeffer Galleries.

Schapelhouman 2006
Schapelhouman, Marijn. *Rembrandt and the Art of Drawing.* Zwolle: Waanders.

Schatborn 1981
Peter Schatborn. "Van Rembrandt tot Crozat. Vroege verzamelingen met tekeningen van Rembrandt." *Nederlands Kunsthistorisch Jaarbook,* vol. 32, pp. 1–54.

Schatborn 1985
Schatborn, Peter. *Tekeningen van Rembrandt in het Rijksmuseum / Drawings by Rembrandt in the Rijksmuseum.* Amsterdam: Rijksmuseum.

Schatborn 1986
Schatborn, Peter. "Review of Corpus I." *Oud Holland,* vol. 100, pp. 55–63.

Schatborn, Tuyll van Serooskerken, and Grollemund 2006
Schatborn, Peter, Carel van Tuyll van Serooskerken, and Hélène Grollemund. *Rembrandt dessinateur: Chefs d'oeuvre des collections en France.* Exh. cat. October 20, 2006–January 8, 2007. Paris: Musée du Louvre.

Schmidt-Degener 1928
Schmidt-Degener, Frederick. *Rembrandt und der Holländische Barock.* Leipzig: B. G. Teubner.

Schmidt-Degener 1932
Schmidt-Degener, Frederick. *Rembrandt tentoonstelling.* Exh. cat. Rijksmuseum, Amsterdam, June 11–September 4. Amsterdam: Druk de Bussy.

Schmidt-Degener 1935
Schmidt-Degener, Frederick. *Rembrandt tentoonstelling: ter herdenking van de plechtige opening van het Rijksmuseum op 13 Juli 1885.* Exh. cat. July 13–October 13. Amsterdam: Rijksmuseum.

Schneevoogt 1873
Schneevoogt, C. G. Voorhelm. *Catalogue des estampes gravées d'après P. P. Rubens.* Haarlem: Les Héritiers Loosjes.

Schoch 2001
Schoch, Rainer. *Albrecht Dürer, das druckgraphische Werk.* Munich: Prestel.

Schneider and Ekkart 1973
Schneider, Hans. Supplement by Rudolf E. O. Ekkart. *Jan Lievens, sein Leben, seine Werke.* Amsterdam: Israël.

Scholten 1904
Scholten, Hendrick Jacobus. *Musée Teyler à Haarlem. Catalogue raisonné des dessin des écoles françaises et hollandaises.* Haarlem: Les Héritiers Loosjes.

Schuckman 1996
Schuckman, Christiaan. *Rembrandt and Van Vliet: A Collaboration on Copper.* Studies in Dutch Graphic Art, vol. 1. Amsterdam: Museum het Rembrandthuis.

Schwartz 1985
Schwartz, Gary. *Rembrandt: His Life, His Paintings.* New York: Viking.

Schwartz 2006
Schwartz, Gary. *The Rembrandt Book.* New York: Abrams.

Scrase and Vignau-Wilberg 1995
Scrase, David, and Thea Vignau-Wilberg. *Das goldene Jahrhundert: holländische Meisterzeichnungen aus dem Fitzwilliam Museum / The Golden Century: Dutch Master Drawings from the Fitzwilliam Museum.* Exh. cat. Staatliche Graphische Sammlung, Munich, November 15, 1995–January 14, 1996; Kurpfälzisches Museum, Heidelberg, February 11–April 8, 1996; Herzog Anton Ulrich-Museum, Braunschweig, May 1–June 30, 1996; The Fitzwilliam Museum, Cambridge, October 8–December 22, 1996. Munich: Staatliche Graphische Sammlung.

Sedelmeyer 1898
Sedelmeyer, Charles. *Illustrated Catalogue of 300 Paintings by Old Masters of the Dutch, Flemish, Italian, French, and English Schools, Being Some of the Principal Pictures Which Have at Various Times Formed Part of the Sedelmeyer Gallery.* Paris: Lahure.

Sedelmeyer Gallery 1901
Sedelmeyer Gallery. *Illustrated Catalogue of the Seventh Series of 100 Paintings by Old Masters of the Dutch, Flemish, Italian, French, and English Schools, Being a Portion of the Sedelmeyer Gallery: Which Contains about 1500 Original Pictures by Ancient and Modern Artists.* Paris: Sedelmeyer Gallery.

Senenko 2009
Senenko, Marina. *Collection of Dutch Paintings XVII–XIX Centuries.* Moscow: The Pushkin Museum.

Senzoku 1986
Senzoku, Nobuyuki. *Rembranto, Kyoto to sono shuhen / Rembrandt and the Bible.* Exh. cat. Sogo Museum of Art, Yokohama, October 31–December 23, 1986; Fukuoka Art Museum, January 6–February 1, 1987; National Museum of Modern Art, Kyoto, February 7–March 22, 1987. Tokyo: Ato Raifu.

Shepherd and Maniura 2006
Shepherd, Rupert, and Robert Maniura, eds. *Presence: The Inherence of the Prototype within Images and Other Objects.* Aldershot, UK: Ashgate.

Sigal-Klagsbald and Merle du Bourg 2007
Sigal-Klagsbald, Laurence, and Alexis Merle du Bourg, eds. *Rembrandt et la nouvelle Jérusalem: Juifs et Chrétiens à Amsterdam au siècle d'or.* Exh. cat. March 28–July 1. Paris: Musée d'art et d'histoir du Judaïsme.

Simpson 1986a
Simpson, Colin. "The Bilking of Jules Bache." *Connoisseur,* vol. 216 (October), pp. 126–31.

Simpson 1986b
Simpson, Colin. *Artful Partners: Bernard Berenson and Joseph Duveen*. New York: Macmillan.

Six 1897
Six, J. "De Homerus van Rembrandt." *Oud Holland*, vol. 15, pp. 1–10.

Slatkes 1992
Slatkes, Leonard J. *Rembrandt: Catalogo completo dei dipinti*. Florence: Cantini.

Slive 1953
Slive, Seymour. *Rembrandt and His Critics, 1630–1730*. The Hague: M. Nijhoff.

Slive 1959
Slive, Seymour. "Rembrandt as a Bible Illustrator." In *The Holy Bible Containing the Old and New Testaments*, pp. 226–29. New York: Abradale Press.

Slive 1964
Slive, Seymour. "A Head of Christ by Rembrandt." *Acquisitions (Fogg Art Museum)*, pp. 38–41.

Slive 1965a
Slive, Seymour. "An Unpublished Head of Christ by Rembrandt." *Art Bulletin*, vol. 47, no. 4 (December), pp. 406–17.

Slive 1965b
Slive, Seymour. *Drawings of Rembrandt: With a Selection of Drawings by His Pupils and Followers*. 2 vols. New York: Dover.

Slive 1978
Slive, Seymour. "Rembrandt at Harvard." *Apollo*, vol. 107, no. 196 (June), pp. 452–63.

Slive 2009
Slive, Seymour. *Rembrandt Drawings*. Los Angeles: Getty Publications.

Sluijter 2006
Sluijter, Eric Jan. *Rembrandt and the Female Nude*. Amsterdam: Amsterdam University Press.

Smith 1829–42
Smith, John. *A Catalogue Raisonné of the Works of the Most Eminent Dutch, Flemish, and French Painters*. 7 vols. London: Smith and Son.

Sotheby's 1996
Sotheby's. *Important Old Master Paintings*. Auction catalogue. January 11. New York: Sotheby's.

Stampfle 1969
Stampfle, Felice. *Rembrandt, Experimental Etcher*. Exh. cat. Museum of Fine Arts, Boston, October 1–November 6, 1969; The Pierpont Morgan Library, New York, November 26, 1969–January 10, 1970. New York: New York Graphic Society.

Starcky and Bazelaire 1988
Starcky, Emmanuel, and Menehould de Bazelaire. *Rembrandt et son école: dessins du Musée du Louvre*. Exh. cat. Musée du Louvre, Paris, October 27, 1988–January 30, 1989. Paris: Éditions des musées nationaux.

Stechow 1934
Stechow, Wolfgang. "Rembrandts Darstellungen des Emmausmahles." *Zeitschrift für Kunstgeschichte*, vol. 3, no. 6, pp. 329–41.

Stechow 1940–41
Stechow, Wolfgang. "The Myth of Philemon and Baucis in Art." *Journal of the Warburg and Courtauld Institutes*, vol. 4 , pp. 103–13.

Stedelijk Museum 1898
Stedelijk Museum. *Rembrandt: schilderijen bijeengebracht ter gelegenheid van de inhuldiging van hare majesteit Koningin Wilhelmina* Exh. cat. September 8–October 31. Amsterdam: Scheltema and Holkema.

Stedelijk Museum 1916
Stedelijk Museum. *Tentoonstelling in het Stedelijk Museum "De Lakenhal" te Leiden, van teekeningen van Hollandsche meesters uit de verzameling van Dr. C. Hofstede de Groot*. Exh. cat. May 12–June 14. Leiden: Stedelijk Museum.

Stedelijk Museum 1951
Stedelijk Museum. *Rembrandt, Hokusai, Van Gogh*. Exh. cat. October–November. Amsterdam: Stedelijk Museum.

Stedelijk Van Abbemuseum 1938
Stedelijk Van Abbemuseum. *Noord-Brabantsch kunstbezit: tentoonstelling ter gelegenheid van het 40-jarig regeerings-jubileum van Hare Majesteit Wilhelmina koningin der Nederlanden*. Exh. cat. August 15–September 15. Eindhoven: Stedelijk Van Abbemuseum.

Steingraber 1986
Steingraber, Erich. *Alte Pinakothek Munich: Explanatory Notes on the Works Exhibited*. Munich: Bayerische Staatsgemäldesammlungen.

Strauss and Van der Meulen 1980
Strauss, Walter L., and Marijon van der Meulen. *The Rembrandt Documents*. New York: Abaris.

Sumowski 1956–57
Sumowski, Werner. *Bemerkungen zu Otto Beneschs Corpus der Rembrandt-Zeichnungen*. Berlin: Humboldt University Press.

Sumowski 1957–58
Sumowski, Werner. "Nachträge zum Rembrandtjahr 1956." *Wissenschaftliche Zeitschrift der Humboldt-Universität zu Berlin*, vol. 7, no. 2.

Sumowski 1958
Sumowski, Werner. *Rembrandt erzählt das Leben Jesu*. Berlin: Evangelische Verlagsanstalt.

Sumowski 1961
Sumowski, Werner. *Bemerkungen zu Otto Beneschs Corpus der Rembrandt-Zeichnungen*, vol. 2. Bad Pyrmont: privately printed.

Sumowski 1962
Sumowski, Werner. "Gerbrand van den Eeckhout als Zeichner." *Oud-Holland*, vol. 77, pp. 11–39.

Sumowski 1964
Sumowski, Werner. "Rembrandtzeichnungen." *Pantheon*, vol. 22, pp. 233–48.

Sumowski 1971
Sumowski, Werner. "Rembrandt Zeichnungen." *Pantheon*, vol. 29, pp. 125–38.

Sumowski 1983
Sumowski, Werner. *Gemälde der Rembrandt-Schüler in vier Bänden*. 6 vols. Landau/Pfalz: Edition PVA.

Sumowski and Janssen 1992
Sumowski, Werner, and Paul Huys Janssen. *The Hoogsteder Exhibition of Rembrandt's Academy*. Exh. cat. Hoogsteder and Hoogsteder, The Hague, February 4–May 2. Zwolle: Waanders.

Sumowski and Strauss 1979–92
Sumowski, Werner, and Walter L. Strauss. *Drawings of the Rembrandt School*. 10 vols. New York: Abaris.

Sutton 1986
Sutton, Peter C. *A Guide to Dutch Art in America*. Washington, DC: Netherlands-America Amity Trust.

Sweeny 1972
Sweeny, Barbara. *Catalogue of Flemish and Dutch Paintings*. Philadelphia: John G. Johnson Collection.

Szabó 1975
Szabó, George. *The Robert Lehman Collection: A Guide*. New York: The Metropolitan Museum of Art.

Szabó 1979
Szabó, George. *Seventeenth Century Dutch and Flemish Drawings from the Robert Lehman Collection*. Exh. cat. October 24, 1979–January 27, 1980. New York: The Metropolitan Museum of Art.

Talbierska 2004
Talbierska, Jolanta. *Rembrandt, Prints and Drawings from the Collection of the Print Room of the Warsaw University Library*. Warsaw: Wydawnictwo Neriton.

Tietze-Conrat 1955
Tietze-Conrat, E. *Mantegna: Paintings, Drawings, Engravings*. London: Phaidon.

Tojner 1992
Tojner, Poul Erik. *Museernes bedste billeder: fra Skagen til Bornholm*. 2 vols. Copenhagen: P. Fogtdal.

Tomkins 1970
Tomkins, Calvin. *Merchants and Masterpieces: The Story of The Metropolitan Museum of Art*. New York: E. P. Dutton.

Trautschold 1957
Trautschold, Eduard. "Zeichnungen und Radierungen von Rembrandt." *Kunstchronik*, vol. 10, pp. 160–63.

C. Tümpel 1968
Tümpel, Christian. *Studien zur Ikonographie der historien Rembrandts: Deutung von Bisher nicht oder Falch Gedeuteten historien*. Hamburg: University of Hamburg.

C. Tümpel 1969
Tümpel, Christian. *Studien zur Ikonographie der historien Rembrandts*. Bussum: Nederlands Kunsthistorisch Jaarbok.

Tümpel and Schatborn 1991
Tümpel, Astrid, and Peter Schatborn. *Pieter Lastman: leermeester van Rembrandt*. Exh. cat. Zwolle: Waanders; Amsterdam: Museum het Rembrandthuis.

Tümpel and Tümpel 2006
Tümpel, Christian, and Astrid Tümpel. *Rembrandt: Images and Metaphors*. London: Haus.

Tümpel, Tümpel, and Gaskell 1993
Tümpel, Christian, Astrid Tümpel, and Ivan Gaskell. *Rembrandt: All Paintings in Colour*. Antwerp: Fonds Mercator.

University of Kentucky Art Gallery 1967
University of Kentucky Art Gallery. *Masterpieces from University Collections*. Exh. cat. April 9–May 10. Lexington: University of Kentucky Art Gallery.

Valentiner 1905
Valentiner, Wilhelm Reinhold. *Rembrandt und seine Umgebung*. Strasbourg: J.H.E. Heitz.

Valentiner 1908
Valentiner, Wilhelm Reinhold, ed. *Rembrandt: des Meisters Gemälde in 643 Abbildungen*. 3d ed. Klassiker der kunst in Gesamtausgaben. Stuttgart and Berlin: Deutsche Verlags-Anstalt.

Valentiner 1920
Valentiner, Wilhelm Reinhold. "Die Vier Evangelisten Rembrandts." *Kunstchronik und Kunstmarkt*, n.s., vol. 32 (December 17), pp. 219–22.

Valentiner 1921
Valentiner, Wilhelm Reinhold, ed. *Rembrandt: wiedergefundene Gemälde (1910–1920) in 120 Abbildungen*. Klassiker der Kunst in Gesamtausgaben. Stuttgart: Deutsche Verlags-Anstalt.

Valentiner 1933
Valentiner, Wilhelm Reinhold. *Rembrandt: wiedergefundene Gemälde (1910–1922) in 128 Abbildungen*, 2d ed. Berlin and Leipzig: Deutsche Verlags-Anstalt.

Valentiner 1925–34
Valentiner, Wilhelm Reinhold. *Die Handzeichnungen Rembrandts*. 2 vols. New York: E. Weyhe.

Valentiner 1930a
Valentiner, Wilhelm Reinhold. "Bust of Christ by Rembrandt." *Bulletin of the Detroit Institute of Arts*, vol. 12, no. 1 (October), pp. 2–3.

Valentiner 1930b
Valentiner, Wilhelm Reinhold. "Important Rembrandts in American Collections." *Art News*, vol. 28 (April 26), pp. 3–84.

Valentiner 1930c
Valentiner, Wilhelm Reinhold. *The Thirteenth Loan Exhibition of Old Masters, Paintings by Rembrandt*. Exh. cat. May 2–31. Detroit: Detroit Institute of Arts.

Valentiner 1931
Valentiner, Wilhelm Reinhold. *Rembrandt Paintings in America*. 2 vols. New York: S. W. Frankel.

Valentiner 1956
Valentiner, Wilhelm Reinhold. *Rembrandt and His Pupils*. Exh. cat. November 16–December 30. Raleigh: North Carolina Museum of Art.

Valentiner and Perrier 1944
Valentiner, Wilhelm Reinhold, and Hector Perrier. *Five Centuries of Dutch Art; Loan Exhibition of Great Paintings under the Distinguished Patronage of His Excellency the Earl of Athlone, Governor-General of Canada, and H.R.H. the Princess Alice, Countess of Athlone, and H.R.H. Princess Juliana of the Netherlands for the Benefit of the Children of Great Britain, the Netherlands and Occupied Countries of Europe*. Exh. cat. March 9–April 9. Montreal: Montreal Museum of Fine Arts.

Van de Wetering 2000, 2009
Van de Wetering, Ernst. *Rembrandt: The Painter at Work*. Berkeley: University of California Press.

Van de Wetering et al. 2006
Van de Wetering, Ernst, et al. *Rembrandt: Quest of a Genius*. Exh. cat. Museum het Rembrandthuis, Amsterdam, April 1–July 2; Staatliche Museen zu Berlin, August 4–November 5. Amsterdam: Museum het Rembrandthuis.

Van de Wetering and Schnackenburg 2001
Van de Wetering, Ernst, and Bernard Schnackenburg, eds. *The Mystery of the Young Rembrandt*. Exh. cat. Staatliche Museen Kassel, November 3, 2001–January 27, 2002; Museum het Rembrandthuis, Amsterdam, February 20–May 26, 2002. Wolfratshausen, Germany: Edition Minerva.

Van den Boogert et al. 1999
Van den Boogert, Bob, Ben Broos, Roelof van Gelder, and Jaap van der Veen. *Rembrandt's Treasures*. Exh. cat. Museum het Rembrandthuis, Amsterdam, September 25, 1999–January 9, 2000. Zwolle: Waanders.

Van den Brink and Van der Veen 2008
Van den Brink, Peter, and Jaap van der Veen. *Jacob Backer (1608/9–1651)*. Exh. cat. Museum het Rembrandthuis, Amsterdam, November 29, 2008–February 22, 2009; Suermondt-Ludwig Museum, Aachen, March 11–June 7, 2009. Zwolle: Waanders.

Van der Meer 1955
Van der Meer, Frederik. *Rembrandt's Evangelie*. Bussum: Moussault's Uitgeverij.

Van Dyke 1927
Van Dyke, John Charles. *The Rembrandt Drawings and Etchings, with Critical Reassignments to Pupils and Followers*. New York: C. Scribner.

Van Gelder 1950
Van Gelder, Jan Gerriet. "The Rembrandt Exhibition at Edinburgh." *Burlington Magazine*, vol. 92, pp. 327–29.

Van Gelder 1951
Van Gelder, H. E. "Rembrandt's Christusverschijningen." *Oud Holland*, vol. 66, pp. 15–17.

Van Gelder 1955
Van Gelder, Jan Gerriet. "The Drawings of Rembrandt." Review of Benesch 1954–57, vols. 1 and 2. *Burlington Magazine*, vol. 97 (December), pp. 395–96.

Van Gelder et al. 1973
Gelder, Jan Gerriet, et al. *Album Amicorum Jan Gerriet Van Gelder*. The Hague: M. Nijhoff.

Van Heugten et al. 2003
Van Heugten, Sjraar, Chris Stolwijk, Leo Jansen, Evert van Uitert, and Cornelia Homburg. *Vincent's Choice: The Musée Imaginaire of Van Gogh*. Exh. cat. Rijksmuseum, Amsterdam, February 14–June 15. Amsterdam: Van Gogh Museum.

Van Mander 1604
Karel van Mander. *Het Schilder-Boeck: waer in Voor eerst de leerlustige Iueghb den grondt der Edel Vry Schildercontst in Verscheyden deelen Wort Voorgedraghen*. Alkmaar: Jacob de Meester.

Van Regteren Altena 1948–49
Van Regteren Altena, J. Q. "Rembrandt's Way to Emmaus." *Kunstmuseets Årsskrift*, vols. 35–36, pp. 1–26.

Van Regteren Altena 1951
Van Regteren Altena, J. Q. *Mostra di incisioni e disegni di Rembrandt*. Exh. cat. Palazzo Venezia, Rome, March 31–April 29; Gabinetto disegni e stampe degli Uffizi, Florence, May 6–June 6. Rome: Colombo.

Van Regteren Altena 1958
Van Regteren Altena, J. Q. *Dutch Drawings; Masterpieces of Five Centuries; Exhibition Organized by the Printroom of the Rijksmuseum, Amsterdam, and Circulated by the Smithsonian Institution*. Exh. cat. National Gallery of Art, Washington, DC; The Pierpont Morgan Library, New York; The Minneapolis Institute of Arts; Museum of Fine Arts, Boston; The Cleveland Museum of Art; The Art Institute of Chicago. Washington, DC: Smithsonian Institution.

Van Rijckevorsel 1932
Van Rijckevorsel, Joannes Leo Antonius Aloysius Maria. *Rembrandt en de traditie*. Rotterdam: W. L. and J. Brusse.

Van Thiel 1969
Van Thiel, P. J. J. *Rembrandt, 1669/1969; Tentoonstelling ter herdenking van Rembrandts sterfdag op 4 oktober 1669*. Exh. cat. September 13–November 30. Amsterdam: Rijksmuseum.

Vignau-Wilberg and Schatborn 2001
Vignau-Wilberg, Thea, and Peter Schatborn. *Rembrandt auf Papier: Werk und Wirkung*. Exh. cat. Alte Pinakothek, Munich, May 12, 2001–October 2, 2002. Munich: Hirmer.

Villadsen 1998
Villadsen, Villads. *Statens Museum for Kunst: 1827–1952*. Copenhagen: Statens Museum for Kunst.

Vippera and Levinson-Lessing 1956
Vippera, B. R., and V. F. Levinson-Lessing. *An Exhibition of Works by Rembrandt and His School*. Exh. cat. The Pushkin Museum, Moscow, May 26–July 25; The State Hermitage Museum, Leningrad, August 15–. Moscow: Gosudarstvennoi izdatel'stvo "Iskusstvo."

Vogelaar 1991
Vogelaar, Christiaan. *Rembrandt and Lievens in Leiden*. Exh. cat. December 4, 1991–March 1, 1992. Leiden: Stedelijk Museum de Lakenhal.

Vollmer 1909
Vollmer, Hans. *Die alte Gemäldegaleri in Kopenhagen*. Copenhagen: Statens Museum for Kunst.

Vol'skaia and Gershenzon 1936
Vol'skaia, V. N., and N. M. Gershenzon. *Rembrandt: Putevoditel' po vystavke (Rembrandt: An Exhibition of Works)*. Exh. cat. The Pushkin Museum, Moscow; The State Hermitage Museum, Leningrad. Moscow: Ob'edinennoe izd-vo "Iskusstvo."

Von Alten 1947
Von Alten, Wilken. *Rembrandt Zeichnungen*. Berlin: Rembrandt-Verlag.

Von Bode 1883
Von Bode, Wilhelm. *Studien zur Geschichte der holländischen Malerei*. Braunschweig: F. Vieweg und Sohn.

Von Bode 1911
Von Bode, Wilhelm. *La Collection Maurice Kann*. Paris: Imp. Georges Petit.

Von Bode and Hofstede de Groot 1897–1906
Von Bode, Wilhelm, and C. Hofstede de Groot. *The Complete Work of Rembrandt*. 8 vols. Florence Simmonds, translator. Paris: C. Sedelmeyer.

Von Einem 1972
Von Einem, Herbert. "Bemerkungen zum Christusbild Rembrandts." *Das Münster*, vol. 25, nos. 5 and 6, pp. 349–60.

Von Ramdohr 1792
Von Ramdohr, Friedrich Wilhelm Basilius. *Studien zur Kenntniss der schönen Natur, der schönen Künste, der Sitten und der Staatsverfassung, auf einer Reise nach Dännemark*. Hannover: Thiel.

Von Seidlitz 1894
Von Seidlitz, Werner. Review of F. Lippmann and C. Hofsede de Groot, *Original Drawings by Rembrandt Harmenz. Van Rijn Reproduced in Photo-type*. *Repertorium für Kunstwissenschaft*, vol. 17, pp. 116–27.

Von Wurzbach 1886
Von Wurzbach, Alfred. *Rembrandt-galerie*. Stuttgart: P. Neff.

Von Wurzbach 1910
Von Wurzbach, Alfred. *Niederländisches Künstler-Lexikon*. Vienna: Halm and Goldmann.

Vosmaer 1868
Vosmaer, Carel. *Rembrandt Harmens van Rijn, sa vie et ses œuvres*. The Hague: M. Nijhoff.

Vosmaer 1877
Vosmaer, Carel. *Rembrandt Harmens van Rijn, sa vie et ses œuvres*. 2d ed. The Hague: M. Nijhoff.

Vries and Tollenaere 1987
Vries, Jan de, and F. de Tollenaere. *Nederlands etymologisch woordenboek*. Leiden: Brill.

Waagen 1854
Waagen, Gustav Friedrich. *Treasures of Art in Great Britain: Being an Account of the Chief Collections of Paintings, Drawings, Sculptures, Illuminated Mss*. 3 vols. London: J. Murray.

Waterhouse 1950
Waterhouse, Ellis K. *An Exhibition of Paintings by Rembrandt: Arranged by the Arts Council of Great Britain for the Edinburgh Festival Society*. Exh. cat. National Gallery of Scotland, Edinburgh, August 20–September 9. London: Arts Council of Great Britain.

Watkins 1941
Watkins, C. Law. *The Functions of Color in Painting: An Educational Loan Exhibition*. Exh. cat. February 16–March 23. Washington, DC: Phillips Memorial Gallery.

Wegner 1957
Wegner, Wolfgang. *Rembrandt-Zeichnungen*. Exh. cat. Staatliche Graphische Sammlung, Munich, March. Munich: Prestel-Verlag.

Wegner 1966
Wegner, Wolfgang. *Rembrandt und sein Kreis; Zeichnungen und Druckgrafik*. Exh. cat. November 8, 1966–January 29, 1967. Munich: Staatliche Graphische Sammlung.

Wegner 1973
Wegner, Wolfgang. *Die niederländischen Handzeichnungen des 15.–18. Jahrhunderts*. 2 vols. Berlin: Mann.

Weisbach 1921
Weisbach, Werner. *Der Barock als Kunst der Gegenreformation*. Berlin: P. Cassirer.

Weisbach 1926
Weisbach, Werner. *Rembrandt*. Berlin: W. de Gruyter.

Westermann 2000
Westermann, Mariët. *Rembrandt*. London: Phaidon.

Weststeijn 2005
Weststeijn, Thijs. "Rembrandt and Rhetoric: The Concepts of Affectus, Enargeia and Ornatus in Samuel van Hoogstraten's Judgement of His Master." In *The Learned Eye: Regarding Art, Theory, and the Artist's Reputation: Essays for Ernst van de Wetering*, ed. Marieke van den Doel, pp. 111–30. Amsterdam: Amsterdam University Press.

Wheelock 1977
Wheelock, Arthur K., Jr. *Perspective, Optics, and Delft Artists around 1650*. New York: Garland, 1977.

Wheelock 1982
Wheelock, Arthur K., Jr. "Vermeer's 'View of Delft' and His Vision of Reality." *Artibus et Historiae*, vol. 3, no. 6.

Wheelock 1995
Wheelock, Arthur K., Jr. *Dutch Paintings of the Seventeenth Century.* Washington, DC: National Gallery of Art.

Wheelock et al. 2005
Wheelock, Arthur K., Jr., Peter C. Sutton, Volker Manuth, and Anne T. Woollett, *Rembrandt's Late Religious Portraits.* Exh. cat. National Gallery of Art, Washington, DC, January 30–May 1; J. Paul Getty Museum, Los Angeles, June 7–August 28. Washington, DC: National Gallery of Art; Chicago: University of Chicago Press, 2005.

Wheelock et al. 2008
Wheelock, Arthur K., Jr., et al. *Jan Lievens: A Dutch Master Rediscovered.* Exh. cat. Museum het Rembrandthuis, Amsterdam, May 17–August 9, 2008; National Gallery of Art, Washington, DC, October 26, 2008–January 11, 2009; Milwaukee Art Museum, February 7–April 26, 2009. Washington, DC: National Gallery of Art.

Wheelock, Woollett, and Sutton 2005
Wheelock, Arthur K., Anne T. Woollett, and Peter C. Sutton. *Rembrandt's Apostles.* Exh. cat. October 1, 2005–January 15, 2006. San Diego: Timken Museum of Art.

White and Boon 1969
White, Christopher, and Karel G. Boon. *Rembrandt's Etchings: An Illustrated Critical Catalogue.* 2 vols. Amsterdam: Van Gendt.

White and Buvelot 1999
White, Christopher, and Quentin Buvelot, eds. *Rembrandt by Himself.* London: The National Gallery; The Hague: Royal Cabinet of Paintings Mauritshuis.

White and Croft-Murray 1956
White, Christopher, and Edward Croft-Murray. *Rembrandt and His Succession.* Exh. cat. London: British Museum.

Whitechapel Art Gallery 1904
Whitechapel Art Gallery. *Dutch Exhibition.* Exh. cat. March 30–May 10. London: Whitechapel Art Gallery.

Wichmann 1923
Wichmann, Heinrich. "Ein verschollener Rembrandt." In *Festschrift für Adolph Goldschmidt zum 60. Geburtstag am 15. Januar 1923.* Leipzig: Seeman.

Wickhoff 1906
Wickhoff, Franz. *Einige Zeichnungen Rembrandts mit biblischen Vorwürfen: Seminarstudien.* Innsbruck: Wagner'sche Universitäts-Buchhandlung.

Wivel 1994
Wivel, Mikael. *Lysets tavev: Niels Larsen Stevns og de store fortællinger.* Copenhagen: Christian Ejlers.

Worcester Art Museum 1936
Worcester Art Museum. *Rembrandt and His Circle: A Loan Exhibition of Paintings, Drawings and Etchings.* Exh. cat. February 4–March 1. Worcester, MA: Worcester Art Museum.

Wright 1975
Wright, Christopher. *Rembrandt and His Art.* New York: Hamlyn.

Wright 2000
Wright, Christopher. *Rembrandt.* Paris: Citadelles and Mazenod.

Yale University Art Gallery 1967
Yale University Art Gallery. *Paintings, Drawings, Sculpture from the Fogg Art Museum, Harvard University.* Exh. cat. October 12–December 3. New Haven: Yale University Art Gallery.

Zell 2002
Zell, Michael. *Reframing Rembrandt: Jews and the Christian Image in Seventeenth-Century Amsterdam.* Berkeley: University of California Press.

Zink 1984
Zink, Jörg. *Wir werden alle auferstehen, Geschenkt, Eine Betrachtung zu Passions- und Osterbildern von Rembrandt Harmensz van Rijn.* Eschbach: Verlag am Eschbach.

SELECTED EXHIBITIONS

Amsterdam 1898
Rembrandt: schilderijen bijeengebracht ter gelegenheid van de inhuldiging van hare majesteit Koningin Wilhelmina. Stedelijk Museum, September 8–October 31.

Amsterdam 1913
Catalogue of a Special Exhibition of Paintings, Water-colour Drawings and Original Etchings of the Art of the Netherlands. Galleries of the Winnipeg Industrial Bureau, April–May.

Amsterdam 1930
Catalogue des nouvelles acquisitions de la Collection Goudstikker. Galerie Goudstikker, April–May.

Amsterdam 1932
Rembrandt tentoonstelling. Rijksmuseum, June 11–September 4. Catalogue by Frederick Schmidt-Degener.

Amsterdam 1935
Rembrandt tentoonstelling; ter herdenking van de plechtige opening van het Rijksmuseum op 13 Juli 1885. Rijksmuseum, July 13–October 13. Catalogue by Frederick Schmidt-Degener.

Amsterdam 1951
Rembrandt, Hokusai, Van Gogh. Stedelijk Museum, October–November.

Amsterdam 1964–65
Bijbelse inspiratie, tekeningen en prenten van Lucas van Leyden en Rembrandt. Rijksmuseum, November 18, 1964–February 8, 1965. Catalogue by L.C. J. Frerichs and J. Verbeek.

Amsterdam 1969
Rembrandt, 1669/1969; Tentoonstelling ter herdenking van Rembrandts sterfdag op 4 oktober 1669. Rijksmuseum, September 13–November 30. Catalogue by P. J. J. van Thiel.

Amsterdam 2003
Vincent's Choice: The Musée Imaginaire of Van Gogh. Rijksmuseum, February 14–June 15. Catalogue by Sjraar van Heugten et al.

Amsterdam 2006–7
De 'Joodse' Rembrandt: de mythe ontrafeld. Joods Historisch Museum, November 10, 2006–February 4, 2007. Catalogue by Mirjam Alexander-Knotter, Jasper Hillegers, and Edward van Voolen.

Amsterdam and Berlin 2006
Rembrandt: Quest of a Genius. Museum het Rembrandthuis, Amsterdam, April 1–July 2; Staatliche Museen zu Berlin, August 4–November 5. Catalogue by Ernst van de Wetering et al.

Amsterdam and Rotterdam 1956
Rembrandt tentoonstelling ter herdenking van de geboorte van Rembrandt op 15 Juli 1606. Rijksmuseum, Amsterdam, May 18–August 5; Museum Boymans, Rotterdam, August 8–October 21. Catalogue by D. C. Röell.

Amsterdam, Washington, DC, and Milwaukee 2008–9
Jan Lievens: A Dutch Master Rediscovered. Museum het Rembrandthuis, Amsterdam, May 17–August 9, 2008; National Gallery of Art, Washington, DC, October 26, 2008–January 11, 2009; Milwaukee Art Museum, February 7–April 26, 2009. Catalogue by Arthur K. Wheelock et al.

Basel 1948
Rembrandt-Ausstellung. Katz Galerie, July 24–September 30.

Berlin 1930
Rembrandt. Preussische Akademie der Bildenden Künste, February 22–April 6. Catalogue by Max J. Friedländer.

Berlin, Amsterdam, and London 1991–92
Rembrandt: The Master and His Workshop. Altes Museum, Berlin, September 12–November 10, 1991; Rijksmuseum, Amsterdam, December 4, 1991–March 1, 1992; The National Gallery, London, March 26–May 24, 1992. Catalogue by Christopher Brown et al.

Boston and Chicago 2003–4
Rembrandt's Journey: Painter, Draftsman, Etcher. Museum of Fine Arts, Boston, October 26, 2003–January 18, 2004; The Art Institute of Chicago, February 14–May 9, 2004. Catalogue by Ronnie Baer et al.

Braunschweig 1979
Jan Lievens, ein Maler im Schatten Rembrandts. Herzog Anton Ulrich-Museum, September 6–November 11. Catalogue by Rudolf E. O. Ekkart, Sabine Jacob, and Rüdiger Klessmann.

Bremen 2000–2001
Rembrandt, oder nicht? Zeichnungen von Rembrandt und seinem Kreis aus den Hamburger und Bremer Kupferstichkabinetten. Kunsthalle Bremen, October 15, 2000–January 21, 2001. Catalogue by Anne Röver-Kann and Thomas Ketelsen.

Brussels and Hamburg 1961
Hollandse Tekeningen uit de gouden eeuw / Holländische Zeichnungen der Rembrandt-Zeit. Albert I-Bibliotheek, Brussels, April 22–June 24; Hamburger Kunsthalle, September 8–October 15. Catalogue by Karel G. Boon et al.

Budapest 1975
Remekműveka Szovjetunio múzeumaiból (Masterpieces from the museums of the Soviet Union). Szépművészeti Museum.

Cambridge, MA 1922
Exhibition of Works by Rembrandt. Fogg Art Museum.

Cambridge, MA 1927
Seventeenth-Century Dutch Art. Fogg Art Museum.

Cambridge, MA 1948
Rembrandt, Paintings and Etchings. Fogg Art Museum, October 19–November 27.

Cambridge, MA 1968
A Tribute to John Coolidge: Purchases of Two Decades. Fogg Art Museum, May 28–July 31.

Cambridge, MA 1984
Rembrandt: A Selection of His Works. Busch-Reisinger Museum, October 18–December 11.

Cambridge, UK 1966
Rembrandt and His Circle: An Exhibition of Drawings from the Collection of the Fitzwilliam Museum. Fitzwilliam Museum, February–June. Catalogue by Malcolm Cormack.

Cambridge, UK 1979
All for Art: The Ricketts and Shannon Collection. Fitzwilliam Museum, October 9–December 3. Catalogue by Joseph Darracott.

Chicago 1935–36
Loan Exhibition of Paintings, Drawings and Etchings by Rembrandt and His Circle. The Art Institute of Chicago, December 19, 1935–January 19, 1936. Catalogue by Daniel Cotton Rich.

Chicago, Minneapolis, and Detroit 1969–70
Rembrandt after Three Hundred Years. The Art Institute of Chicago, October 25–December 7, 1969; The Minneapolis Institute of Arts, February 1, 1970; Detroit Institute of Arts, February 24–April 5, 1970. Catalogue by J. Richard Judson and Egbert Haverkamp-Begemann.

Cincinnati 1959
The Lehman Collection, New York. Cincinnati Art Museum, May 8–July 5.

Cologne 1956
Rembrandt durchleuchtet. Röntgen- und Infrarot-Aufnahmen der Rembrandt-Bilder im Louvre. Wallraf-Richartz-Museum. Catalogue by Madeleine Hours-Miedan.

Copenhagen 2006
Rembrandt?: The Master and His Workshop. Statens Museum for Kunst, February 4–May 14. Catalogue by Eva de la Fuente Pedersen et al.

Detroit 1930
The Thirteenth Loan Exhibition of Old Masters; Paintings by Rembrandt. Detroit Institute of Arts, May 2–31. Catalogue by Wilhelm R. Valentiner.

Detroit 1949
Masterpieces of Painting and Sculpture. Detroit Institute of Arts.

Edinburgh 1950
An Exhibition of Paintings by Rembrandt: Arranged by the Arts Council of Great Britain for the Edinburgh Festival Society. National Gallery of Scotland. National Gallery of Scotland, August 20–September 9. Catalogue by Ellis Kirkham Waterhouse.

Eindhoven 1938
Noord-Brabantsch kunstbezit; tentoonstelling ter gelegen-heid van het 40-jarig regeerings-jubileum van Hare Majesteit Wilhelmina koningin der Nederlanden. Stedelijk Van Abbemuseum, August 15–September 15.

Haarlem 1951
Rembrandt tentoonstelling: tekeningen en etsen. The Vleeshal, June 2–September 3. Catalogue by D. J. A. Geluk.

The Hague 1902–3
Tekeningen van Oude Hollandsche Meesters uit de Verzameling van Dr. C. Hofstede de Groot. Haagsche Kunstkring.

The Hague 1915
Tentoonstelling van oude schilderijen. Kunstzaal Kleykamp, March. Catalogue by Abraham Bredius and J. O. Kronig.

The Hague 1920
Verzameling Dr. C. Hofstede de Groot. Gemeente-museum, August 16–September 16. Catalogue by J. Brouwer-Sierdsma.

The Hague 1948
Masterpieces of the Dutch School from the Collection of His Majesty, the King of England. Mauritshuis, August 6–September 26. Catalogue by Anthony Blunt.

Hamburg 1967
Hundert Meisterzeichnungen aus der Hamburger Kunsthalle 1500–1800. Hamburger Kunsthalle.

Hamburg 1994–95
Rembrandt und sein Jahrhundert; niederländische Zeichnungen in der Hamburger Kunsthalle. Hamburger Kunsthalle, October 21, 1994–January 15, 1995. Catalogue by Eckhard Schaar.

Hamilton, NY 1983
Dutch Painting in the Age of Rembrandt from The Metropolitan Museum of Art. Picker Art Gallery, Colgate University, February 6–April 17. Catalogue by Stephanie Dickey.

Helsinki 2005
Treasures from the Pavlovsk Palace: The Collecting in Russia in the Time of Catherine II and Paul I. Etelä-Karjalan taidemuseo. Catalogue by Satu Eiskonen et al.

Hempstead, NY 1952
Metropolitan Museum Masterpieces. Hofstra College, June 26–September 1.

Indianapolis 1970–71
Treasures from the Metropolitan. Indianapolis Museum of Art, October 25, 1970–January 3, 1971.

Kalamazoo 1967
Alfred Bader Collection: 17th Century Dutch and Flemish Painting. Kalamazoo Institute of Arts, October 8–November 10.

Kansas City, Milwaukee, Montreal, and Hartford 1993–94
Master European Drawings from Polish Collections. The Nelson-Atkins Museum of Art, Kansas City, April 17–June 6, 1993; Milwaukee Art Museum, July 9–August 29, 1993; Montreal, Museum of Fine Arts, October 10–December 5, 1993; Wadsworth Atheneum, Hartford, CT, January 9–March 6, 1994. Catalogue by Anna Kozak, Maciej Monkiewicz and Teresa Sulerzyska.

Kyoto and Frankfurt 2002–3
Rembrandt Rembrandt. Kyoto, National Museum, November 3, 2002–January 13, 2003; Frankfurt, Städelsches Kunstinstitut, January 31–May 11, 2003. Catalogue by Jeroen Giltaij.

Leiden 1903
Tekeningen van Oud-Nederlandsche Meesters. Vereeniging "de Laecken-Halle."

Leiden 1916
Tentoonstelling in het Stedelijk Museum "De Lakenhal" te Leiden, van teekeningen van Hollandsche meesters uit de verzameling van Dr. C. Hofstede de Groot. Stedelijk Museum, May 12–June 14.

Leiden 1991–92
Rembrandt and Lievens in Leiden. Stedelijk Museum de Lakenhal, December 4, 1991–March 1, 1992. Catalogue by Christiaan Vogelaar.

Leningrad, Moscow, and Kiev 1974
Tekeningen van Vlaamse en Hollandse meesters in de re-eenw, uit Belgische en Hollandse Musea en uit het Institut Néerlandais te Parijs. The State Hermitage Museum, Leningrad; The Pushkin Museum, Moscow; Museum of Western and Oriental Art, Kiev. Catalogue by A. W. F. M. Meij.

Lexington 1967
Masterpieces from University Collections. University of Kentucky Art Gallery, April 9–May 10.

London 1835
Exhibition: Original Drawings by P. P. Rubens; Ant. Van Dyke; Rembrandt van Rijn; Claude Lorraine; Nicholas Poussin; Il Parmigiano; Correggio; Ludovico, Agostino and Annibal Carracci; Zucchero, Andrea del Sarto, Caravaggio; Fra Bartolomeo; Albert Dürer; Titian, Raphael, Michelangelo. Lawrence Gallery. Catalogue by Thomas Lawrence.

London 1899
Exhibition of Works by Rembrandt: Winter Exhibition. Royal Academy of Arts, January 2–March 11.

London 1904
Dutch Exhibition. Whitechapel Art Gallery, March 30–May 10.

London 1929
Exhibition of Dutch Art 1450–1900. Royal Academy of Arts, January 4–March 9.

London 1938
Drawings and Etchings by Rembrandt. British Museum. Catalogue by Arthur Mayger Hind.

London 1946–47
The King's Pictures. Royal Academy of Arts. Catalogue by Alfred James Munnings.

London 1952–53
Dutch Pictures, 1450–1750. Royal Academy of Arts, November 1952–March 1953.

London 1956
Rembrandt and His Succession. British Museum. Catalogue by Christopher White and Edward Croft-Murray.

London 1971–72
Dutch Pictures from the Royal Collection. The Queen's Gallery, Buckingham Palace. Catalogue by Oliver Miller.

London 1976
Art in Seventeenth Century Holland. The National Gallery, September 30–December 12. Catalogue by Christopher Brown.

London 1988–89
Treasures from the Royal Collection. The Queen's Gallery, Buckingham Palace. Catalogue by Graham Johnson.

London 1992
Drawings by Rembrandt and His Circle in the British Museum. British Museum, March 26–August 4. Catalogue by Martin Royalton-Kisch.

Los Angeles 1938
Exhibition of Paintings by Old Masters: Lent by Schaeffer Galleries Inc., New York. Los Angeles County Museum of Art.

Los Angeles 1947
Loan Exhibition of Paintings by Franz Hals and Rembrandt. Los Angeles County Museum of Art, November 18–December 31.

Los Angeles, Chicago, and New York 1982
The Jews in the Age of Rembrandt. Hebrew Union College, Skirball Museum, Los Angeles, January 20–March 28; The Maurice Spertus Museum of Judaica, Chicago, April 25–July 4; The Jewish Museum, New York, September 9–December 5. Catalogue by Susan W. Morgenstein and Ruth E. Levine.

Madrid 2008–9
Rembrandt, Pintor de Historias. Museo Nacional del Prado, October 15, 2008–January 6, 2009. Catalogue by Teresa Posada Kubissa, Alexander Vergara, and Mariët Westermann.

Manchester 1857
Art Treasures of the United Kingdom, Collected at Manchester in 1857. Museum of Ornamental Art, May 5–October 17.

Manchester 1957
Art Treasures Centenary: European Old Masters: Commemorating the Famous Exhibition, "The Art Treasures of the United Kingdom," Held at Manchester in 1857. Manchester City Art Gallery, October 30–December 31.

Melbourne and Canberra 1997–98
Rembrandt: A Genius and His Impact. National Gallery of Victoria, Melbourne, October 1–December 7, 1997; National Gallery of Australia, Canberra, December 17, 1997–February 15, 1998. Catalogue by Albert Blankert et al.

Milan 1970
Rembrandt, trentotto disegni. Pinacoteca di Brera, Milan, November 6–December 16. Catalogue by Karel G. Boon.

Milan 2001
Il genio e le passioni: Leonardo e il Cenacolo: precedenti, innovazioni, riflessi di un capolavoro. Palazzo Reale, March 21–June 17. Catalogue by Pietro C. Marani.

Milwaukee 1957
An Inaugural Exhibition of Six Great Painters: El Greco, Rembrandt, Goya, Van Gogh, Cézanne, and Picasso. Milwaukee Art Center, September 12–October 20. Catalogue by Will Beck.

Montreal 1933
Exhibition: A Selection from the Collection of Paintings of the Late Sir William Van Horne, K.C.M.G., 1843–1915. Art Association of Montreal Galleries, October 16–November 5. Catalogue by Art Association of Montreal.

Montreal 1942
Loan Exhibition of Masterpieces of Painting under the Distinguished Patronage of His Excellency the Earl of Athlone, Governor General of Canada, and H.R.H. The Princess Alice, Countess of Athlone; for the Benefit of the Men of the Allied Merchant Navies. Museum of Fine Arts, February 5–March 8. Catalogue by Louis Allard and John Lyman.

Montreal 1944
Five Centuries of Dutch Art; Loan Exhibition of Great Paintings under the Distinguished Patronage of His Excellency the Earl of Athlone, Governor-General of Canada, and H.R.H. the Princess Alice, Countess of Athlone, and H.R.H. Princess Juliana of the Netherlands for the Benefit of the Children of Great Britain, the Netherlands and Occupied Countries of Europe. Montreal Museum of Fine Arts, March 9–April 9. Catalogue by Wilhelm Reinhold Valentiner and Hector Perrier.

Moscow 1969
Vystavka proizvedenii Rembrandta, 1606–1669: k 300-letiiu so dnia smerti khudozhnika (*Rembrandt: An exhibition of his works dedicated to the 300th anniversary of the artist's death*). The Pushkin Museum. Catalogue by K. S. Egorova, E. S. Levitin, and Irina Evgen'evna Danilova.

Moscow and Leningrad 1936
Rembrandt: Putevoditel' po vystavke (*Rembrandt: An exhibition of works*). The Pushkin Museum, Moscow; State Hermitage Museum, Leningrad. Catalogue by V. N. Vol'skaia and N. M. Gershenzon.

Moscow and Leningrad 1956
An Exhibition of Works by Rembrandt and His School. The Pushkin Museum, Moscow, May 26–July 25; The State Hermitage Museum, Leningrad, August 15. Catalogue by B. R. Vippera and V. F. Levinson-Lessing.

Munich 1957
Rembrandt-Zeichnungen. Staatliche Graphische Sammlung, March. Catalogue by Wolfgang Wegner.

Munich 1966–67
Rembrandt und sein Kreis, Zeichnungen und Druckgrafik. Staatliche Graphische Sammlung, November 8, 1966–January 29, 1967. Catalogue by Wolfgang Wegner.

Munich 2001–2
Rembrandt auf Papier: Werk und Wirkung. Alte Pinakothek, May 12, 2001–October 2, 2002. Catalogue by Thea Vignau-Wilberg and Peter Schatborn.

Munich, Heidelberg, Braunschweig, and Cambridge, UK 1995–96
Das goldene Jahrhundert: holländische Meisterzeichnungen aus dem Fitzwilliam Museum. / *The Golden Century: Dutch Master Drawings from the Fitzwilliam Museum.* Staatliche Graphische Sammlung, Munich, November 15, 1995–January 14, 1996; Kurpfälzisches Museum, Heidelberg, February 11–April 8, 1996; Herzog Anton Ulrich-Museum, Braunschweig, May 1–June 30, 1996; The Fitzwilliam Museum, Cambridge, UK, October 8–December 22, 1996. Catalogue by David Scrase and Thea Vignau-Wilberg.

New Haven 1967
Paintings, Drawings, Sculpture from the Fogg Art Museum, Harvard University. Yale University Art Gallery, October 12–December 3.

New York 1912
Loan Exhibition of Old Masters. Knoedler Galleries, January 11–27.

New York 1933
Loan Exhibition of Paintings by Rembrandt: Held for the Benefit of the Adopt-a-Family Committee of the Emergency Unemployment Relief Fund. Knoedler Galleries, April 17–29.

New York 1936
The Great Dutch Masters. Schaeffer Galleries, December 1–30.

New York 1939
Exhibition Held on the Occasion of the New York World's Fair. The Pierpont Morgan Library, May–October.

New York 1942
Paintings by the Great Dutch Masters of the Seventeenth Century; Loan Exhibition in Aid of the Queen Wilhelmina Fund and the American Women's Voluntary Services. Duveen Galleries, October 8–November 7. Catalogue by George Henry McCall.

New York 1956
Religious Painting, 15th–19th Century: An Exhibition of European Paintings from American Collections. Brooklyn Museum, October 2–November 13.

New York 1979–80
Seventeenth Century Dutch and Flemish Drawings from the Robert Lehman Collection. The Metropolitan Museum of Art, October 24, 1979–January 27, 1980. Catalogue by George Szabó.

New York 1993
Splendid Legacy: The Havemeyer Collection. The Metropolitan Museum of Art, March 27–June 30. Catalogue by Alice Cooney Freylinghuysen.

New York 1995–96
Rembrandt / Not Rembrandt in The Metropolitan Museum of Art. The Metropolitan Museum of Art, October 10, 1995–January 7, 1996. Catalogue by Walter Liedtke et al.

New York 2004
Byzantium: Faith and Power (1261–1557). The Metropolitan Museum of Art, March 23–July 4. Catalogue by Helen C. Evans.

New York 2007–8
The Age of Rembrandt: Dutch Paintings in The Metropolitan Museum of Art. The Metropolitan Museum of Art, September 18, 2007–January 6, 2008.

New York, Boston, and Chicago 1969
Rembrandt Drawings from American Collections. The Pierpont Morgan Library, New York, March 15–April 6; Fogg Art Museum, Cambridge, MA, April 27–May 29. Catalogue by Jakob Rosenberg.

New York and Cambridge, MA 1960
Rembrandt Drawings from Stockholm: A Loan Exhibition from the Nationalmuseum. The Pierpont Morgan Library, New York, March 15–April 6; Fogg Art Museum, Cambridge, MA, April 27–May 29. Catalogue by Jakob Rosenberg.

New York and Chicago 1989
From Michelangelo to Rembrandt: Master Drawings from the Teyler Museum. The Pierpont Morgan Library, New York, February 10–April 30; The Art Institute of Chicago, May 13–July 30. Catalogue by Clifford Ackley et al.

Northampton, MA 1928
Exhibition of Old Masters. Smith College Museum of Art.

Novosibirsk, Krasnoyarsk, and Irkutsk 1987
Foreign Masterpieces from the Pushkin Museum.

Oklahoma City 1979
Masters of the Portrait. Oklahoma Museum of Art, March 4–April 26. Catalogue by James K. Reeve.

Paris 1820
Notice des dessins, peintures, émaux et terres cuites émaillés, exposés au Musée royal, dans la Galerie d'Apollon. Musée du Louvre.

Paris 1838
Notice des dessins placés dans les galeries du Musée royal, au Louvre. Musée du Louvre. Re-exhibited in 1841.

Paris 1841
Notice des dessins placés dans les galeries du Musée royal, au Louvre. Musée du Louvre.

Paris 1874
Explication des ouvrages de peinture exposés au profit de la colonisation de l'Algérie par les Alsaciens-Lorrains. Palais de la Présidence du Corps Legislatif, April 23.

Paris 1879
Maîtres anciens exposés à l'École des Beaux-Arts, Paris, June. Catalogue by Charles Ephrussi and Gustave Dreyfus.

Paris 1908
Exposition d'oeuvres de Rembrandt: dessins et gravures. Bibliothèque nationale, May–June. Catalogue by François Courboin, Joseph Guibert, and Paul-André Lemoisne.

Paris 1911
Grands et petits maîtres hollandais. Galerie Nationale du Jeu de Paume, April 28–July 10.

Paris 1921
Exposition hollandaise, tableaux, aquarelles et dessins anciens et modernes. Galerie Nationale du Jeu de Paume, April–May. Catalogue by Léonce Bénédite.

Paris 1937
Rembrandt, dessins et eaux-fortes. Musée de l'Orangerie, 1937. Catalogue by Gabriel Rouchès.

Paris 1955
Rembrandt et son temps: dessins et eaux-fortes de Rembrandt et d'autres maîtres hollandais du XVIIe siècle conservés dans les collections de l'École des beaux-arts, Paris. École nationale supérieure des beaux-arts, May–June. Catalogue by Wanda Bouleau-Raba.

Paris 1957
Exposition Rembrandt et son école: dessins et estampes. Institut Néerlandais, March 12–30.

Paris 1960
Bestiaire hollandais: exposition de tableaux, aquarelles, dessins et gravures par des artistes hollandais des XVIIe–XVIIIe siècles et d'un choix de livres de la même période. Institut Néerlandais.

Paris 1967
Le Cabinet d'un grand amateur, P. J. Mariette. Musée du Louvre. Catalogue by Rosaline Bacou.

Paris 1970
Rembrandt et son temps — Dessins des collections publiques et privées conservés en France. Paris, Musée du Louvre, February 3–April 27, 1970. Catalogue by Roseline Bacou et al.

Paris 1970–71
Le siècle de Rembrandt; tableaux hollandais des collections publiques françaises. Musée du Petit Palais, November 17, 1970–February 15, 1971. Catalogue by Arnauld Brejon de Lavergnée.

Paris 1974
Dessins flamands et hollandais du dix-septième siècle. Institut Néerlandais, April 25–June 9. Catalogue by A. W. F. M. Meij.

Paris 1988–89
Rembrandt et son école: dessins du Musée du Louvre. Musée du Louvre, October 27, 1988–January 30, 1989. Catalogue by Emmanuel Starcky and Menehould de Bazelaire.

Paris 2000
Dessins de la Collection Edmond de Rothschild et du Cabinet des dessins, Département des arts graphiques du Musée du Louvre. Musée du Louvre, March 16–June 19. Catalogue by Pierrette Jean-Richard.

Paris 2006–7
Rembrandt dessinateur: Chefs-d'oeuvre des collections en France. Musée du Louvre, October 20, 2006–January 8, 2007. Catalogue by Peter Schatborn, Carel van Tuyll van Serooskerken, and Hélène Grollemund.

Paris 2007
Rembrandt et la nouvelle Jérusalem: Juifs et Chrétiens à Amsterdam au siècle d'or. Musée d'art et d'histoire du Judaïsme, March 28–July 1. Catalogue by Laurence Sigal-Klagsbald and Alexis Merle du Bourg.

Prague 1966
Tři století nizozemské kresby, 1400–1700. Národní Gallery, June–July.

Provo, UT 2006–7
Salvation: The Life of Christ in Word and Image. Brigham Young University Museum of Art, November 17, 2006–June 16, 2007. Exhibition guide by S. Kent Brown, Richard Neitzel Holzapfel, and Dawn Pheysey.

Raleigh, NC 1956
Rembrandt and His Pupils. North Carolina Museum of Art, November 16–December 30. Catalogue by Wilhelm Reinhold Valentiner.

Raleigh, NC 1959
Masterpieces of Art: In Memory of Wilhelm R. Valentiner, 1880–1958. North Carolina Museum of Art, April 6–May 17. Catalogue by James Byrnes.

Rome and Florence 1951
Mostra di incisioni e disegni di Rembrandt. Palazzo Venezia, Rome, March 31–April 29; Gabinetto disegni e stampe degli Uffizi, Florence, May 6–June 6. Catalogue by J. Q. van Regteren Altena.

Rotterdam 2000–2001
Jezus in de Gouden Eeuw. Kunsthal, September 9, 2000–January 7, 2001. Catalogue by Albert Blankert.

Rotterdam and Istanbul 2005–7
Rembrandt in Rotterdam. Museum Boijmans Van Beuningen, Rotterdam, December 10, 2005–March 5, 2006; Pera Museum, Istanbul, October 17, 2006–January 7, 2007. Catalogue by Albert Elen.

Sacramento, CA 1974
The Pre-Rembrandtists. Crocker Art Gallery. Catalogue by Astrid Tümpel.

San Diego 2005–6
Rembrandt's Apostles. Timken Museum of Art, October 1, 2005–January 15, 2006. Catalogue by Arthur K. Wheelock, Anne T. Woollett, and Peter C. Sutton.

San Diego, Champaign-Urbana, IL, Mobile, AL, Midland, MI, Little Rock, AR 1981–82
5000 Years of Art from the Collection of The Metropolitan Museum of Art. San Diego Museum of Art, October 10–December 6, 1981; Krannert Art Museum, University of Illinois, Champaign-Urbana, January 10–March 7, 1982; Alabama Fine Arts Museum of the South, Mobile, March 30–May 9, 1982; Michigan Midland Center for the Arts, Midland, June 13–August 25, 1982; Arkansas Arts Center, Little Rock, September 19–November 14, 1982.

San Francisco 1938
Exhibition of Paintings by Old Masters: Lent by Schaeffer Galleries Inc., New York. San Francisco Museum of Art.

San Francisco 1939–40
Seven Centuries of Painting: A Loan Exhibition of Old and Modern Masters. California Palace of the Legion of Honor and the M. H. de Young Memorial Museum, December 29, 1939–January 28, 1940.

San José, Costa Rica 1978
Cinco siglos de obras maestras de la pintura en colecciones norteamericanas cedidas en préstamo a Costa Rica. Museo de Jade, May 6–June 30. Catalogue by Dewey F. Mosby.

Schaffhausen 1949
Rembrandt und seine Zeit: Zweihundert Gemälde der Blütezeit der holländischen Barockmalerei des 17. Jahrhunderts. Museum zu Allerheiligen, April 10–October 2.

Stockholm 1956
Rembrandt. Nationalmuseum, January 12–April 15.

Stockholm 1967
Holländska mästare i svensk ägo. Nationalmuseum, March 3–April 30. Catalogue by Pontus Grate.

Stockholm 1992–93
Rembrandt och hans tid: människan I centrum (Rembrandt and his age: focus on man). National-museum, October 2, 1992–January 6, 1993. Catalogue by Görel Cavalli-Björkman and Mårten Snickare.

Stockholm 2005–6
Holländsk guldålder: Rembrandt, Frans Hals och deras samtida. Nationalmuseum, September 22, 2005–January 8, 2006. Catalogue by Görel Cavalli-Björkman, Karin Sidén, Mårten Snickare.

Tokyo and Kyoto 1968
Remburanto meisaku ten (Masterpieces of Rembrandt). Tokyo National Museum, April 2–May 16; Kyoto National Museum, May 25–July 14. Catalogue by the Nihon Keizai Shimbun.

Tokyo and Kyoto 1972
Treasured Masterpieces of The Metropolitan Museum of Art. Tokyo National Museum, August 10–October 1; Kyoto Municipal Museum of Art, October 8–November 26.

Vienna 1956
Rembrandt: Ausstellung im 350 Geburtsjahr des Meisters. Graphische Sammlung Albertina, Fall. Catalogue by Otto Benesch.

Warsaw 1956
Rembrandt i jego Krag. National Museum, March 15–April 30. Catalogue by Stefania Golanska and Stanisława Sawicka.

Washington, DC 1941
The Functions of Color in Painting: An Educational Loan Exhibition. Phillips Memorial Gallery, February 16–March 23, 1941. Catalogue by C. Law Watkins.

Washington, DC 1983–84
Leonardo's Last Supper: Precedents and Reflections. National Gallery of Art, December 18, 1983–March 4, 1984.

Washington, DC, and Cincinnati 1988–89
Masterworks from Munich: Sixteenth- to Eighteenth-Century Paintings from the Alte Pinakotek. National Gallery of Art, Washington, DC, May 29–September 5, 1988; Cincinnati Art Museum, October 25, 1988–January 8, 1989. Catalogue by Beverly Louise Brown and Arthur K. Wheelock.

Washington, DC, Denver, and Fort Worth 1977
Seventeenth Century Dutch Drawings from American Collections: A Loan Exhibition. National Gallery of Art, Washington, DC, January 30, March 13; Denver Art Museum; Kimbell Art Museum, Fort Worth. Catalogue by Franklin Westcott Robinson.

Washington, DC, and Fort Worth 1989–90
Treasures from the Fitzwilliam Museum: The Increase of Learning and Other Great Objects. National Gallery of Art, Washington, DC, March 19–June 18, 1989; Kimbell Art Museum, Fort Worth, November 5, 1989–January 8, 1990. Catalogue by Beverly Louise Brown.

Washington, DC, and Los Angeles 2005
Rembrandt's Late Religious Portraits. National Gallery of Art, Washington, DC, January 30–May 1; J. Paul Getty Museum, Los Angeles, June 7–August 28. Catalogue by Arthur K. Wheelock et al.

Washington, DC, New York, Minneapolis, Boston, Cleveland, and Chicago 1958–59
Dutch Drawings; Masterpieces of Five Centuries; Exhibition Organized by the Printroom of the Rijksmuseum, Amsterdam and Circulated by the Smithsonian Institution. National Gallery of Art, Washington, DC; The Pierpont Morgan Library, New York; The Minneapolis Institute of Arts; Museum of Fine Arts, Boston; The Cleveland Museum of Art; The Art Institute of Chicago. Catalogue by J. Q van Regteren Altena.

Wichita 1977–78
5000 Years of Art from The Metropolitan Museum of Art. Wichita Art Museum, October 23, 1977–January 15, 1978. Catalogue by Howard E. Wooden.

Worcester, MA 1936
Rembrandt and His Circle: A Loan Exhibition of Paintings, Drawings and Etchings. Worcester Art Museum, February 4–March 1.

Yokohama, Fukuoka, and Kyoto 1986–87
Remburanto, Kyosho to sono shuhen / Rembrandt and the Bible. Sogo Museum of Art, Yokohama, October 31–December 23, 1986; Fukuoka Art Museum, January 6–February 1, 1987; National Museum of Modern Art, Kyoto, February 7–March 22, 1987. Catalogue by Nobuyuki Senzoku.

ILLUSTRATED CHECKLIST OF THE EXHIBITION

CAT. 1

Andrea Mantegna (Italian, 1430/31–1506)

Christ between Saints Andrew and Longinus

c. 1472

Engraving on paper

16⁹⁄₁₆ × 13⁷⁄₁₆ inches (42.6 × 33.2 cm)

Musée du Louvre, Paris, département des Arts graphiques, Rothschild Collection, 3844 LR

Plate 7-9, p. 191

SELECTED LITERATURE: Bartsch 1803–21, vol. 13, no. 6; Kristeller and Strong 1901, pp. 400–404, no. 2; Hind and Colvin 1910, p. 342, no. 7; Borenius 1923, F-23, no. 7; Tietze-Conrat 1955, p. 242, no. 2

VENUE: Paris

CAT. 2

Martin Schongauer (German, c. 1450–1491)

The Carrying of the Cross, c. 1470–80?

Engraving on paper

11¼ × 16⅞ inches (28.5 × 42.7 cm)

Musée du Louvre, Paris, département des Arts graphiques, Rothschild Collection, 204 LR

Plate 7-6, p. 188

VENUE: Paris

SELECTED LITERATURE: Bartsch 1803–21, vol. 6, p. 128; Lehrs 1908–34 vol. 5, no. 9; Hollstein 1949–, vol. 49, no. 9

CAT. 3

Lucas van Leyden (Dutch, 1494–1533)

Soldiers Giving a Drink to Christ, c. 1512

Engraving on paper

5⅛ × 4⅛ inches (13.1 × 10.3 cm)

Musée du Louvre, Paris, département des Arts graphiques, Rothschild Collection, 1742 LR

Plate 7-8, p. 190

SELECTED LITERATURE: Bartsch 1803–21, vol. 10, p. 380, no. 73; Hollstein 1949–, vol. 10, no. 73

VENUE: Paris

CAT. 4

Albrecht Dürer (German, 1471–1528)

Holy Face (The Mandylion Carried by Two Angels), 1513

Engraving on paper

4 × 5⁹⁄₁₆ inches (10.2 × 14.1 cm)

Musée du Louvre, Paris, département des Arts graphiques, Rothschild Collection, 531 LR

Plate 7-5, p. 186

VENUE: Paris

SELECTED LITERATURE: Dodgson 1926, no. 71; Meder 1932, no. 26; Hollstein 1954–, vol. 7, no. 26; Schoch 2001, vol. 1, no. 68c

CAT. 5

Hendrick Goltzius (Dutch, 1558–1617)

The Dead Christ in the Lap of the Virgin (Pietà), 1596

Engraving on paper

6⁹⁄₁₆ × 5⁵⁄₁₆ inches (17.7 × 12.8 cm)

Musée du Louvre, Paris, département des Arts graphiques, Rothschild Collection, 2552 LR

Plate 7-7, p. 189

SELECTED LITERATURE: Van Mander 1604, folio 285r; Hirschmann 1919, pp. 81–82; Hollstein 1949–, pp. 81–82; Ackley 1980, no. 7; Riggs and Silver 1993, pp. 82–83; Leeflang, Luijten, and Nichols 2003, pp. 226–27

VENUE: Paris

CAT. 6

Rembrandt Harmensz. van Rijn

Supper at Emmaus, c. 1629

Oil on paper, attached to panel

14¾ × 16⅝ inches (37.4 × 42.3 cm)

Signed at bottom right: *RHL*

Institut de France, Musée Jacquemart-André, Paris, MJAP-P 848

Plate 4.1, p. 108

VENUE: Paris

PROVENANCE: Count of Robiano; sale, Brussels, May 1, 1837, no. 545; Leroy d'Etiolles; sale, Paris,

February 21, 1861, no. 94; Sedelmeyer sale, Vienna, December 20, 1872; Epstein Collection, Vienna, 1873. Acquired by Edouard André from Sedelmeyer, Paris, in 1891; bequest of Madame Jacquemart-André to the Institut de France, 1912

SELECTED EXHIBITIONS: Amsterdam 1898, no. 8; Paris 1911, no. 124; Amsterdam and Rotterdam 1956, no. 10; Paris 1970–71, no. 169

SELECTED LITERATURE: Dutuit 1885, p. 19; Michel 1894, pp. 144, 563; Von Bode and Hofstede de Groot 1897–1906, vol. 1, p. 50, no. 9; Stedelijk Museum 1898, no. 8; Galerie Nationale du Jeu de Paume 1911, no. 124; Freise 1911, p. 143; Hofstede de Groot 1908–27, vol. 6, p. 91, no. 147; Weisbach 1921, pp. 120–21, 463; Van Rijckevorsel 1932, p. 77; Bredius 1935, no. 539; Stechow 1940–41, p. 110; Hamann 1948, pp. 208, 210–11, 234, 250, 290; Leymarie 1956, pp. 125–26; Röell 1956, no. 10; Benesch 1957, pp. 33, 37; Bauch 1960, pp. 132–33; Roger-Marx 1960, pp. 114, 254, 256, 276, 351, no. 14; Bauch 1966, no. 49; Gerson and Schwartz 1968, pp. 15, 28, 94, 182, no. 14; Lecaldano 1969, no. 22; Bergström 1969, pp. 6–7; Bredius and Gerson 1969, no. 539; Brejon de Lavergnée 1970, no. 169; Schwartz 1984, pp. 50–51; Fendrich 1990, pp. 19–20; Bruyn et al. 1982–2006, vol. 1, pp. 196–201, no. A16; Van de Wetering and Schnackenburg 2001, p. 73; Van de Wetering et al. 2006, pp. 145–46; Schwartz 2006, pp. 338–39

CAT. 7
School of Rembrandt Harmensz. van Rijn
Supper at Emmaus, c. 1630–33

Pen and brown ink with touches of black chalk on paper

3 15/16 × 4 5/16 inches (10 × 11 cm)

Harvard Art Museum/Fogg Museum, Cambridge, Massachusetts, Friends of the Fogg Art Museum Fund, 1968.18

Plate 1.4, p. 7

VENUES: Paris, Philadelphia, and Detroit

PROVENANCE: Wilhelm Bode, Berlin. Lucien Goldschmidt, New York; sold to Fogg Museum, 1968

SELECTED EXHIBITIONS: Cambridge, MA 1968; Chicago, Minneapolis, and Detroit 1969–70, no. 99; Cambridge, MA 1984

SELECTED LITERATURE: Hofstede de Groot 1906b, no. 189; Valentiner 1925–34, no. 525; Stechow 1934, pp. 334–35, fig. 2; Benesch 1935, p. 15; Van Regteren Altena 1948–49, p. 7, fig. 3; Rotermund 1952, p. 103, pl. 19d; Benesch 1954–57, no. 11; Sumowski 1957–58, p. 263, fig. 54; Bauch 1960, p. 284; Sumowski 1961, p. 3; Rotermund 1963, p. 266, fig. 243; Gantner 1964, pp. 102, 109; Fogg Art Museum 1968; Gerson and Schwartz 1968, p. 28; Judson and Haverkamp-Begemann 1969, no. 99; Slive 1978, p. 454, p. 457, fig. 8; Sutton 1986, p. 42; Fendrich 1990, pp. 30–31

CAT. 8
Jacob Adriaensz. Backer (Dutch, 1608/9–1651)
Christ on the Cross, 1631

63 × 45 1/4 inches (160 × 115 cm)

Pavlovsk Palace Museum, Russia, ZH-1660-III

Plate 7.3, p. 182

VENUE: Paris

PROVENANCE: Johann Gotzkowski Collection, Berlin, 1763–64, acquired by Catherine II, Empress of Russia, with his collection; given by the empress to Count Grigory Orlov, 1778; moved to Gatschinka Palace, St. Petersburg, by 1834; in Palace Museum, Pavlovsk, since 1956

SELECTED EXHIBITIONS: Helsinki 2005, no. 72

SELECTED LITERATURE: Bauch 1926, p. 78; Eiskonen et al. 2005, pp. 155–56, no. 73; Van den Brink and Van der Veen 2008, pp. 42–43, appendix A22

NOTE: The top of the painting was apparently originally arched in form.

CAT. 9
Jan Lievens (Dutch, 1607–1674)
Christ on the Cross, 1631

Oil on canvas

50 13/16 × 33 1/16 inches (129 × 84 cm)

Musée des Beaux-Arts, Nancy, no. 94

Plate 7.2, p. 181

VENUE: Paris

PROVENANCE: Peter Wouters, Antwerp, inventory August 23, 1673; sale Amsterdam, October 8, 1799, no. 1; Camus Collection; purchased for the museum in 1793

SELECTED EXHIBITIONS: Braunschweig 1979, no. 27; Leiden 1991–92, no. 68; Amsterdam, Washington, DC, and Milwaukee 2008–9, no. 32

SELECTED LITERATURE: Schneider and Ekkart 1973, p. 102, no. 35; Ekkart, Jacob, and Klessmann 1979, no. 27; Bruyn et al. 1982–2006, vol. 1, pp. 343–44; Sumowski 1983, vol. 3; pp. 1797–98, no. 1245; Schwartz 1985, pp. 86–89; Vogelaar 1991, no. 68; DeWitt 2006, pp. 101–3; Wheelock et al. 2008, no. 32

CAT. 10
Rembrandt Harmensz. van Rijn
Christ on the Cross, 1631

Oil on canvas, glued to panel

39 3/8 × 28 3/4 inches (100 × 73 cm), arched top

Signed and dated below Christ's feet: RHL 1631

Collegiate Church of St. Vincent, Le Mas d'Agenais, France

Plate 7.1, p. 178

VENUE: Paris

PROVENANCE: Gift of Xavier Duffour in 1805, to the Parish church of Mas d'Agenais (originally

located in Tarn-et-Garonne), having acquired it at a family auction in Dunkirk

SELECTED EXHIBITIONS: Paris 1970–71, no. 170

NOTE: State 10 of 10; as renumbered by Erik Hinterding (2006), state 5 of 5.

VENUE: Paris

SELECTED LITERATURE: Bauch 1962, pp. 137–44, no. 20; Bauch 1966, no. 54; Gerson and Schwartz 1968, p. 211, no. 56; Bredius and Gerson 1969, no. 543a; Lecaldano 1969, no. 59; Bergström 1969, pp. 157–60; Brejon de Lavergnée 1970, pp. 168–65, no. 170; Schama 1999, pp. 286–89; Neipp 2001, FP. 79–96; Schwartz 2006, pp. 86, 88–89

NOTES: The painting was relined and attached to a panel by Mortemart at the Louvre in 1854, not transferred. According to Ernst Brochhagen and Jacques Foucart (in Brejon de Lavergnée 1970, p. 170), the face of Christ in Rembrandt's 1633 *Deposition* (Alte Pinakothek, Munich) was originally based on the same model as employed for this painting.

CAT. 11A
Rembrandt Harmensz. van Rijn
The Raising of Lazarus: The Larger Plate
c. 1632

Engraving and etching on paper
Plate 14½ × 10⅞ inches (36.8 × 25.5 cm); sheet 14⅝ × 10¾₆ inches (37.2 × 25.9 cm)
Inscribed: *Rembrandt f.1642* (in plate with 2 in reverse)
The Metropolitan Museum of Art, New York, Gift of Henry Walters, 1917 (17.37.195)
Plate 3.12, p. 96
VENUES: Philadelphia and Detroit

SELECTED LITERATURE: Bartsch 1797, no. 73; Hind 1912, no. 96; White and Boon 1969, no. 73; Schuckman 1996, no. 16b; Hinterding 2006, p. 81

NOTE: State 10 of 10; as renumbered by Erik Hinterding (2006), state 5 of 5.

CAT. 11B
Rembrandt Harmensz. van Rijn
The Raising of Lazarus: The Larger Plate
c. 1632

Engraving and etching on paper
12⅞ × 9⅜ inches (32.6 × 23.8 cm)
Bibliothèque Nationale de France, Paris, Rés. CB-13
Boîte 10

VENUE: Paris

CAT. 12
Rembrandt Harmensz. van Rijn
Christ in the House of Mary and Martha
1632–33

Pen and brown ink on paper
6¼ × 7⅝ inches (15.8 × 19.4 cm)
Teylers Museum, Haarlem, O*46
Plate 3.1, p. 74

VENUE: Detroit

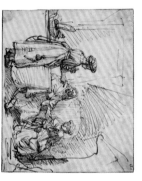

PROVENANCE: J. Pz. Zomer, Amsterdam, his catalogue c. 1722, possibly in portfolio 41; possibly S. van Huls, his sale, The Hague, May 14, 1736, no. 978, bought by Schlij; Thomas Dimsdale; Woodburn 1823; his sale, London, June 17, 1840, Esdaile, July 1835, his sale, London; Sir Thomas Lawrence; William 2d part, no. 93, bought by Hodgson; Mendes de Leon, his sale, Amsterdam, November 20, 1843, bought by Schmidt; H. de Kat, his sale, Rotterdam, March 4, 1867, no. 214, bought by Pool; B. Coster, his sale, Amsterdam, March 18, 1875, no. 83, bought by Van Gogh for the Teylers Museum

SELECTED EXHIBITIONS: London 1835, no. 51; Amsterdam 1951, no. 12; Haarlem 1951, no. 151; Amsterdam 1964–65, no. 100; New York and Chicago 1989, no. 68

SELECTED LITERATURE: Lawrence 1835, no. 51; Vosmaer 1868, p. 508; Vosmaer 1877, p. 591; Lippmann and Hofstede de Groot 1889–1911, vol. 4, no. 170; Von Seidlitz 1894, p. 122; Scholten 1904, p. 106; Hofstede de Groot 1906a, no. 1320; W. Becker 1909, p. 41; Kruse and Neumann 1920, p. 89; Valentiner 1925–34, no. 396; Van Dyke 1927, p. 131; Benesch 1935, p. 15; Stedelijk Museum 1951, no. 12; Geluk 1951, no. 151; Rotermund 1952, p. 110; Benesch 1954–57, no. 79; J. Rosenberg 1956, p. 131; Sumowski 1956–57, p. 257; Drost 1957, pp. 178–79; Frerichs and Verbeek 1964, no. 100; Slive 1965b, vol. 1, no. 180; Schatborn 1981, pp. 18–20, no. 68; Sumowski and Strauss 1979–92, vol. 4, p. 2092; Ackley et al. 1989, pp. 106–7; Royalton-Kisch 1992, p. 41; Plomp 1997, vol. 2, pp. 292–93, no. 322; Bevers et al. 2010, p. 67

NOTE: Peter Schatborn (1981, pp. 18–20) attributed this drawing to Govaert Flinck (Dutch, 1615–1660).

VENUES: Paris and Philadelphia

SELECTED LITERATURE: Blanc 1859, no. 48; Hind 1912, no. 96; White and Boon 1969, no. 73; Hinterding 2006, p. 81

NOTE: State 10 of 10; as renumbered by Erik Hinterding (2006), state 5 of 5.

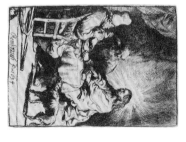

CAT. 13A
Rembrandt Harmensz. van Rijn
Christ at Emmaus, 1634

Etching on paper
Plate 4 × 2⁹/₁₆ inches (10.2 × 7.4 cm); sheet 5⅞ × 4⁹/₁₆ inches (14.9 × 11.6 cm)
Inscribed in lower center of plate: *Rembrandt f.1634*
Museum of Fine Arts, Boston, Katherine E. Bullard Fund in memory of Francis Bullard, 2000.649
Plate 1.3, p. 6
SELECTED LITERATURE: Bartsch 1797, no. 88; White and Boon 1969, no. 88; Baer et al. 2003, pp. 67–79, no. 4
VENUES: Philadelphia and Detroit

CAT. 13B
Rembrandt Harmensz. van Rijn
Christ at Emmaus, 1634

Etching on paper
Plate 4 × 2⁹/₁₆ inches (10.2 × 7.4 cm)
Bibliothèque Nationale de France, Paris, Rés. CB-13
Boîte 13
SELECTED LITERATURE: White and Boon 1969, no. 88
VENUE: Paris

CAT. 14
Rembrandt Harmensz. van Rijn
The Incredulity of Thomas, 1634

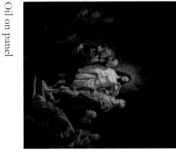

Oil on panel
20⅞ × 19⅞ inches (53.1 × 50.5 cm)
Signed and dated: *Rembrandt. F 1634*
Pushkin State Museum of Fine Arts, Moscow, 2619
Plate 4.5, p. 117

PROVENANCE: Maria Rutgers (widow of Ameldonck Leeuw); by descent, her son David Leeuw (1631/32–1703), inventoried February 7, 1653; Anna van Lennep (widow of P. Roeters and granddaughter of David Leeuw), by 1759; Van Lennep sale, Amsterdam, January 30, 1759, no. 1; bought by the De Neufville brothers, probably Pieter Leendert de Neufville, Amsterdam; Johan Ernst Gotzkowski (1710–1775), Berlin, by 1764; Empress Catherine II of Russia (1729–1796, Czarina from 1762), St. Petersburg, 1764; transferred from the imperial collection to the newly created Imperial Hermitage Museum, 1852; transferred from the Hermitage State Museum to the Pushkin Museum, 1930

SELECTED EXHIBITIONS: Moscow and Leningrad 1936, no. 7; Moscow and Leningrad 1956; Tokyo and Kyoto 1968, no. 4; Moscow 1969; Budapest 1975; Novosibirsk, Krasnoyarsk, and Irkutsk 1987, no. 7; Boston and Chicago 2003–4, no. 47

SELECTED LITERATURE: Von Bode and Hofstede de Groot 1897–1906, no. 133; Hofstede de Groot 1908–27, vol. 6, no. 148; Bredius 1935, no. 552; Vol'skaia and Gershenzon 1936, no. 7; Vippera and Levinson-Lessing 1956, pp. 50–51; Bauch 1966, no. 60; Nihon Keizai Shimbun 1968, no. 4; Egorova, Levitin, and Danilova 1969, pp. 10, 12, 17; Bolten 1981, pp. 1–30; Bruyn et al. 1982–2006, vol. 2, pp. 299, 352, 469–78, 654, no. A 90; Schwartz 1985, pp. 170, 172; Baer et al. 2003, pp. 114–15, no. 47; Senenko 2009, pp. 318–22

CAT. 15
Rembrandt Harmensz. van Rijn
Jesus and His Disciples, 1634

Black and red chalks, pen and brown ink, and various washes on paper
14 1/16 × 18 13/16 inches (35.7 × 47.8 cm)
Signed and dated, top right: *Rembrandt f 1634*
Teylers Museum, Haarlem, O*47
Plate 4.4, p. 116

VENUE: Paris

PROVENANCE: E. Valckenier-Hooft; her sale, Amsterdam, August 31, 1796, no. A4, bought by Hendriks for the Teylers Museum

SELECTED EXHIBITIONS: London 1929, no. 572; Amsterdam 1932, no. 231; Haarlem 1951, no. 148; Amsterdam and Rotterdam 1956, no. 28; Brussels and Hamburg 1961, no. 47; Amsterdam 1964–65, no. 108; Berlin, Amsterdam, and London 1991–92, no. 6 (Berlin and Amsterdam only)
1977, no. 33; New York 1979–80, no. 2; Washington, DC 1983–84, no. 15; New York 1995–96, no. 56

SELECTED LITERATURE: Vosmaer 1868, p. 440; Vosmaer 1877, p. 506; Lippmann and Hofstede de Groot 1889–1911, vol. 1, no. 165; Michel 1893, p. 592; Von Seidlitz 1894, p. 121; Scholten 1904, p. 106; Hofstede de Groot 1906a, no. 1319; Weisbach 1926, pp. 141–42; Van Dyke 1927, p. 29; Valentiner 1925–34, no. 363; Frederik A. Müller & Co. 1929, p. 76; Royal Academy of Arts 1929, no. 572; Hell 1930, pp. 18, 20; Schmidt-Degener 1932, no. 231; Lugt 1933, p. 47; Benesch 1935, p. 20; Benesch 1947, p. 22; Van Regteren Altena 1948–49, no. 18; Geluk 1951, no. 148; Benesch 1954–57, no. 89; Van Gelder 1955, p. 396; Knüttel 1956, p. 54; Röell 1956, no. 28; Rotermund 1956, pp. 197–201; Boon et al. 1961, no. 47; Rotermund 1963, pp. 181–82, no. 184; Frerichs and Verbeek 1964, no. 108; Slive 1965b, vol. 1, no. 1755; Gerson and Schwartz 1968, p. 225; Haak 1969, p. 113; Benesch and Benesch 1973, no. 89; Van Gelder et al. 1973, p. 192; Knipping 1974, vol. 2, p. 450; Bruyn et al. 1982–2006, vol. 2, pp. 473, 476; Schatborn 1985, p. 22; Schatborn 1986, p. 62; Tümpel and Tümpel 1986, p. 162; Brown et al. 1991, no. 6; Royalton-Kisch 1992, pp. 46, 47, 50, 57, 202; Baker 1993, pp. 77–78; Plomp 1997, pp. 294–95, no. 323

NOTE: On the verso is a half-length sketch of Christ (now barely visible), in red chalk, and accountings in black chalk or pencil in an old hand (not Rembrandt's?).

CAT. 16
Rembrandt Harmensz. van Rijn
The Last Supper, after Leonardo da Vinci
1634–35

Red chalk on paper
14 1/4 × 18 11/16 inches (36.2 × 47.5 cm)
Inscribed and signed in red chalk along the lower border: *Wt|| d|| Rembrandt f* (the words preceding "Rembrandt" were erased at an unknown date); annotated in red chalk at the bottom right: *f 10*
The Metropolitan Museum of Art, New York, Robert Lehman Collection, 1975 (1975.1.794)
Plate 3.4, p. 81

VENUES: Paris and Philadelphia

PROVENANCE: Friedrich Augustus II of Saxony, Dresden (1797–1854), and his descendants; Mr. and Mrs. Silver, Chicago; acquired by Robert Lehman from Silver estate through Knoedler & Co., New York, 1963

SELECTED EXHIBITIONS: Paris 1957, no. 122; Washington, DC, New York, Minneapolis, Boston, Cleveland, and Chicago 1958–59, no. 60; Cincinnati 1959, no. 268; New York and Cambridge, MA 1960, no. 9; Chicago, Minneapolis, and Detroit 1969–70, no. 100; Washington, DC, Denver, and Fort Worth

CAT. 17A
Rembrandt Harmensz. van Rijn
Christ before Pilate: Large Plate, 1636

Etching on paper
Sheet (trimmed to plate mark) 21 3/4 × 17 11/16 inches (55.2 × 44.9 cm)
National Gallery of Art, Washington, DC, Rosenwald Collection, 1943.3.7175
Plate 4.16, p. 135

VENUES: Philadelphia and Detroit

SELECTED LITERATURE: Bartsch 1797, no 77; Hind 1923, no. 143; White and Boon 1969, no. 77

NOTE: State 4 of 5

CAT. 17B
Rembrandt Harmensz. van Rijn
Christ before Pilate: Large Plate, 1636
Etching on paper
21 7/16 × 17 1/2 inches (54.5 × 44.5 cm)
Bibliothèque Nationale de France, Paris, Rés. CB-13, recueil

CAT. 18
Rembrandt Harmensz. van Rijn
Christ as Gardener Appearing to the Magdalene, 1638

Oil on panel

24 × 19½ inches (61 × 49.5 cm)

Signed and dated indistinctly on the tomb to the right: *Rembrandt f.¹ / 1638.*

Her Majesty Queen Elizabeth II, The Royal Collection, London, RCIN 404816

Plate 3.16, p. 103

VENUE: Paris

PROVENANCE: Willem van der Goes, Leiden, 1730; Valerius Röver (1686–1739), Delft, purchased 1721; sold by his widow Cornelia van der Dussen to Willem VIII, Landgraf of Hesse at Kassel; removed from Kassel by Comte Lagrange during French occupation in 1806, entered collection of Empress Josephine at Malmaison, by descent to Eugène de Beauharnais; P. J. Lafontaine (dealer); acquired by exchange by Prince-Regent, later King George IV on November 9, 1821

SELECTED EXHIBITIONS: Manchester 1857, no. 84; London 1946–47, no. 333; The Hague 1948, no. 6; Edinburgh 1950, no. 12; London 1952–53, no. 113; Amsterdam and Rotterdam 1956, no. 34; Manchester 1957, no. 109; London 1971–72, no. 155; London 1988–89, no. 35; Berlin, Amsterdam, and London 1991–92, no. 27

SELECTED LITERATURE: Smith 1829–42, vol. 3, no. 103; Museum of Ornamental Art 1877, no. 842; Waagen 1854, vol. 2, pp. 5, 349–50; Hofstede de Groot 1906b, no. 221; Raaf 1912, pp. 6–8; Hofstede de Groot 1916, no. 142; Bredius 1935, no. 559; Munnings 1946, no. 333; Blunt 1948, no. 6; Waterhouse 1950, no. 12; Van Gelder 1950, p. 328; Royal Academy of Arts 1952, no. 113; Slive 1953, pp. 46, 174; Röell 1956, no. 34; Manchester City Art Gallery 1957, no. 109; Bauch 1966, no. 66; Bredius and Gerson 1969, no. 8; Haak 1969, pp. 154, 333, fig. 241; Miller 1971, no. 15; Johnson 1988, no. 35; Brown et al. 1991, no. 27

NOTE: J. de Decker's sonnet about the painting, from the 1726 edition of his 1660 *Rijmoefeningen*, vol. 2, p. 330, is copied on a piece of paper glued to the back of the panel (Brown et al. 1991, no. 27).

CAT. 19
Rembrandt Harmensz. van Rijn
Christ on the Road to Emmaus, c. 1639

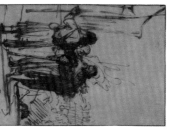

Pen and brush, gallnut ink on paper

8⁵⁄₁₆ × 6⁵⁄₁₆ inches (22.6 x 16.1 cm)

National Gallery of Scotland, Edinburgh, D5131

Plate 4.13, p. 131

VENUE: Detroit

PROVENANCE: B. Houthakker; J. Theodor Cremer; sale Sotheby's New York, January 16, 1985, no. 118

SELECTED LITERATURE: Benesch 1964, pp. 110–12; Benesch 1970–73, vol. 1, pp. 250–51; Benesch 1973, no. 68a; Andrews 1985, p. 122

SELECTED EXHIBITIONS: London 1929, no. 589; Cambridge, UK 1966, no. 4; Chicago, Minneapolis, and Detroit 1969–70, no. 121; Cambridge, UK 1979, no. 165; Washington, DC, and Fort Worth 1989–90, no. 88; Munich, Heidelberg, Braunschweig, and Cambridge, UK 1995–96, no. 106

NOTES: The wash may have been added later, in the eighteenth century; Peter Schatborn stated that he does not accept the attribution to Rembrandt (personal communication, 2009).

CAT. 20
Attributed to Rembrandt Harmensz. van Rijn
Supper at Emmaus, c. 1640–41

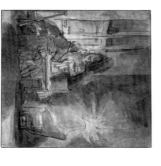

Pen, East India ink, brown ink, and wash on paper, heightened with chalk

7¹¹⁄₁₆ × 7⁷⁄₁₆ inches (19.8 × 18.3 cm)

The Fitzwilliam Museum, Cambridge, R.A. 1937, no. 2139

Plate 1.14, p. 24

VENUE: Detroit

PROVENANCE: Frans van de Velde, sold Amsterdam, January 16, 1775, no. 146; bought by Grebe; possibly sale Simon Fokke, December 6, 1784; possibly W. P. Kops, sold Haarlem, March 14, 1808; bought by Van Leen; J. Goll van Frankenstein, sold July 1, 1833; bought by De Vries; J.L.C. van den Berch van Heemstede, Amsterdam; sold Amsterdam, F. Muller, January 19, 1904, no. 291; bought by Artaria, Vienna; possibly Edward Cichorius; Ricketts and Shannon collection; bequest of Charles Haslewood Shannon, 1937

SELECTED LITERATURE: Lippmann and Hofstede de Groot 1889–1911, vol. 1, p. 193; Wichmann 1923, pp. 102–3; Valentiner 1925–34, no. 528; Royal Academy of Arts 1929, no. 589; Stechow 1934, p. 329ff; Van Regteren Altena 1948–49, p. 12; Slive 1953, pp. 178–79; Benesch 1954–57, no. C47; Cormack 1966, no. 4; Judson and Haverkamp-Begemann 1969, pp. 169–70, no. 122; Darracott 1979, no. 165; B. L. Brown 1989, no. 88; Scrase and Vignau-Wilberg 1995, no. 106

CAT. 21
Rembrandt Harmensz. van Rijn
Christ Awakening the Apostles on the Mount of Olives, c. 1641–42

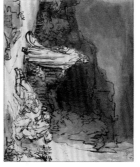

Pen, brown ink, and wash on paper

6⅝ × 8⅛ inches (16.8 × 20.8 cm)

Collection E.W.K., Bern, Switzerland

Plate 1.15, p. 25

VENUES: Paris, Philadelphia, and Detroit

PROVENANCE: Vis Blokhuyzen, Rotterdam; Dr. August Sträter, Aachen, his sale, Stuttgart, Gutekunst, May 10–14, 1898, no. 1175; Prince of Liechtenstein, Schloss Vaduz; his sale, Stuttgart, Stuttgarter Kunstkabinett, November 24–26, 1953, no. 854. Bought from Dr. Bernhard Sprengel, Hannover, 1958–60

SELECTED LITERATURE: Lippmann and Hofstede de Groot 1889–1911, no. 1504; Valentiner 1925–34, no. 447; Benesch 1954–57, no. 513

CAT. 22

Rembrandt Harmensz. van Rijn
Men in Oriental Apparel and Two Half-Length Studies of a Beggar, c. 1641–42

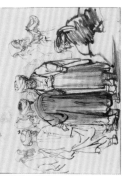

Pen, brush, brown ink, and wash on paper
5⅝ × 7⁷⁄₁₆ inches (14.3 × 18.6 cm)
The Print Room, University of Warsaw Library, inv. zb.d.485
Plate 3.11, p. 93

VENUES: Paris, Philadelphia, and Detroit

PROVENANCE: Count Stanisław Kostka Potocki, donated to the Print Room of the University of Warsaw Library, 1818–21

SELECTED EXHIBITIONS: Warsaw 1956, no. 29; Kansas City, Milwaukee, Montreal, and Hartford 1993–94, no. 72 (Kansas City and Hartford only)

SELECTED LITERATURE: Batowski 1928, p. 41; Benesch 1954–57, no. 667; Golanska and Sawicka 1956, p. 32, no. 29; Sawicka 1977 p. 368; Budzińska 1972, p. 163; Schatborn 1985, p. 60; Royalton-Kisch 1992, p. 86; Kozak, Monkiewicz, and Sulerzyska 1993, p. 101, no. 72; Talbierska 2004, no. 5; Kozak and Tomicka 2009, pp. 61–62, no. 8

CAT. 23A

Rembrandt Harmensz. van Rijn
The Raising of Lazarus: Small Plate, 1642

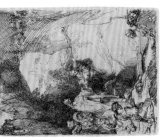

Etching and drypoint on paper
Plate 5⅞ × 4½ inches (15 × 11.5 cm)
Inscribed: *Rembrandt f.1642* in plate, with 2 in reverse
Museum of Fine Arts, Boston, Gift of William Norton Bullard, 1923 (23.1012)
Plate 3.13, p. 97

VENUES: Philadelphia and Detroit

SELECTED LITERATURE: Bartsch 1797, no. 72;
Hind 1923, no. 198; Baer et al. 2003, pp. 198–200, 333, no. 129

NOTES: State 1. Watermark: Foolscap with five-pointed collar variant.

CAT. 23B

Rembrandt Harmensz. van Rijn
The Raising of Lazarus: Small Plate, 1642

Etching on paper
6 × 4½ inches (15.1 × 11.5 cm)
Bibliothèque Nationale de France, Paris, Rés. CB-13
Boîte 10

VENUE: Paris

SELECTED LITERATURE: Hind 1923, no. 198; White and Boon 1969, no. 72

CAT. 24

Rembrandt Harmensz. van Rijn
Christ Preaching, c. 1643

Pen and brown ink on paper
7⁹⁄₁₆ × 9⁹⁄₁₆ inches (19.8 × 23 cm)
Musée du Louvre, Paris, département des Arts graphiques, L. Bonnat Bequest 1919, RF 4717
Plate 3.10, p. 92

VENUES: Paris and Philadelphia

PROVENANCE: Sir Thomas Lawrence. S. Woodburn; sold by Woodburn, London, July 1835; bought by W. Esdaile, London, June 17, 1840, no. 81. G. Leembruggen; sold by Leembruggen, Amsterdam, March 5, 1866, and following days, no. 472; bought by L. Bonnat, no. 62 in his album

SELECTED EXHIBITIONS: Paris 1879, no. 360; Paris 2000, no. 96; Milan 2001, no. 138

SELECTED LITERATURE: Ephrussi and Dreyfus 1879, no. 360; Hofstede de Groot 1908–27, vol. 6, no. 688; Demonts 1920, no. 62; Valentiner 1925–34, no. 358; Neumann 1918, p. 90, fig. 25; Kauffmann 1926, p. 173; Lugt 1933, no. 1131; Benesch 1954–57, no. 543, fig. 673; Jean-Richard 2000, pp. 144–45, no. 96; Marani 2001, no. 138

CAT. 25

Rembrandt Harmensz. van Rijn
Christ and the Woman Taken in Adultery, 1644

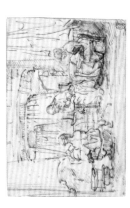

Oil on oak panel
33 × 25¾ inches (83.8 × 65.4 cm)
Signed and dated bottom right: *Rembrandt.f.1644*
The National Gallery, London, NG 45
Plate 3.6, p. 84

VENUES: Paris, Philadelphia, and Detroit

PROVENANCE: Perhaps commissioned by Jan Six (1618–1700), Amsterdam; probably Johannes de Renialme, Amsterdam, inventory 1657, no. 291; probably Jacob Hinlopen, Amsterdam, 1705; Willem Six, Amsterdam, 1718; his sale, Amsterdam, May 12, 1734, no. 5 (bought in). Acquired 1824 with the Angerstein Collection

SELECTED EXHIBITIONS: London 1946–47, no. 67; London 1976, no. 87; London 1988–89, no. 9; Madrid 2008–9, no. 26

SELECTED LITERATURE: Hofstede de Groot 1908–27, vol. 6, no. 104; Bredius 1935, no. 566; Munnings 1946, no. 67; C. Brown 1976, no. 87; Tümpel and Tümpel 1986, pp. 236–37, no. 63; Schwartz 1984, pp. 228–29, no. 248; Johnson 1988, no. 9; Bomford, Brown, and Roy 1988, pp. 86–91, no. 9; MacLaren and Brown 1991, vol. 1, pp. 328–30, no. 9; Bomford et al. 2006, pp. 126–31; Posada Kubissa, Vergara, and Westermann 2008, pp. 172–75, no. 26

CAT. 26

Attributed to Rembrandt Harmensz. van Rijn
Christ in the House of Mary and Martha, c. 1645–50

Pen and brown ink on paper
7 × 10½ inches (17.8 × 26.6 cm)
Staatliche Graphische Sammlung, Munich, 1416 z
Plate 4.19, p. 141

ILLUSTRATED CHECKLIST OF THE EXHIBITION

238

VENUE: Paris

PROVENANCE: Elector Carl Theodor, Munich, inv. no. 1416, inv. 1802–5, no. 4923

SELECTED EXHIBITIONS: Munich 1957, no. 23; Munich 2001–2, no. 56

SELECTED LITERATURE: Hofstede de Groot 1906b, no. 385; Saxl 1908, p. 533; Valentiner 1925–34, no. 398; Bauch 1935, p. 42; Benesch 1954–57, no. 631; Wegner 1957, no. 48; Trautschold 1957, p. 162; Rotermund 1963, no. 180; Wegner 1966, no. 23; Wegner 1973, no. 1094; Vignau-Wilberg and Schatborn 2001, no. 56

CAT: 27
Rembrandt Harmensz. van Rijn
The Supper at Emmaus, 1648

Oil on mahogany panel
26¾ × 25⁵⁄₁₆ inches (68 × 65 cm)
Signed and dated lower left: *Rembrandt. f. 1648*
Musée du Louvre, Paris, département des Peintures, inv. 1739
Plate 1.1, p. xvi

VENUES: Paris, Philadelphia, and Detroit

PROVENANCE: Jan Six, Amsterdam; inherited from his uncle, Willem Six, Amsterdam; sale by Willem Six, Amsterdam, May 12, 1734, no. 57; Th. Wilkens, Amsterdam. Marquis de Lassay, Paris; sale by Marquis de Lassay, Paris, May 22, 1775; Randon de Bosset (1709–1776) sale, Paris, February 27–March 25, 1777, no. 50; sold to Paillet, Parisian dealer of art for Louis XVI

SELECTED EXHIBITIONS: Amsterdam 1935, no. 15; Chicago 1935–36, no. 5; Worcester, MA 1936; Paris 1955, no. 18; Paris 1970–71, no. 177

SELECTED LITERATURE: Descamps 1754, vol. 2, p. 97; Vosmaer 1868, pp. 213–14, 476; Hofstede de Groot 1903–27, vol. 6, pp. 90, 414, no. 145; Bredius 1935, p. 25, fig. 578; Rich 1935, no. 5; Schmidt-Degener 1935, no. 15; Worcester Art Museum 1936; Bouleau-Rabaud 1955, no. 18; Rudrauf 1956, vol. 1, pp. 171–73, no. 154, vol. 2, p. 16, no. 154; Slive 1963a, fig. 10; Gerson and Schwartz 1968, pp. 87, 94, 112, 497; Bredius and Gerson 1969, p. 609, no. 578; Brejon de Lavergnée 1970, pp. 179–80, no. 177; Lecaldano, Veinstein, and Foucart 1971, no. 287; Knipping 1974, pp. 219–21; Foucart 1982, pp. 52–53, 91; Tümpel 1974, p. 178, fig. 3; Foucart 1986, p. 397, no. 69; Keyes et al. 2004, p. 178, fig. 3; Foucart 2009, p. 212

CAT: 28
Studio of Rembrandt Harmensz. van Rijn
Supper at Emmaus, 1648

Oil on canvas
35¼ × 43⅞ inches (89.5 × 111.5 cm)
Statens Museum for Kunst, Copenhagen, KMSsp405
Plate 3.2, p. 78

VENUES: Paris and Philadelphia

PROVENANCE: Acquired by purchase 1759

SELECTED EXHIBITIONS: Stockholm 2005–6; Copenhagen 2006, no. 11

SELECTED LITERATURE: Von Ramdohr 1792, p. 112; Michel et al. 1888, pp. 305–6; Von Bode and Hofstede de Groot 1897–1906, vol. 5, no. 337; Valentiner 1905, pp. 295, 559; Hofstede de Groot 1908–27, vol. 6, p. 90, no. 144; Vollmer 1909, p. 556; Madsen 1911, pp. 7–36; Madsen 1920, p. 140; Hertz 1924, pp. 371, 376; Weisbach 1926, pp. 386, 499; Hind 1932, p. 63; Nilsson 1932, p. 7; Benesch 1935, p. 39; Bredius 1935, no. 579; Hamann 1948, p. 278; Van Regteren Altena 1948–49, pp. 1, 13ff, 18f, 24, 26; Gowing 1952, p. 103; Kai Sass 1953, pp. 112, 115; Bertram 1955, p. 39; Isenstein 1956, p. 14; Plietzsch 1956, p. 213; Reuterswärd 1956, p. 99; Rudrauf 1956, vol. 1, p. 175, vol. 2, p. 156; Sumowski 1957–58, p. 226; Perussaux 1962, p. 322, fig. 4; Gantner 1964, pp. 139–40, 147, 149, 151, 159; Slive 1963a, fig. 9; Bauch 1966, p. 49; Gerson and Schwartz 1968, no. 219; Bredius and Gerson 1969, no. 579, fig. 491; Brejon de Lavergnée 1970, p. 180; Knipping 1974, pp. 220–21; Bolten, Bolten-Rempt, and Adkinson 1977, fig. 370; Reuterswärd 1980, pp. 7, 11, fig. 11; Foucart 1982, p. 52; Zink 1984, pp. 15, 17; Schwartz 1985, p. 247, cat. 247; Guillaud and Guillaud 1986, p. 566, no. 653; Kemp 1986, p. 28; Tümpel and Tümpel 1986, pp. 248, 420, cat. A8; Monrad 1989, pp. 222, 224; Reuterswärd 1991, pp. 337–39; Blankert, Barnouw-de Ranitz, and Stal 1991, p. 172; Slatkes 1992, p. 124; Tejner 1992, vol. 2, p. 74; Tümpel, Tümpel, and Gaskell 1993, pp. 248, 423, cat. A8; Wivel 1994, p. 181; Villadsen 1998, pp. 32, 91, 104, 279–85; Anderberg, Larsen, and Bjerkhof 2005, p. 46; Cavalli-Björkman, Sidén, and Snickare 2005, pp. 77, 81; Ljøgodt 2005, p. 88; Pederson et al. 2006, pp. 80–95, 106–7, 109, 113–14, 190–92, 278, cat. 11; Pederson, Ronberg, and Wadum 2006, p. 9

CAT: 29
Johann Ulrich Mayr (German, 1630–1704)
Christ, c. 1648

Oil on canvas
25⅝ × 21¼ inches (65 × 54 cm)
Private collection
Plate 4.14, p. 132

VENUES: Paris, Philadelphia, and Detroit

PROVENANCE: Galerie Fischer, Lucerne; Dr. Alfred Bader, Milwaukee; Bert van Deun, Beerse

SELECTED EXHIBITIONS: Kalamazoo 1967

SELECTED LITERATURE: Kalamazoo Institute of Arts 1967, p. 9; Sumowski 1983, no. 1449

CAT: 30
Rembrandt Harmensz. van Rijn
Head of Christ, c. 1648

Oil on oak panel
10⅛ × 8¼ inches (25.5 × 21 cm)
Museum Bredius, The Hague, 94-1946
Plate 2.8, p. 67; plates 2.8A, B, pp. 210–11

VENUES: To be determined

PROVENANCE: Lempereur, Paris, May 24, 1773, no. 61 (140 francs). A. Wiegel, Kassel, Germany; purchased by A. Bredius, 1912

SELECTED EXHIBITIONS: The Hague 1915, no. 14; Paris 1921, no. 3; Melbourne and Canberra 1997–98, no. 35; Rotterdam 2000–2001, no. 1; Amsterdam 2006–7

SELECTED LITERATURE: Martin and Moes 1912, no. 15; Bredius and Kronig 1915, no. 14; Hofstede de Groot 1908–27, vol. 6, no. 159; Bénédite 1921, no. 32; Valentiner 1923, p. 25, no. 68; Valentiner 1930a, p. 3; Bredius 1935, no. 620; Rotermund 1956, p. 208, fig. 166; Münz 1957, p. 216; J. Rosenberg 1964, p. 371;

Slive 1964, p. 38; Slive 1965a, Appendix I, no. 1, fig. 1; Bauch 1966, no. 94; Bredius and Gerson 1969, p. 614, no. 620; Blankert 1978, pp. 105–6, no. 135; Blankert, Barnouw-de Ranitz, and Stal 1991, pp. 171–72; Blankert et al. 1997, no. 31; Blankert 2000, cat. 1; Keyes et al. 2004, p. 178, fig. 7; Alexander-Knotter, Hillegers, and Van Voolen 2006, pp. 52–54

CAT. 31
Rembrandt Harmensz. van Rijn
Portrait of a Young Jew, c. 1648

Oil on panel
10 × 8⁹⁄₁₆ inches (25.4 × 21.7 cm)
Staatliche Museen Preussischer Kulturbesitz, Gemäldegalerie, Berlin, inv. 828M
Plate 4.6, p. 118

VENUES: Paris and Philadelphia

PROVENANCE: Acquired 1896, property of Kaiser-Friedrich-Museum-Vereins

SELECTED EXHIBITIONS: Paris 2007, no. 108

SELECTED LITERATURE: Bredius 1935, no. 250; Landsberger 1946, pp. 40–41; Münz 1957, pp. 216–17; J. Rosenberg 1964, pp. 106–18; Bauch 1966, no. 397; Gerson and Schwartz 1968, no. 260; Bredius and Gerson 1969, no. 250; Tümpel and Tümpel 1986, no. 140; Zell 2002, pp. 48–52; Nadler 2003, pp. 51–52; Alexander-Knotter, Hillegers, and Van Voolen 2006, pp. 8–88; Sigal-Klagsbald and Merle du Bourg 2007, pp. 234–36, no. 108

CAT. 32
Rembrandt Harmensz. van Rijn
Seated Man, Half-Length, at Work, c. 1648

Black chalk on paper
5 × 4 inches (12.7 × 10.2 cm)
Private collection, New York
Plate 4.9, p. 124

EXHIBITIONS: Cambridge, MA 1922

SELECTED LITERATURE: Hofstede de Groot 1908–27, vol. 6, p. 239, no. 464; Valentiner 1921, pp. 84, XXII, no. 84; Isarlov 1936, p. 26

VENUES: Paris, Philadelphia, and Detroit

PROVENANCE: J. P. Heseltine; anonymous sale, Christie's New York, January 10, 1990, no. 182; private collection; sale, Christie's New York, January 24, 2008, no. 144

SELECTED LITERATURE: Heseltine 1910, no. 29; Sumowski 1971, pp. 129–32

CAT. 33
Rembrandt Harmensz. van Rijn
Seated Man with Long Hair, Hands Folded
c. 1648

Black chalk on paper
5⁵⁄₁₆ × 3¹³⁄₁₆ inches (13.5 × 9.6 cm)
Collection of Bob P. Haboldt, Paris
Plate 4.10, p. 125

VENUES: Paris, Philadelphia, and Detroit

PROVENANCE: Christie's London, July 8, 2003, lot 100

CAT. 34
Studio of Rembrandt Harmensz. van Rijn
Head of a Pilgrim, c. 1648

Oil on panel
10⅛ × 8⅛ inches (25.7 × 20.6 cm)
Mr. and Mrs. Avram Saban, Miami Beach, Florida
Plate 2.1, p. 46

VENUES: Paris, Philadelphia, and Detroit

PROVENANCE: J. van der Marck, Amsterdam, sale, Amsterdam, August 25, 1773, no. 262, to Fouquet, Paris; Lord Grimthorpe, London; F. Kleinberger, Paris; Watson, New York; John Levy Galleries, New York; Mrs. T. E. Houston, New York, 1943; Major Edward Bauwes, sale, Kende Galleries, New York, November 1, 1946, no. 41

CAT. 35
Rembrandt Harmensz. van Rijn
Head of Christ, c. 1648–50

Oil on oak panel
9¹³⁄₁₆ × 8⁷⁄₁₆ inches (25 × 21.5 cm)
Staatliche Museen Preussischer Kulturbesitz, Gemäldegalerie, Berlin, inv. 811C
Plate 2.6; p. 63; plates 2.6A, B, pp. 206–7

VENUES: Paris and Philadelphia

PROVENANCE: John Henderson, London, February 13, 1882. Rodolphe Kann, Paris, 1907 catalogue, p. 72. Bought by Duveen Brothers, 1907. Presented to the Museum by Mr. and Mrs. Martin Bromberg, Hamburg

SELECTED EXHIBITIONS: Amsterdam and Berlin 2006, no. 57; Madrid 2008–9, no. 29

SELECTED LITERATURE: Von Bode and Hofstede de Groot 1897–1906, vol. 6, no. 413; Valentiner 1908, p. 390; Valentiner 1923a, p. 3; Kunze 1931, no. 811; Bredius 1935, no. 622; J. Rosenberg 1964, p. 371; Slive 1964, p. 38; Slive 1965a, Appendix I, no. 3, fig. 3; Panofsky 1973, pp. 99–100; Schwartz 1984, p. 285; Tümpel and Tümpel 1986, no. 78; Keyes et al. 2004, p. 178, fig. 4; Wheelock et al. 2005, p. 607; Schwartz 2006, p. 303; Van de Wetering et al. 2006, no. 57; Posada Kubissa, Vergara, and Westermann 2008, no. 29

ILLUSTRATED CHECKLIST OF THE EXHIBITION

CAT. 36
Rembrandt Harmensz. van Rijn
Christ in the House of Mary and Martha
c. 1648–50

Pen and wash in brown ink on paper
7 × 10½ inches (17.8 × 26.7 cm)
Paris, Musée des Beaux-Arts de la Ville de Paris, EDUT 01014
Plate 4.18, p. 140

PROVENANCE: J. van der Marck; Ploos van Amstel; A. G. Visser

VENUES: Paris and Philadelphia

SELECTED LITERATURE: Hofstede de Groot 1908–27, vol. 6, no. 771; Valentiner 1925–34, no. 399; Lugt 1927, no. 58; Benesch 1954–57, no. 630.

NOTE: On the reverse is a small sketch of the head of Christ in the same pose, by the same hand.

CAT. 37
Attributed to Rembrandt Harmensz. van Rijn
Head of Christ, c. 1648–54

Oil on oak panel
10 × 8⅜ inches (25.4 × 21.3 cm)
Signed upper left: *Rembrandt f*
Detroit Institute of Arts, Founders Society Purchase, 30.370
Plate 2.7, p. 65; plates 2.7A, B, pp. 208–9

PROVENANCE: J. van der Marck sale, Amsterdam, August 25, 1773, no. 264; Imperial Palace, Pavlovsk, Leningrad. Sold at Rudolph Lepke's, Berlin, June 4, 1929, no. 8; J. Goudstikker, Amsterdam; Founders Society Purchase, Detroit Institute of Arts, 1930

VENUES: Paris, Philadelphia, and Detroit

SELECTED EXHIBITIONS: Amsterdam 1930, no. 49; Detroit 1930, no. 65; Detroit 1949, no. 125; Milwaukee 1947, no. 19; Raleigh, NC 1959, no. 72

SELECTED LITERATURE: Von Bode and Hofstede de Groot 1897–1906, vol. 3, no. 591; Valentiner 1908, pp. 391, 562 Hofstede de Groot 1908–27, vol. 6, no. 161; Galerie Goudstikker 1930, no. 49; Valentiner 1930a, p. 2; Valentiner 1930c, no. 6; Valentiner 1931, no. 99; Bredius 1935, no. 621; Detroit Institute of Arts 1949, no. 125; Beck 1957, no. 19; Byrnes 1959, no. 7?; J. Rosenberg 1964, p. 37?; Slive 1965a, Appendix I, no. 2, fig. 2; Kettlewell 1968, pp. 11, 14, 33, no. 10; Bredius and Gerson 1969, no. 621; Schwartz 1984, p. 284; Tümpel and Tümpel 1986, no. A17; Liedtke et al. 1995, pp. 122–23; Giltaij 2002, p. 152; Keyes et al. 2004, pp. 176–79, no. 72

CAT. 38
Studio of Rembrandt Harmensz. van Rijn, probably a copy after a lost painting by Rembrandt
Head of Christ, c. 1648–55

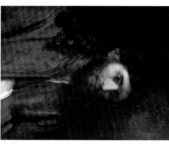

Oil on oak panel
23¾ × 19 inches (60.3 × 48.3 cm)
Museum of Art at Brigham Young University, Provo, Utah, Gift of Vivian Hotchkiss Leonis Vicondo, inv. no. 04028000
Plate 2.10, p. 71

PROVENANCE: With E. Plietzsch, Berlin, 1920. Van Diemen & Co., Berlin, by 1922. Lord Melchett Court, Romney, Hampshire. Duveen Brothers, New York, at least by 1935. Harry John, Milwaukee by 1966; sale, Sotheby's New York, January 11, 1990, no. 45 (withdrawn); Sotheby's New York, January 11, 1996, no. 261; Vivian Vicondo, Utah; donated to Brigham Young University Museum of Art on March 15, 2004

VENUES: Paris, Philadelphia, and Detroit

SELECTED EXHIBITIONS: Cambridge, MA 1927; Northampton, MA 1928; Washington, DC 1941, no. 50; Montreal 1944, no. 50; Los Angeles 1947, no. 20; Raleigh, NC 1956, no. 20; Chicago, Minneapolis, and Detroit 1969–79, no. 19; Provo, UT 2006–7

SELECTED LITERATURE: Hofstede de Groot 1922, p. 4?; Watkins 1941, no. 50; Valentiner and Perrier 1944, p. 3, no. 50; Los Angeles County Museum of Art 1947, p. 70, no. 20; Valentiner 1956, no. 20; Bauch 1966, no. 228; Gerson and Schwartz 1968, pp. 432, 503, no. 378; Bredius and Gerson 1969, no. 627; Judson and Haverkamp-Begemann 1969, p. 49, no. 18; Brown, Holzapfel, and Pheysey 2006, pp. x–xi

CAT. 39
Rembrandt Harmensz. van Rijn
Head of Christ, c. 1648–56

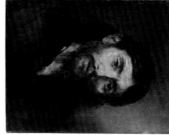

Oil on oak panel
10⅛ × 8⅜ inches (25.5 × 20.4 cm)
Harvard Art Museum/Fogg Museum, Cambridge, Massachusetts, Gift of William A. Coolidge, 1964.172
Plate 2.5, p. 61; plates 2.5A, B, pp. 204–5

PROVENANCE: E. and A. Silberman Galleries, New York, by 1939; sold to Thomas Mitchell, Los Angeles; Paul Kantor Gallery, Los Angeles; William A. Coolidge; gift to Fogg Art Museum, 1964

VENUES: Paris, Philadelphia, and Detroit

SELECTED LITERATURE: Slive 1964, pp. 38–41; Slive 1965a, pp. 407–10; Yale University Art Gallery 1967; Bowron 1990, p. 126, no. 123; Keyes et al. 2004, pp. 176–79, fig. 5; Jordan 2005, pp. 93–94; Wheelock et al. 2005, pp. 121–25

SELECTED EXHIBITIONS: New Haven 1967

NOTE: A version of this painting, perhaps from the seventeenth century, exists on canvas, measuring 25 × 20⅞ inches (63.5 × 52 cm), reportedly from the Duke of Brunswick and thence to a private collection in Dresden, and from there to the dealer Van Diemen in Berlin (per notes written on Rijksbureau voor Kunsthistorische Documentatie photo mount).

CAT. 40
Rembrandt Harmensz. van Rijn and Studio
Head of Christ, c. 1648–56

Oil on oak panel, laid into larger oak panel
14⅛ × 12⅛ inches (35.8 × 31.2 cm)
Signed lower right: *Rembran. / f. 1656*

Philadelphia Museum of Art, John G. Johnson Collection, cat. 480

Plate 2.2, p. 51; fig. 2.1, p. 30; plates 2.2A, B, pp. 200–201

VENUES: Paris, Philadelphia, and Detroit

PROVENANCE: Louis-Michel van Loo sale, Paris, November 1772, no. 27; Mme. De Saulcy, Paris; Comte de la Bégassière, Paris; Sedelmeyer, Paris, 1901; sold to John G. Johnson

SELECTED EXHIBITIONS: San Francisco 1939–40, no. 76; Cambridge, MA 1948

CAT. 42
School of Rembrandt Harmensz. van Rijn
Portrait of a Jew in Profile, c. 1648–56

SELECTED LITERATURE: Basan 1772, pp. 21–22; Vosmaer 1868, p. 555; Vosmaer 1877, p. 555; Dutuit 1885, p. 53; Von Bode and Hofstede de Groot 1897–1906, vol. 4, p. 8, no. 412; Sedelmeyer Gallery 1901, p. 40; Grant 1908, p. 141; Valentiner 1908, p. 390; Hofstede de Groot 1908–27, vol. 4, p. 118; Dacier 1909–21, vol. 5, pp. 18, 29; Johnson, Berenson, and Valentiner 1913, p. 87, no. 480; Valentiner 1931, no. 100; Bredius 1935, no. 624; Bredius 1937, no. 624; California Palace of the Legion of Honor and the M. H. de Young Memorial Museum 1940, no. 76; John G. Johnson Collection 1941, p. 35, no. 480; Douglas 1948, p. 69; J. Rosenberg 1948, p. 371; Fogg Art Museum 1948a, pp. 3, 21; John G. Johnson Collection 1953, p. 157; J. Rosenberg 1964, p. 371; Slive 1964, p. 38; Slive 1965a, Appendix I, no. 4, fig. 4; Sweeny 1972, pp. 70, 227; Sumowski 1983, vol. 3, p. 2179; Schwartz 1984, p. 284, no. 318; Schwartz 1985, p. 284, no. 318; Liedtke et al. 1995, p. 122; Keyes et al. 2004, p. 178, fig.

SELECTED EXHIBITIONS: New York 1936, no. 13; San Francisco 1938, no. 888; Los Angeles 1938, no. 21; Basel 1948, no. 23; Stockholm 1956, no. 41

SELECTED LITERATURE: Valentiner 1930a, pp. 2–3, fig. 3; Bredius 1935, no. 625; Schaeffer Galleries 1936, no. 13; Schaeffer Galleries 1938a, no. 888; Schaeffer Galleries 1938b, no. 21; Fogg Art Museum 1942, p. 25; Nationalmuseum, Stockholm 1956, no. 41 (as Bredius 623); J. Rosenberg 1964, p. 371; Slive 1965a, p. 415, no. 5; Keyes et al. 2004, p. 178, fig. 8

CAT. 41
Rembrandt Harmensz. van Rijn
Head of Christ, c. 1648–56

Oil on oak panel
10 1/16 × 7 7/8 inches (25.5 × 20.1 cm)
Private collection
Plate 2.4, p. 59; plate 2.4A, p. 212

VENUES: Paris, Philadelphia, and Detroit

PROVENANCE: H. M. Clark, London; J. Leger, London, 1934; private collection, Basel; Van der Mühl Collection, Basel; Sarasin Collection, Basel; Galerie Katz, Basel, on loan to Schaeffer Galleries, New York; Kunsthandel P. de Boer, Amsterdam, until 1956; private collection

Oil on panel
7 15/16 × 5 11/16 inches (20.2 × 14.5 cm)
Private collection, New York
Plate 4.15, p. 133

VENUES: Paris, Philadelphia, and Detroit

CAT. 43
Studio copy after Rembrandt Harmensz. van Rijn
Head of Christ, c. 1648–56

Oil on oak panel
9 5/16 × 8 1/4 inches (23.7 × 21 cm) oval
Bob Jones University Museum and Gallery, Greenville, South Carolina, Acq. Julius Weitzner, London, in 1963, P. 63,330.27
Plate 2.9, p. 69

VENUES: Paris, Philadelphia, and Detroit

PROVENANCE: London Art Market, around 1961; bought by Julius Weitzner, London, 1963

SELECTED EXHIBITIONS: Lexington 1967

SELECTED LITERATURE: Kelleher 1964, p. 64, fig. 5; Slive 1965a, Appendix II, no. 1. fig. 15; University of Kentucky Art Gallery 1967; Jones 1968, p. 53; Nolan 2001, p. 113, no. 74

CAT. 44A
Rembrandt Harmensz. van Rijn
The Hundred Guilder Print (Christ Preaching; Bring Thy Little Children unto Me), c. 1649

Etching, engraving, and drypoint on paper
11 × 15 1/2 inches (28 × 39.3 cm)
The Metropolitan Museum of Art, New York, H. O. Havemeyer Collection, Bequest of Mrs. H. O. Havemeyer 1929 (29.107.35)
Plate 1.2, p. 2

VENUES: Philadelphia and Detroit

SELECTED LITERATURE: Bartsch 1797, p. 74, no. 74; Hind 1923, no. 236; Blum 1949; Hollstein 1949–, vol. 18, pp. 39, 54, 65, no. B74; Slive 1965a, fig. 8; White and Boon 1969, no. 74; Freylinghuysen 1993, no. 68; Liedtke et al. 1995, pp. 212–13, no. 91

NOTE: State 2 of 2.

CAT. 44B
Rembrandt Harmensz. van Rijn
The Hundred Guilder Print (Christ Preaching; Bring Thy Little Children unto Me), c. 1649

Etching, engraving, and drypoint on paper
11 1/16 × 15 5/16 inches (28 × 39 cm)
Bibliothèque Nationale de France, Paris, Rés. CB-13, Boîte 11

VENUE: Paris

SELECTED LITERATURE: Blanc 1859, no. 49; Hind 1923, no. 236; White and Boon 1969, no. 74

NOTES: State 2 of 2. With a poem along the bottom signed by H. F. Waterloos.

CAT. 45

Schelte Adamsz. Bolswert (Flemish, 1586–1659), after Peter Paul Rubens (Flemish, 1577–1640)

The Crucifixion, after 1630

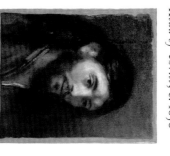

Engraving on paper
21¹¹⁄₁₆ × 14⅛ inches (54.4 × 35.9 cm)
Bibliothèque Nationale de France, Paris, Rés., EC-74c

Plate 7.4, p. 183

VENUE: Paris

SELECTED LITERATURE: Basan 1767, no. 93; Schneevoogt 1873, no. 304; Hollstein 1949–, vol. 3, no. 24; Wheelock et al. 2008, p. 144

CAT. 46

Studio of Rembrandt Harmensz. van Rijn, probably a copy after a lost painting by Rembrandt

Head of Christ, c. 1650

Oil on canvas
16¾ × 13½ inches (42.5 × 34.3 cm); with added strips 18⅝ × 14⅝ inches (47.3 × 37.1 cm)
The Metropolitan Museum of Art, New York, Bequest of Isaac D. Fletcher Collection, Mr. and Mrs. Isaac D. Fletcher, 1917 (17.120.222)

Plate 2.11, p. 73

PROVENANCE: Jan Wandelaar, Amsterdam (until d. 1759; his estate sale, September 4, 1759, no. 13, for fl. 5–:o to Enschedé); Johannes Enschedé, Haarlem (from 1759); [Sedelmeyer, Paris]; Maurice Kann, Paris (by 1883–d. 1906); his nephew, Edouard Kann, Paris (1906–10; sold to Kleinberger);

[Kleinberger, Paris and New York, 1910–12; sold for $55,000 to Fletcher]; Isaac D. Fletcher, New York (1912–d. 1917)

SELECTED EXHIBITIONS: Amsterdam 1898, no. 109; Paris 1911, no. 134; Hempstead, NY 1952, no. 21; New York 1956, no. 17; Indianapolis 1970–71, no. 65; Tokyo and Kyoto 1972, no. 86; Wichita 1977–78, no. 46; San José, Costa Rica 1978, no. 18; Oklahoma City 1979, no. 7; San Diego, Champaign-Urbana, IL, Mobile, AL, Midland, MI, Little Rock, AR 1981–82, no. 49; Hamilton, NY 1983, no. 8; New York 1995–96, no. 35; New York 2007–8

SELECTED LITERATURE: Von Bode 1883, pp. 522–23, 597, no. 295; Dutuit 1885, pp. 51, 60, 69, no. 78; Von Wurzbach 1886, no. 301; Michel 1894, vol. 2, p. 239; Von Bode and Hofstede de Groot 1897–1906, vol. 6, pp. 8–9, 60, no. 414; pl. 414; Hofstede de Groot 1898, no. 109; Sedelmeyer 1898, p. 168, no. 149, p. 169; Bell 1899, pp. 84, 175; A. Rosenberg 1906, pp. 331, 426; Hofstede de Groot 1908–27, vol. 6, p. 117, no. 160; A. Rosenberg 1909, pp. 393, 590; Von Wurzbach 1910, p. 414; Kleinberger Galleries 1911, pp. 74–75, no. 56; Martin 1911a, p. 504; Martin 1911b, p. 173; Von Bode 1911, p. 8; Anonymous 1917, p. 4; Hofstede de Groot 1922, p. 41; Burroughs 1923, p. 273; Meldrum 1923, p. 202, pl. 407; Valentiner 1923, p. 126; Valentiner 1930a, p. 3; Valentiner 1931, no. 104, pl. 104; Bredius 1935, p. 27, no. 626, pl. 626; The Metropolitan Museum of Art 1942, pls. 25–26; Allen 1945, cover, pp. 75–77; Rotermund 1956, pp. 220–21, fig. 174; Valentiner 1956, under no. 20; Duveen 1957, p. 234; Bauch 1966, p. 12, pl. 196; Gerson and Schwartz 1968, pp. 346–47, 498, no. 258; Bredius and Gerson 1969, pp. 527, 614, no. 626; Judson and Haverkamp-Begemann 1969, p. 39; Lecaldano 1969, p. 114, no. 296; Tonkins 1970, p. 189; Panofsky 1973, p. 100, fig. 23; Wright 1975, pp. 63, 67, pl. 51; Bolten, Bolten-Rempt, and Adkinson 1977, p. 193; no. 376; Ainsworth et al. 1982, p. 97 n. 5; Foucart 1982, p. 52; Tümpel and Tümpel 1986, pp. 344–45, 422, no. A20; Jeromack 1988, p. 108; Slatkes 1992, p. 126; Liedtke et al. 1995, pp. 53–74, 118, 120–24, no. 35, figs. 60 and 61; Sotheby's 1996, under no. 261; Blankert et al. 1997, p. 198 n. 7; Liedtke 2007, vol. 2, pp. 708, 749, 758–62, no. 172, pl. 172; Quodbach 2007, p. 37

CAT. 47

Pupil of Rembrandt Harmensz. van Rijn

Christ Conversing with Martha and Mary, c. 1650

Pen, brown ink in two tones, and brown wash, touched with white gouache, on paper
6⅝ × 9³⁄₁₆ inches (16.8 × 23.4 cm)
British Museum, London, PD 1895.0915-1254

Plate 1.11, p. 20

VENUES: Paris, Philadelphia, and Detroit

PROVENANCE: John MacGowan, his sale at Philipe, London, January 26, 1804, no. 539; Thomas Dimsdale; Samuel Woodburn after 1823; John Malcolm of Poltalloch, purchased by the British Museum with his collection

SELECTED EXHIBITIONS: London 1899, no. A12; London 1938, no. 30; London 1956, no. 5; London 1992, no. 93; Amsterdam 2003

SELECTED LITERATURE: Vosmaer 1877, p. 591; Dutuit 1885, p. 85; Royal Academy of Arts 1899, no. A12; Hofstede de Groot 1906b, no. 887; Valentiner 1925–34, no. 397; Benesch 1935, p. 42; Hind 1938, no. 30; Benesch 1954–57, no. 632; White and Croft-Murray 1976, no. 5; Rotermund 1963, p. 181; C. Tümpel 1969, pp. 177–78; Royalton-Kisch 1992, p. 12, fig. 4 + pp. 192–93; no. 93; Van Heugten et al. 2003, pp. 210–11

CAT. 48

Rembrandt Harmensz. van Rijn

Christ Healing a Leper, c. 1650–55

Reed pen, brown ink, and wash with white gouache on paper
5⁹⁄₁₆ × 6⁷⁄₁₆ inches (14.7 × 17.7 cm)
Rijksmuseum, Amsterdam, gift of M. C. Hofstede de Groot, RP-T-1930-24

Plate 3.14, p. 98

VENUE: Paris

PROVENANCE: Jan Pieter, Count van Suchtelen, St. Petersburg, not in his sale, Paris, June 4, 1862;

Remy van Haanen, Vienna; H. Lang Larish, Munich (1900); Cornelis Hofstede de Groot, The Hague, donated 1906, acquired 1930

SELECTED EXHIBITIONS: The Hague 1902–3, no. 71; Leiden 1903, no. 22; London 1904, no. 121; Paris 1908, no. 346; Amsterdam 1913, no. 27; Leiden 1916, no. 81; Paris 1921, no. 57; The Hague 1920, no. 23; Amsterdam 1932, no. 310; Rome and Florence 1951, no. 93; Vienna 1956, no. 129; Stockholm 1956, no. 157; Washington, DC, New York, Minneapolis, Boston, Cleveland, and Chicago 1958–59, no. 71; Amsterdam 1964–65, no. 99

SELECTED LITERATURE: Lippmann and Hofstede de Groot 1889–1911, vol. 2, no. 98; Haagsche Kunstkring 1902, no. 71; Whitechapel Art Gallery 1904, no. 121; Hofstede de Groot 1906b, no. 1270; Wickhoff 1906, no. 26; Courboin, Guibert, and Lemoisne 1908, no. 346; Hofstede de Groot 1908–27, vol. 2, p. 42, no. 28; E. J. van Wisselingh & Co. 1913, no. 27; Stedelijk Museum 1916, no. 81; Hirschmann 1917, p. 19; Bénédite 1921, no. 57; Kauffmann 1922, p. 63; F. Becker 1923, no. 34; Valentiner 1925–34, no. 412; Benesch 1925, p. 128; Van Dyke 1927, p. 29; Brouwer-Sierdsma 1930, no. 23; Hell 1930, pp. 19–20, 113; Schmidt-Degener 1932, no. 310; Benesch 1935, p. 62; Henkel 1943, no. 67; Benesch 1947, no. 257; Van Regteren Altena 1951, no. 93; Benesch 1954–57, no. 1026; Van der Meer 1955, p. 52; Benesch 1956a, no. 129; Nationalmuseum, Stockholm 1956, no. 157; Van Regteren Altena 1958, no. 71; Frerichs and Verbeek 1964, no. 99; Wegner 1973, p. 154; Bernhard 1976, p. 544; Schatborn 1981, p. 14; Hoekstra 1983, vol. 2, p. 20; Schatborn 1985, pp. 94–95, no. 43

NOTES: The contours were incised for transfer by Matthijs Pool (Dutch, 1676–1722/4), who made a print of the drawing. Peter Schatborn (1985, pp. 94–95) noted that an early copy in the Musée du Louvre shows that the drawing was originally larger.

CAT. 49
Attributed to Rembrandt Harmensz. van Rijn
Christ and the Woman Taken in Adultery
c. 1650–55

Pen and brown ink on paper
7⁷⁄₁₆ × 9⁷⁄₈ inches (18.9 × 25 cm)
Nationalmuseum, Stockholm, NMH 1998/1863;
Plate 3.8, p. 87

VENUE: Detroit

PROVENANCE: Perhaps Roger de Piles; Pierre Crozat; C. G. Tessin, his sale 1749; Swedish Royal Library; Swedish Royal Collection

SELECTED EXHIBITIONS: Amsterdam 1935, no. 87; Stockholm 1956, no. 156; Amsterdam and Rotterdam 1956, no. 212; Vienna 1956, no. 137; Stockholm 1967, no. 396; New York, Boston, and Chicago 1969, no. 66; Stockholm 1992–93, no. 154

SELECTED LITERATURE: Lippmann and Hofstede de Groot 1889–1911, vol. 2, no. 12; Hofstede de Groot 1906b, no. 1154; Kruse and Neumann 1920, no. II.5; Valentiner 1925–34, no. 405; Van Rijckevorsel 1932, p. 185; Schmidt-Degener 1935, no. 87; Benesch 1935, p. 62; Benesch 1947, no. 266; Benesch 1954–57, no. 1038; Benesch 1956a, no. 137; Nationalmuseum, Stockholm 1956, no. 156; Röell 1956, no. 212; Clark 1966, pp. 165, 178, 189; Grate 1967, no. 396; Bjurström 1969, no. 66; Cavalli-Björkman and Snickare 1992, p. 355, no. 154

NOTE: Peter Schatborn stated that he does not believe this drawing is by Rembrandt (personal communication, 2009).

CAT. 50
Studio of Rembrandt Harmensz. van Rijn
The Incredulity of Saint Thomas, c. 1650–55

Pen and brown ink on paper
7⁷⁄₁₆ × 12¹⁄₆ inches (19.8 × 30.7 cm)
Staatliche Graphische Sammlung, Munich, 1417 z
Plate 1.10, p. 18

VENUE: Philadelphia

PROVENANCE: Elector Carl Theodor, Munich, inv. no. 1417; inv. 1802/5, no. 5149

SELECTED EXHIBITIONS: Munich 1957, no. 49; Munich 1966–67, no. 135; Munich 2001–2, no. 86

SELECTED LITERATURE: Schmidt 1884–1900, no. 170; Saxl 1908, p. 533; Hofstede de Groot 1908–27, vol. 6, no. 393; Hell 1930, p. 31; Münz 1935, pp. 209–10; Valentiner 1925–34, no. 515; Benesch 1954–57, no. c94; Wegner 1957, no. 49; Clark 1966, pp. 60–61; Wegner 1966, no. 135; Wegner 1973, no. 1195; Vignau-Wilberg and Schatborn 2001, pp. 309–11, no. 86

CAT. 51
Rembrandt Harmensz. van Rijn
The Risen Christ Appearing to the Magdalene (Noli Me Tangere), 1651

Oil on canvas
25⁹⁄₁₆ × 31¹⁄₈ inches (65 × 79 cm)
Signed lower right: *Rembrandt f. 1651*
Herzog Anton Ulrich-Museum, Braunschweig, GG 235
Plate 4.11, p. 127

VENUE: Paris

PROVENANCE: First documented in Salzdahlum in 1710; since 1810 in the Ducal Museum in Braunschweig

SELECTED EXHIBITIONS: Amsterdam and Berlin 2006, no. 56

SELECTED LITERATURE: Querfurt 1710; Bauch 1966, no. 83; Gerson and Schwartz 1968, no. 269; Klessmann 1983, pp. 166–67, no. 235; Tümpel and Tümpel 1986, no. 70; Klessmann 1988, pp. 89–100; Van de Wetering et al. 2006, cat. 56

NOTES: Rüdiger Klessmann (1988) has argued that the poem "Goede Vrijdag" by Jeremias Decker, published in 1660, more logically applies to the Braunschweig painting than it does to the 1638 panel in the Royal Collection (cat. 18), with which it has traditionally been identified, as the latter includes elements not described in the poem or present in the Braunschweig painting. A Rembrandt studio copy of the figure of Christ, excerpted from the Braunschweig painting, painted in oil on panel, 21⁵⁄₈ × 14 inches (55 × 35.6 cm), was sold at Christie's, London, April 27, 2007, no. 47.

CAT. 52
Copy after Rembrandt Harmensz. van Rijn
The Incredulity of Saint Thomas, c. 1651

Reed pen and brown and gray-brown ink on paper
6⁹⁄₁₆ × 10⁵⁄₆ inches (17.6 × 27.1 cm)
Rijksmuseum, Amsterdam. Purchased with support of the Vereniging Rembrandt with additional funding from Prins Bernhard Cultuurfonds
Plate 1.8, p. 16

VENUES: Philadelphia and Detroit

PROVENANCE: Jonkheer Johann Goll van Franckenstein, Amsterdam (not in his sale on July 1, 1833); Jacob de Vos Jbzn., his sale, Amsterdam, May 22–24, 1883, no. 424; acquired by the Vereniging Rembrandt in 1889

SELECTED LITERATURE: Lippmann and Hofstede de Groot 1889–1911, vol. 2, no. 75; Hofstede de Groot 1906a, no. 1175; Neumann 1918, no. 73; Bernard, Bénédite, and Demonts 1921, p. 17; Kruse and Neumann 1920, p. 27; Freise, Lilienfeld, and Wichmann 1921–25, no. 19; Kauffmann 1922, p. 63; Hind 1923, no. 237; Neumann 1923, no. 73; Van Dyke 1927, p. 71; Hell 1930, p. 31; Lugt 1933, no. 1142; Valentiner 1925, no. 513; Benesch 1935, p. 51; Münz 1935, p. 209; Henkel 1943, no. 10; Van Gelder 1951, p. 16; Rotermund 1952, pp. 103–4; Rotermund 1957–53, p. 151; Benesch 1954–57, no. 869; Sumowski 1961, p. 16; Sumowski 1962, pp. 29–30; Rotermund 1963, no. 240; Schatborn 1985, no. 86

NOTES: Peter Schatborn (1985, p. 182) identified this drawing as a copy after a workshop drawing in the Hingst Collection.

CAT. 53A
Rembrandt Harmensz. van Rijn
Christ Preaching ("La Petite Tombe")
c. 1652

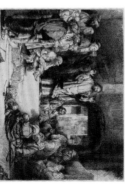

Etching, engraving, and drypoint on paper
Plate 5 13/16 × 8 3/16 inches (15.4 × 20.7 cm); sheet 6 1/4 × 8 5/16 inches (15.9 × 21.1 cm)
Gift of W. G. Russell Allen, 1955.6.5
Plate 3.3, p. 89
VENUES: Philadelphia and Detroit
SELECTED LITERATURE: Bartsch 1797, no. 256; White and Boon 1969, no. 67B; National Gallery of Art 1969, nos. 45, 48
NOTE: Early impression of the only state, with the heavy burr effect, often called the "black sleeve." Nicolaes de La Tombe (1616–1676) commissioned the print and came to own the plate (Hinterding 1994, pp. 261–62).

CAT. 53B
Rembrandt Harmensz. van Rijn
Christ Preaching ("La Petite Tombe"), c. 1652
Etching, engraving, and drypoint on paper
Bibliothèque Nationale de France, Paris, Rés. CB-13
Boîte 9
VENUE: Paris
SELECTED LITERATURE: Blanc 1859, no. 39; Hind 1923, no. 256; White and Boon 1969, no. 67a
NOTE: Later impression of the only state, with the "white sleeve."

CAT. 54
Circle of Rembrandt Harmensz. van Rijn
Christ Conversing with Martha and Mary
c. 1652

Pen and brush in brown ink with gray and gray-brown wash and white gouache on paper
7 1/4 × 10 1/4 inches (18.4 × 26.1 cm)
British Museum, London, PD Oo,10.123
Plate 1.12, p. 21
VENUES: Paris, Philadelphia, and Detroit
PROVENANCE: Marquis de la Mure, his sale, Paris, April 22, 1791, bought by Payne Knight; bequeathed by Richard Payne Knight in 1824
SELECTED EXHIBITIONS: London 1899, no. A88; London 1956, no. 1; London 1992; Amsterdam 2003
SELECTED LITERATURE: Bürger 1858, p. 400; Royal Academy of Arts 1899, no. A88; Hofstede de Groot 1906b, no. 886; Hind 1915, no. 118; Valentiner 1925–34, p. 489; White and Croft-Murray 1956, no. 1; Royalton-Kisch 1992; Van Heugten et al. 2003, pp. 210–11; Royalton-Kisch 2010, no. 112

CAT. 55A
Rembrandt Harmensz. van Rijn
Christ at Emmaus: The Larger Plate, 1654
Etching, engraving, and drypoint on paper
Sheet (trimmed to plate mark) 8 3/8 × 6 3/8 inches (21.2 × 16.2 cm)
National Gallery of Art, Washington, DC,
Gift of W. G. Russell Allen, 1955.6.7
Plate 3.3, p. 80
VENUES: Philadelphia and Detroit
SELECTED LITERATURE: Bartsch 1797, no. 87; Hind 1923, no. 282; White and Boon 1969, no. 87
NOTE: State 3 of 3

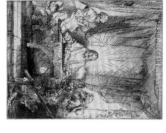

CAT. 55B
Rembrandt Harmensz. van Rijn
Christ at Emmaus: The Larger Plate, 1654
Engraving and drypoint on paper
8 5/16 × 6 5/16 inches (21.2 × 16 cm)
Bibliothèque Nationale de France, Paris, Rés. CB-13
Boîte 12
VENUE: Paris
SELECTED LITERATURE: Hind 1923, no. 282; White and Boon 1969, no. 87
NOTE: State 1 of 3

CAT. 56
Rembrandt Harmensz. van Rijn
The Incredulity of Saint Thomas, c. 1654

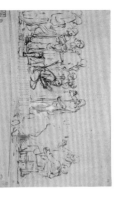

Pen and brown ink on paper
5 7/8 × 9 5/16 inches (15 × 23.9 cm)
Musée du Louvre, Paris, département des Arts graphiques, L. Bonnat Bequest 1919, RF 4726 recto
Plate 1.9, p. 17
VENUES: Philadelphia and Detroit
PROVENANCE: J. Richardson; T. Hudson; J. Reynolds; E. V. Utterson; W. Russell; bought by L. Bonnat Bequest, after 1894

CAT. 57
Follower of Rembrandt Harmensz. van Rijn
Christ Finding the Apostles Asleep on the Mount of Olives, 1654–55

Pen, brown ink, and washes on paper
7 × 9⁹⁄₁₆ inches (17.8 × 24.3 cm)
Staatliche Museen zu Berlin, Kupferstichkabinett, KdZ 2700
Plate 1.13, p. 23
VENUES: Philadelphia and Detroit
PROVENANCE: Th. Lawrence; W. Esdaile; Deperet; Galichon; A. Posonyi
SELECTED EXHIBITIONS: Berlin 1930, no. 398
SELECTED LITERATURE: Lippmann and Hofstede de Groot 1888–1911, vol. 6, no. 66; Freise, Lilienfeld, and Wichmann 1921–25, no. 54; Valentiner 1925–34, no. 450; Friedländer 1930, no. 398; Bock, Rosenberg, and Friedländer 1931, vol. 1, p. 227, inv. 2700

SELECTED EXHIBITIONS: Stockholm 1956, no. 164; Amsterdam and Rotterdam 1956, no. 204; Paris 1970–71, no. 228; Paris 1988–89, no. 57
SELECTED LITERATURE: Dutuit 1885, p. 95; Hofstede de Groot 1908–27, vol. 6, no. 701; Demonts 1920, p. 17; Valentiner 1925–34, no. 514; Benesch Hell 1930, p. 31; Lugt 1933, vol. 3, no. 1142; Benesch 1935, p. 61; Benesch 1954–57, pp. 276–77, no. 1010; Röell Nationalmuseum, Stockholm 1956, no. 164; Röell 1956, no. 204; Sumowski 1961, p. 19; White and Boon 1969, pp. 94–95; Brejon de Lavergnée 1970, no. 228; Bolten 1981, pp. 17, 24; Schatborn 1985, p. 182; Starcky and Bazelaire 1988, p. 65, no. 57

CAT. 58A
Rembrandt Harmensz. van Rijn
Christ Presented to the People (Ecce Homo)
1655

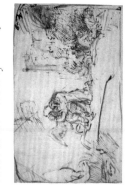

Drypoint on japan paper
Plate 15⅛ × 17⁹⁄₁₆ inches (38.4 × 44.9 cm)
The Metropolitan Museum of Art, New York, Gift of Felix M. Warburg and his family, 1941 (41.1.34)
Plate 4.17, p. 136
VENUES: Philadelphia and Detroit
SELECTED LITERATURE: Bartsch 1797, no. 76; Lugt 1921, no. 219; Hind 1923, no. 271; Stampfle 1969, p. 101, no. 65; White and Boon 1969, no. 76
NOTES: State 2 of 8. The print includes the marks of Barnard and an anonymous collector.

CAT. 58B
Rembrandt Harmensz. van Rijn
Christ Presented to the People (Ecce Homo)
1655

Drypoint on paper
Plate 15⅛ × 17⁹⁄₁₆ inches (38.4 × 45.2 cm)
Bibliothèque Nationale de France, Paris, Rés. CB-13 Ft 3
VENUE: Paris
SELECTED LITERATURE: Blanc 1859, no. 51; Hind 1923, no. 271; White and Boon 1969, no. 76
NOTE: State 3 of 8.

CAT. 59
Rembrandt Harmensz. van Rijn
Christ on the Mount of Olives, c. 1655

Pen and brush with brown ink, traces of body color on laid paper
7¼ × 11¹³⁄₁₆ inches (18.4 × 30 cm)
Inscribed bottom left: *Rembr.*
Kunsthalle, Hamburg, Kupferstichkabinett, 22413
Plate 4.12, p. 128
VENUE: Paris

PROVENANCE: John McGovern (his sale, February 5–6, 1766); William Richardson until 1813; Harzen bequest, 1863, inv. 52
SELECTED EXHIBITIONS: Amsterdam and Rotterdam 1956 (Rotterdam only), no. 217; Munich 1957, no. 31; Hamburg 1967, no. 75; Amsterdam 1969, no. 128; Milan 1970, no. 30; Hamburg 1994–95, no. 100; Bremen 2000–2001, no. 68
SELECTED LITERATURE: Lippmann and Hofstede de Groot 1889–1911, vol. 1, p. 194; Hofstede de Groot 1906b, no. 344; Hind 1923, no. 293; Valentiner 1925–34, no. 454; Pauli 1926, no. 17; Schmidt-Degener 1928, p. 18, fig. 12; Benesch 1935, p. 50; De Tolnay 1943, no. 199; Von Alten 1947, p. 27, fig. 83; Rotermund 1952, p. 107 no. 2; Benesch 1954–57, p. 256; Röell 1956, no. 217; Sumowski 1956–57, p. 256; Wegner 1957, no. 31; Sumowski 1957–58, p. 225, fig. 25; J. Rosenberg 1959, p. 114; Sumowski 1961, p. 16; Haverkamp-Begemann 1961, p. 57; Slive 1965b, vol. 1, p. 138; Hamburger Kunsthalle 1967, no. 75; Hind 1967, fig. 7; C. Tümpel 1968, p. 96, fig. 1; White and Boon 1969, pp. 96, 124; Bonnier 1969, p. 64; Van Thiel 1969, no. 128; Boon 1970, no. 30; Broos 1977, p. 114; Clark 1978, p. 140, fig. 161; Musée du Petit Palais 1986, p. 262, fig. 199; Tümpel and Tümpel 1986, pp. 8, 295; Hamburger Kunsthalle 1987, with no. 92; Brown et al. 1991, vol. 2, p. 93, fig. 25a; Schaar 1994, no. 100; Röver-Kann and Ketelsen 2000–2001, pp. 126–27, no. 68

CAT. 60
Attributed to Rembrandt Harmensz. van Rijn and Studio
Head of Christ, c. 1655

Oil on oak panel
9⅜ × 7⁷⁄₁₆ inches (23.8 × 19 cm)
Netherlands Institute for Cultural Heritage, NK 2774, on loan to Bijbels Museum, Amsterdam
Plate 2.3, p. 57; plates 2.3A, B. pp. 202–3
VENUES: Paris, Philadelphia, and Detroit
PROVENANCE: Probably sale of collection of the widow of Bernard Picart, Amsterdam, May 15, 1737, no. 39 (8 florins, 10). Sale, Sotheby's June 9, 1932, no. 83; H. F. J. Weijers, Tilburg, until July or August 1940; F. Parry (dealer), The Hague; A. Kieslinger, Vienna; Dienststelle Mühlmann,

The Hague; E. Pleitzsch, The Hague and Berlin; A. Neuerburg, Hamburg, September 1940

SELECTED EXHIBITIONS: Eindhoven 1938, no. 81; Amsterdam 2006–7

CAT. 61

Pupil of Rembrandt Harmensz. van Rijn, possibly Willem Drost (Dutch, 1633–1659)
Christ and the Woman Taken in Adultery
c. 1655

Pen and brown ink on paper, white correction at bottom right
7⅝ x 11⅛ inches (19.4 x 28.3 cm)
Museum Boijmans Van Beuningen, Rotterdam, R. 37
Plate 3.7, p. 86

VENUES: Paris and Philadelphia

PROVENANCE: Earl of Dalhousie; P. and D. Colnaghi; P. Cassirer, 1923; F. Koenigs; given by D. G. van Beuningen to the Boymans Museum Foundation in 1940

SELECTED EXHIBITIONS: Amsterdam and Rotterdam 1956, no. 213; Vienna 1956, no. 118; Amsterdam 1964–65, no. 105; Prague 1966, no. 95; Paris 1974, no. 8; Leningrad, Moscow, and Kiev 1974, no. 73; Rotterdam and Istanbul 2005–7

SELECTED LITERATURE: Valentiner 1925–34, no. 407; Weisbach 1926, p. 512; Van Dyke 1927, p. 72; Hell 1930, p. 99, 115; Lugt 1933, no. 1243; Benesch 1935, p. 55; Münz 1935, p. 195; Lugt and Vallery-Radot 1936, p. 66; Borenius 1946, p. 32; Rotermund 1952, p. 101; Benesch 1954–57, no. 964; Röell 1976, no. 213; Benesch 1956a, no. 118; Drost 1960, p. 222; MacLaren 1960, p. 309; Rotermund 1963, p. 187, no. 210; Frerichs and Verbeek 1964, no. 105; Clark 1966, p. 177, fig. 169; Národní Gallery 1966, no. 95; Hoetink and Giltaij 1969, p. 32; Benesch and Giltaij 1973, vol. 5, no. 964, fig. 1246; Meij 1974a, no. 85; Meij 1974b, no. 93; Bernhard 1976, p. 511; Giltaij 1988, no. 52; Elen 2005

NOTE: The top left corner has been repaired; the bottom right has the mark of the Earl of Dalhousie.

NOTES: As Seymour Slive (1965a, p. 416) noted, the French engraver Bernard Picart (1673–1733) published a mezzotint of this panel in 1699 titled *Zenon* in the first state, nothing in the second, and *Zenon Philosophe* in the third and fourth states. Furthermore, a panel described as "Het Hooft van den Philoo." Zeno, van ditto [Rembrandt]" was no. 39 in the May 15, 1737, sale in Amsterdam of Picart's widow's effects.

CAT. 62

Pupil of Rembrandt Harmensz. van Rijn, corrected by Rembrandt
Christ with Two Disciples on the Road to Emmaus, c. 1655

Pen and brush in brown ink and wash with white highlights on paper
7 7/16 × 9¾ inches (19.2 x 24.8 cm)
The Print Room, University of Warsaw Library, zb.d.4280
Plate 1.7, p. 13

VENUES: Paris, Philadelphia, and Detroit

PROVENANCE: Private collection, Amsterdam, 1734, engraved there by Bernard Picart, in reverse, in *Impostures Innocentes*; Count Stanisław Kostka Potocki, donated to Print Room of the University of Warsaw Library in 1818–21

SELECTED EXHIBITIONS: Warsaw 1956, no. 100

SELECTED LITERATURE: Benesch 1954–57, no. 1385; Benesch 1956a, pp. 203–4; Golanska and Sawicka 1956, no. 100; Sawicka 1957, p. 370; Drost 1960; Starcky and Bazelaire 1988, p. 68; Talbierska 2004, pp. 93–94, no. 105; Kozak and Tomicka 2009, p. 74, no. 18

NOTE: Rembrandt corrected the features of the figures on the left and added a hand, and reworked the figure of Christ (Benesch 1973, no. 1385).

CAT. 63

Rembrandt Harmensz. van Rijn
Christ and Two Disciples on Their Way to Emmaus, 1655–56

Pen and brown ink with traces of white body color on paper
6½ × 8⅞ inches (16.5 × 22.4 cm)
Musée du Louvre, Paris, département des Arts graphiques, inv. 22886
Plate 1.6, p. 12

VENUES: Paris and Detroit

PROVENANCE: Pierre-Jean Mariette. Sold, Paris, November 15, 1775, no. 979; acquired by the Office of the King, 1775

SELECTED LITERATURE: Musée du Louvre 1820, no. 488; Musée du Louvre 1838, no. 856; Both de Tauzia 1888, no. 2076; Bruel 1908, p. 462; Hofstede de Groot 1908–27, vol. 6, no. 612; Kleinmann 1913, vol. 5, pl. 35; Bernard, Bénédite, and Demonts 1921, pl. 31; Valentiner 1925–34, no. 521; Hell 1930, p. 37; Lugt 1933, no. 1328; Benesch 1935, p. 56; Rouchès 1937, no. 150; Benesch 1947, no. 240; Rotermund 1952, p. 103, pl. 19c; Benesch 1954–57, vol. 5, no. 987, fig. 1201; Drost 1960, pp. 225–26, pl. 8; Roger-Marx 1960, fig. 93a; Bacou 1967, no. 194; Bacou et al. 1970, no. 225; Starcky and Bazelaire 1988, no. 58; Schatborn, Tuyll van Serooskerken, and Grollemund 2006, no. 55

SELECTED EXHIBITIONS: Paris 1820, no. 488; Paris 1838, no. 856; Paris 1841, no. 856; Paris 1937, no. 150; Paris 1967, no. 194; Paris 1970, no. 225; Paris 1988–89, no. 58; Paris 2006–7, no. 55

CAT. 64

Rembrandt Harmensz. van Rijn
Noli Me Tangere, c. 1655–56

Quill and reed pens in brown ink, with touches of brown wash on paper, corrections in white
8⅝ × 7¼ inches (21.8 × 18.5 cm)
Peck Collection, Boston
Plate 1.5, p. 10

PROVENANCE: Chevalier Ignace-Joseph de Claussin (1766–1844), Paris; Pierre Defer (1798–1870), Paris; Henri Dumesnil (1823–1898), Paris; Defer-Dumesnil sale, Paris, Drouot, May 10–12, 1900, no. 89; Dr. Théodore Tuffier, Paris; Paul Cassirer & Co., Berlin and Amsterdam; Franz Koenigs (1881–1941), acquired through Cassirer during the 1930s; Christine van der Waals-Koenigs, Heemstede; Franz Koenigs Collection sale, Sotheby's New York, January 23, 2001, no. 17

SELECTED EXHIBITIONS: Paris 1908, no. 351; Haarlem 1951, no. 177

SELECTED LITERATURE: Lippmann and Hofstede de Groot 1889–1911, no. 54; Courboin, Guibert, and Lemoisne 1908, no. 351; Valentiner 1925–34, no. 511; Geluk 1951, no. 177; Rotermund 1952, p. 103; Benesch 1954–57, vol. 5, no. 993; Benesch 1960, no. 80; Haverkamp-Begemann 1961, p. 25; Peck and Robinson 2003, pp. 42–45

CAT. 65A
Rembrandt Harmensz. van Rijn
Christ Appearing to the Apostles, 1656

Etching on paper
Plate 6 7/16 × 8 3/16 inches (16.4 × 20.8 cm); sheet 6 5/8 × 8 3/8 inches (16.8 × 21.2 cm)
Signed and dated: *Rembrandt. f 1656*
The Metropolitan Museum of Art, New York, Gift of Felix M. Warburg and his family, 1941 (41.1.43)
Plate 3.45, p. 102

VENUES: Philadelphia and Detroit

SELECTED LITERATURE: Bartsch 1797, no. 8; Hind 1912, no. 237; White and Boon 1969, no. 89

NOTE: On Japanese paper, only state.

CAT. 65B
Rembrandt Harmensz. van Rijn
Christ Appearing to the Apostles, 1656

Etching on paper
Plate 6 7/16 × 8 1/4 inches (16.3 × 21 cm)
Bibliothèque Nationale de France, Paris, Rés. CB-13 Boîte 13

VENUE: Paris

SELECTED LITERATURE: Hind 1912, no. 237; White and Boon 1969, no. 89

CAT. 66
Rembrandt Harmensz. van Rijn
Christ with Arms Folded, c. 1657–61

Oil on canvas
43 × 35 1/2 inches (109.2 x 90.2 cm)
The Hyde Collection, Glens Falls, New York, 1971.37
Plate 4.3, p. 115

VENUES: Paris, Philadelphia, and Detroit

PROVENANCE: Cardinal Joseph Fesch, Rome, 1845; DeForcade, Paris, 1873; Charles Sedelmeyer, Paris; Bamberger, Paris; Count Alexander Orloff Davidoff, Petrograd; A. S. Pushkin State Museum, Moscow; purchased from the Soviet Union in 1933

SELECTED EXHIBITIONS: Paris 1874; New York 1939, no. 308; New York 1942, no. 49; Montreal 1944, no. 44; Cambridge, MA 1948, no. 10; Washington, DC, and Los Angeles 2005, no. 15

SELECTED LITERATURE: Palais de la Présidence du Corps Legislatif 1874; Von Bode 1883, p. 522; Dutuit 1885, p. 54; Michel 1893, pp. 443, 445, 567; Von Bode and Hofstede de Groot 1897–1906, vol. 6, p. 118, no. 162; Valentiner 1920, p. 221; The Pierpont Morgan Library 1939, no. 308; McCall 1942, no. 49; Valentiner and Perrier 1944, no. 44; Fogg Art Museum 1948b, no. 10; Benesch 1956b, p. 348; Rotermund 1956, pp. 233–34; Valentiner 1956, p. 400; Slive 1965, pp. 406–17; Gerson and Schwartz 1968, p. 48, no. 368; Bredius and Gerson 1969, pp. 614–15, no. 628; Kettlewell 1968, pp. 4, 6; Kettlewell 1981, pp. xxii, 108–11, no. 51; Schwartz 1985, pp. 28–5, 315; Tümpel and Tümpel 1986, p. 421, no. A22; Liedtke et al. 1995, p. 124 n. 7; Wheelock et al. 2005, pp. 120–25, 138, no. 15

VENUES: Paris, Philadelphia, and Detroit

Oil on canvas
19 11/16 × 25 3/16 inches (50 × 64 cm)
Musée du Louvre, Paris, département des Peintures, inv. 1753
Plate 3.5, p. 82

VENUES: Paris, Philadelphia, and Detroit

PROVENANCE: Charles-Clause de Flahaut de la Billarderie, compte d'Angiviller, Director General of Royal Buildings from 1774, Paris; seized during the Revolution from his home, Paris, July 20, 1794; Depot at Nesle, no. 1; Musée du Louvre, exhibited at the Château de Compiègne from 1874 to 1901

SELECTED EXHIBITIONS: Paris 1955, no. 19; Cologne 1956, no. 29; Paris 1960, no. 467; Chicago, Minneapolis, and Detroit 1969–70, no. 28; Paris 1970–71, no. 185

SELECTED LITERATURE: Nicolle 1905, pp. 406–7; Hofstede de Groot 1908–27, vol. 6, pp. 91, 414, no. 146; Furcy-Raynaud 1912, p. 248, no. 1; Freise, Lilienfeld, and Wichmann 1921–25, pp. 166–67, no. 98; Bredius 1935, p. 26, no. 597; Bouleau-Rabaud 1955, no. 19; Hours-Miedan 1956, no. 29; Rudrauf 1956, vol. 1, p. 173–75, no. 155, vol. 2, p. 16, no. 156; Institut Néerlandais 1960, no. 467; Gerson and Schwartz 1968, pp. 134, 417, 508; Judson and Haverkamp-Begemann 1969, no. 28; Bredius and Gerson 1969, pp. 611–12, no. 597; Brejon de Lavergnée 1970, p. 192, no. 185; Lecaldano, Veinstein, and Foucart 1971, p. 120, no. 391; Foucart 1982, pp. 76–79, 92; Sumowski 1983, vol. 2, p. 731, vol. 4, p. 2958, no. 1961; Moltke and Belkin 1994, p. 178, no. R37; Milner 2006, pp. 41–44, 102–4; Foucart 2009, p. 218

CAT. 67
Studio of Rembrandt Harmensz. van Rijn
Supper at Emmaus, c. 1660

NOTES: The painting was cut into an oval form in a theft from the Moscow Museum in 1915, and was reunited with the surrounding canvas in 1933. The original canvas was extended by approximately 2 1/2 inches (6 to 7 cm) on each side and a smaller amount at the top and bottom. X-rays reveal that the hands were originally lower and not crossed, leading Wheelock and Sutton (Wheelock et al. 2005) to link them closely to the series of apostles by Rembrandt from about 1661.

CAT. 68
Rembrandt Harmensz. van Rijn
The Risen Christ, 1661
Plate 4.8, p. 120

Oil on canvas
30⅞ × 24⁹⁄₁₆ inches (78.5 × 63 cm)
Bayerische Staatsgemäldesammlungen, Alte Pinakothek, Munich, 6471

Plate 4.2, p. 114

VENUE: Paris

PROVENANCE: Hugo Franz (died 1779), Count of Elz, Dean of Mainz Cathedral

SELECTED LITERATURE: Von Bode and Hofstede de Groot 1897–1906, vol. 6, pp. 9, 64, no. 446; Stedelijk Museum 1898, no. 112; Hofstede de Groot 1908–27, vol. 6, p. 221; Museum zu Allerheiligen 1949, no. 140; Benesch 1976b, p. 351; Bauch 1966, p. 13, no. 240; Gerson and Schwartz 1968, p. 425, no. 360; Bredius and Gerson 1969, p. 615, no. 630; Benesch 1970–75, vol. 1, pp. 190–203; Schwartz 1985, p. 285, no. 321; Steingraber 1986, p. 426, no. 647i; Tümpel and Tümpel 1986, p. 399, no. 87; Brown and Wheelock 1988, no. 39; Giltaij 2002, no. 38; Wheelock et al. 2005, pp. 88–92, 134, no. 6; Dekiert 2006, p. 179

SELECTED EXHIBITIONS: Amsterdam 1898, no. 112; Schaffhausen 1949, no. 140; Washington, DC, and Cincinnati 1988–89, no. 39; Kyoto and Frankfurt 2002–3, no. 38

CAT. 69
Studio of Rembrandt Harmensz. van Rijn
Christ with a Staff, 1661

Oil on canvas
37½ × 32½ inches (95.3 × 82.6 cm)
Inscribed (right center): *Rembrandt f. / 1661*

The Metropolitan Museum of Art, New York, The Jules Bache Collection, 1949 (49.7.37)

VENUES: Paris, Philadelphia, and Detroit

PROVENANCE: Sir C. Bethell Codrington, Bt., Dodington Park, Gloucestershire (by 1836–d. 1843; his estate sale, May 12, 1843, no. 165, to Nieuwenhuys); Chrétien J. Nieuwenhuys, London, from 1843 Baron de Mecklenbourg, Paris (until 1854; his estate sale, Paris, December 11, 1854, no. 15, to Raczynski); Count Raczynski, Rogalin, Poland (1854–1927; sold to Duveen); Duveen, Paris, London, and New York, 1927; sold to Bache; Jules S. Bache, New York (1927–d. 1944; his estate, 1944–49; cats. 1929, unnumbered 1937, no. 38; 1943, no. 37)

SELECTED LITERATURE: Smith 1829–42, vol. 7, pp. 32–33, no. 78; Vosmaer 1877, p. 562; Von Bode 1883, p. 522; Dutuit 1885, pp. 58, 60, 70, no. 80; Von Bode and Hofstede de Groot 1897–1906, vol. 6, p. 9, no. 447; Hofstede de Groot 1898, no. 114; Bell 1899, p. 8; A. Rosenberg 1904, pp. 224, 262; Hofstede de Groot 1908–27, pp. 118–19, no. 164; A. Rosenberg 1909, pp. 454, 478; Errera 1920, p. 302; Valentiner 1920, p. 221; Meldrum 1923, p. 202, pl. 408; Weisbach 1926, pp. 498–99; Eisler 1927, p. 70, pl. 18; Brandus 1928, pp. 189, 192–94; Gibson 1928, p. 320; Alexandre 1929, pp. 121–22; Anonymous 1929a, p. 9; Anonymous 1929b, cover; Bache 1929, no. 38; Heil 1929, p. 4, p. 2; Royal Academy of Arts 1929, no. 127; Cortissoz 1929, pp. 256, 259; Valentiner 1930a, p. 3; Valentiner 1930b, pp. 3, 4; Valentiner 1931, no. 151, pl. 151; Schmidt-Degener 1932, no. 35; M. Knoedler & Co. 1933, no. 12; Bredius 1935, p. 27, no. 629, pl. 629; Bache 1937, no. 38; Duveen Brothers 1941, no. 202; McCall 1942, no. 51; Bache 1943, no. 38; Allen 1945, pp. 75, 77; Rousseau 1952, p. 84; Benesch 1956b, p. 351, fig. 14; Rotermund 1956, p. 230, fig. 182; Bauch 1966, p. 13, pl. 241; Gerson and Schwartz 1968, pp. 702–3, no. 369, p. 429; Bredius and Gerson 1969, p. 615, no. 629, p. 530; Lecaldano 1969, p. 120, no. 397, p. 121; Von Einem 1972, p. 388, fig. 10; Bolten, Bolten-Rempt, and Adkinson 1977, p. 201, no. 529; Strauss and Van der Meulen 1980, p. 480; Ainsworth et al. 1982, pp. 92, 98–99, p. 101, pls. 63–65; Senzoku 1986, no. 12; Simpson 1986a, p. 127; Simpson 1986b, p. 209; Tümpel and Tümpel 1986, p. 400, no. 86, p. 343; Jeromack 1988, p. 103; Broos, Buijsen, and Van Leeuwen 1990, p. 52; Cabanne 1991, p. 152, no. 191; Liedtke et al. 1995, pp. 6, 30, 32, 53, 74, 118, 120, 126–30, figs. 62, 63, 160, no. 37; Liedtke 1998, p. 313; Wright 2000, pp. 173, 176, fig. 156; Wheelock et al. 2005, pp. 29, 110–13, 122, 136–37, no. 12; Wheelock, Woollett, and Sutton 2005, pp. 40–45, no. 12; Van de Wetering et al. 2006, pp. 296–98, no. 77; Liedtke 2007, vol. 1, p. xi, vol. 2, pp. 708, 766–71, 782, no. 174; Quodbach 2007, p. 43; Posada Kubissa, Vergara, and Westermann 2008, p. 182

NOTE: Etched by Georg Friedrich Schmidt (German, 1712–1775).

SELECTED EXHIBITIONS: New York 1912, no. 46; Montreal 1933, no. 41; Montreal 1942, no. 9; Montreal 1944, no. 49; Stockholm 1992–93, no. 63; Melbourne and Canberra 1997–98, no. 25; Paris 2007, no. 109

CAT. 70
Rembrandt Harmensz. van Rijn
Bust of a Young Jew, 1663

Oil on canvas
25⅞ × 22⅝ inches (65.8 × 57.5 cm)
Signed and dated upper right: *Rembrandt f. 1663*
Kimbell Art Museum, Fort Worth, Texas,
AP 1977.04

Plate 4.7, p. 119

VENUES: Paris, Philadelphia, and Detroit

PROVENANCE: Possibly Cardinal Antonio Despuig y Dameto (1745–1813), Rome and Raxa, Palma de Mallorca, Spain; by descent through the counts of Montenegro in Raxa, Palma de Mallorca; Cotoner family (possibly Fernando Cotoner, Marquès de la Cenia), Palma de Mallorca; Rodolphe Kann, Paris, by 1900; sold by his estate to Duveen Brothers, New York and Paris, 1907 possibly M. Knoedler, Paris, 1912; William Cornelius Van Horne, Montreal, by 1912; William Cornelius Van Horne, Montreal, by 1912; by descent until 1945; by descent to Mrs W. C. Van Horne; purchased by Kimbell Art Foundation, 1977

SELECTED LITERATURE: Valentiner 1908, p. 498; Hofstede de Groot 1908–27, vol. 6, no. 407; Knoedler Galleries 1912, no. 46; Art Association of Montreal 1933, no. 41; Bredius 1935, no. 300; Allard and Lyman 1942, no. 9; Valentiner and Perrier 1944, no. 49; Bauch 1966, no. 9; Valentiner and Perrier 1944, no. 49; Bauch 1966, no. 435; Panofsky 1973, pp. 98–99; Robb 1978, pp. 44–47; Tümpel and Tümpel 1986, no. 146; Cavalli-Björkman and Snickare 1992, pp. 214–15; Blankert et al. 1997, pp. 173–77, no. 25; Zell 2002, pp. 48–52; Nadler 2003, pp. 51–52; Sigal-Klagsbald and Merle du Bourg 2007, pp. 234–36, no. 109

INDEX OF NAMES AND WORKS OF ART

PHOTOGRAPHY CREDITS

Photographs were supplied by the owners and/or the following:

Jörg P. Anders: plates 1.13, 2.6, 4.6; figs. 3.4, 3.6, 4.4, 4.5

Michèle Bellot: plate 7.6

Gérard Blot: plate 1.1

Bulloz: plate 4.18

John R. Glembin: plate 4.14

Rik Klein Gotink: plate 2.4

Roland Handrick: fig. 6.4

Katya Kallsen: plate 2.5

Thierry Le Mage: plates 1.6, 1.9, 7.5, 7.8, 7.9

Thierry Olivier: plate 3.10

Herve Lewandowski: plate 3.5

Jan van Esch: plate 2.3

Designed by Katy Homans

Composed in Van Dijck

Printed and bound by Conti Tipocolor S.p.A., Florence, Italy

This book was printed on environmentally friendly Satimat Green, a white, silk-coated paper, 60% recycled, FSC Mixed certified (SGS-COC-003161).

Satimat Green is a product of Arjowiggins Graphic.

SATIMAT GREEN